The Historical Study of Women

The Historical Study of Women

England 1500–1700

Amanda Capern

First published in hardback 2008
First published in paperback with a new preface 2010 by
PALGRAVE MACMILLAN

Palgrave Macmillan in the UK is an imprint of Macmillan Publishers Limited, registered in England, company number 785998, of Houndmills, Basingstoke, Hampshire RG21 6XS.

Palgrave Macmillan in the US is a division of St Martin's Press LLC, 175 Fifth Avenue, New York, NY 10010.

Palgrave Macmillan is the global academic imprint of the above companies and has companies and representatives throughout the world.

Palgrave® and Macmillan® are registered trademarks in the United States, the United Kingdom, Europe and other countries.

ISBN: 978–0–333–66268–7 hardback
ISBN: 978–0–333–66269–4 paperback

This book is printed on paper suitable for recycling and made from fully managed and sustained forest sources. Logging, pulping and manufacturing processes are expected to conform to the environmental regulations of the country of origin.

A catalogue record for this book is available from the British Library.

A catalog record for this book is available from the Library of Congress.

10 9 8 7 6 5 4 3 2 1
19 18 17 16 15 14 13 12 11 10

Printed and bound in Great Britain by
CPI Antony Rowe, Chippenham and Eastbourne

For Glenn and Aubrey, with love

Contents

Acknowledgements

No matter what the pretensions of a survey text such as this to be presenting a new synthesis on a subject it is always going to be indebted to the many historians who have gone before and I therefore thank each and every scholar cited in the footnotes. Marie Peters, Ian Catanach and John Cookson first encouraged me to teach a course on early-modern women's history at Canterbury University, New Zealand. The Scouloudi Foundation awarded me a grant that funded research. I owe a great intellectual debt to my PhD supervisors – Conal Condren and John Gascoigne. I also owe a debt to Jeremy Black, who facilitated this book, and Anthony Fletcher who read, with generosity of spirit, the original proposal. The other debts I owe over many years are to friends in early-modern history – particularly, Ann Hughes, Anne Laurence, Phyllis Mack, John Morrill, Pam Sharpe, Hilda Smith, Judith Spicksley and Sarah Toulalan. Last but definitely not least in this category, Patricia Crawford was a mentor, a supporter and a very dear friend over many years. I miss her. Two anonymous readers offered invaluable advice on the structure of this book which I hope I adequately took, though, of course, errors that remain are my own. My mother and sisters – Terry, Michelle and Andrea – have always been a touchstone of support. The memory of my late father, Ron, lends its own support. My good friends Stephanie Haywood, Carmen Mangion, Louella McCarthy, Louise Robinson and Nicky Stanley helped me keep a sense of humour and successive editors at Palgrave Macmillan helped enormously by keeping faith, most latterly Terka Acton, Beverley Tarquini, Sonya Barker and Kate Haines. My husband, Glenn Burgess, who first suggested I write this book, has now lived with it a long time. So has our son Aubrey. It is to them that it is necessarily dedicated.

Preface

This book is aimed at all students of early-modern history as much as those interested in women's history. Since its first appearance in 2007/8 I have become more rather than less convinced that gender is integral to the study of the past. The phrase 'gender as a category of historical analysis' is one that today frames much historical writing about female and male social identity in historical context. However, even though it was first given currency by Joan Wallach Scott in an article of 1986 (*American Historical Review*, 91:5), the central ideas it encapsulated were not entirely new even then. In a remarkable little book of 1946 called *Woman as Force in History*, Mary Beard claimed that men and women were 'fatefully interlocked' in history. In what Beard termed 'long history', women, she said, 'have done far more than exist and bear and rear children'; rather they 'have played a great role in directing human events as thought and action' (Preface, 13). It seems so obvious that sex and gender are central to the human experience. Gender, as a social construct that defines male and female social place and identity and determines social hierarchies, is embedded in the historical process and can be found located in the languages of social interaction, and the politics both of public and private life. This book assumes the centrality of gender to the history of early-modern England from 1500 to 1700. While it captures and summarises, in as comprehensive a way as possible, all aspects of women's lived experience, it also determinedly looks beyond family life to explore female agency in political and intellectual culture. While doing the former it embeds women firmly in the political events of early-modern England and while doing the latter it acts as a one-stop shop for history students of all the written works by women over the 200 years of the study. The approach is motivated by the belief that the study of women in early-modern England is only complete if women's words and ideas (about male and female social roles and gender relations, about partisan politics and religion and about social change) can be analysed and measured alongside men's. The theoretical underpinning of the book, then, is that the history of female gender construction, or femininity in the case of a book about women, essentially lies at the nexus of social and political history and the history of ideas.

Many histories of early-modern women have made a strong (and feminist) case for female subordination in a society that was patriarchal in thought and structure, one in which the hegemonic ideas about women were framed by men and in which women largely accepted their secondary status in society and had little or no agency. This book claims to be a feminist history too, but it takes issue with the notion that any patriarchal society can be so stable and resistant to change that there is no process of social negotiation and subtle shifts in power and influence that operated not only between the sexes (inter-gender) but between woman and woman as well (intra-gender). Female agency or social and political power, if the 'long history' of early-modern England is fully to be explained,

includes not just the female experience but the shifting negotiation of women's and men's social influence and power over and between one another in different settings and contexts. In other words, female agency is not an isolated category of analysis but is to be found embedded in the historical process itself as society shapes and reshapes over time. The book, therefore, argues, for example, that because what was regarded as feminine in early-modern English society was bound up with questions of morality, religious knowledge and pious spirituality, that the Reformation cannot be fully explained without reference not only to how it affected women but also to a female experience and agency that helped to determine and shape the religious reforming process and English religious culture over 200 years. It also argues that because the religious politics of the sixteenth century were transformed into a complex Civil War in the seventeenth century fought partly through the language of holy war, that gender was crucial to the rhetoric of political conflict from the 1640s onwards. The book, therefore, offers re-evaluations of these key moments of change – Reformation and Civil War – in early-modern English history. The idea is to strengthen the case for a broader understanding of women's historical subjectivity and move it away from the prevalent idea that women's social and political roles and ideas were defined by men or confined to certain spheres of action. Feminist histories of women tend to decry the position of women in the past, but the feminist approach to studying the past is not just about revealing the obvious point that social, political and economic inequalities have existed between the sexes. Instead, feminist history should focus on the female subject to return to her historical agency in a way that can transform – positively – our vision of the past. This is not just a simple case of recovering women and placing them at the centre of a historical study; rather it means reaching an understanding of what women were thinking and how they defined themselves, individually and collectively, and how that ideation and action shaped the world in which they lived rather than just the other way around. At a conference in York recently (*Femininities*, 4 April 2010) Judith Halberstam stated the obvious *viz* that to be feminist is 'to go where the girls are'. By this she meant where women were psychologically and intellectually located in terms of social identity and cultural currency. This book attempts to do this for early-modern England while not for a moment denying the disadvantages early-modern women experienced through legal inequalities in particular.

The structure of the book has meaning and purpose. It begins with ideas about woman, as a social construct defined by men (often negatively, sometimes positively), and ends with chapters specifically on women's ideas on the subjects of religion, politics, sex, marriage, and private life and social welfare, as they were articulated in printed pamphlets and books throughout the period. The approach reveals historical change in ideas about the female body, about women's roles in the family and society, about women's relationship to and participation in the polity and about women's involvement in the intellectual culture of the day. What it also reveals is ideas in flux and in negotiation, rather than fixed and stable, with sex (both biology and sexuality/reproduction) and gender (social identities and roles, and relations between the sexes) embedded in the language

of politics and social commentary as well as that of literary exchange. It reveals female agency present in historical process from 1500 to 1700, but argues for women's social negotiating power improving over time because of the key developments of mass print technology and the interaction of this with education and rising literacy rates. The conclusions of the book are deeply influenced by two seminal works: Elizabeth Eisenstein's *The Printing Press as an Agent of Change* (1979) and Jürgen Habermas's *The Structural Transformation of the Public Sphere* (1962). Taken together these works argue for an early-modern world in which print technology opened up a democratic marketplace of ideas and the argument here is that women were able to exploit the growing world of print culture to alter slightly the social balance of power in favour of their own sex. This book, therefore, makes a case for women themselves shaking off male domination of the construction of femininity found at the beginning of the period. The book argues that critical to this process was women's colonisation and subversion of the negative debate about female nature known to historians as the *querelle des femmes* and their participation in the savage critique of masculinity – which could be called the *querelle des hommes* – that developed in the late seventeenth century. In other words, this is a book that makes the case for the erosion of patriarchal society by 1700. It also suggests that the agenda for nineteenth-century feminism was set by 1700. Many women in early-modern England did strive to claim for their sex a social and political legitimacy based on the moral absolute of sexual equality. Therefore, modern feminism did not begin with the clamour for the vote, but rather with the early-modern female voice when it began articulating arguments about equality in education and marriage and women's rights to the freedoms and responsibilities of full citizenship in the state. Historians always bring a touch of the present into their interpretations of the past and in this I am no different. In the twenty-first century the law legislates for gender equality. So it is perhaps not surprising that one of the major claims of this book is that equalization of feminine and masculine historical subjectivity makes for a lively and interesting study of the past. If any of the conclusions of the book make it into other survey histories of the period, it will have achieved one of its main objectives.

Introduction: Contextualising Early-Modern Women

This book started life as a survey of early-modern women's history and all the main topics of social and political history do receive coverage such as women's experience of family life and marriage, their property ownership, criminality and involvement in politics. However this book also became inspired to answer some questions raised by two books. First, Anthony Fletcher's *Gender, Sex and Subordination in England 1500–1800* (1995), which served to set my mind awhirl with questions about how women's gender construction could ever take place independently from what men wanted women to be in a society he so convincingly painted as a patriarchy. Was femininity really so determined by men? Second, Sara Mendelson's and Patricia Crawford's *Women in Early Modern England* (1998), which argued equally convincingly that women's lived experience cut across the social spectrum resulting in shared feminine identity amongst women. This set me wondering about how women's ideas ever interacted with men's and how the negotiation of gender between the sexes could make a difference to femininity. Was the female sex so hermetically sealed into its own place in the historical moment? So this book has also turned into an extended exploration of the processes involved in the construction of femininity in early-modern England.

 Gender is not the same as biological sex and is taken here to mean the cultural meanings that accrue to the female sexed body or those ideas and terms, signs, words, symbols and images that define the woman as feminine and which collectively shape femininity. Gender is a term that was imported into history by feminist critics beginning with Simone de Beauvoir who said that 'one is not born a woman, but becomes one'.[1] It is that process of 'becoming' that interests gender historians and their approach draws heavily on some of the social constructionist work that originated with the studies of cultural anthropologists such as Margaret Mead whose *Sex and Temperament* of 1935 argued that distinctions between the biological sexes were socially conditioned and Clifford Geertz whose *Interpretation of Culture* of 1975 called for 'thick description' of culture and society.[2] The development of gender history is associated especially with the theoretical work of two historians: Natalie Zemon Davis, who argued that historians should be examining sex roles in the past and the cultural symbolism that defined woman's place in society, and Joan Wallach Scott who argued that gender history was political

by its very nature because it exposed sexual inequality not only through sex roles but also through the way sexual difference and hierarchy was articulated in language.[3]

This book is divided into seven chapters. The first three chapters taken together are focused on those ideas that led to the idealised female gender through prescriptive works that simply asserted what was feminine and works of rhetoric and mockery that underpinned the idealised woman by positing her opposite. Chapter 1 argues that the origins of ideas about women are to be found in Christian texts like the Bible and Classical texts that together constructed woman as being of weak mind and body. It also examines ideas that prevailed about the female body, its sexuality and reproductive functions. For some historians, this question of sexuality is vital to understanding gender. Michel Foucault's work has been seminal in explaining sexuality as socially constructed and therefore inseparable from gender conditioning and identity.[4] Chapter 1 charts change over time in this ideational construction of woman and is essentially in agreement with several historians including Anthony Fletcher that there was a crucial shift at the end of the seventeenth century to the belief that mind and body were separable releasing women from ideas about their lack of reason and educability.

The second chapter is a detailed survey of the debate about female nature that historians have called the *querelle des femmes* or controversy about women. Early-modern men and women would have recognised the debate, which mostly took place in print, as the longstanding joke about women's supposedly natural inclination to sexual impropriety, gabbiness and fractiousness in marriage. The chapter therefore considers the rhetorical reverse side of idealised gender construction and the main conclusion is that at the end of the seventeenth century women joined the *querelle des femmes* and even began an equivalent or *querelle des hommes*, by attacking men and the system of gender training that reduced women to men's slaves especially through unequal education and marriage customs and laws.

The third chapter is about the mechanisms and context for the social prescription of femininity in early-modern England, examining such things as representations of female goodness and beauty and the overarching social prescription of women's sexual chastity (which contrasted so completely with expectation of male infidelity). This chapter deals with the weight of social expectation felt by early-modern women in terms of their looks and behaviour in a sex/gender system that was so firmly patriarchal and based on a double sexual standard that gender formation for women became a process of tense negotiation for them with male norms established about the female sex and its appropriate behaviour. The main conclusion of Chapter 3 is that while religious ideas still underpinned social prescription at the end of the seventeenth century, religious culture itself had changed to a Protestantism that devalued the virginity of the Biblical model of the Virgin Mary and revalued the perfect woman as the pious and restrained wife.

One of the crucial distinctions that should be made is the one between prescription and intellectual foundations – these were not the same. In early-modern England the intellectualised woman was sometimes the opposite of the socially-

prescribed woman. This tension can most clearly be seen in the difference between the intellectualisation of woman as driven by the weakness of Eve into corruption of body and attraction to the Devil and the social prescription of woman as chaste of body and pious of mind and demeanour. Gender construction is a way of explaining the way society is organised so that inequality between the sexes is perpetuated and patriarchy – or male dominance over women – maintained. In the case of prescribed gender the ideal woman was needed to maintain patriarchy and in the case of rhetorical arguments about deviations from the gender norm unfeminine women were needed as a strategy to arrive at reasons for patriarchy.

It is a mainstay of this book that inequality between the sexes was maintained through institutional discourses such as that of education and religion which gave men an 'epistemological advantage' or one that enabled them to control channels of knowledge production and marginalise the female experience.[5] However, there are problems attached to use of the concept of patriarchy.[6] The first is that it is hard to locate its origins historically, though Gerda Lerner did attempt to do this with *The Creation of Patriarchy* in 1988.[7] The second has been the tendency amongst historians to reify patriarchy or turn it into something artificially tangible and monolithic which then makes it difficult to see how social organisation of the sexes ever changes. The last four chapters of this book are an attempt to explore what did change in early-modern England to shift the intellectual foundations and (if at all) the weight of patriarchy.

The fourth chapter is the most focused on the how and why of the social organisation that affected female gender construction. It considers the loci of patriarchal dominance starting with law and the main legal text that dealt with women at different stages in their lives (defined as maid, wife, widow) – *The Lawes Resolutions of Women's Rights* of 1632. The chapter then considers the reach of law into private life by examining marriage (and its dissolution), work occupations, property and the gendered nature of the definition of crime and witchcraft. It is a chapter that touches very much on the condition of women's lives in early-modern England. However, it is less interested in social history than the way gender was constructed in the nexus between the institutional discourse of the law and lived experience. Many of its conclusions concur with those in Mendelson and Crawford's *Women in Early Modern England*.[8] One conclusion is that by the end of the seventeenth century the legal constraints on women loosened over, for example, their working lives, but such was the reassertion of men's right to control women that pockets of gender struggle at law emerged in areas such as marriage dissolution and private property rights. Some contentious decisions have been made in the placement of particular topics. So, for instance, the gendered nature of violence and crime are examined by looking at women as both victims and perpetrators. Also reproduction and production have been placed together because early-modern women themselves made little distinction between the childcare and domestic work they did in paid and unpaid ways. This decision has been informed by the work of historians such as Judith Bennett, who argue that women's historical experience was one largely of continuity in life rather than agency and change.[9] This can be

a radical feminist position to take: it asserts that even the most private areas of women's lives such as pregnancy and parturition were subject to male regulation and that, therefore, women's subordinate role in society was justified by their biological function. However, as a feminist line it has also been mitigated by the idea that women's gender identity might represent a definable female culture, separate from men's culture, which gave women agency within their own historical sphere. This so-called notion of 'female culture' is associated particularly with the work of Carroll Smith-Rosenburg and Linda Kerber and there are methodological echoes in the work of Sara Mendelson and Patricia Crawford.[10]

The fifth chapter of this book is centrally concerned with political power and authority. Joan Wallach Scott once said that 'gender is a primary way of signifying relationships of power' and equally power and politics become important ways for defining gender.[11] Women's exclusion from politics tells us as much about gender as the exercise of power by those women who held positions of public authority. Chapter 5 contains studies of queens, both regnant (privileging Elizabeth I because of the length of her rule and the reach of her historical reputation) and consort (in this case privileging Henrietta Maria because of her role in the causes of the civil war and her centrality in its early military history). One of its main themes is the early-modern perception that female rule or the woman on top in politics constituted a worrying gender inversion. To this end it includes analysis of shifting ideas in political thought that defined both monarchy and subjects.[12] The main conclusion is that while political thought about the origins of monarchy devalued women rulers and that this increased rather than decreased through the period, popular politics featuring female agency dramatically rose in importance in the second half of the seventeenth century.

The conclusions formed from examining private life and politics in early-modern England raise important questions about social organisation and historical change. If 'female culture' reveals a lack of negotiation in gender relations in spaces like the home and if in formal politics the main finding is a reduction of political authority for the female sex, then is it the case that gender hardly changed, except in the direction of a strengthening of men's power over women? It is the main contention of this book that where gender change can be located is in the wake of women's uptake and articulation of religious ideas and in the development of women's writing especially for publication.

Chapter 6 is the longest in the book. Its length reflects the importance of religion to explanations of early-modern femininity. The chapter argues that the seismic cultural shift of the Reformation cannot be fully explained without reference to women. There are several terms that warrant initial explanation here because of their use through the text. At the beginning of the period England was a Catholic country, that is to say its Church owed allegiance to the Pope in Rome and it followed Catholic doctrine. In the 1530s a religious Reformation process began that culminated in England becoming a Protestant country with a confession of faith or doctrinal definition that was determined by the English Church and ratified by the English monarch. One of the purposes of Chapter 6 is to gauge the impact of this religious change on women, as well as women's engagement

with religious ideas. It is important to note that religion and politics were insep-
arable in early-modern England and a woman's private religion was, therefore,
political *per se*. However, the rationale for the chapter is also to insert women
into the historiography (or historical debates) of the very protracted Reformation
process which some historians argue culminated in the 'wars of religion' or civil
war of 1640 to 1660. One of the terms that will be used frequently is 'puritan' and
this can be defined as those particularly zealous Protestant women (and men)
who sought to lead very pious private lives, some of who became involved in the
politics of religious change summed up by the cry for 'further reformation'. It is
an underlying assumption of this book that the Puritanism that started with the
Vestiarian Controversy of the 1560s had led by the 1660s to a quite extraordinary
level of involvement by women in activist and sectarian religious politics.[13] It is
also asserted that Catholic women became religious activists almost by default as
they were forced after the Reformation into an outlawed religious position. It will
become apparent in Chapter 6 that women aligned themselves on all sides of re-
ligious politics during the Reformation and Civil War with a resultant impact felt
on their subjective and collective identity.

Chapter 7 is an exploration of the mutually constructing nature of femininity
and literary cultural production and it is, therefore, centrally concerned with gen-
der and education and how to locate women in the intellectual history of England
between 1500 and 1700. There is one assumption underpinning the chapter and
two over-arching conclusions that arise out of it. The assumption is that while all
women's writing has value to the historian there is a feminine literary canon.[14]
For example, the chapter asserts unashamedly that Mary Sidney was the greatest
Renaissance woman writer and that Margaret Cavendish was the most versatile
and imaginative woman writer of the extraordinary coterie of talent that appeared
after 1650. One conclusion is that a broad (often godly) education replaced the
elite humanist educational principles of the sixteenth century creating a func-
tional literacy amongst women that led directly to women's engagement with
men's ideas about the female sex and to the expression of early feminist thinking
seen most obviously in the work of Mary Astell. However, while this last chapter
argues firmly for a specifically female textual culture, it also argues that feminist
thinking was just one strand of femininity which, by 1700, was multiple and cre-
ated by the interchange between men's and women's ideas about the female sex.

Chapters 6 and 7 between them aim to summarise and analyse most of the
main women's texts of early-modern England and in this sense this is a book of
gender history that attempts to be interdisciplinary. The approach arises from
the belief that history and literary texts are, in a sense, symbiotic and that social
constructions do not exist without ideas. It has, therefore, been a deliberate move
to privilege texts in this work of gender history. In the presentation of ideas found
in women's texts, it becomes clear that while patriarchal ideas and male prescrip-
tion of femininity shaped female behaviour and manner, expectation, ambition
and social presentation, male ideas were not hegemonic and by 1700 this was
so much the case that patriarchy, by definition, was weaker and the motors for

gender change located less in prescription than in women's religious and secular thinking about their place in the world.

The thematic approach of this book has made it difficult at times to decide where to place discussions of some things. Chapter 7, for example, contains summaries of the works of women writers and commentators of the Civil War such as Lucy Hutchinson, Ann Fanshawe and Anne Halkett. However, most historians would place these in the section on the Civil War. It is gender analysis that has determined all decisions of placement, separating into different chapters those women whose gender identity was integrally related to their religious *mentalité* and those whose political identities led them in different literary directions with different results in terms of gender identity. Putting women writers back together again to see what happens with the gender picture then will have to wait for the next book.

1
Woman: Intellectual Foundations

Introduction

This chapter is concerned with the early-modern cultural construction of woman that arose from ideas drawn from the Bible, Christian texts, medical literature and advice manuals relating to women's lives and regulation of their bodies. The chapter has as its over-arching theme the intellectual parameters which helped to define woman as an intellectual category and gave meaning to the female body. Woman was a powerful intellectual construct over which men, as the educated scholars and writers in society, had the most purchase. Men did a lot of writing about women and in so doing they provided the intellectual foundations for the patriarchal ordering of early-modern society. As a consequence men's ideas about woman dominate the anthologies of primary sources about woman that are available to students. However, it can also be argued that while men's ideas dominated notions of what constituted womanhood, women worked hard at a form of individual and collective self-determination as well.[1] But when historians try to recount women's construction of a collective identity they strike a problem in the paucity of written sources left by women. The degree to which this unbalances studies of the cultural construction of woman is difficult to gauge, though what can be established is that while woman was predominantly a male construct, ideas about woman were not forged by men alone and women's gender construction interacted with the intellectual foundations outlined in this chapter. In early-modern England the sexed body itself had a gender, but the degree to which women shared Biblical and Classical conceptions of woman as body and sexual being can only be established through analysing the interaction of scholarly texts with what remains of women's recorded experience.

Christian and classical ideas

The dominant intellectual foundations of womanhood in early-modern England came from Judaeo-Christian texts. It was a society with a Christian *mentalité* – God was a given, not a choice. In terms of gender construction, the Old Testament of the Bible produced a negative stereotype of woman drawn from the first woman, or Eve, in the Book of Genesis. Two ideas about Creation were drawn from Genesis.

First, that Adam and Eve had been created simultaneously (Genesis 1:27). Second, that Eve was created later from Adam's rib (Genesis 2:21–23). The first of these accounts was frequently mooted by theologians who drew from Saint Augustine's Confessions 13 the allegorical notion that Adam was the genderless progenitor of humankind which came 'forth from his womb... [like] salt sea water'.[2] However, it was the latter account, separating Adam and Eve definitively into two sexes and with a sex order, which came to dominate in early-modern religious thought. It provided an explanation of the origins of womanhood that subordinated women to men as, by this account, Eve was created from Adam in order to help Adam (Genesis 2:18). Church of England sermons and 'puritan' lectures, political tracts and advice manuals, all reiterated the Creation parable to present women's role in society as being subordinate and subservient to men.[3]

Genesis additionally supplied the lesson of women's responsibility for sin, one that ensured their exclusion from the ministry. Eve was tempted by the serpent to disobey God and eat an apple from the tree of knowledge. She persuaded Adam to follow her example, resulting in 'the fall' and 'original sin' entering the world (Genesis 3:1–7).[4] A number of conclusions were drawn from this story. Women were considered to be lacking in reason, weak-willed, and naturally-inclined to evil. Eve and Adam's sudden awareness of their nakedness was taken as indicating women's inability to resist lust and their natural lasciviousness. The moral barb embedded in the Biblical story of the Fall was not just a negative stereotype confined to sermons. It informed all genres including literary epic poetry in John Milton's *Paradise Lost* (1667) and it crept into popular conduct books. In *Finch His Alphabet, or, A Godly Direction, Fit To Be Perused by Each True Christian* published in the 1630s, the writer opened with the message 'Adam our Father being the first man, Through Eve his wife the which vile sinne began'.[5] Early-modern visual representations of the Fall showed Eve's face twisted with pain and remorse and the didacticism often went a step further, depicting the serpent with a woman's head even though the Bible gendered the serpent male.[6] Adam and Eve were both punished for their disobedience by being thrown out of the Garden of Eden, Eve's punishment being compounded by her responsibility for Adam's suffering (Genesis 3:23–24).

Women's guilt crossed all literary boundaries. John Marston's play, *The Insatiate Countess* of 1613 shifted in one line from the particular case of his lustful central character to the general case that 'Man were on earth an angel but for woman'. Like the rib from which they were made, 'women are crooked by nature', said Joseph Swetnam in a vitriolic polemical tract called *The Arraignment of Lewd... Women* in 1615: 'no sooner made, but straightway her mind was set upon mischief, for by her aspiring mind and wanton will, she quickly procured man's fall'. John Brinsley's conduct book of 1645, *A Looking-Glass for Good Women*, stressed that it was not Adam but Eve who had been deceived by the serpent; it was she who solicited and he who 'yielded... out of a loving and indulgent affection towards her'.[7] The moral lesson was here aimed not only at women, but also men; women needed firm control. Adam and Eve were deployed to make a particular case about contemporary gender relations, especially in marriage. Swetnam declared that

although women had been made for men 'most of them degenerate from the use they were framed unto … to the great hindrance of their poor husbands'. John Marston's countess set man against man, inciting one of her lovers to kill two others. John Brinsley told his readership that Adam's indulgence of Eve meant that he was 'overcome, even as Sampson was by his Delilah and Solomon by his wives'.[8]

Women's subordination through the telling and retelling of the story of the Fall was lent further credence by reminders of God's specific punishment of Eve: 'I will greatly multiply your pain in childbearing, in pain you shall bring forth children'. The consequent association of childbirth with sin combined with ideas from Judaic law that deemed women unclean during menstruation and after childbirth (longer if they had given birth to a girl than a boy).[9] God's curse on Eve continued with a very specific prescription for women's subordination to men: 'yet your desire shall be for your husband, and he shall rule over you' (Genesis 3:16). This translated into the early-modern marriage service which emphasised women's duty of obedience to their husbands. Although mutuality of honour and love also formed the framework for this ceremony, it was nevertheless the case that 'honour' and 'love' were gendered terms, predicated upon a hierarchical relationship within marriage. The man's love was equated with Christ's love of his church, whereas a woman's love was measured by her faithfulness and obedience.[10]

It is a mistake to think of early-modern theology as simply misogynistic. After the Reformation a Christocentric concept of salvation stressed the spiritual equality of women with men; both sexes were believed to be equally capable of seeking Christ's love and both stood an equal chance of receiving God's grace and salvation. *Finch His Alphabet* reminded readers that after sin entered the world 'God of his mercy thought it very good, We should be sav'd through Christ our Saviour's blood'.[11] Early-modern defenders of women were also able to offer a counterweight to the charge that women were responsible for sin by indicating the way in which Jesus was born of a woman and relied on women at crucial times to reveal to others his role in the salvation of mankind.[12] Nevertheless, this Christian message sat alongside and in tension with the more influential conception of woman as the 'weaker vessel'.[13]

Old Testament ideas combined with a New Testament Pauline theology that lay at the heart of English Protestantism and produced an essentially negative stereotype of women with instruction on how to keep their harmful potential in check.[14] In his first letter to the Corinthians St Paul set out the following hierarchy, drawn partly from the lesson of Genesis: 'But I would have you know, that the head of every man is Christ, and the head of every woman is the man … For the man is not of the woman, but the woman of the man.' This translated into a set of specific instructions about women keeping their heads covered when praying.[15] However, it was, more importantly, taken as a model of social hierarchy, especially in the family.

The principle of a hierarchical ordering of the early church was repeated in Paul's letters to the Ephesians and the Colossians.[16] Women's subordination

required two other social gestures: the first was modesty of apparel, as set out in Paul's letters to Timothy and following the model of the good wife in Proverbs 31; and the second was silence, as indicated in Paul's first letters to the Corinthians and to Timothy. The silence was twofold: silence in the church and silence under the authority of men, specifically husbands. In his letter to Timothy he again called on the order of Creation and responsibility for sin from Genesis to explain the requirement: 'Let the woman learn in silence with all subjection; But I suffer not a woman to teach, nor to usurp authority over the man, but to be in silence; For Adam was first formed, then Eve; And Adam was not deceived, but the woman being deceived was in the transgression.'[17] The influence of the teachings of the epistles of St Paul on clerical attitudes towards women cannot be overestimated. Pauline theology gained considerable ground in the sixteenth century through the sermons and commentaries of John Calvin and much of the Pauline instruction delineated above about women's behaviour in relation to male authority in the church and home was repeated verbatim in the speech delivered by every minister at the end of the marriage service. It was bolstered by the New Testament text of 1 St Peter, which added the requirements of modesty of demeanour, submissiveness, chastity and silence.[18]

Thus, the Bible represented the primary source for early-modern Christian construction of woman, and the supposedly positive constructions of femininity from St Paul and St Peter – silence and chastity being paramount – arose out of the negative portrayal of the first woman – Eve. To be a 'good' woman, a woman had to be the inverse of Eve, drawing on Biblical models such as Sarah, the submissive and obedient wife of Abraham. Margaret Sommerville has pointed out that it was assumed that women would resist their subjection to the rule of men; that their sinfulness and weakness would make them naturally disobedient and that this was an integral feature of the continuing punishment for Eve's sin.[19] In other words, the model of the 'good' woman/wife was there, but the default setting was the negative construction of the 'bad' woman from which all women had a duty to try to escape. The unattainable nature of the 'good' woman made the model of femininity negative in its essence.

The Biblical construction of womanhood was filtered through the writings of the early Church Fathers (the Patriarchs), who were frequently cited as secondary authorities by early-modern writers. The most important was St Augustine (354–430 A.D.).[20] Like St Paul, Augustine tended to bypass the example of Jesus' relations with women to set out the implications of women's secondary creation and Eve's role in the Fall. The serpent chose 'the weaker part of that human alliance' as Adam would not have been deceived: 'The man could not bear to be severed from his only companion, even though this involved a partnership in sin.' In *City of God* Augustine envisaged a utopian spiritual society that was patriarchal, with Christ as the head of man and man as the head of woman. The household was seen as 'the beginning or element of the city', the head of the household was a man and he 'ought to frame his domestic rule in accordance with the law of the city'. Those whom he cared for had a duty of obedience. Thus, in this model, the obedience of women, demanded as the price to pay for Eve's transgression,

was closely linked to civic order through the device of giving a spiritual utopia a temporal framework, with solid walls and houses. This translated into a firm connection made between the nature of women and the potential for social disorder in society. The model of the 'godly household' was regarded as the antidote.[21] The household was not only microcosmic of the orderly state, its maintenance was crucial to the continued stability of the body politic. Indeed in Robert Filmer's *Patriarcha* (1632) the obedience of children encapsulated by the Fifth Commandment 'honour thy father' was the basis of regal authority. Obedience to women in the second half of the commandment 'honour thy mother' was lost in the over-arching formula that at Creation 'man' was given dominion over all.

The other church fathers – most importantly, Tertullian (155–222 A.D.), Origen (185–254 A.D.), Jerome (345–420 A.D.) and Chrysostom (345–407 A.D.) – all owed the same intellectual debt to St Paul. However, according to Katherine Rogers they reinterpreted Biblical material for their own purposes. Patristic writing frequently suggested that while women were physically weaker than men, their souls (which often included the intellect) were equal. The tension between portraying women as weak, yet capable of spiritual equality, can be explained by the Church Fathers inheriting ideas about women's inferiority while also trying to hold up Christian women as exemplars of the early Church.[22] Patristic writings about women range from the misogynistic tirades of Tertullian, who described women as 'the devil's gateway'[23] to the hagiographical texts about women written by some of the lesser known Fathers such as Gregory of Nyssa (*c*.335–395) and Basil of Caesarea (*c*.330–379). The latter used examples of devoted women to promote their Christian mission so John Chrysostom, for instance, supported the teaching work of women deacons.[24] In early-modern England the Church Fathers were usually deployed as authorities to promote the idea of Eve's responsibility for sin, but the missionary imperative also constructed women as guardians of the faith and spiritual rectitude.

Patristic writing also followed Paul in arguing that the celibate life for men was to be preferred to any contact with women.[25] However, Gregory of Nazianus (*c*.329–389) was willing to share the responsibility for sin equally between man and woman[26] and all patristic writing venerated both male and female celibacy. The virginal life for women, or *integritas*, was in some senses to be aspired to more than the celibate life for men, as it enabled women to transcend their sexuality and the association with Eve's sin, particularly if they were called upon to make 'heroic' sacrifices in defence of their virginity.[27] Patristic veneration of female virginity resulted in two things. First, it gave spiritual or moral authority to women who entered monasteries rather than embark upon the only other path open to women, that of marriage. Second, it led directly to a medieval cult of virgin-martyrs that survived into the early sixteenth century and beyond for Catholic women religious.[28]

The deployment of patristic ideas by early-modern writers depended very much on the literary and rhetorical context.[29] For example, in works portraying women in a negative light, Chrysostom's words in support of the female diaconate were absent while his thoughts on how women could be easily seduced by false prophets

were used to persuasive effect.[30] John Knox (1514–1572), the Scottish reformer, in *The First Blast of the Trumpet against the Monstrous Regiment of Women*, trotted out Tertullian because he was most useful to Knox's argument against female rule: 'Dost thou know…Thou art the first transgressor of God's law…And what I pray you is more able to cause woman to forget her own condition than if she be lifted up in authority above man?'[31]

However, if the primary religious text for the construction of femininity – the Bible – provided a negative model in Eve, it also provided the positive model of Mary in the New Testament. Both Eve and Mary worked through men in the scheme of Fall and Salvation that described the relationship between 'man' and God. In this sense, these two representations of women were critical to the schematised Biblical narrative about the way in which God had dealings with his initial Creation – Adam – and Adam's seed. Mary was a very powerful symbol of salvation, one that provided women with an alternative model of femininity. Medieval thinkers such as Bernard of Clairvaux in the twelfth century elevated her to a position of prominence and in the fifteenth century the Dominican cult of the rosary transformed her into an intercessor between God and fallen Man.[32] In her role as mother of Christ, she was the primary agent of man's salvation. The medieval cult of Mary led to her veneration in literature and poetry and to the extensive use of her image in the decoration of churches from the parish church up to the Cathedral and her name was woven into the social fabric of village life. For example, in the church of St Peter and St Paul in Clare, a fifteenth-century rood screen combined the initials M.A.R.I.A. with the family crest of the local lord of the manor. As Susan Groag Bell has pointed out, until the Reformation Mary's image was everywhere: 'in the graceful and nodding statues…in the multitudinous lady chapels…in the thousands of little wayside shrines'.[33]

The medieval cult of Mary complicated the inheritance of early Christian ideas and womanhood became distinctly binary: woman was the 'ianua diaboli', the temptress and wellspring of sin or Eve, but she was also a pure mother figure to be adored. Ideas about female duality, of good and bad co-existing in woman, resulted in the *querelle des femmes*, a debate about women's nature that had at its heart the juxtaposition of the Biblical models of Eve and Mary. Women were like Janus and commentators chose to gaze upon one face or the other according to the rhetorical purpose. However, the second result of medieval Mariolotry was that Mary became a model of positive female identity, but how this worked in England after the destruction of Catholic worship and theology was complex and ambiguous. Mary the virgin floated free from the original religious context of Mary as the mediatrix between God and 'man' and can be seen in non-Catholic works such as Anthony Stafford's *The Femall Glory: Or, the Life and Death of Our Blessed Lady* of 1635.[34] Phyllis Mack has argued that despite the jettisoning of the female saints after the Reformation, the traditional, positive qualities of femininity that they represented, such as 'humility, receptivity and emotionalism', 'remained appropriate to express women's values'.[35] Mary was the *exemplar par excellence* and Ian Maclean has pointed out that Mary's virtues were 'in no way inconsistent with traditional female virtue, and Mary [could] therefore be easily

transformed into a perfect model of womanhood'.[36] The example Phyllis Mack uses indicates that the symbolic, even iconic, nature of Mary was central to this gender construction. In 1675, when George Fox, the Quaker, 'met with a sort of people that held women have no souls' he countered them with the example of Mary who said 'My soul doth magnify the Lord, and my spirit hath rejoiced in God my saviour'. In other words, despite Protestant rejection of the mediating function of Mary, she was still representative of women's spiritual relationship with God and with the goodness of women.

The reasons for the survival of Mary's cultural purchase after the Reformation are complex but several basic suggestions will be made here. First, the work of some historians is indicative of grassroots survival of Catholicism.[37] For Catholic recusant women this meant the continued power of Mary as a symbol of female intercession with God as well as her general iconic status as virgin. However, even Protestant women, who believed that faith in Christ alone would save, could still believe that Mary as the mother of Christ was important in some vague and understated way in this process. Second, the low rates of literacy resulted in visual symbolism retaining its power to persuade and Protestant theology could and often was dressed up with visual images that were redolent of Catholicism. For example, Richard Day's *A Booke of Christian Praiers* (1569) had an elaborate title page with a picture of Mary top-centre with an adult-looking Jesus seated in her lap. The entire cameo is circled with a halo, indirectly suggesting Mary's crucial role in the process of salvation. The tradition of using 'the Virgin' to depict queens in royal iconography was deployed in the reign of Elizabeth I giving Mary further cultural purchase.[38] Tessa Watt has said: '[t]he early seventeenth-century village still contained many images to help its inhabitants in converting the words of the Protestant religion into visualised experience'.[39] Despite the fact that Protestantism outlawed the worship of idols and the reign of Edward VI witnessed the destruction of rood screens and wall paintings, cheaply-printed broadsides and posters with Biblical images circulated widely and were pasted onto walls of homes and taverns. One example was *Christus Natus Est* (1631).[40] The picture was a complex representation of the nativity designed to summarise and reinforce the four texts about the significance of Christ's birth that surrounded it; all of which aimed at different levels of literacy. The central message of the broadside was summarised in two lines just under the title: 'Angels clap hands; Let men forbeare to Mourne: Their saving-Health is come; For CHRIST is Borne'. Mary stands over him, with a halo hovering strategically, just above her head. The Protestant theology was unimpeachable, but the Catholic Marian symbolism was retained and Mary's divinity strongly implied.

Woodcuts of images were used again and again. Images of Mary in composite pictures such as that adorning Day's *Booke of Christian Praiers* might be removed and reused for a cheap and basic Protestant catechism designed to be sold by a chapman at the village level to a yeoman farmer and his wife. In this way the yeoman farmer's wife would daily look upon the same image of Mary as the well-to-do wife of a London merchant who purchased Day's *Booke of Christian Praiers*. As a cultural symbol of women's religious and social identity, the image of Mary

cut across social barriers of wealth placing both women in what Tessa Watt has called '[t]he same iconographical universe'.[41] According to Helen Hackett, Marian iconography was so widely received and disseminated that it 'should not therefore be surprising to find elements of [it] surviving or resurfacing in various areas of culture after the official Reformation'.[42]

The Classical foundations of early-modern ideas about woman also served to produce dualistic woman. Plato (*c*.428–*c*.348 B.C.) believed that women were physically inferior to men, though he had conceived of a civic community in which talented men and women could share in the guardianship of the state.[43] However, his pupil, Aristotle (384–322 B.C.), envisaged a society in which women were 'naturally-suited' to – and therefore confined to – the domestic sphere.[44] These were ideas that were supported by other Classical writers such as Plutarch and Xenophon.[45] It was Aristotelian thought that dominated in late sixteenth-century England and was reinforced by the system of logic based on taxonomic dichotomies invented by Peter Ramus.[46] Aristotle's conception of public life and domestic affairs was arrived at through his dualistic understanding of human physiology. He believed that women were physically passive, with a tendency to inactivity, and that men were active. This sexual difference was determined at conception, with defective conception leading to the birth of a female child. According to Aristotle women's biological inferiority dictated that they were short of prudence (*prudentia*) and judgement (*consilium*), both of which were required for the exercise of authority (*imperium*). Lack of judgement was associated with lack of self-control and emotionality. Thus Aristotelian notions of women's inability to control their passions fitted well with the Biblical model of Eve. It was deduced from this that there was a sexual division of labour and that women's good citizenship was dependent on their obedience as the 'natural' gender order dictated that men were the civic rulers and household masters.[47]

Aristotle's conception of the 'natural' gender order involved thinking in terms of binary opposites: 'subjection by nature' was determined by the soul which had two parts – 'one part commandeth by nature and the other part obeyeth'. Everybody had some of both parts, but social hierarchies, including the gender order, were determined by the balance. Women had some prudence and judgement, but men had so much more that they were 'apt to govern' while women were 'naturally' apt to serve.[48] His views on the social position, qualities and duties of slaves and children were similarly argued. Aristotle saw the household as a microcosm of the state. In *Politics* he stated: 'a husband and father rules over wife and children … For although there may be exceptions to the order of nature, the male is by nature fitter for command than the female.'[49] Similar reasoning is to be found in his book of *Ethics*: 'The man is master, as is right and proper, and manages everything that falls to him to do as head of the household.'[50] By the same logic, the stability of the public sphere was dependent on the maintenance of this 'natural' hierarchical ordering of affairs within the family: 'It is necessary to refer the instructing and ordering of women and children to such magistrates as have the oversight of the states of cities, if it be convenient for the making of a virtuous city.'[51]

Aristotelianism was enormously influential in early-modern England. Its impact was felt in political and legal thinking and Aristotle's conceptualisation of the patriarchal family as the bedrock of stable civil society was most commonly cited by church leaders and jurists alike. There was, in early-modern England, what Margaret Sommerville has called a 'comforting consensus of all authoritative sources' on the subject of woman.[52] The Christian/Aristotelian nexus was, therefore, a very powerful determinant of gender, and ideas about female characteristics inherited from Eve and Mary came together with Aristotelian ideas to create a world in which women's dualistic nature was permanently under discussion and their social and political subordination was accounted for by their biological 'inferiority'.

Renaissance concern with and deference to non-Christian Classical authorities, especially Aristotle, required a task of synthesis with medieval Christianity, a task mostly associated with the work of Thomas Aquinas (*c.*1225–1274). His *Summa Theologica* represented the epitome of the type of Christian philosophy usually referred to as scholasticism. Scholasticism was so successful in defining the combined weight of Classical and Christian authority that by the early-modern period, the Classical and Christian origins of normative statements about gender order and sexual morality were almost impossible to disentangle because they had been interpreted in the light of one another for so long.[53] John Knox's *First Blast of the Trumpet against the Monstrous Regiment of Women*, relied entirely on an argument which placed one Christian or Classical authority after another – 'Aristotle doth plainly affirm…Augustine proveth that…with Augustine agreeth in every point St Ambrose'. Christian and Classical examples of 'good' and 'bad' women reflected and reinforced one another. For example, Pandora, the first woman of Classical legend who released trouble on the world and spawned the entire female sex, could be exchanged for Eve and was often used in the same breath as her to stand for 'bad' women.[54] Women martyrs of Greek legend were cited as 'good' women in the same way as the female saints, Katherine and Barbara.

Scholastic theologians systematised Christian thought by importing into it Aristotelian dualism about perfection/imperfection.[55] The notion of women's natural inferiority was welded to the Creation narrative from Genesis. Aquinas portrayed women as inherently inferior; creation from Adam's rib implied more than just secondary status because he used Aristotle to argue that both God and nature sought perfection in creation and achieved it with 'man'. Women represented imperfect creation, or the result of incomplete conception. Aristotle had said that 'we should look upon the female state as being as it were a deformity, though one which occurs in the ordinary course of nature'. Aquinas echoed this with 'woman is defective and misbegotten, for the active power in the male seed tends to the production of a perfect likeness according to the masculine sex'.[56]

The Reformation did little to undermine the authority of the scholastic synthesis on the subject of women. Martin Luther was hostile to the case that women were botched men (because of the implied fallibility of God) but his writings were otherwise deeply misogynistic. Jean Calvin, the head of the reformed church in

Geneva, demonstrated indifference to Aristotelian ideas about women's imperfection, but left scholastic ideas about women to stand. This fed into Elizabethan Calvinist theology. Calvin's pastoral teaching drew heavily on St Paul influencing directly the pastoral concerns of the English church after the accession of the Protestant queen too.[57] The post-Reformation Church of England taught that souls were not characterised by sexual difference and the baptismal ceremony for male and female children was identical.[58] Nevertheless, the authority of Aristotle in scholarly texts led to the popular notion that women may be similar to animals in having no souls. A popular rhyme held that 'the souls of women are so small, that some believe they have none at all'. John Donne treated the idea of women having a soul as a paradox requiring resolution.[59] The effect was to rob women of spiritual authority. Thus, non-Christian, Classical ideas had the power to gender the soul and render women spiritually inferior. Few people were able to make the fine distinction Aquinas had made between women being inferior in nature but not inferior in their capacity to access and receive God's grace.[60]

The ideas about woman that informed 'patriarchy' in early-modern England mostly arose out of the Aristotelian/Christian nexus as forged by medieval scholasticism and left largely intact by the English Reformation. Most importantly, dualism informed early-modern understanding of female nature and ideal femininity. The debate about women's nature was constant and often took the form of anxious discussion between men about gender relations and the 'fight for the breeches' because the idea that woman was quintessentially binary in nature transformed into a belief that they could and did display both positive and negative behaviours.[61]

The female sex

In the first half of the sixteenth century, ideas about female biology were based on the work of the Classical natural philosophers, Aristotle, Galen and Hippocrates. From the late sixteenth century, medical writers, some of whom were physicians and midwives, but many of whom were herbalists or just educated women of the gentry, struggled to assimilate new anatomical findings to theories that were over 1,000 years old. Anthony Fletcher has summarised the conceptual framework inherited from the ancients as involving three crucial ideas from which all understandings of the body, its reproduction, health and illness, were derived: 'one sex, the humoral system and a common corporeal economy'. The three ideas – or, more accurately, sets of ideas – were linked and informed one another.[62]

Before about 1600 works on physiology emphasised continuities between male and female bodies.[63] The 'one-sex model' of the body arose, in the first instance, out of conflation of the sexes in Platonic thought, overlaid with the Aristotelian idea that women were imperfect men and Galen's understanding of the female body as a male body turned inside out.[64] The Galenic view focused on the reproductive organs and suggested almost exact inversion in the female. The ovaries were testicles retained inside the body and the uterus was an inverted scrotum. The cervix and vagina represented a cunningly designed inverted penis. As late

as 1671 Jane Sharp's *The Midwives Book* described the vagina in these terms and popular sex manuals kept the idea current well into the eighteenth century.[65] In the sixteenth century learned debate took place within this 'one-sex model', between Aristotelians who believed that only men produced *sperma* or seed and Galenists who believed that women also produced semen during the sexual act.

By 1600 the works of experimental anatomy of Andreas Vesalius and Gabriele Fallopio had made an impact and the one-sex model of the body was slowly replaced by a greater emphasis on the separate functions of male and female sexual organs, though Anthony Fletcher has argued that there was a transitional stage of 'complementary functional anatomies'. In other words, there was neither a one-sex model of the body nor admission of two completely separate sexes.[66] One crucial factor here was the discovery of the clitoris; its similarities with the male penis, as described in 1561 in Fallopio's *Observationes Anatomicae*, threw into question the Galenic model of the vagina as inverted penis.[67] Jane Sharp described the vagina in 1671 within the framework of the one-sex model of the body, but she nevertheless also described with accuracy the functioning of the clitoris and drew a comparison with the male penis.[68] Helkiah Crooke's *Microcosmographia* (1615, 1631) also abandoned strict Galenic parallelism, demonstrating not only the existence of the clitoris and its function as a locus of female sexual pleasure but also suggesting that unlike the male penis, the clitoris was not the conduit of semen. Crooke was direct in his rejection of the ancients. '[T]his opinion of Galen and Aristotle we cannot approve,' he said. 'For we think that nature as well intended the generation of a female as of a male: and therefore it is unworthily said that she is an error or monster in nature.'[69] In his rejection of the 'ancients' he anticipated a group of thinkers who emerged at the end of the seventeenth century called the 'moderns'.

Robert Martensen has also argued that during a transitional phase female and male bodies were represented 'as both similar and different, as both one-sex and two-sex'. What made them different for contemporaries 'was the difference between male and female economies of fluid' within the humoral system.[70] At its most basic, this 'corporeal economy', as Fletcher has termed it, was about temperature and humidity. Following the ancients, most early-modern physicians and medical commentators believed the body was composed of four humours, or fluids – blood, choler or yellow bile, melancholy or black bile and phlegm. Each had a temperature and moisture specification – blood was hot and moist, choler was hot and dry, melancholy was cold and dry and phlegm or pituata was cold and moist.[71] The humours had various functions and organs had different properties according to their use of particular humours – e.g. phlegm was used by the cold and moist organs such as the kidneys. All illness was diagnosed as dysfunction or imbalances in these four humours and was treated according to the principle of tinkering with their balance.[72] According to Fletcher: '[i]t was an economy that had to be held in balance...Seminal emission, bleeding, purging and sweating ... were all part of the maintenance regime'.[73] Emphasis on fluids transformed bathing into a medical affair. The wet body was conceptualised as being 'open', both to harmful disease ('miasmas') and to cures. Cupping glasses

were used to draw off harmful humours. The vulnerability of wet bodies turned personal hygiene into a 'waterless affair'. Liberal use of powders dried and protected the body while scents rendered it pleasant-smelling.[74] Women's bodies appeared more open and were, therefore, believed to be wetter than men's.

The humoral system ensured that biological sex and gender were closely connected. Although individuals varied and personalities were divided into four types that reflected the four humours – sanguine, choleric, melancholic and phlegmatic – women were deemed to be colder and moister and men hotter and drier. And just as the four personality types could suffer alterations in their individual humoral balance, so too could men and women move along an axis which had masculinity at one pole and femininity at the other.[75] The difference in temperature and humidity was employed to explain almost everything about sex difference. Choler, being hot and dry, aided the process of removal of excrements from the body. Men, being hot and dry, therefore, sweated more, ejaculated their seed (which would putrefy if retained in the body) and did not menstruate because their bodies burned up the blood. On the down side for men their heat rose upward and burned their hair causing baldness. However, heat made men more rational, courageous and honest and all of these characteristics became defining features of early-modern masculinity. Defining women as a 'deprived' version of men had implications for the conceptions of femininity; by default, feminine women lacked reason, courage and honesty. Women's biological features meant that they were not so much cold, as lacking the heat required to have perfect [male] bodies. Women were not the sexual 'other', but sexually-unfinished because of temperature and, indeed, Aristotelian generative theory explained the conception of a female foetus in terms of a sexual act committed when there was not enough heat to produce a male. The female foetus developed more slowly and, thus, women retained their sexual organs within the body because there was not enough heat for their expulsion and external development. Women had smaller shoulders and wider hips because they lacked the heat required to push the physical matter of their bodies upwards. They menstruated because the blood was not burned up by heat.[76]

The concept that the female sex was lacking in some way has encouraged historians to follow the work of sexologists like Thomas Laqueur in arguing against the essentialism of sex regarding even biological sex as subject to cultural (and, therefore, gender) construction. The historian who has done the most work on the early-modern female body – Laura Gowing – calls women's bodies 'ideologically loaded narratives requir[ing] disentangling and deconstruction'. Bodies were highly symbolic and open to interpretation with the result that learned discourse jostled with vernacular guides about hygiene, sex and conception to produce the construction of the 'unstable body/bodies' in ways that rendered women uncertain about the separateness of their identity from men.[77] Thus, ideas about the female body made it not only a site of gender definition but of gender negotiation between the sexes. Jane Sharp's midwives' manual of 1671 shared some ideas with male midwives like Nicholas Culpeper – for example, about female lustfulness – but she also spoke with an alternative voice that sometimes lashed out at male

midwives and physicians. Hester Shaw championed the training of female midwives and in the 1680s Elizabeth Cellier tried to set up a College of Midwives, but all such efforts at regulation of the female body by women were opposed by the College of Physicians and the Church and male domination of the medical discourse about women's bodies continued.[78]

Anthony Fletcher has argued that changing ideas about the [female] body between 1500 and 1700 actually placed patriarchy on a firmer footing. He argues that the two-sex model of the body, when it emerged, allowed for a separate female identity over which men gained social control. Despite the modifications to sexual and biological knowledge the female body was still cast as weak and became subject to 'hysteria'.[79] For example, Thomas Willis's *Cerebri Anatome* of 1663 asserted an association between the female brain and mental instability.[80] Therefore, sexual separateness could be transformed into medical knowledge like the 'Willisian paradigm' which could then be used to shape a new relationship between sex and gender that argued for female weakness, bringing women's bodies at least as firmly if not more firmly under the control of men.[81]

Sexuality, menstruation and illness

The ideological foundations of early-modern sexuality were Christian and Classical too. Attaining adult sexuality was a bodily experience commonly interpreted through a religious *mentalité* that idealised sex as a means to reproduction. Merry Wiesner-Hanks, David Cressy and other historians have spoken of an 'internalisation of Christian norms' that led to personal constraint of sexual activity and a 'popular theology' that embraced Paradisian ideas about men sewing seeds in God's garden and women being fruitful like vines.[82] Equally, if the biological sex of a person was determined by temperature, their adult sexuality and reproductive capacities were determined by the same and women's sexual desire was explained in terms of women desiring the heat that they lacked.

Sexuality was a question of degree and not difference for most of the early-modern period because within the biological sexes there were sliding scales of femininity and masculinity.[83] Men could be classified into three degrees of hotness and dryness and women into three degrees of coldness and moistness. Women of the first degree were most like men and could be recognised by their greater wit and intelligence. Women of the second degree represented perfect femininity and women of the third degree tended to be overweight and under-intelligent.[84] Laura Gowing has pointed out that because uncertainty surrounded sexuality, attempts made to discover answers about people's sexual behaviours were worked into hierarchies of social power. Women prodded and poked one another to uncover the signs of illicit sexual behaviour and men similarly subjected each other to humiliating forms of touch that invoked the 'whoredom' of womanhood. For example, in 1611 John Pulford fought with Robert Pyle, pulling his genitals from his breeches and 'roll[ing] them upon the table saying, look what a fine thing...my whore hath'.[85]

Anthony Fletcher has argued that the sliding scales of sexuality led to 'anxious masculinity', but ideas about the body resulted in anxious femininity too. Women of the first degree represented a threat to male social hegemony and men with cold and moist characteristics threatened to betray their sex by being unable to withstand female challenge. Medical manuals did nothing to assuage anxiety about sexuality for either sex. Men who fathered daughters were told this resulted from weak seed that was cold and moist, placing them in the category of man whose masculinity most closely emulated female characteristics. Nicholas Culpeper's *Directory for Midwives* of 1651 told its audience that 'weakly men get most girls, if they get any children at all'.[86] Women were told that vigorous activity, especially during puberty, could result in a penis sprouting spontaneously as their sex organs might be forced by the heat of exercise outwards.[87] The sexual identity of a man with a testicle that failed to drop was presumably quite tortured, indicating as it would internal retention due to lack of heat. According to Fletcher, 'Understanding the body was how people sought to understand gender and what they learnt was that the one provided no quick and easy demarcation for establishing the other.'[88]

In an imagined world in which anatomy and fluids provided only a worrying concept for differentiating between the sexes, the uterus became the central signifier of woman. This cold and moist organ, though often described as an inverted scrotum, was an object of far greater mystery and power than its male counterpart and was used to explain most aspects of women's sexual desire as well as their health and illness, from the time of puberty. In the humoral system, girls were said to reach puberty earlier than boys because their moist physiology resulted in accelerated decay.[89] At menarche their womb (also called 'the matrix') took control.[90] In the sixteenth century, neo-Platonists discussed the uterus as if it were an animal separate from its female host, able to throw itself about when angry, possibly even able to smell.[91] Treatments for uterine and menstrual dysfunction included the use of fragrant pessaries when the physician wished to attract the wayward 'animal' and fumigation when the desired outcome was to drive it away. By the seventeenth century, experimentation had forced physicians to modify their thinking. Nicholas Fontanus in *The Womans Doctour* of 1652 dismissed the idea of the womb as 'some straggling creature, wandering to and fro' as 'fantastical conceit' because 'though a woman be dead, yet you can not with an ordinary strength remove the matrix from the natural place'.[92] However, early-modern medicine constantly attempted to assimilate empirical evidence to the Aristotelian-Galenic framework and the uterus was described as having rather magical properties. For example, it was commonly believed that the moon could exert a powerful external influence on the womb and result in birthmarks and multifarious deformities if a woman's imagination could not be controlled during certain lunar cycles.[93]

Humoral theory also dictated that because the uterus was a cold and moist organ it was changeable. Nicholas Fontanus described it as having 'a sympathy with all the parts of the body' so that 'the matrix is the cause of all those diseases which happen to women'. For example, breast tumours were caused by a malignant

'humour' that flowed upwards from the womb to the breast.[94] Depression and other mental illnesses in women were covered by the generic term 'hysteria', after the Greek word for uterus, and were believed to be caused by the rising of venomous vapours from the womb to the woman's brain. Intense interest focused on menstruation to establish the humoral cause of disease and sometimes menstruation itself was described as the 'monthly diseases'. Some medical theorists followed Galenic principles in regarding menstrual blood as unused semen (*menstruum*). Others, like Martin Akakia, followed Aristotelian principles and regarded it as the matter (*menses*) from which a foetus would form.[95] More generally it was described as being the evacuation of an excess of blood that the cold female body had failed to consume with heat. The tendency to synthesise the Christian with the Classical resulted in association of menstrual blood with God's curse placed on Eve. Scriptural metaphors about the false church being like 'a menstruous cloth' contributed to the idea that menstrual blood was unclean and somehow ungodly. William Whately, the advice book writer, advised married couples to avoid sexual intercourse when a woman was menstruating because 'it is simply unlawful' and he cited several passages in Leviticus.[96] Women's menstrual blood represented a male taboo – its odour was so unpleasant that it was sinister and it could spoil meat, blunt knives and kill bees.[97] One manual, *The Secret Miracles of Nature*, told its readers that 'a woman abounding with excrements, and sending out ill smells by reason of her terms; makes all things worse, and spoils their natural forces'.[98] Many women must have shared in this perception; Isabella de Moerloose asked her husband to sleep in another room because 'the stink will cause thee to feel aversion for me'.[99]

Hilda Smith has argued that 'it is difficult to stress too greatly the constant interweaving of woman's social and sexual functions in the determination of her proper diagnosis and treatment'.[100] Medical interpretation of the function (or malfunction) of the female menstrual cycle is a good case in point. Nicholas Fontanus in *The Womans Doctour* told his readers that 'women were made to stay at home and to look after household employments, and because such business is accompanied with much ease…nature assigned them their monthly courses'.[101] Some writers reasoned in reverse: because women were too cold and moist to burn up their blood, they were best suited to confinement in the domestic sphere. Surplus menstrual blood (often associated with dysmenorrhoea) was seen as healthy removal of unused fluids. If menstrual blood appeared to be flowing too heavily, treatment aimed to force the blood upwards. The physician achieved this through bleeding a woman from the arms, encouraging the blood up and out through a different hole artificially-created. Other remedies were less scientific while retaining a certain mechanical logic. One cure depended upon the blood flowing into a hole over which there was a three-cornered stake.[102] The opposite problem of light and/or skipped menstrual bleeding (amenorrhea) caused more concern as it indicated retention in the body of toxic fluid.

Menstrual blood was inextricably tied to descriptions of female sexuality because of the temptation and weakness of Eve who was cursed by God. All women had the potential to behave like Delilah and weaken the resolve of the strongest

man and menarche was the time at which this potential was released in young women. Their developing sexuality was discussed in terms of sin and preparation for the reproductive role. It was thought that between menarche and marriage (which was often a decade later), seed was concocted from menstrual blood, but it was immature and this could cause health problems. Its retention could lead to 'greensickness' or 'chlorosis' which was described as the virgin's disease and even 'lovesickness', which caused 'the Mother' to 'be fuming up their throats upon the least disturbance of their amours'.[103] This contemporary term for amenorrhea described a condition of putrefaction of unused seed and blood the cure for which was marriage. The advice became a commonplace making its way into popular ballads, almanacs and women's 'receipt books'. One ballad described a young woman who 'lay panting in her bed' looking 'as green as grass … [needing] some lusty lad'. Sarah Jinner's almanac of 1658 advised that a pessary of 'red storax, lignum aloes, [and] cloves' would do the trick, but '[i]f the patient be a maid, a husband is the best medicine'. Women themselves were more pragmatic, recording a variety of cures ranging from chamomile boiled with marigold, to candy with saffron and milk to desiccated worms in white wine.[104] Women's efforts to regulate their own bodies were inventive, conscientious and wide-ranging.[105] They responded with a range of cures for their own 'putrefaction', attempting to remove symbolic bodily substances like vaginal discharges, which were commonly termed 'the whites'.[106] The 'lady experimenters' occasionally turned 'household science' into publications such as Alethea Talbot's *Natura Exenterata* of 1655.[107]

The interweaving of the biological and sexual with the social can also be discerned in medical manuals that divided women's gynaecological illnesses into social categories of womanhood. Nicholas Fontanus divided women's diseases into 'four classes', including one that was specific to virgins and widows. Both were considered prone to 'stoppage of the courses' (amenorrhea) due to retention of seed and severe cases were termed 'mother fits', 'strangulation' or 'suffocation of the womb'. Harmful vapours rose up through the afflicted woman's body and the brain would fill with a 'black and dark smoke'. The severest case, when the womb was in a 'frenzy' led to depression, 'asthmatical effects', convulsive fits, even cessation of breathing. Nicholas Fontanus followed Galen in thinking that when a woman's 'mother fits' were so bad that she ceased breathing she survived by 'transpiration alone'. He advised marriage, though only for virgins. Thus, the married woman was idealised as the biologically and sexually perfect woman. 'Wives are more healthful than widows or virgins', said Fontanus. His stated reason was that female sexuality, properly expressed in marriage, had humoral benefit: the married woman was 'refreshed with the man's seed and ejaculate[d] their own'.[108] However the marriage paradigm placed some women on the margins in terms of sexual health, broadly conceived. Prostitution was caricatured as an evil but necessary method of preserving the chastity of other women, but because marriage was perceived as an institution based upon an agreed exchange of economic and sexual benefits, sexual infidelity in men caused married women to accuse their husbands' mistresses of being 'whores'.[109] Ideas about female sexuality were also confined to heterosexuality and the idealisation of sex in marriage informed ideas

about same-sex desire. Medical writers termed lesbians 'tribades' and regarded sexual penetration of a woman by another woman as against the laws of God and nature.[110] Jane Sharp regarded it more as a curiosity and something that happened in 'the Indies and Egypt' where women sometimes grew a large clitoris, or a 'counterfeit yard'. She, therefore, understood lesbianism only against the model of heterosexual sex.[111]

The menopause was commonly referred to as 'the time the courses are about to leave them [women]' and that, in itself, was not negatively regarded.[112] However, because widows suffered like virgins from the 'mother fits' they sometimes required medical intervention and Nicholas Fontanus suggested alleviation of misery by 'the hand of a skilful midwife, and a convenient ointment'. This sat comfortably with the advice of writers such as Juan Luis Vives who told widows that remarriage proved their inability to control through religious discipline and diet their innate sexual weakness.[113] However, the social definition of the older woman without a man could carry with it notions of deformed or deranged sexuality. The woman who had never married was stigmatised as the 'old maid' and the 'widow' was regarded as barely able to contain her lust having tasted the delights of sex. Christian Custance in *Ralph Roister-Doister*, written in the 1550s, was one in a long line of widows who were fictionalised in comic drama as foolish and sexually-unrestrained. Clergymen such as Jeremy Taylor warned that widows needed to 'restrain...memory and...fancy'. Occasionally women's remarriage was regarded as almost bigamous, as if in remarrying a woman cuckolded the dead husband. As a consequence some women treated sexual fidelity to their dead husbands as a duty to them, their children and a duty to God. It was a decision that left them with the potential medical problem of 'mother fits', their social and legal definition as widow essentially medicalising their future sexuality.[114]

Fertility, maternity and lactation

Medical knowledge about fertility, conception and pregnancy came from a combination of Christian and Classical ideas and the ideas of 'cunning' men and women and midwives. The ideas of midwives in particular reached a wide reading audience through several influential printed manuals. Married women – whom writers such as Nicholas Fontanus divided into socio-religious categories of 'fruitful' and 'barren' – were bombarded with conflicting, confusing and sometimes worrying advice. Frequent pregnancy was represented as desirable and the 2- to 3-year birth intervals of most fertile couples were seen as the norm. Indeed, the pregnant or 'great-bellied' woman was seen as aesthetically beautiful.[115] Pregnancy was thought to result from mutually-enjoyed marital sex, but on the other hand, tracts advised that over-frequent copulation could deform any resulting child.[116] Indeed, manuals advised that prostitutes failed to conceive because they did not enjoy the sex they had with their clients and the 'many and various seeds are mingled together...whereby the neck of the matrix is made so slippery, that it cannot retain the mans seed'.[117] The association between sex and sin was hard to overcome and dominated conceptualisation of the reproductive woman.

There were two competing and incompatible models of conception. In the Aristotelian model, male semen provided all the active life force or *spiritus* during conception; it acted upon *catamenia* in menstrual blood, which merely provided the matter out of which the foetus was formed.[118] In the Galenic model, male and female seeds were concocted during the sexual act and their union led to the formation of the foetus. Early-modern conceptualisation of the union as 'concoction' obscured knowledge of early pregnancy. The influential treatise, *Aristotle's Masterpiece*, described conception as a curdling process as if '[t]he matter that would become a child…was shaped by slow coagulation'.[119] Because concoction was thought to take place at orgasm it was believed that pregnancy only resulted from sex that was enjoyed by both partners. In rape cases a woman who conceived was deemed not to have been raped but to have willingly participated. This complicated women's court testimonies of sexual abuse and structured the language used to explain assault, which was often described by women passively as an experience during which men 'made use of' their bodies.[120]

How to achieve conception was a topic constantly explored partly because infertility affected about 20–25% of all married couples. There were many ideas and 'recipes' designed to bring about conception and many cautions about the reasons for failure which included over-frequent copulation, poor cosmological timing, the wrong food and drink and dangerous 'apish ways' that unsettled the imagination. Nicholas Culpeper's *Directory for Midwives* combined fairly run-of-the-mill medical advice with astrological and alchemical advice including the need to avoid iron dust and emeralds in order to maintain fertility. His recipe for conception was a pessary made from 'the runner of an hare', a 'load-stone carried about the woman', '[t]he heart of a male quail carried about the man', eating peony roots, a plaster of laudanum over the area of the womb and copulation two days after the end of menstruation. Sarah Jinner's *Almanac* of 1658 offered a less fussy approach and just advised a potion of boiled 'wormwood, mugwort…[and] goat's milk'.[121]

Infertility or 'barrenness' in marriage was usually attributed to the woman or 'want of love between man and wife' and was explained in Biblical terms as punishment from God. For example, Nicholas Culpeper had a series of explanations including the idea that the man and wife were of 'one complexion' when God formed nature in its perfection from 'a composition of contraries'. According to Fontanus's *Womans Doctour* of 1652, married women who did not conceive were 'more tormented with sickness'. His explanation for this was the retention of 'earthy and feculent' blood. He advised that a man's duty of love should continue with a 'barren' wife to maximise her sexual health.[122] Culpeper offered another humoral explanation for infertility, that blood-letting of virgins dried up their wombs before marriage. The trick, he suggested, was only to blood-let virgins below the womb, for example, in the foot. He added, only finally, that the failure of a woman to conceive might be due to lack of copulation.[123] None of this advice would have been any consolation to a woman like Sarah Savage who could 'scarce quiet [her] spirit' as the months passed without conception after marriage.[124] Women's trauma over infertility was intensified and lent deeper significance by

puritan works like William Perkins' *Christian Economy* (1609) which stated that '[c]hildren are the gift of God'. His advice was to pray for 'blessed seed' in a body that he conceptualised as 'a fit temple for the Holy Ghost to dwell in'.[125] Thus he subsumed an anatomical explanation within one that deployed the idea of God's providence.

Medical manuals, however, provided ideas and recipes which were based on keeping the 'fungible fluids' of the woman's body in correct balance and which, ironically, often focused on achieving menstrual blood flow. There were dozens of plants believed to contain blood-flow agents (many of which do indeed possess strong anti-oestrogenic properties) and one man admitted in 1651 that his lover 'knew what things to take to bringe it goinge'. However, recipes for 'bringing on the courses', or forcing menstruation, were not necessarily designed to result in abortion. Infusions of several plants could be drunk as purgatives or they could be made into pessaries and inserted into the vagina, sometimes attached to the cervix with a stick; the latter undoubtedly would have opened the cervix and caused miscarriage. Sarah Jinner offered at least two recipes for blood flow: a concoction of lovage, sporage, capers, grass liquorice, currants and rosemary flowers which could be drunk or 'seeds of small endive, of melons, of gourds, of pumpkins, cucumbers and lettuce, of which pessaries may be made to use in the womb'. She advised that 'things by nature cool…move the terms [menstruation]' and she wisely pointed out then when used in pessary form they should always have a string attached for removal.[126]

For most of the period there was an enormous gulf separating the regurgitated ancient obstetric knowledge of childbirth manuals such as Eucharius Roesslin's *The Birth of Mankinde* (1513; printed in English in 1540 and reprinted many times until 1676) and the practical obstetrics and herbal advice of midwives. Contemporary knowledge of reproductive processes led to very uncertain identification of the pregnancy when it was achieved. Because menstruation was understood as evacuation of surplus blood its cessation was not understood as evidence of pregnancy, although by 1671 Jane Sharp's *The Midwives Book* told women that if menstruation stopped unnaturally then pregnancy might be the cause. Most women relied upon the first signs of movement of the foetus at about 20 weeks, or 'the quickening', to identify pregnancy.[127] Once recognised, anxiety could surround retention of a pregnancy. A midwife's book of 1625 included a recipe of egg yolks and sugar to prevent miscarriage.[128] Jane Sharp's *The Midwives Book* of 1671 provided some guidance about when a pregnancy would come to term and Sarah Jinner's *Almanac* advised pregnant readers (ominously!) that to retain a pregnancy they should wear a plaster soaked in olive oil, soap and lead. Despite the fact that there was a flourishing industry in manuals about female health and reproduction many of the texts were inhibited by the concern that precise description of the female anatomy would be read as pornography by men. One of the most graphic and accurate was Culpeper's *Directory for Midwives*, but his readers balked at his apparent 'obscenity'. Men's erotic fascination with the processes of childbearing not only stemmed from but also resulted in the notion of the unknowable and secret nature of the female reproductive body. Sara Mendelson and Patricia

Crawford have pointed out that '[d]uring pregnancy, parturition and lactation, a woman's body was at its most different from that of a man' because it was only at these times that the female body was not so obviously just the inverse of the male body.[129]

Ideas about the foetus were highly systematised. Galenists put the determination of the sex of the foetus down to the provenance of the male and female semen according to a general principle that the right side of the body was hotter than the left. If the semen from both male and female originated on the right side, a male foetus resulted from their union. Male and female semen from the left side resulted in a female foetus. The left side was essentially the wrong side, or the sinister side that boded ill, an idea that stemmed from Christian tenets. Male semen from the right side that landed in the left side of the uterus produced an effeminate male; female semen landing in the right side of the uterus produced a masculine female (often termed a 'virago').[130] Once the foetus was formed the association of the right side with the production of male babies continued. The earliest midwives' manual for the period, *The Byrth of Mankind* (1540), advised '[if] it be a male then shall the woman with child be...bigger toward the right side than the left, for always the man child lyeth in the right side, the woman in the left side'.[131] A century later the association continued: *The Complete Midwife's Practice Enlarged* (1656) told its readers that a woman carrying a boy had a clearer right eye, a more uplifted right breast, a brighter right cheek, and, in addition, she felt movement on the right side and favoured her right leg for mobility. The association of a [female] left-sided pregnancy with deprivation (because of lack of heat) was strongly implied: 'If she have conceived a female the signs are for the most part contrary to those aforesaid.'[132] These signs included various types of infirmity, such as greater pain during pregnancy (also during birth when a female child, being less active, was less able to help the mother), a pallid complexion, swollen genitals and numbness. James Guillemeau told his readers in 1612, '[t]hey which be with child of a boy are more quick and nimble in all their actions...without being subject to many infirmities which commonly happen to women with child of a wench.'[133]

Pregnancy was conceptualised as a mysterious and dangerous time which placed women outside the 'normal' human state.[134] Pregnant women existed in an unstable, rather unknowable and spiritually-precarious condition and what they saw could transmogrify a foetus into any sinister creature observed. One amongst many widely-held beliefs was that seeing a hare would cause a harelip. Ideas about the uncertain spiritual state were closely linked to ideas about the porosity of the mother's pregnant body, its extra fluidity increasing the tendency to corruption and disease.[135] Laura Gowing has pointed out that a whole series of metaphors such as 'valve', 'floodgate' and 'cask' imagined the female body as one that was so leaky that its regulation became an urgent matter of keeping some fluids in and letting others out; this was never more so than at childbirth.[136] Thomas Willis advised that women who were involved in physical work out of economic necessity or who were 'Viragoes, and Whores' gave birth 'without great difficulty' because of the more regular evacuation of their blood. 'Nice women, and such as

live idly, during the time of their being with child [suffered in childbirth because] the mass of blood becomes impure and fermentative'. Infection after childbirth (known as puerperal fever) was explained the same way – it was conceptualised as an accumulation of 'Miasms' because some women suffered more from the 'Divine Curse'.[137]

Ideas about parturition ranged from believing it to be spiritually and physically unclean to mystically transforming. Many of the rituals surrounding pregnancy and childbirth, such as appeals to Saints like St Margaret and the Virgin Mary, or Protestant prayers to ease the soul ahead of childbirth, helped women to interpret the danger and suffering of their childbearing more positively as a potentially saving experience. Women resorted also to the protections of 'cunning folk' such as 'eagle stones' worn around the neck (signifying the child nested within the mother) which were believed to protect against death. Recipes were turned to for ease of labour. One woman's manuscript recipe book preserved at Cambridge University Library contains a concoction to drink of oil of sweet almonds to 'procure speedy labour' and one of egg yolk and Spanish tobacco 'to bring away the afterbirth'; these were inserted amongst the woman's everyday cookery tips for Florentine biscuits and how to bake 'an excellent cake'.[138] Uncomplicated childbirth was regarded as 'deliverance' in two senses of the word – it was the safe delivery of a child and it was God's mercy or deliverance in the preservation of the mother. David Cressy has pointed out that childbirth deliverance sermons used the same vocabulary as sermons that heralded deliverance of the nation from internal disorder and external threat. Devotional exercises found in works such as Thomas Bentley's *Monument of Matrons* were designed for use by pregnant women and church ministers arranged to pray with women before they went into labour. King James I issued public prayers for Queen Anne in 1605, encouraging his subjects to beg God 'for the queen's majesty's safe deliverance in her childbirth'. Her private travail thus became a public event that mirrored the bodily experience of many of her female subjects and bound her together with them in a physical as well as spiritual experience.[139] Childbearing was, thus, viewed within a dual paradigm; it had both a spiritual and physical significance that at once fascinated and terrified men and the 'lying-in room' was, for most of the early-modern period, an exclusively female space.[140]

Phyllis Mack has argued that just after giving birth women were perceived as being drained of physical humanity and therefore more pious and open to the grace of God. However, practical treatment of the safely-delivered woman turned again to medical recipes to relieve, for example, vaginal bruising – one midwife's book suggested application of a long-boiled breast of mutton.[141] A woman remained 'lying in' for at least two weeks and mystery surrounded this time also in the eyes of men. The midwife left, but childbed attendants increased in number and the pejorative term 'gossip' originated in the male anxiety generated by the gathering of sisters-in-God or 'God-sibs'. Thomas Dekker's satirical work *The Batchelars Banquet* of 1603 envisioned a scene in which women drank alcohol freely and plotted 'petty treason against their husbands'. Only if the woman remained well was the soiled bedding then removed and the woman bathed and given fresh

clothing. This was referred to as the 'upsitting' and was expected to happen about half-way through the journey to being received back into the church congregation. The latter took place in a ceremony called 'churching', a ritual derived from Biblical notions of cleanliness and based upon the tenets of Leviticus 22:1–8. The uterine blood of childbirth (in parallel with menstrual blood) was believed to be unclean and have suspicious magical powers. Thus, the mother's body required symbolic cleansing as part of the return to Church. However, David Cressy has argued that churching, to some extent, empowered women and he presents evidence of some women refusing either to wear a veil or even attend a 'churching' because they felt able to dictate their own terms in this one area of public spiritual activity.[142] It is difficult to estimate how many women actually rejected the more negative ideas about childbirth in early-modern England, but it is interesting both that Lady Pickering overheard one woman in labour screaming that she wished Eve had choked on the apple and that Lady Pickering herself was completely shocked by the outburst.[143]

The lactating woman was described within the framework of the humoral system. Nicholas Culpeper's view was standard: '[t]he blood that nourished the child in the womb is turned into milk to nourish him after he is born'. Because milk was believed to be blood transformed for infant nurture, uncertainty surrounded its link with fertility so some writers thought that milk was 'blood twice concocted' and others that it was whitened by the nipples. Cold, moist men, it was thought, had the potential to lactate. Lactation also had spiritual significance and some male commentators mixed religious ideas with medical ideas when giving advice about lactation. Robert Cleaver's advice manual, *A Godly Form of Household Government* (1598), told women it was one of their household duties to breastfeed their infants because 'experience teacheth that God hath converted her blood into the milk wherewith the child is nursed in the mother's womb'. Putting a child out to wet-nurse, he argued, would cause harm to the baby and the mother and it was 'against the law of nature and also against the will of God'. A tract called *The Countess of Lincoln's Nursery* of 1622 gave the same advice, Elizabeth Clinton herself exhorting women of her own class to breastfeed according to what she regarded as God's law. She warned that only 'women of little grace' did not feed their infants, as women were bound to carry out God's ordinance and milk came directly as a result of providence. Grace was a state linked to salvation.[144] However, advice about whether or not a woman should breast feed was as contradictory as all other advice to do with female reproductive health and welfare. Jane Sharp observed that wet-nursing was 'a remedy that needs a remedy' because it 'exposeth the infant to many hazards', but she also advised choosing a midwife with a 'sanguine complexion' as this guaranteed the best milk. Of course the practice of passing a baby to a wet nurse for feeding after childbirth resulted in the flow of milk ceasing for the mother and a return to fertility more quickly than was necessary and the link between milk and fertility (as with the link between blood and fertility) was simply not properly understood.

Breast care after birth was the subject of dozens of recipes and cures including juice of vervain.[145] Some medical writers addressed the question of sexual

activity during lactation and again the advice provided nothing that was fully reassuring. Some writers argued that sexual intercourse during lactation soured the milk, thus endangering the infant.[146] Jane Sharp, who had experienced difficulties with nursing, made no connection between sexual intercourse and spoilt milk: 'by experience we see that mothers that live with their husbands, and use congress, nurse the child without hurt'.[147] Anxiety about lactation extended to its impact on an unborn child and some writers thought that a woman who became pregnant while feeding another infant deprived the baby of milk because the concocted blood was diverted to the new foetus. The lactating woman 'restamps her own good qualities upon her offspring' said one writer in a positive vein, but another piece of advice was that a remarried woman feeding the infant of her first husband while carrying the child of her second was essentially betraying the children of her first husband through diversion of milk.[148]

Lactation had a very considerable spiritual symbolic function. The naked female body with plentifully-lactating breasts (sometimes grotesquely depicted by artists as multiple breasts on one body) served as a visual representation of the fertile earth and of 'mother nature'. The Virgin Mary feeding Christ was a highly-charged image and mother's milk was advertised for its curative powers. For example, a mother's milk expressed directly into the eyes was believed to cure eye infections. Phyllis Mack has provided one of the most interesting interpretations of the spiritual and religious significance of lactation. She has argued that milk offered spiritual power to women and desexualised their role as lactating mothers because early-modern ideas embraced the notion of Christ as nursemaid. Christ was sometimes even visually depicted as expressing milk to nourish his Church. Both women and men were represented as married to Christ while infantilised in their relationship to him as they drank from his spiritual milk.[149] In the case of the woman as lactating mother, then, her very wetness gave rise to a whole host of interconnected ideas about female spirituality and God's relationship with his subjects, some of which were mediated through images of Christ at Mary's breast and then Christ himself in the nurturing role. In this way, woman's blood, a negative component of her body, transformed itself into milk at childbirth, rendering the maternal female form positive.

Conclusion

Christian, Classical and medical ideas formed the intellectual foundations of early-modern patriarchy. However, it is a mistake to think of these as an unambiguous underpinning of early-modern society. The biological-sexual and reproductive woman was very much an intellectual and cultural construction with the power to shape femininity, but this was neither a monolithic construction nor one that was wholly negative. For all women, the negative Biblical and medical construction of woman was difficult to escape, but it has been asserted in this chapter that the model of woman's sinfulness was, at the very least, juxtaposed with the positive role model of Mary. Eve's ubiquity did not make her hegemonic and the virginal Mother Mary, whilst unattainable, was a positive role model for women

and her role as mother of Christ linked directly with ideas about eternal salvation through the spiritual nurture symbolised by a woman's milk.

The current debate about the female body from 1500 to 1700 is between a model of change and one of continuity in ideas. Anthony Fletcher has argued for change: 'the ramshackle edifice of Classical learning', of a one-sex model of the body and sexual variations according to humoral balances in moisture and temperature, was replaced by a new 'mechanical philosophy' that abandoned Aristotelian notions of woman as the 'unfinished' sex and replaced it with the idea of two sexes.[150] The model based on the Bible, Galen and Aristotle made it difficult for women to escape the medical construction of their gender. By contrast a model of continuity – or the 'persistence' of old medical ideas – has been proposed by Karen Harvey who argues that as late as the nineteenth century discussions of masturbation and the sexual feelings of prostitutes (or rather their unfeeling) was another way of figuring the 'one-sex model' of the body. She suggests instead 'short term shifts in language with a range of enduring themes'. In this account, sex and gender are fluctuating cultural products with multiple discursive meanings that demonstrate no simple linear progression towards 'the modern body'.[151]

According to the model of change, in 1500 Christian and Classical ideas dominated the intellectual construction of woman, but by 1700 medical ideas arising out of the 'new science' became more influential and woman, like the natural world, was deemed more 'knowable' by men and less directed by God. The idea of woman as the inferior sex remained unchanged, but the rationalisations for that inferiority radically altered as the Christian *mentalité* gave way to Enlightenment discourses about sex and sexual difference. However, it can also be argued that if the shackles of Eve were partially removed, then men paid a high price. The idealised woman whose gender arose out of social training rather than biology may have provided a firmer base for patriarchy, but the emerging Enlightenment idea that 'the mind has no sex' meant that a new woman could surface who was better able to assert her own femininity more obviously and with greater social power than before.

2
Querelle des Femmes

Introduction

This chapter explains the way in which the contradictory symbolic construction of woman was expressed in a rhetorical debate about women's nature that historians call the *querelle des femmes*. It sets out to provide the historiography and chronological contours of a controversy that was marked by several peaks of literary activity as well as several topical sub-debates from 1500 to 1700. Contributions to the *querelle des femmes* in early-modern England (and, indeed, throughout Europe) represented the 'negotiation' of women's gendered identity within the cultural setting of the Renaissance. Studying the *querelle des femmes* involves shifting the focus away from the Christian, Classical and medical texts to pamphlets, ballads and works of rhetoric and polemic that established other lines of debate about femininity in early-modern society. The *querelle des femmes* featured works that either attacked woman's nature or vigorously defended it, and the texts that will be examined offer what Joan Wallach Scott has called the 'culturally available symbols' that are multiple and sometimes contradictory that evoke woman and force feminine stereotypes into dialogue with the subjective identities of real women.[1]

The *querelle des femmes* can be defined in ways that are inclusive of many literary genres. All men had an awful lot to say about woman and female nature and, therefore 'the woman question' was inherent in prescriptive literature, works of philosophy as well as religious treatises.[2] However, pamphlets and bawdy ballads were the main conduit of the *querelle des femmes* and the debate about the nature of women flourished in the new world of print, which addressed a largely pre-literate society partly through woodcuts and visual representations of 'the good woman' and 'the bad woman'.[3] Ultimately, the *querelle des femmes* could not have taken place without a general acceptance amongst men that woman, as a gender construct, was negotiable and that relations with women involved tension and conflict. For this reason, historians have posed the question 'was the *querelle des femmes* a dialogue between misogyny (attacks on women) and feminism (defences of women)?'. Both attacks and defences in the *querelle des femmes* were locked into shifting topical contexts that ultimately informed women's role in society. Thus,

querelle des femmes works reflected and influenced relations between men and women and in this sense the debate was not divorced from social reality.

The exact chronology of the *querelle des femmes* has not been resolved, but most scholars place it between the late fourteenth and the early eighteenth centuries. The beginning is often taken to be the publication on the continent of two self-conscious defences of women – Giovanni Boccaccio's *De Mulieribus Claris* ('Of Famous Women') around 1380 and Christine de Pizan's *Le Livre de la Cité des Dames* ('Book of the City of Ladies') in 1405. The translation of *The City of Ladies* into English in 1521 ensured the development of an English *querelles des femmes* literary tradition. Christine de Pizan's book was written in direct response to the barrage of medieval attacks on women by celibate clergymen and writers in the courtly love tradition in which secular models of 'the good woman' and 'the bad woman' mirrored the Biblical models of Mary and Eve. In the last chapter it was explained that the main feature of early-modern construction of femininity according to early-modern medical and religious discourses was dualism. This dualistic conception of woman was nowhere more apparent than in the *querelle des femmes* and particular women were used as metaphors for all good women and all bad. The writers who contributed to this debate knew that they were entering a rhetorical fray with some set rules and had some sense of contributing to a particular literary exercise.[4] Eve had no one secular counterpart (except, arguably, 'everywoman'), though Xanthippe, the scolding wife of Socrates, became the main Classical model of 'the bad woman'. Mary had a single counterpart in Griselda or Grissill (who appeared under many names) and whose origins lay in medieval chivalric literature.

Xanthippe is an instructive example of the use of verbal and visual symbolic language in the construction of gender. The legend that she threw urine over Socrates when he did not respond to her nagging demands was transformed into a parable about the emasculation and humiliation of early-modern man at the hands of woman. The story was repeated frequently in ballads and pamphlets and figured in woodcuts that featured a man in bed as his wife drew off the bolster (bed cover) and soaked him. Sometimes the chamber pot or 'piss pot' stood alone as a symbol of the brawling wife. Xanthippe was figuratively Griselda's opposite – in Samuel Butler's *Hudibras* (1664) 'impatient Grizel | Has drub'd her husband with Bull's pizzel [urine]'. The other Classical figure used to construct suspect femininity was Phyllis, wife of Aristotle, who appeared in verse and picture as the domineering woman. In *The Decyete of Women* (1561) she was featured riding side-saddle on his back, holding a whip and steering him with a bridle in a dramatic inversion of the scold's bridle usually used as a punishment for women.

The good woman, Griselda, was more subtly deployed. While Xanthippe's wickedness was unambiguously displayed, Griselda, like Mary, was ambiguous and sometimes presented as the unattainable ideal of womanhood. The prose chapbook, *The Ancient True and Admirable History of Patient Grisel* (1619) issued a challenge to English women to 'surpass the French in the goodness of their lives'. Griselda was the peasant girl who patiently endured torments inflicted on her by her husband, the marquis of Saluce, including the demand to kill their children.

The Griselda story presented authors with the chance to explore not only issues of love and gender relations but also the knotty problem of compatibility between people of different social classes. For example, a much-reprinted (and sung) ballad of 1503 presented Griselda as *The Nutbrown Mayde*, whose prospective husband tested her love by telling her he was really an outlaw who loved another woman. The maid accepted that he loved another and said 'ffor in my mynde of all mankynd I love but you alone'. She was rewarded for her loyalty through the revelation that he was really the son of an earl.[5] In *A Most Pleasant Ballad of Patient Grissill* (1600) the marquis rails at his courtiers for their prejudice saying: 'The chronicles of lasting fame, shall evermore extoll the name, of patient Grissill my most constant wife'. The Griselda story provided an idealised model of womanhood: she was, in the words of Judith Bronfman, 'everyman's dream'.[6]

In England the development of the *querelle des femmes* into a literary genre owed much to the work of Geoffrey Chaucer in the fourteenth century. His *Canterbury Tales* contained gender relations and the nature of women as a central motif. In 'The Wife of Bath', Dame Alice was portrayed as the formidable woman of independence who wore out five husbands and took many lovers. 'The Clerk's Tale' provided the counterpoint with the Griselda model. Chaucer's representation of these women was complex – the Wife of Bath appeared admirable as well as formidable and some later *querelle des femmes* tracts and ballads did blend praise and blame, though most were self-revealing as an attack on women or a defence of them.[7] Evidence for contemporary awareness of a Europe-wide debate is overwhelming – pamphlets, poetry and drama about the nature of women in Latin were translated into the vernacular in several countries and treatises originally written in one European language were reprinted in translation. William Heale's *An Apologie for Women* (1609) argued that 'it is a custome growne so common to under valew their [women's] worth, as everie rymer hath a libell to impeach their modestie'.[8] There is also evidence of collection and collation of groups of satirical attacks and earnest defences. Between 1570 and 1585 Sir Richard Maitland collated 21 satires in the controversy into a manuscript now preserved at Magdalene College in Cambridge. John Marston's play, *The Insatiate Countess* (1613) made reference to a formalised controversy that had a ready male audience when a woman complains that her provocative and annoying husband 'has compiled an ungodly volume of satires against women'.[9]

The *querelle des femmes* in England to 1700 can be divided roughly into three periods of literary activity: 1500 to 1580 when the medieval inheritance of dualistic rhetoric and ambiguity dominated; 1580 to 1640 when all ambiguity about women's nature gave way to a polarised debate; 1640 to 1700 when the debate was permanently and radically transformed by the impact of the Civil War. There have been many surveys and interpretations of the *querelle des femmes*: Francis Utley's *The Crooked Rib* of 1944, two contributions in the 1950s – Carroll Camden's *The Elizabethan Woman* and Ruth Kelso's *Doctrine for the Lady of the Renaissance* – and two from the 1980s – Linda Woodbridge's *Women and the English Renaissance* and Katherine Henderson and Barbara McManus' commentary and anthology, *Half Humankind*.[10] All have dealt with questions about what literature should

be included within the definition of *querelle des femmes* and whether or not the attack/defence framework of the debate may be classified as a dialogue between misogyny and 'feminism'. The perspective on these two questions taken by individual historians working on the *querelle des femmes* has depended on which of the periods they covered and when they themselves were writing. So, for example, Utley's *The Crooked Rib* was written before the rise of modern women's history and it focused entirely on the period of the 'medieval symbolists' up to 1568. Both the approach and Utley's own time in place enabled him to conclude that '[e]xuberant over feministic progress' in scholarship fails 'to take into account the symbolic approach to life'.[11] Woodbridge's survey written after the rise of modern women's history included the virulently misogynistic attack on women by Joseph Swetnam (which was a later tract of 1615) and this inclusion strengthened the case for misogyny.

Historians have also made a distinction between the 'formal controversy' and the wider literary world that deployed woman as metaphor and joke. The development of theatre in the late sixteenth century can be defined as either widening the *querelle des femmes* genre or remaining outside of it. Utley strengthened his case against misogyny by arguing that the true heir to the medieval *querelle des femmes* was the theatre and not the vicious pamphleteering of writers like Swetnam. Henderson and McManus, whose survey covered both the early satire and the Swetnam controversy of the early seventeenth century, drew a distinction between the 'formal controversy' and 'literature', but argued that while authors were 'nourished by medieval theology and allegorical literature' the satirical attacks 'blend these modes of argument with sheer invective against women'.[12]

Thus, a historian's interpretation of the levels of misogyny involved in the *querelle des femmes* depends entirely on what early-modern literary genres are included in its boundaries and how those genres are defined. Utley argued that Renaissance humanist works introduced a sexual equality against which the male controversialists of the seventeenth century were reacting, but a number of historians writing more recently and including a wider range of texts (e.g. Katharine Rogers) have argued, perhaps more convincingly, that misogyny was not diminished by humanist ideas and that the seventeenth-century *querelle des femmes* reveals popular attitudes about women through biting jokes and sexual puns.[13] Sara Mendelson and Patricia Crawford point out that woman was, in herself, 'considered problematic' and Ian Maclean has demonstrated that the idea that women may not be human gave shape to a popular language of misogyny that turned into a literary form.[14]

However, exposing misogyny on one side of the debate is a more simple exercise than finding 'feminism' on the other. Joan Kelly, Moira Fergusan and Constance Jordan have all argued for 'feminism' in the defence tracts. Kelly, for example, argues that defences of women formed 'a conscious, dialectical stand in opposition to male defamation and subjection of women'. Her definition of the *querelle des femmes* was 'the vehicle through which most early feminist thinking evolved'. According to Kelly, 'feminist' thinking started with de Pizan and was 'oppositional to the dominant [male] culture' by being polemical, by concentrating

on gender issues and by exposing the mistreatment of women.[15] Henderson and McManus use Hilda Smith's definition of feminism – recognition that women are a 'distinct sociological group' which suffers 'indoctrination from earliest childhood' – to form a slightly different view. They conclude that the authors of both the attacks and defences (who were sometimes the same authors anyway) treated women as a 'distinct sociological group', but that while elements of feminism can be found in isolation in some *querelle des femmes* texts, a fully feminist position did not develop until later in the seventeenth century.[16] The difficulty of defining 'feminism' in pre-modern texts arises over and again for historians; and in the end, finding misogyny and/or feminism is a historical problem that can only be resolved by close examination of the intentions of a past author and deciding how to place their text into the literary context of their own age.

Satires and the dualistic woman, 1500–1580

The early period of the *querelle des femmes* in England was characterised by the medieval style of argument that set out to resolve a question through the juxtaposition of antitheses. According to Henderson and McManus '[t]he controversy developed a set of conventions and motifs (stock examples and anecdotes)' which drew on the Biblical and Classical intellectual foundations of thinking about women, but 'viewed [them] through the lens of…stylised medieval controversies'.[17] Two writers in this period were the heirs of Chaucer in England: John Skelton and Robert Copland who, together, dominated ballad-writing about women. Skelton wrote at least three satires in the 1490s about wanton women and their rebellious male lovers and his *Tell You I Chyll* (1506–1512) was a popular satire which employed the stereotype of the gossiping ale-wife to jocular effect. The reader was left in no doubt that drunken women who talked too much were a threat to husbands; the gossips bartered household goods for alcohol. Writing slightly later, in the 1530s, Copland's women in satire were idle and shrewish and his satires suggested that male celibacy was preferable to marriage.

 The threatening woman appeared in a host of other satirical ballads of the early sixteenth century. John Heywood's *God Spede You, Maysters, Everychone* (1533) depicted women as shrewish and untrustworthy, and in his *Among Other Things Profiting in Our Tongue* (1546) aimed to scare men into avoiding marriage vows. Marriage was at the centre of the cultural joke and it was frequently combined with Biblical reference and parody. The debate was given impetus by the publication of a number of translations of continental texts. An enormously popular tract by Antoine de la Sale, translated from French to English in 1507, was *The Five Joys of Marriage* which parodied the five joys of Mary – usually employed in defence of her sex – to poke fun at men's troubles in marriage. These included sabotage of their marital bliss by midwives during a woman's confinement, an idea that was popular and evergreen. The anonymous writer of *Glory unto God* (1509) invoked three angels sent by God to attack the institution of marriage. He included the deeply misogynist Saint Chrysostom as one of the angels. Another translated French ballad used Biblical parody to ridicule marriage and its supposed

dangers. In *The Gospelles of the Dystaves* (1515), the Evangelists were represented as old wives, their good news or gospels being advice on how to rule husbands. The metaphor of the distaff (a hand-held spinning implement) served as a deliberate distortion of the 'good woman', or the wife who stayed at home, obedient and busy with her spinning.

Two pieces of evidence can be offered from this early sixteenth-century period to suggest a certain self-consciousness of genre. The first is a satire that poked fun at the debate itself. *The Debate of the Man and of the Woman* (1525) was dialogic in format and exemplary in content. A male narrator provided Eve as an example of the evil nature of woman and a female narrator countered his example with that of Mary. The man drew on Classical as well as Christian narratives for examples of bad women – Bathsheba, Solomon's wives, Virgil's mistress, Helen of Troy, Delilah. The female speaker countered with Esther and Judith. The reader was left to decide who won the debate. The second piece of evidence for a Europe-wide debate comes from Scotland, where William Dunbar plied the same trade as Skelton and Copland, only even more profitably in his case. Dunbar was responsible for contributing at least a dozen works to the *querelle des femme*, beginning with *Rycht Airlie on Ask Weddinsday* (c.1504), which employed the standard device of teaching about 'bad' women through two drunken 'gossips'. Dunbar's treatises tended to have certain features in common. Gossiping, drinking women were standard fare. *Apon the Midsumer Ewin* (1508) featured a drunken Wife of Bath figure telling two other women how she extracted money and jewels out of her husband in exchange for sexual favours while keeping a lover. Dunbar also employed parodies of the medieval courtly love tradition, his aim being to attack marriage and refute any possibility of harmonious gender relations. *My Hartis Tresure, and Swete Assured So* (1503–13) exaggerated the torments of a courtier teased by his love. In *Inconstancy of Luve* (1503–13) he complained that love was deceitful and that it was easier to find loyalty in a love match than make a dead man dance.

One of Dunbar's most successful satires was *The Ballad of Kind Kittok* (1508) in which the drunken Kittok hitchhikes to heaven on a snail (the metaphor of the 'good' wife). She does not even reach her destination before stopping at a tavern and having a drink. Encouraged by alcohol she proceeds to harangue St Peter into letting her through the gates to heaven and drinking once she gets there. In true Chaucerian tradition *Kind Kittok* is at once damning and gently humorous. Dunbar is important as he provides perhaps clearer evidence than any other popular writer of the sixteenth-century *querelle des femmes* that the genre was as much about satire as misogyny. Dunbar wrote a large number of ale-wife ballads, but he also wrote *Now of Women This I Say for Me* (1508–13) in which he argued that nothing on earth surpassed the value of women.

The *querelle des femmes* was complicated and given impetus in the early sixteenth century by the arrival of the continental humanist ideas of Desiderius Erasmus and Juan Luis Vives favouring women's education. Thomas Elyot's *The Defence of Good Women* obliquely praised Catherine of Aragon's education of her daughter and Richard Hyrde, who was tutor to the daughters of the English humanist, Thomas More, translated Vives's *Instruction* and *Plan of Studies*.[18] The satirical

response came with the anonymous *The Scholehouse of Women* published prob-
ably in 1541 which enjoyed such success that it was reprinted three times before
1572. According to *The Scholehouse* women 'have tongue at large, voice loud and
shrill...they flush and flame as hot as fire, and swell as a toad for fervent ire'.
Women were duplicitous, never remembering praise and always remembering
criticism. Young women seduced men and then tricked them into marriage. Once
married a man needed to keep his wife well or 'another man come aloft'. They
required expensive clothes and ate rich foods that increased the chances of their
infidelity because of the increased heat of the blood. The 'scholehouse' was a
school of women who sat around gossiping, the young complaining to the old
who taught them how to 'be sharp and quick' with their husbands: '[t]hus among
they keep such schools | The young to draw after the old |...So that within a
month they be | Quartermaster, or more than he'.[19]

The discussion of women's nature was, thus, closely connected to the author's
concern with gender relations. Accordingly, the author presented his version of
the story of Socrates and his scolding wife, Xanthippe. In this version Xanthippe
is a bad influence on Socrates' second wife, teaching her how to break a 'piss-pot'
over his head. He followed this with his own version of the story of Creation and a
parable about a tongueless woman whose husband was so intrigued to know what
she was frowning about that he made the mistake of asking the devil to replace
the missing organ: 'From that day forward, she never ceased | Her bolster babble
grieved him sore | The devil he met and him entreated | To make her tongueless as
she was before'. He proceeded from the attack on female speech to a set of clichés
about women's jealousy, ill-temper and lack of remorse citing Biblical precedents
such as Jezebel and Lot's wife.[20]

The Scholehouse stands out amongst *querelle des femmes* texts because of its inordin-
ate length and the thoroughness with which it lists women's faults. The author's
stated motivation was that he wrote in reply to Edward Gosynhill's defence of
women, *Mulierum Paean*, which had offered standard Biblical defences of women:
women should not be blamed more than men for transgression in Eden and God
showed special favour to women who were like Rebecca. Biblical examples were
followed by female Christian martyrs and Classical martyrs like Lucretia.[21] There
has been much controversy over the authorship and dating of *The Scholehouse*
and *Mulierum Paean*. Despite some suggestion that they must have had different
authors, Utley concluded that Gosynhill was the author of both, writing in the
medieval tradition of 'satire and palinode'. The seven-line metrical structure of
the poems was identical.[22] Woodbridge has concluded the same; *The Scholehouse*
and the *Mulierum Paean* must be seen in their Renaissance rhetorical context as
examples of 'classical oration', probably worked on in unison by Gosynhill in
his attempt to produce the 'rhetorical paradox' in the form of two 'judicial ora-
tions'.[23] However, while Utley dismisses the possibility of this literary exercise
being inspired by misogyny, Woodbridge does not.

There was a flurry of literary activity around the publication of the humanist
defences of women's education. Another defence came in the form of *A Dyalogue
Defensyve for Women* (1542), written by Robert Vaughan or Robert Burdet, which

drew heavily on Elyot.[24] In 1542 also Heinrich Cornelius Agrippa's *De Nobilitate et Praecellentia Foemenei Sexus* (originally written *c.* 1509) was translated by David Clapham into English as *A Treatise of the Nobilitie and Excellencye of Woman Kynde.* This continental tract, according to Woodbridge, mixed tediously long lists of good women with the suggestions that Medea was a more accomplished magician than Zoroaster, women's speech was more eloquent than men's and Christ would have appeared to humans as a woman if God had wanted to demonstrate the virtue of humility.[25]

Satires on marriage continued apace and in 1550 the joke about women's education was revived with the translation into English of Wolfgang Resch's *The Vertuous Scholehous of Ungracious Women.*[26] The period from the 1550s witnessed the appearance of a secondary debate about women's capacity for female rule, encouraged by the commercial success of tracts like *The Scholehouse* and linked pamphlets, many of them from the press of John Kynge.[27] During these years attacks on female clothing also became prominent with pamphlets like Charles Bansley's *A Treatyse Shewing and Declaring the Pryde and Abuse of Women Now a Dayes* (*c.*1550). These were closely linked to works attacking the bad influence of the London stage on people's morals, fashions and sexuality. Stephen Gosson's *The School of Abuse* (1579) warned women to stay away from stage plays, even turn to their books instead if they wished to avoid corruption.[28]

There was a printing revolution in the late sixteenth century that facilitated a greater number of pamphlets in the *querelle des femmes.* Pamphlets and ballads vastly multiplied in number and the content and structure of works became less formulaic than before. Woodbridge's survey concluded that defences of women outnumbered attacks by four to one and that, therefore, attacks were essentially responses and received their structure and logic from those works that portrayed women as good.[29] However, if one allows a wider definition of a *querelle des femmes* text to include the popular broadsides that became increasingly accessible, the figure for 1500 to 1580 increases tenfold and it can be said that attacks outnumbered defences by about four to one.[30] After 1580 the stylised *querelle des femmes* texts of a medieval 'formal controversy' about woman therefore gave way further to a broad literary genre with enormous popular appeal with the result that the debate took on a sharper edge, reflecting and feeding some level of gender tension in early-modern society.

Jane Anger and the Swetnam controversy, 1580–1640

From 1580 there was an alteration of tone in the *querelle des femmes* and three factors in the late Elizabethan period made an impact. First, a rather pernickety debate about woman prompted a more bitter form of pamphleteering. A crucial text was Acidalius's *A New Disputation against Women* (1595), which led to a debate in intellectual circles about whether or not women were human and/or had a soul. Second, the new fashion for stage plays, with their subversion of dress codes and use of make-up, coincided with oblique attacks on the ageing Queen Elizabeth and the women of her court. Third, women writers joined the *querelle*

des femmes, responding to attacks with defence tracts of their own. Historians have concentrated on two questions: 'how important were the anti-theatrical tracts that reviled the morality of the stage' and 'was there an authentic female voice in the *querelle des femmes*'?

Stephen Gosson was one of the early anti-theatrical writers whose warnings against men dressed as women in stage plays appeared in *School of Abuse* (1579) and *Plays Confuted in Five Actions* (1582). His arguments drew on Deuteronomy 22: 'The woman shall not wear that which pertaineth unto a man, neither shall a man put on a woman's garment: for all that do so are an abomination unto the Lord'. Philip Stubbes's *The Anatomie of Abuses* (1583) employed the same Biblical reference and warned that the theatrical fashion of men wearing women's clothing would lead to men who were 'weak, tender and infirm'.[31] Jean Howard and Phyllis Rackin have argued that the anti-theatrical tracts represent a fear of the collective effeminization of men that would result in the weakening of the political nation.[32] Laura Levine and Anthony Fletcher have argued also that in the work of the anti-theatrical writers we can see anxiety about 'castration, porousness, effeminization', as if masculinity was something unstable and femininity was the default position towards which men might slide during cross-dressing on stage.[33] In this account, humoral theory lay behind a very real fear of gender slippage in early-modern society. According to Fletcher '[m]en were nervous about whether their boys would acquire the secure manhood to which the inheritance of their hotter seed entitled them'. Cross-dressing on stage involved sexual frisson in a 'mental world of sexual ambiguity'.[34] Thus, the *querelle des femmes* was dominated in the 1580 to 1640 period by fears of confused gender identity as a result of the growth of dramatic performance in the age of William Shakespeare.

Simultaneously, the first ostensibly 'female voice' of the *querelle des femmes* also appeared in print in the form of *Jane Anger, Her Protection for Women* of 1589. This text was addressed to 'the gentlewomen of England' to whom 'Anger' committed her own and their protection. She issued a challenge to men as follows: '[f]ie on the falsehood of men … whose tongues cannot so soon be wagging but straight they fall arailing. Was there ever any so abused … or so wickedly handled undeservedly as are we women?'[35] However, there are reasons to question the authenticity of 'Anger' as a 'female voice' as a fuller examination of the text demonstrates.

The text was a specific reply to a text now lost, *Boke His Surfeyt in Love* (1588). Anger juxtaposed her attack on all male writers with a satirical assault on 'the Surfeiter' or 'old Lover' whom she accused of being 'diseased when he did write it'. She claimed to be defending women not only from him but 'all other like Venerians'. Her pamphlet was 'sent abroad to warn those which are of his own kind from catching the like disease' and much of the rest of the text concerned itself with the foolishness of men's lust. Anger employed a standard technique in the *querelle des femmes*, arguing that because God created women second, they were moulded out of a more refined material than the 'dross and filthy clay' that formed Adam. On the whole, though, Anger did not employ Biblical reference to defend women. She argued that 'the Gods' 'bestowed the supremacy over us to a man' because women's 'virtues' so far exceeded the 'Cockscombs' of men.

When she resorted to examples of 'bad' men these included Roman emperors and Frankish kings. In a sustained attack on men she answered the 'old Lover's' suggestion that women seduce and allure men with '[i]f we clothe ourselves in sackcloth and truss up our hair in dish clouts, Venerians will nevertheless pursue their pastime, If we hide our breasts, it must be with leather, for no cloth can keep their long nails out of our bosoms'. This reversed the standard notion that in woman, starting with Eve, can be found the responsibility for sexual weakness and sin.[36]

Henderson and McManus have characterised Anger as an opponent of 'misogynist invective' and Constance Jordan enlists her on the side of 'Renaissance feminism'. Woodbridge also never questions the sex of the author.[37] However, Diane Purkiss has argued that our reading strategies are wrong; they are clouded by present-mindedness and the wish to locate female agency in the 'female voice' we find.[38] Is it possible that 'Jane Anger' was not a woman? There is no evidence of the existence of a real Jane Anger, although the name is plausible as both the Christian name and the surname were common.[39] The second point that can be made is that it is possible to read *Jane Anger, Her Protection* as a parody, one that satirises both the *querelle des femmes* and the earnestness of defences of the female sex. As modern readers we are not alert to early-modern speaking positions and it is possible that early-modern readers would instantly recognise 'Jane Anger' as a man. Certainly the pamphlet has at the end a satirical poem signed 'Jo. A.' which could ambiguously suggest 'John' instead of Jane (equally it could be 'Joan'). The poem addresses 'Jane Anger' in the third person as 'she', allowing even more ambiguity to creep in: 'Though sharp the seed by anger sown … For Anger's rage must that assuage, as is well understood'.[40] In early-modern England any 'speaking' woman could be characterised as an unruly, angry or 'sharp' woman, and Purkiss suggests that the allegorical content of the pseudonym 'Jane Anger' is not to be found in the figure of the woman expressing reasonable outrage at attacks on her sex, but in its reference to the stereotypical scolding or nagging woman punished during the village ritual of charivari that shamed gender inversion.[41]

Purkiss also points out that there was a whole tradition of men dressing as women as a 'means of troping disorder in a manner which sought to make male agency visible and render female engagement in politics [or political writing] a male masquerade'. Men dressed as women during festivals and food riots as a form of symbolic inversion and, therefore, early-modern readers may have read the same symbolic inversion into *Jane Anger, Her Protection*. Certainly lines such as 'Deities knew that there was some sovereignty in us women which could not be in them men' seem suspicious.[42] In short, 'Jane Anger' may not be a 'female voice' at all but that of a male 'ventriloquist' and the *querelle des femmes* genre was taken in new directions.

According to Woodbridge the 'formal controversy' fell quiet after about 1590. There were a few formal defences of women in the period including Anthony Gibson's *A Womans Worth, Defended against All the Men in the World* (1599), *An Apologie for Women-Kinde* (1605) by I. G. and Lodowick Lloyd's *The Choyce of Jewels* (1607). Satirical attacks included Thomas Nashe's *The Anatomy of Absurdity* (1589), the anonymous *Quippes for Upstart Newfangled Gentlewomen* (1595; an attack that

linked female fashions with lack of chastity), and Nicholas Breton's *The Wil of Wit, Wits Will, or Wils Wit* (1597).[43] However, the peak in literary activity between 1580 and 1640 followed the publication of Joseph Swetnam's *The Arraignment of Lewde, Idle, Froward and Unconstant Women* in 1615.[44] Swetnam's pamphlet was exceedingly well-received and ran into 10 editions in the first decade of its literary life.[45] Its popularity can be explained in terms of its controversial nature. It was rather different from past attacks on women's nature because it was so unmistakably misogynistic.

Swetnam began his tract by addressing his alleged audience of women: 'Neither to the best nor yet to the worst, but to the common sort of Women.' The ambiguity this introduced about the nature of women carried over into the text itself. Swetnam claimed to be 'hoping to better the good by the naughty examples of the bad', but he quickly denied the existence of any wholly 'good' women. Swetnam invited men who enjoyed 'bearbaiting' to 'trudge to this bear garden apace and get in betimes'. Purkiss has noted in Swetnam the misogyny of young men's clubs and the masculinist culture of treating women as objects of sexual entertainment that can be bought, sold and exchanged.[46] The argument that followed contained many of the standard elements employed in *querelle des femmes* texts. For example, Swetnam argued that the Bible described women's secondary creation, from the rib of man, and for the purpose of being 'a helper unto man'. However, he broke the usual conventions of the debate by extrapolating from the Biblical texts lessons that were of a proverbial or anecdotal nature. Ribs are crooked, therefore women were born crooked and were instantly looking for 'mischief' and 'procur[ing] man's fall'. From the Biblical text that women were created as 'helpers' he drew the lesson that they 'helpeth to spend and consume that which man painfully getteth'.[47] Thus the text was provocative not because it said anything new, but because of the increased use of plainly misogynistic popular stereotypes within a Christian paradigm.[48]

The rest of Swetnam's attack featured popular anecdotal notions about how women proved difficult for their husbands. Women cry 'dissembling tears' to get their way and they 'are called night crows for that commonly in the night they will make request for such toys as cometh in their heads in the day'.[49] There is a suggestion here that just as women manipulated men through false tears, they also manipulated men through withholding sexual favours and sleep:

> For women have a thousand ways to entice thee and ten thousand ways to deceive thee…They lay out the folds of their hair to entangle men into their love; betwixt their breasts is the vale of destruction; and in their beds there is hell, sorrow and repentance. Eagles eat not men till they are dead, but women devour them alive. For a woman will pick thy pocket and empty thy purse, laugh in thy face and cut thy throat.[50]

Swetnam attacked all aspects of women's physical presentation, including dress, clothes and hair. He included the usual advice that a 'bad' wife 'will have to be supported in her wickedness', a 'foul' wife will be loathed by everyone and a 'poor'

wife will need to be maintained. But he reinforced the idea that there were no good women at all by turning on its head the usual assumption that female nature was dualistic. 'Good' wives, according to Swetnam, 'will be quickly spoiled', 'fair' wives 'must be watched continuously' because like a 'whetstone everyone will be whetting thereon' and 'rich' wives need to be 'pampered'. Widows were the worst of the lot, being 'commonly … froward … waspish, and … stubborn'. Swetnam set up an argument that was hard to refute. 'Good' women could be assumed to have good repute, but he conflated them with 'fair' women whom, he argued, were naturally given to vanity and, therefore, quickly moved from 'good' to 'bad' repute. A 'good' woman was also silent. Therefore, the angry response he anticipated from 'many stinging Hornets' was assumed in advance to be the hollow cry of the guilty party. It is impossible to know for certain if Swetnam really anticipated responses from women, though he did say that 'I know I shall be bitten by many because I touch many'.[51]

Swetnam's tract provoked several responses including Daniel Tuvill's *Asylum Veneris, or a Sanctuary for Ladies* (1616) which defended the female ideal of chastity and silence. There were also three female responses.[52] The first was *A Mouzell for Melastomus* (1617) written by Rachel Speght.[53] Speght concentrated on attacking Swetnam's style and Biblical interpretation. In reply she argued that Eve was the victim of both the serpent's focus on her as the 'weaker vessel' and Adam's inability as her 'head' to reject the temptation offered him to sin. Eve was not the direct cause of man's Fall and when punished, God delivered a specific curse on Eve, but blamed Adam for the Fall. Speght put together Genesis 3:15 with Galatians 3:6–29 to argue that when God promised to bruise the serpent's head with the woman's seed he offered salvation and spiritual equality to both sexes in Christ. She equated God's promise as being the same promise later made to Abraham which released humans from the law and made them equal in Christ.[54]

Speght's main technique for refuting Swetnam was to take his oblique Biblical references and offer an alternative interpretation. To Swetnam's references to 1 Corinthians 7:1, when St Paul advises against contact with women, Speght answered that this was specific to the context of Corinth and the persecution of the early church. To Swetnam's list of wronged Biblical men Speght provided answers. Swetnam collapsed two sections of the Bible (1 Kings 11 and Ecclesiastes 7:28) to argue that Solomon's many women 'made him quickly forsake his God'. Speght replied that the passages from 1 Kings 11 were about Solomon's repentance after taking 700 wives and 300 concubines making him primarily responsible for his sin and rejection of God.[55] Speght answered Swetnam's attack on woman as the 'helper' (wife) of man through an extended argument about woman being created from the rib to be close to a man's heart, as well as being physically correspondent. The Pauline injunction that men, as husbands, are placed at the head of women was interpreted by Speght to mean that this 'title yet of supremacy' gives 'no authority [to the husband] … to domineer or basely command and employ his wife as a servant'. This was combined with the metaphor of two oxen yoked together to make the case that 'woman was made to be a companion and helper

for man', yet just as the stronger ox will have to pull harder, so will the man, and only in this is superiority to be seen.[56]

Speght attacked Swetnam, not so much for demeaning women as for being 'irreligious'. She apologized both for her youth and imperfection in learning and offered the double-edged defence of women that they needed to be forgiven as the 'weaker vessel'. Speght's representation of the 'paradigmatical' or ideal chaste and silent woman in *A Mouzell for Melastomus* has made her defence of women seem less than adequate to the modern feminist critic. Purkiss has argued that Speght's tract has not been taken as seriously as others with female signatures because of her primary focus on Swetnam's offensiveness to God rather than women. Yet hers is the only 'female voice' of defence that was almost certainly that of a known woman. The internal evidence of both *A Mouzell for Melastomus* and Speght's later *Mortalities Memorandum* (1621) are suggestive of a woman with a puritan motive making a serious attempt to join the commercial economy of publication. Speght was probably the daughter of a London clergyman and Purkiss has suggested that she not only claimed authority from her father but also stole from him patriarchal 'discourses of morality', ones that represent an ideal femininity so alien from our own that we are unable to see in Speght the real 'female voice' of the early *querelle des femmes*.[57]

There were another two supposedly 'female' responses to Swetnam. The second, *Esther Hath Hanged Haman* (1617) came from an author claiming to be 'neither Maid, Wife nor Widow, yet really all and therefore experienced to defend all'.[58] Most modern scholars accept the female authorship of this tract and one feminist critic has taken the clue 'neither Maid, Wife nor Widow' to mean that the author intended an extended criticism of early-modern, middle-class marriage policy.[59] The pseudonym used was 'Esther Sowernam' and most scholars point out the conscious play on the name of the opponent. However, Purkiss has pressed the point further: '"Sowernam"...is simply the opposite of Swe[e]tnam, sour (like scolds and shrews) where he is sweet.'[60] This raises doubts about the sex of the author. Would a female author deliberately caricature herself as a shrew? Juxtaposition of Sowernam with the name Esther, a Biblical figure deployed frequently to defend the female sex, further places the tract within the usual terms of the formal controversy but fails to resolve the question of the author's sex.

Esther Hath Hanged Haman opens with an address to 'worthy Ladies, Gentlewomen and virtuously disposed of the Feminine Sex'. The first section of *Esther* attempts to answer directly Swetnam's *Arraignment* and the next three chapters build an argument from the Bible co-opting the authority of God in defence of women. Sowernam's answer to Swetnam was essentially that he misinterpreted the story of Creation and indulged in blasphemy when he transformed the woman as helpmeet to the woman who helped men spend money. She employed his argument that women were crooked, being made from Adam's crooked rib, to suggest that Adam was then even more crooked. 'See how this vain, furious and idle author furnisheth woman with an argument against himself and others of his sex,' she announced triumphantly. The Biblical exegesis that followed, though, was injected with less wit. The author was theologically-knowledgeable. Sowernam explained

the rights and roles bestowed on women by God through the three ages of the law of nature, the time of the Mosaic Law and the New Testament age of the law of grace. Some of the conclusions were standard *querelle des femmes* fare. For example, women were created 'to add perfection to the end of all creation', being created from more refined material than Adam, and 'although woman sinned first, the sin was not completed until Adam fell; he alone was responsible for bringing sin to the rest of mankind'. Her most elaborate claims were for woman's role in salvation. 'Yet what by fruit she lost, by fruit she shall recover' and 'as woman was a means to lose paradise, she is by this made a means to recover Heaven'. The name Eve means 'mother of the living' and examples taken from the New Testament, such as the Virgin Mary, provided evidence of God's employment of women at the time of Christ when the saving law of grace came into operation. In true *querelle des femmes* fashion, Sowernam followed this Biblical chronology with a list of 'good' women drawn from classical sources and ancient English history.[61]

Chapters five and six of *Esther Hath Hanged Haman* turned the 'arraignment' around to charge and indict Swetnam in a mock trial run by women. Sowernam argues that when she acquainted other members of her sex with Swetnam's 'idle, furious and shameful discourse against women' they decided to arraign him before two female 'judgesses: Reason and Experience'. Ultimately, though, the trial is postponed for fear of charges of irregularity in the proceedings if all present are women and Sowernam then goes on to deliver a speech against Swetnam and his wrongdoing to the female sex. Here Sowernam took up Swetnam's central theme about women causing men's lustfulness and reiterated her own central point about his blasphemy. The final section of *Esther Hath Hanged Haman* raises the most questions about authorship. It took the form of a ballad, summarising the argument about men's sexual morality and musing at length on the futility of women trying to satisfy men as to their good nature: 'The humours of men – see how froward they be | We know not [how] to please them in any degree | What can we devise to do or to say | But men do wrest all things the contrary way'.[62]

Esther Hath Hanged Haman begins with a hint at the social context and reception of the *querelle des femmes* – a 'supper amongst friends where … there fell out a discourse concerning women, some defending, others objecting against our sex'.[63] Sowernam self-identifies as a woman but the final section of verse was not signed by Esther but was instead ascribed to 'Joan Sharp'. The name Sharp is (like Anger) evocative of the scold and suggests the possibility of a male author's mocking defence of the woman gossip. There are other clues that Esther Sowernam may not be a real woman and Purkiss has suggested, for example, that the mock trial in *Esther Hath Hanged Haman* locates Esther's 'female voice' in the social context of the Inns of Court, an area known for prostitutes and unruly women.[64] Ultimately, the authorship of *Esther Hath Hanged Haman* is a mystery.

The third female response to Swetnam was *The Worming of a Mad Dogge* (1617) in the name of 'Constantia Munda'.[65] The pamphlet opened with a dedication to 'Prudentia Munda … Most Dear Mother' which, in essence, says that Munda wishes to return all her mother's love and work on her behalf by 'worm[ing] a dog that's mad [Swetnam]'. Addressing directly Swetnam's opening line – 'Musing

with myself, being idle', Munda suggested that '[y]our idle muse shall be franked up, for while it is at liberty, most impiously it throws dirt in the face of half humankind'. Most of the pamphlet concentrated on this theme of the fashion for 'every pedantical goose quill' to attack women unjustly and on Swetnam's particular tendency to cast good women in with bad. Munda's tract is learned, fluent, bilingual (English and Latin), satirical and counter-offensive: 'Woman ... the second tome of that goodly volume compiled by the great God of heaven and earth, is most shamefully blurred and derogatively razed by scribbling pens of savage and uncaught monsters.' Subversively Munda comments that 'printing ... is become the receptacle of every dissolute pamphlet ... Every fantastic poetaster, which thinks he hath licked the vomit of his Coryphaeus ... will strive to represent unseemly figments imputed to our sex'.[66]

The very subversive vigour of *Worming of a Mad Dogge* raises questions about authorship. Statements such as '[t]hough feminine modesty hath confined our rarest and ripest wits to silence, we acknowledge it our greatest ornament' sound suspiciously as if they could emanate from the pen of a man. The writing also betrays prejudice based on popular stereotypes of women: '[a] private abuse of your own familiar doxies should not break out into open slanders of the religious matron together with the prostitute strumpet ... of the chaste and modest virgins as well as the dissolute and impudent harlot'. The language is that shared between men in early-modern society and is supported in the text by masculine concerns and masculine metaphors of aggression: 'I hear you foam at mouth and growl ... like the triple dog of hell [Cerberus]'. Munda talks of attack – 'dash your rankling teeth down your throat' – and revenge and legal retribution – 'methinks it is a pleasing revenge that thy soul arraigns thee at the bar of conscience'.[67]

Scholars are divided over the question of female authorship in the Swetnam controversy because of the issue of how to define historical feminism. On the one hand, Simon Shepherd has interpreted the responses as being the 'sound and fury' of the female voice, 'imprisoned by patriarchal discourse', yet 'stepping, very consciously, into a risky and dangerous world'.[68] Ann Rosalind Jones has argued that Speght, Sowernam and Munda 'reveal the potentials of protofeminist discourse at the end of the Renaissance'.[69] On the other hand Purkiss, while not dismissing the possibility of some female authorship, suggests that to read the controversy with modern eyes is to miss crucial points about early-modern satirical techniques; Swetnam's tract may have been popular because it provoked some men into pretending to be women, their chosen pseudonyms placing the respondents to Swetnam, not on the outside (as a woman would have been), 'but at the centre of the woman debate'.[70] The pseudonym 'Constantia Munda' is the best example of this. Meaning 'worldly constancy', it immediately invokes the archetypal 'good' woman. According to Woodbridge, Munda was the only female respondent to Swetnam who 'deliberately refus[ed] to play the old game' and 'had a good rant' while 'breathless' with 'rage' at Jacobean misogyny.[71] However, the Latin epigram that follows 'Constantia Munda' on the title page – 'dux foemina facti' – roughly translates as 'making a woman the leader', revealing 'Constantia Munda' as the disorderly, talkative, defiant woman of *querelle des femmes* attacks.

'Munda', therefore, was claiming to place women on top, an unlikely speaking position for a woman in print in 1620.

Thus, the Jacobean *querelle des femmes* featured verbal transvestism and gender disorder in print. There were also two pamphlets of 1620 that satirised cross-dressing in practice. The first, *Hic Mulier: Or, the Man Woman* vigorously attacked women who were '[m]asculine in Mood, from bold speech to Impudent action'. The author 'pretended' to address 'good women' who 'in the fullness of perfection' are 'the complements of men's excellencies' and who are 'ever young because ever virtuous'. The remainder of the pamphlet complains about women whose 'deformity in apparel' included the wearing of broad-brimmed hats, yellow ruffs (in the fashion of Frances Howard, infamous for divorcing her husband and arranging the murder of Thomas Overbury in 1613), and French doublets that were 'all unbuttoned to entice…and extreme short-waisted to give a most easy way to every luxurious action'. The author associated masculine attire with lewd speech and loose sexual morality and associated the fashions with attending stage plays. The tract ended with an appeal to the male defenders of masculine women to reassert authority over them. The second, *Haec Vir; or, the Womanish Man* took the form of a dialogue between 'Haec Vir' [the womanish man] and 'Hic Mulier' [the mannish woman]. At the beginning the (masculine) woman mistakes the (feminine) man for a woman and the (feminine) man mistakes the (masculine) woman for a man. Every ounce of humour was extracted from this gender confusion in a text that was stagy and performative. In the dialogue 'Hic Mulier' defends her right to dress in broad-brimmed hats on the grounds that 'I was created free, born free and live free'. She argues that woman should not be 'the Bondslave of Time' and that '[c]ustom is an idiot'.[72] The argument about custom sounds surprisingly modern. However, the pamphlet deployed cross-dressing as a literary device for revealing traditional male fears about women's vanity, the infamy of women's speech and 'whorish' modes of dress, the susceptibility of women to moral corruption and the problems women were alleged to create in marriage.

The context for literary cross-dressing in the *querelle des femmes* was the plot device of the stage and it incorporated the central joke about gender relations in marriage. In William Goddard's *A Satirycall Dialogue or a Sharplye Invective Conference, betweene Allexander the Great, and That Truly Woman-Hater Diogynes* (1616), the character of Diogenes dressed as a woman to infiltrate a meeting of women to prove that they were abusive gossips. He declared that he would 'rather dwell…in hell' than with a woman because 'there's no Divell cann (like to a wife) torment a mary'd man'. Arthur Newman's *Pleasures Vision…A Short Dialogue of a Womans Properties* (1619) took the form of a dialogue between an old man and a young man in which the old man, who was attacking women, accused the young man, who was defending women, of being a woman in disguise. The implication was that a man in contact with female company ran the risk of being effeminized.[73] According to 'W.P.' in 1620 in *The Gossips Greeting: Or, a New Discovery of Such Females Meeting*, some women were 'unworthy the name of women' because they were frightening sexual predators.[74] The trope of the woman who sat around chatting to other women all day had a long literary pedigree that brought together

fears about idleness and the dangers of gender inversion. 'What be they' asked George Gascoigne in *The Steel Glas: A Satyre* (1576), 'women masking in men's weeds…and if they could as well change their sex…I think they would as verily become men indeed'. However, while the perceived threat is easy to quantify in the texts, the social reality of women's masculine fashion is more difficult to assess. However, hanging at Burton Agnes Hall in East Yorkshire is a 1620s portrait of Frances Griffith, the eldest of the three daughters and co-heirs of Henry Griffith, showing her wearing a dated Elizabethan ruff in combination with a masculine broad-brimmed hat, her masculine attire perhaps symbolising her role as property heir in the family.[75]

The fashion for cross-dressing grew out of the increasing popularity of the Jacobean stage. It also coincided with the notoriety on the London streets of Mary Frith, a transvestite criminal (also known as Moll Cutpurse) who wore men's clothes and carried a sword. Plays featuring a man disguised as a woman were regularly staged, including Thomas Middleton's *A Mad World My Masters* (1608). In a later collaborative effort with Thomas Dekker – *The Roaring Girl* (1611) – Middleton drew on the life of Mary Frith to turn the cross-dressing joke around. Mary Frith herself appeared at the beginning of one performance, but thereafter a man disguised as a woman took the part of Mary Frith, so doubling the gender joke. However, there is disagreement about the importance of this cultural fixation with cross-dressing in the first two decades of the seventeenth century. David Cressy has suggested that it was simply a literary device deployed to invoke laughter about [heterosexual] sex and therefore not causing anxiety about sexuality at all. There was laughter about the way in which men and women gained access to each other through pretending to be a member of the opposite sex. '[T]he transvestite male appears more energized than emasculated by his temporary change of clothes'. Cressy cites Ben Jonson's *Epicoene* (1609), a play in which a cross-dressed man is able to join female company freely. Cressy's conclusion is that '[I]f there is a sexual charge to…cross-dressing, it is in the access…to female bodies, not in any erotic frisson from the women's clothes themselves.' He points to the many other occasions when men dressed as women without fear of effeminisation: during festivals such as Shrovetide, when men cross-dressed as 'May Marions'; during riots to escape legal punishment; during prison escapes. The problem with female transvestism, according to Cressy, was not really that it threatened to effeminize men, but that it hinted at looseness of sexual morality and even promiscuous femininity.[76]

If female transvestism signified female sexual promiscuity it also signified a destabilisation of gender roles. Although women were thought to be naturally promiscuous, women with loose morals were socially unacceptable. However, more importantly, female transvestism always contained within it the possibility of women trying to usurp the roles of men. In a relatively unknown play, *Appollo Shroving*, written in 1626 for the male students of Hadleigh School in Suffolk, a male speaker is interrupted by a woman who objects to use of Latin and then attempts to subvert the homocentric educational world by demanding to take a man's part and 'wear the breeches'. It is clear that laughter was invoked in the

cultural production of theatre to stave off the very thing objected to and feared – the perceived attempt of women to dominate men. This is further illustrated by the 'cultural production' of the village charivari – in *Hudibras* (1664), the woman in masculine attire being forced to 'ride the stang' (a horse or mule, backwards) is 'impatient Grizel', or the inversion of the patient wife Griselda who has 'drub'd her husband with Bull's pizzel, and brought him under Covert-Baron'.[77]

The anti-theatrical writers linked female transvestism with the growing trend of women attending the theatre. Whether dressed in masculine fashions or not, women who went to see plays staged in public were associated with prostitution. In Thomas Cranley's *Amanda, or the Reformed Whore* (1635), Amanda visits playhouses to attract male dining partners whom she then seduces.[78] However, there was also a female court context for the cross-dressing furore of the Jacobean period. The queen, Anne of Denmark, initiated a fashion for elaborate court masques (small plays that were often allegorical) and patronised playwrights like Jonson. Using this forum, women of the Jacobean court dressed in masculine attire and with less modesty than was usual or considered ideal. After the staging of Samuel Daniel's *Vision of the Twelve Goddesses* (1604) Dudley Carleton remarked that he discovered women had legs and feet as they wore dresses that were shorter than was normal. A year later he was shocked by Daniels' *The Masque of Blackness* (1605) in which the queen and her courtiers were spilled out of scallop shells onto the stage, painted black and not fully clothed.[79] Drawings by Inigo Jones of the countess of Bedford's costume as Queen of the Amazons for Ben Jonson's *The Masque of Queens* (1609) show her dressed like a Roman legionnaire, chest and arms bared, skirts hitched up and wearing a soldier's helmet with heavy feathers, symbolic of masculinity, cascading down her neck.[80]

James I lent further impetus to the cross-dressing debate by ordering the clergy in 1620 'to inveigh vehemently and bitterly in their sermons against the insolency of our women, and their wearing of broad-brimmed hats, pointed doublets, their hair cut short or shorn'. John Chamberlain reported in a letter of 25 January 1620 that 'our pulpits ring continually of the insolence and impudence of women'.[81] The king's comments encouraged attacks on female fashions such as John Williams' *A Sermon of Apparel* (1619) and were undoubtedly influential in bringing the topic of transvestism into the *querelle des femmes* as witnessed in the *Hic Mulier/Haec Vir* controversy of 1620. Art imitated life and the gender relations of the court were played out on stage. The theatre itself, where transvestism was licensed, became a locus for discussion about the nature of woman and the *querelle des femmes* was carried on as much in plays after about 1600 as in pamphlets and ballads, so broadening the literary reach of the *querelle des femmes*. According to Woodbridge, plays defending or attacking women were staged as matching pairs, such as Nathan Field's *A Woman Is a Weathercock* (1609–10) which he followed with *Amends for Ladies* (1610–11), following the usual conventions of the *querelle des femmes*.[82]

The connections between cultural fixation with cross-dressing and the late Elizabethan/early Jacobean *querelle des femmes* can be most clearly seen and best explored in another play, also from the 1615–1620 heyday of the Swetnam

controversy. This was the anonymous *Swetnam the Woman Hater*, first performed on 2 March 1619 at the Red Bull Theatre by Queen Anne's players, just before her death in the following month.[83] Coryl Crandall has argued against the play's 'feminism' but in favour of its moderate concern with equality between the sexes.[84] However, more recently Constance Jordan has argued that the play is a defence of women that 'criticizes patriarchalism as a system of thought and social order'.[85] The plot reveals why Jordan might make this case. Atticus, king of Sicily, tries to marry his daughter, Leonida, to Nicanor, his first minister, in order to keep personal control of the kingdom. Watching is his son Lorenzo, who later cross-dresses as the Amazon, Atlanta, in order to defend his sister and her freedom to choose a husband.[86] The main plot is a love story that explores gender relations and is resolved by a faithful servant of the king, Iago, who blames sexual misconduct on both of the sexes and advises in favour of Leonida's love-match with the son of the king of Naples, Lisandro. The secondary plot is closely linked to this and takes Swetnam to task. He appears in disguise as Misogynos and his presence is used by the men and the women in the play to re-educate Atticus on the twinned subjects of women and gender relations. The staging of Atticus' re-education is instructive in itself. Misogynos is tried in a court with Atticus' wife, Queen Aurelia, presiding as judge. This echoes Esther Sowernam's mock-trial in *Esther Hath Hanged Haman* of 1617 which, of course, itself echoed Swetnam's *Arraignment*.

The overtones of *Swetnam the Woman Hater* are serious. Misogynos is sentenced to physical punishment and exile. However, humour in the play was provided by the interaction between the cross-dressed Lorenzo/Atlanta and the woman-hating Misogynos. Misogynos accuses Lorenzo/Atlanta of the feminine crime of scolding and the young prince replies 'I forget myself'. There is confused court-ship as Misogynos becomes attracted to Lorenzo/Atlanta and then is defeated by him/her through fencing, a sport that almost iconically represented masculinity in Jacobean elite culture. *Querelle des femmes* and cross-dressing are resolved at once with a denouement of unmasking and a marriage between Leonida and the man of her choice. Misogynos and Nicanor are forgiven as Aurelius presides over a converted Atticus and the political governance of the two kingdoms is settled on the next generation.

Swetnam the Woman Hater was designed (by Queen Anne's own servants) to address the sharp debate about female nature exemplified by Swetnam's *Arraignment* and the debate about female fashion that culminated in *Hic Mulier/Haec Vir*. The woodcut on the front of *Swetnam the Woman Hater, Arraigned by Women* is enlightening. While Swetnam is represented standing in the dock in front of a female monarch, Lorenzo is represented as a very contemporary 'Amazon', with doublet and broad-brimmed hat. The visual portrayal is almost identical to the woodcut of a 'mannish-woman' in *Hic Mulier*. All the *bona fide* women arranged around the dock in *Swetnam the Woman Hater* were shown dressed in exactly the same female fashion. It can be concluded from this that the Jacobean *querelle des femmes* was shaped by the culture of the London court and stage and possibly even by the domestic affairs of the king and queen.

After 1620, for a few years, serious-minded defences dominated the *querelle des femmes*. These included Christopher Newstead's *An Apology for Women* (1620), Abraham Darcie's *The Honor of Ladies* (1622), Thomas Heywood's vast tome, *Gunaeikeion: or, Nine Books of Various History Concerning Women* (1624) and William Austin's *Haec Homo* (1637).[87] Both Austin's *Haec Homo* and Newstead's *Apology for Women* came close to arguing for sexual equality, Newstead by turning around the Creation narrative and saying 'Eve then tempted Adam, but now Adam tempts Eve'. Like many defenders of women, Newstead argued for the greater achievement of women on the grounds that they overcome the impediments of the weaker vessel to begin with. His view of gender relations was a generous one; friendships between women and men were better than between men and men, though this was predicated on women's greater fidelity, even their willingness to die to be with their deceased husbands. He subverted the commonly held belief in women's cold moist humours by saying that their acute wit could be accounted for through 'the pureness of the temperature of the body'.[88] *A Woman's Worth* (c.1620–34) took the argument about equality between the sexes as far as it could go within the confines of Biblical thinking. The author speculated that if s/he proved Eve's superiority before the Fall then this could even be an argument for female rule.[89] However the existence of such tracts, both in published and manuscript form, does not prove that anxiety about gender role reversal disappeared. In 1633 William Prynne published one of the fiercest anti-theatrical treatises of all – *Histrio-Mastix* (a work that was filled with exaggerated anxieties about the impact of stage plays on the sexual behaviour and gender identity of the nation) – and in the late 1630s and during the civil wars the tone of the debate returned again to that of sharp invective.

Querelle des femmes: 1640–1700

In mid-seventeenth-century England the figure of the garrulous woman took on a more sinister set of meanings. The extraordinary *Anatomy of a Woman's Tongue, divided in five parts: a Medicine, a Poison, a Serpent, Fire and Thunder* of 1638, was a pseudo-medical text, with a crude picture of a tongue on the front. The organ was gendered female by its areas that spat poison and ophidian venom. The tongue had traditionally been seen as woman's greatest ally in the war against men and the image of the tongue was sometimes sexualised by being depicted as a penis, an image that had a dual symbolic impact; the garrulous woman was a sexual predator and scold who was made masculine by her attempts to usurp male authority through speech. Lisa Jardine has shown the extent to which the female tongue was used to symbolise voracious female sexuality, arguing, for example, that in *The Taming of the Shrew* Petruchio's taming of the tongue of Kate is symbolic of his enforcement of patriarchal control in marriage.[90]

The context of the English Civil War brought about a change in emphasis in the *querelle des femmes*, the concerns over cross-dressing of *Hic Mulier* and *Haec Vir* transforming into anxiety about female speech. Much of this shift can be seen initially in the work of John Taylor (1578–1653), the writer most associated

with the return to sharp invective against women in the late 1630s. Taylor was a prolific author of satires and travel-writing, bawdy verses and jest books. After a Gloucester grammar school education, he came to London and became one of the 3,000 boatmen who carried courtiers, lawyers and members of parliament up and down the Thames in small 'ferries'. His dual occupation earned him the nickname 'the king's water poet'.[91] John Taylor serves as a cultural intermediary; he opens wide the doors of seventeenth-century London for viewers of the twenty-first century to peep inside. For example, his *Carriers Cosmographie* (1637) listed all the taverns frequented by booksellers, especially in the expanding north London suburbs. Taylor's verse was filled with common jests about women: '[t]he greatest females underneath the sky | Are but frail vessels of mortality ... | Lust enters, and my lady proves a whore'.[92] The sexual banter in his poetry was reflected in his social life; he was accused of sexual slander for accusing another man's wife of being 'an arrant whore'.[93]

Taylor joined the controversy about woman in 1639 with *A Juniper Lecture, with the Description of All sorts of Women* which was quickly followed by an enlarged edition plus the *Divers Crab Tree Lectures* (1639). In *A Juniper Lecture* Taylor explained that the juniper tree is symbolic of the dual nature of women; juniper burns continuously, like women's vengefulness, yet it is also an antidote to snake bite. His concern with female speech was indicated from the outset: 'a womans words [were] very piercing to the ears and sharp to the heart' like the prickles of the juniper. He then divided women into a sizeable 'bad' majority and a tiny 'good' minority, before running through a set of stereotypical scenarios in which different types of women used their scolding voices to exercise dominion over men. These included the nagging wife complaining about her servitude, the young widow teasing an elderly suitor, the old and rich widow teasing the young suitor, jealous wives, angry farmers' wives and wives who scold just because they want more fancy clothes.[94] Taylor got to the crux of the matter with the following passage:

> It is better for a man to have a fair wife that himself and every man else will love ... or a deformed wife that would hire others to make much of her (...), or a drunken ... or an old wife that were bedridden of her tongue ... or a proud one that would waste all his estate in fashions ... or a lazy wife ... or a sluttish wife that would poison him ... I say it were better for a man to marry with any of all these forenamed wicked kind of women than to be matched and overmatched with a scold.[95]

Taylor's anxieties about women's subversion of male authority were revealed by his privileging of scolding over all other female 'vices'. His sequel, *Divers Crab Tree Lectures*, dwelled at length on how to tame a shrew. The lines 'I know not which live more uncouth lives, obedient husbands, or commanding wives' make his concern with gender order very clear.[96]

At the conclusion of *A Juniper Lecture*, Taylor employed the standard advice of heralding an answer to his own work: 'There are divers women set their helping

hands to publish … [a] Book, called by the name of *Sir Seldom Sober or the Woman's Sharp Revenge.*' He then published *The Women's Sharpe Revenge: Or an Answer to Sir Seldome Sober* in 1640. This pamphlet claimed to be 'performed' by 'Mary Tattlewell' and 'Joan Hit-Him-Home', the names obviously symbolic of the scolds Taylor had so roundly attacked in *A Juniper Lecture*. In *The Women's Sharpe Revenge* the good-hearted scold Long Meg arraigns the poet of *A Juniper Lecture*. She makes him drop to his knees and apologise to women for his 'error' or she will 'break his jugs about his pate'. Thus, the symbolism of Socrates and Xanthippe was employed in an ambiguous opening to a supposed 'defence' of women.[97] The prose that followed this verse opened with the retitling of John Taylor as 'Sir Seldom Sober', who was then tried by a jury of women, an obvious reference back to the 'arraignments' of the Swetnam controversy. The jury of *A Juniper Lecture* included 'Sarah set-on-his-skirts', 'Kate call-him-to-account', 'Prudence pinch-him', 'Moll make-him-yield' and 'Helen hang-him'.

Taylor was above all else an entrepreneurial writer aiming at a popular audience; both the attack and the defence cast women in a negative light though some historians have been fooled into finding 'feminism' in *The Women's Sharp Revenge*. The latter contains passages that prefigure later proto-feminist arguments about the relationship between women's lack of education and their subjection to men in society: '[w]hen we, whom they style by the name of weaker vessels … have not that generous and liberal education … if we be taught to read, they then confine us within the compass of our mother tongue … And thus if we be weak by nature, they strive to make us more weak by nurture.'[98] Henderson and McManus called these sections on education 'revolutionary', but most historians follow Simon Shepherd in thinking that Taylor himself wrote the second pamphlet and that this is a mock 'female voice'.[99]

Through the 1640s and 1650s the *querelle des femmes* had two faces, the first recognisable from what had gone before and the second that used stereotypes about women in ways that were very specific to the context of the Civil War which reconfigured the symbolic meanings of sex and gender through war propaganda. Most *querelle des femmes* contributions between 1640 and 1660 were attacks and the following examples are designed to demonstrate the difference between those that were traditional in format and those which featured themes reflective of the divisive religious and political debates of civil war England. A traditional *querelle des femmes* tract can be found in 1642, when 'I. H. Gentleman', writer of the pamphlet *A Strange Wonder or a Wonder in a Woman, Wherein Is Plainely Expressed the True Nature of Most Women*, made reference to Tom Tell-Troth (Swetnam, amongst many others, claimed this title) and trotted out standard anecdotes about women's wily ways. For example, women were portrayed as using counterfeit coyness to get their way. They scolded, pouted and behaved in idle and sluttish ways. Gossips tried to wear the breeches and women's lust was insatiable because they were the 'weaker vessels'. Similar sentiments were repeated in plays like *The Ghost: Or, the Woman Wears the Breeches* (1653) in which, Aurelia, on her wedding night, pulls off her husband's breeches and threatens to 'have preheminence [*sic*] in all affairs'. She proceeds to straddle him like a horse – a reference to Phyllis riding Aristotle – and

her servant raises the breeches aloft on a pole in imitation of charivari and street festival. Wearing his breeches sexually invigorates her and Aurelia promptly turns into a whore.[100] *The Ghost*, with its class and gender inversions, is a carnivalesque form of *querelle des femmes* literature. It inverts and mocks, ultimately reinforcing the norm of men wearing the breeches.

However, many of the tracts that satirised women between 1640 and 1660 drew attention to deeper and more dangerous religious concerns. *A Strange Wonder or a Wonder in a Woman* told its readers that '[w]oemen are admirable angels, if they would not be drawne with angells to become Devills'. The pamphlet then linked religious corruption with sexual corruption arguing that a woman involved in religious radicalism was given to sexual abandon: 'According as the spirit moves her, the fire of her zeale, kindles such a flame…she can…cover the lust with religion.'[101]

Lucy de Bruyn has demonstrated that women were long represented as coming into contact with the Devil and turning into wantons, witches and shrews. The difference in 1640 was that woman herself was often portrayed as the Devil.[102] For example, the author of *A Bull from Rome, Consisting of 15 Pardons for Delinquents in These Kingdomes* (1641) told the story of St Peter accidentally transposing the heads of the Devil and a woman when they were courting: he 'set the Divells head upon the woman; and, as I thinke, there it remaineth yet; for surely it must needs be a Divels head, which hath such an evil tongue within it'. The author then went on to say that in Rome each new Pope was examined to see 'whether he be a man or a woman' because an English woman once fooled them.[103]

The suggestion that the anti-Christian Pope and English women were equally evil and dangerous was a forcible one. It was reflected strongly in men's propaganda aimed at male enemies. 'K. R.', attacked Taylor with 'Oh! the wonders of our age; wherein Poets turne Divels' and argued that the words emitted from Taylor's mouth were vile because a Devil, represented as a woman, had urinated directly into that orifice. The male tongue became the female tongue which spat evil and the world became polluted as a consequence. Woman traditionally had been the propagandist's inversion of all that was good. The Catholic Church was gendered by zealous Protestants as female, or the 'whore' and Thomas Grantham attacked the untrue church of his enemies by implying that they were married to the wrong wife: 'Leah instead of Rachel'. The impact of men gendering their male enemies feminine altered the tone of the *querelle des femmes;* it became very bitter and its focus changed so that the female tongue loomed far larger than the masculine attire that had featured so weightily in the *querelle des femmes* of the 1620s.[104]

Studies of the *querelle des femmes* have concentrated their efforts on the years prior to 1640 and an argument can be made for the formal literary debate, governed by the old, medieval rules of satire, blowing out its last breath with John Taylor and the bawdy ballads of the English Civil Wars. However, other late seventeenth-century and early eighteenth-century pamphlets fit into traditional literary tropes of attacks and defences of women. As late as 1716 Ned Ward's *Female Policy Detected* contained the same warnings against the wiles of women

and advice against marriage as *The Scholehouse of Women* of 1541. Anthony Fletcher has argued that the social and political disruption of the 1640 to 1660 period brought with it serious renegotiation of gender that cast women and 'the feminine' both as cause and symbol of social disorder.[105] It might be expected that the *querelle des femmes* would change to reflect this recasting of woman in society. However, after 1660 the association of women with religious turmoil in society was far less important than a diatribe about their rampant sexuality and impiety, both of which were seen as posing a threat in their individual relationships with men.

The *querelle des femmes* was given new impetus in 1682 by the publication of Robert Gould's *Love Given O're: Or, a Satyr against the Pride, Lust, and Inconstancy, &c of Woman*. Gould was an embittered satirist who claimed he did not want to offend good women and that he was glad to be free of the bonds of love and the bother of the war between the sexes. He also claimed knowledge of the past controversy, including Swetnam's outburst, and expressed the hope that his contribution in verse would extend the debate beyond his death. He began, as nearly every other *querelle des femmes* writer before him, with Eve ushering in 'plagues, woes and death, and a new world of sin'.[106] However, while the subject matter was traditional, the language was more secular and anecdotal than the pamphleteering of the past. The Civil War model of women's connection with the Devil was established at the outset: 'True, the first woman gave the first bold blow, and bravely sail'd down to th' Abyss below' where she would 'surely raise a civil war in hell'. All women would be whores if they dared; their greedy wombs meant they resorted to masturbation devices such as dildos. Women's responsibility for this was also implied marking a shift away from ideas about women's inability to control their sexual desires.[107]

Other post-1660 *querelle des femmes* tracts also demonstrated a fascination with female sexuality. The context for it was changing ideas about the origin of women's mental illness. Walter Charleton's *The Ephesian Matron* (1668) drew on the ideas of his friend, Thomas Hobbes (*Human Nature* [1650]) to describe the descent into passion of a young woman and a soldier beside the grave of the young woman's husband. Charleton was a physician at the Stuart court and a member of the Royal Society for whom 'womb madness' had been replaced by the belief in a Hobbesian state of nature.[108] Robert Gould's *Love Given O're* repeated the tale of the Ephesian Maiden to exemplify his comments about women's recurring inconstancy. Their free will was highlighted through a secularised Biblical metaphor. Women were described as being like apples – they could look perfect on the outside but be rotten on the inside. When not actually being the Devil, they worshipped the 'Deity of Pride' and their irreligion was proved by the ease with which they broke religious vows and oaths. By this Gould meant the vows taken at marriage, though he used this topic as a way of inverting the commonly-held notion that women were naturally pious.[109]

Love Given O're was instantly popular; it was reissued in 1683, 1685, 1686 and 1690. It was joined by a series of attacks by Richard Ames – *Sylvia's Revenge* (1688), *A Consolatory Epistle to a Friend Made Unhappy by Marriage* (1688/9) and *A Satyrical*

Epistle to the Female Author of a Poem call'd Sylvia's Revenge (1691). Ames provoked literary debate by writing defences as well – *The Pleasures of Love and Marriage, a Poem in Praise of the Fair Sex* (1691) and *Sylvia's Complaint of Her Sexes Unhappiness* (1692). Ames' personal view of women cannot be ascertained from his pamphlets. However, his knowledge of the standard tactics of the *querelle des femmes* can be in no doubt. In *The Folly of Love; or an Essay upon Satyr against Woman* (1691), a rather anodyne attack, he began with the common address to women: 'Perhaps some angry SHE may be offended with some biting lines; but let her fret on ... heaven deliver me from love and dotage.' He also began with Eve, ran through women's pride, provided echoes of the 1620s debate with an attack on women's love of dress – 'fardingales, stiff ruffs ... washes, paints, perfumes' – and echoed his fellow-satirist, Robert Gould, through mention of the same masturbation devices used by lustful women.[110] However, in *The Folly of Love* there were some elements which were new to the late seventeenth century. For example, snipes were made at women for attending playhouses and being educated and he associated both with female lust. The strict Biblical basis for women's sinfulness was abandoned in favour of a subversion of the story of Creation – in Ames' version Eve was pregnant before she tasted of the tree of knowledge. The latter indicated a radical escape from the Biblical intellectual foundations of the idea of woman.[111]

The literary outpourings of Gould and Ames provoked a response from one woman – Sarah Fyge or Fige (Field Egerton) – who wrote *The Female Advocate: Or an Answer to a Late Satyr Against the Pride, Lust and Inconstancy of Women* (1687). Her contribution signals a change in the *querelle des femmes*. The only definite female voice before 1640 had been that of Rachel Speght. By the end of the seventeenth century Sarah Fige was one amongst several women rising to the defence of their sex in print. An immediate difference can be spotted between the approaches of Fige and her predecessor; while Speght had been apologetic about appearing in print (like many other women publishing on other subjects before 1640), Fige displayed only a false modesty, saying that she ought to keep what she had to say brief to prove that the 'great commendation of our sex, is to know much and speak little ... lest censuring critics should measure my tongue by my pen, and condemn me for a Talkative by the length of my Poem'. The educated woman or 'talkative' had first appeared in Richard Brathwait's complaints in *Ar't Asleepe Husband* in 1640 about women who were 'Talkative Girles' and 'University Viragos'. 'Feminine Disputants should be silenced' he had said, but during the Civil War women had not been silent and by 1686 the 'Feminine Disputant' was less apologetic than Rachel Speght had been.[112] Fige's *Female Advocate* reveals both lack of coyness in defence of the female sex and the altered emphases of the debate itself. 'I think, when a man is so extravagant as to damn all womankind for the crimes of a few, he ought to be corrected', Fige proclaimed. 'Women are the truest devotionists, and the most pious', and, like men, they possessed 'rational souls'. While piety was a traditional defence of the ideal woman, possession of a 'rational soul' was not, and the use of this idea in the *querelle des femmes* was linked to changing notions about the female body and mind. More traditionally, Fige defended women on the

grounds that 'the very name of whore [woman's] soul affrights'. Women were, constant, gentle, faithful, modest/not proud and so on. Men were the opposite.[113]

Thus, women's capacity for escaping the worst accusations against them can be attributed partly to the slow collapse of the Christian and Aristotelian *zeitgeist*. Fige did not believe that her default position was the Biblical 'weaker vessel' exemplified by Eve, nor did she believe women incapable of reason. Indeed, Fige's defence of women claimed a monopoly for women of religious piety.[114] If the attack side of the debate altered only in topical content, the defence side did radically change, not so much through content as the addition of a genuine female voice that turned a stylized debate into one that placed tension between the sexes plainly in print. Men continued to write both attacks and defences, but, significantly, women wrote only defences and they became more polemical. Sometimes they paid a price for this – Sarah Fige's father – a physician – banished her from the house.[115] Women also addressed the male warnings against marriage found at the heart of much of the *querelle des femmes* literature. In reply to John Sprint's offensive sermon of 11 May 1699 at Sherborne, Dorset, demanding complete control of women by men in marriage (published as *The Bride-Woman's Counsellor* [London, 1700]), the pseudonymous 'Eugenia' (real identity unknown) claimed proudly never to have come 'within the clutches of a husband'. Her pamphlet was entitled *The Female Advocate; or a Plea for the Just Liberty of the Tender Sex* (1699) and it set out to refute every point made by Sprint. 'Eugenia' pointed out that Sprint demanded more obedience of women than God had done and that Sarah's use of the term 'Lord' for her husband was customary rather than the most common practice. Lady Mary Chudleigh (1656–1710) also wrote anonymously in reply to Sprint. In *The Ladies Defence* (1700) her fictional female speaker – 'Melissa' – argued with three [also fictional] male speakers – Sir John Brute, Sir William Loveall and a parson. She used their debate to refute Sprint's concept of wifely submission and to advise women to 'shun that wretched state' [of marriage].[116]

Thus, by the end of the seventeenth century the *querelle des femmes* had been irreversibly altered by the participation of female authors as women became integrated into the debate as defenders of woman. Occasionally they brought a critical edge to the debate that previously had been absent, seen in the counter-attacks made on men. For example, in *An Essay in Defence of the Female Sex* (1696), Judith Drake attacked William Walsh's defence of women on the grounds of his misplaced chivalry. Drake launched a full-scale counter-offensive: male scholars were 'bigotted idolaters', country squires were noisy drunks and buffoons, the town was filled with 'fop poets' and 'coffee house politicians' and so-called men of nice honour proved their honour through brawling. Drake's offensive on the male sex attracted a popular audience in the same way that Swetnam's attack on the female sex had done 76 years before and her tract went into a third edition by 1697.[117]

Male and female defenders of woman continued to employ exemplars of 'good' women to defend female nature. However, the emphasis turned to their rationality and ability to function in the male political sphere (prefiguring eighteenth century

topical debates about woman and citizenship). William Walsh's anonymously-published *A Dialogue Concerning Women, Being a Defence of the Sex* (1691)[118] took the form of an exchange between Misogynes and Phylogenes who argued not only about women's virtue, but also their capacity for reason and their ability to rule. At the heart of Phylogenes' praise for women was an ability to rise above the disadvantages of a slight education. In 1692 the male author (probably Nahum Tate of Walsh's circle and friend of John Dryden) of *A Present for the Ladies, Being an Historical Vindication of the Female Sex* joined the late seventeenth-century *querelle des femmes* with a similar defence, employing examples of British female rulers to prove that 'we [men] should no longer look upon them as entertainments of idle hours, but place them in the venerable estimation which is due to their merit'.[119] Thus, men's defences of women changed in tactic also, moving away from Biblical modes of argument to assertions about the positive benefits the female sex brought to men.

The attack side of the *querelle des femmes* continued beyond 1640 and was equally (to some extent reactively) transformed. The scold driven by her uncontrollable passions and greed became the scold whose tongue was foolishly loosened by book-learning and education so that she had the temerity to write and be published. After 1660 women playwrights fell into this category. In 1696 the author ('W.M.') of *The Female Wits* launched a vicious attack on female playwrights, in particular Mary Pix, Delarivier Manley and Catharine Trotter, Pix being represented as 'a poetess that admires her own works' and Trotter as 'a lady that pretends to the learned languages'. Thus, the *querelle des femmes* of 1700 anticipated a world filled with the female voice and written works including *The Female Wits* came to caricature the female sex as talkative 'scribblers' and gender relations as an unholy alliance between such women and a new breed of man – the 'fop'.[120]

Conclusion

In the sixteenth century, a formal, stylised debate about the nature of woman overlapped with the widespread printing of satires about ale-wives and bad marriages. Woman was construed as a problem and at times the debate was deeply misogynistic in tone. However, by the end of the seventeenth century ideas about the stereotypical 'bad' woman had changed from the drunken scold to the educated woman whose acquisition of knowledge was potentially destructive of those virtues which were normalised as 'good' in a woman like humility and modesty. Anthony Fletcher has observed that a dislike of intellectual women emerged because '[m]en had a vested interest in not wanting women to develop their minds'.[121] The changed face of the 'bad' woman reflected positive change that resulted in women like Bathsua Makin, Mary Astell, Judith Drake and Sarah Fige writing in defence of their sex to counter negative portrayals of woman. Their work irreversibly changed the *querelle des femmes* and may be regarded as a nascent feminism. However, it is a mistake to univocalise women writers who contributed to the late seventeenth-century *querelle des femmes* – Sarah Fige wrote in

defence of her sex, but her one-time friend, Delarivier Manley wickedly satirised her complicated and bitter married life in *The New Atalantis* in 1709.[122] Indeed, in defence of their sex women became engaged in an intrinsically divisive rhetorical exercise that placed the model of woman as guardian of social morality at the heart of a new debate *about* femininity that was internal *to* femininity; this debate conducted by women about women ensured that the power of the *querelle des femmes* to construct femininity, as an idealised social construct, was eroded once and for all.

3
Femininity: Prescription, Rhetoric and Context

Introduction

There were many types of texts that were vehicles for prescribing behaviour in the ideal woman between 1500 and 1700. Collectively they represent what Joan Wallach Scott has called those 'normative statements' of gender that asserted a consensus view of what a woman should be like through the denial or negation of alternatives.[1] Because discussions of femininity never took place far from the debate about gender relations, the *querelle des femmes* intersected with prescription and placed the model of marriage at the centre of debate about women's lives. Normative statements of femininity developed models of 'good' womanhood that were based upon the archetypal 'good' woman, or Griselda, but in scenarios designed to appeal to women, at least women of some affluence. Just as a major sub-genre of *querelle des femmes* writing was the marriage pamphlet, so too did marriage and the married woman dominate works of prescription which usually came in one of two forms – 'how to' guides or conduct manuals and godly household books. Richard Brathwait's *The English Gentlewoman* (1630), which was a conduct manual aimed at the socially-aspiring woman, instructed women on how to ensure that men would be satisfied with them when they became wives. Works of prescription had one other thing in common with *querelle des femmes* pamphlets – they were almost entirely written by men. Thus, the male definition of the ideal woman dominated gender construction at one level through most of the period 1500 to 1700 and women's self-determination (another component of gender construction) was formed through a complex process of reinterpretation of and adaptation to monolithic expectations of ideal female behaviour. The femininity that was a product of women's ideas can be found in their diaries, religious and political texts which are treated in later chapters and only touched upon here.[2]

Prescription

Men of the early sixteenth century inherited from the medieval period a vision of the social hierarchy that placed women after almost all categories of men which

started with dukes, earls, knights and so on. One continental sermon collection of 1220 CE listed 28 'estates' in which women were twenty-seventh, after 'rebellious [male] peasants'. Women were not described according to rank or occupation, but rather by their sex. This medieval division of the world echoed through William Harrison's *Description of England* in 1577 which made distinctions between only four social groups, all of whom were adult males. Sixteenth-century division of the social world into groups of men arose out of the universal belief in women's natural inferiority and decreed subjection. The degree to which this prescription of a woman's place determined femininity is a matter of some debate. However, it can be said that acceptance, by both men and women, that women were subordinate in society resulted in influential prescription by men of female gender attributes.[3]

The classic normative statements of gender in the period appear primarily in conduct manuals, which had the exclusive purpose of prescribing the 'good woman', and texts generated by institutions such as homilies and sermons of the Church as well as eulogies and printed funeral elegies.[4] The most influential conduct books were Juan Luis Vives' *Instruction of a Christian Woman* which came out in English translation in 1529 and Baldassare Castiglione's *The Book of the Courtier* which was originally written in 1528, but not translated until 1561.[5] Castiglione's prescription of femininity reached the upper classes of Tudor society through the medium of the Elizabethan court. The lower classes received similar prescription through tales of chivalry and love ballads.

Ruth Kelso, in a study of prescriptive texts, summarised the most desirable features of a feminine woman as chastity, obedience and silence. This triad of virtues was accompanied by a series of proscriptions which included anger and jealousy, all of which demonstrated the wish for a compliant wife. Other desirable qualities in a woman were virginity in an unmarried woman and chastity in a married woman or widow, discretion, love and modesty, including modesty of demeanour (especially blushing and covering the face when embarrassed), dress (which needed to be comely but not forward) and facial presentation (including rejection of the use of cosmetics). Chastity was the crucial prescription from which all others followed. Chastity in unmarried women involved different kinds of behaviour from those who were or had been married. For the unmarried woman it involved avoidance of all sexual congress and for the married woman it involved avoidance of sexual congress with anyone but one's husband. However, the prescription of chastity went further – the chaste unmarried woman had no thoughts of sexual intercourse and the chaste married woman thought only of appropriate sexual intercourse with her husband. In a world in which God could see into your soul, thought and deed were the same. The married woman also worried about the behaviour of other men towards her. This involved her in a more difficult balancing act than an unmarried woman for whom contact with men was simply forbidden; she acted in proxy when her husband was away from home and chastity under these circumstances involved a combination of sociability while putting up a barrier to intimacy.[6] The other two crucial prescriptions of obedience and silence were fraught with difficulty for the married woman too. She was supposed

to combine obedience and silence with almost sole responsibility for the running of the household, including ordering servants. The prescription of silence was inherently ambiguous. It was not silence *per se*, but the ability to order speech and make it appropriate to the company and the moment in ways that did not undermine male authority.[7]

Prescriptions of femininity involving bodily beauty were even more ambiguous. Women were warned that while bodily beauty was a desirable quality to have, it was not one a woman should aspire to achieve through unnatural enhancement or spending on clothes. Arthur Dent's *Plain Man's Pathway to Heaven* (1607) warned that women were prone to be 'proud of apparel... [and] baubles... lacing and braving up themselves in most exquisite manner'.[8] Prescription of female chastity and sartorial modesty emanated from the same source – male anxiety about female sexuality. Passages from the Bible such as Proverbs 6:24–6 warned men against the inherent danger of female beauty as it could lead them into sexual sinfulness and prescriptive literature aimed at women reminded them of the need to discourage the sinfulness of sexual flirtation. Writers warned men that female beauty did not equate with feminine perfection and that it could, in fact, disguise disease. Warnings against female beauty even found their way into puritan verse such as John Milton's *Paradise Lost* (1667) – '[h]er loveliness, so absolute... all higher knowledge in her presence falls [d]egraded]'.[9]

The question of female beauty was seriously complicated by the tradition of courtly love that celebrated the female form and desexualised it in something close to a type of secular worship equated with the virgin state. Prescription was distorted and challenged by neo-Platonic love poetry that escaped the strictures of the Biblical woman. This can be seen in Richard Lovelace's *Gratiana Dancing and Singing* (1649): 'See with what constant motion Even, and glorious, as the sun, Gratiana steers that noble frame.'[10] The gyrating body of a woman could be represented as something natural, even cosmological in its harmoniousness, as in John Davies' poem, *Orchestra, or a Poem on Dancing*: 'For Love within his fertile working brain | Did then conceive those gracious virgins three | ... All decent order and conveniency'.[11] Davies transformed beauty, overcoming its potential for hiding sin and even 'mak[ing] it shine with glorious beauty and with divine grace'.[12] According to N. H. Keeble, one of the 'commonplaces of courtly culture' was that 'love is moved by beauty... and is thus a means to ascend beyond the physical (and sexual) to spiritual bliss'.[13] There were other visions of the female form: in the great hall of Burton Agnes in East Yorkshire, in a plaster frieze of 1603, the foolish virgins were cast as dancing and singing and playing the English bagpipes. By contrast, the wise virgins were represented in kitchen and bedchamber, meditating, washing and spinning. The beautiful dancing virgins represent spoilt femininity, as symbolically demonstrated by upturned lamps in the scene.[14] The 'beauty problem' crept into advice about how to identify a future 'good wife'. Thomas Becon's influential *Catechism* of the early 1560s advised that '[i]t shall not be unfitting that all honest and godly disposed maids content themselves with comely and seemly apparel'.[15] Men were advised when seeking wives to ensure that their physical appearance was beautiful enough to prevent a man

from wanting to seek sexual pleasure elsewhere (and ensure the production of well-formed children), but not so beautiful that the woman's appearance would cause anxiety about her fidelity. Indeed women's moderate beauty was a sign of male social success.[16]

The reign of Elizabeth I complicated the beauty discourse. Elizabeth used dress to symbolise her power and cosmetics to project political authority. Miniatures and portraits of the virgin queen provided a representation of perfection in an unmarried woman that was elaborate and unattainable and her dress exaggerated her idealised femininity. For any other woman such attention to dress symbolised a lack of modesty hinting at sexual impropriety and stepping out of appropriate modes of dress for social class, but for Elizabeth the pearls that accentuated her body shape were symbolic of royalty and virginity.[17] Elizabeth subverted prescription about the use of cosmetics also. She used powders of white lead to cover her face and the fashion spread. In an attempt to dissuade women from the use of such cosmetics writers warned [rightly] of appalling skin damage that could result. To avoid the accusation that they did not blush, women used a mercury compound to bring colour to their cheeks and this also corroded the skin.[18] Despite the lurid warnings, it is clear from portraits of wealthy Elizabethan women that they followed the fashion-lead of the queen, while male criticism of cosmetic use intensified. Philip Stubbes' *Anatomie of Abuses* (1583) used a mythical dialogue between 'Spudeus' and 'Philoponus' on an island called AILGNA to denounce 'curled, frisled and crisped hair...under-propped with forks', the sign of 'ensign pride [a sin]'.[19]

Ambiguity of representation continued under James I. '[I]t is not enough to be good, but she that is good must seem good', said Thomas Tuke in his *A Discourse against Painting and Tincturing of Women* (1616) adding 'she that is modest must seem to be so and not plaster her face that she cannot blush'. However, Anne of Denmark was responsible for a continuation of the ritualised and highly stylised projection of femininity begun by Elizabeth. Lucy Harrington, countess of Bedford, had herself painted by John de Critz as the 'Power of Juno' before appearing in Ben Jonson's *Hymenaei* in a court masque. The allegorical and Classical symbolism of her costume cut across sexual propriety, creating a dual image of the beautiful woman holding herself in a stiff and demure pose in a dress that was cut above the ankle with a bared chest and vast head-dress.[20]

The prescriptions of silence and obedience also appeared in the multiplicity of seventeenth-century conduct books. Writers such as Brathwait argued that silence, modesty and submission to male authority were the key ingredients that persuaded men (and other women) that a woman was 'good', by which they usually meant marriageable. Nicholas Breton in *The Good and the Bad* (1615) said that '[a]n unquiet woman is the misery of man...[h]er voice is the screeching of an owl...her pride is insupportable'.[21] Thomas Bentley put it unbendingly in 1582: '[i]f she walk not in thine obedience, cut her off then from thy flesh'.[22] Lack of silence indicated disobedience: *Counsel to the Husband* of 1608 warned that 'to scold and speak presumptuously...is intolerable contention'.[23] The 'good' woman did not question men and like Sarah she obeyed silently as instructed to do so in the homily on marriage.

The prescription of silence was conveyed through warnings about its opposite in scolding and was linked to a general prescription of humility, abasement and a willingness to submit to the superior authority of men.[24] Silence was not so much a prescription for women as a sign to men that a woman showed the necessary qualities that led to obedience. Robert Burton told his readers in *Anatomy of Melancholy* (1621) that women 'who give content to their husbands...be quiet above all things, obedient, silent and patient'. More unusually, he actually prescribed a device to achieve silence advising women that if they held a glass of water in their mouths it was an 'excellent remedy'. In silence, as in all male prescription of female attributes, there was a double standard at work – Burton told his readers that the female silence thus achieved a cure to man's impatience.[25] Behind all the prescription, all the 'normative statements' about perfection in womanhood, lay the assumption of men's possession in and of women, and the double standard at work in early-modern society was nowhere more evident than in the code of behaviour prescribed for female sexuality.

The double sexual standard

In his seminal article 'The Double Standard' in 1959 Keith Thomas painted a bleak picture in which early-modern women were advised by conduct books and male relatives alike to expect and tolerate sexual infidelity from their husbands. 'The world in this is somewhat unequal', the Marquis of Halifax told his daughter, without the slightest trace of remorse.[26] Meanwhile, male prescription of female chastity had two functions: to define and circumscribe female sexuality and provide the model of the perfect female marriage partner. The 'double sexual standard' had an Old Testament pedigree, though it was not uncomplicated. The first three Books of Moses recorded the practice and sanction of polygyny (plurality of wives). However, theologians tended to follow the lead of St Paul and St Augustine to outlaw all polygamy (plurality of spouses by both sexes), arguing that it was against natural law. In other words, monogamy was preached for both sexes by the Church, using especially the Biblical authority provided in the Pauline texts of I Corinthians 7. These texts also provided the idea of equal sexual rights in marriage. Just as a man had a conjugal right to his wife's body, a woman had a conjugal right to her husband's body. There was a single sexual standard employed in canon law in the sense that men and women sinned equally when they committed adultery. Canon law reflected the Pauline model of monogamous and faithful marriage by meting out equal punishment to male and female adulterers, though this was the theoretical model and not necessarily the practice.[27]

The impact of puritanism from the late sixteenth century was reassertion of the rigid definition of the constraints on women and men, but greater pursuit of transgression in female sexual behaviour. The Elizabethan religious settlement gave particular authority to the Pauline texts resulting in a measure of theoretical sexual equality: all sex needed to be procreative sex and only marital sex was considered ordained by God. '[M]arriage is ordained to avoid fornication' Henry Smith advised in his *A Preparative to Marriage* (1591). Adultery, therefore,

disrupted the plan of circumventing illicit sex between unmarried couples or for-nication or sexual congress that took place apparently for sexual pleasure rather than procreation. Non-procreative sex acts within marriage, such as fellatio and sodomy, were also sinful and punishable under canon law. Some writers took this set of principles to their logical conclusion by proscribing sexual congress in elderly, non-fertile couples. Adultery was the one cause for dissolution of marriage through separation *a mensa et thoro* (from bed and board) and almost all canon lawyers argued for sexual equality in this. English theologians drew on canon law and the works of early Protestant writers such as Jean Calvin in their prescriptive advice about adultery. Richard Baxter's *A Christian Directory* (1673) argued that it was a female as well as a male privilege to 'put away' an adulterous spouse and suggested that the reason why Christ spoke of men was that 'he was occasioned only to restrain the vicious custom of men's causeless putting away their wives'. 'Men having the rule did abuse it to the woman's injury, which Christ forbid-deth' he continued '[and] I know of no reason to blame those countries whose laws allow the wife to sue out a divorce as well as a husband'. Canon lawyers even argued that equality in sexual matters was such that if there was adultery on the part of the husband and the wife, the case was cancelled out by the mutual sin and no separation could be granted.[28]

Bernard Capp has recently argued that the influence of this Christian morality was so strong that men as well as women were defensive of their sexual reputa-tions. According to Capp, 'middling' married men who committed adultery were regarded with disgust by their male peers. Even Anthony Fletcher, who makes a case for a 'double standard' that propped up and was a major feature of early-modern patriarchy, has conceded that the young men boasting in the taverns about their sexual conquests ended their days in 'sober manhood'.[29] Capp cites the case in 1648 of one of Ralph Josselin's godly parishioners who, having made a servant pregnant, 'now keepes out of man's sight in regard of the shame'. Capp concludes that the paradigm of a 'double sexual standard' needs to be modified in the light of puritan sexual morality.[30]

However, Margaret Sommerville has argued that there was a tension between the equality of the sin of adultery preached in Christian teaching and the unequal consequences of adultery stressed by lay theorists and lawyers. *A Preparative to Marriage* warned that God had created 'divorce' (though separation was often referred to as divorce, in law this was technically just allowing a second mar-riage to take place rather than dissolution of the first marriage), just as he had created marriage, because it was the only answer 'when her children are not his children ... [and] she seems no more to be his wife but the other's, whose children she bears'.[31] In other words, the adultery of a [married] woman led to unlawful pro-creation, the evidence of which remained in the form of a child. 'Bastard children be not lawful' said Thomas Becon in *The Book of Matrimony* (c.1560). He argued that even though the civil law allowed a man to separate from his wife if she tried to murder him, separation on these grounds was not justifiable by God's law. However, it was justifiable in the case of 'whoredom' because this led to 'base-born ... son[s] of the people'. Thus, the prescription in conduct books that used

Biblical authority to insist on a single sexual standard for women and men tended to be negated by anxieties about the consequences of female adultery leading to a customary double sexual standard.[32]

The arguments for a double sexual standard existing are persuasive. Amongst young men, lionisation of sexual conquest was a major constructor of masculinity and Brathwait's *The English Gentleman* (1630) assumed a stage in masculine development called 'youth' when men's behaviour would be dominated by idleness, lust, and vengeful, rash actions. Anthony Fletcher has pointed out that Shakespeare's young men do not just make love to women, they seduce and conquer them sexually; they 'board' them, 'ride', 'breach' and 'vault' them. The sexual terminology was often proprietary and writ large in words such as 'occupy'.[33] Both Sommerville and Fletcher have argued that the slackening of Christian authority and fracturing of what some historians have termed the 'Calvinist consensus' (which included puritanism) in the later seventeenth century led to a strengthening of the double sexual standard, with retention of the strict code of behaviour for women alongside an acceptable much looser morality for men in a less 'puritan' world.[34]

Common law followed canon law (which was not replaced after the Reformation until the Marriage Act of 1753) in only allowing dissolution of marriage in the case of adultery. Although marriage was not a sacrament after the Reformation, it was still regarded as an indissoluble spiritual union.[35] Adultery was punished by the church courts, but the breakdown of their clerical jurisdiction during the 1640s resulted in the rise in informal private separations by deed gained through a civil magistrate.[36] In practice this led to a double sexual standard; men succeeded in gaining separations for their wives' adultery, but women usually needed to prove cruelty as well to succeed.[37] During the Cromwellian period there was an attempt to bring statutory law in line with God's law through an Act against Adultery in May 1650. The Act rendered adultery a separate and more serious crime than fornication and its impact was reflected in very low illegitimacy rates.[38] The new law defined married women who were sexually unfaithful as adulteresses, but prosecuted unfaithful married men for what was redefined as the lesser crime of fornication. Both cases carried the death penalty, but the double sexual standard was institutionalised in this also, with women only needing to break the law once to be punished, whereas a man needed to be unfaithful twice before attracting the full weight of the law.[39]

The legal double standard reflected custom and gave form to the language used to describe male and female infidelity. Women were 'adulteresses' while men were merely 'fornicators'. Female infidelity was, thus, linguistically coded as the graver crime (and sin) and more firmly linked, by semantics, to the institution of marriage. In the words of one contemporary: 'Custom, which is the master of language, [has] in a manner appropriated the title of adultery to the falseness of the wife...and absolved the husband from the imputation of it where he did not defile another's bed.'[40] The entire language of sexual honour surrounding adultery was heavily loaded against women. Women's lovers were 'adulterers' while men's lovers were 'harlots'. Women who committed adultery were 'whores' and the drop in their

husbands' status was great. When a man's wife transgressed, he symbolically grew the horns of a 'cuckold'. Men who committed adultery were 'whoremongers' [i.e. their crime was contingent on there being a 'whore'] but the status of their wronged wives was not affected at all. Married women were expected to protect their sexual honour. Bernard Capp may be right that in some social circles men were supposed to protect their sexual honour too, but their social status was ultimately more easily protected by ensuring the chastity of their wives than keeping their own chastity intact.[41]

Customary standards of sexual honour informed the language of the courts at the same time as legal prescripts dictated behavioural standards in society. Almost all cases of sexual slander brought to the church courts were brought by women whose aim it was to restore their sexual reputations. In some cases the accuser was a man, but in most cases the customary double sexual standard resulted in women accusing other women over the issue of sexual honour. In 1579, for example, Alice Amos took Susan Symonds to the church court for sexual slander because Susan had leant out of a window in Boar Head Alley off Fleet Street in London and hollered at her with extreme vulgarity '[t]hou art a whore'. Susan's accusation was that Alice had slept with her husband and in this early-modern London community the adultery of Richard Symonds counted for less than the fornication of Alice.[42]

Some prescriptive literature did advise equality of restrictive sexual behaviour. The theologian, William Perkins, advised in a marriage manual that the aims of marriage were procreation of children, procreation of the holy seed and avoiding fornication by subduing the 'burning lusts of the flesh'. He made no distinction between men and women in his prescription of chastity.[43] By contrast the very popular and prolific writer of conduct books, Richard Brathwait (1588–1673), made a very clear distinction between the two sexes by providing them with separate manuals of behaviour in *The English Gentleman* (1630) and *The English Gentlewoman* (1631). A distinction can be made here between different types of normative statement. Both authors 'prescribed' particular kinds of sexual conduct, but Perkins had more appeal to the very zealous Protestant, or puritan reader.

The laxer morality of Brathwait was reflected in the advice he promoted. *The English Gentleman* drew on Renaissance civic humanist ideas to instruct men in the ways of moderation and virtue. In *The English Gentlewoman* he addressed female virtue using equally secular terms, though feminine virtue was equated with sexual honour.[44] *The English Gentleman* concerned itself with a man's life stages under heads such as 'education' and 'vocation' while *The English Gentlewoman* subsumed female education under women's behaviour and outward presentation, the sub-headings of the text being 'Decency', 'Apparel', 'Estimation', 'Gentility' and so on. He did not stress the negative inheritance of Eve. Instead he advised that women had the power to capitalise on 'gentility [which] is derived from our Ancestors to us…There are native seeds of goodnesse sowne [which]…may be ripened by instuction'.[45] However, Brathwait's work was not without a Christian sub-text and the double standard in his work had several elements. Underlying all was the notion that women were largely responsible for sin and, therefore, they

were the ones who required sexual restraint. Brathwait told men in *The English Gentleman* that young men had their minds diverted from the exercise of virtue '[w]hen that sex where modesty should claim a native prerogative [i.e. the female sex], gives way to foments of exposed looseness'. Women were the 'weaker sex' amongst whom there were '[i]nfamous Ladies...whose memories [were] purchased by odious lust.' 'Maids' were told in *The English Gentlewoman* to 'preserve your honour without staine'. The onus was on the woman to prevent 'an entry to affection'. 'Chastity is an inclosed Garden', Brathwait told his female readers and they were advised to expect that men would try to 'gain entry' (again, tacit acceptance of male sexual misdemeanour). Women were not to encourage men through actions such as exchanging tokens – 'Let nothing passe from you, that may any way impeach you'.[46] Other writers said similar things. Juan Luis Vives told unmarried women that they should keep themselves 'from either hearing or saying or yet thinking any foul thing...bridle [the body]...and press it down'.[47]Alexander Niccholes' *A Discourse of Marriage and Wiving* (1599) said that 'chastity doth not only consist in keeping the body from uncleanness, but in with-holding the mind from lust' and Richard Allestree's *The Ladies Calling* (1673) told women that 'every indecent curiosity...is a deflowering of the mind and...defilement to the body'.[48]

Conduct manuals reflect the social expectations of the landed elite, gentry and urban professional classes and merchants, most of whom did not attempt to meet the rigorous standards of the puritan clergy. Brathwait prescribed for women a domestic life in which they could 'work at their needle' in 'household Academies' while tempering 'that labour with some sweet meditation tending to God's honour'. He trotted out all the commonplaces about perfection in femininity such as '[m]odest shamefastnesse [is] a womans chiefest ornament' and '[s]ilence in a woman is a moving rhetoricke'. However, he was willing to allow to women much more social freedom than some of the church writers and, enlighteningly, he accepted a customary double sexual standard in which men were expected to behave with a lack of sexual decorum.[49]

Brathwait's thinking reflected common attitudes about the dualistic nature of women and he additionally wrote conversational and rhetorical treatises about female nature including *A Good Wife: Or a Rare One amongst Women* (1618). In his *Ar't Asleepe Husband: A Boulster Lecture* (1640) he addressed 'modest dames', but the rest of the treatise comprised a series of anecdotes about love and illicit sex and featured women who 'have bestowed their agility onely upon cruelty, tyrannizing above the softenesse or delicacy of their sex'. The bolster of the title represented Xanthippe or the 'bad wife' and he also poked fun at 'joviall wenches'.[50] *Ar't Asleepe Husband* was in the same genre as John Taylor's *The Needles Excellency* (1631) – neither prescription nor *querelle des femmes* text alone. Taylor prescribed needlework as a feminine occupation because it will encourage women 'to use their tongues less and their needles more'. It was only a short step from here to the prescription of silence. Brathwait prescribed female chastity as an antidote to female loquaciousness. Thus while godly puritans were concerned with both male and female sexual restraint, most writers depicted women as being sexually weak

and were mainly concerned to keep female sexual activity within the confines of marriage.[51] Brathwait told men in *The English Gentleman* to expect to go through a stage of 'youth' that included immoderate behaviour while advising that their male honour was dependent upon their 'blood' not becoming 'corrupted', and 'estates confiscated' by female dishonour. A woman's reward for a life of 'virtue' (sexual chastity) was a perfect death, when her 'Angelicall perfection' became her heavenly 'Crowne'.[52]

One question that vexes historians is the degree to which women positively received and acted on male prescriptive advice. Suzanne Hull concludes that women's 'voices were whispers among the shouts of men' and Fletcher has argued that the male voice of the normative texts translated into popular literature and drama leading to women's very considerable acceptance of a set of medical and religious ideas that demanded and received their subjection.[53] Lady Elizabeth Sleigh had sitting on her bookshelves a combination of a standard advice book on gynaecological and obstetric matters and the behaviour and marriage advice literature of the puritan preachers William Gouge, Thomas Gataker and John Dod.[54] Women who were not literate came into contact with the prescribed behaviour through chapbooks and in sermons.[55] The Marquis of Halifax gave his daughter prescriptive advice that echoed *The English Gentlewoman*, stressing the need for her sexual obedience to protect male property interests. He admitted the double standard: 'Our sex seemeth to play the tyrant in distinguishing partially for ourselves … [t]he root and excuse of this injustice is the preservation of families from any mixture which may bring a blemish to them.'[56]

Women were told privately by fathers and brothers that their power with their husbands lay not in struggling against the injustice of a double sexual standard, but in exercising extreme patience. John Wolferston, upon hearing the news of his sister's recent marriage alliance, wrote to her on 1 December 1627 wishing her the husband she deserved. However, he quickly moved to contingency plans in case her future husband turned out to be a philandering rogue: ' … if thare bee anie thing which I can wish good in a husband which is wanting in yours, I doubt not but your good nature will in time beget … stooping (though with reservations) to the imperfictions of his froward will … to rule or please him in the crossest of his affections.'[57]

Wolferston half expected his sister's future husband to have a 'raw nature … for hee is a gentleman'.[58] Therefore, it can be said that the double sexual standard was so commonplace it moved beyond the conduct books into frank and loving brotherly advice, which was especially ironic given that the justification for women's submission to their husbands was female rather than male sexual 'weakness'.

The double sexual standard moved also into the works of the Elizabethan and Jacobean dramatists who anticipated a largely male audience. Although many plays were culturally symbolic texts offering subversions of gender order, there were several Shakespearean plays that echoed prescriptive literature, packaging and reprocessing idealised norms for the mostly male theatre audience. The ones that most thoroughly explored female chastity include *Othello* and *Troilus and*

Cressida and the latter is particularly instructive. The setting of *Troilus and Cressida* was the lengthy war between the Greeks and Trojans fought over the abduction of Helen, wife of Menelaus. The defining speech of the play was delivered by Ulysses, one of the Grecian commanders, to Agamemnon, the Grecian general and brother of Menelaus. Ulysses tells Agamemnon that Troy was holding out against the mightier power of the Greeks because the Greeks had succumbed to a breakdown in 'natural' social hierarchy: 'When degree is shaked...the enterprise is sick.' Ulysses goes on to summarise social order as a male hierarchy based on 'brotherhoods' and 'the primogenity and due in birth'. 'Take but degree away', he warns 'and hark what discord follows'.[59] The reason for the collapse of male society predicted by Ulysses was the breakdown of female chastity that preceded it. Once in Troy, Helen willingly became the lover of Paris, a younger son of the Trojan King, Priam. The breakdown of degree amongst the Greeks was mirrored by the breakdown of degree amongst the Trojans as a direct consequence of Helen's adultery. Hector, the eldest son of King Priam, argues against continued warfare with the Greeks, but Troilus, another younger son, persuades Hector of the rectitude of Paris' cause, using the famous lines that Helen's face had 'launched above a thousand ships'.[60] Hector judges that the 'hot passion of distempered blood' of his younger brothers robs them of reasoned judgement, but in a reversal of degree, brought about because of a false defence of Helen's honour, Hector gives way, allowing dissolution of the male hierarchy in favour of Troilus's argument that '[m]anhood and honour should have hare hearts...[r]eason and respect make livers pale'.[61]

In Shakespeare's version of this classic tale, Troilus pays dearly for his rejection of the correct way to defend female chastity; after exchanging vows with Cressida and consummating his marriage to her she is returned to the Greeks, where she promptly betrays her honour with Diomedes. The ultimate violent drama between the male Greeks and Trojans is, thus, precipitated by the lack of female chastity in Helen and Cressida and when Hector is slain, his words 'Now Troy, sink down! Here lies thy heart, thy sinews and thy bones' symbolise the death of a truly honourable nation represented as a man. Troilus is left to make a final traumatised speech about the death of his older brother, symbolic of the disruption to proper patrilineal descent. In *Troilus and Cressida* Shakespeare did not seek to challenge the norms of gender in society; instead he offered a bleak incontrovertible view of femininity and masculinity and the consequences of adulterous sex and tarnished male and female honour.[62]

While conduct books, plays and family advice demanded chastity from women, it was not clear what women could use, apart from guilt, to demand chastity from men in return. Bernard Capp has argued that women used men's misbehaviour to extract promises and gains – promises of marriage and financial support for illegitimate infants and promises of more power within the household. He cites Samuel Pepys' miserable reflection in his diary that when Elizabeth found him in bed with a maid, she 'is by this means likely forever to have her hand over me, that I shall forever be a slave to her'.[63] However, Pepys went on philandering, unconcerned about his sexual reputation and worried only about how to

maintain his wife's subjection when she held the moral highground. This was the customary double standard in practice and it held at least as much weight in early-modern society as religious prescriptions of faithful and loving sex between marriage partners. The double sexual standard in practice was, therefore, reflected in and reinforced by some conduct manuals and by the legal distinction that was made between male and female adultery.

Marriage, vocation and occupation

Marriage and women's role in society was prescribed by a model of patriarchy provided by Christianity that had three Biblical sources: the Fifth Commandment – 'honour thy father and thy mother' – that set up a system of hierarchical obedience within the family; Genesis 3:16 – 'unto the woman God said...thy desire shall be to thy husband, and he shall rule over thee' – which set up a model of women's obedience to men in marriage and St Paul's epistles to the Corinthians 11:3 and 8:10 – 'the head of every man is Christ, and the head of the woman is man'. The last set up an anatomical metaphor of head and body that ran through the prescriptive literature and set up a model of women's total obedience to men.[64] Repetitions of the idea of women's obedience in marriage were to be found in Ephesians 5:22–24 – 'wives submit yourselves unto your own husbands...for the husband is the head of the wife, even as Christ is the head of the Church...Therefore as the church is subject unto Christ, so let the wives be to their own husbands in everything'. This Biblical model argued for female obedience very specifically within marriage. The Pauline inheritance was supported by the role model provided by the patriarchs or Fathers of the early Christian church. Early-modern people believed that God's law underpinned all state and family government. Thus they believed that the Biblical model set out above dictated a social order that was dependent upon the good government of each and every household run by a man [the patriarch] whose position in the household was often equated with the head's position in relation to the body. The head and body could not function independently, but the head dictated the movement of the whole. Gender order, then, was equated with the maintenance of good health and men of the gentry were expected to keep an open house so that their private household was open to public scrutiny. There was a whole language of marriage as a private calling for women that encompassed women's duty to husbands any failure of which, it was thought, had implications for good order in the whole state.[65]

Ruth Kelso once argued that both before and after the Reformation '[t]he girl in her father's house had no recognised permanent status'. It was believed that girls were only dependent on their fathers temporarily and that a place would be found for them outside the family home upon reaching maturity.[66] Before the Reformation there were three choices open to young women: service given to the lord of another household either as a noblewoman in his care or as a domestic servant, service given to the church (more precisely, God) as a nun or service to a spouse as a wife within marriage. All three involved deference to male authority;

even the choice of the convent involved submission to the will of an abbot. As with service owed to a father, service owed to another male householder was regarded as a temporary solution or life stage before marriage; one ordinance of 1492 prevented women under the age of 50 from setting up house independently and ordered them to find posts as servants until marriage. Although aimed at prostitutes, every woman was caught in this legal net, prescribing servitude rather than independence for all women of marriageable age.[67] Only becoming a nun or marrying were solutions discussed in terms of permanence and vocation. Therefore, the training of girls, combining as it did religious and domestic instruction, prepared girls ultimately for one of these two paths in life. After the Protestant Reformation, reformers promoted married life with renewed vigour to some extent prompting changes in feminine identity.

Pre-Reformation conduct and training literature for girls made clear that the vocational choices for women were primarily the church or marriage. Vives' *Instruction of a Christian Woman*, which went through over 40 editions and translations by 1600, advised instruction in '[t]he studie of wisdome', not eloquence, the Bible and Church Fathers, but not 'Boccaccio's fanciful tales or any chivalric romances or poetry'. From the age of seven girls should be given a dual training of religious and domestic instruction on how to 'order' and 'keep' a house. A girl was to 'both learn her book, and beside that, to handle wool and flax'. When learning to write a girl should not be writing verses 'nor wanton or trifling songs, but some sad sentences prudent and chaste, taken out of holy Scripture, or the sayings of philosophers'. The vocational side of this training was that a girl was learning for 'her young children [so that when she married she could educate her children] or her sisters in our Lord [if she became a nun]'. She was to be taught not to go out, never be heard in public and learn to live under the direction of a husband.[68] Vives also dealt specifically with a woman's preparation for marriage, with chapters on who to love, who not to love and how to seek a husband. Once married a woman was instructed that the two virtues she should have were 'chastity and great love toward her husband'. Chastity in a married woman was declared even more important than chastity in an unmarried woman because of the double offence caused to God and husband in the case of infidelity. Large sections of the Second Book of *Instruction* concentrated on how a woman should love and look after her husband and Vives went on to write a complementary treatise – *The Office and Duty of a Husband* (translated 1555) – about how men should choose wives, discipline, instruct them and hand over to them the everyday running of the household.[69]

Vives was one of the small group of humanist scholars promoting a fairly considerable classical education for girls but his recommended book list began with St Jerome's caveat 'let her learn to hear nothing…but it that pertaineth unto the fear of God'. Accordingly, Homer and Ovid were banned, though some works of Plato, Seneca and Cicero sat alongside 'the gospels, the acts, the epistles of the apostles, and the Old Testament, St Jerome, St Cyprian, Augustine, Ambrose' and so on. Every holy day and a part of every working day should be devoted to religious study and girls should be taught 'that chastity is the principal virtue of

a woman'. The instruction was driven home by lengthy tales about the horrible murders of unchaste maids at the hands of relatives. A woman needed to be 'shamefast, sober and reasonable of mind' and keep indoors.[70] As long as the total package of a woman's training transformed her into a chaste and devout wife a man could boast about, even Latin was considered an appropriate accomplishment prior to the Reformation. Elizabeth Lucor, who died at the age of 27 in 1537, was described on her monument by her merchant husband as being so domestically accomplished that she knew every kind of needlework and could embroider 'beasts, birds or flowers' as well as being able to sing, play several musical instruments, and speak, read and write Spanish, Italian and Latin. Most importantly, she was described as learning 'prudence…by graces purveyance…| reading the Scriptures…directing her faith to Christ, the onely marke'.[71]

Therefore, Catholic humanist writers of the early sixteenth century wrote works that prescribed a programme of education for women indistinguishable from their extensive training in becoming perfect wives. European writers were crucial to defining the holy state of marriage; important were the two works of the Dutch humanist, Erasmus – *Encomium Matrimonii* (1518 translated 1536 as *In Laud and Praise of Matrimony*) and *Institutio Christiani Matrimonii* (*Institution of Christian Marriage* 1526 translated 1568 as *A Modest Means to Marriage*).[72] Continental Protestant reformers followed Erasmus's praise of the holiness of the married state and their works were well received in England. For example, Henry Bullinger's *The Christen State of Matrimony* was translated by Miles Coverdale in 1541. In a section on the raising of 'daughters and maidens', Bullinger advised avoidance of idleness and '[l]et them not read fables of fond and light love, but call upon God to have pure hearts and chaste'. Reading the Bible and singing hymns was advised along with instruction on how to work to love their husbands and children.[73]

Catholic writers were not supposed to elevate the married state above the celibate, but both were considered vocations for women and the humanists like Erasmus promoted marriage with as much eloquence as their Protestant successors. Margo Todd has stressed that continuities can be found between pre- and post-Reformation prescriptive literature aimed at women. Margaret Sommerville also has argued that Protestant Reformers had little that was new to say about women and marriage.[74] However, other historians such as James Johnson, Lawrence Stone and Christopher Hill have argued the case for discontinuity, pointing to evidence such as the homily on marriage to suggest that the Reformation resulted in a 'resacralisation' of marriage.[75] There is some evidence for the latter, though it is based more on prescription that was dropped rather than what was retained. Prior to the Reformation, much general advice about marriage was combined with advice on educating young women. However, later in the sixteenth century prescriptive literature abandoned the humanist interest in a classical education for women. Giovanni Bruto's *La Institutione di una Fanciulla nata Noblimente* (1555; translated by Thomas Salter as *A Mirrhor Mete for All Mothers, Matrones and Maids* in 1579 and again as *The Necessarie, Fit and Convenient Education of a Yong* [sic] *Gentlewoman* in 1598) shifted the balance away from book-learning. Women 'ought to be attentive

to govern our houses', Bruto argued, receiving a religious and domestic training and not learning Latin.[76]

Therefore, Protestantism did not result in much alteration of the prescription for training girls to become wives, but it did tighten the grip of men over women through the institution of marriage. Fletcher has most recently revived the case that there was something qualitatively different about Protestant – especially puritan – normative texts. Following the lead of Patrick Collinson, Fletcher has suggested that new Protestant prescription 'riveted home patriarchy'. The work of Christine Peters is essentially in accord with this; she has argued that 'in stripping the decision to remain unmarried of its religious value, Protestants ... were left with no safe ground from which to insist on marriage and the big question became persuading women to continue living under male authority'. In other words, linking marriage to goodness and piety was part of a strategy of persuasion upon which maintenance of the gender hierarchy depended and the Protestant clergy found themselves prescribing codes of behaviour modelled upon their own experience as married men (Protestant clergy, unlike their Catholic counterparts, were able to marry). Jacqueline Eales has pointed out that what this led to was, in fact, the prescription of the ideal marriage between clergyman and wife.[77] The language of clerical marriage manuals betrays their provenance: 'The family is a seminary of church and commonwealth', the preacher William Gouge told his readers in *Domesticall Duties* in 1622. He added that the family is a 'lively representation' of 'a little church and a little commonwealth'. Gouge cited Ephesians 5:22 to equate female submission to husbands with submission to God and he cited Ephesians 5:23 to make the case that '[t]he place of the husband ... is expressed under the metaphor of an head, and amplified by his resemblance therein unto Christ'. 'As an head is more eminent and excellent than the body, so is an husband to his wife'; the 'head' governed, protected and preserved 'for that is his office and duty'. After the Reformation, then, gender roles and the institution of marriage were remade in the mould of the Protestant church and the values and experience of its episcopate and ministry.[78] Prescriptive literature shifted away from prescribing educational texts for women and, instead, marriage was imbued with the spiritual significance that used to be attached to the vocational choice of entering a convent. Marriage became a private vocation, one that aided a woman's path to piety and heaven. There was little difference in practice between the piety of a Protestant married woman and the piety of a Catholic married woman, except that Protestants turned their marriages into sites of spiritual fulfilment.

Most importantly, after the Reformation the expectation that the clergy would marry meant that marriage as an ideal became a mainstay of pastoral care in the church. Peters has concluded that this led to a changing model for those women who were destined to remain single, but equally it led to a changed model for women destined to marry.[79] The effect of this on gender in religious representation can be seen, for example, in Anthony Stafford's tract *The Femall Glory* of 1635 which was described on its title page as 'a treatise worthy the reading and meditation of all modest women'. In this extraordinary Protestant (but crypto-Catholic) work the intercessory (or effective spiritual) powers of the Virgin Mary were denied,

but her pseudo-sanctity was taken to be representative of the feminine virtues of modesty, obedience and so on in all women.[80] One preacher told women that their virginity was not their own to dispose of and that their pre-marital chastity was integrally connected to their parents' rights to dispose of them in marriage.[81] Some women learnt the lesson well. In 1667 Elizabeth Delaval noted in her diary that she would 'never more...hear a young man talk of love to me...unless he is approved on [*sic*] by my parents'.[82] She may have been attempting to correct a past error, but she drew on the advice of conduct books to construct herself as a person who waited for permission to love the man who would succeed her father as the authority figure in her life. The need to find large dowries made fathers more inclined to demand a good match. Usually, fathers (and sometimes mothers) succeeded in imposing their will. Out of several children of the earl of Cork, Mary Boyle was the only one who succeeded in rejecting her father's choice of a husband for her, to marry a younger son whom he considered an unequal and therefore unsuitable match.[83]

Evidence for the increased social imperative for women to marry can be found in a number of published sermons and conduct books from the late sixteenth century. In 1547 Edward VI had *Of the State of Matrimony* published along with 11 other sermons or homilies and ordered that the clergy read out the whole series twice to their congregations. In 1562 Elizabeth I issued a rewritten version of Edward VI's homilies with the same instruction to read through the whole series and the two books were published together by James I in 1623, in plainer English to make them even more accessible. Doris Stenton has pointed out that as these were 'written by masters of English rhetoric', their impact must have been considerable and it was the English Protestant clergy who were at the forefront of making congregations of ordinary people focus on their message.[84] The homily on marriage was also read out during wedding ceremonies in church; men were exhorted to care for their wives and women were told of their duty of obedience and behaviour in accordance with their subjection to their husbands. Marriage was ordained by God for procreation, to avoid sin and 'increase the kingdom of God'. The homily created a metaphor of the married state as Paradise, the place in which two people could (and should) together avoid the temptations of the Devil. In this sense, marriage was the institution in which men and women could atone for original sin. St Peter was quoted that men might honour their wives as 'the weaker vessel' and that women would learn to be 'in subjection to obey your own husband'. St Paul was quoted that women might know that they were 'subject to their husbands, as to the Lord'. A man was supposed to be patient with his wife (understanding her weakness, even though she owed him subjection), but if he was cruel to her, she was to remember that passivity and obedience was the only acceptable response, her reward coming later in heaven. The second half of the homily employed Biblical example to repeat the advice in rhetorical form.[85]

Protestant prescriptive literature was quantitatively as well as qualitatively different from its medieval antecedents. By the early seventeenth century prescriptive texts competed with *querelle des femmes* texts for sheer volume and the market for conduct books expanded dramatically. Protestant conduct books did not present

the model of the woman at court but the more accessible model of 'the English gentlewoman' who could be of the mercantile or professional classes or just the middling landowning family. Sermons and pamphlets on marriage were joined by what Gordon Schochet has called 'family obedience books' and marriage, family life and domestic work became the subjects of prescriptive works that ranged from large theological works to very small work manuals. An example of the former is Richard Hooker's *Of the Laws of Ecclesiastical Polity* (1597) which turned its attention at one point to the custom of fathers giving away their daughters in marriage because 'it putteth women in mind of a duty whereunto the very imbecility of their nature and sex doth bind them, namely to be always directed, guided and ordered by others'.[86] An example of the latter was Gervase Markham's *The English Housewife* (1631) which defined and prescribed the duties of a 'housewife' as 'physick, chirurgery, cookery, extraction of oyls, banqueting stuff... ordering of wool, hemp, flax; making cloath and dying [dyeing]; the knowledge of dairies... brewing, baking, and all other things belonging to an household'.[87]

Historians such as Margaret Sommerville have argued that while household duties were important, keeping women under male authority was, for men, the critical issue. The covenant theologian, William Perkins, said 'the very soul and life of the contract' was 'the free and full consent of the parties'. However, William Whateley's *A Bride-Bush, or, A Direction for Married Persons* (1619 and 1623) was more forthright arguing that a wife 'must acknowledge her inferiority [and] ... must carry herself as an inferior'. 'If ever thou purpose to be a good wife', he told women, 'set down this with thyself: mine husband is my superior, my better; he hath authority and rule over me; nature hath given it to him ... God hath given it to him'. The advice was repeated in most other household conduct manuals. Robert Snawsel's *A Looking Glass for Married Folks* (1610) concentrated entirely on gender relations within marriage, but more particularly on the wife's behaviour towards her husband as a subordinate.[88] In the period 1590 to 1640 there were several marriage books written by church ministers, many of them from sermons already delivered to congregations. Some of the most important in terms of their impact were John Dod and Robert Cleaver's *A Godly Forme of Household Government* (1598), William Whateley's *A Bride-Bush* (1617), Thomas Gataker's *Marriage Duties* (1620) and *A Good Wife God's Gift* (1624), William Gouge's *Of Domesticall Duties* (1622) and Daniel Rogers's *Matrimonial Honour* (1642).

The marriage manuals emanating from the Protestant church contained many things in common. The first was the idea that the relationship between man and wife was equal. Whateley used the word 'associate' to describe a wife and Perkins talked about husbands and wives as 'yokefellows'. Cleaver talked about women walking 'joyntly' with their husbands.[89] The second thing stressed was the complementarity of the roles of wife and husband, especially in their work roles. Fletcher has suggested that it is in the area of work that prescription of equality in marriage and practice were most closely matched.[90] Amy Erickson has pointed out that the skills of housewifery and husbandry were equally praised because at their heart was the household virtue of thrift. Women were formally apprenticed in 'housewifery'.[91] This spawned a whole range of household manuals aimed at

women and prescribing thriftiness and specific household duties. Thomas Tusser's *Five Hundreth Points of Good Husbandry United to as Many of Good Huswiferie* (1573), written in verse (which was easy to read and remember by women whose levels of literacy might be low) and describing all the agricultural work of the seasons, laboured the idea of thrift, resulting in women's greater numeracy. Tusser advised men to look for wives who were 'all willing to save' and ended with rhyming couplets that juxtaposed the 'good housewife' with the 'ill housewife': 'Ill house-wifery bringeth a shilling to naught | Good housewifery singeth her coffers full fraught ... Ill housewifery craveth in secret to borrow | Good housewifery saveth today for tomorrow'.[92] The housewife of Tusser's verse was the model of thrift and efficiency: she had charge of a dairy, a buttery, a brewery, a spinning room, hens, pigs and a kitchen garden. The expected exercise of her authority over servants and children is enlightening and Michael Roberts has pointed out that in household manuals the woman theoretically exercised 'a sophisticated authority [that] ... was represented as genuinely parallel to that of her husband'. However, the complementary nature of work roles could disguise the fact that a woman's authority was differently represented from a man's whose role as 'head' was unquestioned while the wife's authority took the form of constantly facilitating the efficient activity of servants and children in the running of a man's estate. Together they 'serve God ever first', said Markham, but on a daily basis, wife and dependants served a man.[93]

Male prescription of 'the good housewife' was sometimes the context for camou-flaged criticism of women, indicating again a blurred boundary between prescription and *querelle des femmes*. Not only did Markham's 'good housewife' combine many different skilled jobs to satisfy the requirements of her vocation she must 'be of chaste thought, stout courage, patient, untired, watchful, diligent, witty, pleasant ... wise in discourse but not frequent therein, sharp and quick of speech, but not bitter or talkative' and so on.[94] Thus, he provided not only the model for the 'good housewife' but also the model of deviance. He sometimes based this squarely on women who bungled their specific tasks; not getting enough wrinkles in their cheese, scouring their cloth white with bran, hanging rennet bags up chimney corners, leaving a cow half milked.[95] Here was 'the bad housewife' of *querelle des femmes* ballad. The household manual was serious-minded enough, but the dualistic woman was there as a warning to its female readers.

Another prescription stressed by Protestant marriage manuals was mutual enjoyment of marital sex. Protestant clergy wished to distance themselves from Catholic prescriptions of the ideal life of celibacy with the result that they pro-claimed the joys of marital sex. 'Marriage ... is a state more excellent than the condition of single life', said Perkins, and he expressly condemned the Catholic practice of banning clerical marriage.[96] There was a duty to desire one's marriage partner, but also a belief, in the words of John Dod and Robert Cleaver, that the sexual duty of marriage performed 'cheerfully' 'maketh the marriage yoke light and sweet'.[97] Puritan clergy were uninhibited in their advice to women and men alike: 'I come now to such [duties] as concern the marriage bed' said Whateley in *A Bride-Bush*, a publication aimed at women. '[M]atrimonial meetings' should be

'cheerful', he said, and the couple should 'lovingly, willingly, and familiarly communicate themselves unto themselves, which is the best means to continue and nourish their mutual natural love'.[98]

The harmony implied by prescribed mutuality of love hid serious tensions. Marriage was constructed as a private vocation for women and a public duty or calling for men and the slight difference established a sexual hierarchy that men had to maintain. As Mark Breitenberg and Anthony Fletcher have both pointed out, a man's public reputation depended on his wife's private behaviour; his honour was bound up with her chastity and obedience. Therefore, his duty to love, cherish, instruct and command her involved a paradox; he was in charge, but she held the key to his masculinity particularly over matters of sex.[99] Some historians, most notably, Ralph Houlbrooke and Keith Wrightson, have stressed that this reconfigured 'man' came under considerable pressure to love his wife, placing a limitation on patriarchy.[100] Wrightson has said that 'it was...commonly agreed that the husband had duties towards, as well as privileges and authority over, the "weaker vessel"'.[101] The zealous, reforming Protestant prescriptive literature of the Elizabethan and Jacobean period built a model of the patriarchal family in which male tyranny and harmonious joint governorship of a spiritual household or 'godly family' co-existed. A woman had a duty to love, but obey even without love returned. The degree of freedom of action and speech a woman had depended, theoretically, on how much she was given. Thus, mutuality was determined by the man and a woman who acted in contravention of the prescription risked conflict and destruction of the working relationship of the marriage.[102]

Social expectations about gender roles in marriage were all-pervasive. They were sanctioned by the monarchy and reinforced by the monarchy. In 1616 James I published his own advice book, originally written for his eldest son, Prince Henry who died in 1612. James advised about careful choice of a woman to marry and proceeded then to his son's duty to rule his wife:

> Treat her as your own flesh, command her as her Lord, cherish her as your helper, rule her as your pupil, and please her in all things reasonable... Ye are the head, she is your body: It is your office to command, and hers to obey; but yet with such a sweet harmony, as she should be as ready to obey, as ye to command; as willing to follow, as ye to go before.[103]

The text contained advice peculiar to Prince Henry's station – for example that his wife should not be allowed to meddle in state affairs – but the model James suggested was appropriate for any married man. Princes and male subjects alike were to be patient, firm and in command of wives.

Patriarchy (or rule of 'fathers' in the literal but also widest sense) was given new meaning through the Protestant device of transferring spiritual authority over women from male priests to fathers and husbands. 'Fatherhood', in the words of Michael Walzer, was transformed into a religious office, with its 'duties and its obligations prescribed in the Word'. The main instruments of this priest-father were the Bible and family catechism. Canon 59 of the 1604 canons instructed

all fathers, mothers and mistresses to 'cause their children, servants and apprentices, which have not learned the Catechism, to come to the Church ... obediently to hear and to be ordered by the Minister'. This placed women in the ambiguous position of being subordinate to their husbands but also responsible for the religious instruction and welfare of their husbands' other dependants.[104] The duties and obligations performed a social and political function, each well-run spiritual household helping to ensure the smooth-running of the 'godly commonwealth'. Christopher Hill has suggested that fathers were expected to become 'intermediaries between the central government and their own servants and dependants, no less than between the latter and God'.[105] Arguably, the advice book writers expected too much from male heads of households. A clause in a 1601 bill of parliament placing the onus on male householders for the attendance of their wives and servants at church caused an outcry amongst MPs. It was largely aimed at Catholic households, but caused Anthony Dyott to repeat in the House of Commons the proverb '[e]very man can tame a shrew but he that hath her'. The Homily of Obedience, drawing on Romans 13 and Acts 5:29, instructed women that they should follow conscience because they owed obedience in the first instance to the command of God. Thus, patriarchalism and religious division in English society fitted together slightly uncomfortably.[106]

Fletcher has pointed out the degree to which this model of patriarchal family life was open to abuse. The 'godly family' provided the model for the 'godly commonwealth', but the 'godly commonwealth' did not sufficiently regulate in return abuses of power within individual family situations. Lady Anne Boteler's husband claimed that she was not sufficiently respectful and obedient. Between 1664 and 1671 he regularly beat her on the breast and kicked her in the abdomen (even when she was pregnant). He punched her in the face, hit her with a chair and, in an ironic inversion of the Socrates and Xanthippe story, he twice flung a chamber pot at her. All the prescriptive advice about bearing patiently with his treatment was observed by Anne, but instead of the story ending with him penitent and reformed as she might have expected from prescriptive works he once told her 'I hate you the more because you love me so well'.[107] Wife-beating was, put simply, culturally acceptable, but distorted versions of the patriarchal family were not envisaged in the prescriptive literature.

The clerical conduct book that took the prescription of a wife's duty of obedience to its most logical extreme was William Gouge's *Of Domesticall Duties*. Published in 1622 it drew upon the already well-developed puritan model of the family as microcosmic Christian commonwealth headed by a husband/pseudo-Christ and comprised a number of sermons delivered at Blackfriars from 1608. Gouge's dedicatory epistle is enlightening. He saw himself in a paternal role, fulfilling his duty to God to instruct his parishioners in how to live for their 'spiritual edification':

> Oh if the head and severall members of a family would be perswaded every of them to be conscionable in performing their own particular duties, what a sweet society, and ... what excellent seminaries would families be to Church and Common-wealth? Necessary it is that good order be first set in families ... as

they were before other polities…good members of a family are like to make good members of Church and common-wealth.[108]

Of Domesticall Duties was divided into eight treatises. The first was 'an exposition of that part of Scripture out of which Domesticall Duties are raised' and the second dealt with 'right Conjunction of Man and Wife' and 'Common mutual Duties betwixt Man and Wife'. Gouge moved from the general to the particular, listing the sets of mutual duties in three sets of relationships to be found in the godly household in which there was unequal power. These were wives/husbands, children/parents and servants/masters. In each case he dealt with the dependant and inferior first, before moving to the superior – husbands, parents and masters – who were, with the exception of mothers, the same person – the male head of household. Here again we can see the ambiguity of the wife's position, wedged between the authority of her husband and the subordination of her children and servants, both of whom deferred to the man first anyway.[109]

Susan Amussen has said of this tension found in all conduct books that '[m]ost writers…seem to have hoped that the difficulties would disappear with the definition of complementary relationships…based on conventional attributes of men and women'. So the writers delineated women's specific work roles that entitled them to think of themselves as 'joint governors' of the family but defined their relationships with their husbands as being subordinate. Gouge reassured women that 'the uttermost extent of [their]…subjection' would be limited by men feeling duty-bound not to 'stand upon the uttermost of [their]…authority'. The justification for this 'uttermost authority' was that men were naturally suited to being in charge. Edmund Tilney's *A Brief and Pleasant Discourse of Duties in Marriage* (1571) said that '[t]he man…is the most apt for the sovereignty' because he has the 'capacity to comprehend, wisdom to understand, strength to execute, solicitude to prosecute, patience to suffer, means to sustain, and above all, a great courage to accomplish, all which are commonly in a man, but in a woman very rare'.[110] Gouge's *Of Domesticall Duties* worked hard to show the way in which the theoretical 'uttermost subjection' of women and 'uttermost authority' of men only operated in practice when there was a failure of duty on one side or both in a marriage. He juxtaposed those duties of women/men that had a correspondence in maintaining the balance required for a harmonious, godly marriage: subjection/wisdom and love; acknowledgement of superiority/acknowledgement of near conjunction; an inward fear/an inward affection; reverend speech/mild and loving speech and so on. The whole system depended on women's obedience and on men's magnanimous willingness to treat women with love and respect.[111] Clearly it was a system that fell apart when men were unwilling to keep their side of the bargain.[112]

Gouge was more extreme on the subject of female obedience than some conduct book writers: 'The extent of wives subjection doth stretch it selfe verie farre, even to all things.' Some women 'cannot endure to heare of subjection' he complained because 'ambition' had made them 'imagine that they are made slaves thereby'. He hoped that through his explanation of the 'duties which the husband in particular oweth to his wife' he would demonstrate to women 'that this subjection

is no servitude'. He then went on to explain that a woman needed to accept the general point that husbands were superior before fully accepting the particular point that her own husband was superior. No matter what station or age of the husband, he was her superior from the time she chose him for a husband because 'by vertue of the matrimoniall bond the husband is made the head of his wife'. Indeed, even if the husband 'in regard of evill qualities may carrie the Image of the devill, yet in regard of his place and office he beareth the Image of God'. Once Gouge reached the duties of husbands he waffled at length about male authority being 'seasoned with love'.[113]

Dod and Cleaver's *Godly Forme of Household Government*, which was reprinted from the 1598 original in 1630, called the householder the *'Pater Familias'*, extending fatherly care to servants 'as if they were his children'.[114] Thus, adult women and servants were infantilised in a system that Amussen has argued was 'central to social order'.[115] Dod and Cleaver pointed out that 'the husband ... hath more to do in his house with his own domestical affairs, than the magistrate'. Social order relied on men accepting the lesson that chaos would reign if they did not perform this public duty in the private sphere: 'Every man's house is his castle ... wherein if due government be not observed, nothing but confusion is to be expected', warned Brathwait.[116] The prescription was so precarious that social commentators had more to say about women's behaviour than men's. Thomas Becon's *Catechism* (c.1560) had five times as much to say about the upbringing of girls as boys and included many more restrictions on their behaviour.[117]

The conduct manuals were quoted by many men in their dealings with family. Ralph Verney sent advice about his god-daughter to her father that she was to learn 'to live under obedience' and 'if she would learn anything, let her ask you, and afterwards her husband, at home'.[118] However, it is difficult to determine exactly how much prescriptive advice was positively taken on by women as part of the process of building their gender identity. Gouge indicated in his preface that he had received objections from his congregation to the model of female subjection offered in his sermons. Jacqueline Eales has suggested that '[t]he boundaries of gender construction may well have been negotiable for gentry wives with dowries and large estates to administer in their husbands' absences, or for city wives such as Gouge's parishioners'. However, the impact of the conduct literature on gender construction was greatest for clergy wives, or, in other words, the wives of the conduct book writers themselves in godly families. For them, a strictly pious upbringing combined with lack of opportunity to participate in their husbands' affairs, meant that '[gender] negotiation was more limited'.[119]

In summary, it can be said that while the prescriptive literature of the godly clerical writers informed directly the gender construction of clerical daughters and wives, it did not speak so directly to all women. Protestant conduct literature did, however, speak to all men, especially those with a strong sense of public duty, and, therefore, it dictated their relationships with their wives and daughters upon whom they attempted to impose a heavy male expectation of obedience. The private life of a male householder was at once a public and a private demonstration of his dominion over the women, children and servants in his life and the private

sphere of the household, at least in theory, was not supposed to function as an area of female authority. Any female power in the household was exercised as a subsidiary to male authority. Prescriptive tracts and social pressure made it clear that men were in charge in the domestic sphere as linguistic formulations such as 'lord' and 'master' used in the marriage relationship indicated. Therefore, any gap between male expectations and female behaviour in practice became a potential source of tension – for husbands and wives and fathers and daughters – over matters of female subservience, sexual morality, household management and control of property.[120]

Rhetoric and context

Gender construction by prescription was neither static nor confined to the medium of the prescriptive text. Joan Wallach Scott has described the gender categories of man and woman as being 'at once empty and overflowing... [e]mpty because they have no ultimate, transcendent meaning' but '[o]verflowing because even when they appear fixed, they still contain within them alternative, denied or suppressed definitions'.[121] At the heart of this are questions about gender formation. Norms may be established by prescriptive literature, but resonances of prescription can also be found in literary sources in which art imitated life and the norm was negotiated with and challenged.

In this way, the package of cultural meanings of femininity changed as they shifted between different textual genres. The fluidity and negotiation of gender construction can, therefore, most easily be discerned in the interplay between early-modern conduct books and ballads, stories, poetry and plays. The last three can be classified as cultural performances or productions that tested and played with gender definitions for the sake of keenly gender-aware early-modern audiences and their cultural symbolism thus contributed to the changing meanings of the categories of man and woman. William Shakespeare's plays provide the best evidence of this gender construction at work.

For example, *The Taming of the Shrew* reveals Shakespeare linguistically toying with the dual prescription of feminine silence and obedience through the plot device of the dualistic good woman/bad woman of *querelle des femmes* fame. Lucentio says of Bianca that 'in... silence do I see Maid's mild behaviour and sobriety', but when Baptista orders his disobedient daughter, Katherina, to 'ply thy needle' she refuses saying that Bianca's 'silence flouts me'. Petruchio complains of the rebellious Kate that she is a 'slow-winged turtle' (symbolic of the woman who was slow to become domesticated or stay in her house or shell), but declares his intention to 'tame you, Kate, and bring you from a wild Kate to a Kate conformable as other household Kates'. When he succeeds, the domesticated Kate, who learns what he calls 'virtue and obedience', delivers a lengthy speech to Bianca promoting the value of the protection to be found when submitting oneself to a man, 'thy lord, thy life, thy keeper, thy head, thy sovereign'.[122] The 'bad' Katherina turns into the 'good woman' who then instructs Bianca, who has turned into the 'bad woman', how to behave. While Shakespeare's own perceptions of the perfect woman cannot

be deduced from *The Taming of the Shrew*, his representation of a prescribed (but also contested) femininity in the form of silence can be taken as a reflection of what he saw in early-modern society.

Prescription was mediated as well through works of political theory and sermons, but also cheap printed material such as ballad and chapbook. Robert Filmer's *Observations on Aristotle's Politiques* (1652) – a work of political thought – drew on his earlier extended work on patriarchal government – *Patriarcha* – to argue that maintenance of the godly family lay at the heart of good government.[123] However, gender was arguably as firmly laid down through cheap chapbooks or 'penny editions' of household books with printed images that reached a very wide audience. Markham's *The Good Housewife* was abridged in popular form and for those not sophisticated enough to read even abridged 'how to' manuals, ideas about good 'huswifery' appeared in poster form for sticking on walls. Adriaen van Ostade's painting 'The Violin Player' of 1673 depicts a farmer's wife leaning through the top half of a door by an advice poster that is pinned to the door-frame. The inside walls of cottages were hung with homiletic verses reminding families about rules of behaviour. Many posters combined practical advice with prescribed morality. *The Good Hows-Holder*, which was printed from at least 1565 to 1607, depicted a sober-looking man and contained a ballad designed to encourage his patriarchal demeanour. According to Tessa Watt 'the good householder was not only the product, but the market for the product'. So was his wife.[124] Tusser's *Points of Huswiferie* combined three styles – that of conduct manual, almanac and ballad. The use of verse guaranteed the reach of the message. The prescription of femininity – chastity, modesty and obedience – can also be found in the ballads and chapbooks designed specifically to be read by women born into poor families. *The Virgin's ABC* (1656) was a tabulated account of these femininities; its subtitle made the moral imperative clear – *An Alphabet of Vertuous Admonitions for a Chaste, Modest and Well Governed Maid*. In it women were advised to keep their tongues under control by not laughing or speaking raucously.[125]

Courtship and marriage advice was also written into ballad and chapbook form for a poorer audience. In the *Art of Courtship* a married woman celebrated her 'solid bliss' and said 'I'd not be a virgin now' suggesting that housewifery could combine with sexual contentment.[126] *A Country New Jig between Simon and Susan* (*c*.1620) prescribed courtship only within the context of seeking parental approval, particularly from the parents of the woman.[127] Prescription of the model wife can be found in Samuel Rowlands' *The Bride* of 1617 (which was in verse) where the emphasis was on frugality: 'A modest woman will in compass keep | … Not diving in the frugal purse too deep.'[128] As was so often the case in prescriptive texts the dualistic woman was used for rhetorical effect. In *The Bride* the gossiping woman who gadded about was juxtaposed with the modest woman who 'love[d] her own house best'. Women in taverns and play houses made an appearance to highlight the 'modesty' of the contented, domestic wife.[129]

Thus, prescription and rhetoric went hand in hand, mimicking and feeding the *querelle des femmes*. Both genres drew on the intellectual foundations of the dualistic woman, but employed them for different rhetorical effect. The intention

of prescription was to present a picture of the ideal woman (according to men) whose gender attributes were uncontested and the negative imagery served only to highlight positive femininity. The context for the *querelle des femmes* text was jocularity and bitterness. Operating in reverse to a prescriptive ballad such as *The Bride*, a *querelle des femmes* ballad presented the picture of a good woman as abnormal; the 'good woman' was there to prove that the bad woman dominated. Some ballads celebrated the two models of womanhood in one woman, such as *Long Meg of Westminster* (1583), in which a popular bandit and transvestite in London transformed into the perfect wife – when offered a cudgel to return her husband's blows she is supposed to have said, 'Whatever I have done to others it behoveth me to be obedient to you, and never shall it be said, though I cudgel a knave that wrongs me, that Long Meg shall be her husband's master.'[130] When Long Meg masquerades as patient Griselda in a literary work it becomes crucial that historians place each text in its context.

Cheap print in the seventeenth century contributed to a rising literacy rate for women. Michael Roberts has argued that texts such as housewives' manuals were 'issued at an interesting moment in the history of women's relationship with books'. He cites the case of John Aubrey, whose nurse he described as being from 'the old ignorant times, before women were readers'. Cheap printed prescriptive literature reinforced verbal gender training. *The Mothers Counsell* (1630) advised women in the ways of chastity, humility, temperance and beauty and books such as *The Good Housewife* had considerable impact.[131] The evidence for this is found in the relatively large number of household commonplace books belonging to women that survive in family archives such as Elinor Fettiplace's book of 1604 and Mary Thompson's of the 1650s.[132]

Prescription of femininity was further reinforced by posthumous eulogies and hagiographical biographies of women who had lived chastely, modestly, obediently and so on. John Batchiller's biography of the musician, Susanna Perwick, who died at the age of 24 in 1661, celebrated her aesthetic, virginal life. Entitled *The Virgin's Pattern*, it described her routines of Bible reading and pious meditation and her admonitions to the girls of her parents' boarding school in Hackney to wear plain clothes and reject the fashion of uncovered necks and cosmetic patches. However, it also told of how her virginal life was chosen after the premature death of a man to whom she was betrothed. In other words, while virginity was still celebrated in 1661, the norm was the contented married woman and Batchiller went so far as to create a secret lover kissed by Susanna on her deathbed.[133] The main posthumous model was of the good and godly wife. Funeral sermons of Lady Alice Lucy (d.1648) and Lady Elizabeth Langman (d.1664) described them as silent, obedient, submissive wives, who deferred to their husbands' greater learning.[134] Dr Anthony Walker reported in his *Holy Life* of his wife, Elizabeth, that she had given birth to eleven children, only three of whom survived, though they did not outlive her. At the end of a life punctuated by devastating losses Elizabeth Walker devoted her energies to her only grandchild because she thought that children were 'the nurseries of families, the church and the nation'. In Elizabeth Walker the 'great-bellied' or procreative woman was projected as a feminine ideal.[135]

Biographies of godly women increased in number from the late sixteenth century, one of the earliest and most enduring being Philip Stubbes' posthumous biography of his wife Katherine, *A Christal Glass for Christian Women* (1591). Stubbes depicted Katherine as spending her short life in constant devotion to God. His didactic motivation cannot be doubted; he was also the author of *Anatomie of Abuses* (1583) which attacked the vanity of female fashions. The popularity of Stubbes' account of Katherine was so great that this work went into over 20 editions over 50 years.[136] *A Christal Glass* was far from being the only biography in this genre. *Monodia. An Elegie, in Commemoration of the Vertuous Life, and Godlie Death of…Dame Hellen Branch* of 1594 represented the same sort of posthumous praise in verse. The author, Joshua Sylvester, advised 'virgin Ladies' to attend to his verse and went on to describe Helen Branch as 'for maids, and wives, and widows all a pattern'. Her fecundity was celebrated; she had eight children, but 'all these fair blossoms were untimely blasted'. Sylvester described them as nevertheless finding contentment in 'a Christian life'. When her first husband died Helen Branch remarried only after 'modest and meet intermission' and her marital chastity was celebrated further in verse when describing her behaviour as a widow for the second time: 'But now become herself her self's commander, To shield her life safe from all shot of slander |…She passed her time in holy meditation |…And all the duties of a Christian life…'.[137] In a beautifully-phrased Biblical allegory of the 'maid-wife-widow model' of early-modern womanhood Sylvester ended this section with '[s]o that her threefold godly life alludeth to virgin Ruth, wife Sarah, widow Judith'.[138]

By the seventeenth century, the posthumous godly biography became a specific and formularised literary genre. William Leigh's eulogy of Katherine Brettergh was distilled from two funeral sermons and went through four editions between 1601 and 1617.[139] Funeral sermons (and their attending elegies) were published as part of a family grieving process, but as they were written by clergymen who were clients of the family they also sought to flatter, reinforce and advertise the godliness of their patrons. The titles sometimes make this clear. Lucy Thornton's eulogy was published as *A Pattern for Women* in 1618. The minister who delivered her sermon described her as being like Abigail because of her understanding of the Scriptures and like Mary for acknowledging 'herself [God's] humble handmaiden'.[140] Lucy Thornton's femininity was based upon a continuous, diligent but humble and submissive piety and her model in life became prescription for other women after her death. *A Pattern for Women* described her at the end of her life as doubly obedient, showing 'due subjection to her own husband' and God. Elegiac works of prescription too sometimes trotted out the 'bad woman' to throw light on the good: Lucy Thornton was likened to Sarah while other women were decried for being like Jezebel or Rachel who quarrelled with their husbands and battled for ascendancy over them.[141]

The quality of writing within this biographical genre varied as much as the style of presentation. Lucy Thornton's minister made a dreary biographer, but in 1620 poignant and beautiful verse and prose accompanied the funeral of Elizabeth Crashaw who died in childbirth at the age of 24. The funeral itself was conducted

by the renowned Irish Calvinist scholar and churchman, James Ussher. Elizabeth Crashaw's perfect femininity was encapsulated as 'piety, chastity, devotion, modesty, sobriety'. 'Housewifery' was included as part of her package of femininities. Very specific qualities of youth, beauty, health and motherly affection (to her stepchild) followed the initial list. 'Beauty and virtue both together dwelt in her fair breast' according to the elegy of a friend and other friends suggested that, as a woman who could well have become vain and wanton, she was an exceptional model of womanhood.[142] Samuel Clarke's anthological works of puritan lives such as the *Lives of Sundry Eminent Persons in this Later Age* (1683) capitalised on the many funeral sermons already circulating in print and presented women as unfailingly chaste and godly.[143] He presented Alice Lucy (d.1648) as entering 'early into the conjugal state and condition [when she] ... resigned both her reason and her will unto her head and husband'. Margaret Charlton, who married the nonconformist minister Richard Baxter and died in 1681, was 'unspotted, holy, pure, invested in Christ's mild white snowy robes'. Elizabeth Langham (d.1664) 'was exceeding modest'; she had a 'handsome body' and a face of 'beauty ... had she thought fit to have made use of them'.[144]

Historians are divided about the usefulness of such formularised prescriptive material in assessing contemporary feminine identity. Sara Mendelson and Patricia Crawford suggest that prescriptive texts are useful only if read 'against the grain' and Gerda Lerner has pointed out that gender role indoctrination may be most forceful when there is an opposite trend in society. However, it can be argued that preachers such as Clarke reflected their clientele, their funeral sermons only able to work if the congregation recognised in the preacher's description something of the deceased. Church ministers, in particular, were interested in reflections of their social world: when his own wife died in 1675 Samuel Clarke published her diary *A Looking Glass for Good Women to Dress Themselves By*.[145] Some prescriptive texts were devoted to diary-keeping and some guides to pious introspection were sometimes specifically aimed at women. John Featley's *A Fountain of Tears* (1646) included a list of 38 questions women could ask of themselves every night to ensure that their day had followed a godly pattern. The questions were designed to measure feminine piety such as 'How devoutly prayed I?'[146] Paradoxically, women could assert some female agency through powerful co-option of the virtues expected of them by male prescription. Dorothy Leigh's *The Mother's Blessing* (1616) urged her sons to choose 'godly' wives and to call any daughters they had after the Biblical model of Susanna 'famous through the world for chastity' and Elizabeth Joceline's *The Mother's Legacy* (1624) revealed her desire for her daughters to be instructed in the ways of chastity and silence.[147] Sometimes women used their piety to assert their femininity against men. For example, Jane Ratcliffe refused to wear a dress from her husband on the grounds that it would undermine her feminine humility. However, Fletcher has argued that 'for the most part women contained the personal potency that their religion gave them within conventional forms and structures of deference and passivity' and it can be concluded that the genre of prescriptive text had considerable power over a large number of early-modern women.[148] For those women who had neither

the skills nor the time for diaries and continuous spiritual reflection, the prescription of marriage and a life of thrift and work was equally powerful and dictated for many their active response to the world in which they lived.

Conclusion

All prescription was an attempt to capture and dominate the terms of the debate about ideal femininity. Prescribed femininity fed off the discursive paradigm of woman as a duality – good and bad – which was the creation of a patriarchal society in which men were obsessed with 'the other'. Man was object and woman was subject but she was also mercurial and binary – chaste woman/whore, silent woman/scold, obedient woman/shrew and so on.[149] Prescriptive texts set out to construct an ideal woman that a real woman could aspire to, but like the *querelle des femmes* pamphlets and dramatic works such as *The Taming of the Shrew* they were texts largely written by men. The result of this was, in the words of Natalie Zemon Davis and Arlette Farge, that woman 'figured to an extraordinary degree in the realm of discourse and representation…to establish order in the [male] universe'.[150] However, this creates a conundrum for historians as it sets up a rather circular historical process in which patriarchy generates male-dominated discourses and they in turn support patriarchy. If this is the case how does gender construction change and does it ever change?

It can be said in partial answer to this question that male prescription of femininity can change in its essential features without eroding patriarchy. This is the answer that has been given by Anthony Fletcher who has advocated the idea of some measure of gender change during the period 1500 to 1700. Fletcher has argued that the negative ideological underpinnings of prescribed femininity were to some extent mitigated by a more positive vision of womanhood offered by some conduct book writers at the end of the seventeenth century. The main evidence for this can be found in works such as Richard Allestree's *The Ladies Calling* of 1673, which went through 10 editions by 1727 and influenced much of the other conduct literature aimed at women by the early eighteenth century. According to Fletcher, Allestree wanted women 'defined and controlled' and this required women's subscription to a prescribed femininity that removed 'any religious influence… [in] gender training' replacing it with the active responsibilities of married women in a gender system that heavily promoted the idea of romantic love and affective marriage.[151] The change in gender construction perceived by Fletcher is one of a move away from the negative construction of femininity that had been underpinned by the lessons of the Bible and other Christian texts in the sixteenth and early seventeenth centuries to a positive construction of femininity informed by new scientific notions of sexual difference that stressed mutual but different masculine and feminine social attributes. None of the prescribed feminine virtues was new – modesty, chastity, meekness, mercy, compassion and so on continued to be relevant – they were just differently cast as virtues that women themselves had the power to seek and cultivate. Therefore, aspiration to the ideal was less thwarted, in a sense, than it had been when the default setting

of womanhood was considered to be represented by the temptations and sins of Eve.[152] Additionally, according to Fletcher, the earlier key prescription of obedient wife was replaced by the wife whose role was guardian who actively safeguarded man's wealth, spiritual health and social reputation.[153] Therefore, Fletcher's vision of gender change is one that argues, on the surface, for a return to women of some agency in gender construction alongside a new underpinning to patriarchy – the new secular religion of love. It is an argument that has synergies with the older argument of Lawrence Stone *viz.* that the eighteenth century witnessed a shift away from the cold, loveless marriages of the seventeenth century to 'companionate marriage'.[154]

However, questions remain unanswered by this model of a secularised woman captured by love such as whether or not one can advocate a new 'positive femininity' if it leads to strengthened patriarchy and how piety in women can remain so dominant in gender construction if the motor for gender change is the shift to a more secular culture. *The Ladies Calling* is certainly a text that muddles the religious message with the secular. In the frontispiece woman is represented as reaching to heaven with one hand, a crown descending through the light in her direction, but with symbols of temporal wealth and power like jewels lying at her feet as if her piety and social success together gave her access to heaven.[155] The traces of Eve are abandoned in Allestree's woman, but it can be argued that traces of Mary remain in this earthly woman who has a direct link to the heavenly host. 'Positive femininity', thus, is underpinned by religious iconography. The change in prescription runs parallel with changes in Protestantism, in particular the doctrine of grace, away from atonement for sins and towards more mystical ideas about assured election and temporal contentment. The impact on gender construction can be seen also in the changing values attributed to female virginity. In 1700 the chaste married woman had more symbolic power than the chaste virgin of Catholic culture, transforming Mary into something homely and accessible – 'everywoman'. John Davies' *A Contention betwixt a Wife, a Widow and a Maid*, a poem of the sixteenth century, celebrated a maid's advantage in her virgin state over wives and widows in a way that simply could not be repeated a century later in Protestant England.[156] Equally, sixteenth-century allegorical paintings of Eve standing by a serpent with a female face no longer held as much cultural power.[157] By the eighteenth century, then, marriage entered into by the devoted wife was, indeed, the framework which effectively subjugated and disadvantaged women rather than Biblical narratives of the Fall. However, one of the motors of historical change was the shifting but persistent religious culture rather than a simple process of de-Christianised gender.

4
Law and Private Life

Introduction

Every past patriarchal society has systemic features that are culturally unique to it and which are channelled through institutions such as the law and the Church involved in the definition and regulation of marriage, employment and the administration of criminal justice. The belief that women were inferior in early-modern society justified and ensured men's effective control of all institutions and so the private life of an early-modern woman was, to some extent, lived according to the precepts laid down by men.[1] This chapter is an extended exploration into the reach of patriarchy into private life through examination of two things: first, the law's definition of women's position in society, their rights in marriage and to property and their treatment at law when convicted of crimes and, second, the impact of the Church, religious ideas and law on aspects of women's lives like marriage (including domestic violence and marriage breakdown), motherhood and work.

The intersections between public and private life have traditionally been considerable and, therefore, historians have commented extensively on the question of whether or not it makes sense to speak of separate spheres of public and private that map onto a spatial gender divide in society. The origins of a public/private dichotomy are Classical. Hellenic society spoke of the *polis* or public sphere of men including the law and marketplace and the *oikos* or household to which women were essentially confined. However, the idea of separate spheres with which historians are mostly concerned originated in the liberalism often associated with the work of John Locke in the late seventeenth century. Locke's *Two Treatises of Government* (1680) argued (using a universal notion of 'man') that '[t]he natural liberty of man is to be free from any superior power on earth', an idea of freedom for male citizens in a public state which, according to Carole Pateman, Patricia Springborg and others, created a private sphere or domestic space over which men had dominion including rule over women. The seventeenth-century feminist writer, Mary Astell, recognised the implications arguing that women were contractually-enslaved: 'Conjugal society is made by a voluntary compact between man and woman … rule should be placed somewhere, [and] it naturally falls to the man's share.'[2]

However, a number of historians have pointed out that in practice men's control over women in the private sphere was diminished by women's own agency in that sphere and that the exigencies of employment in particular resulted in women's ability to operate in the public sphere too. Whether it was in the public or the private sphere (as actual physical locations) the location of male and female authority was under constant negotiation. Thus, gender was not just a set of prescribed ideas mediated through institutional patriarchy and, in the end, male and female agencies did not just map onto public and private spheres of activity.[3]

The Lawes Resolutions of Women's Rights

Early-modern law was very complicated. There were several types of law court administering different types of law. Parliament was responsible for executing Statute Law which was then carried out through civil law courts. The House of Lords could assemble as a bench of judges hearing, for example, property and marriage separation cases. The complex network of royal law courts administered common law which comprised a series of judgements and precedents rather than there being any book of codified law. Courts like the Quarter Sessions and Assizes heard serious criminal cases of murder and felony and major cases (e.g. sometimes witchcraft cases) would be taken to one of the central law courts such as the Star Chamber. The Court of Chancery administered not common law but equity, a form of law that worked as a supplement to common law making judgements in the interests of fairness and justice to the plaintiff. Chancery began life as a court under the direction of the Lord Chancellor and equity law arose originally out of the concept of the 'king's conscience' – its business had multiplied by the end of the seventeenth century. The ecclesiastical or Church courts administered canon law, a completely different jurisdiction dealing with marriage and cases of sexual morality. The final type of court was assembled under the direction of property owners who held a demesne or manor and these small manorial law courts made decisions based on custom about tenancy agreements, widows' 'freebench' rights and community disputes.[4]

All historians point out that women were treated unevenly according to two factors – their status (unmarried/married) and the jurisdiction they were facing (common law, equity, customary law). The critical differences were that the unmarried woman or *feme sole* had full responsibilities and rights in law and the married woman or *feme covert* theoretically (though not always in practice) had rights and responsibilities that were covered by those of her husband.[5] The division into two legal types – the unmarried and the married woman – meant that women experienced law as something that could be quite different at different stages in their lives.[6] The other critical distinction was between common law, which tended to make the clearer division between *feme sole* and *feme covert* and the other two legal jurisdictions of equity and customary law which allowed for more female agency in practice. Practice was all in English law: lack of codification meant that legal treatises amounted to interpretative texts about the law's provision and the law was essentially regarded as in constant evolution,

even though in practice different law courts developed systematic practices that women as well as men came to understand well and work within. Historians have debated vigorously the question of whether or not women's rights declined or increased between 1500 and 1700 though the answer depends entirely on status and jurisdiction examined plus the changing nature of the law itself with regard to criminal and civil prosecution and so on. For example, it is possible to argue simultaneously that the property rights of both married and unmarried women increased in equity, but that the rights of married women declined in canon law in cases of marital separation.[7]

There was one legal treatise that dealt with the legal position of women – *The Lawes Resolutions of Women's Rights: Or, the Lawes Provision for Women* published in 1632 though written earlier. The subtitle suggests that the text was intended as a helpful handbook for women seeking simple legal applications pertaining to their marriage and property rights. It, therefore, assumed that these were the central legal concerns for women and the text was very conversational in parts as if anticipating a female readership and inviting a female response. *The Lawes* began with the Scriptural basis of temporal law, summarising Creation including the idea that woman was 'taken out of Man' so that as husband and wife Adam and Eve became one. In this sense, the idea that the laws of England originated in God's Law and Natural Law resulted in overlaps between legal discourse and the discourse of social prescription. *The Lawes* was a lengthy tome divided into five books. From the beginning the author pointed out that even though the law subsumed the legal identity of woman under man when married, in practice it sometimes treated the *feme covert* as *feme sole*.[8] *The Lawes* started with discussion of Adam and Eve's sins and differing punishments from God (his of mortality and hers of the pain of childbirth and subjection to her husband) and then moved to 'The Ages of a Woman' with marriage as the central formula. The author explained the ages at which a female child could be married – at 7 by her father (with her dissent allowed up to the age of 14 years) and at 12 giving her own consent. The author's interest in ages of marriage for women was directly related to his interest in being an advocate for their property rights and he noted that a girl became dowable at 9 and at 21 could 'make a feoffment'. In other words, at 21 years a woman could own, transfer or convey her own freehold land. A woman, thus, came of age twice in relation to different things – at 12 years when she could give away the property of her person/body in marriage and at 21 years when she could give away her real (land etc.) and personal (chattels or goods) property. The author set out the principles of common law in relation to inheritance. Girls who were the daughters of wealthy men 'participate seldom in heirship with males' but nevertheless could do so in examples of 'right line, right blood and [in some] manner of giving'. He told his readers that daughters were preferred ahead of illegitimate sons and male cousins, except when land is subject to a male entail (a legal device to settle land on men alone). There was a discrepancy between when women came of age in body and when they came of age in property which left them open to abusive wardship practice. They could not petition to be released from wardship until 14 and many heiresses found that they were compelled to

marry men who held wardship of their lands, often being forced to consent to this at 12 as will be seen.[9]

In the second book the author of *The Lawes* set out his intention 'to instruct women grown, first such as are or shortly shall be wives and then widows'. He laid out the laws governing marriage – a marriage was contracted when consent was given but was 'not accounted consummate, until there goe with the consent of mind and will conjunction of body'. 'Sponsion' or first promise of marriage, with gift and word or oath exchanged, could take place at seven years for a woman but this did not constitute full contract of marriage, even with the consent of parents, and a girl could not be compelled to fulfil such a contract. A girl could marry another man if two years expired from the date originally given for full marriage to take place. However, in theory, she was not supposed to marry another after a first promise marriage unless her future spouse suffered accident or disease that could arguably prevent procreation or if he renounced religion or abdicated the 'true religion' (in effect, Protestantism after the Reformation) in which case the Bishop could intervene directly to dissolve the marriage contract. The distinction drawn at law between the contract of a future or a present marriage was made solely according to judgements about when a girl was able to procreate and differed somewhat from the age of consent out of wardship:

> Those which the Latines call *puberes*, that is, they which are come once to a state, habit and disposition of body that they may be deemed able to procreate, may contract Matrimony by words of the time present, for in contract of wedlock, *pubertas* is not strictly esteemed by number of yeares, as it is in wardship, but rather by the maturity, ripenesse and disposition of body.[10]

The ambiguity in the law about when a woman had the right to consent to giving away her bodily property in marriage (either at 12 or at puberty) occasionally led to disputed marriages in those cases where marriage had taken place at 12, but consummation did not follow until later.[11]

The Lawes set out a series of reasons for marriage – avoiding fornication and achieving procreation – and impediments to marriage – primarily consanguinity (closeness of blood relationship), religious difference and already being married. Full dissolution of marriage *a vinculo matrimonii* was reinstated at the Reformation (because of rejection of marriage as a sacrament), but resisted by the Church in practice. Edward VI used the arguments of the German reformer, Martin Bucer, to argue for remarriage of the innocent party in cases of adultery, but England became the only Protestant country not to legalise dissolutions and the canons of 1604 formalised the pre-Reformation situation of limitation to separation *a mensa et thoro* (from bed and board). The author of *The Lawes* noted that two types of adultery could justify this separation – carnal adultery allowed separation in the civil law courts and spiritual adultery allowed separation under canon law. Although carnal adultery involved a case put to the civil courts, these cases also took as their intellectual basis for the law Biblical precedents *viz* Deuteronomy 24:1–2 and Matthew 19:3–9 dealing with the so-called divorcement of the

'unclean'. Marriages could be voided in cases of male impotence and women were free to remarry after five years if a man went missing and was presumed dead. However, *The Lawes* warned that '*quos Deus conjunxit, homo non separet* [Those whom God has joined, man may not separate]'; it was a serious Biblical precept from which the civil law was not expected to depart.[12]

The laws governing property transfer at the time of contracting marriage were immensely complicated. The author of *The Lawes* advised women that tokens given as symbolic of future marriage (usually highly personal items such as rings and bracelets) *ex sponsaliorum largitate* [from the bounty of the betrothal] constituted property that should be recovered if marriage did not ensue. Land transferred in what was called fee simple could also be recovered by women if 'the feoffment was for intent of [the] marriage'. Oddly, any land given by a man to a woman ahead of marriage remained as her life interest if he broke the condition of marriage. Both legalities indicate that the man was regarded as the primary agent in the marriage contract. That procreation was the primary purpose of marriage was indicated by another legal oddity regarding a woman's property. If a child was born but later died, by the 'courtesy of England' the husband would inherit his wife's estates at her death, but only if they were held in fee simple rather than leased out by her and only if there was a live child at birth. The legal definition of a 'live child' depended on Scriptural definition: 'all crye that come from Eve', so that if a baby emitted any other sound than crying before dying, officially 'courtesy' could not be claimed by the father. It could also not be claimed if the husband was ever convicted of a felony (even if later pardoned).

The Lawes is an interesting treatise because the author was keen in all cases cited to encourage acquisition as well as preservation of female property. In a more rhetorical section than some he pointed out that though '[a] husband *per se* is a desirable thing...donements or feoffments [gifts and transfers of land], better the stomach' and he argued that even the first marriage in Paradise between Adam and Eve involved jointure or joint holding of land. From this he proceeded to tell women of their current legal rights to dower, or the endowment they received out of a dead husband's property. He advised firmly against a woman accepting less than the common-law dower of one-third of a man's lands and advowsons [rights to present church livings to ministers]. He also advised women against the old custom of accepting deeds as dower at the church door because this discouraged joint ownership during coverture of moveable goods such as coaches and horses that a woman might need if her husband died. Dower attached not to the woman, as such, but the conjugal union or marriage and if the marriage was dissolved, the dower was dissolved too. The author instructed women to accept 'the dower of the new learning jointures'. His argument was that dowers had to be waited for and sometimes sued for upon a man's death, but what was called a jointure was a 'present possession' jointly held with the husband and could not be lost through conviction of a felony.[13]

The third book of *The Lawes* summarised laws relating to women who were wives and therefore defined as being subsumed into the legal personhood of baron and feme (the author noted that at best they became half a person and at

worst their legal identity was obliterated by name change). Society might treat the couple as two separate people but the law regarded them as 'one undivided substance'. Customary transfer of control [not necessarily ownership] of property from wife to the single entity of baron and feme took place not when the *de prae-senti* (present tense promise of marriage) under God's law took place but when nuptials or public celebration and recognition of the marriage took place under the laws of the land. Literally, the couple were not married without the intention, publicly demonstrated, to procreate and there was no entitlement to dower for the woman until the priest and witnesses believed sexual union to have taken place. In order to secure dower, the author advised women 'when supper is done dance a while, leave out the long measures till you be in bed, get you there quickly and pay the minstrels tomorrow'.

Property ownership after marriage became complicated by the unity of the legal entity of baron and feme. Land subject to a return to the use of someone else after a man's death could not become part of a woman's dower and all lands owned by the man prior to coverture remained his alone. Equally by pre-marital arrangement lands owned by the woman could be retained in the woman's ownership. If men attempted to exercise control over their wives' separate property after marriage, they did not do so with legal authority. After marriage, all dower lands belonged to the single entity of baron and feme and lands acquired after marriage were acquired 'by intierities' and 'not severall moities' of the man and woman. In other words, the property came to two people (with both names on the title deeds), but as they, themselves, were regarded as one person, their entitlement was indivisible. Crucially for women there was a distinction between legal ownership by baron and feme and customary use of property. By custom, a woman could not lease, sell or acquire land without her husband's consent, whereas the man had customary right to control their joint property. Of course, this meant that in individual marriages, husbands could, if they wished, empower their wives with control, acquisition and sale of property by customary freeing of her from her state of dependency. A woman could not take out a writ in her name because the husband was the *primus motor* or prime mover in the entity of baron and feme, though she could if he committed a felony, because she became essentially the same at law as a widow after his conviction. A man could not give his wife land because it would be the same thing as giving it to himself, but he could transfer it to a third party who then gave it back to her as her separate estate. There was a tricky distinction made between landed property and chattel in which men had a greater 'prerogative'. According to *The Lawes* '[t]he very goods which a man giveth to his wife are still his own: her chain, her bracelets, her apparel'. As a consequence some men named their wives' personal jewellery and clothing in their wills in order to bequeath goods officially at death to them. Chattels brought to the marriage by the woman became the disposable property of the man and moveable goods could become a man's through use, whereas landed property was more carefully governed by transfers of title deeds. Wardships of children held by women through their own seigneurial rights were regarded as moveable property over which a man gained lifetime use. According to *The Lawes* there were few

things that could rob a woman of her entitlement to dower – she could murder her husband and remain dowered, but elopement stripped her of dower rights because of the transfer of her bodily property.[14]

The fourth and fifth books of *The Lawes* considered the rights of widows and remarrying widows. The fifth book began with an appealing paragraph about a 'fair, young, rich, gracious' widow whose friends did not applaud when she remarried because, despite all the attention received from young men and widowers, this would entail giving up her independence. The author described the widow as a body with its head removed. The widow figuratively and legally lost 'a moiety of herself'. However, he asked '[w]hy mourn you so, you that be widows? Consider how long you have been in subjection under the predominance of parents, of your husbands; now you be free in liberty, and free at your own law'. It was not necessarily the case that the new widow had never before been free at law to control her own property and person; if she had attained the age of 21 years before marriage she would have spent some time legally as *feme sole*. The *feme sole* widow had exactly the same legal rights (and obligations) as a single man including all ownership and control of bodily and material property. Prescriptive texts, such as Richard Brathwait's *The English Gentlewoman* (1631) advised women that fidelity to the memory of dead husbands was a sign of feminine chastity, but the author of *The Lawes* suggested the more positive virtue for women in controlling their own lives and destinies.

The Lawes ended with some advice for women who were the victims of violence, noting that if they were raped, the Elizabethan statute removing benefit of clergy in 1576 gave legal redress.[15] The rape of a married woman was legally a crime against her husband (the woman could not sue a man for rape without her husband's consent). *The Lawes* included a short section on the legality of beating wives, the author noting that 'God send gentlewomen better sport or better company' and advising that a man had no legal redress if a woman beat them back in marriage.[16] However, just as in practice the law did not take seriously the issue of men's violence against women, neither did the author of this legal handbook for women; most of the text concentrated on a woman's material property through the three legal stages of life defined by law – maid, wife and widow.

Courtship, marriage and divorce

Two basic things need to be known about marriage in early-modern England: the first is that people could contract marriages surprisingly easily before the Marriage Act of 1753 (which suppressed marriage by private contract or clandestine ceremony) and the second is that many people thought they were married when, legally, they probably were not. It was possible to contract a marriage simply through exchanged verbal promise or betrothal. There were two types of betrothal (or, spousals) – *de futuro* and *de praesenti*. To be legally binding, betrothal needed to take place in front of witnesses. The most conventional form of betrothal did involve a priest, but only as witness to the exchange of vows and intended consummation. The betrothal usually took place either at the bride's

house or in the church porch, followed by an exchange of gifts and hand-fasting with a ring. Cohabitation was not supposed to take place until the calling of the banns for three weeks, but it usually followed directly upon *de praesenti* spousals and was taken to mean that a legal marriage was complete. Even a verbal contract for future marriage was considered to be legal marriage in the present if followed by public consummation or *carnalis copula*. Children born after cohabitation were not normally regarded as illegitimate, though if their legitimacy was challenged, a woman would need to produce witnesses to her betrothal.[17]

The impact of an ambiguous marriage system on women's lives can be clearly demonstrated through the number of disputed marriage cases brought to court. Women trod very precariously between the need to be chaste before marriage and acceptance of consummation as validation of marriage. Premarital intercourse was a sexual crime or fornication and was dealt with by the church courts. However, the ambiguities inherent in the making of a marriage encouraged pre-marital sex as something akin to rehearsal of legal contract with the result that possibly up to one-third of all women were pregnant already when the marriage was eventually finalised. Sexual relations between couples who were intending to marry seems to have been widely accepted amongst ordinary people. Chapbooks and 'penny merriments' such as those in the Pepys Collection abound with tales of wooing and love and make it clear that for most people romance and intimacy was expected to precede marriage.[18] However, vague promises followed by sexual intercourse without reliable witnesses could be a dangerous business for women. They could end up in a long-standing customary union that would not stand up in the courts or, worse, in no customary union at all but pregnant. The widespread practice of 'bundling', when a fully-clothed young couple was left alone in a bed together for the night, made matters worse. Lawrence Stone has pointed out what could go wrong through the case of Abigail Harris, whose mother allowed so many episodes of 'bundling' that pregnancy occurred before even the most informal of marriages had taken place with one of Abigail's suitors. Nobody wanted to claim paternity of the child.[19]

The Harris case also demonstrates the way in which children of both sexes could be subject to the decision-making of their parents who customarily made marriage choices for them. Women of the poorer classes were more likely to make an independent choice of partner (especially if they were living and working away from the parental home).[20] However, there was an increasing tendency to allow girls of the gentry and upper classes some right of veto over parent choice. Catherine Cholmley begged her father to let her marry her music tutor even though a portion of £1,000 had already been paid to another man; he decided that he would rather lose the money than let her marry 'against [her] liking'. Mary Boyle who was the daughter of the Earl of Cork, stubbornly rejected her father's choices until she eventually was allowed to marry the man of her choice.[21] In individual cases, therefore, it can be seen that men themselves put aside their customary paternal prerogative and did not demand obedience from daughters unhappy with the choices being made about their marriages.

The *feme sole* widow could come under pressure to marry men chosen for them by fathers and sometimes brothers and a small error of judgement on their part

could result in them contracting a marriage almost by accident. Heiresses and widows were open to men attempting to prove a marriage to them by any means that looked legal and both things can be seen in the case of Elizabeth Wiseman who was widowed at the age of 37 in 1684. Elizabeth was left a fortune of £20,000 and found herself almost shunted into a marriage to Sir Robert Spencer by her eldest brother, Lord North, and his wife, Katherine. She disliked Spencer so much that she told her servants not to let him enter the house, but her sister-in-law brought Spencer back time and again, conspiring also to get Elizabeth to her own house on several occasions and forcing her to stay alone with Spencer both in the house and the garden. Elizabeth desperately tried to escape his presence on every occasion and told him 'I would never have him…and did assure him I would never marry any [person] contrary to my mind to please any particular person.' Her brother and sister-in-law eventually trapped her in a drawing room with Spencer where she was 'tormented with this man's flames and nonsense' and her brother placed her hand on that of Spencer declaring 'come, come, make a quick business of it and kiss her upon that account'. Elizabeth Wiseman was forced into enlisting the legal help of another brother, Roger North, a lawyer who advised her to counter Spencer's charge of breach of marriage contract with a jactitation case in the Court of Arches by which she could prevent Spencer from publicly claiming marriage to her. In an age of highly dubious contracting of marriage 14 per cent of the marriage cases dealt with by this court were jactitation cases brought by people desperate to escape the shenanigans of unscrupulous family members. Widowed women like Elizabeth Wiseman were in a better position than never-married women when it came to exerting control in situations involving pushy relatives.[22]

The Wiseman case tells us much about the association made between female chastity and the concept of privacy. Brathwait's *The English Gentlewoman* advised women to '[m]ake then your chamber your private theatre'. In closing themselves off from public gaze and, especially, touch, unmarried women literally performed gender by protecting their sexual property. When Brathwait also advised women not to mix with people in 'publike concourse' this was not because it took them outside the home, to a different, open, populated, physical space, but because in an age in which women no longer wore veils they could not hide 'that secret inscreened beauty…bashful modesty'.[23] It was 'bashful modesty' and not the physical location of home that ensured a woman inhabited the private sphere. Equally Elizabeth Wiseman's privacy could be assaulted, so robbing her of her central asset as a woman whether she was at home, at the house of her brother and sister-in-law or in the street. Not only because of prescription, but also because of the failure of the law to locate marriage in one public place, Elizabeth Wiseman was in sexual danger every time her unwanted suitor attempted to grab her hand.

Ownership and control of a woman's bodily property depended to a high degree on a woman's status at law. Elizabeth Wiseman was an independent widow, but unmarried women whom the law regarded as dependant on their fathers were more susceptible to being manoeuvred into marriage simply because they did not imagine they had a choice. When Jemima, daughter of Lord Sandwich, was

asked how much she liked the man chosen for her to marry she replied that she 'could readily obey what her mother and father had done'. Jemima's chastity was a matter of public concern and the intimate exchange of her body was witnessed by Samuel Pepys who had been appointed as an intermediary and negotiator in the marriage. On her wedding day Pepys found her 'mighty sad, which troubled [him]', but his mind was put at rest by the 'gravity of this business', which he found 'decent'. His role had involved taking the young man to Jemima's bed, kissing the bride and closing the curtains on them. This represented public consummation of the betrothal, which had taken place earlier in the day at the church, and the marriage was thus complete.[24]

There is evidence that some women viewed their loss of the bodily privacy of the unmarried state with some anxiety. Alice Thornton and her siblings were persuaded into various marriages when their widowed mother found that the value of her dower had dropped to unacceptably low levels during the 1640s. Alice Thornton later recorded that 'for my owne perticuler, I was not hastie to change my free estate…wherein none could be more sattisfied'. She interpreted her change of estate providentially, recording also that she would serve God (as much as her mother) 'in those duties incombant [*sic*] on a wife', but she fell violently ill on the evening of the wedding and it is to be presumed that the marriage was not consummated until a later date.[25] Some evidence can be found on occasions of women not being unfavourable to marriage itself, but perhaps being anxious about or even hostile to the idea of sexual union. Elizabeth Grey (a daughter of the earl of Shrewsbury) refused to sleep with Henry Grey for the first year of their marriage. When she finally gave in, her mother was advised by letter that 'my Lady Elizabeth did yield her willing consent to admit my cousin Grey to lodge in bed with her [t]he end purpose thereof we all assure ourselves is acted'.[26]

Consummation had to be achieved and witnessed to place a legal seal on marriage. Social rituals and cultural symbolism surrounded the wedding night as a result. Family and friends sometimes helped the couple to undress, often amidst noisy celebration, and placed them in the marriage bed. The bed-head itself might feature carvings of Adam and Eve, a less than subtle reminder of the act that was about to take place.[27] Sometimes the bed had been given to the couple by the bride's family, a material gesture that symbolised the family's transfer of the bride as bodily property to the man. Mendelson and Crawford have pointed out that women could experience marriage 'as a violent discontinuity'; they were expected to behave differently and dress according to a certain manner with a 'matron's scarf' to mark their change of physical and social status. They speculate that women of the lower and middling classes experienced this change in less dramatic and disruptive ways. They were often moving out of service, having already left the family home and were usually older. However, they still had to suffer a change in community perception of their status, marked most notably in church where they moved to an area of the congregation reserved for matrons rather than maids.[28]

Issues of gender and property (both of women and estates) were deeply embedded in the legalities of marriage. During marriage negotiations women were vulnerable

to bad treatment from members of their family because the law treated them firstly as the property of their fathers.[29] In a prolonged and deeply unpleasant negotiation between the parents of Edward Griffin and Elizabeth Harpur, her father tried to reduce her marriage portion when it seemed she might die, thereby putting a lesser price on her head.[30] Children were also treated as the property of men.[31] The case of Katherine More is a particularly good one for demonstrating how both women and children could be treated as property during negotiations for marriage and during any conflict that arose over its legality. Katherine More was the daughter and sole heir of Jasper and Elizabeth More of Larden in Shropshire. Her parents contracted with Richard and Sarah More of Linley in Shropshire that she would marry her younger cousin, Samuel More. The marriage was designed to consolidate the estates of Larden, Linley and the manor of Downton. Larden was to remain in the use of Katherine's mother after her father's death and then pass to her heirs by Samuel More. The couple were married on 4 February 1611, when Samuel was just 16, eight years younger than his bride.[32] However, Katherine regarded herself as already contracted in marriage to Jacob Blakeway, who was three years her senior, and there is a chance that her parents knew of the love match already, arranging an alternative marriage (which could be classed as bigamous) to extricate their daughter from Blakeway who was the poor son of one of their tenant farmers. Katherine and Samuel More cohabited at the house of her parents, but she continued her sexual relationship with Jacob Blakeway, suggesting that at least one of her parents was willing to tolerate their liaison, perhaps because Samuel More's youth hindered sexual consummation of the marriage.[33]

Katherine More had several children and Samuel More began to accuse her of adultery because of 'the apparent likeness and resemblance of most of the…children in their visages and lineaments of their bodies to…Blakeway'. He felt cuckolded by Katherine's 'continuance in sinne' and soon after turning 21, he cut the entail on the Larden estate and his father cut the entail on Linley and Downton. The children were taken from Katherine and placed with tenants at Linley. Samuel More then decided to use his prerogative as the legal father of the children to send them away altogether. Katherine tried to retrieve the situation by 'alleging a precontract with…Jacob Blakeway…which contract…was all one before God' and she applied in June 1616 to the Chancellor of the Consistory Court of the Diocese of Hereford to have her marriage to Samuel More declared bigamous to legitimise the contract to Blakeway. The application failed because she was unable to provide witnesses to a *de praesenti* betrothal with Jacob Blakeway and charges of adultery were then brought against her in the Court of High Commission. Samuel More retaliated by suing Blakeway in the common law courts for what was termed criminal conversation (or, use of the property of his wife's body) and in 1619 the Lent Assizes awarded him £400 damages. Blakeway then fled his farm, deserting Katherine, whereupon Samuel More sued for separation from her and this was granted. An appeal Katherine lodged against the separation was turned down.[34]

Katherine More lost her battle in tragic circumstances, but her children, who were treated as chattel during the legal disputes, suffered the most. Between 1619,

when Blakeway fled, and July 1620 when she lost her separation appeal, Katherine refused to let the children out of her sight, verbally and physically harassing their guardians at Linley and accusing her in-laws of trying to engineer their collective murder. Her fears were not without foundation; immediately after the failure of her appeal, Samuel More took the four children – Eleanor (8), Jasper (7), Richard (6) and Mary (4) – to London and placed them on *The Mayflower* bound for Virginia in New England. Katherine petitioned the Lord Chief Justice, but her husband fought back claiming that the children were conceived in adultery and the four children then set sail on a journey that resulted in the deaths of three out of the four of them.[35] Not content with this victory, in 1622 Samuel More forced Katherine to renounce any claim to the Larden estate in the Court of Common Pleas before he married again (bigamously) in 1625. The Linley and Larden estates passed to his eldest son by this second marriage.[36]

The Katherine More case – and many others – raises questions about the impact of gender expectations and women's uneven treatment in marriage law on women's levels of happiness when married. Indeed, the historiography on marriage has been concerned with the question of whether or not marriage was an institution that was based on love or the pressing and sometimes oppressive demands of duty leading to a lower expectation of affective love. The debate was first generated by Lawrence Stone in *Family, Sex and Marriage* in 1977 in which he suggested that 'the demographic facts' such as high adult mortality rates led to an expectation of a brief marriage that was not especially characterised by warmth and affection. He argued that arranged marriages made 'close affection between husband and wife…ambiguous and rare' before the more loving and 'companionate marriage' of the eighteenth century.[37] This model has been challenged or reworked by several historians including Patricia Crawford, Ralph Houlbrooke and Antonia Fraser who have all pointed to the variety of experience of marriage that can be found by using qualitative sources instead of extrapolating conclusions from demographic data that is quantitative by nature.[38] For example, Houlbrooke used correspondence and diaries to demonstrate the functionality of loving, working partnerships. A major tool in the argument has been testimonies of women's grief at the premature death of a spouse.[39] Indeed, in the diaries and letters that survive from the gentry it is possible to find examples of women whose experience of love and grief was intense whether they had been through an arranged marriage or not. For example, when faced with the imminent execution of her husband in 1655 Arundel Penruddock wrote to him 'were it possible, I would with my own blood cement your dead limbs to life again…[or] wish my own dissolution with you, that so we may go hand in hand to Heaven'.[40]

The equation between law, custom and experience was not simple. After marrying the man of her choice, Mary Boyle (Rich) had a very difficult marriage during which she complained of attacks of 'the spleen' by which she meant migraine headaches. But when her husband died she was beside herself with grief.[41] There was also no simple equation between female submissiveness in marriage and happy marriage; many men developed strong relationships with their wives because they were women who were able estate and household managers and

showed spirit in their presence. James Clavering viewed his very dependant wife, Catherine, with disparagement, comparing her unfavourably to Ann Liddell, his cousin, who acted as her husband's agent in the coal trade from their Tyneside home.[42] However, for every man who valued a strong-willed wife, there was a man who did not and issues of possession and control were inherent in the whole process of courtship and marriage. David Cressy argues that men treated court-ship like a military campaign to be won and while there were rituals common to both partners such as gift exchange, only for men did the final stages involve what William Lawrence described to his brother as 'enter[ing] triumphantly into my new possession'. According to Anthony Fletcher achieving manhood meant becoming 'the sober little patriarch' of the family, ensuring that many women experienced marriage as being in a state of formal dependency and heavy con-trol.[43] Indeed, while the debate between historians has mostly erred on the side of love and affection dominating in early-modern marriages, more recently the case for marriages characterised by misuse of male power and dysfunction has been recast by Fletcher in *Gender, Sex and Subordination* (1995). According to Fletcher, early-modern England was 'a society suffused with personal relationships of dominance and submission' and he has followed Margaret Hunt's work in pla-cing wife-beating and domestic violence 'at the core of early-modern patriarchy'. Violence against women in marriage was normalised within a social context of male control of women. Fletcher points to proverbs which prove rather the oppos-ite case to the one for love such as 'a spaniel, a woman and a walnut tree | the more they are beaten the better they be'.[44]

Examples of domestic violence against women do abound. Sir Oliver Boteler punched his wife regularly and taught their children to spit in her face. He was a serial adulterer who forced her to have sex in front of the servants and twice infected her with gonorrhoea. He called her 'whore' and terrorised their children into beating her as well. Anne Boteler continued to endure this humiliation and torment until all her children had been taken away by their grandmother and Sir Oliver Boteler brought his reign of terror to new heights by threatening to kill her.[45] This case came to court and the details of the cruelty and violence when they emerged were not uncommon. The court eventually granted separation after three years, but Anne Disbrow was less fortunate, being forced to stay with the husband who beat her so severely she coughed blood in the courtroom.[46] Elizabeth Fowler, daughter of a barrister, had the misfortune to marry the aptly-named Holcroft Blood in 1686 who was an adulterer. He called Elizabeth 'bitch' and 'whore' and raped her in May 1700. She left home, but the violence continued – he hit her so hard in the face that her nose streamed with blood and the neighbours eventually called a constable.[47] Marriages that featured violence were often dealt with informally by family and servants attempting to protect women from harm. Hester Temple sent her husband and son to the house of a son-in-law to put a stop to the violence he was meting out to her daughter.[48] However, frequently domestic violence only came to the attention of the courts if neighbours were disturbed and the issue moved from being a private family affair to a public social order matter. For example, Melchior Smith was brought before the ecclesiastical

court in York for likening bishops to 'doome dogges and theves', but at the same time he was accused of treating his wife so badly that on one occasion she leapt from a staith into the slimy mud and filthy water of the River Hull to escape him. His only defence was that at times he and his wife 'did not…agree so perfytelie [perfectly] as they aught to do'.[49]

Anthony Fletcher, like Lawrence Stone before him, argues for gradual change as wife-beating became unacceptable reflecting better gender relations in marriage by the eighteenth century based on romance, love and affectivity in ways that reasserted rather than diminished men's control in marriage. In this Fletcher follows the lead of feminist historians who would argue that 'romantic love [is] a patriarchal narrative'. In this model, the 'companionate' marriage suggested by Stone, is actually a 'gilded cage'.[50] However, it is possible to turn the evidence around and argue the case differently, that, in fact, it was not control through force that was replaced by a more positive affectivity, but rather the 'happiness' conditioned by religion and expectation that had given cultural meaning to women's entrapment in the sixteenth and seventeenth centuries. Cressy has suggested that 'while the emotions themselves are enduring marks of human sensibility, the manner in which they are expressed and the language used to describe them are socially and culturally conditioned'. In other words, there is a need for caution in interpreting women's more formal pronouncements of love as 'low affect'. More important was the ideology that people used to structure and interpret their experience of love and marriage. Protestantism provided a framework for marriage that privileged male superiority and required women's obedience, but it also provided a set of rules for life that encouraged acceptance, a quiet spirit and happiness. Therefore, happiness in marriage needs to be contextualised and understood in these terms. Equally the gendered nature of ideas about marital happiness needs to be understood; arriving at a state of happiness was a greater expectation for women than men. Sarah Henry, whose father, the nonconformist minister Philip Henry, arranged her marriage in 1687 to a widower with a child, was so shocked she recalled it as the 'saddest day that ever came over my head'. However, she recorded in her diaries that she arrived at acceptance and she claimed to have found happiness.[51] Even when marriages were not entirely perfect gender expectations encouraged women to cultivate a state of equability. Grace Mildmay's husband spent two decades of their marriage avoiding living at home, but her 'Meditation' as his body lay in its coffin included the Christian concept of their eternal unity: 'He was as I am, and as he is, I shall be.' She regarded him as God's gift to her and prayed that Christ 'shall raise my corpse and make us both partakers with himself of a joyful resurrection'. Both Sarah Savage (Henry) and Grace Mildmay, in a sense, performed their marriages as mutually loving unions according to early-modern ideas about Christian conjugal love.[52]

Marriages ended for women in one of two ways – most commonly through being widowed and far less commonly through separation. The early-modern widow had two faces – that of myth and that of reality, though in law it was straightforward enough and the widow again became *feme sole*. The myth was the woman liberated from male domination and control warranting satirising as a sexually

voracious, potentially powerful, figure whose independence should be held up to public scrutiny. Dorothy Osborne told William Temple that at dinner one night in 1653 she met a widow who had 'broke loose from an old miserable husband' and intended spending all his money before she died. Richard Allestree's *The Ladies Calling* (1673) warned women that they were at their 'most miserable when they are at most liberty' – he wanted to make clear that a woman should be devastated without a husband. The reality was that many of them were, and women's experience of bereavement usually involved a deep sense of personal loss that was frequently compounded by changed economic circumstances.[53] Many women moved from a state of mutual subsistence in a working partnership to destitution. This was the case for the widow of Charles Stratford who found herself having to beg for a loan of £40 for 'the relief of her povertie' when her husband died.[54] Alice Thornton was left utterly bewildered when her husband died. He left heavy debts after a miscalculated business venture and she feared the estates and goods left to her by her mother would end up paying the debts because a relative told her that estates 'did fall due to the husband, for the property was in him, and not in the wife, being under covert barr'. Luckily her mother had foreseen the problem and placed everything in the hands of *feoffees* in trust for her and the grandchildren. Alice Thornton was acutely aware of the impact of the law on her precarious situation stating that 'if I had had any relation or friend with me that would have stood up for the widow's right, either law or equity, things must not have gone soe'. In law she was independent, but in character she was not and a kin member stepped in, helping her to identify her goods, which her mother had sensibly marked in her daughter's name, so that only her husband's estate and chattel went towards his debts. Thornton's widowhood was, thus, experienced as a violent discontinuity in her life, her grief mingled with the ambivalence generated by her precarious economic situation.[55] It was not always thus; some widows continued the businesses of their husbands as brewers, bakers, printers, weavers and carpenters, carrying on the trade with full ownership of stock left at the time of their husbands' deaths and with the same ability to take on apprentices. Their legal position as *feme sole* allowed them to operate in the public world of trade and capital. Barbara Todd, Pamela Sharpe and others have calculated that remarriage amongst widows declined and there is some evidence to suggest that the self-sufficiency of the widowed took on greater appeal as the period progressed.[56]

Dissolution by legal means in early-modern England was complicated and uncommon because pulling apart a marriage was extremely difficult before the passing of the 1857 Divorce Act. Couples could apply for a legal separation (after which, neither of them could remarry) or a marriage could be annulled. Annulment was dependent upon the marriage being invalid at inception (fraudulent identity of one partner, secret Catholicism of one partner, consanguinity including the prior marriage of one partner to a sibling of the other, criminality, prior *de praesenti* marriage) or rendered invalid after marriage contract through male impotence. Remarriage was allowed if non-consummation could be proved. Famously, Frances Howard's marriage at 15 to Robert Devereux, the 14-year-old earl of Essex, was not consummated at the time of the wedding to allow the groom

to attain full sexual maturity. However, once Frances Howard and her husband became *puberes* and consummation was due she avoided sexual congress with him, instead starting an affair with Robert Carr, earl of Somerset. In 1612 she brought a marriage nullity case on the grounds of her husband's impotence. Annulment was allowed, the court arguing a case of the earl of Essex's temporary and specific impotence with Howard. The case caused enormous scandal, not least because Carr was King James's favourite and Howard was later found guilty of poisoning Sir Thomas Overbury who had tried to stand in the way of her remarriage. As annulment turned on proving a marriage invalid, there was no termination of a marriage or divorce as such and the trope 'whom heaven joins, let none dare put asunder' was a reality lived by many women.[57]

More commonly marriage was broken through the informal, non-legal separation of a private and negotiated settlement between propertied couples or through desertion, elopement and bigamy. Very occasionally spouse murder was the end point of marriage breakdown and in extremely rare cases mock 'wife-sales' amongst the poorer classes led to escape from an unhappy union.[58] Private separations were a practice that originated in the 1650s as a consequence of the breakdown in the business of the ecclesiastical courts during the Interregnum. Their development as a way of securing a satisfactory outcome in separation for people of property coincided with the growing importance of several types of private contractual law affecting marriage such as pre-nuptial settlements and negotiated dowers or jointure. Such agreements were engineered by the families of couples in much the same way as their pre-nuptial marriage settlement. Actual attempts to separate at law were very few in number – perhaps three or four a year in the main consistory courts at London and York. 'Self-divorce by bigamy' was vastly more common, a fact reflected in penalties being introduced for it as an offence as early as 1603. Bigamy could be punished by death but in reality, according to the estimates of Lawrence Stone, thousands of men and women were living in bigamous partnerships in early-modern England. The middling sort regarded a hasty and clandestine marriage conducted by a parson in the chapel attached to the Fleet Prison in London (until the activities of its 100 or so parsons were curbed by Hardwicke's marriage act of 1753) as sufficient to prove respectability. Stone cites the case of Robert and Sarah Tipping, who seemed to regard their marriage as being terminated by mutual consent in 1715 through private settlement as evidence that early-modern couples began to make use of the fact that it was difficult for the courts to distinguish truly illegal from just irregular marriages in order to remarry, sometimes over and again.[59]

The law lagged behind the practice of informal separation and even behind some opinion. John Milton's *The Doctrine and Discipline of Divorce* of 1643 argued for full divorce in cases of 'incompatibility'. Milton did not depart from the precept of the Biblical institution of marriage and he argued that God's law had to underpin dissolution of marriage – while one end of marriage was procreation (resulting in impotence being a ground for annulment) so also was God's provision of man's 'help meet' for 'meet and happy conversation'. Indeed, Milton argued that there were two types of barrenness – of the body and of the soul. His was an unusual

argument and it led to no change in the law, but after the Restoration of the Stuart monarchy Milton was followed by three high-profile cases causing legal change as well as a considerable increase in separation by private settlement. The first was the case of John Manners, Lord Roos, and his wife, Anne. He was heir to the Belvoir estates of the earls of Rutland and his wife was one of the two female heirs of the Marquis of Dorchester. Their marriage featured drunken sexual failure on his part and sexual promiscuity on hers. The paternity of several children was questionable and Lord Roos presented a private bill for separation to parliament in 1670. In the end he was granted not exactly a dissolution of the marriage but a combination of separation from his wife through the church courts with an Act of Parliament that allowed him to remarry on the grounds of his wife's adultery.[60] Then in 1698 the Macclesfield case was arguably the first real parliamentary divorce as it granted the Earl of Macclesfield the full right to remarry prior to any case of separation or criminal case against his wife's lover. Dissolution of contract was achieved by the return of his wife's marriage portion. The same thing happened in a case that ran from 1692, when Henry Howard, Duke of Norfolk, drew up a private member's bill to divorce his wife of 15 years, Mary Mordaunt. Norfolk did not approach the church courts for legal separation because although his wife was adulterous, his own sexual conduct was as bad; his case in the civil courts against his wife's lover for reparations resulted in only a pyrrhic victory of a small sum.[61] The Norfolk case was accompanied by several years of pamphleteering and propaganda by the couple. The duchess of Norfolk published a pamphlet in her defence in 1693 entitled *A Vindication of Her Grace Mary Dutchess of Norfolk* arguing against the separation and her husband's accusations.[62] In 1700 *The Duke of Norfolk's Case* was published attacking his wife.[63] The duchess of Norfolk replied with *The Lady's Answer to a Divorce: Or, a Vindication of the State of Matrimony.* In the latter she argued that 'there can be no great grief where the Husband and Wife are both guilty'. She also argued against the double sexual standard: a 'whorish woman' was 'an intolerable plague' to her husband but, equally, an 'unconstant husband' is 'an intolerable burden' to his wife because of his 'uncleanness'.[64] The duchess of Norfolk fought her husband because she stood to lose lands that had come to her at the death of her father in 1697, but the Duke of Norfolk's bill was finally passed, giving him the right to remarry, and her £10,000 marriage portion was returned to her family in a private settlement.[65]

By 1700 the loosening of sexual morality evident in the Roos and Norfolk cases and the precedents in marriage dissolution they set led to public fixation on the scandalous breakdowns of upper class marriages as well as a moral panic about male impotence and family name.[66] Civil dissolutions of marriage with right to remarry excited considerable controversy and old collections of opinions on 'divorce' were collected into editions for popular consumption.[67] The Norfolk dissolution case opened the floodgates to public debates that were entirely different from the perspective only a few decades earlier. Earlier printed works that had warned of the fearful judgement of God in cases of adultery were replaced by tracts that debated the right to remarriage of the innocent party whatever their sex.[68] The anxiety of the earlier period about women's sexual lasciviousness

was joined by new anxieties about men's 'whoring'. An *Essay towards a General History of Whoring* of 1697 matched the duchess of Norfolk's language about male 'uncleanness' and reflected fears about the breakdown of the main institution of patriarchy – marriage – through male (rather than female) neglect and misconduct.[69] It appeared alongside a swathe of sexual scandal sheets that abandoned the association of adultery with sin found in the *Acts* of 1650 in favour of a prurient fascination with adultery and legalistic discussions of the grounds for dissolving marriage.[70] For example, in 1780 the legalistic history *Trials for Adultery* was published in London against a backdrop of publications that pressed for legislation against the crime (as opposed to the sin) of adultery. The impact on women of this change in sexual morality and the definition of sin was complex. It gave them greater sexual freedom without giving them greater property rights in their [married] bodies. It also made them subject to a double standard that became codified at law to include dissolutions of marriage that were almost exclusively available to men because of the cost and need to apply to parliament. After 1700 the number of private separations increased: one example was the agreement made through lawyers for the separation of Pierce Fitzgerald and his wife Susanna in Norwich in 1731 in which Pierce agreed to convey one-third of some land in Allington in Lincolnshire to trustees for the upkeep of his wife.[71] However, also between 1670 and 1857 there were 325 dissolutions by Act of Parliament, though only a tiny proportion of the parliamentary dissolutions of marriage that followed the Roos and Norfolk case were brought by women, and separation by private settlement with the help of families remained the better option for the female sex even though it involved no right to remarry.[72]

Men's pursuit of marriage dissolutions in the late seventeenth century ironically had a context of fear over marriage breakdown and subsequent failures of male lineage. Marriage was reasserted as a central paradigm for society against a backdrop of rising rates of singleness. The ultimate challenge to patriarchal society was celibacy and by 1700 the celibacy rate for women had risen to almost 20 per cent.[73] Christine Peters has argued for a changing model of singleness from the occasional unmarried daughter whose family supported her, to the emergence of the figure of the 'spinster' whose expectation was economic independence achieved in the first instance through inheritance. The unmarried woman remained symbolically highly significant, more so than the widow who had travelled to another physical and spiritual state as a consequence of marriage.[74] The never-married woman had a different spiritual status. For example, at the funeral of Elizabeth Ellinor, who died in 1680 in Beverley, East Yorkshire, a maiden's garland of flowers symbolic of her virginity was placed on her funeral bier and whilst hers is the oldest maiden's garland in the country known to survive, it is also known that the practice continued beyond 1700.[75] However, the Protestant Reformation, according to Peters, led to a redefining of single women and not a discrediting of their celibate lives and this is reflected in the wills of men who left them the means for self-sufficiency. George Cumpayne left his unmarried daughter for her life a chamber to live in by the fire in his house, bedding and pots for her comfort and sheep, a garden, an acre of land and a small annual sum of 3s 4d for her

upkeep.[76] Peters has pointed to ballads that celebrated female singleness as a way of life which allowed maids to escape the demands of husbands. Fathers were not the only people who sought to protect single women in their wills and wealthier men and women alike left charitable bequests to poor, single women of the parish. Matthew Beadle's will of 1590 gifted his interest in three leases of land for the upkeep of 'six poor unmarry[ed] sole women' plus an additional cash sum to buy them gowns and veils.[77] These were bequeathing practices that carried on despite the panic over rising rates of singleness at the end of the seventeenth century.

However, what did change at the end of the seventeenth century was women's willingness to critique the marriage paradigm being reasserted by men. Whereas Vives had told his female readers of the sixteenth century that 'if thine husband be foul, yet love his heart and mind whereunto thou art married indeed', it is clear that by the end of the seventeenth century this was a dictum being seriously questioned by a female critique, at least of bad marriage, that can be seen in both the private and the public sphere.[78] The case of Anne Dormer for example, whose unhappy marriage has been extensively documented by Sara Mendelson and Patricia Crawford, is instructive. Dormer discovered that her marriage was an incarceration involving psychological torment as her husband followed her around the house smashing doors. Although she said 'I submit most cheerfully to his absolute dominion over me', she nevertheless also retaliated by telling him that as it was his house he could 'sh-- in every room' if he wanted.[79] Women began consigning their private rebellion against oppressive marriages to diaries, poetry and political pamphlets by the end of the seventeenth century. In 1703 Lady Mary Chudleigh commented sarcastically that 'wife and servant are the same'.[80] Her comment was an encapsulation of the lengthier political arguments of Mary Astell's *Some Reflections upon Marriage* which came out in 1700. The latter was a public critique of the gender hierarchy in marriage that was very influential amongst women of the educated elite. Astell used the precedent of female rule to point out that if *all* women were inferior to *all* men in natural law (as manifested on the continent in Salic Law) then English queens would have been inferior to their footmen. She deployed John Locke's thinking about political sovereignty to argue that if it was agreed that absolute sovereignty was unacceptable in the state, then so it should be in marriage: 'Is it not then partial in men to the last degree, to contend for, and practice that Arbitrary Dominion in their Families, which they abhor and exclaim against in the State?' Like Locke, Astell rejected notions of Eve's natural subjection and like other defenders of women before her, she also pointed out that at the time of the Fall women were made the means for human salvation. However, what made Astell's work stand out from earlier *querelle des femmes* defence tracts were her arguments about 'natural freedom' which overturned old ideas about women's 'natural' inferiority. If women are kept in 'Ignorance and Slavery' it was not with any Biblical authority she argued, before warning that inequality in marriage led men to 'puff up' with power and that because obedience is a 'bitter cup' men could expect that women, like a mule kicked, to kick back.[81] The practice of absolute sovereignty in marriage was more heinous than in the state, she argued, because '100000 Tyrants are worse than one'. Her most

famous line – 'If all Men are born free, how is it that all Women are born slaves?' – has rightly been seized upon by modern feminist historians to argue that Astell was one of the first feminists because she constructed forceful arguments against the institutional patriarchy of marriage and they were taken up by other women.[82]

Anne Dormer's letters to her friends about her unhappy marriage are evidence of a sea change in female attitudes. She used the same language as Astell to describe her subjection in marriage and Lady Mary Chudleigh referred to women's loss of freedom in ways that also hinted at Astell's ideas: 'Will the nuptial contract break | Like mutes, she signs alone must make | And never any freedom take.' Chudleigh described marriage as an institution that gave all power to men, a female complaint that cannot be found earlier when the Pauline prescription for women's subjection in marriage overlapped with law and experience more powerfully.[83] In 1703 Sarah Egerton called marriage 'the fatal slavery'; she pointed out to the readers of her poetry what all women knew and what men's increased access to marriage dissolution at law further ensured: that 'the husband with insulting tyranny | can have ill manners justified by law'.[84]

Reproduction and production

Women's working lives, paid and unpaid and including the work of childbearing and childcare, brought women together in shared experience. Their mutual knowledge and shared space shaped and informed their gender identity. It was in this aspect of their lives that they had the most ability to form their own identities in what Carroll Smith-Rosenburg once called a 'female world of love and ritual'.[85] Some of this female world was secret and hidden away from male eyes. The secrecy of the woman's body during reproduction rendered it mysterious to men and gave women the agency and the power to define their own world of maternal welfare, birth and infant care.[86] By contrast, some women's work was perfectly public and open to greater male scrutiny including care of older children and some heavily-gendered work roles such as spinning and cloth work. This section aims to look at both reproduction and production to consider the maternal and work identities of early-modern women and the interaction of this female culture with law, church and public regulation.

Motherhood is a topic that has received renewed attention since the 1990s. Although most of it has focused on the rituals of childbirth and the relationship of a mother with her infant child, Linda Pollock has drawn attention to women's relationships with their grown children too.[87] The demographics of early-modern fertility are quite well established. Approximately 70 per cent of women were able to bear children and most of them – though not all – did so within marriage. The research of Dorothy McLaren on marital fertility has indicated several things. First that there was a period of high fertility between 1640 and 1679 and she calculated that family size was also slightly larger in those years. From 1640 to 1720 over half of the fertile women she surveyed (99 women in total) had six or seven children – so this was a norm – but larger families still of greater than nine children were more prevalent between 1640 and 1679. Second, intergenesic intervals

(or the periods between births) were found to be two-and-a-half years between the first and second infants and two years and nine months between later infants, though the intergenesic period was less between the first and second infant if the first died. Third, McLaren's research has confirmed that prolonged lactation in women who breastfed lengthened birth intervals, so that fertility was highest amongst richer women who put their infants out to nurse.[88] Aristocratic women married younger than the rest of the population and so could look forward to about 20 years of fertility if they survived the enormous physical demands of pregnancy and childbirth. In fertile women the period between marriage and the first birth was often only 10 months, though a significant number of women were pregnant at marriage.[89]

Midwives were enormously important to pregnant and labouring women (not to infant care which was the preserve of the mother or wet nurse) and it was in the licensing procedure for midwives that there was most intersection between the private world of pregnancy and parturition and the male authorities. Midwives were licensed by the bishop from the early sixteenth century and the Reformation intensified the demands made by the episcopal authorities that midwives be not only skilful but 'godly' and free from 'papistry' [Catholicism]. Most commonly midwives were the wives of 'respectable' men of the parish such as the wives of ministers and tradesmen.[90] Not all villages had a reliable and trusted midwife and, if they did, sometimes the demand on her time was such that she could not be in two places at once. Ralph and Jane Josselin temporarily let their midwife go after Jane's 1658 labour had started because there was another woman in greater need. The midwives' job was literally physical attendance of the birth and their 'godliness' was necessary to relieve social anxieties about their intimate examination, lubrication and manipulation of women's genitals.[91]

During pregnancy itself women could suffer very badly.[92] Eclampsia, or epilepsy induced by high blood pressure in pregnancy, could not be treated and post-natal infections ran their course un-medicated. Margaret Cooper may well have died of eclampsia. Her husband noted that six weeks before coming to term with her fourth child she 'fell suddenly into an apoplectical convulsion fit...complained only in her head...then never came to speak again'. The wife he described as 'most sweet [and] affectionate' appears to have died of a stroke.[93] Alice Thornton's first pregnancy struck problems at about seven months, with a rise in her temperature that would not abate. Returning from seeing a doctor, she was forced to walk down a long and steep hill, the consequence of which was further fever for two weeks until she went into premature labour.[94]

Knowledge of childbirth itself was shared amongst women and involved only a very small number of man-midwives at the very end of the period. Childbirth was both a rite of passage and a ceremony.[95] Ahead of labour, women prepared their childbed linen, which included a white sheet for the bed, a shift to wear and swaddling linen for the infant. The preparations were quite expensive: Mary Robinson's 'child bed sute' cost 18s in 1680, more expensive than any petticoat or stomacher that she bought in the same year.[96] Midwives' stools or 'groaning stools' were sometimes used, very similar to a birthing stool today, though more

important than the actual position of birth was the chamber itself, which was kept very warm, free of draughts and dark. A pregnant woman arranged which women they wanted in the chamber with them as 'gossips' (god-sibs or sisters-in-God) and they chose a preferred midwife. Only at the end of the period did some women begin stating a preference for male medical practitioners rather than women midwives to be present at the birth.

Childbirth itself was much more hazardous than pregnancy. It was nearly always very painful; it involved no pain relief and was often protracted without modern aids such as forceps and caesarean sections. Alice Thornton's fifth child was a breach birth that put her 'upon the racke ... with such exquisitt torment, as if each lime [limb] were divided from other'. Each successive labour became more dangerous as Thornton's case exemplifies. Her sixth labour was 'hard and hazardous', her seventh labour was 'five houers torment' with a 'violent and terrible flux of blood', her eighth labour was 'an exceeding sharpe and perillous time'.[97] With her eighth child Alice Thornton admitted that her seventh labour had left her so 'terrified' that she had 'little hopes of being preserved in this'. She ordered all the deeds and entails on her estates to be put in a 'red lether [*sic*] trunk' and delivered to a trustee for her surviving children.[98]

Alice Thornton's perception of the danger she was in was uncannily accurate. Risks to mothers were greatest with the first child and then again after several had already been born. One in six pregnancies was high-risk and Alice Thornton had reached the point of borrowed time with her seventh. Women had roughly a 6 to 7 per cent chance of dying from childbirth through their childbearing years with aristocratic women faring worst because of their extended period of fertility compared with the rest of the female population. London was a special case; the death rate in childbirth was higher there than the rest of England. Nehemiah Wallington recorded it as a great 'deliverance' of God that his wife 'was safely delivered of a man child' because he had heard horror stories of dozens of women dying in childbed in the parish of Shoreditch in East London.[99] Some historians argue that women's fears outstripped the risk in childbirth, but the risks were high enough and death in childbirth so frightful if it took place that many women, understandably, prepared for the worst. For example, during pregnancy Elizabeth Joscelin prepared her own winding sheet, which was a macabre act of household management carried out by many women. In Joscelin's case the winding sheet was needed in the end as she died nine days after the birth of her child in October 1622.[100] Occasionally women wrote wills ahead of childbirth or even during it if it appeared to be going badly. In 1682 Sarah Smith of Basingham in Lincolnshire wrote her will while 'being of sound mind and memory, but doubtful of my deliverance in the danger of childbirth' and it was witnessed only by women, strongly suggesting that it was penned in the childbed chamber. Perhaps even more telling are the reports of husbands about the plight of their labouring wives. Samuel Woodford fretted about (and prayed for) his wife throughout the later stages of her pregnancy and Elias Pledger 'was extremely affected and put up frequent prayers and ejaculation when ... [his wife's] pangs were upon her'. The powerlessness felt by men at the danger they perceived their wives to be in

is palpable when reading their diaries and they record that only prayer helped to alleviate their acute anxiety. In those cases where men lost their wives in child-birth, they recorded their grief in monumental epitaphs. When Mary Coke died in September 1642, her husband Frances buried her in Salisbury Cathedral with the following words: 'One sonne she had which was to her soe deere | That whiles shee gave him life, shee dead lies here.'[101]

The importance accorded a midwife's 'godliness' related directly to the Church's anxiety about the souls both of the mother and the child. The midwife might be the only person available to hear a dying woman's prayers or to baptise a dying newborn using an abbreviated version of the baptism service available in the *Book of Common Prayer*. For this latter purpose, Bishop Rowland Lee of the Diocese of Coventry and Lichfield instructed his clergy to advise women that the birthing room needed clean water for use by the midwife to christen the child 'in time of necessity'. The Protestant service of baptism consisted of a reminder that men were born in sin and that they needed to be 'regenerate and born anew of water and the Holy Ghost'. The water acted as a visible sign and seal of the acceptance of the baptised into the invisible church.[102]

Babies born who remained un-baptised for the first few days or weeks were regarded as in a liminal state. Therefore, diocesan authorities urged church min-isters not to neglect the baptismal needs of illegitimate babies even if the mother seemed inclined to hide or move on to another parish. The illegitimacy rate throughout the period fluctuated, being at its highest point at just over 4 per cent in the first decade of the seventeenth century and its lowest rate at about 1 per cent during the 1650s.[103] Maternity was made peculiarly difficult for unmarried mothers and the demands of pregnancy and the circumstances surrounding childbirth often very traumatic. Female servants were very vulnerable to sexual abuse and rape leaving them sometimes with a pregnancy they did not want and subject to the demands of their abusers to get rid of the child. Francis Carew, who regularly raped his servants, told Alice Rawlyns 'to take a knife and slyt the childe out of her bellye', boasting to his neighbours that he had had sexual relations with so many women he could not be expected to maintain all the progeny that resulted.[104] The civil authorities thought there was a link between secret births and infanticide and in 1624 passed a law making it illegal to conceal a birth. However, women's expression of love and loss was not simple. When children were abandoned in churchyards by single women it was because they were unable to cope with the care of an infant and they perhaps hoped that their child would be found and looked after. Mothers who lacked paternal and community support were simply in the worst position to care for newborn infants and some cases of violence against illegitimate children can perhaps be explained by the extreme social and emotional pressure experienced by the mother. Anne Laurence cites the case of one unmarried mother who killed her six-year-old son by pushing him into a fire; the emotional pressure she may have felt when she committed such a terrible act of violence could be explained by her being pregnant again.[105]

Married women rarely experienced maternity without the pain of losing one or more infants. Mary of Modena, wife of James II, gave birth to four children

in very quick succession between 1675 and 1678 and none of them survived.[106] Sometimes the loss was almost immediate: Frances Assheton delivered a child 'with such violence as the child died within half an hour'.[107] Other women experienced the loss of infants not only at birth but also in the first few days or weeks of life. Two of Alice Thornton's infants died just after birth, a further two lived just two weeks (just long enough for intense emotional engagement during their fatal illnesses) and one child, who had rickets and a chest infection, died at 18 months of age. Anne Somers endured eight years of giving birth to four children who survived only a few weeks or months, though she finally had a fifth child who survived. Her sixth child also survived, but two more died at one day and at five months.[108]

Knowledge of infant survival rates can be gleaned from the family records both men and women kept of the births and deaths of their children usually in the front of a Bible where they recorded God's blessings, though others such as James Digby and his wife, kept a notebook especially for the purpose.[109] Stone's work on stillbirth has suggested that the rate was actually rising through the period, to perhaps as high as 10 per cent, with a further 10 per cent of infants not surviving the first year of life. He argued that the result was lack of parental emotional engagement with infants as a form of emotional self-defence, but this argument has been much criticised by Ralph Houlbrooke, Antonia Fraser and others who have suggested that 'maternal instinct' is universal and, therefore, unaffected by cultural mores. However, the relationship between maternal instinct and the expression of love is not entirely simple. Both Laurence and Houlbrooke have pointed out that cultural factors meant women may have expressed their grief in ways that were culturally conditioned and that might sound discordant and uncaring to modern ears. Women interpreted infant death as God calling children 'home' and often expressed their loss as a form of acceptance of God's will. For example, Elizabeth Egerton's loss of her toddler, Katy, left her 'much grieved' in 'heart' and 'even my soul', but she expressed her total love for the child by offering God thanks 'that he once was pleased to bestow so great a blessing as that sweet child upon me' before taking her 'back'.[110] Because the records make it possible to cite one woman after another expressing their grief at the loss of an infant a variety of responses can be discerned. Katherine Phillips, the poet, lost her only two children as babies and when writing about the loss of her son in 1655 expressed her sense of how transitory their relationship had been: 'I did but see him, and he disappeared.'[111] Some women expressed grief through guilty self-examination. Alice Thornton consoled herself with the thought that God had 'called them [her infants] home', but she nevertheless cast around for particular causes of death in every case, deciding, for example, that one baby born breach died because of a fall she had had three months earlier. The death of one infant who lived just a couple of weeks left Thornton desolate. She expressed her grief as a combination of taking comfort from the child's baptism and 'seale of regeneration [in Christ]' and guilt about the care she had given the child in case it had died 'through [the] cold upon his dressing' which she had placed on his rash.[112] The diaries and letters of women of the gentry and upper classes whose children survived the danger of

infancy are filled with expressions of joy at motherhood: 'a livelier and merrier thing was there never yet seen' Anne Clifford said of her infant daughter when writing to her own mother in 1614.

Women who were poor or alone could not afford to do anything but breastfeed from the time of birth, but the lying-in room of many richer women included a wet nurse whose job it was to see to the needs of the baby in its first few hours and then to feed it for up to two years. Valerie Fildes has pointed out that wet nursing was a well-established practice in Renaissance Europe in 1500 and that criticism of the practice did not feature until the seventeenth century, when it was provoked partly by the Protestant godly who deemed the breastfeeding of infants to be God's ordinance, and partly by men and women of the elite who became concerned that poor wet nursing could be linked to infant death. Henry Newcome in 1695 called wet nursing the 'brutish custom [which triumphed] over reason and religion' and at the heart of his argument was fretfulness about male lineage at a time when failure of the male line in many families was causing concern. Elizabeth Clinton, duchess of Lincoln, as early as 1622, also had anxieties about the physical health and welfare of wet nursed babies and may have been responding to the spread of syphilis. She attributed the deaths of possibly two of her own children 'by the default of these nurses'.[113] However, whether women nursed their own infants or not, the duties and work of motherhood were highly vocational for most women. To some extent the love they felt for their children overlapped with the love and duty felt to their husbands: 'My affection is very equal to them all' Frances Hatton told her husband about their three small daughters in 1678, before describing in a letter to him their teeth, their looks, their manners and so on.[114]

There was a growing female market for domestic manuals such as Gervase Markham's *The English House-Wife* (1631) and midwives' manuals, household manuals and prescriptive religious and educational texts between them provided plentiful advice about infant care and the upbringing of older children. Women were advised to swaddle their infants tightly to prevent deformity of growth and protect against household accidents (such as toddlers falling into the large open fire in every kitchen). Infant weaning included combining milk with barley to feed a growing child. There were few books about actual physical childcare that went beyond care of infants, though Thomas Phaer's *Boke of Chyldren* (1544) was an exception. Women instead collected and kept recipes that were specific to infant and childcare to battle everything from worms to rickets. Lady Grace Mildmay's recipes included 'mastic pills' for her wet nurse and a specific recipe for children with 'falling sickness' that infused a variety of herbs including aniseed and fennel with oil of roses and 'brown sugar candy'.[115] All advice to mothers about later childcare centred on attendance to a child's spiritual and moral education. Proverbs 22:6 – 'train up a child in the way wherein he should walk and he will not depart from it when he is old' – underpinned the package of instruction and, therefore, the dilemma facing early-modern women was the same one faced by women today – how to combine their role as instructor and disciplinarian with that of loving mother. In their role as instructors they used religious catechisms appropriate to the level of the child to instruct her/him in religious doctrine in

question and answer format. Women mostly taught children by example and love verbally expressed and physically demonstrated through embrace, though the prescriptive demand for obedience resulted in some women being strict disciplinarians in their mothering.[116] Richard Norwood was regularly and severely beaten by his mother in the absence of his father though this level of violence and punishment at the hand of a mother was unusual and women sometimes intervened to prevent their husbands from beating their children.[117]

In most cases a woman's identity as mother remained with her from the time of her first lying in whether her children survived to adulthood or not and it included the Christian component of believing that her personal nurture of a child would affect both her salvation and that of the child's salvation. This perception determined women's relationships with their growing and adult children and they routinely involved themselves in their adult children's lives. They were especially involved in marriage negotiations for daughters and provided for them childbed sanctuary. Hester Temple's many daughters all came home to their mother when it was time to give birth.[118] Women also went on worrying about the education and employment of their sons long after their own teaching role had ended. During 1687 and 1688 Mary Woodforde fretted dreadfully when her son, John, was 'in rebellion at the college at Winton' and she corresponded with him about his choice of tutor. Sarah Cowper left written instructions for her son that were cribbed from Lord Burghley's printed advice to his son; she, thus, felt it her duty as a mother to co-opt the role of a father.[119] Unlike today, it was not unusual for early-modern women to face death before their children had grown up and in these cases their posthumous care took the form of financial provision and the arrangement of guardians. In 1689 the widow Margaret Fairweather wrote a will leaving her 'loving friend' William Thompson as trustee of cash sums for her several children and in 1700 she died. In the same year the widowed Anne Bell had nothing much to leave but wrote a will stating that she left her two young daughters in the guardianship of her mother and brother. Other women set up wardships for their young children, usually with male kin and occasionally women's wills reveal very precise instructions to older children to sell up real estate for capital to care for and educate younger children.[120]

Therefore, women's identities as mothers did not always stay confined within the patriarchal paradigm of duty owed to a husband and father of offspring. The work of mothering went on through the life of a child and the love for children went on beyond the grave. Although the surviving records make it difficult to assess whether or not unmarried women were in a position to experience unmitigated happiness as mothers, their duty of care as mothers was the same as for married women and glimpses of unmarried mothers forming deep bonds of affection with their children can also be found in the wills and legal arrangements they made for their financial welfare. In 1650 Grace Clough left her 'natural son', George, and 'natural daughter', Ann, all of her goods and chattels; as a family, this woman and her two illegitimate children did not own much but when she died she ensured that her estate was used to their benefit. Cases like that of Grace Clough indicate that within communities single mothers and illegitimate children

were not completely without acceptance and support. In 1605 Elizabeth Nelson was left a field by her father and her natural mother, Elizabeth Ellerker, seems to have been fully integrated into village life in Catton in North Yorkshire.[121] This would suggest that single mothers in a position of independence and enjoying community support were able to love and care for their children as well as married mothers.

In the case of both married and single mothers there was a high degree of overlap between their household domestic and nurturing work and their unpaid and paid work outside of the home. Women were thought best qualified to play the role of healer, physician and nurse not only for their immediate families, but also for kin and neighbours. Their gendered identity in the public arena of neighbourhood was, thus, an extension of their domestic private identity. In the home they brewed and distilled, for example, roses for body-washing, cordials and vinegars for household consumption, as well as soap and other lotions for bodily hygiene. The distilling process was an early-modern invention, new in the late Tudor period, and the still-room became one of the series of chambers that made up the kitchen area of larger houses. Women retreated to this room to work with alembics and glass distilling bottles emerging with candles and toothpowders made of rosemary and alum combined.[122] Women who became domestic servants were expected to have similar skills. This is evident from the anonymous publication of 1677, *The Compleat Maid-Servant: Or, the Young Maiden's Tutor*, which had lengthy sections on 'physick and chirurgery' so that servants could help with household medicine and hygiene. There were many other publications aimed at all women: *A Closet for Ladies and Gentlewomen* (1611), *The Ladies Cabinet Opened* (1639), *The Ladies Cabinet Enlarged and Opened* (1654) and *The Gentlewoman's Companion: Or, a Guide to the Female Sex* (1675) all contained recipes and cures. Thomas Tryon's many works of the 1680s and 1690s included *The Good Housewife Made a Doctor* and *Monthly Observations for the Preserving of Health* but they also included *The New Art of Brewing Beer* suggesting very little separation between these female activities of general and medical household care. Grace Mildmay at Apethorpe in Northamptonshire distilled her own laudanum and treated conjunctivitis with a concoction of egg white, breast milk and rose water; when she prepared her recipes for 'falling sickness' that were designed 'for children betwixt 3 and 10 years old', she was being physician and mother in one.[123] She collected and devised 270 cures which she recorded in her commonplace book for everything from the plague to syphilis. Lady Margaret Hoby personally dressed the wounds of her servants and tenants calling them 'my patients'.[124]

Women sometimes used their collections of 'recipes' as an opportunity to publish manuals for use by other women. Hannah Woolley's *The Accomplisht Lady's Delight* (1675) visually depicted women making medicines on its front page and a similar but earlier manual by Elizabeth Grey – *A True Gentlewoman's Delight* (1651) – went into 19 editions over 34 years suggesting wide female readership on the subject of general health care.[125] Women's occupational identity as housewife/nursemaid turned into paid employment outside the home. Women were employed by the parish to nurse abandoned and orphaned infants and to work in foundling hospitals.

They were also employed to care for the sick and infirm and to distribute legacies bequeathed in people's wills, foster infants, and lay out the dead. Parish employment methods were usually short term – in 1601 one parish paid 'Mother Middleton' for two nights to watch another woman's child when she was sick and in 1698 another parish paid a woman 15s to look after a woman and her newborn illegitimate child for three weeks. Parishes also employed about five women to be 'keepers', delivering food and water to houses affected by plague, and 'searchers' or 'viewers' who reported to the parish authorities on any signs of plague on corpses. Payment of such charitable relief systems that relied on the work of women came from endowments and rates raised according to the guidelines of the Poor Relief Act of 1601. Dangerous care could be lucrative – women who visited plague houses earned about 1s a day, which compared favourably with the 4d a day that might be earned by a woman put to spinning hemp.[126]

The kitchen became an area of women's creativity as well as thrift – Mrs Meade called her lemon mousse a 'lemon delicious pudding' and Mary Thompson had a recipe for 'an excellent cake', which is, indeed, very good.[127] Whether in rural or urban areas women kept kitchen gardens the produce from which was related to and integrated with the operations of the household's kitchen, bakery, brewery, pantry, larder and still-room.[128] Thrift dictated the use of every scrap. Thomas Tusser advised to 'save droppings and skimmings, however, ye do, for medicine for cattle, for cart and for shoe'.[129] The food and drink produced was not always just for family, but sold on. Selling brewed drinks and pies in the market was an extension of the domestic economy and the line between unpaid and paid work, therefore, was very indistinct. The nomenclature of the labour market reflects this – 'henwives' sold the chickens they kept and 'fishwives' joined the market economy when they had finished salting fish for their families to eat.[130] However, those whose actual paid employment was brewing and dairying in the economy of food and drink were well paid because of the high degree of responsibility involved. Any job involving the care of large animals commanded respect and attracted good wages. During the early 1640s Amy Foster worked as an ostler; she provided stabling and grass, hay, oats and beans to feed the horses of the countess of Cumberland for which the latter paid £2 4s.[131] Unspecialised and seasonal agricultural labour was by contrast low paid.[132]

Of course, caring for infants was the job that came with the highest responsibility and it was this job which was most domestic while at the same time engendering the deepest sense of professionalism. In 1616 some women midwives attempted to have their trade brought under licensing agreement and in 1687 the midwife, Elizabeth Cellier, established a plan for a training college though it came to nothing. A good midwife could earn an annual income of £20. For some families, a woman's midwifery wages formed the sole family income. There were regional variations in the professional recognition afforded to midwives, ranging from a licensed network of midwives in London to the patchy and informal arrangements that David Harley has found in the North West. However, the greatest social affirmation of their status came from their clients, who judged them according to the number of safe deliveries they performed and who comprised an informal network

that circulated reputations through word of mouth and provided individual mid-wives with written references.[133]

Upper class women followed the prescription of domestic work role as diligently as their poorer female servants and neighbours even though there was no need for them to work. There was, therefore, not a huge gap between the prescription of ideal femininity and the working lives of many women through much of the period.[134] The 'housewife' who was employed as an apprentice had defined duties that were no different from the woman who was the unpaid manager of her own kitchen. Both rose at dawn, organised breakfast for family and servants and organised the milking of cattle for dairy products before turning attention to the preparation of lunch.[135] The position of the apprenticed 'housewife' in the economy is clear, but the unpaid housewife was as much a part of England's productivity. Both paid and unpaid housewives also did the household book-keeping and account management; in the case of the unpaid wife this activity encouraged her to pursue economic wealth, which set her up well to manage on her own if she was widowed and in some cases encouraged a desire for property ownership.[136] Women kept inventories of the linen they kept in a chest at the bottom of their beds and they listed the incomings and outgoings of the kitchen and cellars. They also kept lists and inventories of books, furniture (noting its location room by room in the house), items of clothing and so on. Through listing women developed an intense sense of possession. Jane Cavendish defined her 'inventory of my waring [wearing] clothes 1635' as 'Personall, My Esteat [estate]'. She included not only the clothes with silver trimmings; the inventory listed down to her 6 pairs of gloves and various ribbons. Lady Anne Cheyne devised a personal system for keeping her victual accounts. She set out each day for a page of her account book. One section of the page listed what had been bought or brought into the household for the day followed by a series of boxes with totals of items held by the household on that day. For example, on 3 April 1630 her household poultry consisted of 4 hens, 36 chickens, 21 capons, 6 turkeys, 9 peacocks and 6 pheasants. The next page listed the day's menu, which included a boiled leg of mutton, a roasted turkey, a tongue, some cut cheese and bread. She could tell at a glance that in cutting her cheese she had 14 rounds of cheese left.[137] In other words, women's unpaid work included a form of household management that used identical skills to facilitate their provision of a large household and to keep track of tiny items of loved personal property. Jane Cavendish's listing included the inventory of her 'child bed linen' of sheets and shirts, bibs and smocks, some of it for her and some of it for the infant.[138] Thus, women were trained to be highly numerate and their managerial and entrepreneurial skills were integral to their gender identity as housewives and mothers.

Similarly women had a very high identification with cloth-making and clothing as well as laundering. The production and mending of clothing kept women in work at home and in paid employment in towns and countryside alike. Domestic servants did laundry, but poorer women took laundry in to make money. By the Statute of Artificers of 1563 women between the ages of 12 years and 40 could be ordered into just this sort of domestic service or they could be set to spinning in

small parish workshops. It was a highly-controlling piece of legislation, though also one that reflected social expectations about the gender divisions of work. All women were engaged in and associated with needlework, though the type of needlework they did depended upon their class rather than their location in public or private sphere. Lower class women made clothing for piece rates; middle class women altered clothing and made napkins, tablecloths and curtains. Upper class women embroidered, their gain coming not in financial reward but in the less tangible benefit of avoiding idleness, as well as making their homes comfortable and being able to distribute to kin and patrons gifts.[139] Bess of Hardwick embroidered dozens of hangings and cushions – which survive – for her New Hall in the 1590s. Women producing linen yarn did so by soaking and fermenting flax plants, essentially combining agricultural and industrial skills, sometimes while working just in a small rural cottage.[140] Thus, there was a blurred line between agricultural and industrial work and large numbers of women were employed in sewing and dressmaking, cap and glove-making and, increasingly, making wigs and soft furnishings. All trim, tassels, cords and ribbons on men's and women's clothing were stitched on by women whose job it was specifically to do finishing work. Women, such as the wife of Lancelot Russell in Salisbury in the 1620s, ran 'factories' which pre-dated full industrialisation and which taught children and apprentices cloth-working and how to make lace.[141] By contrast, poor women were forced into piece work that they combined with many other types of employment, both industrial and retail.[142] They spun wool and hemp and bought and sold on scraps of cloth. The poor women in Salisbury in the 1620s gave up the children they had who were over the age of six on the instruction of the civil authorities so that the children could be employed in sewing and knitting, spinning and making bone lace and buttons. Women sometimes ran very small businesses as adjuncts to their husbands in the clothing trade. For example, Abigail Bull apprenticed Conquest Taylor for five years to help her in 1648 when she was retailing Thomas Bull's buttons which he made at home.[143]

It was in urban areas that women found they were able either to thrive in mercantile trades if they were middle class or combine a variety of job opportunities if they were poorer. The makeshifts of mending and selling cloth and wool could more easily be combined with street vending or 'hawking' of food such as bread, fish and fruit. Poorer married women and widows crowded into this category of 'huckster', adding bought local products to their made wares and selling them on again. Some women became 'petty chap[wo]man' carrying a pack of goods from place to place to earn a living.[144] Richard Sheale, a minstrel, recorded his wife's work as a pedlar in verse – 'my wyff in dede is a silk woman'; she peddled her wares in markets within a ten mile radius of their home in Tamworth.[145] Peter Earle's work on London working women of the late seventeenth and early eighteenth centuries is very instructive. He has used court records to discover women's work roles and has confirmed that women were clustered in domestic service, needle-work, care-work and food and drink retail but he has dispelled the myth that women tended always to work in the same trades as their husbands. Earle found female maidservants married to sailors; washerwomen married to shoemakers

and coachmen; nurses married to exiled Jacobite gentlemen and mathematical instrument makers. He found midwives married to felt-makers; needle-workers and mantua-makers [petticoat and silk gown maker] married to vintners, glass grinders and sword cutlers and (intriguingly) a brandy shop manageress married to a hartshorn rapper [someone who extracted the contents of a deer's antler].[146] Earle's findings accord with those of Sue Wright who found that in Salisbury women who inherited the trades and tools of their husbands were rare. This suggests the independent work activity of most of those married women who needed to work.[147] Single women may have been more inclined to follow family trades. In manorial court records Patricia Crawford and Laura Gowing have found women's payments of what was known as 'stall and art' or trading fees paid by merchants who ran market stalls. Elizabeth Wheeler learnt her 'art' of linen drapery from two unmarried aunts and became the last single woman in Southampton to have her right to trade in the market questioned, suggesting women's increased activity in mercantile trade and general acceptance of their occupational status by 1700.[148]

Pamela Sharpe's work on Hester Pinney demonstrates how a single woman of family mercantile wealth and knowledge could actually thrive in early-modern England. While many poorer women were involved in making lace, Pinney's family traded in the finished product. The lace was made in east Devon and sold in the Royal Exchange in London. Sharpe describes Pinney as a 'dynamic operator'. Her affair with a man who married an heiress eventually led to her inheritance of the manor of Monken Hadley and her strategic lending to her nephews and nieces led to her considerable economic influence in the family. She essentially operated as the family bank. Outside the family her economic influence was extended through investment on the lottery and in East India Company stock. Investment was what brought with it real opportunities for women's economic agency and women can be found in part-ownership of ships and their cargoes, increasingly benefiting from overseas trade in coal, pig-iron and – shockingly and shamefully in retrospect – slaves.[149] Even though the guilds (and certainly women's access to them) declined between 1500 and 1700, the diversification of economic activity in mercantile trade meant that by the early eighteenth century 5–10 per cent of businesses were run by women (e.g. there were 40 women goldsmiths one of whom, Katherine Mangey in Hull, began in the family business in the same way as Hester Pinney). This is unsurprising and represents only an extension of women's traditional role in urban and rural areas of market selling and trading.[150]

Women's work has, in many ways, been the area of historical study of early-modern women most pursued by historians. Studying women's work has always involved difficulties not the least of which is that many of the crucial records like wills and probate inventories routinely reveal a man's occupation but do not necessarily reveal a woman's, often only defining women by their legal designation of 'spinster', 'wife' or 'widow'. For example, of the 71 surviving probate inventories detailing all the 'purse', business, household and personal goods of widows who died in Lincoln between 1661 and 1714 only one recorded the occupational identity of mercer (textile and silk merchant). It is clear from the contents of

the inventories, however, that amongst these women are saddlers, brewers, inn-keepers and so on.[151] Further complicating the historian's task is that most women had multiple work identities including paid and unpaid labour and, therefore, the sociological framework that informs our understanding of what is work was simply not part of the early-modern feminine *mentalité*.

However, despite these difficulties it is in the area of work that early-modern women's history has the most richly-developed historiography. It began with three classic studies by Olive Schreiner, Alice Clark and Ivy Pinchbeck published 1911, 1919 and 1930 respectively.[152] All three were informed by Marxist explanations of work and labour and were predicated on the idea that industrialisation destroyed traditional domestic craftwork and the agricultural economy and separated work-place from home resulting in separate spheres.[153] Olive Schreiner described indus-trialisation as the process that 'tended to rob woman ... of her ancient domain of productive and social labor'. 'Year by year, day by day, there is a silently working but determined tendency for the sphere of woman's domestic labors to contract'. She argued that industrialisation resulted in a wholesale female parasitism.[154] Alice Clark produced a similar account arguing that women's work underwent an unfavourable transformation. According to Clark, by the late seventeenth cen-tury capitalism was destroying the complementary nature of women's and men's work in 'a [past] society where there was no rigid separation between home and work, and where a woman's place in the wider economy flowed inevitably from the skills she acquired in the domestic sphere'.[155] She also argued that by the end of the seventeenth century the wealthy (capitalist) classes had been transformed from 'the energy and hardiness of Elizabethan ladies ... [to] the idleness and pleas-ure which characterised the Restoration period'. This transition from women of graft to women of idleness was one that she believed was mirrored lower down the social scale though her focus was primarily the middling orders. In the agri-cultural classes 'the wives of the richer yeoman were withdrawing from farm work' and were unable to make a living wage. Spinning, she suggested, became underpaid 'women's work', while women were gradually forced to withdraw from guilds and craft organizations. She cited brewing as an industry that most fully demonstrated the effect of the rise of capitalism on women's work, 'for as the term "brewster" shows, originally it was a woman's trade but with the development of capitalism it passed completely from the hands of women to those of men'.[156] The middle-class women of Clark's tale, by the end of the seventeenth century, were well on their way to the 'parasitic' dependency of nineteenth-century women cited by Schreiner. Both accounts are posited on the notion of a pre-capitalist, pre-industrial 'golden age' of women's work, an account that was given further credence by Ivy Pinchbeck's account of women's work from 1750 to 1850 which argued for a decline in the status and roles of women workers as a consequence of economic change.[157]

Therefore, the historiography of early-modern women's work used to be one that assumed several things: first, that there was a 'golden age' of women's work when there was a greater measure of gender equality because of the domestic nature of the workplace; second, that the rise of capitalist industry bred one

class of women (the bourgeoisie) whose domestic idleness was parasitic upon the employment in factories and in domestic service of other women and, third, that the rise of a capitalist economy led to a decline in the work roles and conditions of women.[158] How well has this model of the history of women's work stood up to revision by historians such as Bridget Hill, Pamela Sharpe, Peter Earle, Sara Mendelson and Patricia Crawford working more recently?[159] Modern women's history of the 1960s and 1970s tapped the older historiography of labour, and feminist historians of women's work found a 'natural home' between the pages of the socialist *History Workshop* journal. However, there quickly emerged a tension in the debate over whether or not the rise of capitalism or patriarchy was at the root of women's subordination in the workforce. Bridget Hill, for example, elaborated on Pinchbeck, placing capitalism as central to historical change, but Judith Bennett emphasised women's continuous subordination in a labour market that had always featured a gender hierarchy.[160] The very detailed account of women's working lives by Sara Mendelson and Patricia Crawford in *Women in Early Modern England* (1998) synthesised these two arguments based upon a class analysis of continuity and/or change and concluded that women of the middling ranks during the early stages of industrialisation had the education and training to develop new and shifting 'occupational identities' that lent them some agency in the processes of economic change. Their account thus produced a more positive outlook that cut across older ideas about female parasitism. They follow Peter Earle's lead in arguing that women, particularly of urban areas, were uniquely placed to take advantage of economic change, especially in the late seventeenth century when single women comprised up to 20 per cent of the female population. New areas of work exploited by women at the end of the seventeenth century included shopkeeping, theatre work, coffee shop ownership and teaching. Mendelson and Crawford find continuity in what Olwen Hufton once called the 'makeshift economy of the poor' between 1500 and 1700, but change for women of the middling classes at the end of the period. Therefore, capitalism (also arguably something that was not new to the seventeenth century) seems to have increased rather than decreased overall female work opportunity.[161] Revisionist accounts of early-modern women's work have also stressed greater continuity between the traditional agricultural past and what some historians now call the 'industrious revolution' which saw the household remain as the main unit both of production and consumption.[162] The employment opportunities of women in rural areas continued to be more restricted than those for women in urban areas, but equally there was not a completely sharp divide between urban and rural work and this continued beyond 1700.[163] Finally, arguably what changed most dramatically was not women's work but their potential for economic agency through greater access to capital. Women's income generation through lending and investing embedded them thoroughly in the processes of economic change.[164]

There are several important conclusions to draw from the recent historiography. The first is the almost universal rejection of the idea of a 'golden age' of women's work prior to industrialisation and a rapid and transforming change in the nature of women's work after the rise of industrial capitalism. There were

many continuities between 1500 to 1700 – most women were underpaid and of low status throughout the period and there was a survival of domestic craft work and finishing work such as lace-making that carried on in the household. The wholesale shift to work in the public space of the factory rather than the private sphere of the home has been overstated as has the idea of women's idleness which recent research has thoroughly undermined. Amanda Vickery has pointed out that there was a gender division of labour, with women always clustered in a series of often devalued 'feminine' trades, but convincing evidence of 'a female descent into indolence and luxury' originating in the late seventeenth century is hard to find. The other important overall conclusion to draw is that Marxist explanations of women's work and the impact of capitalism on women have been replaced by a privileging of gender explanations that embed women more thoroughly in economic change and reveal them as integral to historical processes such as industrialisation and the rise of capitalism. It can be argued that the revisionist approach to women's work has effectively challenged older male-dominated histories, returning economic agency to women while at the same time providing better tools for analysing the operation of patriarchy and the sex/gender system of the labour market.[165]

Property

The historiography of women and property in early-modern England has pointed in two slightly contradictory directions. First, there is the observation made by Amy Erickson, Susan Staves and others that even 'ordinary' women owned relatively large amounts of property and that this extended even to separate estate at law held by married women.[166] The latter contradicts the theoretical legal position of married women as stated in *The Lawes Resolutions of Women's Rights* that all property devolved to the husband, but *The Lawes* had indicated some slight improvement in the position of women because the 1536 Statute of Uses allowed property to be held for even married women in trust.[167] The second conclusion reached by some historians has been that women's property rights actually declined over the period. This is in spite of the fact that women's ownership of property remained quite high and may even have increased. How can the law point in one direction while private ownership and patterns of inheritance point in another? The answer to this question is partly to be found in the varying experience of different categories of women and alterations in legal practice of the transmission of property.[168]

At the beginning of the period, most people died intestate and primogeniture (by which the eldest son inherited all), by custom and common law, immediately came into operation. Women's experience of this varied according to their position in the family. If they were the daughters of a dead male property owner, they were left property-less in favour of their eldest brother and in the same position as younger sons. However, if she were the widow, common law dower came into operation by which the woman gained life use of one-third of her husband's landed estate and its rental income. At the end of the period, however, private

conveyance of land became more common through legal contracts, most not-ably marriage settlements, strict settlements and wills, and all private conveyance could override the legal precepts of the default of common law. The results for women were complex and uneven across different categories of women.

Marriage settlements were used to gain jointure lands for women, or jointly held property such as land, buildings and bonds, that devolved to the married woman upon her husband's death. Jointure was perceived as an exchange for the dowry that a woman would bring to marriage. The use of marriage settlements resulted, by about 1650, in a drop of the level of dower property being inherited by widows from the common-law third to the 10 per cent jointure of the aver-age marriage settlement.[169] In this sense, the legal rights to property of widows declined. However, in practice marriage settlements were also used by the parents of daughters to convey property to them in trust, sometimes at the expense of an eldest son. Mary Prior has found that the use of trusts led to an increase in married women leaving wills between 1558 and 1700 and as married women also used the expedient of transferring landed property during their lifetime the level of their land ownership was higher even than indicated at death.[170] Elizabeth Sherburn, whose husband relied upon her to manage all of their financial affairs, bypassed the interests of their son and transferred, through a trustee, landed estates, a house and all its contents to their daughter, Anne Constable, who was also married. Anne's brother was furious and attempted to take legal action, but was advised that 'things in writing [i.e. in wills and indentures or agreements] shall not be avoided or altered'.[171]

The most influential legal change that affected women's inheritance was the use of strict settlements which decided the future transmission of land and were most commonly used to establish a male entail to ensure patrilineal descent of real estate. In the sixteenth century female inheritance of large landed estates fluctuated between 5 per cent and 10 per cent. Strict settlements meant that the rights of 'heiresses at law' declined resulting in a low in female inheritance of about 5 per cent in the 1680s, but the crisis in male succession continued and in 1700 female inheritance had risen to 15 per cent again and it continued to rise until a high of almost 30 per cent in about 1760.[172] However, while the increased use of strict settlements introduced a form of landed estate planning that was used to assure male inheritance of land, it also established dowries for unmar-ried daughters, born and unborn. In practice strict settlements increased the likelihood of daughters getting some cash settlement out of their fathers' estates. Younger daughters in particular stood to make gains in this system.[173] Marriage portions became inflated as a result of the older landed aristocracy marrying into the new commercial wealth of London businessmen and investors. By the end of the seventeenth century a wealthy daughter's portion could be as much as £4,000, £7,000 or even £10,000. Eldest sons complained about the costs of their sisters, but sometimes the crippling charge on an estate could make a direct impact on widows too. For example, when Elizabeth Lindsey arranged her son's marriage settlement in 1678 she had to revoke her claim to a one-third dower so that the marriage portions promised by her dead husband to their daughters

could be met out of her son's estate. She was also forced to release much land held in trust.[174]

Wills were the most common form of private conveyance of property and more people (including women) left wills by 1700 than they had in 1500. One-fifth of all wills were made by women and women who had property – no matter how little – willed property. Anne Deane distributed a tiny sum of cash to the three children of her sister, a chest to her aunt and a coverlet to her sister. Her property was not worth more than £2. Sarah Brighouse left just one rood (a quarter of an acre) of land plus the west end of one barn to two nephews in 1700.[175] At the other end of the scale, Catherine Willoughby, Anne Clifford and Sarah Jenyns, duchess of Marlborough, all owned vast estates that they bequeathed with precision to a multitude of beneficiaries.[176] The landed property of wealthy women could be real estate such as land and buildings, but also the rights of office and voting that might be attached to them. It could also comprise personal estate (chattel) such as valuable personal items and linens, Bibles and other books and clothing. There was a vast range in the wealth of personal possession: Anne Nicholson owned a green apron, stockings and a brass pot worth just £2, but the duchess of Ancaster had a necklace containing 40 diamonds worth over £657 alone.[177] In between were the many women who left just enough to cover their funerals, small bequests and gifts to the poor and a 'portion' of a few pounds to each of their children. The funeral could take up most of the bequest: in 1681 'widow Hunt's funeral cost over £27 of the £39 1s 7d she left to her adult children.[178]

The legal status of property was very complex in early-modern England. As Patricia Crawford has pointed out, it could extend to a person's body and, indeed, it could extend to their souls. Sarah Ogle's widowhood released her body, in a sense, from the ownership of her husband, James Ogle, when he died in Jamaica in 1720. However, his will transformed her into the property owner of several people who were enslaved. Theologians taught that while God owned a person's soul, each individual owned responsibility for its salvation. Property also had a set of complex legal definitions according, in part, to the jurisdiction under which it fell. Common law, manorial law and equity acted in dialogue with one another to set precedents upon which lawyers and judges made their decisions in property cases.[179] Women's experience of property ownership was, thus, a series of negotiations in life all of which helped to shape their relationships, especially within the family; social theory, legal treatises and prescriptive texts all confirmed that men should be the property owners in this patriarchal society, but the law allowed for female property ownership in amorphous and constantly shifting ways.

There were several contributing factors that led to women's greater wealth and property ownership in practice than theory. First and foremost were the affective ties that prompted men to bequeath their capital, chattel and landed property to wives and daughters in a way that undermined any straightforward operation of patriarchy. A strict settlement drawn up by the Boynton family in 1661 provided £4,000 as a marriage portion for the oldest daughter and £5,000 to be shared equally between all surviving younger daughters. Artisans and tradesmen left daughters small capital sums and rentals from properties held in trust by

their male heirs. For example, in 1648 George Dickens, who was a fishmonger in Derby, confirmed that the rents from a shop he inherited from his father in the Shambles in Chesterfield would devolve to his sister, Mary Dickens, for her subsistence. Their father had requested that this happen.[180] A relatively wealthy yeoman farmer of Lincolnshire left his bed, chair and linen press (i.e. the furniture of his bedroom) to his son along with his house, but his daughter, Rebecca, received the remainder of his household goods and a portion of £140. There was a catch – Rebecca had to use the portion to marry Thomas Newcomen 'whom I have taken lyking unto'.[181]

Women's access to and ownership of property could come into conflict with patriarchal expectations that property was a male preserve. Material possessions might be perceived as being feminine in some way – jewels, furniture, linens, clothes – but land and capital was associated with men, their public employment and reputation, and their posterity associated with the family name. *The Lawes Resolutions of Womens Rights* stated that all real property became the husband's at 'conjunction' to dispose of, though this was not exactly the case. Convention alone encouraged men to think they could control their wives' separate real estate and prescriptive texts reinforced convention. William Gouge's *Of Domesticall Duties* (1622) claimed that 'the authority which God hath given an husband' gave men the right to 'restrain' a woman's 'power and liberty in that which is her own', but the law courts did not agree with this if a woman fought custom in individual cases.[182] Women who owned land and inherited capital challenged men's perceived rights and, therefore, their public status.

Two categories of women particularly endangered male expectation of landed wealth: heiresses and widows. One method used by men to deal with heiresses was to attempt to capture them in marriage to gain their fortune, but it was a tactic that did not always succeed. In 1655 when Frances Alleyn died just a few months after her husband, she left their only daughter, Arabella, an infant of 18 months, estates in Essex and Yorkshire worth £1,400 *per annum* in rent. A year later Arabella was abducted by one of her guardians, William Thompson, who hid her in a French convent before bringing her back to England at the age of seven and betrothing her to his underage son, Francis. For several years Arabella Thompson's other guardians and relatives fought to have her released from virtual house arrest, but at 12 she was 'bundled' with Francis Thompson and forced to sign a document giving her consent to a clandestine marriage. The marriage featured domestic violence as Francis Thompson tried to bully her into assigning her property, something she flatly refused to do. When Arabella Thompson died at the age of 90 in 1746 she willed her vast landed estates and £30,000 of capital back to the Alleyn family.[183] Arabella Thompson is not an isolated case: when a member of the Grosvenor family (ancestors of the current duke of Westminster) married Mary Davies, an underage heiress, he found she was reluctant to relinquish her London property to him when she came of age.[184] Widows were often truculent and intransigent when it came to landed possession. Elizabeth Ferrers went to arbitration with her kinsman, Sir John Ferrers of Tamworth Castle in 1609 because he complained that she was ruining the manor of Walton on Trent which

formed her jointure lands. He feared a destroyed inheritance as she cashed in on the value of the trees by cutting them down.[185] The ambivalence of society to widows can be seen in the humorous and mocking representations of pamphlets and ballads. However, the laughable widows in plays such as *Ralph Roister-Doister* (*c*.1550), who are desperate to remarry, were not matched in reality by the women who chose new husbands carefully, if at all, and used every legal means to protect their property. Indeed, the real women came closer to William Wycherley's 'widow Blackacre' in *The Plain Dealer* (1677), seemingly conscious of the advice of *The Lawes Resolutions of Women's Rights* that a widow's 'estate is free from controlment'.

The perception of land and capital as being a male preserve was seriously at odds with the sheer number of wealthy women, some of whom inherited estates of several thousand acres raising rental income of thousands of pound every year.[186] Additionally, the trend towards jointure settlement of lands altered women's perceptions of their property rights because jointures were unique, giving them a certain appeal even if they were less than the old dower provision.[187] If women remarried they became canny about protecting their land and capital with pre-nuptial settlements. Amy Erickson has calculated that one in ten women with property protected it through pre-nuptial agreements. Thomazin Buckford appointed a trusted uncle as a trustee to her property to make it clear to her second husband that he was not to interfere with what she had inherited. Really wealthy widows, such as Susanna, countess of Warwick, appointed several trustees so that future husbands had 'no power at all to alter, revoke or frustrate' her control over her landed estates. According to Barbara Todd, 'The remarriage of widows [became] increasingly less common in the seventeenth century when the stage widows flourished.' Her research suggests that whereas in the sixteenth century about half of all widows remarried, by the middle of the seventeenth century, the percentage who remarried may have been as low as one in four. Katherine Austen, who was widowed and left devastated by loneliness and loss at the age of only 29, ultimately did not remarry, but concentrated instead on increasing her husband's estates to benefit their children. 'And let me not consider whether it is not possible to be happy without a second marriage' she wrote in her diary. However, she concluded that although her fortune, built from a £2,000 portion, estates from her father and her husband, 'could entice a person of honour', she would rather look after her estates and not let the 'costliness and splendour of my life' eat the estates away. Significantly, she wanted her children to include her in the respect that was due to all their male predecessors to whom they owed their wealth.[188]

Even many childless widows chose to cling possessively to land and wealth and pass it on to relatives. For example, in 1624 Mary Boyd was left the 999-year lease on the manor house and lands of Strubby in Lincolnshire. When she died in 1649 she left the remainder of the lease to her niece Mary Heneage, instructing her to hold it in trust and distribute profits to two other female 'kin'.[189] Lucy Roach wanted to leave her estates to her god-daughter, Lucy Swayne, but attempted to exercise control over her from beyond the grave by making them conditional upon her marrying a kinsman, George Roach. Lucy Swayne's mother and aunt refused to let George Roach near her, choosing to sue for the estates themselves.

They locked up the elderly Lucy Roach 'in a chamber as a prisoner'.[190] This case illustrates just how ruthless women could be when tempted by landed property. It is not a unique case. The childless widow, Lady Susan Bellasise, preserved her title to lands in Suffolk and Lincolnshire when she married James Fortrey and only eventually released them to him and a godson when she died.[191]

Therefore, despite a legal system that could, and sometimes did, work against women's ownership of property, women themselves incorporated property ownership into their feminine identity. They cemented friendships and kin relationships with loans of money and gifts of material items such as hand-stitched Bible covers. When they came into large swathes of landed property they sometimes behaved like male landowners, building family church monuments to celebrate lineage and pursuing dynastic titles in their own right.[192] Bess of Hardwick's fanatical house-building is well known, but there were many like her. Even women uninterested in the connection between property and family name kept careful track of everything they owned. Married women may have been subsumed under the legal identities of their husbands as set out in *The Lawes Resolutions of Women's Rights*, but they did not regard their property as belonging to their husbands. When Jane Cavendish was given £50 at Christmas in 1658, she carefully noted in her household account book that she had given away some of it to an 'ould gentlewoman' and her sister's footman, but she had 'lent' £1 of it to 'my deare husbande', and she recorded his debt to her.[193] The wealthier the woman, the more control she was able to exercise over her personal property in marriage with enormous implications for marriage harmony. If a man felt threatened by his wife's wealth, this could cause tensions and even legal disputes between husbands and wives. Such tensions were often (but not always) greater in second and subsequent marriages and could involve convoluted rows that drew in several family members and the law courts.

It can be said in conclusion that there was also no simple decline in women's legal rights in relation to property between 1500 and 1700. Private conveyance of land, cash and material goods through marriage settlements, strict settlements, deeds and wills could undermine a woman's claim to family wealth but as often established their rights at law. Individual settlements of jointure reduced a widow's rights commonly from one-third to one-tenth of her husband's property, but equally left widows with a greater sense of their right to dispose of their own property. Women could even override private conveyance and claim instead the common law default of a one-third dower because all private conveyance was regarded as taking place within, rather than in competition with, the precepts of common law. Women regarded property as a major component of their identity and this involved for them a bundle of negotiable legal rights. The very negotiability of those property rights sometimes encouraged them to pursue property ownership (especially land) at the expense of husbands, would-be husbands and sons despite patriarchal expectations and the theoretically unfavourable legal position as outlined in *The Lawes Resolutions of Women's Rights*.

Crime

There are several general points that need to be made about early-modern women's criminality. The first is that crime itself was gendered, partly because the law treated men and women differently and partly because women's levels of involvement in crime and types of criminality differed from that of men.[194] Women were treated unequally from men at common law because of the division into *feme sole* and *feme covert*. Only single women (unmarried or widowed) had equality at law with men both in terms of bringing cases to court and being prosecuted for criminal offences. England was unusual in this regard. In the rest of Europe, one country after another went through a process of legal codification that brought men and women equally under the jurisdiction of Roman law. In England, men could sue and be sued, but married women could not. For example, women who were the victims of theft (a type of felony) could only properly bring an accusation if they were *feme sole*. Married women did report and give evidence about the theft of any of their personal possessions but their husbands were named as the legal owners of the goods indicating a gap between the law and the feminine concept of property possession. The same applied to female servants, who named their masters as the legal owners of their goods. Married women were in custodial possession of their property only, so that when Mary Smith stole goods from Margaret Brereton, the indictment appeared in the name of Margaret's husband and the property was listed as his.[195]

Categorisation of a large section of the female population under or within the legal identity of men (whether the legal custodian of the woman was a 'husband' or 'master') was the thing that had the most impact on women's private experience of the law. Married women could use obedience to their husbands as a legally-valid excuse for criminal activity, becoming involved in several forms of political protest, such as bread and enclosure riots, partly because it was believed that married women would not be held legally accountable.[196] However, the law did not operate so simply. Leniency towards some types of female criminality led to the application of coverture in some cases and to the belief in special privileges for women through lesser punishment, but a married woman could be tried in the common law courts if her case was considered serious enough as was confirmed by the author of *The Lawes Resolutions of Womens Rights*. '[A]s Adam's punishment was severall from Eves, so in criminall and other speciall causes our law argues them severall persons'. Thus, Adam and Eve were one, but only sometimes, and both God and secular law agreed in treating them differently just on some occasions.[197] For example, Anne Raine (wife of Edmund Raine) of Gateshead was indicted in her own name at the Durham Quarter Sessions for a physical assault on John Stapleton in 1677.[198] Mary Combe's drunk and disorderly behaviour was so sexually aggressive in public (she walked home naked and invited men to have sexual intercourse with her) that several charges were brought against her by men who gave evidence that her husband did nothing to control her actions.[199]

Social expectations and the double sexual standard led to some crimes being considered unnatural in women and in these cases women were punished more

harshly than men. The murder of husbands and children fell into this category and prurient printed accounts such as *The Bloudy Mother* (1610) related tales of women who committed 'unnatural murder' – in this case, Jane Hattersley's murder and burial of her children in an orchard. Men who murdered their wives were also considered 'unnatural' and were tried for murder, but women who murdered their husbands were tried for murder and petty treason. If they were found guilty they could be burnt at the stake. Richard Smith noted in his obituary book that two women he knew were burned for killing their husbands in different months in 1632, whereas in 1635 Elizabeth Evans was hanged for ordinary murder committed with the help of a man.[200] As late as 1757 Mary Ellah was burned alive in York for murdering her husband.[201] In other words, social construction of the female sex and representations of femininity made an impact on definitions of female criminality and led to a complicated set of legal responses to women's crimes which ranged from overlooking them altogether to punishing them with the most violent death.

The law did a lot of bodily punishing of women (and men) in early-modern England. Women who sold 'short ale' (i.e. ale watered down) were cucked, scolds were ducked, men and women were punished in the stocks, prostitutes were carted, stripped to the waist and whipped, thieves of both sexes were branded and witches and murderers were hung and burnt. Women found guilty of the crime of scolding could be forced to walk through the streets wearing a heavy iron frame or bridle over their heads, their tongues immobilised by a thick metal tongue press. In these cases, a man would walk behind the woman holding a lead attached to the scold's bridle, a punishment highly symbolic of men's power to silence female speech. High standards of sexual morality at law resulted (ironically) in bodily testing which occurred with great frequency at the hands of midwives and 'goodwives' (or women of good repute) in the neighbourhood. Women accused of illicit sex and bearing illegitimate children had their breasts examined for milk. Women claiming rape had their genitals examined. Women accused of witchcraft had their genitals examined for evidence of a bloodied teat on the outside or even inside the vagina.[202] All testing of women in these instances was an exclusively female drama through which there was little or no distance between the law and a woman's private and embodied life. The law defined women far more fully than just in terms of rights; it defined their respectability, their place in the community and their bodies as sites and symbols of sin and crime. Their most intimate details were reported to male magistrates, judges, bishops and the men of the Privy Council. When Agnes Bowker, an unmarried servant in Market Harborough in Leicestershire, allegedly gave birth to a cat in 1569 the details did not remain private; the women of the village disseminated information about her sexual experiences and details of the birth. The details reached the village curate, several tradesmen of the village including the baker, the archdeacon of Leicester, the earl of Huntingdon, William Cecil, the queen's secretary, and Edmund Grindal, bishop of London.[203]

Common law was only one jurisdiction under which women experienced the law. Sexual misconduct, marriage breakdowns and cases such as that of Agnes

Bowker were dealt with by the church courts (most notably the Consistory Court) under canon law. Thus, there were other double legal standards beyond and in addition to those of the common law that worked very much against women in cases of misdemeanour as has already been seen with prosecution of adultery cases. Laura Gowing has shown that male adultery was on display in the church courts, but only obliquely as women accused other women of being 'whores' for sleeping with one another's husbands. The depositions in these cases reveal the extent to which women themselves exonerated men for adultery. The language of insult used by women about each other reflects the double standard. They called each other 'harlots', 'jades', 'whores', 'queans', 'strumpets' and they embellished their insults with reference to caricatured physical characteristics ['shitten whore', 'pissabed whore'], their sexual reputation ['daggletaile queane', 'tinckers trull'], their neighbourhood reputation ['droncken whore'], their foreignness ['welsh jade', 'high Dutch whore'] and their potential for carrying disease ['pocky whore', 'mangy carrion', 'burntarse whore']. Sometimes women resorted to elaborate combinations of caricature such as 'pockey lousey hedge whore'.[204]

The insults traded between women reflect also women's economic dependence on the men to whom they were married; women accused other women of dangerously undermining the family economy. Again men were not made primarily responsible for their inappropriate behaviour. When Susan Symonds accused Alice Amos of the sexual corruption of her husband in 1579, her husband actually agreed: 'Yea, thou art a whore indeed: for I ... did occupy the[e] myselfe sixe tymes'. Male adultery was transformed by women's own words into a female crime to be publicly revealed to neighbours in the streets and in the church courts. Susan Symonds put her head out of a window to tell all her neighbours in Boar Head Alley off Fleet Street that Alice Amos had 'put her hande into his [her husband's] codpiece very rudely'.[205] But, while male adultery could be moulded into a female sin/crime, female adultery was taken so seriously that at law the man with whom a woman committed adultery could be sued by her husband. Therefore, adultery was defined according to the legal assumption of a man's property rights to the body of his wife. There was also a sense in which family order and conduct within marriage was a public rather than a private concern. There was a very large and diffuse area of legal activity in which women's behaviour was scrutinised and their actions sometimes punished by both their neighbours and the church authorities and it is almost artificial to separate plaintiff, neighbour and churchwarden in these informal and formal arenas of jurisdiction. Those thought to be 'whores' were ghettoised to areas of bawdy houses such as Turnbull Street in Clerkenwell, London, or their faces scratched to mark them out from other women. Thus the geography of respectability was marked by street name or the shaming of the body.[206]

Steve Hindle's work on 'the shaming of Margaret Knowsley' has also shown the degree to which a woman's sexual reputation could suffer if the church authorities decided to protect a minister from accusations of sexual impropriety. Knowsley told friends and neighbours that Stephen Jerome, minister of the parish church at Nantwich, was constantly accosting her, once ejaculating onto her clothing

in a failed attempt at rape in his bed-chamber. Even though his past employers described similar behaviour she was forced to retract words that started as gossip and ended as slander when Jerome took her to court. The case split the community and ended with her being carted and whipped. Hindle concludes that 'this was an environment where men themselves largely determined what ought to be public', and that female gossip or spoken words could be overridden by the written public words of men. Robert Shoemaker has found that women did not bring indictments to court for the same reason – they feared their words and evidence would not be taken seriously in a world that afforded only the private words of men any public authority.[207] The formal censure of the church courts was mirrored by informal justice meted out in village and town during charivari. This form of community trial involved carting a couple around to 'rough music' or the banging of pots and pans to verses and rhymes such as 'ran a dan, ran a dan ... Alice Evans has beat her good man'. According to Fletcher, charivari 'was for centuries the authentic voice of the English people about what is tolerable and what intolerable in marital relations'. Although it was used primarily to punish women who beat their husbands (considered to be an inversion of patriarchal notions of household disciplinary procedure) the men were portrayed as cuckolds, as if domestic violence implied the woman's sexual lasciviousness as well.[208]

Sexual inversion was equated with a high degree of social disorder. Social disorder of any kind had gendered symbolic meaning and women were implicated through suspicion and anxiety about the assertive female figure.[209] For example, the female vagrant was regarded with greater suspicion than the male vagrant because of society's expectation that women should be under the authority of men. There was a contemporary stereotype of the vagrant woman leading the high life on the road that was completely at odds with the reality of poverty. According to Mendelson and Crawford '[w]omen had few occupations which would justify an itinerant existence' and keep them free from suspicion (particularly of prostitution) with the result that they got into trouble with the law, and their neighbours, over and again. Informal grumbling turned into official reporting and prosecution. In 1615 the neighbours of Mary Ferries landed her in court for having lodgers of both sexes. In 1642 the Lord Mayor of London sent Martha Maddoxe to Bridewell because 'she is a vagrant woman, is out of service and can give no good account'. Sometimes women were stripped and whipped in public as a punishment for social disruptiveness. In 1697 two women were prosecuted for singing lewd ballads in Bristol, though they claimed just to be ballad singers in desperate economic circumstances. Mary Thomas was several times in the 1690s dragged before the courts for disorderly behaviour because she refused to go into service when ordered to do so. Her life 'on the road' was a hard and circumscribed one and she was later discovered in an unlicensed alehouse in bed with a man. Alehouses frequently provided cover for women who sold sex.[210] Margaret Atkinson became a prostitute almost by accident – after arriving in London *circa* 1612 she spent five years 'getting a living' by being a peripatetic maidservant during which time a number of men had sexual intercourse with her and began paying her.[211]

The reality for most female criminals was a hard and precarious life, but the 'free' woman of popular mythology was personified by Mary Frith whose life became almost iconic and whose representation was that of the powerful and successful woman upturning the sexual hierarchy. In *The Life and Death of Mrs Mary Frith Commonly Called Mal Cutpurse* (1662) 'Moll' (supposedly) described her life of crime in jocular tone. In her account she works with the 'Grendees…of Thievery, the Blades and Hacks of the Highway'. She takes up their habits and their fashions, drinking in taverns and joining them as the first woman to become a 'huffer' and 'puffer' of tobacco. She describes herself (apparently) as having a 'flourishing trade' even in her 'declining years' 'so that I lived in great plenty, and took swing of my delights and pleasures, which way soever they invited me'. Her exploits are described as humorous anecdotes – she makes the reader laugh and there is never a hint that her life as a thief is anything but fun and lucrative. After a 'drunken rencounter' in the Devil Tavern she reels and rolls about in the streets of London until she comes across a black sow near a dunghill that she falls into in her efforts to steal the pig. She takes the pig home and keeps the piglets it is carrying before returning it to its confused owner. Pigs were worth a lot of money in early-modern England. This was major larceny and 'Moll' had reportedly in it 'no little rejoycement'.[212] The female rogue of the popular imagination may have offered female thieves a strand of identity. Jodi Mikalchki has discovered that one female vagrant, Frances Ashley, gave her evidence to the court in the rogues' 'cant' of scandalous broadsides. Mikalachki argues that this was a form of linguistic co-option of the male voice to subvert masculine authority.[213]

While women's crimes of social disorder were over-punished, crimes against them were frequently under-punished and prescription and law disagreed. The law legitimised wife-beating but the practice met with customary disapproval and it was not the case that neighbours never intervened – in 1703 a saddler interrupted a neighbour to prevent him from beating his wife further.[214] There was an absence of legal support offered to beaten women resulting from the general acceptance of the principle that a man had a right to 'keep order'. Garthine Walker points out that rape constituted only 1 per cent of felonies brought to court, though this is a little deceptive as most felonies brought to court were property crimes. If violent crimes are taken to be murder, infanticide, witchcraft, rape and the other sexual crime of sodomy, then rape indictments constituted around 7–10 per cent in total. In legal terms, rape was a heinous crime. If the woman was married it was a property crime and Julia Rudolph has pointed out that its original legal definitions were linked to abduction of the woman's body.[215] Serious cases of domestic violence got into print if a woman was murdered. *Two Horrible and Inhumane Murders Done in Lincolnshire, by Two Husbands upon Their Wives* in 1607 told the stories of one man disposing of his sick wife 25 years previously without anybody discovering what he had done and another man disposing of the body of his wife in a large fire at home. However, rapes rarely got into print.

The legal distinctions between male and female violence were reflected in a difference in the representation of crime to be found in the popular press. Pamphlet literature treated husband-beating as a social joke to be shared amongst men

about female nature, but wife-beating took place behind closed doors, staying out of the press and the courts alike. There was a gendered hierarchy of horror and violence that was deemed unnatural. The husband in *Two Horrible Murders* crossed over a social boundary into the realms of the unacceptable in the same way that women did when they killed their children. Elizabeth Barnes and Anne Willis were similarly portrayed by the author of *Natures Cruell Step-Dames* in 1637. One of them had slit her daughter's throat and they were both executed at Tyburn. They were described by the author as 'Matchless Monsters of the Female Sex' and they shared pamphlet space with John Flood, found guilty of raping his own child. Jane Hattersley's murder of her three children in 1609 was marginally more sympathetically treated in print because she committed suicide after the event.[216]

Questions about the extent and nature of female criminality in early-modern England have resulted in very interesting work. The historiography has been dominated by a debate about femininity and women's capacity for violence. This debate was generated by J. M. Beattie's finding that women, while involved in largely the same range of crimes as men, were, nevertheless, involved in lesser and, crucially, more passive types of criminality. According to Beattie, women stole from places rather than people, while men stole from both and were more inclined to incorporate physical assault into their crimes of theft. Beattie's work on crime was supported by J. S. Cockburn's studies of patterns of criminality and between them they drew a picture of the subordinate female felon, acting as a lookout, passing on stolen goods and hiding the criminal activities of other [male] members of their family.[217] This argument has more recently been challenged, especially by the work of Garthine Walker who has suggested that female crime has been under-represented for several reasons. First, concentration on the records of common law courts has tended to exclude married women who were under-represented there. Second, female criminality has been under-represented because of a tendency to devalue the types of assaults and murders women committed. Third, there has been a tendency to believe that women were naturally less powerful and therefore less capable of acts of violence. Beattie himself found that around 20 per cent of all assaults were committed by women, but historians have followed the lead of early-modern commentators that women such as Mary Frith were abnormal women behaving like men. Walker argues that this portrays women as more innocent of violent crime than some of them really were so diminishing female agency. Finally, more recent work suggests that the early-modern authorities themselves treated women as less capable of aggressive criminality and acquitted them, skewing the picture of female criminality handed down to us by the legal records.[218]

The administration of justice was complicated because it was arranged through the series of civil and church courts at provincial and national level. On manorial land smaller matters of social disorder and property destruction were dealt with by the lord of the manor in a manorial court. Lesser crimes of social disorder and petty theft were brought before the quarter sessions that assembled in small towns, but any theft over one shilling constituted grand larceny and would reach the assizes at a regional level or Star Chamber at the national level. The Church or

ecclesiastical courts were similarly arranged with apparitors or messengers serving orders for appearances throughout the countryside and plaintiffs and defendants expected to attend informal sessions locally or one of the Consistory courts (presided over by the bishop as judge) at a regional level. The multiple systems of justice jostled at the jurisdictional boundaries throughout the period. Redefining a crime as felony could move it from ecclesiastical to civil jurisdiction, as happened with witchcraft in 1563 and bigamy in 1604, with varied results – felonious bigamy cases were under-punished, usually relieving men of the burden of punishment, while cases of witchcraft were punished with occasional outbursts of ferocity mostly aimed at women.[219] The gendered nature of crime was, therefore, multi-layered like the court system itself.

Women's criminality was wide-ranging and, therefore, the female sex was represented in all courts. Women were involved in crimes that can be loosely defined as crimes of social disorder, crimes of morality and the most serious crimes of theft and murder. When involved in enclosure riots they broke down fences and when involved in food protests they broke into grain stores to demand a fair price for bread. In Maldon in 1629 a large crowd of women with their children overwhelmed a ship that was about to set sail, one woman shouting 'I will be your leader, for we will not starve'. Rioting women could abandon responsibility through claiming female irrationality or coverture. In the Maldon case the women were only treated leniently when they acted alone, though Ann Carter, later went to the gallows with men whose protest she had joined.[220] Crimes of social disorder in women included what might be called crimes of verbal disorder. The normative construction of women as silent led to prosecution of women at a higher rate than men for subversion of that ideal. The two interrelated crimes of scolding and barratry illustrate gender expectations in early modern society. The term scold was a derogatory term applied to women, its negative impact second only to whore. However, it was also a technical term in common law and could, theoretically, be applied to men though it rarely was in practice. The scold was closely linked in popular thinking to the woman who was the shrew, or woman whose anger might demonstrate her possession by the devil and whose Biblical model was Noah's doubting, angry and verbose wife. David Underdown has argued that prosecution of women for scolding in early modern England indicates a 'crisis in gender relations', though Martin Ingram has more recently argued that scolding women were closely linked in the legal lexicon to barrators who were largely male. Both men and women convicted of scolding and barratry were, according to Ingram, disruptive and dishonest members of communities and he cites evidence of women whose behaviour was so determinedly rude that the ducking stool only made them worse (though perhaps this is not surprising). Ingram's work is classically revisionist – he returns to women agency through finding them guilty of the crimes for which they were tried. Scolding was usually prosecuted through the civil courts. Mary Cole was found guilty of scolding in the Cheshire quarter sessions of 1626 at the same time as her husband was found guilty of barratry. The couple had attacked neighbours whom they then accused in turn of scolding and barratry. Scolding was very much a crime that arose out of community disputes

and in some cases it was not always clear which court – civil or ecclesiastical – would become responsible for trying the woman involved.[221]

Crimes of morality were similarly split between church and civil courts. Women accused of prostitution were brought before the quarter sessions and punished by carting and whipping, sometimes by branding, whereas a woman accused of illicit sex might be brought to a church court and made to do penance by standing on a white sheet in church. Confusion over what constituted prostitution reflected both its widespread nature and its variety from the single woman selling sex to the brothels of Petticoat Lane filled with prostitutes in London. When the courts attempted to reach the 'truth' in cases of sexual morality they immediately entered into a complicated discourse about female reputation and honesty. In many cases the prostitute was the private woman who no longer defended her reputation in public against accusations of sexual immorality. Adultery and fornication, though legally separable, were terms often used interchangeably by people in the church courts and cases of adultery could involve monetary exchange which could be termed prostitution. For example, in the village of Keevil, John Wattes, a miller's servant, took advantage of his relatively wealthy status in comparison to a cottager's wife, Alice Gough, to give her sixpence for sex. She argued that she had defended the honesty of herself and her husband but honesty was a mercurial term in such cases and it did little to separate the good wife from the prostitute. Women who became involved in organised prostitution and lived in what were commonly termed bawdy houses sometimes became keepers of bawdy houses when their own youth faded. Margaret Ferneseed, who was burnt at the stake for murdering her husband, told the court that after years of prostitution she had taken 10 shillings a week from girls she put out on the street. If caught, prostitutes could be imprisoned. As an indication of how any crime of sexual morality could be associated with prostitution, a house that lodged a single mother might also be referred to as a bawdy house. The sexual reputation of the woman and not the paternity of the child or the sexual act from which it was conceived (rape, paid sex or consensual sex) was what defined the place itself in the same way that all women who suffered a failure to defend their honesty became termed whores and nightwalkers. In contemporary lexicon these were women who 'wandered', like a travelling scourge moving by cover of night.[222]

Women's involvement in property crime was quite significant. Garthine Walker has argued that women were aggressively involved in property crime even if it was to a slightly lesser extent then men. Thus, like Ingram she also returns agency to women essentially by finding them guilty. Walker's work on the Cheshire court records found that in the 1590s, 18 per cent of prosecuted felons were women, in the 1620s, 23 per cent were women and in the 1660s, 25 per cent were women. Their criminality was not dependant on male collaboration; although they did not usually steal alone, as one-third of all men did, they nevertheless stole sometimes in all-female networks, taking valuable linens and household goods that they could most readily convert in markets and taverns. Nearly one-quarter of the female thieves in Cheshire in the 1620s committed acts of grand larceny involving goods worth over 40 shillings. Women who committed burglary did

so opportunistically. Margaret Foster broke into a butcher's house on her own in 1624 and took an item of clothing, a dish made of pewter and some herrings. The item of clothing was a child's jacket and the case suggests a woman trying to feed and clothe a child. Mendelson and Crawford have argued that much female criminality can be explained by women needing to steal to help their families survive. Understanding female criminality thus becomes a matter not of diminishing its extent and women's agency, but nevertheless balancing agency against the causes of crime which were then – as now – poverty, social alienation and need. Agency and victimhood are only artificially and semantically separated.

Earlier works on female criminality stressed that women were often the receivers of goods rather than the thieves. However, when Ellen Hutchins was accused by Margaret Grice in 1624 of being 'a Receiptor and her children Thieves' she clearly did not think Grice was a semi-innocent bystander. She was rewarded for her accusation by being called 'the Egge of a whore and a Cuckolde bird'. The court process in these cases could follow a lengthy stretch of community conflict. In 1669 Aurelia Savage went straight around to the house of Arthur Fisher after having clothing and linen worth 9s stolen. There she found some of her goods in the possession of Elizabeth Fisher and two maids. There was no passivity in such confrontations and it was not unusual for women to hit one another. Women stole a wider range of goods than men. Walker has pointed out that they 'stole the types of goods of which they had knowledge and a means of disposal', but clothes and kitchen pans also had a higher value than today. Stealing an animal could be the equivalent of stealing a car. Thus, Mary Frith's theft of a pregnant sow detailed earlier was a major crime. Theft as a crime was punished more severely than sexual crime. Mary Carleton, bigamist and confidence trickster who passed herself off as a series of rich women to capture men for marriage, was a prostitute, but she was judged fairly leniently for her sexual crimes. However, in 1671 she was transported to Jamaica for stealing a silver tankard and then hung in 1673, not for netting the money of her lovers but for stealing silver plate.[223]

Aggressive female criminality can be found in news-sheets and broadsides in addition to the court records. Infanticide and the murder of older children made news.[224] Infanticide represented 10 per cent of all murder cases, a statistic that suggests the degree of desperation many women felt. Nearly all accused mothers were unmarried. James Sharpe has found that in some counties more women were executed for infanticide than witchcraft and Mendelson and Crawford have argued that the statute of 1624, which made concealing birth a crime, resulted in presumption of female guilt. A woman's chance of escaping execution if tried for infanticide varied from place to place. In 60 cases in Essex between 1601 and 1665 just under 50 per cent were sent to the gallows; in other places, juries were harsh, judging a woman's sexuality rather than looking for signs of murder, and execution rates were higher.[225] The peak in illegitimacy rates in the early seventeenth century possibly lead to moral panic. However, legal changes never reflected well the psychopathology involved when a single woman faced pregnancy. In cases of rape and reluctant paternity a woman might try all kinds of strategies of denial. Even during labour in 1673 Elizabeth Michell told a neighbour she needed a remedy

for menstrual pains. Concealing the birth was just the end of a lengthy process of denial for many women, which might include lying about the sex act, wearing heavy clothing to hide pregnancy and finding a place to give birth away from the gaze of neighbours. Cunning and conscious, premeditated behaviour does not fully explain these cases; pregnant single women were sucked into an unreal and fearful situation from which they rarely emerged undamaged. Execution rates for infanticide tailed off in the late seventeenth century when juries became more sensitive to evidence presented that women tried to prepare for live births despite being under stress. Such evidence would include buying childbed linens, something most women were able to prove somehow.[226]

Women comprised fewer than 20 per cent of those convicted of other types of murder and evidence suggests that they tended to kill people they knew rather than strangers. This statistical evidence is used in earlier studies of women and crime to argue that women's criminality reflected their gender role as less autonomous and more passive in their relationships. However, arguments that women killed in less violent ways do not hold much weight. There is nothing passive about the administration of poison, even if it is administered by a hireling. When Francis, countess of Somerset, in 1613 got one person to prepare poisoned tarts and another person to deliver them to Sir Thomas Overbury in the Tower she did so with premeditation and must have known he would die in agony.[227] Some women were capable of the same degree of contact violence as their male criminal counterparts. There was also a hidden area of female violence – women's cruelty to servants and children was under-reported and/or under-prosecuted. In 1673 a neighbour complained when she saw a child who was hanging by the neck as a punishment inflicted by her mother and the child died a year later in suspicious circumstances. J. M. Beattie found evidence of women complaining to Justices of the Peace after their daughters were verbally and physically abused at the hands of female mistresses, though sometimes the tables were turned. *Horrid News of a Barbarous Murder Committed at Plymouth* (1676) told its readers that a nurse called Elizabeth Cary and a housemaid called Ann Evans conspired to murder an old woman and her daughter by boiling up mercury with their broth. They were executed. Women who committed stranger murder were viewed as being more freakish than men who did the same and there is evidence to suggest that they were dealt with more harshly. When John Talbot had his throat cut by 'six men and a bloody woman', three men and the woman were caught, but only two men and the woman were hung.[228] Francis Dolan's work on domestic violence indicates how stereotypes about female behaviour and gender relations ran through all accounts of women murderers. Some pamphlets, such as *The Adulteresses Funerall Day* (1635), exhibited some sympathy for battered wives if their subjection to domestic violence seemed to cross a line of acceptability, but others portrayed murdered husbands as cuckolds, duped by deceiving and sexually promiscuous women. Most women who murdered their husbands were portrayed as women out of control. In *A True Relation of the…Murther of Master James* (1609) the woman concerned was portrayed as inciting servants to rebellion against their master and even though she proclaimed her innocence of the

actual crime it is clear that she was tried as a murderer and not as an accessory to the crime.[229]

In conclusion it can be said that contemporary court treatment of female criminals and public representations of the female criminal have both disguised and exaggerated various elements of female criminality making historical judgements about this area of women's lives slightly difficult. However, by returning historical agency to female criminals, historians have been forced to abandon accounts that diminish their criminal responsibility. Theft was theft, though women were dealt with more leniently than men for this crime while it is now clear that infanticide attracted a very harsh treatment that ignored the plight of women who were victims of sexual crime, social discrimination and neglect. Amongst the papers of Lord Ellesmere there survives a series of dockets detailing pardons to women – Catherine Jones for stealing valuable sheep, Sybil Warren for stealing plate belonging to the royal court and Agnes Owsedge 'for speaking certain traitorous words against her Majesty' [Elizabeth I].[230] Sadly, many of the women who faced the courts for infanticide had sentences that far outstripped the sentences of the women who stole and swore and brawled their way through their difficult lives.

Witchcraft

The historiography of witchcraft in early-modern England has been dominated by two questions: first, the comparisons and contrasts that can be made between witchcraft ideology (and witch-hunting) in England and Europe and, second, the gendered nature of witchcraft and its prosecution.[231] In Europe (including the British Isles) and New England about 110,000 people were tried for witchcraft and between 40,000 and 60,000 were executed.[232] Men accounted for 20–25 per cent of those executed in Europe. Witch accusations were not age or sex specific necessarily and many of the women accused (many of whom were willing to incriminate themselves) were not ultimately sentenced to death.[233] However, many others were, and explanations for intense periods of persecution vary. Some historians have argued that it was a form of mass hysteria, others that it represented the imposition of elite fears onto popular belief, while others still have made links between the Reformation and fear of heresy and the usefulness of witch trials to early-modern state building.[234]

In England witchcraft was one of the most gendered crimes. About 90 per cent of the witches brought to trial were women, but explaining the preponderance of women can be very difficult.[235] Witchcraft trials were not simply misogynistic attacks on women and most trials involved accusations against a network of witches, both male and female, that had slowly been revealed by a community ahead of involvement of the legal authorities. Lara Apps and Andrew Gow have recently argued that witchcraft ideology needs to be understood through 'a relational concept of gender' because Normandy, Estonia and Iceland uniquely generated a predominantly male witch culture. The defining text of witchcraft knowledge or belief, the *Malleus Maleficarum* of Heinrich Kramer and Jakob Sprenger (1487), used both *maleficus/malefica* (masculine and feminine) forms of

'witch'. In Old English, masculine forms appeared alongside feminine as *wicca* and *wicce* and early-modern writers about witchcraft developed gender distinctions between male and female sorcerers, witches and others who practised good and bad magic such as necromancers. It is the case that some early-modern writers – most notably Reginald Scot – were specifically responsible for classifying witches as old women, but often this was to discredit their power rather than lend it credence and in some of the larger witch trials men were accused of wizardry as well. For example, amongst the 70 people implicated at Berwick on the Scottish border in 1590 was the earl of Bothwell.[236]

The details of witchcraft trials were widely disseminated to a popular audience through the print media – over 100 pamphlets and tracts were published between 1566 and 1736.[237] The accusations of murder and magic had a sensationalist appeal that was fuelled by belief in the maleficent work of the Devil. John Jewel warned Elizabeth I in 1560 that witches and sorcerers 'are marvellously increased within your grace's realm' and prompted her to bring into being the 1563 Witchcraft Act. However, it was James VI's *Daemonologie*, written in Scotland in 1597, that gave English witchcraft belief its intellectual foundations and turned it into an extension of English reformed theology.[238] *Daemonologie* announced 'the fearfull abounding at this time in this countrie of these detestable slaves of the devill'. The work was an answer to the scepticism of Reginald Scot's *The Discoverie of Witchcraft* and it asserted belief in the diabolical pact with the devil.[239] In the 1580s belief in diabolism had become prevalent enough for Reginald Scot to complain that 'the fables of witchcraft have taken so fast hold … that fewe or none can (nowadaies) with patience indure the hand or correction of God'. However, Scot's scepticism was borne of the belief that only God could have such absolute power and it did little to alleviate fear of the power of the Devil.[240]

James VI's concerns began with Agnes Sampson who claimed to have bound a dead man's body around a cat before drowning the animal to sink his ship as James returned from Denmark with his new bride. The incident found popular expression in Shakespeare's Scottish history play, *Macbeth*, in which the three 'weyard sisters' made a compact with Macbeth and created storms in the natural world and a disorder in the political world, the metaphor for which was Lady Macbeth's unsexing and control over her husband. After ascending the English throne, James's Witchcraft Act (1604) made pacts with the devil a capital offence and in 1608 William Perkins, the puritan divine, wrote a series of sermons that explained witchcraft in terms of the Devil's work in the world. At the centre of this idea was the Witches' Sabbath (or Sabbat), a ceremony presided over by the Devil (supplanting God or his representative on earth) and involving an inverted Eucharist during which the Devil drew blood on the witch while s/he entered into a covenant to do the Devil's work.

Enslavement to the Devil was believed to come with certain rituals and accessories such as sexual union and the supply of a familiar or helpmeet (usually in the shape of an animal) which would be nourished with the blood flowing from the witch's mark. Occasionally, witches were empowered to fly using an ointment made from the fat of dead children, squeezed from the forehead (the site of infant

baptism) and infused with herbs such as wolfbane.[241] The depositions in the case of Margaret and Philip Flower in 1619 testified to the power of Satan. There were visions of the Devil, spirits came and went in the form of a woman called 'Pretty', small creatures such as crows, kittens and moles and Margaret Flower's sister, Philippa, suckled a white rat on her left breast to whom she had given her soul in exchange for the love of Thomas Simpson. A compact sealed in blood was central to the narrative of witch/Devil union and it was believed that drawing blood off a witch's victim would result in the Devil losing his grip on the victim.[242]

The English courts followed the lead of courts in Europe in hunting witches involved in diabolism, or diabolic magic as originally defined in the *Malleus Maleficarum*. The idea that Europe had hysterical witch-hunts while England was relatively restrained in its search for witches has recently been challenged. It is now believed that the English case fitted one of several patterns of witch-hunting to be found in Europe. The work of Robin Briggs and Malcolm Gaskill has shown that while 'the heartland of persecution' was in Central European provinces such as Treves, Cologne, Westphalia and Wurzburg, there were a number of small but significant areas in Europe that witnessed intense witch-hunts and severe persecution and these included East Anglia in 1645.[243] English witch-hunts also followed the pattern in Europe of witchcraft being brought to light after many years of community tension. Witchcraft trials were essentially public revelations about what had previously been private (often domestic) dramas. Focusing on community tension as an explanation for witch-hunting has thrown light on the question of gender. The stereotypical representation of the witch was the malevolent old hag and historians such as Alan MacFarlane and Keith Thomas have interpreted this figure as poor and dependent on the village community. Sona Rosa Burstein and Lyndal Roper have also suggested that witchcraft accusation focused on the older woman and can be linked to fear of mental instability during the menopause.[244] However, recent research suggests community persecution of older women who were resented for their independence. In a society that regarded women as the weaker vessel, a woman with power might be regarded with suspicion and thought to have received her powers from an external source. Alison Rowlands has found that in the Lutheran imperial city of Rothenburg in south Germany, 56-year-old Appolonia Glaitter suffered a two-month trial for witchcraft (before being released) involving testimonies from her neighbours and friends covering two decades of personal interaction. Rowlands has concluded that the focus should be on the equality of aggression between accusers and accused and she rejects the argument that poverty was a primary factor. Instead she argues that inter-generational tensions were started by younger people resentful of independent older women, particularly if the older woman had seemed, in the past, to be only too willing to lend money and ask for interest on the loan. Appolonia Glaitter, for example, brought dowries to four marriages and owned 11 cows and like many single women she maintained herself by lending money to neighbours.[245]

The case of the Lancaster witches of 1612 has archetypal features which demonstrate the social dynamics of witch accusation and persecution and so confirm

many of the points made by Rowlands.[246] At the centre of the drama was Elizabeth Sowtherns, whose nickname of Old Demdike points to her role as ageing witch in the area of Pendle Forest. Sowtherns had, early in her career, drawn in her daughter, grandchildren and another woman called Anne Whittle alias Chattox. Sowtherns died in prison awaiting trial but not before confessing that she had been approached by 'a Spirit or Devill in the shape of a boy' and that her procedure for killing someone was to make a clay image of them and then burn it so that 'the whole body [would] consume away'. Anne Whittle condemned herself by saying that through Sowtherns' 'wicked perswasions and counsell' she had agreed to enter into the profession of witchcraft. Sowtherns' grandchildren testified at length about seeing her give suck to familiars or devils, after which cattle had died. Her daughter, Elizabeth, testified that she had teats for suckling familiars with blood. She testified that the entire group met regularly at the Malking Tower in Pendle Forest on Friday evenings to decide who would next be killed, but her own children then testified against her in turn. Thus, the family tore itself apart in a judicial forum, though not before outlining for judges and jury all the standard components of what might be termed the anti-theology of witchcraft of the *Malleus Maleficarum* and *Daemonologie* in which a central figure (usually a woman) covenanted with the Devil. In this complex tale, built of several private testimonies and public declarations, the Devil tricked God's creatures through shape-shifting and the covenanted woman suckled familiars to send them on errands and enchant others and do harm to enemies; the witches could make real human bodies dissolve.

The judges found that Elizabeth Sowtherns and Anne Whittle hated and accused each other but concluded that the hatred stemmed from Sowtherns' pre-eminence in the group. Unable to try her, they concentrated their efforts on Whittle, 'a very old, withered spent and decreped creature' who was taken to be 'next [in order] to that wicked fire-brand of mischiefe, old Demdike'. The shape of the Devil as described by the witnesses in 1612 constantly changed – dog, bear, cat, hare, man – but the involvement of the Devil was woven into the fabric of all of their stories, including those of the children. Margaret Pearson was brought to trial three times for murder and bewitching and wrecking other people's goods as 'the Devill and shee knows best'. Conjuring the dead to bewitch the living was another narrative theme. James Device, grandson of Sowtherns, testified that Whittle had raided the church after burials for scalps to remove teeth and bury them with bewitched clay images. It is important to note that witnessing to such deeds reflected not the wild imagination of the witness but their interpretation only of the misuse of popular superstition, spells and magic. John Aubrey's account of the survival of superstitious practice in Bristol in the 1630s includes recollection of women scouring churchyards to remove teeth from skulls to hang around their necks to ward off toothache. Garnering flesh and bone from different parts of the bodies of the dead to heal the same parts of the body in the living was common and the practice included scraping the semi-decomposed flesh from shin bones to make a plaster for gout.[247] Bad witchcraft, therefore, was only misuse of magic, and was only in the eye of the beholder.

The gendered nature of witchcraft accusation suggests that communities used women as conduits for hatred between warring factions and they colluded with the framework of the Witchcraft Acts. Accusations about possession of children also opened up the possibility for using another susceptible group – children – as a vehicle for anger. This is dramatically revealed in the case of Anne Gunter, whose father, after many years of arguing with other members of his community, persuaded her to feign sickness (including projectile vomiting of foreign objects), trances and fits and accuse three women of bewitching her. Witches were commonly believed not only to cast spells and issue curses but to send spirits to possess their neighbours. In 1606 Gunter was questioned in the Star Chamber, where she confessed to lying; she told the court that she had read of past cases of witchcraft, imbibing information about the symptoms of being bewitched. The power of the witchcraft discourse was tellingly on display in this case; while embroiled in the village drama, Gunter's belief in witchcraft was at its peak, but when removed from it she came to doubt the veracity of her own claims.[248] In this case, as in many others, the accused and accusers were social equals and knew each other well. Suspicion was not bred of alienation from the community but from what Malcolm Gaskill has called the 'dark reverse' of neighbourliness – malice. In other words, Gaskill advocates the need for applying historical imagination to gain fuller understanding of the early-modern *mentalité*, one in which people not only believed in witches (and fairies) but were 'willing to pursue personal quarrels with a degree of persistence and ruthlessness…appalling to us…[but] within the accepted mores of the period'. It is an important point – in sexual slander and libel cases, property cases, witch trials, indeed in the very litigiousness of early modern people, we see people who were more given to the social and legal transaction of conflict than ourselves. A major part of this community malice was the unspoken and legally-reinforced custom that it was not the victims, like Anne Gunter, who made the diagnosis and accusation of witchcraft. Peter Rushton has pointed out that it emerged as a community consensus. Malice had a communal face rendering the victimisation a truly terrifying ordeal and experienced almost equally (at least up until the execution), by accusers and accused alike. Within the community and even in the household 'witches were known and unknown, familiar and dangerous', provoking compliance and resentment from neighbours until neighbours victimised in their turn.[249]

Witchcraft cases were usually inter-familial and intra-familial as local communities tried to make sense of what was happening. For example, some members of the Nutter family testified to being struck down by Elizabeth Sowtherns in the 1612 trials, but one member of the Nutter family, young Alice Nutter, was actually tried along with 12 other women and two men for practising witchcraft with Sowtherns' group. Three women and two men were found not guilty, but none of the acquitted came from the three main families whose longstanding and deep feuds of two decades formed the backdrop to the trials.[250] Witchcraft involved women and men and witchcraft accusations came from women and men. A woodcut of the Lancashire witches shows a trio of evil on broomsticks, one woman, one man and the Devil riding between them. However, in both extent and cultural

representation witchcraft was a female crime and Alison Rowlands points out that because witchcraft was thought to be a learned art, the presence of some men in families of the accused can be explained by their proximity to the female witch who acted as educator of family and kin.[251] The woodcut of the Lancashire witches shows all three on their brooms being called to from the ground by Sowtherns. A woodcut of the punishment by hanging of the Chelmsford witches of 1569 shows Joan Prentis looking on as her evil sisters swing from the gibbet. She is surrounded by imps and toads and animal familiars, one of them licking her face as she holds her breast suggestively with one hand. The imagery is a subversion of the maternal.

In St Oses in 1582 the 8 year old illegitimate son of Ursula Kempe accused her of having four spirits working her magic and the prosecution case here was able to exploit tensions between a mother and her son. Other cases in England, such as at Warboys in 1593 and Gooderidge in 1597, also reveal the role of children and youth in accusing. The Throckmorton children in Warboys kept swooning at the sight of the elderly, widowed Alice Samuel, clearly afraid of the way she looked in her black widow's weeds with wrinkled, disfigured facial features.[252] Rowlands rejects the arguments of Diane Purkiss, Deborah Willis and others that hostility by children towards aged maternal figures might be expressed as witchcraft accusation.[253] However, recent debate has suggested that the single most important feature about witchcraft accusation was that it was a way of identifying evil as something that can be located at its source in older women.[254]

The sexual nature of diabolic pacts and women's protection and nurture of devilish animals automatically involved other women in proving witchcraft. Midwives examined for teats on and inside the body, particularly the genital area. As late as 1699 a midwife in Essex was reporting that she had inspected the body of an alleged witch finding 'two long biggs' which had been 'frequently sucked' and which 'issued blood'. To find these teats she had examined the woman's vagina which was then described to the whole court as being 'open like a mouse hole'.[255] In an influential article in 1993 Clive Holmes outlined the role women played in testifying against other women in witchcraft trials. He summarised women's functions as witnesses and searchers arguing that '[i]n both instances the female deponents appear to acquiesce in and reinforce theories of witchcraft'. According to Holmes women were simply better placed to discuss this crime. He argues against 'the sophisticated misogyny…of Biblical and Aristotelian emphases on female inferiority', but, of course, elite ideas about bodily and spiritual weakness underpinned popular ideas about women's magical, shape-shifting and nature-controlling powers as well.[256] In 1645–7 England experienced one major witch-hunt, led by the notorious witch finder, Matthew Hopkins, involving the prosecution of at least 250 people in East Anglia, over 100 of whom were hanged for their alleged crimes. Although witches could be condemned to death for diabolism in theory, in practice people were executed in cases only where it was proved that witchcraft had actually brought about death. Thus, in all cases a significant section of the local community was convinced that death had resulted from the supernatural misdeeds of the accused indicating the power and extent of popular

belief in witchcraft.[257] For example, the 13 St Oses witches of 1582 were tried for killing 24 people as well as cattle and other valuable village animals in an extended family feud involving death.

The domestication of evil needs to be understood within the context of the Reformation and it has been argued by Christina Larner that the actual witch-craze, as opposed to belief in witchcraft, coincided with the post-Reformation period when church authorities were keen to demonstrate their religious commitment.[258] Scott McGinnis has demonstrated the connection between late sixteenth-century puritan pastoralism and witchcraft trials. Several works by puritan ministers were influential including George Gifford's *A Dialogue Concerning Witches and Witchcraftes* (1593). Puritan tracts represented witchcraft as the failure of the Reformation church to turn its congregations away from the Devil. Practice of *maleficia* was thought to be an internal spiritual problem, one that could be solved by ministers practising exorcism.[259] Indeed, exorcism was a widespread practice and brought elite and popular ideas into conjunction. Exorcism by parish clergy worked in tandem and in competition with 'cunning men' and 'wise women' whose powers of exorcism were only a reversal of their powers of enchantment. Witnesses in trials gave evidence that reflected puritan fears especially about Catholicism and Antichrist. In the 1612 trials a witness, Isabel Robey, warned that in Lancaster witches were as prevalent as 'Seminaries, Jesuites and Papists'. Cunning men and women colluded in vague and unexplained ways to subvert the work of the church in the parish. In St Oses in 1584 the parish priest told his wife, who was believed to be dying because of the maleficium of a 'light woman' and 'whore', Annis Herd, to 'trust in God … and he will defend you from her and from the Divill himself'. He begged his wife to consider what his parishioners would think if her faith was so weak that the Devil could work through Herd to bring about her demise. Although he later thought that she had 'departed out of this world in a perfect faith' it does not bear thinking about what his wife thought as she died, crying out 'Oh Annis Herd … she hath consumed me'.[260] During the zealous East Anglian witch-hunt of 1645 there was a breakdown in church order because of the civil war and Matthew Hopkins was supported in his witch-finding by several church ministers and Robert Rich, earl of Warwick, a puritan magistrate. If Hopkins had not died in 1647, what happened in East Anglia would have been even more extensive. According to Malcolm Gaskill, what made the English witch-hunt of the 1640s unique was the preparedness of the authorities to employ torture to extract confessions of diabolic pacts. Puritan theology, with its notion of the covenant with God, provided the framework of an inverted covenant theology involving a pact with the Devil which underpinned the witch trials.[261] As late as 1682 Joan Buts was accused of casting a spell on Mary Farmer after totally submitting herself to the Devil.[262]

While some historians explain the gendered nature of witchcraft in terms of the belief in women's magical powers and the concern of the godly with the Devil, many feminist historians place misogyny at the core of their explanation. Some, like Mary Daly and Marianne Hester regard witch-hunting as 'woman-hating' and witch burnings as a form of 'gendercide'. Daly has argued that witches

were persecuted because they challenged the gender order and the late Andrea Dworkin famously cited the figure of nine million women murdered.[263] However the identification of women themselves with magical power and witchcraft is not in question. Many women self-identified as witches, a phenomenon that Lyndal Roper and Diane Purkiss have attempted to explain. Roper has commented that 'witchcraft accusations centrally involved deep antagonisms between women ... [t]heir main motifs concern suckling, giving birth, food and feeding', all female concerns to do with bodies and the care of infants and all shared between accusers and accused. What is at issue here is if in choosing to claim the identity of a witch, women exercised agency or if the society in which they lived offered so few avenues for the exercise of any real social power that their choice was that of the powerless victim. As with other types of crime committed by women, there is an indistinct line that separates being a victim or agent. Roper suggests a 'collusive dynamic' between accusers and accused and the discourse of diabolism had such a cultural symbolic power, shared by witches and accuser alike, that the witch became both an agent and a victim as she claimed a power not possessed by her neighbours even as they harassed, questioned, bullied, tortured and, eventually, caused her to be burnt.[264]

While it can be argued that classifying witch persecution as 'gendercide' might be to overstate the case, it is important to point beyond the social tensions of the close-knit community to explain the power of gender construction as a factor in witch accusation. The Christian construction of women as the daughters of Eve meant that women had figuratively inherited Eve's capacity for temptation by the Devil. In witchcraft trials women were accused by witnesses of having sexual congress with the Devil so their power to harm their neighbours was gained through their sexuality. James Sharpe has pointed out that while 90 per cent of those accused of malefic witchcraft in Essex at the height of the English witch-craze were women, at least two-thirds of the local cunning folk who practiced magic were actually men. Therefore, built into the pathology of the witch-hunt was the belief that good witches tended to be men and bad witches tended to be women. Thus, it is not enough of an explanation that women's nurturing occupational roles such as midwife, wet nurse, dairy maid, domestic cook and brewer of household ales and medicines placed them in a position of knowledge and opportunity. Masculine knowledge of cures and spells exonerated men, but women remained open to the charge of misuse of knowledge as if transforma-tive and scientific knowledge could not be trusted in the hands of a woman. In England, hunted male witches were closely connected in some way with a central female witch figure, but in areas of Europe where male witch-hunting was common, this was not the case.[265] Thus, if there is to be a revision of the case for England's singularity, it may be that instead of the English witch-craze being less severe than the rest of Europe, it was just more severely focused on women.[266] In York between 1564 and 1598 both men and women were presented to the ecclesiastical courts as people who could tell when a person or animal was 'forspoken' or bewitched, but only a woman – Alison Wells – was also accused of witchcraft.[267]

The period covered by this book – 1500 to 1700 – encompasses the main period of witch-hunting in England. Popular belief in witchcraft pre-dated 1500 but it is the conjunction of popular belief with the theological notion of diabolism that created the witch-craze or witch-hunting from the late sixteenth century. Looking for evidence of Sabbats taking place can be dated principally by trials that used female witnesses to search for the witch's mark. After the publication of Richard Bernard's 1627 *Guide to Grand Jury Men*, looking for evidence of familiars who sucked teats or paps became the commonplace in English trials. According to Clive Holmes, women's involvement in witch trial proceedings as witnesses, and searchers for the 'mark' increased from 38.2 per cent at the end of the sixteenth century to 43.4 per cent in the reign of James I and over 50 per cent by 1660. During the Lancaster Assizes of 1634, 16 women and 4 men were accused of witchcraft and 13 of the women were searched and found to have the witch's mark, 11 of them displaying the evidence in their pudenda. Intellectual scepticism about diabolism began almost at the same time as the idea itself started to underpin witchcraft trials, possibly because of the witnessing of women.[268] James I himself was at the centre of exposing fraud, when in 1616 in Leicester he brought the trial of 15 witches to a halt after 9 had been executed.[269] In the 1634 case, four of the women were re-examined by London midwives overseen by the famous physician, William Harvey, and all the marks were declared explicable, 'natural', 'nor any thinge lyke a teat or mark'.[270] The scepticism in this case found literary expression in Thomas Heywood's stage comedy *The Late Lancashire Witches* which played at the globe in 1634 and made fun out of the witches' familiars in the case: 'Come Mawsey, come Puckling | And come my sweet suckling | ... Fall each to his duggy | As tender as nurse over boy | Then suck our bloods freely | and with it be jolly | Well merrily we sing, hey, trolly, lolly'.[271]

By 1677 scepticism took a more serious literary form. John Webster's *The Displaying of Supposed Witchcraft* of that year argued that there was no 'corporal league made betwixt the Devil and the Witch', there was no sexual union and no suckling of familiars, no shape shifting and no 'tempests or the like'.[272] His scepticism confirms the juxtaposed rise of science and the 'decline of magic' found by Keith Thomas and, more recently, Malcolm Gaskill.[273] The last execution for witchcraft was Alice Holland in Exeter, not long after Webster's tract, in 1684. The last conviction for witchcraft was that of Jane Wenham in 1712 in Walkern, Hertfordshire, and was initiated by parish clergy determined to stop the tide of scepticism and reassert hegemonic Christianity. Wenham was convicted, as in all cases, after years of neighbourly suspicion of her activities and evidence was found of the witch's mark. However, the judge, uncomfortable with the verdict of the jury, secured a royal pardon and not many years later, in 1736, the Witchcraft Act was repealed and witch trials (not witchcraft and witch belief) ended.[274]

Conclusion

At the beginning of this chapter it was suggested that early-modern England was a patriarchal society founded on legal principles that exposed the private domain

to a high degree of public scrutiny so that all areas of private life were closely defined and regulated by a legal system that was supposed to reflect God's law. Criminality is an area of private action that will always intersect with law and become public and the fusion of private and domestic life with public legal process can be seen most clearly in the prosecution of cases of witchcraft. Witchcraft was a treasonable offence and women who were found guilty of witchcraft stepped directly out of the boundaries of their homes, work and social lives, where they might mix cures and potions and think dark thoughts about their neighbours, and into the public realm of criminal offences against the state.[275] Though more obliquely subject to regulation, women's lives as mothers and workers in early-modern England were equally conditioned by heavy expectations of and demands upon their public behaviour.

Through most of the period, constructions of the private sphere took place at the discursive and regulatory nexus between law and the individual and relied heavily on models of obedience drawn from St Paul and the Decalogue, most particularly, the Fifth Commandment that embedded the figure of the mother within the patriarchal hierarchy as a giver and receiver of subservient behaviour. Morality and propriety were not considered secret and family life was not an area of activity to be defined as separate from the state. William Vaughan's *The Golden Grove Moralised* of 1600 conflated the government of person, household and country and included private economic activity and work as a public activity. It was in the lying-in chamber that the greatest secrecy could be achieved, and where women's activity could cause the most concern to men, excluded as they were from female knowledge. However, while there is no doubt that the lying-in chamber was an area of uniquely female construction of feminine identity, it is anachronistic to privilege the private sphere as simply a sphere of female power and influence in early-modern England.[276] Ideas about sexual hierarchy and systematised patriarchy were located in the home.[277] Women's work and behaviour in the home had a public face and women's status within the private sphere was defined externally, their roles within it prescribed and delineated through mechanisms of control, collusion and consent based upon gender expectations, prescriptive literature and social pressure.

This is not to say that early-modern women had no sense of independence of action or spatial privacy, or a private life of the mind. The evidence for this lurks in the terminology of the secrets of a woman's closet found in medicinal and household manuals such as *The Treasury for Hidden Secrets, Commonly Called the Good Huswives Closet of Provision for the Health of Her Household* (1659).[278] Women's lives demanded a constant interaction with male norms about the female sex that formed a component of their gender construction and construction of subjective identity. However, circumstance could affect and determine degrees of female agency. There was nothing specific about the activities women carried out in the private sphere that lent them power and privilege inside or outside the household. Childbirth is an important case in point – knowledge of the physical process lent all women some power over men; expertise and employment in it, as in the case of the midwife, gave power over men and even greater power over other women.[279] Men

could establish their dominance through constructs such as name and property, but equally women could subvert masculine domination of the private domain of the household through co-option of masculine values about family name and through real ownership of property, especially land. Therefore, conclusions about women's property are critical to understanding gender and power in early-modern England – in a society intensely and legalistically defined by property ownership (e.g. property decided status in terms of access to formal politics) women's ownership of land was a chink in the armour of patriarchy and a leveller in terms of sexual relations. Men's and women's wages could be (and were) unequal, but land value was unchanged by the sex of the owner.

The end of the seventeenth century witnessed several changes and the imagined boundaries of public and private were redrawn. John Locke's *Two Treatises of Government* (1689) established a case for natural freedom rather than obedience, a freedom that allowed the individual [assumed to be male] to establish his rules for private life. Gordon Schochet, detects this shift in Bernard Mandeville's *The Fable of the Bees* (1705), which 'overtly [presumed] a coherent distinction between the public and the private realms'. Schochet argues that belief in the separate moral conscience of the private sphere was an idea that slowly developed alongside religious toleration after the settlement of 1689.[280] Private sexual morality became a matter more for individual conscience than public scrutiny, at least in theory, leading perhaps to a loosening of the laws that governed marriage dissolution.

The redrawing of public and private boundaries resulted in the reaffirmation of home as an area of male domination and control and, therefore, the reassertion of patriarchy. The ontological transformation that took place gave the modern world concepts like private property and the private individual both of which were masculine by association; Locke introduced the idea of 'equal donation' by God to all men and women, but then undermined ideas of female agency and power by arguing that God foretold a gender hierarchy. He separated public and private spheres of authority: 'The person of a private father, and a title to obedience due to the supreme magistrate, are things inconsistent.' The private [male] individual moved in 'civil society', an imagined arena of private activity that included all things of so-called private interest that were owned by him in some way. These included his wife, his family, his property, his work, finances and political connections; in other words, those areas of female life that crossed public and private boundaries became privatized and de-feminised. Joan Landes has argued that a whole raft of things became labelled as private, partly universalising the masculine and concomitantly particularising and undermining the feminine.[281] Wealth and property were masculinised discursively leading to the emergence of concepts like private credit, private trade, private land and so on. In these ways patriarchy was shored up by 1700, with new intellectual foundations that helped keep it in place into the eighteenth century, though ironically its masculine discursive foundations ran counter to the reality of higher levels than before of women's land and capital ownership and greater access to the labour market.

Leonore Davidoff has argued that 'individualism (the bedrock of modern liberalism) was predicated on the idea of a "dichotomous other" which carried a

covert dimension of power'. For women this meant some social and legal change emerging symbiotically with an ontological change. It led to the devaluation of women's work, because work came to be seen as the private economic activity of the [male] individual; it led to the de-feminisation of property as property itself was reconceptualised as a 'thing' owned by a [male] individual rather than a bundle of rights to which women had access. Crucially, it led to redefinition of the [male] individual's 'private life' of the family so that women, as wives and daughters, themselves became more firmly the property of men.[282] In the Lockeian intellectual universe women were actually worse off than before. Woman was transformed from the irrational creature of Paradise whose rampant sexuality demanded patriarchal vigilance from fathers and husbands alike to the property of man or the 'private individual' (the 'false universal', as Hilda Smith has termed it). This historical shift was reflected in sentimentality (which is not the same thing as affectivity) in family relations, new laws allowing remarriage mainly accessed by men and an obsession with the patronym. Male descent of land, sons following fathers into schools, universities, army and church, and almost self-parodying representations of the father as head of the family all become features of eighteenth-century private life. Put another way, the intellectual foundations of patriarchy changed to incorporate a powerful sense of the importance to men of their ownership of the private sphere within which women were imagined to exist. However, this vision was divorced from women's reality of increasing access to the public sphere and, as will be seen, from women's own critique of the male structures from which they were supposed to gain their gender identity.

5
Politics

Introduction

Political history has, until recently, owed its greatest debt to the Rankean revolution in historical method of the nineteenth century which cemented the close association between the concept of what was political and male office holding. Politics and statecraft were captured by Edward Augustus Freeman's comment that 'history is past politics and politics present history' and several generations of historians followed the nineteenth-century vision of politics as an evolutionary process at the heart of which was the English parliament.[1] Political histories tended to universalise the male experience. The biographies of queens regnant ignored the political activity of female courtiers and even the most recent work on Elizabeth I focuses almost sole attention on Elizabeth's 'men of business' in Privy Council and parliaments.[2] It is only recently that serious attempts have been made to rewrite political narratives and histories of political ideas in ways that focus entirely on women.[3]

Women can enter political narratives through a combination of placing them at the centre of the historical enquiry and through broadening the definition of 'political' to incorporate the popular politics of protest and high politics conducted informally through patronage. Sara Mendelson and Patricia Crawford have pointed out that 'women's activism during this period tends to be obscured by its informal nature'.[4] The exercise of political 'power informally in the court' and houses of the aristocracy and country gentry can be documented through surviving family papers and state papers, but finding sources for the participation of the less wealthy woman in the informal politics taking place in the home, alehouse, street and shop is very difficult. Women were outspoken on those matters that touched most nearly their own lives, especially religion, the domestic economy and marriage. They also spoke in ways that reflected gender concerns. For example, Margaret Chanseloer, angry at Henry VIII for casting off Katherine of Aragon, was dragged before the courts for calling Anne Boleyn 'a goggle eyed whore'. Elizabeth I was subjected to the same sort of feminine moral judgements that reflected patriarchy – in 1577 Mary Clere called her 'base born' and Cecily Burche and Joan Lyster were placed in the pillory for complaining that a woman

should not rule.[5] Social disorder and seditious words were resorted to by women 'who had no formal political power' and they were, therefore, associated with resistance to the state and a society disordered.

The model of the disorderly woman was a spectre that informed the political thought of the seventeenth century and in political thought there was what Ian Maclean has called a 'near unanimity in the distaste shown for the notion of women's involvement in politics'. Drawing upon Aristotelian thought, political thinkers argued that women's cold and moist humours deprived them of the prudence necessary to exercise public authority and a major component of their 'imperfection', it was thought, was lack of judgement.[6] Jean Bodin, the French political theorist, said 'gynaecocracy [rule by a woman] is squarely against the rules of nature that give men the strength, the prudence, the arms, and the power to command and take away from women'. Nor did rules of nature allow female rule in the private sphere of the family. Private families were the 'historical precursors of the universal political realm' and the public political sphere comprised the community of familial patriarchs.[7] Aristotle's *Politics* argued that the ordering of a virtuous city involved 'ordering of women and children to such magistrates as have the oversight of the states of cities'. The men who were the magistrates were also the husbands and fathers of women and children and after the Reformation, male heads of households acquired additional religious authority.[8] Women's private lives had political purchase, but women, themselves, at least in theory, had no political authority.[9] The model applied to women of all social classes but women who were wealthy could wield political power within their kin circle and beyond. For example, in 1691 fifty-six women shareholders in the East India Company held voting powers in the company itself and the power to lobby members of parliament over regulations to do with foreign trade.[10]

Early-modern legal opinion of women's political authority was unequivocal: *The Lawes Resolutions of Women's Rights* (1632) pointed out that 'women have no voice in Parliament, they make no laws, they consent to none, they abrogate none'.[11] In other words, women had no formal role in the statutory politics of the English nation. However, in practice, three queens between 1500 and 1700 made laws, through prerogative powers and in their role as 'queen-in-parliament' – Mary I (1553–1558), Elizabeth I (1558–1603) and Mary II (1689–1694) – and in 1702 a fourth queen – Anne – succeeded to the throne. While no other women played a part in law-making as such, quite a number of other women held court positions. A queen consort had some independent political power in the sense that she had a court separate from the king's, and female courtiers held specific public offices with salaries and titles attached. Whether queen regnant or consort, queens (and queenship) represented a challenge to ideas about women in the public realm of politics.

Examples can also be found of women holding church offices.[12] Opportunities were greater in small villages than in towns though they had diminished in number by 1700. In the sixteenth century there were a number of female churchwardens. The parish of Kilmington elected a woman six times between 1560 and 1581 and she had authority over everything from fabric repairs and parish

bee-keeping to religious discipline. In Morebath in 1528 the high warden was Margaret Borston. Other women followed – Joan Morsse in 1542, Joan Goodman in 1543, Lucy Seely in 1548, Joan Morsse again in 1554, Joan Rumbelow in 1557, Alison Perry in 1561, Alison Norman in 1563, Joan Norman in 1570, Margaret Taylor in 1571 and Grace Timewell in 1575 (at which point the priest's record ended).[13] However, the dissolution of the convents during the Reformation led to long-term erosion of women's authority and, therefore, public office holding in the Church.

There are also examples of women having a formal political role through holding public office. Lady Anne Clifford served as sheriff from 1650 when she finally took possession of her father's estates in Yorkshire and Westmorland. She advised the justices of the peace when they arrived for quarter sessions and signed all writs certifying the election of candidates to parliament. She was unable to vote herself, but when she wanted her grandson elected for the borough of Appleby it was conceded by her male opponents that '[the] old lady is as absolute in that borough as any are in any other'.[14] The author of *The Lawes Resolutions of Women's Rights* was aware of such exceptions. 'I know no remedy' he said of women's lack of political power, 'though some women can shift it well enough'.[15] Women who attained political power tended to be explained in terms of rising above the constraints of their sex. Political women represented an inversion of the gender order in politics and were satirised this way in public performance and rhetorical debate. The most popular icon symbolic of female rule was Phyllis riding Aristotle, when 'youth overthrows age, and sexual passion, dry sterile philosophy; nature surmounts reason, and the female, the male'. Natalie Zemon Davis has concluded that '[t]he holiday rule of the woman on top confirmed subjection throughout society', but, as this chapter will show, the subjection only ever partially succeeded and had eroded in one important respect by 1700.[16]

Gender and politics in the early Tudor state

The most powerful woman of early Tudor England was Margaret Beaufort who was born in 1443 and became countess of Richmond and Derby.[17] Married at the age of six to John de la Pole, son of the earl of Suffolk, she was destined to marry three more times, all her marriages being forged for political and economic reasons rather than love. Her second child, Henry Tudor, was born in January 1457, some three months after the death of his father, and became Henry VII.[18] Margaret Beaufort acted as kingmaker after the death of Edward IV in 1483, negotiated with Richard III her son's return from French captivity, participated in an attempt to release the princes from the Tower and supported her son's military campaign at the Battle of Bosworth in 1485, after which he was proclaimed king. She witnessed the consolidation of his claim to the throne when he married Elizabeth of York a year later.[19]

Margaret Beaufort retained considerable power after her son came to the throne. She was granted Coldharbour House, which became the site of her court, along with Collyweston, where she became president of the regional royal council in

the Midlands. In 1488 she was admitted to the Order of the Garter and she acted in full proxy for Henry VII, signing herself 'Margaret R'. She may have held the office of High Commissioner of the Council of the North after 1507. Her political power was legitimised by and extended through independent ownership of property. Her landholding covered 36 counties of England and Wales and brought her an income of at least £3,000 per annum. She ensured her economic independence from her fourth husband by having herself declared *feme sole* and in 1492 took a vow of chastity. This enabled her to initiate legal action, make independent decisions about her property and make her own will. She exercised her political power mainly through the calculated deployment of her wealth through patronage. Her household included scholars, lawyers, physicians and a keeper of her jewels. Her son placed his most important wards in her care, including Edward, third duke of Buckingham, his brother Henry Stafford as well as James Stanley, Hugh Oldham and William Smyth, all future bishops. Other noble families placed their children in her care in the hope of advancement with the king.[20] She reserved most of her patronage for religious and educational purposes. She endowed the Lady Margaret lectureships in theology at Oxford and Cambridge and John Fisher was elected president of Queen's College, Cambridge, at her behest. She eventually concentrated her energies on Cambridge; in 1504 the king granted her the power to found a university lectureship and she founded two colleges, Christ's and St John's College. She also financed a crusade of the Order of St John at Rhodes and poured money into a hospital, and chantries and chapels in Windsor and Westminster Abbey.[21] During Henry VII's final illness, between 1507 and his death in April 1509, Margaret Beaufort was in constant attendance; she was made executrix of her son's will and primary mourner at his funeral. She died just a few days after watching the pageants and celebrations for the coronation of her younger grandson Henry VIII (the eldest, Arthur, was dead) and Katherine of Aragon in June 1509.[22]

Although Margaret Beaufort's political power was exceptional, the means by which she gained that power as a woman was not as Barbara Harris's book, *English Aristocratic Women 1450–1550* (2002), has amply shown. Social status and wealth allowed some women political manoeuvre and authority through strategic marriages, acquisition of property, patronage and litigation. Multiple marriages, in particular, could make women wealthy and powerful. Lettice, Lady Tresham married three times – to Robert Knollys, Sir Robert Lee and Thomas Tresham – becoming successively wealthier and demanding of her third husband a pre-nuptial agreement that protected her separate property and enabled her to make a will even as a *feme covert*. Her marriage-making was possible because her own patrons – Sir Thomas and Lady Margaret Bryan – held positions in the courts of Henry VIII and Catherine of Aragon and all three of her husbands were courtiers. She used her ties to the court effectively. After the death of her second husband in 1539 she petitioned Thomas Cromwell to intervene for her in a Chancery case she was defending against the property claims of her stepson. She sent Cromwell a £10 gift and promised to renew his position as Master of the Game on one of her landed estates and the result was that her jointure arrangement on the Rotherfield estate was upheld.[23]

Many remarrying widows protected their wealth through pre-nuptial agreements. Catherine Willoughby, who had become the ward and then, at 14, the wife of the duke of Suffolk, received nearly all her father's lands at his death in 1526 and became a wealthy widow in 1545. She managed estates at Grimsthorpe by herself and held the wardship and right of marriage for her eldest son. Sadly, both her sons died within an hour of each other in 1551, but after her remarriage to Richard Bertie she threw her money and patronage into religious reform. She offered financial support to Miles Coverdale, Hugh Latimer and John Foxe, the martyrologist, and lobbied Queen Elizabeth about 'further reformation'. Independent wealth bought her the political authority she desired and the power to voice her religious opinion.[24]

Barbara Harris has argued that the aristocratic women who became powerful were just the most successful at what was essentially a career. Central to women's careers was the judicious placement of their own children and patronage of other people.[25] Networks of noble families competed for political power at a national and regional level, with aristocratic country houses functioning like microcosmic mirror images of the court itself. At the heart of this system was marriage, lineage and property inheritance. 'England was governed from the court', but the court was just the main centre among many domestic *loci* of political power.[26] Children were treated as property by both men and women of the aristocracy and were not only placed in the care of others to advance the family cause but were also crucial to the system of marriage politics. Women marrying for a second time occasionally included the marriage of one of their children to a child of their next husband in their pre-nuptial agreement. Margaret, countess of Bath, arranged for her daughter by her first marriage to Sir Thomas Kitson to marry her new husband's heir. Harris has found no fewer than 18 such examples. Child placement could amount to a young woman's escape from a life of relative penury. Elizabeth Hardwick, whose four marriages brought her accumulated wealth and the title of countess of Shrewsbury, began life as the barely marriageable third daughter of John Hardwick, who died when she was ten. Lady Zouche offered her a place in her London house and she was subsequently married to Robert Barlow when only about 15 while he lay – conveniently – dying. She spent 14 years quietly living with Barlow's relatives before marrying Sir William Cavendish in 1547. Cavendish's desire to demonstrate his status in building projects became hers as well and she spent the rest of her life building first Chatsworth House and then Hardwick New Hall, having her initials engraved into the stonework of the latter's towers to advertise and celebrate her grand design.[27]

Women's involvement in early Tudor politics partly arose because of a political system in which the boundary between a public sphere of politics and a private sphere of family life had little meaning. The early Tudor household was a locus of political activity that bound families to the court. Politics itself had a domestic face. Harris has pointed out that '[s]ome of what appears to be casual socializing clearly had political significance'. On 31 March 1544 Edward Seymour, earl of Hertford, sent a letter to the duchess of Suffolk, who replied through a servant that she was pleased he liked the horse she had sent and that she would call on his

wife that afternoon. The gift of the horse made the visit the more possible. He later sought a marriage between her eldest son and his daughter. Harris has pointed out that '[t]he constant exchange of gifts…had political implications'. Courtiers could expect a continuous supply of deer and other game, quails and swans, provisions such as fruit, cheese and wine, and pets such as dogs. All social rituals and ceremonies were highly charged with political significance though New Year was the crucial time in the politics of gift-giving. Gifts were given only to people of equal or greater status and tokens, or personal items given on a temporary basis, were symbolic of a particularly close alliance. Women avoided giving the latter to men because it could signal a marriage arrangement. As gift-giving was very much an extension of household management, men relied on their wives to manage this side of their political affairs. Conducted with lack of skill, gift-giving could spell political disaster, making a man's choice of wife crucial to their future political success as a couple.[28]

Political favours, in this system, were granted (or not) upon request or petition and Harris has pointed out that women were as active as men in political petitioning. Elizabeth, Lady Dacre, asked her brother, the earl of Shrewsbury, to represent her on behalf of two of her husband's servants with the Council of the North. Catherine, countess of Westmorland, asked the duke of Norfolk to intervene with Thomas Cromwell on behalf of a servant in trouble for robbery. Katherine Blount petitioned Thomas Cromwell in an attempt to have an election overturned in favour of her son. The women who gave gifts and even annuities to Henry VIII, Thomas Cromwell and Cardinal Wolsey, also petitioned them on behalf of relatives and husbands, to gain them places or have them released from jail, and on behalf of themselves when trying to protect jointures, secure income from a husband or regain custody of their children. Some petitions by women were very direct political appeals: Katherine Audelett asked Thomas Cromwell to mediate in her husband's lawsuit with the abbot of Abingdon. Women also negotiated compensation payments when their husbands were accused of treason and petitioned in person to save their lives if under threat of execution.[29]

As patrons, women who were wives were also in a position to receive political information on behalf of their husbands. They had less power to shape events than women who were widows, but they were also closer to military affairs than unmarried women. During 1534 Lady Elizabeth Dacre was reporting to her husband in detail on affairs on the Scottish border and advising him on what action to take in the case of a peace treaty. The small number of women in the queen's household may have been more subject to circumstances than able to shape events. The queen's maids of honour (of whom there were about 16–25) were defined as unmarried whether they were married or not and spent their days literally waiting on the queen's command while being subject to the political manoeuvrings of male courtiers and the sexual interest of Henry VIII. With status came vulnerability. All involvement in what Harris calls high politics came at a risk – Lady Margaret Bulmer was burned for her role in the Pilgrimage of Grace in 1536 and those who opposed the king's divorce from Katherine of Aragon languished in the Tower for a while. Harris has said that only three women of the court – Margaret

Beaufort, Anne Boleyn and Catherine, duchess of Suffolk 'can be unequivocally credited with ... [involvement in high politics] ... during the early Tudor period' (she could add Katherine of Aragon's regency in 1513) while '[o]f the twenty-two women notable for their activity in this period ... fifteen ... were connected to the court'. In other words, connection *to* the court may have afforded more room for the exercise of power than being *of* the court.[30]

The politics of reproduction affected heavily the lives of Tudor queens consort. Elizabeth of York's coronation emphasised her state as a married (and, it was hoped, reproductive) woman. Richly dressed, but without the symbols of power accorded to a monarch, she rode in a litter with her hair flowing down her back. She bore seven children and died with the final confinement in 1503. By contrast with her mother-in-law (Margaret Beaufort), her power was circumscribed, but she had produced the son (the future Henry VIII) that gave her public political status, if not much real political authority.[31] The politics of the royal bed could make or break a queen consort and contemporaries were keenly aware of this: an image entitled 'The royal bed' preserved at Trinity College Cambridge depicts the king and queen in the act of copulation while rather matter-of-factly peering into each other's eyeballs.[32] The king wears a nightcap while the queen shows off her royal reproductive role with a crown uncomfortably poised on top of her head. It was commonly held that the fault lay with the woman in all failures of reproduction – failure to produce any children, failure to produce surviving children, failure to produce a son. For royal women, these were political failures that brought dishonour to their families. The Tudor queen consort who most exemplifies this is Katherine of Aragon, though all of the women involved with Henry VIII were precariously involved in the politics of dynastic empire-building or the sexual politics of reproduction.

Katherine of Aragon, who was the daughter of Ferdinand of Aragon and Isabella of Castile, was originally brought to England with her Spanish retinue as a marriage partner for Henry's older brother, Arthur. Both were infants when the negotiations began and their eventual marriage lasted a few months only, between November 1501 and Arthur's untimely death in April 1502. Over the next year, further negotiations took place to arrange the marriage of Katherine with Prince Henry, though she sometimes went for months without seeing him, complained bitterly of being kept poor and was only eventually fully married to him in June 1509, after the death of Henry VII. In 1510 Katherine of Aragon gave birth to a premature and stillborn daughter, though she quickly became pregnant again. She had political leverage and authority at this stage and was able to have Henry VIII's first recorded mistress removed from the court, though she was also anxiously writing to her parents about the stillbirth because it was 'a bad omen'. Her second child, a boy born on 1st January 1511, died a few weeks later, and two more dead sons followed in 1513 and 1514. In 1516 she gave birth to Mary, who was to be her only surviving child and on whom both she and Henry lavished attention for several years. However, Katherine was five years older than Henry and her political authority decreased with each failure to produce a surviving son. According to Sebastian Giustinian, the Venetian ambassador, '[n]ever had

this entire kingdom ever so anxiously desired anything as it did a prince'. In 1519, one of the king's mistresses, Elizabeth (Bessie) Blount, gave birth to a living son, Henry Fitzroy, and this rival but illegitimate birth intensified Katherine's knowledge that her failure to produce a son could spell her political downfall.[33] Henry VIII's lack of a legitimate male heir came so to obsess him that he infamously married five more times. Most schoolchildren learn about Henry VIII's six wives through the mnemonic 'divorced, beheaded, died, divorced, beheaded, survived' and Kjarten Poskitt's marvellous musical, *Henry the Tudor Dude* (1995), instructs children about the fate of each wife through humour and song, with a glorious chorus: 'Your body's going to rock, Your head is going to roll | Tomorrow six o'clock you're going to take a little stroll' and so on. However, history turned into comic farce can mask both the sadness as well as the political significance of all six of Henry VIII's wives.[34]

Katherine of Aragon's political marginalisation, when it came, was excruciatingly slow and inextricably tied to the political position of her daughter, Mary. In the early years of Mary's life Katherine was involved in training a child she thought to be heir to the throne. She brought the humanist scholar Juan Luis Vives to England in 1523 and commissioned a tract from him on a girl's education that was the female equivalent of a 'mirror for princes' work and in 1525 Mary was also sent to Ludlow in preparation for being Princess of Wales. At only five Mary had been betrothed to Charles V of Spain who was Holy Roman Emperor or temporal head of the Roman Catholic Church. However, Katherine's power to influence events was not great, she was granted little opportunity for separately communicating with Charles V and when the Anglo-Spanish alliance collapsed in favour of an Anglo-French alliance between 1527 and 1528, there was nothing she could do about it.[35]

In 1527 the king showed his favour publicly to Anne Boleyn for the first time by dancing with her in front of Katherine and although Anne Boleyn's rise is often portrayed as a genuine love story, the backdrop of rejection of Spain in favour of alliance with France is equally important.[36] Anne Boleyn had been in Katherine's court from late 1521 after returning from an education in France and the Low Countries as a maid of honour in the court of Margaret of Austria and then Claude, queen of France. Her education had been carefully arranged by her father, Thomas Boleyn, earl of Ormond and Wiltshire.[37] She had learnt the French cultural language of courtly love, fashionable dress and the dancing that featured in all indoor pageants and festivities and was highly sophisticated. This may seem trivial, but it was not. Anne Boleyn's had been a very successful gender-specific training in sixteenth-century feminine court politics and she stood out in the English court as being uniquely beautiful, educated and polished. She and her sister, Mary, were two of eight women who participated in a Shrove Tuesday pageant held in the London house of Cardinal Wolsey in 1522 in which they were dressed in white satin and were placed in towers and given the names of feminine chivalric virtues – Perseverance and Kindness. The pageant involved a symbolic assault on the women by a man – Ardent Desire – who succeeded in drawing the virtuous women down from the towers to dance as, indeed, Henry VIII did with

both Boleyn sisters in the Tudor court.[38] Anne Boleyn also learnt from Margaret of Austria not to trust the 'sweet speeches' of 'those who offer you service' and to rely on wit to succeed in court politics. Eric Ives has suggested that this 'carried her to the heights of courtly success' and it is certainly the case that Anne knew the significance of dancing with Henry VIII in front of Katherine and the court. She was deeply involved in court politics both by default (because of her father's initial political ambitions) and also personal political design.[39]

It was not until Katherine of Aragon sent Henry VIII a gold cup as a New Year's gift in 1532 and it was returned (with concomitant discontinuance of all gift-giving to Katherine's court by the king) that the end of their relationship was signalled, years after the end of any sexual relationship in about 1524. When Henry was pressing Anne Boleyn to become his mistress, she sent him a symbolic gift: a pendant in the shape of a ship with a woman on board. The ship symbolised safety (like Noah's Ark) and Anne wished to signify her desire for his protection. He began addressing her in letters as 'My Mistress and Friend' (17 love letters survive)[40] and returned a trinket, 'my picture set in a bracelet'. This made their affair official, from late 1527, though she did not cohabit with him until mid-1532, becoming pregnant by the end of that year prompting their secret (and, arguably, invalid) marriage in January 1533.[41] In other words, despite the common perception of a speedy romance, the affair between Anne Boleyn and Henry VIII was protracted and lasted longer than their subsequent marriage.

Henry VIII did not divorce Katherine of Aragon as such. Encouraged partly by the birth of at least one son out of wedlock Henry became convinced that God was punishing him for consanguinity by not providing him with a legitimate male heir. The specific prohibition of Leviticus 18:1–19 of sexual relations with a brother's wife had hung over Henry's union with Katherine of Aragon before their marriage and led to nasty rumours about Mary's legitimacy amongst Henry's enemies after her birth. Prior to his affair with Anne Boleyn he had elevated Henry Fitzroy to duke of Richmond, possibly with an eye to making him an heir to the throne. Between 1527 and the Act of Succession in 1534 there were several milestones in the controversial and illegal 'divorce'. In 1527 Henry denounced his original spousals to Katherine; Thomas Wolsey (in his capacity as papal legate) began to question the validity of the marriage; Katherine was advised of Henry's 'scruples' and she appealed to the Pope to denounce the authority of Wolsey and maintained from then on that her marriage to Arthur had not been consummated. A papal commission headed by Cardinal Campeggio came to England in 1528 and over the next two years heard Henry's case as well as Katherine's continuous appeals to Rome which she extended, in 1531, to a personal defence of papal supremacy over the English Church after Convocation (the legislative church assembly) translated Henry to the title of Supreme Head of the English Church.[42]

Katherine and her daughter were mutually supportive throughout this period. Mary oscillated between the court of her father and her mother's household (though Katherine was banished in 1531 and Mary did not see her again after this date), her early loved and elevated status empowering her openly to criticise the king's new mistress. In 1533 Katherine was advised that Henry was married

to Anne Boleyn and that her title had been changed to Princess Dowager; several members of her household were dismissed. After the birth of a daughter to Anne Boleyn – Elizabeth – in September 1533 (when Mary was 17) the Council ordered Mary to stop using her designation of Princess and transferred her to Hatfield House where she came under the authority of the Boleyns. Thus, Anne's rise threatened the position of Princess Mary as much as that of her mother. In 1534 the Act of Succession rendered her illegitimate in favour of Anne Boleyn's children, though Katherine defended the succession rights of her child by refusing to sign the Oath that went with the Act, and she found support in Rome's eventual decision in favour of the legitimacy of her marriage to Henry. As far as Katherine was concerned (and Mary) Anne Boleyn was the king's mistress and Elizabeth was illegitimate. As far as Henry was concerned, his marriage to Katherine of Aragon was void.[43]

Anne Boleyn unwittingly caused the political downfall of Cardinal Wolsey. There were other casualties such as Thomas More who refused to recognise the legitimacy of the marriage and was executed in 1535. Anne's courtship and marriage to Henry VIII has become inextricably associated with the process of Reformation that followed and she is consequently portrayed in different ways by those commentators whose partisanship is either firmly Catholic or Protestant. Her destructive role was emphasised at the time by Catholics and the faction opposed to the divorce, beginning with reports of men such as Eustace Chapuys, ambassador from the court of Charles V. She was demonised through rumours about moles on her body and a sixth finger which was supposed to mark her association with witchcraft.[44] Protestant commentators such as John Foxe took a different line, portraying Anne as a model early reformer and stressing her role as the mother of Elizabeth I and, therefore, connecting her with the later Elizabethan (Protestant) religious settlement. The political significance of Anne Boleyn as supporter of the Protestant faction at court and ally of Thomas Cromwell has also been much explored by historians; she is known to have been a conduit of petitions to Cromwell. She was also an advocate of reform in her patronage of churchmen such as Hugh Latimer, bishop of Worcester, and Thomas Cranmer, who became archbishop of Canterbury. She visited the nuns of Syon convent and, while 60 of them lay prostrate before her, she accused them (very unfairly) of moral laxity. She has been hailed as a believer in worship in the vernacular and for offering the nuns primers in English to replace their Latin texts. Her chaplains were all reformist scholars from Cambridge colleges, including Matthew Parker, another future archbishop of Canterbury.[45]

However, the explanations for the political twists and turns during Anne Boleyn's short reign lie not in Reformation politics but in the entangled politics of sex and succession. Once in the king's bed Anne's future political success became dependent (much more so than it had been with Katherine of Aragon) upon the birth of a son. The pageants prepared for her coronation ceremony symbolised and celebrated her beauty, nobility and, according to Eric Ives, 'above all … [her] pregnancy … [which was] her supreme achievement and her greatest merit'. A mechanical falcon proclaimed her personal emblem and a verse celebrated 'Anna

the Queen is here, the preservation of your future'. However, after the birth of Elizabeth, her second pregnancy disastrously resulted in the miscarriage of a son in 1534. According to Ives, Henry VIII 'said to one of his intimates in the secrecy of the privy chamber that God was again denying him a son; he had been seduced into marriage with Anne by witchcraft – the marriage was null and void and he would take a new wife'. There is also some evidence that Henry's growing anxiety led to infrequency of sexual relations, so contributing to the problem. Anne was not pregnant again until late 1535 and the miscarriage of a further son proved too much for the fraught king.[46] Anne Boleyn's tenure as queen consort was short-lived. There has been considerable historical debate about the political reasons behind her fall, much of it obliquely interested in the relative power of Henry VIII and various courtiers. Some historians have argued that Anne Boleyn was guilty of adultery as charged, though more have argued for her innocence and suggested that her fall was in fact murder connived at by Henry (and/or a faction including Thomas Cromwell) either because he believed God was cursing him or because he wanted a simple, pragmatic cull of some of his out-of-favour courtiers.[47]

If Katherine of Aragon's fall from grace was excruciatingly slow, her usurper's fall was horrifically swift and the most recent reassessment of the event by Greg Walker has argued that 'it was probably briefer and more pyrotechnic than most accounts allow' as Henry worked himself into 'frenzied accusation and interroga-tion' in his quest for 'truth' in the matter of the queen's sexual fidelity.[48] Henry was already taking an interest in Jane Seymour (who had served in the courts of both Katherine and Anne) at the beginning of 1536 and she was supported by the faction around Princess Mary who encouraged her to press for marriage. Jane Seymour involved herself as readily as Anne had before her in the polit-ical game of king-catching; while Anne was heavily pregnant Jane was point-edly refusing the king's gifts as inappropriate until she could make a marriage.[49] Thomas Cromwell moved against Anne at Easter 1536. The arrest of the first of her five alleged lovers – Mark Smeaton – took place on 30 April. His incarceration in the Tower was rapidly followed on May Day by the arrest and imprisonment of Henry's chief gentleman of the privy chamber, Henry Norris, who insisted he was innocent but was offered a pardon if he would betray others. The very next day Anne herself was arrested and she suffered a nervous collapse inside the Tower gates, surrounded by men she had previously patronised. Several more men were arrested and charged with adultery with the queen; all were tried and all of them were quickly dead.[50]

The evidence against Anne Boleyn included giving tokens to men and dancing with them. There was inherent danger to queens consort in the conventional court conduct of patronage–client relationships. The 'masquerade of courtly love' that involved the continuous praise of the queen by male courtiers through mock flirtation and the presentation of love sonnets could easily lead to misinterpret-ation and charges of misconduct.[51] Anne Boleyn was almost certainly innocent of the charges of adultery made against her. On 17 May, Cranmer, another of Anne's clients, declared her marriage to Henry VIII null and void, so bastardising her two-year-old daughter, just as she had been responsible (directly or indirectly)

for the bastardisation of Mary a few years earlier. On 19 May 1536 Anne Boleyn was beheaded. Her ladies in waiting performed their last act of service by swiftly wrapping her head and her body separately and carrying them to the chapel of St Peter, where her clothes were removed and her remains placed in a chest for burial in the chancel.[52] She had not been an especially popular queen and loyalty towards Katherine, who had died only a few weeks earlier, remained high. Both women suffered badly because of the politics of reproduction and at the end of Katherine's life she had lived confined to one room, having her food cooked in front of her to allay her fears about being poisoned.[53]

Henry VIII was betrothed to Jane Seymour one day after Anne Boleyn's execution.[54] She was presented to the court at Whitsuntide and in June was ceremonially presented at the Mercers' Hall in London. Jane Seymour was an unassuming queen consort and court life featured a measure of stability that had been absent for years. The Seymour family flourished under Henry's patronage (Jane herself received generous jointure lands) and Jane Seymour succeeded in reconciling Henry to Princess Mary, whom he had not seen for nearly three years. She was an open and friendly stepmother, both to Mary and Elizabeth.[55] Henry did not have to wait long for the legitimate male heir he craved as on 12 October 1537 she gave birth to Edward. On the day of the birth she wrote to a number of public figures, among them Sir Edward Willoughby, foreman of the jury that had tried Anne and her co-accused. The letter illustrates the political purchase on the infant that the queen consort expected and it would have been one of many:

> ... by the inestimable goodnes and grase of Almighty God we bee delivered and brought to bed of a Prince conceyved in most lawfull Matrimony by my lord the Kings Majestie ... for the love and affection which ye beare to us and to the Commonwealthe of this Realme ... we have thought good to certifie you of the same ...[56]

On 18 October Edward was pronounced Prince of Wales, the title designate for heir to the throne, and on 24 October Jane Seymour died from septicaemia. Henry mourned for an extended period and Barrett Beer has argued that Jane Seymour's docility had suited Henry and that he had been briefly happy with his third wife.[57]

Henry VIII's next two queens consort – another foreign princess, Anne of Cleves, and the politically-inept Katherine Howard – suffered different but equally unfortunate fates. Anne of Cleves was suggested to Henry as a successor to Jane Seymour to produce another male heir. After a search of Europe – involving ambassadors and painters who sent Henry portraits of potential candidates – Henry settled on Anne, daughter of Johann III, duke of Cleves-Berg-Jülich and Maria, heiress to the duchy of Juliers. Both Cleves and Juliers were Protestant principalities in the lower Rhineland and Henry's choice was heavily determined by long-term as well as immediate political considerations rather than physical attraction. Anne's pedigree was impeccable – her ancestry could be traced to Edward I – and Henry desired a Protestant alliance that was simultaneously anti-papal but doctrinally

conservative and the alliance with Cleves fitted the bill. In October 1539 marriage contracts were signed and on New Year's Eve Anne arrived at Rochester where the king met her, as was custom, in disguise. He immediately became suspicious about her marital state and began interrogation of her ambassadors about her prior contract to Francois of Lorraine. Between their formal marriage in January and the summer of 1540 Henry failed to consummate the marriage and it was terminated on 9 July on the grounds of temporary impotence in the case of Anne. The prior contract to Lorraine was treated as *per verba de praesenti* to strengthen the case for annulment. Perhaps fearing the same fate as Katherine of Aragon, Anne of Cleves consented to the annulment but chose to stay in England rather than face a humiliating return home. After the annulment Henry treated her with friendship and gave her estates including Anne Boleyn's old home – Hever in Kent. She died naturally on 16 July 1557 so outliving Henry and, as it turned out, all of his other wives.[58]

Katherine Howard attracted the king's attention before the annulment from Anne, possibly as early as April 1540. Henry married her on 28 July, the very day Thomas Cromwell was executed for his part in arranging the Cleves marriage. The case of Katherine Howard perfectly illustrates aristocratic women's vulnerability to sexual exploitation when shifted around several households. Katherine Howard was placed with her father's stepmother, the dowager duchess of Norfolk, whose lack of supervision led to Katherine having sexual encounters with two men of the household – Henry Manox, a music teacher, and Francis Dereham, a kinsman. Katherine was placed in the royal court in late 1539 and when she came to the king's attention she responded ambitiously and unwisely by lying about her past. When Henry VIII gave her £4,600 *per annum* to keep her household, she established old friends in posts, possibly to buy their silence, though, in this, she failed. Like Anne Boleyn before her, she acted independently, intervening on behalf of disgraced courtiers and successfully petitioning on behalf of her relatives at court. Unlike Anne Boleyn, the people from her past were very dangerous to her. Francis Dereham began pressing her for a post and a young courtier from the king's privy chamber called Thomas Culpepper began to pay suit to her. In the spring of 1541 they began to meet secretly and Katherine Howard was accused of adultery, arrested on this charge in November 1541 and then executed on 13 February 1542. Both Culpepper and Dereham were executed for their involvement with her, as was Lady Rochford for her ancillary role in gaining Culpepper access to the queen.[59]

Within just five years, Henry VIII had abandoned his longstanding wife of 20 years, beheaded her successor in the year that Katherine of Aragon and his illegitimate son died, lost a further wife to premature death, made a monumental error of judgement with a second European wife and followed it with monumental cruelty to her before marrying a woman whose lack of chastity left him bereft again and lashing out by ordering further executions. Henry's catalogue of marital disasters is not fully explained by his fervent quest for male heirs. It may also be explained by the combination of the convoluted and highly domestic politics of the extended court, sexual dysfunction (on his part) and plain bad luck. With

all of his first five wives (except perhaps Jane Seymour) a double sexual standard operated in conjunction with the norms of informal high politics at court to the misery and disadvantage of several women. All of them had no choice but to tolerate Henry's affairs and a quick browse through Kathy Lynn Emerson's biographical dictionary of sixteenth-century women reveals several more women who bore Henry's illegitimate children. For example, Catherine Carey, who was born to Mary Boleyn in 1522, may have been the daughter of Henry VIII. Luckily for his last wife, Katherine Parr, Henry's ability to impose misery through sexual infidelity was impaired by age.[60] They married in 1543. Katherine Parr was an intelligent and scholarly woman with a genuine interest in religious reformation who patronised Protestant reformers and projects for the translation of religious works into the vernacular. She had received a humanist education with Princess Mary under the tutelage of Juan Luis Vives and passed this education on to her two youngest stepchildren, Elizabeth and Edward. She encouraged Elizabeth's religious translations and herself became the first woman writing in English to publish printed works bearing her name. Her two vernacular religious works, *Prayers or Medytacions* (1545) and *The Lamentacion of a Synner* (1547) were written in the last two years of Henry's life and were Lutheran in doctrine. She was interested in education generally, was involved in the education of her tenants in Clare, Suffolk, and may have been involved in the production of a reading primer. It was her plan, energy and patronage that led to the publication of *The First Tome... of the Paraphrase of Erasmus* (1548). The dedication of this work, written by Nicholas Udall, paid high tribute to her role in turning women of the court and nobility of England into scholars and reformers.[61]

Katherine Parr's achievements as queen consort in just four short years were remarkable. In 1544 the king left her as regent-general while he joined Charles V in a military operation against France.[62] Her council was stacked with those who shared her reforming interests.[63] Perhaps predictably, she made enemies of religious conservatives at court who plotted (and nearly achieved) her downfall. They were led by Stephen Gardiner, bishop of Winchester, who, in the end, had to settle for the execution of her co-religionist, Anne Askewe. Katherine Parr positioned herself to be regent if Henry died while Edward was a minor, but she was ultimately excluded from his regency council and instead remarried after his death in 1547, to Jane Seymour's brother, Thomas; she then died in 1548 following the birth of her only child. Long after her death in 1782, Katherine Parr's body was located at Sudeley Castle and disinterred. When her casket was opened, witnesses to the scene claimed that her face and body were so perfectly preserved that she looked asleep, but then disintegration began to take place and it was guaranteed by several more exhumations by curious eighteenth-century tourists.[64] This seems a very unfortunate postscript for the one queen consort who survived Henry VIII. It stands very much as a metaphor for the way many historians have treated Parr – as the queen whose face disappears rapidly. However, her reputation and significance have recently been restored by Susan James' biography, *Kateryn Parr* (1999), which gives fuller explanation than ever before of the political successes of Henry's last queen. Most notable perhaps was her active role as stepmother, not only to the

Protestant younger children, but also to Mary, whom she drew back into the family believing that she would ultimately reconcile her to Protestantism. Her longstanding influence was, therefore, the impact this had on future Tudor succession and on the religious faith and conviction of the future queen, Elizabeth.[65]

Female rule 1553–1603: Mary I and Elizabeth I

Edward VI ruled only for six years before his two sisters ascended the English throne in quick succession, in 1553 and then in 1558. England was under female rule and it stayed that way for 50 years. Mary I was England's first queen regnant.[66] Queens regnant, in many ways, faced similar problems to queens consort, being subject to the politics of reproduction and male factionalism. However, they faced also a more challenging problem – intellectual dispute about the legitimacy of female rule and the problem of feminine political authority in a world that defined women's rule over men as an inversion of the gender norm. Humanist scholars discussed female rule within the larger debate about woman's nature. For example, both Cornelius Agrippa's *De Nobilitate et Praecellentia Foeminei Sexus* (1529) and Thomas Elyot's *The Defence of Good Women* (1540) used the example of Queen Zenobia to defend female rule as part of a larger rhetorical defence of the female sex. However, when Mary I came to the throne in England, there were two other powerful Catholic women in the royal courts of Europe – Mary of Guise in Scotland and Catherine de Medici in France – and the theoretical questions posed by women's political authority took on a greater urgency. In exile in Calvinist Geneva, the Scottish Protestant reformer, John Knox, responded to the Catholic Mary I coming to the throne by writing a vitriolic attack against her rule in a work called *The First Blast of the Trumpet against the Monstrous Regiment of Women*. He was to gain the support of other Protestant reformers such as Christopher Goodman and Anthony Gilby, though other continental Protestant reformers with whom he corresponded such as Heinrich Bullinger demonstrated less anxiety about female rule *per se* than Catholicism. Judith Richards has pointed out there was an ambivalence verging on acceptance of female monarchs that can be seen in the retelling of historical accounts of queens such as Semiramis in the works of many male scholars.[67]

Mary's succession illustrates the extent to which aristocratic Tudor women became caught between male warring factions and were themselves central to the politics of religious division and reformation. Mary was not the desired successor of the Protestant reformist tutors and councillors who had guided Edward and religious tension had run high through his reign as a result. In his efforts to prevent Catholic backsliding, Edward resorted to constant attacks on his sister Mary for refusing to convert to Protestantism and he changed his will in 1553 to remove both his half sisters from the succession in favour of Lady Jane Grey. As a consequence, the latter was proclaimed by her supporters to be queen when he died on 6 July 1553. Jane Grey was married quickly to the son of the duke of Northumberland and her husband was declared king with her. However, Mary Tudor responded by relocating herself at Kenninghall in Norfolk and then at the

heavily fortified Framlingham Castle in Suffolk, where she raised rapid support in the form of money and troops from the Catholic gentry and nobility before entering London, regally dressed in a heavy purple gown embroidered with gold and pearls. Her actions pre-empted the full resistance of Northumberland whose support from the primary earls of the kingdom fell away. Mary was then declared queen on 19 July. Mary's upbringing as an heir to the throne, traumatic as this had been, had enabled her to seize control of the situation in a way that Jane Grey could not despite determined faction-fighting and Protestant resistance to her succession.[68]

Mary's reign has been judged with the hindsight of the later successful and enduring re-establishment of Protestantism and it can be argued that her image as 'Bloody Mary' (there have been many biographies simply titled 'Bloody Mary'), or the Catholic queen with Protestant blood on her hands, was partly formed because she left no heir. Her decision to marry Philip II of Spain caused dismay amongst some of her male councillors and female confidantes but can be understood in terms of her early upbringing under the influence of Katherine of Aragon's Spanish courtiers and ambassadors and her mother's deference to Charles V. Her defiant loyalty to Catholicism was a loyalty to her rejected mother. Much of the assessment of Mary's reign has focused on her re-Catholicisation of England.[69] There is no question that this took place and that the Reformation, halting as it had been, went into reverse. Mary began almost immediately to restore Catholic bishops who had been deprived and to return the universities to old statutes. Altars reappeared in churches (sometimes unbidden) and the mass began to be heard up and down the country. Books of doctrine and catechisms were published along with explanations of the seven Catholic sacraments. Thomas Cranmer's conscientious objection resulted in his imprisonment and the conservative bishop, Stephen Gardiner, was elevated. After silencing reformist episcopal authorities, Mary turned to a programme of episcopal visitation to restore Catholic discipline. Those clerics who thought there might be just a return to the position of the Church at the time of Henry's death in 1547 were quickly disappointed. Theological disputations ordered for April and May 1554 shamed the Protestant position of bishops Cranmer, Latimer and Ridley and anti-Catholic protests and publications were responded to swiftly, though with varying effectiveness. Small but critical changes of administration signalled the fact that Mary was willing to relinquish political authority in a show of obedience to the see of Rome – she altered the coronation oath, gave up the title Supreme Head of the English Church and liaised with the Catholic activist Cardinal Reginald Pole in deciding new benefices.[70] In many ways, then, Mary's Catholicism was a greater threat to her potential for political control of England than her sex.

The cultural association of Mary with Catholicism at the time manifested itself in ballads that sung the praises of a queen who shared her name with the Virgin. Helen Hackett points out that this was just a continuation of the iconography of Henry's queens consort and earlier medieval royal women, but the restoration of Catholicism found full expression in deliberate confusions of Marian terminology used to revere the new Catholic queen.[71] However, Mary underestimated the

degree of Protestant change already embedded by Edward VI.[72] She also under-estimated the problems created by the changes of title to monastic lands – any return to Catholicism raised questions about the legitimacy of lay ownership and challenged hundreds of land gifts and sales. In early 1554 she faced serious and widespread rebellion (usually known as Wyatt's Rebellion after one of the leaders) and responded by executing Jane Grey and imprisoning her own sister Elizabeth whose symbolic role to Protestants was central. Mary's authority for the remain-der of her reign became dependent on restraining the appeal of and to her sister and in this she was largely successful.

Mary's programme of re-Catholicisation had ambiguous constitutional founda-tions; she was England's first queen with absolute authority and used that author-ity to relinquish some of her political power to Rome. Additionally, even though Mary's marriage treaty stated clearly that she was absolute in her rule, Philip II's presence resulted in continuous doubts and discussions about his political power over issues such as his right to become regent in the event of Mary's death giving birth to a live child.[73] There were features of Mary's reign which indicate both political instability and personal unpopularity and some historians speak of a 'mid-Tudor crisis' precipitated by her accession. However, the degree of political instability has sometimes been overstated. It is the case that Mary changed her closest advisors several times, though her reasons for doing this have recently been revised by Anna Whitelock who has argued that Mary successfully deployed a divide and rule policy. She developed a very personal style of governing reliant upon close bonds between herself and her political intimates with the effect that she reduced the chance of her Privy Council gaining the upper-hand.[74] However, the unpopularity of herself and her advisors, at least within Protestant circles, has not been overstated. The elevation of Cardinal Pole to the archbishopric of Canterbury in 1555 was deeply unpopular (Cranmer had been burnt at the stake for opposition to her policies in 1556). Philip II was unpopular and his potential to advise the queen was mistrusted. He spent a lot of time on the continent waging a war against, ironically, the papacy, straining English relations with Rome at a time when England was newly returned to the religious doctrines of the Catholic Church.

However, the 'mid-Tudor crisis' also involved adaptation of Mary's subjects to female rule which required accommodations in thinking that were not always made in the minds of Mary's subjects. At her coronation she was carried on a lit-ter through the streets of London wearing a dress of blue velvet that was trimmed with ermine to symbolise the office of monarchy and Mary's royal status. However, some of her subjects reported that she wore white, like a queen consort, and they misinterpreted the way she had to hold a heavy gold cap above her head, instead seeing her hair flowing freely as if a new queen consort. At her funeral the bishop of Winchester's confusion of words that she had been 'a queen and by the same title a king also' reflected the theoretical problems posed by her reign. Her political authority lay uncomfortably alongside her married state and Richards has pointed out that there were symbolic reminders that the crown had dual occupancy to be found on charters, seals, medals, coinage and tokens – sometimes Mary and

Philip were displayed one on each side and at other times they were head to head. Philip's absenteeism, combined with rumours about his possible English coronation, caused considerable unease. Rumours flourished about the English crown passing to Spain, fuelled by Protestant polemic. These emanated especially from Geneva where several hundred of Mary's English subjects relocated in a self-imposed exile rather than change religious faith and worship. Pamphleteers warned that Philip might invade England or populate the country with his troops by stealth. From 1557 Philip fought the French, losing Calais in 1558 and so losing English confidence. Mary responded only weakly with propaganda to counter fears about Philip's longer-term intentions and Richards has demonstrated that it was not just the challenge of female rule that caused constitutional crisis in the reign of Mary, but the possibility that the person of the queen [i.e. Mary] would transfer her office of monarchy to a foreign prince who involved himself in costly foreign fights.[75]

Mary's central dilemma was that she needed to be married to have any hope of securing Catholic succession, yet having a husband raised questions about gender and who was the marital and political head. The success of her Counter Reformation was dependent on producing an heir, but, like other royal women before her including her mother, Mary was to be defeated by physiology. At 37, when she came to the throne, her fertility was unquestionably impaired. In November 1554 there were rumours that she was pregnant and anticipation ran very high amongst her supporters. The next few months must have been excruciating for her – news of her pregnancy was publicly proclaimed, months of celebrations followed, including the queen presenting herself to crowds with swollen abdomen prominent, and she moved to Hampton Court (transferring her sister Elizabeth there ahead of the confinement) where on 30 April it was reported she delivered a son even though there was no child and she went on believing that she was pregnant. In August 1555 she accepted the truth of her childlessness; her swollen abdomen and the pain that left her rocking on cushions for hours were the symptoms of uterine cancer. During 1558 Mary added a codicil to her will acknowledging Elizabeth (though not actually naming her) as her heir and she let her sister know through advisors that this was what she expected.

There has been a tendency to dramatise the conflict and comparisons between Mary I and Elizabeth I.[76] However, despite the fact that Mary burned 287 Protestants and forced many hundreds into exile, it is worth reserving some compassion for England's first queen regnant. Mary's Catholic loyalties were the extended loyalties she felt for her abandoned mother and her behaviour was that of the initially loved child who was later shunned and who then went on to suffer from ill health and chronic pain her entire adult life. When she died on 17 November 1558 she had caused suffering (as, indeed, her father had before her), but she had functioned in a permanent state of suffering herself in a political atmosphere that was hostile to female rule and that judged women politically and morally according to bodily processes that, in the end, were beyond their control.[77]

When Elizabeth ascended the throne in 1558 men of politics were again confronted with the question of female rule, though unlike her sister's more ambiguous

coronation, Elizabeth's coronation served to reinforce her status as monarch despite her sex. She was carried aloft to Westminster on a litter draped in a cloth of gold and white satin, with five pageants along the way featuring Time's daughter Truth and Elizabeth as Deborah saviour of Israel, all of which was designed to link her back to the Protestant reformation of Henry VIII and Edward VI and establish her as the new monarch in whom Protestant hopes rested.[78] According to Ernst Kantorowicz Tudor kingship/queenship was defined as having its origins in the mystical perpetuity signified by the halo in medieval art and the liturgical authority and divinity inferred and transferred to the person of the king/queen by God. The idea of the *corpus mysticum*, or the mystical body of the church, was one co-opted to the concept of monarchy and conflated with secular ideas about corporation and succession which became, in the writing of late medieval jurists, 'a mystical body of the *respublica* [state] the head of which is the prince'. Thus, the individual life of a monarch was mortal, but there was a sense in which the life of monarchy was not as encapsulated in the cry 'the king is dead, long live the king'. Oaths of allegiance were owed more to the crown than the person of the monarch and the distinction was consolidated in law by the separation of Crown estates and the personal property of a king. Thus the 'crown as fiction' with inalienable rights came into being and individual kings through hereditary succession acted only as guardians of a reified office of state defined as masculine *per se*.[79]

By the time Elizabeth came to the throne, Mary's reign had prompted some articulation of the gender implications of this idea and Richards has pointed out that Mary's reign had actually established a precedent for female rule, including an oath of allegiance sworn by her councillors 'in terms that left no doubt that queenly power was to be comprehended as the full equivalent of kingly power'.[80] However, this did not stop a full-scale theoretical assault on female rule with the belated publication of John Knox's *The First Blast of the Trumpet against the Monstrous Regiment of Women*. Knox argued that there was a threefold prohibition on gynaecocracy – it was against the laws of nature, against the laws of God and against the weight of classical authority and historical custom. The 'regiment' to which Knox referred was government rather than an army of women and the intellectual thrust of the text is encapsulated in the word 'monstrous' in the title. Knox used the metaphor of the headless body to explain female rule ('a people or nation left destitute of a lawful head') and asked 'how abominable before God is the empire or rule of a wicked woman, yea of a traitoress and bastard.' Those who supported female rule were aligned by Knox with the reprobate, or, the ungodly who 'promote a woman to bear rule'. The first part of his argument spoke of God's law revealed in nature and concluded that women were created 'weak, frail, impatient, feeble and foolish...and lacking the spirit of counsel and regiment'. Further, he argued, that men in contact with women's authority would degenerate into effeminacy. For the revealed word of God, Knox turned to the Pauline dictum that 'woman in her greatest perfection was made to serve and obey man, not to rule and command him ... [t]his sentence... did God pronounce against Eve and her daughters'. Knox turned to the Church Fathers – Tertullian, Chrysostom, Origen, Augustine – to reinforce his case from patristic authority arguing, for

example, that Augustine attested that 'woman...beareth not rule and lordship over man' and that 'with Augustine agreeth in every point St Ambrose'. The Holy Ghost 'illuminated their hearts and directed their tongues and pens that, as they did conceive and understand one truth, so they did pronounce and utter the same'. Knox bolstered religious authority with the Classical ideas of Aristotle, concluding that '[i]n the natural body of man God hath appointed an order that the head shall occupy the uppermost place...[a]nd no less monstrous is the body of that commonwealth where a woman beareth empire'.[81]

There is a considerable literature on Knox's *First Blast of the Trumpet* out of which arise several points.[82] Knox's tract constituted anti-Catholic polemic and publishing it a few months into the reign of Elizabeth constituted an egregious political error.[83] Further, the treatise attacked women so attracting several replies or defences that together with *First Blast of the Trumpet* formed a sub-debate of the *querelle des femmes*.[84] The most important – John Aylmer's *An Harborowe for Faithful and True Subjects* of 1559 – deployed dualistic notions of woman to defend Elizabeth by claiming for her an extraordinary status on one side of woman's nature: 'women are of two sorts, some of them are wiser, better, learned [etc]...but another and a worse sort of them...are fond, foolish, wanton, flibbergibs, tattlers, triflers, wavering, witless, without council, feeble, careless, rash, proud...evil-tongued, worse-minded, and in every way doltified with the dregs of the devil's dunghill'. In 1567 John Jewel's *A Defence of the Apologie of the Church of England* took the argument further, contrasting women like Eve with the virtuous women like Elizabeth who was described as having 'princely virtues as have not been seen in many men'. Other respondents, such as Thomas Craig, argued from the more legalistic position of property law and the *corpus mysticum* that there was nothing in divine, natural or civil law to prevent female succession either to real estate or the perpetual office of monarchy.[85]

However, Protestantism ensured that the debate about female rule was a bit different in 1558 from the debate that ensued with the reign of Mary. Reformed religion free of papal control recast the monarch as absolute in sovereignty and the Act of Supremacy confirmed Elizabeth as Head of the Church despite the blindingly obvious gender inversion this implied. The queen became 'defender of the faith' whose lines of monarchical legitimacy were actually doubled – the royal line and the line that was conceived as running from the Israelites to Elizabeth's coronation. The absoluteness implied by the Protestant monarch's role (especially coming after an unwelcome return to Catholicism) spawned a 'cult of authority' that combined the monarch's 'moral responsibility' to avoid tyranny and the subjects' responsibility not to resist her rule. According to Edward Smith in a seminal work on the Elizabethan 'doctrine of the prince': '[i]n *her* sacred and secular were finally united...[t]hrough the anointment [during the coronation], the prince was united with Christ' according to the order laid out in the *Liber Regalis*.[86]

Thus, while male defenders of Elizabeth's female rule used dualistic notions of woman to support her reign Elizabeth herself relied on an equally medieval dualistic model of kingship to co-opt masculine authority to herself as queen. She was sufficiently rattled by the challenge to her authority made by Knox to annotate

her letters with anxious reflections about her 'due right of descent' but, from the first swearing in of her council, Elizabeth in fact defined herself as 'but one bodye naturally considered ... [though] by [God's] permission a bodye politique to govern'.[87] In other words, she relied heavily on the construction of the king's two bodies (person and office) to reassure herself of her right to rule and establish her personal political identity.

During Elizabeth's reign the theory of the king's two bodies became a legal formulation that also entered the discursive and representational realms of the public sphere. In a defining ruling in the Duchy of Lancaster Case of 1561 (over corporate lands belonging to the crown but kept separate from crown estate) the crown lawyers judged that

> ... the king has in him two bodies, *viz* a body natural, and a body politic. The body natural (...) is a body mortal, subject to all infirmities that come by nature or accident, to the imbecility of infancy or old age ... But his body politic is a body that cannot be seen or handled, consisting of policy and government ... and the management of the public weal, and this body is utterly void of infancy, and old age, and other natural defects and imbecilities.[88]

The queen did not physically occupy more than one space in this formulation; rather, the body politic, which Marie Axton has described as being like the metaphor of the body of the realm but a distinct concept, was contained within the body natural of the queen 'created out of a combination of faith, ingenuity and practical expediency, [and] held to be unerring and immortal'. Thus, in Shakespeare's *Henry V* the monarch is 'twin-born with greatness, subject to the breath of every fool' and in *Richard II* the king is 'deputy elect' of God whose treachery dissolves his body politic simultaneously with the dissolution of his reign as 'in the king's name the king himself [is] uncrowned'.[89] If the key to understanding Mary's vision of female rule and her political authority is re-Catholicisation, the key to understanding Elizabeth's is her powerful sense that in all policy decisions and political relationships she acted as God's deputy-elect and with the authority of a queen who had two bodies through right of succession from her father. Marie Axton has argued that 'the queen's two bodies' underpinned the symbolism and iconography of her reign, but the concept of the queen's two bodies helps to explain much more besides.[90]

There is a veritable industry of historical work on Elizabeth I.[91] Many older biographies focused on Elizabeth's relationship with her councillors and parliaments, but more recently there have been a number of feminist rereadings of the politics of gender and cultural life at the Elizabethan court. A portrait of Elizabeth as a young girl of about 13 years shows her expensively but not extravagantly dressed with her hair pulled back in a modest headpiece and holding a prayer book.[92] Her coronation portrait 10 years later shows her with hair flowing and holding the orb and sceptre of rule; she wears ermine to signify royalty and pearls to signify virginity. There is no trace of the demure smile of a decade earlier. The Imperial Ambassador's assessment of her at this moment was that she was 'a very strange

sort of a woman'. Historians and literary scholars alike have argued that Elizabeth was the mistress of a 'female glamourization' that was deployed to project a controlled political authority. For example, in the 1585 Ermine Portrait Elizabeth is bedecked with jewels and an exquisitely intricate lace ruff follows the curve of her neck, merging almost imperceptibly into a crown that follows the dual curves of her hair. Her long white fingers are held rigidly for display and a small ermine stands on her arm as a symbol of royalty staring her in the face while wearing a miniature crown. Thirty years into her reign the vision of Elizabeth's queenship was perfected and the cultural memory laid down – cold, feminine, untouchable and rightful royalty.[93]

One of the first political questions Elizabeth had to address was that of marriage which was less a question of love and more one of succession. She faced the same dilemma as Mary – if she married a foreign prince, England automatically became embroiled in European dynastic politics, and if she married one of her own subjects, unequal rank added to and complicated problems posed by gender. Elizabeth also knew that if she named a successor in the absence of marriage she would curtail her personal safety: 'I know the inconstancy of the people of England' she once said, 'how they ever mislike the present government and have their eyes fixed upon that person who is next to succeed'. She told William Maitland in 1561 that if she declared Mary Queen of Scots her successor it would be tantamount to placing 'my winding sheet before my eye!' She thought the same of children: 'Princes cannot like their own children, those that should succeed unto them,' though she used the term 'child' as a metaphor for any successor. Elizabeth's political anxiety was combined with a deeply felt sense of personal responsibility. '[T]he burden that is fallen upon me maketh me amazed; and yet, considering I am God's creature, I will thereto yield.' For this reason she dutifully listened to the petitions and appeals of her parliaments of 1559 and 1563 that she marry but responded by arguing that she was married to her kingdom (which she termed 'husband'), suggesting that 'though I can think it best for a private woman, yet do I strive with myself to think it not meet for a prince.' As early as 1559 she conceived of herself as a gendered duality – prince/king in her body politic and virgin in her natural body. She told her parliament of 1559 that if God intended her not to marry 'in the end this shall be for me sufficient: that a marble stone shall declare that a queen, having lived such a time, lived and died a virgin'. Therefore, by representing her natural body as virgin Elizabeth co-opted for femininity some of the mystical state of her body politic.[94]

Elizabeth I played out several courtships during her reign the most important being with Robert Dudley (who became earl of Leicester), Archduke Charles of Austria and Charles IX of France, all in the early 1560s, and Francis, duc d'Anjou (or Alençon) in the 1570s. All except that with Dudley had implications for foreign policy and the extended courtship with Alençon between 1572 and 1579 was partly engineered by Catherine de Medici who wanted closer Anglo-French relations for support against Spain.[95] Between 1579 and 1582 there were further marriage negotiations with Alençon, supported by William Cecil, Lord Burghley, who tried to convince the queen it would be good for her physical health.[96] Susan

Doran has argued that on two occasions Elizabeth seriously considered marriage –
in 1560, when Robert Dudley's wife, Amy Robsart, died in odd circumstances (she
fell down a spiral staircase leading to rumours about her being murdered) and in
1579 when her relationship with Alençon became intense.[97] Doran argues that
Elizabeth may not have chosen to stay single and that the image of chastity was
forced upon her by her ministers. However, Elizabeth's inertia was so powerful
that it amounted to practical choice. In 1566 she told the House of Commons:
'Your petition is to deal in the limitation of the succession … it is not convenient,
nor never shall be without some peril unto you and certain danger unto me'.[98]
The portrait of 1579, which was painted by George Gower just as the final set of
marriage negotiations with Alençon got underway, is the earliest known to depict
Elizabeth holding a sieve; the latter was symbolic of Tuccia the Roman virgin in
Petrarch's *I Trionfi* which celebrated in allegory the Roman 'triumphs' including
the 'triumph of chastity' (Tuccia proved her virginity by carrying water in a sieve
without spilling a drop). There were several more sieve paintings from 1579 to
1583, referring at once to Elizabeth's virginity and her imperial status and helping
to cast the ageing queen as nubile.[99]

Assessment of Elizabeth's reign has been focused, to some extent, on the ques-
tion of whether or not she was responsible for establishing a successful religious
via media in the settlement of religion that was forged with great speed between
1558 and 1562. The Act of Supremacy established Elizabeth as Supreme Governor
of the Church and the Act of Uniformity reinstated and enforced the Edwardian
Prayer Book of 1552. In 1562 the Thirty-Nine Articles established the official
confession of faith as a brand of moderate Calvinism that stressed salvation of
God's elect.[100] In conjunction with this, Elizabeth was represented as Deborah,
or the queen who would work with the *revenants*, or returned Marian exiles, to
restore Israel. The most circulated image of her through printed books was of the
Protestant queen who restored the true faith.[101] Hackett has argued that the fem-
inine imagery of a struggle between the true church and 'the whore of Babylon'
was quickly transposed to Elizabeth – she could be depicted as 'mother' and 'vir-
gin', co-opting the role of the Virgin Mary to the position of female monarch of
a besieged Protestant state.[102] This pseudo-sanctification of Elizabeth was further
reinforced by John Foxe's *Book of Martyrs* in 1563 and her role as defender of
Protestantism gained continuous relegitimation from Catholic threats both real
and imagined such as the Northern Rebellion of 1569 (which led to the execu-
tions of 600 of her Catholic subjects) and her excommunication by the Pope in
the following year. Carole Levin and David Cressy have both pointed out that
celebrations marking the day of Elizabeth's accession – 17 November – began as
an almost spontaneous patriotic response to her excommunication by Rome and
took on religious significance to fill the vacuum left by the abolition of Saints'
Days.[103]

There have been two views presented by historians about the depth of Elizabeth's
commitment to the Protestant faith she came to represent. The older view, repre-
sented by the work of Sir John Neale, was that Elizabeth was coerced by a puritan
faction in the House of Commons into a more Protestant settlement than she

wanted. Elizabeth certainly, at times, felt pressurised by some members of the clergy. She famously resisted the puritan pressure of Archbishop Grindal in 1576 so that when he died in 1583 he had endured years of house arrest.[104] The newer view, represented by the work of Norman Jones, is that Elizabeth was always clear that she wanted to restore the situation as it existed under her brother Edward VI. Jones regards her Protestant commitment as firm and argues that the real challenge of her reign was not radical Protestantism (or puritanism that emerged in the 1560s), but the Catholic opposition that she encountered in the House of Lords and Catholic rebellions.[105]

Examination of Elizabeth's private religion gives insight into the level of commitment to her role as the Protestant Deborah. Elizabeth was a deeply pious woman who attended private chapel daily and carried, attached to her waistband, a 'girdle book' of private prayers.[106] Her written prayers and meditations on her political role are highly instructive. She frequently used the submissive terminology of handmaid of the Lord in her private prayers and linked it to her role as prince: 'O King, may I Thy handmaid and Thy universal people committed to me be readied by Thy grace in all things to proclaim Thy glory and to acknowledge Thy supreme sovereignty.' Elizabeth's prayers inverted her role as king as a sign of her Protestant piety – '[t]hou art my God and my King; I am Thy handmaid' – and in this way she explained her temporal sovereignty to herself and her female rule as God's revealed will. Her acknowledgement of the omnipotence of God placed her on a level with her subjects – '[i]ncline our hearts to Thee, that we may walk in all Thy ways and keep Thy commandments' – and empowered her as temporal handmaid-*cum*-king to hold absolute power over her subjects as her unique and personal duty to God. The construction of herself as God's deputy and handmaid gave her a multiple gender identity – she was like Christ to her Church, wife to the Lord and mother (or wife) to her subjects. At the end of her reign, in her Golden Speech of 1601, she summarised her own vision of her monarchical role over the half century before: 'I was never so much enticed with the glorious name of king…as delighted that God hath made me his Instrument to maintain his truth and glory, and to defend this kingdom.' Elizabeth's powerful sense of a God-given duty thus helps to explain not only her determination to settle religion in her kingdom, but also her decision not to complicate her role through marriage. To be a prince most fully, she needed to remain an unmarried woman and her private piety helped her achieve her political status as God's temporal lieutenant.[107]

In her public religion Elizabeth was a pragmatist. She suppressed Catholicism – for example, imprisoning Catholic bishops when they tried to attend the House of Lords in 1559 – but expected slow and patchy change of religious worship at the grass roots level of the parish. She went through periods of persecuting Catholics, but she tempered these with selective blindness to private Catholic worship.[108] Some historians argue that her policymaking tended to be reactive, but equally it could be argued that she demonstrated strength in knowing the limits of the possible. She dampened the reformist zeal of her puritan bishops; after being told how many parishes they wanted filled with learned men she reputedly shouted at them 'Jesus! thirteen thousand!' and advised them to concentrate on finding

ministers who were 'sober and wise'.[109] By the end of Elizabeth's reign the religious politics of Reformation England had perceptibly changed to an ecclesiastical polity based more firmly on *jure divino* (or, divine right) ideas of episcopacy that more closely matched the *jure divino* ideas of monarchy to which Elizabeth firmly subscribed.[110] Rather than a *via media* Elizabeth established early (and refused to budge on) a moderate Calvinist theology for the Church of England, but her ecclesiastical policy evolved to become more authoritarian. The success of the former was that it was capable of maintaining a broad Calvinist Protestant consensus in matters of faith and the success of the latter can be measured by the relative stability of episcopal government.

Historians have also disagreed over Elizabeth's relationship with her Privy Council and parliament. The most recent view of parliament is that it was a secondary institution called by Tudor monarchs to conduct business and raise money and 'to be used or ignored by agencies whose real power base ... lay elsewhere – at court or in council'.[111] Certainly Elizabeth herself regarded parliaments in this way – when she ran into trouble over a subsidy in 1566 she said to her parliament 'let this my discipline stand you in stead of sorer strokes, never to tempt too far a prince's patience' and when she dissolved parliament in 1567 for trying to bribe her into marriage she barked, 'God forbid that your liberty should make my bondage.'[112] Elizabeth called only 13 parliaments in her long reign and the most recent work suggests that attendance in parliament was very poor as MPs drifted back to the duties of their country estates. Crucial to success was management of parliaments by the strategic placement of five to eight councillors to get the desired outcome. Elizabeth and her MPs did not regard low levels of contact between themselves as a measure of failure but as a sign that Elizabeth was a frugal monarch who did not need their subsidies. And Elizabeth was frugal – to the point of being parsimonious. She only ran into financial difficulties when expensive military campaigns plagued the latter part of her reign.[113]

Elizabeth's relationship with her Privy Council was less clear-cut. It was intimate and she met with the Council twice a week at the beginning of her reign and daily by the end. She chose to have a much smaller Council than Mary, she said to avoid 'discord and confusion', and the active clique was only 7–10 strong.[114] William Cecil was principal secretary from 1558 to 1572 and Lord Treasurer from 1572 to his death in 1598. He was 1st Baron Burghley from 1571. Burghley was the most important of Elizabeth's ministers and his patronage was critical to any courtier seeking office and 'the queen's bounty' – he literally told people what to write when requesting something from the queen. One historical interpretation is that Burghley and other ministers of the crown, most notably the earl of Leicester, were in competition with one another for the queen's favour. This view of factional politics is associated with the work of John Neale and has recently received support in the work of Catherine Bates, Natalie Mears and Paul Hammer. Bates has argued that Elizabeth used her gender to woo and control her male advisers using a 'game of courtship' as a 'tool of policy' using wigs, low-cut dresses, perfumed handkerchiefs and cosmetics. Hammer has observed the powerful semiotics of nomenclature, such as Elizabeth calling the earl of Leicester her 'eyes' and

Sir Christopher Hatton her 'lids'. He has also remarked on the law of diminishing returns for her political authority as she aged.[115]

However, some historians argue that the queen's ministers manipulated Elizabeth to gain policy decisions of which they were collectively in favour.[116] Burghley and Leicester were part of a loose network of men who believed in the providential struggle between Protestantism and Catholicism and this did raise the temperature of religious politics at Court and drew attention to Catholic plots both internal and external. In 1584 Burghley and Leicester formed the Bond of Association with the zealous Protestant Francis Walsingham and this involved plans to run the country from the Privy Council in the event of Elizabeth's assassination. Elizabeth could be coerced by Burghley and Walsingham, for example into priming the 'men of business' in parliament to notch up fears over 'obstinate papists…schismatics and heretics'. However, if Elizabeth did not want to act she eventually became eloquently defiant.[117] She gained a reputation for being indecisive, for example when she oscillated between action and inaction over alliance with the Protestant Netherlands against Catholic Spain. She and Burghley were not always in complete accord. John Guy has said that until 1585 they were at odds over the question of the Queen's executive power with Burghley trying to convince the queen that her *imperium* did not exist but was instead confirmed by conciliar advice. Certainly one of the outcomes of political tension between Elizabeth and the Bond of Association men was a shift towards a more belligerent foreign policy resulting in the 1585 Treaty of Nonsuch that (expensively) pledged 6,000 English troops to the Netherlands under the command of the earl of Leicester. It also led to Elizabeth's reluctant and ambivalent permission granted for the execution of Mary Queen of Scots in 1587 after the Babington plot.[118]

In light of the tensions between Elizabeth I and her councillors it can be argued that Elizabeth's dramatic projections of her royal status seem aimed at her courtiers and Council rather than her subjects and the maintenance of her authority depended on constant reference to the royal lineage that gave her power. To her courtiers she was the Sun Queen: Sir Christopher Hatton described being away from court as missing 'the brightness of that sun that giveth light unto my sense and soul' and he built the magnificent Kirby Hall to receive her on one of her summer progresses that took her from house to house. Burghley's house at Holdenby was built for Elizabeth, but became a fully-staffed shrine to a queen who never arrived. The summer progresses took Elizabeth from London through the English countryside in a baggage train of at least 500 people moving at four miles per hour amongst her people.[119] The more formal processions to celebrate anniversaries and open parliaments emphasised her mystical power and divinity but juxtaposed this with public accessibility.[120] While being entertained at pageants she was, again, on show and Stephen Greenblatt has argued that her self-fashioning was that of queen as the 'embodiment of Renaissance power'.[121]

Elizabeth's projection of her authority as prince/queen had visual as well as verbal components and her political thought is embedded in both. Her visual image was dual – prince and virgin queen – and despite the small number of official images (she probably only sat for seven official portraits, though there were

many copies and imitations that circulated widely), it is the visual iconography of her reign that is responsible for the cultural memory of this queen.[122] If Elizabeth's visual political thought may be seen most vividly in the prince represented as the Virgin Queen, quintessentially feminine but above the corruption of the female sex, her political thought in words rarely deployed womanhood except to shed even brighter light from the sun on her role as the prince.[123] In other words, her verbal representation was, on the whole, more masculine. She told her 1566 parliament: 'Though I be a woman, yet I had as good a courage as ever my father had.' Royal celebratory propaganda after the Armada victory reveals the difference of representation between word and picture. Her most famous speech on the beach at Tilbury on 9 August 1588 deployed femininity only to give greater weight to her masculine role and authority: 'I know I have the body of a weak and feeble woman, but I have the heart and stomach of a king and of a king of England too.' The double imagery at the end of the speech confirmed the royal descent of her body politic and harked back to the European battle successes of Henry VIII. However, the Armada portrait that was later painted displayed her femininity. Her elaborate dress, replete with ribbons and pearls, was the height of fashion at the Valois court; she was ornately revealed, her face and hair arguably more elegant than in any other of her portraits.[124] Her right hand rests with imperial majesty over a globe signifying her *imperium* while her left hand uncomfortably pins a glorious feather fan between thumb and forefinger.

The power relationships that Elizabeth held with her peers can be examined through her use of gendered political language. She deployed maternal language with her parliaments, for example, telling the 1566 parliament that they would 'never have any more mother than I mean to be unto you all'. This is quite extraordinary language for a woman of 33 addressing men many of whom were older than herself. When she was painted by Nicholas Hilliard in 1574 in the Pelican Portrait, the symbolism was breathtaking; the jewelled pelican sat at the breast she was willing to peck to feed her young with her own blood. However, when James VI of Scotland wrote humbly denying any involvement in the murder of the son of the earl of Bedford and addressed her as 'Madame and Mother' and himself as 'son' she replied referring to herself as his 'affectionate sister and cousin' to assert their equal status as princes. When writing to him two years later about the execution of his mother, she called it a 'miserable accident', signing herself off 'loving kinswoman' (hinting at his potential position as heir to the English throne) but also warning him that princes should not interfere in one another's business.[125]

The image -v- the reality of Elizabeth's reign is something that historians grapple with as her portraiture implies a success that was sometimes not matched by the more qualified successes of her foreign and domestic policies. During the 1590s she lost to death her longstanding ministers, and court politics became dominated by unstable relationships with male courtiers such as the impulsive Sir Walter Ralegh and the handsome poltroon, Essex, who was responsible for rebellion in Ireland in 1601. Campaigns in France cost several thousand men and at least £300,000.[126] As if to compensate for these losses, the portraits at the end of

Elizabeth's reign were the most complex of all.[127] The Ditchley Portrait by Marcus Gheeraerts the Younger painted in 1592 celebrated Elizabeth's divine power with a celestial orb suspended from her left ear and the Rainbow Portrait by Isaac Oliver of 1600 showed a queen more youthful than the real sitter, celebrating her own immortality, a crescent moon on her head like the goddess Cynthia and wearing the transparent veil of Juno, wife of Jupiter, goddess in the heavens. The heavily embroidered serpent that snaked its way up one arm represented Elizabeth's political cunning. Embroidered eyes and ears on her dress heard and saw all. The inscription, *non sine sole iris* (no rainbow without the sun) reminded people that she was the sun without whom the court would receive none of its light. This is Elizabeth's imago, or the *jure divino* monarch emerging in full glory from its coronation chrysalis. In addition, Elizabeth as goddess was enacted in the cultural life of the *fin de siècle* court; she was a patron of new theatre and principal guest at the earliest performance of *Midsummer Night's Dream*.[128] Throughout her life she treated the court and country as her stage and the projection of her political power was a performance that was all the more powerful for her being a woman. As Susan Watkins has put it, she was the Virgin Queen and every variation possible on the goddess myth – 'Diana, Pandora, Belphoebe, Astraea, Oriana, Gloriana'. And in one further powerfully-symbolic inversion she juxtaposed the goddess with the humble queen who told her 1601 parliament that 'no prince...loveth his subjects better'.[129]

Elizabeth I died in the early hours of the morning of 24 March 1603. She had reached her seventieth year. Although she had stayed active and apparently healthy till the end, she ate very little and was troubled and sometimes depressed in the last two years of her life. Perhaps a clue to her melancholy can be found in her behaviour and that of those around her in the final days. While she rested on cushions, her minister Robert Cecil drew up a proclamation that would declare James VI of Scotland her successor. However, as late as 23 March she thundered at Lord Admiral Howard that her 'seat hath been the seat of kings' and 'I will have no rascal to succeed me'. Later in the day she raised herself in bed to make the gesture of a crown above her head. After 45 years Elizabeth's belief that her successor represented her 'winding sheet' proved correct and on 24 March her natural body reluctantly expired leaving her body politic to be mystically consumed by the natural body of James VI of Scotland.[130]

Elizabeth's posthumous reputation is evidence of the powerful impact she exerted on the national imagination and it began quickly with William Camden's *The True and Royall History of the Famous Empresse Elizabeth* (1625) and *The History of the Most Renowned and Victorious Princess Elizabeth* (1630).[131] Camden established her as valiant queen who preserved England from the Armada and his work engendered in early Stuart politicians an English patriotism summed up by Sir John Finch in 1628 when he observed that 'Spain hath cause to remember her'.[132] Elizabeth as founder of a settled English Protestantism was a reputation that shone brightly for at least 200 years. Bishop Burnet's *History of the Reformation* (1679) represented her in its frontispiece as 'England's Minerva' who holds the knowledge of heavenly wisdom, the Bible in her right hand the cornucopia or

horn of plenty in her left.[133] However, her reputation could be co-opted not just to a nationalist religion, but also to the agenda of femininity. Diana Primrose's *A Chaine of Pearles* (1630) listed Elizabeth's pearls as the female virtues of 'chastity', 'temperance' and 'clemency' but listed also the virtues of a good monarch such as 'prudence' and 'justice' and concluded that the pearl that gave lustre to all was '[t]he goodliest Pearle in faire Eliza's Chaine…true religion'.[134] Elegies at the time of Elizabeth's death described her as a goddess and virgin on earth, now ascended to be goddess and virgin in heaven.[135]

The reign of Elizabeth can be analysed in terms of finance, foreign policy, domestic policy and religious reform and in all of these areas there are arguments that can be made for success or shortcoming. However, gender analysis of the reign of Elizabeth as female rule is in many ways more revealing. If a woman ascended the throne and successfully co-opted a masculine mantle of state in early-modern England, the impact of this at the time and the cultural memory it laid down was more powerful and enduring than anything that could be achieved by a man. Mary's reputation as 'Bloody Mary' is a negative version of this process of gendered historical memory, but in Elizabeth's case her long Protestant reign shines with extra brightness because of the original constraints imposed on her rule by ideas about her sex and gender.

Early Stuart patriarchal political thought

Early Stuart political thinkers from 1603 tended to talk in terms of a hierarchy of authority based on the 'rule by fathers' (i.e. patriarchy) with no separation into public and private spheres of power and influence.[136] The starting point of patriarchy was the Christian inheritance but the fullest expression of patriarchal political thought was Robert Filmer's *Patriarcha* which was written in about 1632. The work was driven by the central fear that '[t]here is no tyranny to be compared to the tyranny of the multitude'.[137] The central argument of *Patriarcha* was that Adam as the first father was the first to possess royal authority and that this descended directly to his sons. In this Biblical model of royal succession monarchs could trace their royal authority back to the patriarchs of the early Christian church. Filmer argued that the divine institution of royal power was established at Creation resulting from the first father's (Adam's) authority over women and children 'by right descending from him the patriarchs did enjoy [lordship that] was as large and ample as the absolutist dominion of any monarch which hath been since the creation'.[138] It was, therefore, an argument highly dependent upon gender.

Filmer argued that after the flood, royal authority devolved to the sons of Noah and that after the confusion of Babel fathers of distinct families became rulers and 'after a few descents, when the true fatherhood itself was extinct…the title of prince or king was more significant to express the power of him who succeeds only to the right of that fatherhood'.[139] By this means even children could become 'pater patriae' [father of the fatherland]. In Filmer's model, succession needed to be maintained, requiring a parallel model of non-resistance to royal authority.

Obedience became crucial and Filmer used the Fifth Commandment – 'honour thy father and mother' – to place subjects in the role of children to obtain obedience even to a child king. Fathers held a 'natural right of regal power' and the natural duties of kings and fathers were the same.[140] The central idea determined the monarch's relationship to other institutions of the realm. For example, all laws are the king's laws and as 'kingly power is by the law of God, so it hath no inferior law to limit it' because '[t]he father of a family governs by no other law than by his own will'.[141]

Filmer's work (though not published until 1680) distilled and reflected the political thought of James VI's *Basilicon Doron* of 1598. In 1603 this work was reprinted in London to coincide with James becoming king of both Scotland and England. *Basilicon Doron* was a book written in the tradition of kingly advice to the heir and it accordingly started off with an address to James' son, Prince Henry: 'Your father bids you studie here and read, How to become a perfite king indeed.' James told Henry that he owed duty to God because he '[has] made you a little God to sit on his throne'.[142] The king's court was the patriarchal householder's domain writ large and, equally, it was on show as a model of good order in society. Furthermore, the king himself was on show to male heads of households: '[l]et your owne life be a law-booke and a mirrour to your people; that therein they may read the practise of their owne lawes; and therein they may see, by your image, what life they should lead'.[143] The analogy with the well-ordered 'little commonwealth' of the householder continued as one in which servants 'know no other father' but the king.[144] Thus, James' gift to his son was a model of good kingship based primarily on how to be a good man. As a logical part of this instruction, James advised Henry about the choice of a wife and how to maintain a well-ordered marriage. The advice was identical to the prescriptive model for marriage – 'Yee are the head, she is your body; It is your office to command, and hers to obey.'[145] James' advice ended with the instruction that if he died before the present queen, his son was to place her 'in a throne on your right hand'.[146] Thus, patriarchal political thought was firmly founded on 'honour thy father and mother' and if a father was absent, authority to him was honoured through the mother, the model extending from ordinary widow to female regent or dowager queen.

In the same year that James offered his son Henry the model of the perfect king he offered political thinkers his model for the perfect institution of monarchy in *The Trew Law of Free Monarchies* (1598), a work that has often been taken as a statement of absolute monarchy. In it James drew a model of the office of monarch that matched the body natural of the perfect king so that the line between the king's two bodies was blurred when the monarch was a man: 'Kings are called Gods by the prophetical King David because they sit upon God his throne in the earth … [and] By the Law of Nature the King becomes a natural Father to all his Lieges at his Coronation.' The arguments that followed again mirrored those in domestic manuals. As a 'kindly father' the king nourishes, educates and governs his children in a fair manner and in return they should demonstrate obedience. The king was *pater patriae* and, therefore, 'compare[s] to a father of children, and

to a head of a body composed of divers members…The head cares for the body, so doeth the King for his people'. And like children, the king's charges had no right to resist; such action would be 'monstrous and unnaturall'. The king could punish, as cutting off 'some rotten member' will not debilitate, but cutting off the head [i.e. the king] destroys the whole.[147]

The political language of *Trew Law of Free Monarchies* is highly gendered so mothers crept into the argument as a metaphor for unlawful and unnatural resistance to kings. James argued that while kings were like natural fathers, such was their divinity, that it was God who transformed them from private individuals to 'public magistrates' in whom the sword of state alone resided. The model of irresistible king matched exactly the model of husband upon whom good household government was dependent. Thus he used the language of gender relations in marriage as a rhetorical tool in his political speeches. For example, when he was trying to persuade the English members of the 1604 parliament that they wanted legal and economic union with Scotland made statutory he said: 'I am the husband and the whole isle is my lawful wife; I am the head and it is my body.' The marriage metaphor framed the entire speech, extinguishing any distinction between the public and the private sphere: God united the kingdoms and he was the head of this multiple body that he gendered female in order to describe the relationship of duty of obedience upwards from the body to the head and the duty of care downwards from the head to the body.[148] There is an interesting contrast to be made here with Elizabeth; to establish her authority she had relied on the Fifth Commandment and located herself as mother, but for James I, political authority was backed automatically by the gendered political language of father. Therefore, masculinisation of the politics of the Stuart state was a consequence of the two ideas that most constructed early-modern monarchy – the divinity of the king in his/her natural body mirroring exactly a male Godhead and the quintessential masculinity of the office of the king in the theory of the king's (or queen's) two bodies. The fact that James' natural body or sex was male just confirmed the gendered concepts embedded in Tudor and Stuart political thought and James co-opted notions of the godly householder in a move that de-mystified but simultaneously empowered his role as king.

Queens consort: Anne of Denmark and Henrietta Maria

James VI married Princess Anne of Denmark in 1589, their union taking place after lengthy negotiations that resulted in a £150,000 dowry. Anne's trip to Scotland was horrendous, the Danish fleet taking 50 days just to get her across stormy water to Oslo where she was met by her new husband. On 22 December the 15 year old Anne, who spoke no English or Scots but could communicate with James in French and probably spoke Latin as well, left Oslo in a sled with the king of Scotland, only arriving weeks later at the Firth of Forth. She was ill in the sled and frightened at sea. Her arrival on 1 May was celebrated with cannon fire from an official landing pontoon draped in gold. Once at the Scottish

court she withdrew with her small circle of Danish courtiers. Scottish tradition dictated that her children when born were given to Scottish noble families to be raised and her first child, Henry (born in 1594), was given to John Erskine, earl of Mar and his mother, the dowager countess. Anne hated them and in 1603 she refused to move to England without Henry.[149] The marriage between Anne and James was punctuated by tension, though their correspondence does also reveal some companionability and unity in grief over the loss of five of their eight children.[150]

Anne's court was separate from that of James' and quite complex; it had maids of honour, ladies in waiting, officers of 'works', heralds/pursuivants, musicians, 'sergeants' and even 'justices of the assize'. It had female courtiers, but also men who held office in both her court and the court of James. Linda Levy Peck has said her 'household was thus a political web from which patronage connections radiated'.[151] As the central figure of her court Anne acted as matchmaker to female courtiers, universal godmother to their children and as conduit to the king, taking petitions and suits from men and choosing whether or not to support them in her written communications with James. For example, she was solidly supportive of the jurist, Edward Coke, and, more significantly for the future, George Villiers, duke of Buckingham, who was knighted by James in her bedchamber and went on to become the favourite of her son, Charles.[152] Thus, her political authority as queen consort amounted to wide-ranging powers of patronage so that for her courtiers closeness to the queen was all. Some women such as the countess of Hertford were ladies of the bed chamber, while others were attached to the drawing chamber. The queen expressed her favour in many ways, not least by dispensing gifts of her own clothing. An inventory of her wardrobe listed and described all of her dresses and their redistribution. So, for example, in 1610 a skirt of black satin and lace was 'given by her Majestie to Mistress Bridget Anslow'.[153] Leeds Barroll has argued that '[p]aradoxically... the accession of James... [activated], for the first time in decades the political aspirations... of a number of ambitious and talented women', especially the Essex Group around the countess of Bedford who seized the initiative in 1603 by meeting Anne's entourage as it travelled south from Scotland. The Essex Group was politically more powerful at the court of the queen than their husbands were at the court of the king and they were the ones to whom other women (and men) went for patronage.[154]

Anne was, in modern parlance, a culture vulture. Her parents, Frederick II and Sophia of Mecklenburgh, were highly learned and supported the arts and sciences, most notably being patrons of the astronomer, Tycho Brahe (who was famous for having a prosthetic nose moulded in silver and gold). Anne's entertainments in her English court ranged from the small-scale play called *Gramarcy* put on by the Company of the Revels on 30 December 1621 which cost the Exchequer £3 6s 8d, to Samuel Daniel's *The Masque of Blackness*, in which the queen herself performed to mark Prince Charles' elevation to duke of York in 1605, and which cost £8,000.[155] The queen's political power of patronage resulted in her household containing courtier poets and painters such as John Florio and Isaac Oliver who became grooms of the privy chamber.[156] The countess of Bedford emulated the

queen, keeping her house at Twickenham as a hub of cultural activity and offering support to writers such as Ben Jonson.[157]

Jonathan Goldberg has argued that Anne of Denmark's love of theatricality and disguises served as a form of 'self-revelation' and it enabled her to participate in a political culture that presented her union with James as analogous to the early-modern family. In Ben Jonson's *Masque of Queens* she appeared as BelAnna, ushered in by Perseus whose virtue helped her and the king to give birth mutually to the 'House of Fame'.[158] The court masque – a medium so favoured by Anne – was designed, according to Jerzy Limon, 'to celebrate a particular occasion and to honour their monarch'. Acted by members of the nobility, masques deployed the codes of Greek and Roman mythology to signify and venerate the spectacle of royal power.[159] Thus, Anne exercised political power as patron and broker, but she was also important in the development of a court culture that reflected and sometimes reinforced James' political vision of monarchy as having its origins in early patriarchy and its echo in the private families of subjects.

Assessment of Anne of Denmark's time as queen consort results in a mixed picture. During her time at the English court it was rocked by two political scandals – the secret marriage and imprisonment of the king's cousin, Arabella Stuart, and the adulterous affair of Frances Howard with Robert Carr which culminated in the murder of Thomas Overbury.[160] The latter was the most damaging because of Howard's close connection to the queen. Balladeers had a field-day: 'Theare was at Court a ladye of late | That none could enter shee was so straight | But now with use shee's growne so wide | Theare is a passage for a Carre to ride'.[161] However, Anne was largely a popular queen consort. Her conversion to Catholicism was discreet and ambiguous and was offset anyway by promotion of a Protestant foreign policy up until the time of her death. Anne and James' daughter, Elizabeth, was married in 1613 to the Protestant count of the Rhineland Palatinate, Frederick, and in 1618 James lent his overt support to the Protestant Synod of Dort. One year after Elizabeth and Frederick's marriage they were forced out of the Palatinate and off their newly-acquired throne of Bohemia by Spanish Hapsburg (Catholic) invasion at the outset of the Thirty Years War, and James I's support of his daughter signalled Britain's union with Protestant European nations.[162] Anne was also popularly seen to be a great patron of the arts, music and architecture and it is certainly the case that the legacy of Inigo Jones' palace at Greenwich and her influence on her son's art collecting was of considerable importance. A contemporary eulogist likened her to 'Dido's sister' and 'Diana' but added what was perhaps most obvious in terms of her political significance: she 'was the first Anna-Queene, that anywhere | An Union-Crowne of Gold began to beare'.[163] Anne of Denmark died on 2 March 1619, after being the first early-modern queen to wear both the Scottish and the English crowns.[164]

The reputation of the next queen consort was very different. In the 1620s James I began to seek a marriage match for his only surviving son, Charles. In a change of policy direction encouraged by Charles himself, the ageing king allowed disastrous courtship first with the Catholic Spanish Infanta in 1621 and then Princess Henrietta Maria of Catholic France. A marriage treaty was in the end signed

with the French in November 1624. Henrietta Maria was the devoutly-Catholic daughter of Henri IV and Marie de Medici.[165] Her marriage settlement brought her property and considerable powers of patronage. She acquired swathes of land in Bedfordshire, Cumbria, Nottinghamshire, Lincolnshire, Norfolk, Suffolk, Sussex, Surrey, and lordships and land in Eltham, Twickenham, Grantham, Canterbury, and Yorkshire properties in Pickering, Knaresborough and Patrington; her 'Book of the Manor' of 1631 indicates rents of *circa* £6,000 from jointure lands alone.[166] She had a large French retinue at court and her court's annual budget was £20,000.[167]

The marriage of Henrietta Maria to Charles after he became king in 1625 involved the suspension of some penal laws against Catholics in England altering altogether England's alignment with European powers in the tense religious politics of the Thirty Years War in Europe. Charles I came under internal pressure to uphold the doctrinal settlement of the Synod of Dort. However, Henrietta Maria was expected by France and Rome to lobby her new husband on behalf of Catholics in England, Scotland and, especially, Ireland, in return for the papal dispensation that had allowed the marriage to take place. Britain's political stability had been highly dependent on the monarchy upholding the Calvinist consensus of the Church with the godly or puritan laity, but this was rapidly eroded by the publication of Richard Montagu's two crypto-Catholic works, *A Gagg for the New Gospell? No a New Gagg for an Old Goose* (1624) and *Appello Caesarem* (1625). The latter, especially, argued for some degree of salvation through the intercession of saints and raised fears of a rise of Arminian theology of the kind that had fractured European Protestantism and prompted the calling of the Synod of Dort. Charles I's defence of Montagu and promotion of the interests of Arminians and particularly William Laud was deeply disliked and interpreted along with his marriage to a Catholic as part of a wider trend away from the true religion of [Calvinist] Protestantism.[168]

During the 1630s Charles embarked on a long Personal Rule during which he called no parliaments and religious discontent became focused on his Catholic wife.[169] Political suspicion of the royal court was exacerbated by Charles I's inaccessible and mercurial style of kingship, a distance from his subjects that he put down to the need for order.[170] Charles I, despite his reputation for being an authoritarian king, brought about a shift in political culture away from Elizabeth's cult of the prince/virgin queen and James' patriarchal monarchy to projection of his political persona as the uxorious and domesticated monarch. Both Kevin Sharpe and Jonathan Goldberg have argued that Charles' royal image was double, or that of king and his queen. Familial imagery dominated portraits and monarchical symbols such as the crown were often positioned between Charles I and Henrietta Maria. Their marriage was glorified by other symbols such as the presence of angels at their promissory hand-holding and their children in family scenes. Court masques such as *Love's Triumph* placed the couple at the centre of political celebration and, according to Sharpe, 'they celebrated a union of virtues greater than either possessed in themselves'.[171]

In other words, Charles I drew attention to Henrietta Maria whose court, in both its organization and financing, was quite distinct from his own, and overtly

Catholic. Suspicions, therefore, arose about her entertainment of ambassadors from Rome and papal agents. Her court appeared to be tainted and politically dysfunctional, her political ambitions equated with those of her country of origin and Counter-Reformation Catholicism and indeed she was under instruction from her confessors to observe Catholic religious practices without fail.[172] Her link to the Pope was too obvious. For example, on 6 April 1625 she wrote to Urban VIII saying that 'nothing in the world...is so dear to me as the safety of my conscience and the good of religion'.[173] Hers was a transparently partisan religious faith and her position as queen consort encouraged Catholic writers to publish thinly-disguised works of Catholic veneration through equation of her with the Virgin Mary, such as Henry Hawkins' *Parthenia Sacra* (1633) and *Maria Triumphans* (1635). Other works such as Anthony Stafford's *The Femall Glory* (1635) exploited the metaphor of the 'blush' to express a poetic love for the queen in deeply unpopular, crypto-Catholic terms.[174] The queen's circle at court became the focus of anti-Catholic and xenophobic anxiety and, although it is difficult to measure the extent of her unpopularity in the 1630s, it is known, for example, that Henrietta Maria and her retinue suffered physical attack during an enclosure riot in East Anglia in about 1631.[175]

Sharpe has argued that despite Charles' love for Henrietta Maria her political leverage with him was limited and the king, who was himself in daily contact with the papal agent, did not bend to the pope's agenda. However, Sharpe concedes that Henrietta Maria gained greater leverage after 1635 and this was destructive of precariously-balanced English politics and led to increased fear about the influence on Charles of Henrietta Maria's many Catholic lobbyists. Gregory Panzani wrote weekly reports to Rome in the late 1630s expressing his desire that God 'with vilifying rays...enlighten the king...that these poor souls may come forth out of darkness' and he promoted Henrietta Maria's role as the agent of England's national reversion to Roman Catholicism.[176]

Many historians have noted Henrietta Maria's importance as a player during the civil wars after 1640, but her involvement in the descent into and causes of civil war are as important.[177] In 1635 she strongly backed the Anglo-French alliance potentially leading England into the war on the continent with Catholic allies.[178] In 1637 there was a rash of highly-publicised conversions to Catholicism in her court and in the same year Charles' attempt to impose the English prayer book on the ultra-Calvinist Presbyterians of Scotland led to widespread protest, the signing of the Scots National Covenant and the ejection of Scottish bishops, many of whom fled to Ireland where they were unwelcome amongst the Catholic population. Henrietta Maria was deeply implicated in the political turmoil of the Bishops' Wars; she used her connections with France to coordinate an alliance between Cardinal Richlieu in France and Robert Maxwell, earl of Nithsdale, who was Charles' advisor on the Scottish Privy Council. Nithsdale was an important figure in the survival of Catholicism in Lowland Scotland and was responsible for suggesting the tactics of the first Bishops' War in 1638 which ended in humiliation with the pacification of Berwick.[179] The second Bishops' War in 1640 was even more messy and resulted in the invasion of north-east England by the

Scottish Covenanting Army. During 1640 Henrietta Maria was sending tactical instruction to Nithsdale via a messenger and when Nithsdale failed to defend his castle at Caelaverock, Charles I was forced to authorise surrender.[180] In other words, Henrietta Maria's actions contributed to the early defeats and humiliations of Charles I in the skirmishing that preceded full civil war.

The main political role played by Henrietta Maria during the 1640s was as counsellor to a king whose lack of compromise with his subjects she strongly supported and encouraged. She became his military logistical supporter and her liaison with Catholic Scots set the pattern for her involvement in the English Civil War from 1642 when she sided against the Scottish Covenanters and their English puritan allies in parliament.[181] Michelle White has pointed out that her assertive behaviour was perceived as the royal marriage in a state of 'disorder' and her influence on Charles perceived as contributing to a situation in which the king was subject to the ill advice of evil counsellors including herself. As household order was considered the model for order in the state, the inverted gender hierarchy was viewed with deep distrust. In 1641 Henrietta Maria retreated to Holland claiming that if she had done anything illegal it was out of 'dear and tender affection to the king' and because she was 'ignorant of the law'.[182] She promised to remove the papal agent from her court and reduce Catholic worship in her entourage. However, in 1642 suspicion about her role intensified when she encouraged Charles I to arrest the Five Members of the House of Commons and began raising arms and money for him by selling her jewels in the Netherlands. The streets of London were awash in tracts that warned of her duplicity like *The Queens Proceedings in Holland* and *The Queens Resolution Discovered by Some Letters in the House of Commons*. Her letters were intercepted and printed and her bellicose intentions reviled.

Some letters Henrietta Maria sent were designed to be intercepted and give false information about her imminent return to England. On 17 March 1642 Henrietta Maria told Charles that he must secure the sea port of Kingston upon Hull and she added that 'whatever may be said to you, do not break your resolution'.[183] He did not manage to take Hull, to his disadvantage, and he did not break his resolution, also to his disadvantage. In April 1642 Elizabeth of Bohemia told Thomas Roe that 'the queen is against any agreement with parliament but by war, and the king doth nothing but by her approbation'. She certainly constantly advised him to take pre-emptive action against parliament, telling him not to delay or yield anything, not to 'lose courage', pleading with him not to make her look 'ridiculous' by giving in.[184] Carola Oman's sympathetic biography of Henrietta Maria pointed out that in the decade before Charles' execution Henrietta Maria continuously 'existed in an atmosphere of alarm, ceaseless intrigue and insecurity'.[185] Oman used Henrietta Maria's title for herself – *generalissima* (little female general)[186] – as the title of the chapter that covered her civil war activity.

In January 1643 Henrietta Maria returned to England; she was tossed around in the North Sea by storms and fired upon by parliamentary forces stationed on the Yorkshire coast. On her way from Bridlington to York she stopped for two weeks at the house of a member of parliament, Walter Strickland, before leaving with

all the family silver as a payment towards the war effort. She eventually left York with a force of 3,000 men, joining up with Prince Rupert and then Charles at Oxford where he was stationed with the royal court.[187] However, Henrietta Maria's aspirations to be a militarist queen consort were terminated by pregnancy and she retreated to Exeter where she gave birth to a daughter on 16 June 1644. She was then spirited in disguise to Cornwall and set sail for France where she established a court in exile in Paris.[188] She continued to contribute money and logistical support to her husband but never saw him again. After the battle of Naseby in 1645, the king's cabinet of letters was seized and their correspondence became integral to parliamentary propaganda. Charles was ultimately executed in 1649, though Henrietta Maria did not die until 10 September 1669, by which time she had returned with their son to England.

Henrietta Maria was a queen consort whose patronage extended to the arts; she can be attributed, for example, with the high profile attained by Inigo Jones. However, her more enduring reputations are as agent of popish plotting and evil counsellor of Charles I, or as heroine of the Royalist cause and devoted wife depending upon which side of the story one reads. Tracts such as *A Mappe of Mischief* of 1641 were responsible for her bad reputation, the author wishing upon her 'hell and confusion' for 'endeavour[ing] to overthrow a Common-Wealth' (a deeply radical political sentiment for 1641). Her reputation as heroine was partly established at the Restoration in 1660 when tracts such as *The History of the Thrice Illustrious Princess Henrietta Maria de Bourbon, Queen of England* appeared. Most recently Caroline Hibbard has said that Henrietta Maria's political importance has been overlooked because of the tendency to view seventeenth-century Britain as a nation state, the political hub of which was king and parliament, instead of an *ancien regime* in which her dynastic and religious manoeuvrings and fundraising were very important.[189] To this I would add the powerful and iconic significance of Henrietta Maria as a Catholic queen consort in a composite kingdom divided in two by religion and torn apart by civil war.

Queens, mistresses and coffee houses 1660–1700

The civil wars of 1640 to 1660 changed the face of English political culture. The political power of patronage of aristocratic women remained after the Restoration of the Stuart monarchy in 1660 though the link to the power of the court was less clear and the queens consort of the later Stuart kings had much less political influence than their predecessors. Recent historical debate has stressed a functional difference in the political culture of the late Stuart period because of the extent to which public opinion could make an impact on events. This change in political culture has been encapsulated by the phrase the 'rise in the public sphere' which is a concept associated with the work of Jürgen Habermas, especially his *Structural Transformation of the Public Sphere* which first appeared in German in 1962. Habermas' argument was that at a fairly precise historical moment a larger slice of society became involved in political activity.[190] Habermas defined the public sphere as a sphere of human activity located between society and the

state as an 'institutional location for practical reason in public affairs' involving appropriation by private individuals of political opinion so that state authority became 'monitored through informed and critical discourse by the people'.[191] In other words, popular politics gained political currency and high politics became influenced by public debate in a more fluid and democratised society.

Habermas' model of a rise of the public sphere was essentially a neo-Marxist historical formulation and, indeed, he argued that it came into being pretty much in conjunction with the mercantilism and growth of capital wealth associated with the founding of the Bank of England in late Stuart England. The recent appeal of his model can be seen in revisionist political histories of seventeenth-century England which classify the popular politics of the English Civil War as a precursor to democratic political philosophy and activism in an essentially bourgeois or liberal state associated with the discursive separation of the public and the private spheres.[192] The location for a growth in public political debate could be the private sphere of the home as people increasingly discussed the events contained in news-sheets and pamphlets, though Habermas and the historians who have followed his lead have placed greater influence on the opening of coffee houses as places of public debate. The first London coffee house appeared in St Michael's Alley off Cornhill in 1652 and represented the teetotal answer to the tavern as a place for talking the godly politics that dominated the 1650s of Oliver Cromwell's political supremacy. Inns and alehouses had always been places of gossip, but coffee house culture was different both in atmosphere and scale of news exchange.[193] In 1673 Thomas Player complained that '[t]hese sober clubs [coffee houses] produce nothing but scandalous and censorious discourse' and he lamented the loss of the supposedly more civilised discourse produced by the consumption of sack and claret.[194] By 1673 coffee houses were populated by men whom one female critic satirised as 'buzzing insects … [who] carry news from one neighbour to another, and have their stages about town as regular and certain as a penny postman'.[195] Coffee houses increased quickly in number – by 1663 there were 83 in the capital and within a century there were over 400 more.[196] They became institutions that defined political partisanship and, to some extent, created it: the Whigs came to meet at St James' coffee house, while Tories flocked to the Cocoa Tree on Pall Mall. The new world of debate and opinion did not need knowledge of the classics, but called for literacy which it encouraged *per se* amongst the newer merchant and professional classes.[197] Newspapers flourished: *The Tatler* appeared for the first time in 1709 and, in a corner of Button's Coffee House there was a lion with open jaws for posting letters of opinion to the editor of *The Spectator*.[198] According to John Brewer, newspapers allowed a 'public … to imagine itself'. Equally, it allowed a public freer criticism of the monarchy.[199]

Additionally, Charles II populated his court with courtesans who were not part of the nobility so blurring the line between royalty and popular culture and opening the monarchy up to greater moral scrutiny. Before the arrival of his wife, Catherine of Braganza, in 1662 he was romantically attached to Barbara Palmer, countess of Castlemaine. He also already had an illegitimate son, James Scott (later duke of Monmouth), from a short-lived affair with Lucy Walter, whom some

thought he had clandestinely married in France. Catherine of Braganza was buffeted by the politics of sex and reproduction and her failure to produce a son guaranteed that she had little political agency. She suffered continuous gynaecological problems that manifested themselves as heavy uterine bleeding and miscarriages. Her childlessness combined with her Catholicism led to pressure on Charles to dissolve the marriage. But the king refused and he made a point of chivalrous public displays of affection whenever his wife was under threat.[200]

While some historians link the political failings of the Restoration court to the decadence and sexual immorality of Charles II, the language of sex in politics in fact actually first surfaced during the political turmoil of the 1640s. Robert Wood, for example, has argued that sexual scandal in political debate 'defus[ed] the smouldering extremes of English political society' and was not, therefore, primarily concerned with moral judgement of the behaviour of Charles II.[201] However, the framework of political scandal sheets in the 1660s and 1670s was determined partly by the sexual exploits of Charles II. For example, much was made of the rivalry between Charles' various mistresses. The rumours that Nell Gwyn had slipped Mary Davis a laxative before one sexual encounter with Charles were still surfacing in 1716 when *The School of Venus* was performed, promising, as it did, 'a secret history' of 'cuckold kings'. The earl of Rochester, a man whose vile poetry epitomised the descent into a pornographic political culture, wrote: 'Poor Prince! Thy prick, like thy buffoons at Court | Will govern thee because it makes thee sport.' At least as part of the polemical strategies of Restoration politics, Charles' mistresses assumed an iconic status that was greater than their real political clout and their names fuelled the gossip of the coffee houses. The countess of Castlemaine was labelled by contemporaries 'that prerogative queen' (hinting at her use and misuse of the king's prerogative powers) and Nell Gwyn's status as 'the Protestant whore' was figured in jest to highlight the dangerous Catholicism of her main rival, Louise de Kéroualle. The fact that Nell Gwyn and Louise de Kéroualle both had sons by Charles II – both called Charles and born two years apart in 1670 and 1672 – intensified the bi-polar nature of Protestant -*v*- Catholic politics and made them useful in a partisan war of words.[202] Charles seems to have preferred women who did not become involved in politics and biographies of Gwyn and de Kéroualle reveal little evidence that they ever raised political matters with the king beyond a little patronage.[203] However, some historians mistakenly attribute to the courtesans the political influence that late Stuart contemporaries imagined existed between the sheets.

The political landscape of later Stuart England was quite different from the one before the 1640s and partisanship came to inform and dominate political discourse. Tory and Whig satires flooded the market with malice, making claims to speak for a 'public' that was as much a fiction as the stories and lies propounded. Partisan print thus not only defined opinion but also functioned, at least according to one contemporary, Mary Astell, 'to embroil the state by working on the fears and jealousies of the weak and injudicious'.[204] Thus, sexual and political immorality joined as one and a form of political pornography emerged in the late Stuart state

that not only tainted the monarchy itself, but led to association of the figure of the prostitute with a corrupting democratic political culture.[205]

Nell Gwyn, herself, was deeply conscious of her greater political, if not social, respectability (which is not the same as influence) as Charles' patriotically Protestant and English mistress. Her friendship with the duke of Monmouth aligned her with those who were paranoid about a possible Popish Plot behind which might lurk the malign influence of the Catholic queen (Catherine) and Catholic whore (Louise de Kéroualle). The scare about a Popish Plot began in 1678 with the fabrication by Titus Oates and Israel Tonge of 43 assertions about a possible assassination attempt on Charles II by Catholics wanting to replace him with his brother James, duke of York, who, in his position as Lord High Admiral, had fought against the Protestant Dutch Republic. After his Protestant wife, Anne Hyde, died in 1671, James had stopped taking communion in Church of England services, converted to Catholicism and married the Catholic Italian princess, Mary of Modena, in 1673. Requests from the House of Commons to void the marriage, because of its potential to bring a Catholic heir to the throne, went unheeded. James' second wife had countless miscarriages and pregnancies, but her fertility was not in question and anxieties about the religious faith of Charles' successor led parliament to introduce several bills from 1679 to 1681 intended to exclude any Catholic heir to the throne. In this atmosphere of heightened political and religious tension, the danger of women's words was invoked in the person of a Catholic midwife called Elizabeth Cellier who was accused of smuggling documents to 35 Catholic prisoners being held in Newgate.[206] This secondary affair in the Popish Plot became known as the Meal Tub Plot and Cellier's published defence, *Malice Defeated* (1680), lent ammunition to already frenzied Whig MPs as she attempted to accuse them of a counter Whig plot to torture and treat Catholic prisoners inhumanely. *Malice Defeated* was followed by propaganda in *The Tryall and Sentence of Elizabeth Cellier for Writing, Printing and Publishing a Scandalous Libel Called Malice Defeated* and *The Midwife Unmasked or the Popish Design* both in 1680 and *The Popish Damnable Plot* in 1681. These were all meant to serve as a warning about the threat to true or Protestant religion.[207]

Elizabeth Cellier's publication is just one example of women's greater participation in the political debates and popular political activity of the 1670s and 1680s. In 1675, for example, Mary White bought three dozen copies of a political tract that attacked bishops at a coffee house that was tucked behind the Royal Exchange. She was later found guilty of keeping six copies for herself and selling the remainder to a third woman in Charterhouse Lane. By this means she combined political subversion with entrepreneurialism.[208] Women such as the so-called mercury women of the *Athenian Mercury* were involved in newspaper print and distribution.[209] Many ran coffee houses where news was passed round so entering the public sphere as envisaged in the Habermas model. Mrs Streeter ran a coffee house in Drury Lane that was famous for political plotting and in the provinces Mrs Burry ran the Dolphin, Chichester, getting herself into trouble in the 1680s for Whig plotting. Joan Webb had a coffee house in Bristol and Mrs Jamieson had one in Preston. Rebecca Weedon was found guilty of distributing political

news and opinion in seditious pamphlets in the coffee house near the Exchange in 1678.[210] The fact that the late Stuart monarchy demanded oaths of allegiance from some women indicates its fear of women's political subversion. Lucy Douglas, countess of Nithsdale, was required in 1683 and again in 1685 to declare her loyalty to the king in order to continue claiming a pension of £200 for fear that she might be a Scottish Covenanter.[211]

In the polarising political context of the early 1680s the political capital of two people rose, but for different sides: first, the duke of Monmouth, as Charles' oldest and Protestant son (albeit illegitimate), became important to the Whig cause and, second, James' wife Mary of Modena, rose in importance because of her reproductive political role that was far greater than any of the courtesans connected to Charles II in case she produced a legitimate male heir to James.[212] When Charles II died on 2 February 1685, an anonymous balladeer joked at the fall of 'loving Nell' and the Catholic James II came to the throne.[213] The duke of Monmouth, became symbolically more important as the Protestant alternative, and he was pulled into conspiratorial politics against his uncle that culminated with the Rye House plot and a rebellion in mid-1685. Monmouth was defeated and executed and his removal from the political scene resulted in attention turning fully to the childbearing of Mary of Modena. Fears about continued Catholic succession were intensified by the fact that James II also already had illegitimate sons some of whom were being brought up as Catholics and, indeed, James' sexual life outside of marriage was as active as his brother's had been. His early mistresses had included Godotha Price and Elizabeth Denham; his later ones, Arabella Churchill and Catharine Sedley. Male courtiers were in the habit of removing their wives from the court to protect them from James who was a sexual predator.[214]

The empowerment gained by female courtiers when they became royal mistresses was quickly eroded by the sexual competition into which all women, including the queens consort, were drawn. Mary of Modena was less tolerant of James' affairs than Catherine had been of Charles', but her ability to change things was limited. In late 1687 another pregnancy for Mary of Modena was confirmed and the tension about a Catholic heir rose again to fever pitch. James' Protestant daughters by Anne Hyde, Mary and Anne, became highly implicated in spreading rumours about a false pregnancy. The eldest, Mary, had been married to William of Orange for 10 years. Her life in the Netherlands as the unhappy, childless wife of a Dutch *staadholder* (who was rumoured to be homosexual) had been relieved before 1685 mostly by visits from the hapless duke of Monmouth whose rebellious talk had encouraged her to see herself as the potential protector of English Protestantism. She steadfastly rejected all of her father's attempts to convert her to Catholicism. Her sister Anne was married to George, prince of Denmark, and the couple were under the constant advice of the duke of Marlborough and his wife, Sarah Churchill (née Jenyns), who was Anne's close friend. Edward Gregg points out that after the death of Charles II, Anne was 'the highest ranking Protestant member of the royal family resident in England'. Thus, she had symbolic status amongst the Whig opposition to James II, and her communications with William and Mary of Orange were vital to the outcome of the crisis over Catholic succession.

Anne also was childless, having lost two infant daughters to smallpox and had at least one miscarriage. On 14 March 1688 she told Mary by letter that the 'queen's great belly is suspicious' (she herself was pregnant again but lost the child a month later) and 'when she is brought to bed, nobody will be convinced it is her child'.[215] Mary also decided there was 'some deceit' being played. Their feelings were shared by Whig MPs keen to detect a Catholic conspiracy such as Sir Richard Temple who came to call the baby 'a pretended brat'.[216] In this atmosphere, Mary of Modena gave birth on 10 June 1688 to a son, James Stuart. Stories immediately circulated of either a baby smuggled into the chamber in a warming pan or a dead baby switched for a live one in a similar fashion. James II responded with publication of a series of deposition statements taken from witnesses who were present at the birth of his son. These were mostly the statements of women of the bed-chamber and midwives and were published to testify that the queen's body had indeed shown the signs of pregnancy. For example, the countess of Peterborough testified to seeing milk on the queen's smock. However, the burden was to prove a live [male] birth and not just a pregnancy and the Lord Chancellor, for example, testified that he had seen a child 'black and reaking...newly come from the womb' and the Lord Chamberlain claimed to have seen a boy.[217]

The anti-Catholicism generated in the 1680s ran deep and was vicious. A London pamphlet declared 'Here, here, here is pig and pork...shewing how a lustful Roman bore made a delicate piggin riggin a Catholic whore'. Woodcuts circulated on illicit packs of playing cards featuring Mary of Modena praying to the Virgin Mary for a son.[218] The sexualised language of politics talked of women as 'whores' and identified the Catholic or 'Romish' enemy with whorish women. Women were used as propaganda tools in other ways also: *The Princess Anne of Denmark's Letter to the Queen* of 1688 was a broadside publication of a document alleging Anne Stuart's blamelessness in the plots against her father. Supporters of James II, however, deployed the language of sex to discredit their Whig enemies. John Norris called them 'a murnival of knaves', cackling 'hens', 'gossips', 'drabs', 'stews', 'whores' and 'trulls' who were wedded to 'the good old cause' (or the English puritanism and Scottish Covenanting of the Civil War). In response, anonymous Whigs, such as the author of *The Character of a Jacobite*, complained that Jacobites were guilty of 'spiritual fornication' and were like 'Carnal Harlots' who adhered to 'spiritual Whore-mongers'.[219] In other words, what became modern parliamentary party politics with the party labels of Whig and Tory began life as arguments between men who savagely attacked each other using negative gender and sexual reference.

However, while the idea of woman figured as a political weapon it is also possible to see how this divided political world opened a space for women's political interventions. In December 1688 William of Orange landed at Torbay where he was met by Anne's husband, Prince George of Denmark, and the duke of Marlborough both of whom immediately joined his cause. The threat to James II was clear and in January 1689 Mary of Modena fled the country, arriving with her baby son at St Germain outside Paris where she stayed in exile for the rest of her life. Mary of Orange followed her husband to England, arriving on

12 February. She assented immediately to the Declaration of Rights that set up a dual monarchy. The downfall of James II can be partly attributed to the influence, status and sheer determination of his two Protestant daughters. Maureen Waller's account of James' 'ungrateful daughters' has pointed out that while England held its breath over the Popish Plot it ultimately fell prey to a gigantic, constitution-changing, Protestant one. Jonathan Scott has insisted upon the European religious context for the events of 1688–9, which he classifies as a 'foreign invasion' of England in which Mary of Orange's role was greater, symbolically, than that of her husband, though he had lobbied the English Whig opposition to James II for some time.[220]

By the time Mary of Orange became queen regnant the political thought and culture that informed thinking about female rule had utterly altered since Knox's *First Blast of the Trumpet against the Monstrous Regiment of Women*. Women were simultaneously venerated and reviled for their involvement in political affairs, their political currency greater, yet at the same time demeaned by the very public sphere of political opinion that they entered. And enter the public sphere they did. For example, Aphra Behn's work, *Love Letters between a Nobleman and His Sister*, of 1685–7, created the character of Philander who became a vehicle for Behn, who was a Tory, to critique what she saw as the Whig's political treachery and personal libertinism.[221] Women's entry into political commentary was accompanied by sentimental publications about Tudor women and their political status. John Banks' *Vertue Betray'd: Or, Anna Bullen* of 1682 was typical of the genre and Banks followed it with a portrayal of another tragic queen from the sixteenth century in *The Island Queen: Or, the Death of Mary, Queen of Scotland* in 1684. The latter was banned, perhaps because of its contentious portrayal of a remorseful Queen Elizabeth, but Banks used poetry and the story of the rival queens not only to turn Tudor history into soap opera, but also to invest in women powerful political *personae* and agency.[222]

In this context, the debate about female rule that ensued with Mary of Orange was muted and mostly supportive of her because of the precedent set by Elizabeth I who had also been a Protestant saviour. Lois Schwoerer has pointed out that between 1675 and 1689 there were five books about Elizabeth I published, and that John Shirley's *The Illustrious History of Women* appeared in 1686 in the run up to the Whig *coup* that put Mary II on the throne. However, it is also the case that the very political thought that lent legitimacy to invasion and usurpation of a rightful monarch, undermined women's claims to political authority once on the throne. The *de facto* theorists of the late 1680s countered early Stuart patriarchal thought by claiming legitimacy for monarchs by contract rather than divine succession. Robert Filmer's *Patriarcha* of 1632 was republished and became what Mark Goldie has called the 'textbook of divine right Toryism'. It was countered by Locke's *Two Treatises of Government* of 1689 the purpose of which was to justify William of Orange's invasion 'in the consent of the people'. His basic argument was that all people were born free and equal but that they chose to enter into a social contract to leave the state of nature and join a civil society, the political institutions of which, like monarchy, were not

divine but rationally and collectively chosen.[223] Some historians argue that it was the Lockeian contract theory that accompanied Mary II coming to the throne that was responsible for the first appearance of a distinction between a public and a private sphere associated respectively with masculinity and femininity. According to Carole Pateman, in Locke's *Two Treatise of Government*, liberalism and patriarchalism were reconciled with the consequence that 'women (wives) [were] excluded from the status of "individuals" and so from participating in the public world of equality, consent and convention'. In other words, women freely gave up the mandate to rule to men. If this was the case, the irony was that the political thought justifying a woman coming to the throne de-legitimised women's involvement in politics at the very time when women's participation in a broader democratic politics was on the increase.[224] The women who paid the price were royal women and women of the court because the loss of the sacrosanct status of monarchy excluded women more thoroughly from kingship than older patriarchal political thought because the latter had guaranteed to queens regnant like Mary I and Elizabeth I a claim to a divine right of succession that negated the prohibitions of their gender construction. In the case of Mary II, despite her Protestantism, her political authority was undermined by two further factors. First, when she came to the throne she was already under the dominion of a husband's authority and he had insisted that he would not become his wife's 'gentleman usher'. Second, she lacked the rigorous humanist education of her sixteenth-century forebears that might have educated her for the role of queen.[225] In other words, Mary II may have wanted to be the second English Protestant Deborah, but she was ill-prepared for her part as queen regnant and her political authority was seriously impaired by her marriage and by late Stuart political thought.

Historians have presented different pictures of Mary's shared reign.[226] William Speck argues that the coronation was unique in that William and Mary were both assigned coronation chairs and crowned. However, Lois Schwoerer argues that subtle ceremonial differences, such as William being the first to be anointed, made the hierarchy of political authority clear from the outset. The Declaration of Rights vested in William primary political power and, indeed, when he left for Ireland in 1690 the powers of administration had to be transferred to Mary by Act of Regency. The joint reign is always referred to in a way that ignores both succession title and alphabetical precedence as 'the reign of William and Mary'. This reflects the new king and queen's own preference as seen when they set up the William and Mary College in Virginia in 1693. The order of precedence is now embedded historically in academic publications such as *The William and Mary Quarterly*. However, Mary ruled as regent for about 50 per cent of the time raising questions about why her historical profile is not larger. Part of the answer lies in her not reigning long enough or clearly independently enough to leave a strong cultural memory.[227]

During Mary's 32 months as regent she ruled with different objectives from William. She demonstrated a clear preference for social and religious politics

rather than foreign affairs and military campaigns. One MP of the Convention Parliament commented that England needed a King 'to go before us & fight our battles... [because] a Woman cannot so well do', and William fulfilled this role while Mary enacted her dream of protecting the English Church. She did this through a combination of taking charge of episcopal appointments, favouring Latititudinarians such as John Tillotson, and tolerating Protestant dissent. Her goal was to maintain the strength of a broad church. She supported Thomas Bray's foundation of the Society for Promoting Christian Knowledge and began a £600 *per annum* endowment for the training of missionaries at the William and Mary College. She also provided a foil to the more strident and militant Calvinism of her Dutch husband and she inspired loyalty in her subjects so quickly during her short reign that her death from smallpox on 28 December 1694, according to Schwoerer, 'provoked an extraordinary outpouring of grief'. Her earliest publicist was Gilbert Burnet, a Scots churchman, and it is her reputation as a supporter of English Protestantism that has led one recent historian to call her 'a great woman with an impressive strength of character'.[228] Even if one classifies the comment as latter-day 'whiggism', Mary's providential belief that her usurpation of her father was part of God's plan for the protection of the true church needs to be taken seriously to counteract Jacobite (support for the deposed James II and his son) claims that she was a woman driven solely by political bloodlust and greed.

By the time Mary II died she had been estranged from her sister Anne for three years, but all attempts to curb the ambitions of Anne and the Marlboroughs failed and when William III died on 8 March 1702 Anne ascended the throne as sole ruler and Sarah Churchill, duchess of Marlborough became immensely powerful. Mendelson and Crawford have pointed out that the consequence of a woman on the throne was that a larger number of women came into powers of patronage and an ability to lobby the monarch directly. It is certainly the case that the political career of the duchess of Marlborough has been underestimated by historians until the seminal work of Frances Harris. The duchess' income from four political offices was £6,000 *per annum*.[229] Anne ascended the throne childless: she had 17 pregnancies (including twins) and her one surviving son had died of smallpox on 30 July 1700. Towards the end of her life she was physically disabled and could barely walk suggesting osteoporosis. Anne followed Mary and William's style of monarchy relying on political managers to avoid being trapped into a Whig -v- Tory agenda which, by 1702, had become more ritualised and embedded in parliamentary manoeuvring and rhetoric. The politics of party was reflected, for example, in more consistent party voting in the House of Commons and the formation of the separate political dining clubs, the Whig Kit-Cat Club and the Tory Society of Brothers.[230] Reassessment of Anne's reign by Edward Gregg has pointed out that without her eventual move towards the Tories and her collaboration with parliaments, including smooth handling of the Act of Union with Scotland, the security of the Hanoverian succession would have been jeopardised.[231] In other words, if Mary II did not live long enough to leave a significant legacy, her sister and successor to the throne did.

When Anne died on 1 August 1714 the Stuart succession to the English throne died with her according to the Whigs, but not according to Jacobites who rebelled in 1715 and again in 1745 in an attempt to restore the deposed Stuart line. Thus, the events of 1688 and 1689 had long-term consequences not the least of which was damage to the reputations of two Stuart queens regnant. One Jacobite/Tory poem of 1690 envisaged Mary confronted at night by her mother, Anne Hyde, who asks 'Can quiet slumber ever close thine eyes? | Or is thy conscience sunk too low to rise?' Other pamphlets equated her with Tullia who encouraged the treachery of her husband Tarquin in her greed to acquire her father's crown.[232] Whig propaganda gained a new lease of life as well in reactive pamphlets such as John Dunton's *The Hereditary Bastard: Or, the Royal Intrigue of the Warming Pan* and, indeed, the very terminology of the warming pan scandal, about women's deceit and fake births, first properly appeared in response to Jacobitism one year after the death of Queen Anne in 1715.

Conclusion

By the end of the seventeenth century patriarchal political thinking and organisation was as strong as in the century before. However, its intellectual foundations were different and arguably more ambiguous and diffuse. Political authority was no longer so closely focused on the person (or, indeed, the office) of the monarch, though the monarch, and all who held political office were firmly expected to be men. Merry Wiesner has argued that in early-modern Europe generally 'politics in its broadest sense was becoming increasingly male' as part of an historical process that gendered political power as a masculine acquisition, along with a man's family name, private property and private life of the family.[233] In England, masculinisation of the high politics of state was accompanied by a sexualisation of political discourse and debate that demeaned and de-legitimised women, but that was also part of a process of opening up the public sphere of political opinion in ways that were, structurally, gender-inclusive. It is very clear from the evidence of the coffee houses, newspapers and print world of Mary Astell that women were no longer so effectively excluded, as they had been in the sixteenth century, from the sphere of political discourse and public commentary. The language of sex in bawdy politics used woman as a discursive tool that effectively ensured women's diminished authority in the world of formal politics and the royal court, but while women's formal political agency may have been slightly eroded over the period, the power of the many to access informal channels of political activity nevertheless improved by 1700.[234] The proto-feminist voice of female political commentators such as Mary Astell did not exist in a vacuum and, arguably, can be attributed to a rise in the public sphere. Print was an ungendered domain that had an enormous impact not only on the development of women's political opinion but also on the literacy they needed to express it.[235] In 1500 women's literacy rates were perhaps as low as 1 per cent of the population, but by the mid-eighteenth century they were roughly 25 per cent rising to perhaps as high as 75 per cent in London. In this altered and freer political and literary culture, Sarah Churchill's comment

of 1713 that she 'should have been the greatest Hero that ever was known in the Parliament ... [if she] had ... been a Man', makes sense.[236] However, the observation would have been unthinkable from a woman in 1500 when the monarch was divine and political society was organized along the lines of patriarchal families in which women owed obedience to men and in a state whose subjects owed unconditional obedience upwards to the *pater patriae*.

6
Religion and Civil War

Introduction

There has been very considerable historical interest in the topic of women and early-modern religion which has led to a rich historiography that includes Patricia Crawford's overview – *Women and Religion in England 1500–1720* (1993) – and several subject studies such as those on women prophets and Quakers by Phyllis Mack, Kate Peters and Catie Gill, and Claire Walker's study of English Catholic nuns.[1] The thread underlying this chapter is that the English Reformation was a process rather than an event. The Civil Wars of the mid-seventeenth century have been called by John Morrill 'the last of the wars of religion' and they can be seen as a consequence and even the endpoint of the Europe-wide religious Reformation.[2] Early-modern religion was articulated through a gendered discourse that worked in complex ways to shape female identity and the process of Reformation led to renegotiation of the social construct that was woman and to altered relationships within the 'holy household'. As the Stuarts ruled a multiple monarchy divided by Protestantism and Catholicism, the holy household could be of either faith and, therefore, English (and, obviously, British) women were caught up in the deep struggle for loyalty between Catholic and Protestant, their responses ranging from passive acceptance of religious change to angry activism.[3] The political turmoil of the Reformation gave women the chance to participate in religious politics and the role of religious radical women during the English Civil War has received the most attention since Keith Thomas' groundbreaking article in 1958 on female sectarianism.[4] However, as Diane Willen has also pointed out, while Protestant reformism offered 'escape from passivity in a highly patriarchal society' the importance of the domestic nature of female spiritual activism and personal piety should not be overlooked. All women acted as a bridge between clerical institutions and family and made choices about private worship that were political by their nature. The personal *was* political and the Reformation cleared the way for feminine political activity that was unique and ubiquitous and led to irreversible gender self-fashioning by the female sex.[5]

Gender and Reformation historiography

Merry Wiesner and Lyndal Roper have both pointed out that the historiography of the Reformation and the historiography of women and their responses to and

uptake of religious change have remained quite separate. Roper has pointed to the 'relentlessly male' imagery of historical analysis of the Reformation which has consigned women's role to family and household.[6] For England, there are two distinct but overlapping historiographical traditions: the first is a longstanding historical debate about the nature and success or failure of religious change that followed Henry VIII's break from the Church of Rome and the second is the newer debate about the nature of women's spirituality and confessional loyalties.

In terms of legislative and institutional change the English Reformation can be succinctly outlined. Up until 1529 Catholic rites such as the seven sacraments, prayers and masses for the dead and the invocation of saints were all part of a woman's daily religious observance. Protestantism replaced the seven sacraments with only two (baptism and the eucharist or communion) and placed more emphasis on prayer and preaching than ritual. The Saints were stripped away and their centrality was replaced by the Book of Common Prayer. From 1532 various statutes alienated the role of the papacy in territories under the English crown to permit Henry VIII's divorce in 1533, and the 1534 Act of Supremacy gave English monarchs sovereignty over the English Church. Between 1536 and 1539 nunneries were suppressed, Saints Days were abolished, pilgrimages and the collection of relics were both prohibited and an initial Protestant confessional statement was articulated in the Six Articles. The reign of Edward VI between 1547 and 1553 saw the removal of vestiges of the worship of the Latin mass and church statuary and furnishings were redeployed, destroyed or sold. The reign of Elizabeth I from 1558 resulted quickly in the Acts of Supremacy and Uniformity and a confession of faith in the form of the Thirty-Nine Articles. The latter combined the Lutheranism of the reign of Edward VI with the main tenets of Calvinism as elaborated in Jean Calvin's *Institutes of the Christian Religion*.

However, recent historiography has stressed that the Reformation, far from being a series of legal changes easily imposed upon a compliant population, was in fact a process that involved interaction between legal change and parish level response and a slow shift in people's faith. Voices on the subject do vary. On one side of the debate Diarmaid MacCullough and Robert Whiting have suggested that the Reformation was a huge success; the populace simply obeyed the confessional changes as they came about. On the other side of the debate Christopher Haigh has suggested a Reformation that failed in the sense that large sections of the population rejected conformity and only ever achieved a limited understanding of Protestant doctrine.[7] In the middle lies the view of a Reformation comprising a series of religious changes that left people in what Alexandra Walsham has called 'a kind of confessional limbo' until the 1570s, after which there was widespread Protestant conformity involving accommodations of faith and the final exile of Catholicism. Michael Questier has argued for the outlawing of Catholicism by the 1580s, but, unlike Walsham, has stressed people's active confessional choice, in favour of one side or the other, rather than just 'grudging conformity'.[8]

Religious belief for many Protestants involved accommodation between the old and the new. Tessa Watt's work on godly ballads, printed pictures and penny chapbooks demonstrates how these various printed media aimed at a popular

audience incorporated old religious iconography into the new Protestant message. This involved some spatial change: the paintings on the walls of pre-Reformation Catholic churches were replaced by printed pictures and Biblical stories pasted onto the walls of cottages and alehouses. Walsham points out that Saints' days were replaced by greater emphasis on other forms of communal festivity such as bonfires and John Craig has shown that in the cloth town of Hadleigh in Suffolk, where Protestant Reformation may be deemed to have quickly taken hold, Whitsun festivals survived alongside energetic reform by Protestants whose zealousness attracted the label 'puritan'. Thus, current Reformation historiography stresses a long reformation that ended with Protestantism established, but not without some accommodation of past practice.[9]

Debate about women's spirituality falls into two categories: older accounts which emphasise confessional divisions (Catholic/Protestant) and some newer accounts that place stress on shared female spirituality. Crawford has stressed the fluidity and pragmatism of women's beliefs and this account has synergies with those views of the Reformation that find the old retained alongside the new. Mothers would try to keep away sickness in a child by hanging some alphabet letters around their necks and would also appeal to God in prayer.[10] In this account women clearly chose between more than just Catholic or Protestant doctrine and religious ritual in order to satisfy their spiritual needs. According to Crawford, '[f]or the populace at large, the boundary between orthodox and unorthodox belief was not always clear'.[11] However, there are differences to be found between most of the populace and the educated elite. For the latter, once partisan and doctrinal choice had been made, purity of religion – Protestant or Catholic in formulation – became paramount.

A recent study of the parish of Morebath in Devon by Eamon Duffy confirms women's heavy involvement in the Reformation, embracing, defending, rejecting and adapting to religious change. In Morebath, where there were several female churchwardens between 1520 and 1575, the priest, Christopher Trychay, presided over slow change only beginning in 1534 with the Oath of Supremacy. Duffy describes Morebath as a place in which people held conventional and sincere beliefs that were woven into the very fabric of their social lives and it was not until 1574 that the parish church finally bought a communion cup.[12] Claire Cross also argues for slow adaptation and change finding that '[a]ctive Protestant piety seems to have taken a full generation after Elizabeth's succession to come into being in Hull' at which time women like Katherine Jackson finally dropped the preamble in their wills about the Virgin Mary.[13] In Morebath statues of saints were destroyed in the late 1530s but many people continued to believe in the efficacy of prayers to saints for decades and hid church rejects at home. Christopher Haigh has pointed out that during Mary's reign 'people did not need to be weaned from Protestantism, merely reminded of their lost Catholicism'. However, by 1590 Protestantism was secure, driving Catholics into occasional conformity or what contemporaries called 'church papistry'. Catholic survivalism split; church papists (who were often male church attendees with recusant wives)[14] came under furious attack from those Catholics who did pay recusancy fines for non-attendance

at church because the success of Protestantism led increasingly to their isolation. The listing of recusants in 1601 in Suffolk and Warwickshire shows that over half of them were women, quite a few of them single.[15] Haigh has suggested that women's lower level of education helps explain their indifference to theological doctrine but Catholic dissenting women after 1590 expressed their recusancy as firm rejection of Protestant teaching.[16]

Thus, the process of Reformation had irreversibly taken place by the late sixteenth century when the more educated godly on both sides became motivated by a desire for doctrinal purity and partisan piety. The Protestant godly demanded further reformation and the Catholic community embraced the reforms of the Council of Trent and reluctantly accepted their minority status.[17] Individual examples of both can be found. For example, small glimpses of women entering into precise disputation about Protestant faith can be glimpsed in diary and manuscript sources. The separatist John Penry jotted in his diary that on 15 December 1592 he sat talking with three women at the house of Lady West 'wher shee and I could not agree in sum poyntes'. The point at issue was ministry: the women followed the 'pure' religion but refused to 'see priesthood for what it was'.[18] Penry also noted in his diary that a group of women in 1593 approached both houses of parliament to petition for 'pure religion' but were treated harshly.[19] All Catholic women were activists in the sense that they had to defend the religious position developed within family networks (symbolically represented for some families by the large priest holes that lurked in their houses) and the walls of foreign cloisters.[20] Some zealous puritans chose exile, separating from the English Protestant Church and leaving for New England. The earliest such group was the Brownists who included women from ordinary backgrounds, like Anne Woodhouse, Mary Cole and Bridget Strange, all of whom were hauled before magistrates for examination of their activity.[21] Thus, separation in both Catholics and some godly Protestants was a simultaneous response to irreversible Protestant change by 1590.[22]

Printing helped to create partisanship and encouraged women's religious dedication and activism. Works by Reformation and Counter-Reformation theologians, many of them in translation, helped encourage private contemplation and, according to John Brewer 'established a new framework within which reading and the pursuit of solitude and privacy … could be understood'. Protestantism encouraged reliance upon the word of God, so that women read the Bible and commentaries, catechisms and books of prayers in the vernacular.[23] The logocentricity of English Protestantism did empower women to become educators and carriers of Protestant culture. However, equally, the printed word made women's profession of Catholicism and its transmission possible in a Protestant world. English Catholic women found that their exilic existence could be supported by smuggled works by Catholic authors (often in translation) that reminded them of the wider European network to which they belonged, the symbolic centre of which was the Pope. Visits from Jesuit priests were reinforced by publication of their works of theology and casuistry, hidden and read by women.[24] Equally, print culture popularised religious change and served to define and polarise confessional loyalties through ridicule of the other side.[25] Negative literary constructions of 'woman'

became embedded in the polemic of religious loyalty and the extent and impact of that on religious political culture will become apparent later.

Catholicism

The story of women's Catholic activism in early-modern England begins, inevitably, with the gradual loss of institutionally-supported religious vocation. The distinction made between cloistered and lay women in pre-Reformation England is somewhat false and it needs to be made clear that lay religious vocation often took place through attachment to the church and mimicked the church's provision for its women religious. Thus, when cloistered nuns faced the dissolution of their houses, lay women too suffered loss because of the myriad ways that lay women sought to exhibit and pursue their devotion to the Virgin Mary and God. Widowed women were no longer able to take vows of chastity through a public veiling ceremony at the hands of a bishop that mimicked entry to the novitiate. Margaret and Joan de la See both took the veil when their respective husbands died in 1495 and 1500.[26] Many more women were no longer able to establish chantries in their names, leaving money that established chantries and provided for specific priests to pray for the souls of themselves and other family members.[27] Lay sisterhoods were abolished. Even more painfully, the vocational choice of poverty and spiritual purity was lost to women outside as well as inside the cloisters. Anchoresses could no longer emulate the most famous of them all, Julian of Norwich, and live as hermits in small rooms attached to a church, receiving mass on one side and food from the outside world on the other. Although a lay woman, Julian's attachment to the institution of the church was as real and symbolic as that of a nun and she wrote an early work of mysticism – *XVI Revelations of Divine Love* – which grew out of and defined her gendered religious identity.[28]

There were roughly 130 nunneries in pre-Reformation England, 24 of them in Yorkshire alone and about 1,900 nuns at the time of the Reformation. The large and wealthy nunneries, only four of which had over 30 nuns, were in the south, while the largest number of nunneries was in the north and tended to have only a very small number of nuns, usually 10 or less.[29] Cloistered piety offered local women, particularly of the gentry, education and the routine of days structured by the divine office or *opus Dei*. This began at two in the morning with Matins and ended late at night with Nocturnes. *The Myroure of Our Ladye* (1530), a devotional tract by Agnes Jordan who was abbess of the Bridgetine Monastery of Syon, outlined a spirituality in which Mary provided the nuns with inward understanding. Writing in English to reach a wide female audience, she exhorted women to use Mary as a mirror into their own souls. Nunneries were social units as well as houses of prayer and devotion to God. In the larger houses, some nuns held important offices under the abbess and were called obedientiaries. Offices included those of treasuress (who managed the church lands and finances), chantress or precentrix (who managed the church services), sacrist (who took care of the fabric of the church) as well as various posts like almoness, cellarer and chambress whose duties were very much about household management,

such as the provision of glasses, needles and thread, and the provision of food and clothing.[30]

The dissolution of monastic houses was patchy and unpredictable and women's experience of losing their status as nuns was painfully slow. For some nuns it involved exemptions and reprieves and even relocation before final ejection from the cloistered life. Discipline and good order, as well as the size of the house, were taken into account when early exemptions were granted. Nuns in smaller convents were given the chance to relocate to bigger houses from 1536 and many of them took this option.[31] Research has indicated that success in maintaining discipline in the religious houses varied and directly affected the timing of dissolution. Margaret Wodall prioress at the Benedictine nunnery at Goring showed leadership talent and strong discipline and this was taken into account, but the prioress at Littlemore in Oxfordshire was found, in 1517, to have a grown-up daughter whose father was the chaplain and this counted against her.[32] Early exemptions included St Mary's in Winchester. After being commended for its piety, the house was ordered to pay 500 marks and manorial title to Sir Edward Seymour and this delayed ejection until after 1538. The speed with which nunneries were dissolved sometimes depended upon past politics. When Cecily Willoughby, abbess of the big (and socially fashionable) Benedictine convent at Wilton, died, there was intense competition to replace her, between Eleanor Carey who had connections with Anne Boleyn and was supported by the king, and Isabel Jordayn, a committed reformer who was supported by Cardinal Wolsey. Resolution in favour of Jordayn badly affected the relationship between Henry VIII and Wolsey and, in turn, affected the way the convent was treated at the dissolution.[33] Much of the traditional historiography on the subject has focused on morality and discipline in the nunneries, as if those houses with lax discipline deserved their fate. However, this approach simply diverts attention away from the more important subject of the disbandment of female communities whose connectedness with lay religious women was greater than the word cloister might imply. Women's political power and autonomy suffered immediate and deep undermining by the closure of the nunneries.

It is possible to find evidence of powerful nuns attempting to escape the traumatic dismantling of the fabric of their convent lives. Lady Katherine Bulkeley, who was abbess of Godstow outside Oxford, used her influence with Thomas Cromwell to plead with him for her convent. 'I have done the beste in my power to the maintenance of God's trewe honor', she told him 'with all truethe and obedience to the king's majestie'. She continued: 'I trust to God, that I have never offendyd God's lawes, nor the king's, whereby that this poore monasterie ought to be suppressed'. Bulkleley told Cromwell that she thought her nunnery was being singled out for dissolution because she had engaged in vicious disagreements with John London who stood to gain property by closing the cloister. He is 'my mortal enemye' she told Cromwell. Indeed, he arrived at the nunnery and threatened her and the nuns 'sayeing that he hath the king's commission to suppress the house spyte of my tethe [in spite of her political power]'. Bulkeley did not give in to London's bullying and she told Cromwell that she would not surrender

'till I knowe the king's gratious commandment' and asked him 'to direct your honourable letters to remove him hens [hence]'. Bulkeley's supplication failed; she received a pension of £50 and went back to her family in Cheadle where she stayed until her death in 1560.[34] However, she was one of the lucky ones – many ex-nuns received a pension of less than £2 per annum and went on to lead lives of destitution.[35]

Dismantling their convent life was extremely hard to face for many women religious and after the Reformation former nuns often stayed together. For example, the wills of the last abbesses of Nunnaminster and Wherwell, Elizabeth Shelley and Morphita Kingsmill, indicate that they were both still living with five or six members of their old convents at the time of their deaths in 1547 and 1569.[36] Their activism took the form of refusal to disengage from profession of their vocation. Ten former nuns who left wills in Yorkshire mentioned 24 others when making their bequests. The Franciscan order of Minoresses was outlawed, its property in the Minories in London and around Cambridge dispersed, and the last abbesses of the three houses, like Elizabeth Savage (London) and Mary Page (Waterbeach), stripped of their jobs in 1539. Some women returned willingly to life outside the order. 'A fair young woman' cried tears of joy to be returning to her husband and four children. However, most, like Elizabeth Throckmorton, last abbess of the third house at Denny, returned to their families, where they continued to dress in their habits and live an invented and private conventual life. As Elizabeth Throckmorton left Denny with about half a dozen others, Sir Edward Eldred moved in to take ownership of the land and manors. Returning nuns could have a huge impact on the family. Once back home in Coughton, Throckmorton and her nuns continued to behave as if still cloistered; they rarely ventured from their rooms and were only infrequently seen even by family members. Coughton remained from that time a Catholic house of recusants and Elizabeth's brother, George Throckmorton, became resident at the English College in Rome, where the sons of English recusant families were educated and where he remained until he died in 1582.[37]

When nunneries closed, some men directly benefited in a vast redistribution of wealth that created a new landed [male] gentry. St Radegund's convent in Cambridge became Jesus College. In this case, the property of Catholic women ultimately benefited Protestant men who were training to take up their vocation in a new Protestant church.[38] There were other ways in which men fared better than women during the dissolution of the monasteries – a number of men moved out of monasteries and into the new ecclesiastical establishment, a route that was not open to women.[39] Therefore, the Reformation permanently diminished the status of women in the established church. Even in the highest echelons of the Protestant church, the wives of bishops were reduced to lowly status, often through continued royal hostility to them and their families. Margaret Cranmer, tried to become involved in the print market of reformist texts, but Henry VIII forced her into exile first in England and then abroad, and Elizabeth I deeply disapproved of bishops' wives, banning them from court.[40]

However, Catholic activism amongst women sought to redress the losses of the Reformation. It took several forms, most notably martyrdom, recusancy, mission

work in the form of joining an overseas convent, and the writing of spiritual auto-
biographies and works of collective biography that were intended as models par-
ticularly for women who joined a holy order overseas. At the very beginning of the
Reformation, for many people, perhaps especially women, at the heart of the mat-
ter was a perceived injustice to Katherine of Aragon and anxiety about the spiritual
consequences of the dissolution of her marriage to Henry. When Henry VIII sent
his bishops into the provinces and towns to promote his marriage to Anne Boleyn,
some of them were stoned by crowds of women.[41] One of the earliest Catholic mar-
tyrs was a young woman called Elizabeth Barton who opposed Henry's abandon-
ment of Katherine.[42] She was the servant of one of the archbishop of Canterbury
stewards and, as such, was uniquely placed to do some damage to the reputation
of the king. After an illness involving trances and visions in 1525, large numbers
of people came to hear her speak and stand at the image of the Virgin Mary where
she claimed to have been cured. Eventually, she was brought before the king and
warned him against leaving Katherine. He ignored her until she began to prophesy
his death upon remarriage, whereupon he imprisoned her and burnt all her writ-
ten prophesies before executing her on 20 April 1534.

Some historians have argued that female martyrdom had a generalised psy-
chological function – it allowed women some control in areas of their lives in
which they were normally powerless. Crawford has pointed out that while male
commentators may have spoken of God using his weakest instruments in women,
female martyrs felt themselves able to make powerful statements about their
faith. Elizabeth Barton's trances and visions lent her some measure of political
authority as a preaching nun (in contrast to being just a maidservant). Her mar-
tyrdom ended amidst humiliating accusations that she was a fraud, but she still
achieved posthumous authority through Catholic martyrology.[43] Jan Rhodes and
Marie Rowlands have spoken of the 'cult of…new martyrs' and the 'theatre of
martyrdom' in which followers expected (and got) political narratives from the
scaffold. Followers collected body parts and pieces of clothing drenched in blood
to sacralise the event and promote future sanctification of the Catholic dead. In
reality there were not a large number of Catholic women executed in the early-
modern period. At the peak of her anxiety in the year of Armada (1588) Elizabeth
executed 63 lay people and only three of them were women.[44] Six years later,
when she arrested Anne Stanley (Arundell) for harbouring Father John Cornelius
for 11 years, she quickly released her but executed all of Stanley's London male
contacts for the same crime.[45]

The most enduring boost to female activism was the importation of the revital-
ised continental Catholicism associated with the Council of Trent that sat from
1545 to 1562. Most female Catholic martyrs suffered not because of political
opinions expressed but because they were caught in the act of sheltering Catholic
priests. At the very end of Elizabeth's reign, in 1601, Anne Line, a convert to
Catholicism, was hanged because she had kept three safe houses in London for
receipt of seminary priests arriving from the English Catholic colleges abroad.[46]
However, the best-known example of a woman who died for hiding priests was
(and is) Margaret Clitherow of York who every week had the Eucharist and

a sermon 'Catholicly in her house'. Clitherow's life is largely known to us through the work of her hagiographer, John Mush. She was born Margaret Middleton in York, where she married John Clitherow, a butcher. She is said to have struggled with her conscience before resolving to return to the Catholic faith. Mush described her as being 'to God most charitable, and…of rare obedience to her ghostly father'. He also spoke of her charity to neighbours. 'Charity' was a powerful early-modern concept involving inclusion in a spiritual network defined by God and neighbours, or friends and kin. Clitherow was imprisoned on several occasions over two years. She fasted constantly in prison, refused to denounce her faith and boldly told two judges on 14 March 1586 that she knew of 'no offence whereof I should confess myself guilty'. She refused to plead pregnancy, a condition that would have resulted in a stay of her sentence, and held out against questioning that went on for days. Despite all efforts by the church authorities to prompt a change of heart, she told them 'you charge me wrongfully'. On 24 March 1586 Margaret Clitherow walked a few yards from her cell in a prison on the Ouse Bridge to the Toll Booth where she was ordered – distressingly – to undress with men present. The women with her then clad her in a linen robe that she had prepared for her death and she lay on the ground. A sharp stone was placed against her breast bone and a heavy door laid on the stone. Her hands were then bound to two stakes in the ground before four beggars hired for the execution began placing weights on the door until she was crushed to death.[47]

Why did some women make the choice not to attend worship at their local Protestantised parish church if faced with the death penalty? Some of the answer to this question lies in what some women felt they had lost. The women of Morebath had lost Saint Sidwell who had local significance. Sidwell was a Saxon virgin decapitated by her stepmother and her statue was surrounded by the rosaries of women who had died in the parish.[48] The women of Exeter felt they stood to lose so much that they armed themselves with pikes to defend the priory of St Nicholas from demolition. Protestantism resulted in startling changes to the gendered symbolism of the church. Saints of both sexes, adorning walls, pews and rood screens, had provided an easy conduit to God for worshippers of both sexes. In Westhall in Suffolk women sat on the south side of the church, men on the north; Ethelreda, Sitha, Agnes, Brigida, Catharine, Dorothy, Margaret and Appolonia were (and, unusually, still are) painted on the south side of the rood screen. Women of the congregation faced the female saints and prayed to them while men prayed to their own saints.[49] Mary's prominence highlighted the value of female spirituality; she was the mirror to a Catholic woman's soul. Mary's presence diminished the negative impact of Eve. Even if all other female saints were eventually jettisoned, losing Mary was for many women one step too far. In Halesworth, also in Suffolk where the majority of pre-Reformation imagery is still to be found, a niche on the outer wall of the church contains a statue of the Virgin with child – all of the other niches are unnaturally empty and can be read as the spaces left in people's minds.

All women were in a powerful position to promote and maintain Catholicism through recusancy especially after the papal bull of 1570.[50] The law offered them

some immunity from prosecution because the church authorities concentrated on male non-attendance at church and the household became the centre of Catholic worship. John Bossy has said that '[o]n few points in the early history of English Catholicism is there such a unanimous convergence of evidence as on the importance of the part played in it by women, and specifically by wives'.[51] Lisa McClain has pointed out that Catholics were forced to reconceptualise religious space after the Reformation and this resulted in the family home becoming the central place for prayer and devotion. This placed the wives of Catholic men in a unique position. Their role in Catholic worship became paramount because they were primarily responsible for the hospitality and protection offered at home to Catholic priests. They also became the main agents of transmission of Catholicism from one generation to the next through their role as educators of their children, a task they carried out in the home. In this way ordinary rooms became sacred spaces.[52] Elizabeth Cary took her role as educator so seriously that she quarrelled with her eldest son over her kidnap of her two younger sons when she sent them abroad for a Catholic education. Women's power to subvert Protestant education was not lost on the anti-Catholic polemicists who portrayed Catholic women as disorderly and in close contact with the devil.[53]

Recusant women were ordinary women of all classes whose politics of opposition bridged the private and public spheres. Gertrude Blount's opposition to Protestant reform led to discussions with papal agents about possible rebellion led by Rome. Her husband, the earl of Exeter, was executed for his opposition in 1538, but Blount remained determinedly Catholic, being rewarded for it with landed estates when Mary came to the throne.[54] Blount died just before Mary, but there were a number of women whose recusancy in the early part of Elizabeth's reign was a continuation of their loyalty to Mary after her death. Both of the daughters of Sir William Dormer were Marian Catholics in upbringing and Jane Dormer, in particular, is an important example of a woman whose life was shaped by loyalty to Mary. On the queen's death she was responsible for taking her jewellery to her sister, Elizabeth I, and after completing the job she left England and later married a Spanish nobleman. She took her grandmother, Jane Newdigate, who was also a Catholic, and six other women with her. Her Catholic activism did not end with exile. She was friendly with Mary Queen of Scots until the latter's execution and devoted her time to supporting other English Catholics in exile. Philip II was so impressed by her political skills and ability to run her husband's estates that he came close to appointing her as Spanish regent in the Netherlands.[55]

One would expect aristocratic Catholic women born during Elizabeth's reign to be persecuted by her, but some were protected instead. Ellen Preston, Lady Mounteagle, flatly refused to attend the Protestant Prayer Book service after the pronouncements of the Council of Trent in 1562 but was not persecuted. Her granddaughter, Anne Dacre, whom she raised to become a leading recusant, housed the priest and martyr, Robert Southwell, whose embalmed remains still lie in a glass case in Westminster Cathedral. Her husband was executed in 1595 but she escaped corporal punishment and her considerable personal landed estate was returned by James I when her son returned to the Protestant church.[56]

The politics of opposition practiced by aristocratic and gentry women did not stop at housing priests, holding Mass at home in custom-made chapels and refusing to attend church. A number of women were involved in rebellions and uprisings. Anne Somerset and Jane Howard, who were married to the earls of Northumberland and Westmorland respectively, have been credited with instigating the Northern Rebellion of 1569, the most serious internal threat to Protestantism during the reign of Elizabeth. Although the earls amassed an army of 500 from amongst tenants and other disaffected commoners who supported Catholicism, it was Anne who rode up and down the ranks inciting the men to rebellion. She paid the price – her husband was executed and the three children she had to abandon in England almost starved to death.[57] Rebellion could take many forms. In the 1580s, only 20 miles from London, Cecily Chamberlayne, wife of Sir Francis Stonor, used the cover of his large landed estate to hide Father Campion and help him set up a printing press for Catholic propaganda.[58] Anne Vaux and Agnes Fermer were both arrested at the time of the Gunpowder Plot in 1604 for systematic hiding of several leading Jesuit priests, but, again, both escaped without corporal punishment. Undeterred, Anne Vaux started a school for the Catholic children of the gentry in the 1630s, though its operations were quickly halted by the Privy Council.[59]

The sporadic nature of Reformation in many parish churches meant that adherence to old ways was possible for some decades but in the longer term recusancy was not just lazy adherence to the familiar. Catholic women made an active and brave choice to defend their religious practice particularly after the 1580s. Michael Questier has said that 'the machinery for enforcing conformity evidently had teeth' and convicted Catholic recusants often conformed for a while, but then tended to return to Catholic worship when pressure from the authorities subsided. In 1592 Dorothy Swaile of North Stainley was placed under remarkable pressure to conform and eventually did so, but in 1609 she was dragged before the authorities again.[60] In the early 1590s Jane Shelley was examined on several occasions and imprisoned for a year – Justice Richard Young brought charges of witchcraft and treason against her presumably to frighten her into exposing the hiding place of several priests.[61] The recent work of Marie Rowlands and others has advanced our understanding of the politics of Catholic opposition and shifted attention away from the country house religion of gentry and aristocratic women to 'Catholics of the common sort'. The picture that emerges is one of a loose and complex network of people who refused to attend church despite living in isolated pockets in households that contained conformists and nonconformists alike. There was a preponderance of women recusants, supporting John Bossy's claim of several years ago that refusal to conform was 'attractive to women'. By 1576 there were 70 recusants in York and nearly all of them were women. The 1615 visitation for North Yorkshire recorded that in Hovingham 21 out of 24 recusants were women and in Drax all of the recusants were female. Some of them testified that they did not attend church because there was no priest, altar or sacrament. In other words, these women felt that the Protestant service was fundamentally lacking in the accoutrements necessary for salvation. Attending

to their spiritual needs were seminary priests, who were trained abroad and who were greeted and hidden by recusants in coastal ports around England. Dorothy Lawson had a missionary base at St Anthony's on the edge of the River Tyne; when ships dropped anchor, priests jumped ship and made for her safe house. By 1616 she had been bold enough to build a chapel on the side of the house for Mass. The inns, farmhouses and trade shops of many ordinary women had small chapels built into the roof. Other recusants simply gathered around a mobile altar stone. At least 800 priests arrived in England this way; only a small number were Jesuits, most being priests on the circuit.[62]

The activist choice that Catholic women made had a double edge. On the one hand they had to stay one step ahead of church authorities and on the other they had to prove their loyalty to priests and Jesuits to whom recusancy or non-attendance at Protestant churches was the crucial demonstration of their Catholic identity and loyalty.[63] The authority of the priest weighed more heavily. Elizabeth Darrell risked her life to save a hidden priest by escaping from her chamber, where she had been imprisoned, to cut off the end of a girdle used for Mass when she saw it hanging over the door to the chamber where he was hiding.[64] Women paid not only their own composition fines (a levy on their assessed income), but, if necessary, those of their servants. They requested that their Catholic neighbours and friends bury them in the parish church in the dead of night to avoid the Protestant service.

Women also read the many works of polemic that rolled off the 17 Catholic printing presses that existed in England between 1575 and 1630. There were dozens more on the continent and books were smuggled into England and passed between families.[65] Catholic women were also inspired to write spiritual autobiographies, the model for which was St Teresa of Avila's *Book of Her Life* (1562) and her work of mysticism, *The Interior Castle* (1577). These were used as conduct manuals and Catholic women also turned to lives of the Virgin Mary such as Chiara Matriaini's *Life of the Virgin* (1590) and lives of the Saints such as those by Lucrezia Marinella. Marinella also turned out a work of inspiration about the Virgin Mary in 1602. *The History of the Angellical Virgin, Glorious Saint Clare* (1635) said she was of the 'feminine sexe, but masculine virtue'. During the 1630s tracts venerating the Virgin Mary were published in London aimed at Protestant as well as Catholic women. The most influential was Anthony Stafford's *The Femall Glory, or, the Life, and Death, of Our Blessed Lady, the Holy Virgin Mary, God's Owne Mother* of 1635.[66] Lay women followed the model of sanctity in their spiritual diaries. Religious women overseas wrote histories of convents such as Elizabeth Shirley's biography of Margaret Clement that formed the basis of the *Chronicle of St Monica's* (1612).[67] Jane Owen's *Antidote against Purgatory* (1634) urged English recusant women to stay resolute in their faith and refuse to attend church, her publisher claiming that she was 'the Honour of her Sex for Learning in England'. The majority of the work was a translation of the Catholic polemicist, Cardinal Bellarmine, and was intended to whip up obedience to Rome. Damnation to eternity was promised to all those who did not practice the good works necessary to avoid purgatory. Owen addressed herself to female recusants directly 'to whom in

regard of my sexe I may be the more bold to speak freely ... Well (Worthy Ladyes) let a Woman once preach to Women'.[68]

The presence in England of an openly Catholic queen consort in the 1630s led to Catholic sentiment expressed more frequently in public. However, although Henrietta Maria had a legal embassy chapel in Somerset House for herself and her large French Catholic retinue there were few opportunities for turning piety into calling in England and some Catholic women chose to move or set up religious orders on the continent. Daughters were regularly sent to convents abroad.[69] Detailed work on these female communities has now been done by Claire Walker who rightly asserts that 'the English cloisters were no less significant than their European counterparts' and that they became 'well-known symbols of Catholic nonconformity' in England. Indeed, she makes an important case for nuns in English cloisters abroad replicating 'country house religion' through the 'dual pursuits of salvation and household management'. The earliest communities of English nuns abroad were exiled groups from nunneries that had been dissolved. They attached themselves to European convents, often moving from one to another. One example was the Bridgetine nuns of Syon Abbey, who fled to the Netherlands and led a peripatetic life before finally establishing themselves independently in Lisbon in 1594. Shortly afterwards, Lady Mary Percy established an English Benedictine convent in Brussels in 1598. Margaret Clement, whose parents had been in the household of Thomas More, established an English cloister of the Augustinian convent, St Monica's, in Louvain in 1609 and was prioress for 38 years. When women like Percy and Clement applied to establish English cloisters they were able to poach English nuns living exiled in European convents, sometimes causing tension with European abbesses. Walker's research reveals the establishment of 22 English cloisters between 1594 and 1678, with high points during the 1610s and 1620s while James I was on the throne and a further surge of establishments during the English Civil War. According to Walker, 'the contemplative life for women had not died in English minds'. However, this was not apolitical female spirituality. English nuns 'felt that in foreign communities they were on the margins of the struggle to restore the faith in their homeland ... and [had] to keep alive the memory of their families' sufferings for the faith'. Catholic families did not separate in their minds recusancy and sending daughters abroad; both were part of the same struggle and some families sent almost all of their daughters to overseas nunneries.[70]

The woman whose energy for establishing English outposts of female communities is best known is Mary Ward. Her Franciscan Poor Clares was set up in 1608 at St Omer before transferring to Gravelines and had 65 nuns by 1625. It was founded after Ward had a vision directing her to build a community of women whose activism reflected the practices of the Jesuit priests. By the 1630s there were 17 houses of the Poor Clares. Ward's success may be attributed to her appeal not to a pre-Reformation vision of female cloistered piety, but a post-Reformation vocation that placed religious women in the new role of conversion and defence of the Catholic faith. Indeed, other groups of women religious like the Carmelite community in Antwerp were also under the direct influence and even orders of

the Jesuits and so were part of a post-Tridentine Catholicism that stressed mission on earth as much as devotion to God. These two callings were closely linked for Catholic women and Ward's *Constitutions* are interesting for their stress on sole obedience to Rome. However, while women like Mary Ward followed the Jesuit example, there was always tension between these English women exiles and the Catholic authorities in Rome. Despite – or perhaps because of – establishing houses of women religious in Rome, Naples and Perugia in the 1620s, Ward encountered considerable opposition from male church authorities and in 1624 the newly-established papal Congregation of Propaganda decided that her cloisters should become enclosed. After meeting with Pope Urban VIII Ward agreed to confine her houses to Flanders, Germany and England where there were large numbers of English Catholic women, but she also compromised by agreeing to a limited membership. However, she still found herself faced in 1631 with a papal bull condemning the Institute of the Blessed Virgin Mary and it is ironic that several hundred nuns lost their livelihood at the hands of Catholic authorities. Ward herself was briefly imprisoned in a convent jail. She died while hiding with Catholic friends and relatives in Yorkshire in 1645. However, her houses in Rome and Munich survived the suppression order and in 1703 finally achieved the canonical status that Mary Ward herself had tried to achieve.[71]

Claire Walker has concluded that English cloisters abroad were so insufficiently funded in the early stages that while Rome enjoined the women religious to lead the contemplative life of Mary, they were nevertheless forced by circumstances to pursue the labours of Martha. While Rome stressed passive piety, English nuns defined their life of prayer as an active mission: '[t]he principal task of Mary was to pray for the conversion of England'.[72] Jane Owen's *Antidote against Purgatory* (1634) had a specific purpose alongside its general admonition to recusant women at home – to encourage wealthy Catholic women to divest themselves of their wealth. Widows 'enriched with more than ordinary affluency' should consider giving up their 'lands, money and temporall goods' for the benefit of Catholic scholars abroad and young women should give up a part of their marriage portion.[73] The former appeal to English recusant women to stay resolute may have struck a chord, but the latter seems not to have made a great impact on the English nuns on the continent, whose lives were dominated by poverty and makeshift. The tension between staying solvent and the imperative to give up all worldly goods was ever-present. After Mary Ward's Poor Clares moved from St Omer to Gravelines the abbess wrote to John Cotton, father of a new recruit, to say that while they thought they had not needed Mary Cotton's portion, this was not now the case as the building had cost them more than they had anticipated and they were about £900 in debt.[74] Their plight was intensified by the financial pressure felt by Catholics at home. Jane Owen could make her plea to English widows but Lady Cecily Stonor had her jointure lands in Buckinghamshire separated from her son's inheritance and claimed by the crown for her recusancy in 1592.[75] After years of Catholic activism, a woman like Lady Stonor often no longer had the resources to help. However, lay women who had sought refuge abroad sometimes did. In 1635, when the elderly Mary Green died of plague in Louvain, she left all

of her money to the English Augustinian nuns there. She was an Englishwoman in exile who had spent 50 years living alongside the cloister of St Monica's and who had 'lived all her life a maid [and]…would have that virgins should be her heirs'. Virginity was clearly central to her gender identity and it is interesting that she extended the idea to women some of whom, like Sister Grace Babthorpe of St Monica's, were, in fact, widows.[76]

As the seventeenth century progressed, English Catholic women continued to join nunneries abroad despite the fact that some measure of toleration came into being in England, at least after the anti-Catholic outburst of the alleged Popish Plot in 1678.[77] Families placed more children in nunneries. Some of them were as young as four years old and some, like Elizabeth Kennet, who joined the Benedictine nunnery in Cambrai in 1697, brought with them large portions that revitalised the finances of their chosen houses. Some became highly influential. Catharine Burton, a member of the Antwerp Carmelites who were founded in 1619, became known as Mother Mary Xaveria. She died in 1693 and her autobiography was collected together for publication with her writings by Thomas Hunter in the nineteenth century. Hunter also edited a life of Mary Ward, indicating the degree to which the activism of these English Catholic women was regarded as integral to the struggle of the outlawed English Catholic faith for centuries to come. The tradition of martyrdom and suffering bound together women recusants in England with lay sisters and professed nuns on the continent. Burton read the works of Saint Teresa of Avila before being sanctified in turn by Hunter's biography. Sister Magdalen Augustine's *History of the Angellical Virgin, Glorious Saint Clare* was translated into English in Douai in 1635 for consumption by the Poor Clares and other English nuns who sought inspiration from her as a female role model.[78]

Arguably, the topic of women's Catholic activism in early-modern England demonstrates more effectively than any other the interconnectedness of the public and private spheres. Catholic women were involved in a combination of a dangerous form of public confessional politics of opposition with a hidden, secret and domestic form of worship. Recusancy was not just non-attendance at church and secret worship of the Mass; it was an unwavering attempt by quite a large number of women to support, promote and build an exiled and outlawed religious institution that ran in the face of the Oaths of Supremacy and Allegiance. As Claire Walker has amply demonstrated, the revival of conventual life abroad was the institutional arm of recusancy and was initiated and sustained by women.[79] However, it is not just the convents abroad that make women's Catholic activism more than just a 'country house religion' in Tudor and Stuart England; it is also the mapping of a network of loosely organised resistance outside the home that turned private choices about piety into public and political declarations of faith. The Reformation process was a time of loss for some women but oddly benefited many more. Margaret Clitherow learned to read and write in prison which then enabled her to defend publicly her Catholicism.[80] In the very act of choosing sides women gained in religious literacy and sometimes in literacy itself. This generalised literacy can be viewed as a form of power in the sense that it gave women the

upper hand in some situations. The true knowledge they felt they had gained was revealed by all Catholic women whose defiance in the face of church authorities (including their own) lent them power within their embattled families and their female communities.[81]

Protestantism and puritanism

The early years of the Reformation created as many Protestant martyrs and exiles as Catholic ones.[82] The period of most intense Protestant suffering was during the reign of Mary I and amongst the unsung victims of Marian persecution were the wives of Protestant clergymen exiled to a life of pretending to be unmarried. During the visitation of Norwich in 1556 two clergy were reported and punished for continuing to support their ex-wives with money and food for subsistence.[83] Protestant martyrs were sometimes just out of kilter with state-sanctioned Protestantism, as was the case with Ann Askew. Perhaps the most famous Protestant martyr, Askew, has entered the canon of female Protestant saints through the work of her biographer, John Bale, who drew heavily on medieval hagiography to put together *The First Examinacyon of Anne Askew* (1546) and *The Lattre Examincyon of Anne Askew* (1547).[84] Askew's martyrdom began with a domestic dispute. Her husband, Thomas Kyme, ordered her to stop reading the Bible and when she did not he forced her out of the family home with their two children. She assumed her maiden name and moved to London, but her husband's family spied on her and began sending information to the bishop of London.[85] She was questioned and released but then arrested in 1546 and interrogated about her views on the Eucharist. Askew rejected the Catholic doctrine of transubstantiation whereby it is believed that the ceremonial bread and wine transmute into the saving body and blood of Christ during communion. Instead she believed the bread and wine to be a 'signe or token...of the inestymable benefyghtes of his most prescyous deathe and bloud'.[86] When asked over and again what she would say if the Scriptures taught transubstantiation, she answered repeatedly 'I believe as the Scripture informeth me'. When told it was the 'kynges pleasure' she should change her mind, she answered that she would willingly 'shewe hym [the king] the truthe' and that good kings, like Solomon, heard 'poore comon women'.[87] When the bishop's representative specifically confronted Askew with the Scriptural injunction in St Paul that women should not 'speake or...talke of the word of God' she said that 'I knewe Paules meanying so well as he'.[88] The weapon of Askew's silence was never greater than when she told one churchman that she had little to say because 'God hath geven me the gyfte of knowledge, but not of utterance'.[89]

John Bale represented Askew as a weak woman lent strength by the voice of God.[90] During her second spell in prison she was questioned about the female connections she had at court and her case throws light on tensions between Henry VIII and his last queen, Katherine Parr, over Protestant reform. Parr provoked the hostility of the conservative bishops by holding Scripture reading sessions (despite the 1543 act prohibiting women from Bible study) with her ladies of

the bedchamber including Anne Seymour, wife of the duke of Somerset, whose male enemies attributed to her 'ambitious wit and mischievous persuasions'.[91] Information about Parr's circle was what Askew's torturers sought, though she claimed to have withstood their pressure.[92] She said of the king that 'it was an abominable shame unto hym, to make no better of the eternall worde of God therein, than of hys slenderlye conceyved fantasye'.[93] At the end of her ordeal she angered and humiliated the men who fervently wished her silent: 'They ded put me on the racke...and bycause I laye styll and ded not crye, my lord Chauncellour and mastre Ryche, toke peynes to racke me their owne handes, tyll I was nygh dead.'[94] Askew was finally burnt as a heretic on 16 July 1546. On the day, she was unable to stand and had to be carried to the post where she still refused to recant.[95] Hers was a daring stand against the church authorities and the king. Traditionally her martyrdom has been located within the propagandist Anglican view of the Protestant English past and she became the first in a line of Protestant martyrs captured by John Foxe in his *Book of Martyrs* and used over many generations in works of propagandist value such as William Bruce's *Book of Noble Englishwomen* in 1875. Bruce's nineteenth-century view was that Askew was a 'weak, delicate, and sensitive woman' who was to be even more admired than men for willingly bearing 'the torments of the scorching flame'.[96] In this way gender increased her propaganda value.

Katherine Parr's promotion of Protestantism at a time when Henry himself was lukewarm about reform endangered her life but also had long-term consequences. She wrote two works that elaborated the Lutheran concept of *sola Scriptura*, or the notion that Scripture alone could save. The first, *Prayers or Medytacions* was published in 1545.[97] It had enduring popularity, with about 20 editions published between 1545 and 1645. The work followed the model of Thomas à Kempis' *Imitatio Christi* and comprised a lengthy appeal to Christ with five prayers. It was designed as a template for women's private devotion and it encouraged in them complete supplication to the figure of Christ, including abandoning all claims to human free will in salvation: '[i]f thou wilte that I bee in light, bee thou blessed: if thou wilt that I bee in darknesse, be thou also blessed'. The work attributed Christ's blood shed with all the powers of salvation and combined this with a formula for imitation of his life.[98] Parr claimed to be in constant struggle with sin and corruption and claimed a [feminine] silence that informed Christ of her forbearance and anticipation of his presence. She denied all bodily things and relinquished her soul to Christ as if in a mock sexual relationship with him: 'quicken my soule' she pleaded, 'that it may cleave fast, and be joyned to the[e] in joyfull gladnesse of gostely ravishinges'. Her second work – *Lamentacion of a Synner* – which was published in 1547 after Henry's death, moved with the Reformation and contained more Calvinist ideas. It appealed directly to women to put aside the Pope's idols in favour of the Gospel and it called for good preachers to dispel the idea that ritual was as good as the doctrine that would save the elect.[99] The long-term consequences of Parr's devotional Protestantism was the effect it had on the princess Elizabeth who, under her tutelage did a trilingual translation of her *Prayers or Medytacions* and whose Protestantism was firmly founded by her stepmother.[100]

Protestant reform was from the outset strongest in large towns like London and Bristol and smaller port towns like Exeter and cloth towns like Colchester. The small minority of the firmly Protestant during the reign of Henry VIII tended to cling on during the Catholic reversal of Mary I. In Devon, Agnes Prest was a lonely member of the godly amongst a population that was grateful to return to Catholic worship between 1553 and 1558. Prest travelled to Exeter to meet other outlawed Protestants and was ultimately burnt for her Protestant beliefs. This is all the more remarkable because she was not a woman of Ann Askew's standing, but rather an illiterate labourer's wife who left her family to pursue her godly career of learning the Word.[101] Women like Prest are critical to the cultural and national memory of Marian persecution largely constructed by Foxe's *Book of Martyrs*.[102] The *Book of Martyrs* was first published in Latin in 1554 and in English in 1563, expanded and republished three times in 20 years and circulated in nine separate editions. It was a huge (1800 pages) expensive volume but still sold well. Foxe's women martyrs were woven into a history of England represented as a struggle against the false church for the true church and which included 55 (or about one in six) female Protestant martyrs executed during the reign of Mary.[103] Apart from Joyce Lewis, they were all from the artisan class and lower. Alice Driver described herself as 'an honest poor man's daughter'. They also were not women who simply followed their husbands to the stake. Only some of the 28 married women who were executed had husbands who were burnt and 21 of the women were single, half of these unmarried and the other half widowed.[104]

Femininity in Foxe's account of Protestant martyrdom served to highlight women's greater bravery and as such rendered women the more important rhetorical device in the text. Perotine Massey, whose abdomen was slit open to release her unborn child before the child itself was thrown onto the fire, made better propaganda than even the most anguished man. Christopher Haigh has argued that Mary's regime tried to convert as much as it punished but even he is unable to deny that there was something of a holocaust during Mary's short reign. From early 1555 to Mary's death in 1558 those who held on to an activist form of Protestant faith were searched out, imprisoned and put to death. In Stratford-le Bow in 1556 nine Protestant martyrs were burnt, two of them women. Of these two, Elizabeth Pepper was pregnant.[105] The exile of many more Protestants during Mary's reign also fed the construction of Protestant national identity. Protestant exiles tended to be women of the wealthier classes;[106] 125 followed the Scottish Calvinist reformer, John Knox, to Geneva taking with them 146 children.[107] Elizabeth Bowes departed for Geneva and never saw her husband again. In 1555 she arranged for the marriage of her daughter, Margery, to Knox and stayed with the reformer even after her daughter had died in 1560. Ann Locke's exile was as devastating and total. She left her husband in London and took her two infants to Geneva. One of them died very soon after arrival, whereupon she threw herself into a translation of the sermons of the Genevan reformer, Jean Calvin.[108]

After Elizabeth came to the throne, the Marian exiles returned and Protestant women's activism took the form of the zealous reforming faith of 'the hotter sort of Protestant' or puritan. During the Vestiarian Controversy of the 1560s, they

made their dislike of Catholic vestments known by starting church riots and in the 1580s they joined lay preaching circles called conventicles.[109] By 1600 there was a wealth of Protestant and Catholic propaganda arising out of and reinforcing religious division in English society, setting women against one another. Francis Savage's *A Conference betwixt a Mother a Devout Recusant and Her Sonne a Zealous Protestant* (1599) was Protestant propaganda deploying gender stereotypes to persuade Catholic women to give up the old faith for the sake of the next generation, visualised, of course, as represented by the eldest son.[110]

Those women who did commit themselves to a godly brand of Protestantism made a choice that held for them some positive benefits, not the least of which was adoption of the early Lutheran doctrines of *sola fidei* and *sola Scriptura*, placing emphasis on individual faith and Bible reading for salvation. This could place women in a more direct communication with God than that previously offered by Catholic ministry. Other changes that were arguably regarded as gains by some women included the elevation of the role of marriage and stress upon the domestic value of godliness. The Homily on Marriage stressed women's obedience but laid it alongside the mutual duties and comforts of marriage as an institution. The expectation that priests would marry led to downgrading of celibacy as a vocational choice for women.[111] Despite the role of the husband as patriarchal head of a godly family the role of the wife carried spiritual and didactic authority as well. In the church, segregated pews were replaced for wealthier families with boxed family pews. The hotter the Protestantism, the greater the emphasis on a community of believers (or visible church) made up of godly families. In 1614 the puritan preacher, John Dod, summed up what he thought women had gained by embracing the new religion of Protestantism: Jesuits 'tie the woman to the wheele and spindle' he told them, but in Protestantism they had equal access to the priesthood of believers.

The late Elizabethan period featured Protestant women's activism that took a variety of forms from intense personal piety to writing meditative works for public consumption. Protestant women's publication in the cause of religious introspection became acceptable. Parr's *Prayers or Medytacions* were just the first and became an important example to women in the publication of devotional works designed to promote the Protestant cause. Indeed one of Parr's own ladies-in-waiting, Elizabeth Tyrwhit (d.1578), published *Morning and Evening Praiers, with Divers Psalms, Himnes and Meditations* in 1574. Tyrwhit had been Princess Elizabeth's governess and the British Library copy of Tyrwhit's book of devotions belonged to Elizabeth when she was queen. Beautifully illustrated, it was intended for the contemplative instruction and moral training of wealthy women. In 1582 a further sample of Tyrwhit's devotional and meditative verses appeared alongside those of Frances Abergavenny in Thomas Bentley's *Monument of Matrons* published by puritan publisher Henry Denham. Bentley's 1,500-page work not only drew on the writings of many women authors, it was 'tailored to the needs of a female audience'. Thus by 1582 there was a market for pious Protestant women's writing in print aimed at other women.[112]

Anne Wheathill's *A Handfull of Holesome (though Homelie) Hearbs* (1584) was also published by Henry Denham (who held the patent for printing the Psalter, or

primer for children), and it too was illustrated at front and back.[113] This work comprised 49 prayers for different times of the day and for different devotional occasions such as expressing faith, confessing sin and declaring repentance. It was decorated with flowers around the borders and was addressed to 'all religious Ladies'. It used maternal metaphors of suffering to describe Wheathill's sinful state. The prayers represented a second generation of Calvinism because they introduced Bezan ideas about double predestination which included austere warnings about God's punishment of the reprobate or damned alongside the doctrine of election for the saved. Wheathill used the austerity of the Calvinist message of human sinfulness to relieve women of some of the burdens of sin by blaming both Adam and Eve equally for the Fall and accusing Adam of bringing death into the world. Wheathill used God to lend authority to her controversial reading of Genesis: 'God dooth know I have doone [*sic*] it with a good zeale, according to the weakness of my knowledge and capacitie' she asserted.[114]

The arrival of a second generation of Calvinist ideas from Geneva generated the rise of English puritanism. The embattled Protestantism of Europe, in England became an internal cry against the moderate Elizabethan doctrinal settlement in favour of 'further reformation'. Concepts of Protestant community became incorporated with notions of an invisible church of believers comprising the predestined elect. Parallels were drawn between Protestant England and Biblical Jerusalem. The original formulation of the doctrine of predestination by the Swiss reformer, Jean Calvin, emphasised God's omnipotence but also stressed the mitigating grace given to God's elect. While this version of the doctrine informed the Elizabethan Thirty-Nine Articles it was the more unremitting version of predestination that stressed sin and the casting aside by God of the reprobate that underpinned puritan pastoral theology. Therefore, the puritan woman sought assurance of her election to the community of the elect or Saints foretold in the Bible. Puritanism embraced the covenant theology that emerged from 1590 involving the belief that God made a compact with Adam that was later ratified with Moses promising life to believers, so giving assurance to people who believed themselves inherently sinful.[115] As Questier has recently put it 'the puritan [did] not think to fulfil the Covenant by sanctified activity but want[ed] to see whether [she was] in the Covenant at all' because the alternative was unimaginably horrible.[116]

Many English women were drawn to the puritan strain of Protestantism. Gender construction of femininity stressed the need for female piety so that Protestant activism could quickly transform itself into seeking signs of election. Puritanism led to a form of spiritual account-keeping in women as they scrutinised their own lives in the form of spiritual diaries, private prayers and meditations for signs of conversion. They laid aside the female saints of Catholicism yet they resurrected themselves as the converted, or Protestant Saints. The puritan woman perceived herself as building rather than knocking down the walls of faith, a concept often framed by reference to Jerusalem. One of the earliest woman defenders of Continental Reformation, Ann Locke, a Marian exile, spoke of bringing 'my poore basket of stones to the strengthening of the wals of that Jerusalem, whereof (by grace) we are all both citizens and members'.[117] Private exercise of spiritual

devotion effortlessly turned into public profession of the new faith for women like Locke and her translation of Calvin's sermons on King Hezekiah included her own sonnet sequence that was a metrical reworking of Psalm 51 advocating prayer and total humility: 'Have mercy upon me, O God…wash me of sin…open thou my lips [to sing of the righteousness of God].'[118]

There has been debate about whether or not female puritanism was quintessentially a private or public affair. There is evidence for both. The public face of women's puritanism can be seen in the circles of women who socialised and attended sermons together, especially in London. When Ann Locke married Edward Dering, she shared the company of this popular puritan preacher constantly with Lady Grace Mildmay and a host of other women. The congregation of St Anne's in Blackfriars was mostly made up of wealthy puritan women who patronised puritan preachers and offered them domestic hospitality. Women acted as nursemaids or shunamites to St Paul's cross preachers, providing them with food and board.[119] The charity and patronage of the committed Protestant woman could be vital to clerical careers: the countess of Bedford regularly gave board to the puritan preacher, Thomas Wilcox; the countess of Sussex endowed Sidney Sussex College in Cambridge and Lady Mary Vere secured a bishopric in Ireland for the staunch Calvinist James Ussher.[120] On the other hand, women felt compelled to exercise a meditative piety that was self-examining and quintessentially private. Fletcher has argued that '[t]he steps which women took to conceal their devotional writings indicate the importance to them of the privacy of this sphere of their living'.[121] Both Mendelson and Fletcher have spoken of women's immersion in devotional exercises from an early age that arose out of their gender construction as being close to nature and the mysteries of birth and death and could involve highly sexualised language and 'erotic transference'. Elizabeth Delaval was just 14 when she began her private introspection. Some women desired that their writings be burnt, but there was a tension for women between privacy and activism on behalf of the true church so that the slippage between the two was considerable.[122]

Two diaries from the late sixteenth century reveal this female puritanism at work as well as the tension between its private and public face. Lady Margaret Hoby's diary survives from 1599 to 1605, though almost half was written in the first year; the entries towards the end becoming, perhaps significantly, much less spiritually reflective.[123] Lady Grace Mildmay's diary is a different sort of survival, being rather a collection of retrospective autobiographical notes and household books. Although not exact contemporaries (Mildmay was born in 1552, Hoby in 1571) their spiritual meditations were recorded at about the same time. Hoby's puritanism grew out of and expressed itself through contact with a circle of puritan women. She was in London for six months between 1600 and 1601 during which time she visited people like Anne Bacon, wife of the Lord Keeper, and Elizabeth, Lady Russell, her mother in law. Both were the learned daughters of Sir Anthony Cooke and active defenders of the Protestant faith.[124] By contrast, Mildmay spent much of her married life 'shunning all opportunities to run into company' and refusing to go to court. The private face of their puritanism

differed too – Hoby expressed continuous spiritual anxiety ('this day I…found inward Corruption to my great greffe [grief]') whereas Mildmay seems to have found assurance of her election by the time she recorded her spiritual thoughts for posterity. Both women were involved in essentially the same task of engaging with their Protestant faith in a way that was expected of women of their social class. Only Mildmay anticipated a reading audience in the shape of her daughter and grandchildren: 'Thus have I given my mind unto my offspring as my chief and only gift to them,' she said. Her aim was to provide a living example to them of shunning worldly goods in favour of contemplative imitation of Christ. While Hoby, in her daily ritual of prayers, Bible reading, lecture and sermon attendance, catechising, meditation and self-examination (and self-punishment over worldly affairs), lived her life in imitation of Christ, she did not, as Mildmay did, envisage her written work as anything but private reflection and diarising of her life: '[t]his book of my meditation is the consolation of my soul, the joy of my heart and the stability of my mind.'[125]

What the diaries of Mildmay and Hoby had most in common was the theological underpinnings of second generation Calvinism. Both women believed in predestination and Mildmay believed that her gift of a diary to her offspring would lead them towards eternal life. Their self-examinations were designed to reveal human sin and corruption as a step towards leaving behind human imperfection and attaining salvation through reception of God's freely given grace. Puritan practical divinity had schematised this meditative process by 1600, encouraging people to believe that there were defined stages in the regeneration process. Anxiety about election was ideally followed by a transition phase of alternating hope and increasing despair (again, in imitation of Christ, some puritans believing that hitting the depths of despair was a necessary imitation of Christ's descent into hell) and a final stage of assurance (full acceptance only came with glorification after death).[126] Two things could affect a person's meditation on their state – personal happiness and their mental disposition. Hoby's writing vacillated between insecurity about her election, hope and the depths of despair, suggesting at times either personal unhappiness and/or a depressive disorder. She may well have been unhappily married as her husband, Thomas Posthumous Hoby, was, by all accounts, an uncooperative burden to his mother and a menace to his neighbours.[127] Like Hoby, Mildmay prayed at regular intervals through the day, read the Bible and commended to her children and grandchildren Foxe's *Book of Martyrs*. Both women were involved in attending to the sick and wounded in their households, but while Mildmay attained hope, Hoby fluctuated constantly between hope and misery. On 18 May 1605 she was full of 'wandering distractions' but by 10 June she had attained 'peace of mind'. By 27 June she was discovering 'inward corruption' again.[128] Thus, Hoby's constant anxieties about her sins of 'commission' and 'omission' would suggest 'anxious puritanism' which might be classified as reaching a different emotional point from Mildmay's state of assurance.

Patricia Caldwell has spoken of a 'morphology of conversion' which involved formulaic 'conversion narratives' and 'death narratives' both of which can be seen in expressions of female puritanism from the late sixteenth century.[129] Such

narratives enabled women to look for evidence of a transit to eternal life through 'preparedness' and a 'correct death'. The elect found evidence of their election in small things, but assurance of election began with the experience of conversion and never strayed far from thoughts of mortality and death.[130] Mary Rich, the puritan wife of the earl of Warwick, claimed to have experienced conversion at the age of 21 years: 'I was so much changed to myself that I hardly knew myself, and would say with that converted person "I am not I"'. However, years later when her brother was buried in the family tomb at Felsted she experienced 'very large meditations of death' and 'had very moving thoughts of my lying down in the bed of darkness, and did…cry to God for mercy against a dying hour'. She was then relieved at the regenerative thought that 'nothing died finally and totally in a child of God but sin'.[131] There are considerable overlaps between the formulaic puritan conversion narratives and spiritual autobiographies and sets of prayers. For example, Anne Wheathill's prayers – *A Handfull of Holesome (though Homelie) Hearbs* – set out the puritan journey to eternal life, appealing to the Holy Ghost and God 'to inspire…hearts' and 'illuminate…understanding' so that the faithful could come to Christ whose blood had saved the elect. The prayers took the reader through the stages of repentance and regeneration, suggesting that those who rejected God's law and chose evil over good, rejected also the promise or covenant God made with Abraham who was the second Adam to whose seed God promised life in Christ. At the hour of death, the elect 'ascend to the heavenlie Jerusalem, where [they] shall rest in the bosome of [their] father Abraham'.[132] Wheathill's title echoed that of the earlier work – Thomas Becon's *The Flower of Godly Prayers* (1560) and the anonymous *A Godly Garden* (1574).[133] However, her Prayer 37 invoked God to disperse his enemies amongst whom she numbered those God had damned: 'O God almightie, thou dost punish thine elect by measure, & givest them grace to beare it; but to the reprobate, it is thy just vengeance, to drive them headlong to all madnesse…thy omnipotence hath all power in it selfe'.[134] Therefore, while Wheathill drew upon earlier puritan works for her floral imagery, the double predestinarian and covenant theology of her prayers anticipated William Perkins' *Golden Chain* of 1591 and Arthur Dent's *Plain Man's Pathway to Heaven* of 1601 making her the most important female Protestant religious thinker of the late sixteenth century and an important exponent of the conversion narrative.

The first classic death narrative demonstrating a puritan woman's preparedness was published as *A Christal Glasse, for Christian Women* in 1591 by Philip Stubbes who outlined his wife's godliness and words proving her salvation in her final days. Katherine Stubbes is reported as having said: 'Oh sweet death thou art welcome…welcome the messenger of everlasting life…set my soul at liberty…into thy blessed hands I commit both my body and my soul.' She was also represented as battling with the devil: '[Y]ea Satan, I was chosen and elected in Christ to everlasting salvation…and therefore thou maist get the[e] packing, thou damned dog'. In this way, a woman's deathbed could become the female equivalent of the male pulpit. Women were empowered to preach with the purpose of converting others at the time of their death. Philip Stubbes spoke of his wife calling her neighbours

around her as she expired so that 'those...that are not thorowly resolved in the trueth of God, may heare and learne what the spirit of God hath taught [her] out of his blessed and al[l] saving worde'. Their witnessing to her faith at the hour of her death provided both her and her family with assurance of her salvation and her neighbours with the knowledge of their own potential salvation. 'God hath given me grace to open the doore unto him' she told them, before advising them to 'imprinte my wordes in your hearts, for they are not the words of flesh and blood, but the spirite of God'. Twice she told her listeners that her voice was really that of God whose spirit was in her 'and in all the elect of God' (more ominously, 'unless they be reprobates') and so she claimed the highest divine authority in her most vulnerable moment.[135] There were at least 28 imprints of *A Christal Glasse* before 1664 indicating early authorisation of a form of women's preaching in the cause of Protestantism.[136]

By the early decades of the seventeenth century, puritan theology with its emphasis on sin and conversion was embedded in female gender identity. There were just two published works of female puritan theology in the 1620s and 1630s, but both reveal the theological outlines of female puritanism. The first was Rachel Speght's *Mortalities Memorandum* of 1621 which was a meditative reflection on the death of her mother. It was a poetic work in two parts with a double predestinarian framework. The first part introduced the prophetic dream of her mother's death and the second was an exploration of Creation, the meaning of 'death by sin' and the reasons why 'Death is that guest the godly wish to see | For when it comes, their troubles ended be.' The poem reflected on how death was a release from sin and sorrow, pain and care for the godly, but the beginning only of eternal death for the reprobate.[137] The second work of puritan theology by a woman was Alice Sutcliffe's *Meditations of Mans Mortalitie* of 1634 which spoke of 'a woman's skill' in bringing devotional knowledge to other women and was a call to 'conversion', speaking of the terror of those who at judgement day would pay the price for renouncing God.[138] Sutcliffe's work comprised six chapters of meditations that concentrated completely on human wickedness and the sinful state, and her message was that without leading a godly life there could be no hope of 'eternal happiness'. The meditations were structured around selected sections of the Bible and in this sense they were like a delivered sermon. They were followed by a poem of 88 six-line stanzas which exhibit a systematic theology employing the notion of man/woman's double Adamic inheritance. Sutcliffe used the text I Corinthians 15 ('Of our losse by Adam, and our gayne by Christ; the first Adam was made a living soule, the second Adam a quickening spirit; For as in Adam wee all dye, so in Christ, shall all be made alive') as her starting point.[139] However, the poem was unusual in totally feminising human sin by concentrating heavily on the role of Eve: 'Wicked woman | To cause thy husband dye...| Thy husband not alone | The fault must rue | A punishment for sinne | To thee is due.'[140] Adam's sin was replaced throughout the poem with Eve's and Sutcliffe reminded that sin had infected Eve's offspring and called this 'a female sinne'.[141] The only mitigating section reminded readers that the seed of the woman shall bruise the head of the serpent and life was offered again in Christ. Sutcliffe's work was praised by several

men in the introduction, her husband saying that the reader should not 'disdain to take that knowledge, which a woman's skill can bring | All are not siren notes that women sing'.[142]

Therefore, while for most women the Protestant Reformation signified slow acceptance of a changed faith involving greater attention paid to Scriptures than sacraments, for puritan women it meant serious soul searching. Women's conversion narratives and death narratives, calls to repentance and reminders of God's will, whether printed posthumously or during life, were the female puritan's equivalent of men's preaching and they enabled women to abandon the gender expectation of silence and bypass men in a puritan quest for salvation. For example, Alice Sutcliffe had no male minister in mind when she argued that God himself was 'the looking glass to the eyes of the elect'.[143] However, what is most interesting is that while many historians have concentrated on the piety and emotional content of puritan women's meditative work, women like Wheathill, Speght and Sutcliffe seem most interested in demonstrating their understanding at an intellectual level of the new, systematised predestinarian and covenant theology of the early seventeenth century.

Godly motherhood and prophecy

Protestant women were as central to the task of promoting their faith as Catholic women in their role as the mothers and educators of children. This resulted in a veneration of maternity and women viewing their own fertility providentially. Godly women not only measured their daily sins and prayers but also measured God's pleasure with them through their childbearing and childcare. Lady Elizabeth Mordaunt recorded her live births as blessings in her diary, but when she lost twins she blamed her own spiritual failings. Live births, like that of her son, John, were a sign of God's 'mercy' for which she offered thanksgiving. Infertility was an even greater sign from God of his displeasure than dead infants. Childless women never escaped the curse of Eve while never being able to claim the role of Mary as mother either. Women who had children suffered painful childbirth but their survival was always read as a sign of God's particular mercy or favour to the elect. Women prayed fervently for the continued health of their infants and when children died they struggled in their relationship with God. Lettice Falkland interpreted her excessive grief at the loss of her son as temptation to sin by the devil.[144]

Religious devotion and godly motherhood represented a powerful combination for women and lent women authority in their relationships with their children, families and a reading public. Domestic manuals placed responsibility for religious instruction on the shoulders of godly matrons leading especially to strong bonds between mothers and daughters.[145] According to Kenneth Charlton the importance of this to the success of the Protestant Reformation cannot be overestimated. Early-modern England was a 'godly community...operating to maintain itself' and women were agents of Reformation and mothers were educators. The cultural transmission of Protestant ideas relied on women and involved a range of

domestic educational media ranging from Bible study to the embroidery of godly samplers as Bible covers.[146] The connection between female religious expression and women's maternal identity was very strong. Godly motherhood was a vocational role for women as indicated in the growing number of spiritual diaries they left behind. Anne Halkett left instructions to her children in her diary, as did Margaret Godolphin, and it is clear that amongst the literate elite maternity and diary-keeping were linked. Katherine Austen called her diary a 'scribal exercise directed to myself' but she included advice to her son, Thomas, on 'civil behaviour' while at college and told him of her gift to him of instruction in providential understanding of the world. She also included advice to her daughter, Ann, on the 'virtue', 'goodness' and 'industry' of her mother and grandmother.[147]

Several godly motherhood tracts appeared in print, the first being Elizabeth Grymeston's *Miscelanea, Meditations, Memoratives* (1604) that was reprinted under the slightly different title of *Miscellanea, Prayers, Meditations* in 1608 and 1618. The text was addressed to Grymeston's son Bernie, and contained a madrigal of his composition. Grymeston hinted darkly at her own demise – 'a dead woman among the living' – and told her son that she felt compelled to leave him some direction because she also felt 'doubtful of thy father's life'. She authorised the text through 'mother's affection' and her maternal duty to 'advis[e] hir children out of hir owne experience, to eschue evil and … do that which is good'. The text was divided into 14 chapters the majority of which dwelled on the wages of sin. The message was that true Christians suffered out of respect for God's justice. She advised her son to fear the former and gain hope from the latter. The text was more reflective than prescriptive though she did also advise her son that 'happie is the man whose life is a continuall prayer' and reminded him that he should be 'chief commander in [his] little world [i.e. the household]'.[148]

Grymeston's *Miscelanea* resembles Mildmay's rather unstructured instruction of her offspring of the need for godly behaviour and prayer. However, as the seventeenth century progressed godly motherhood tracts began to resemble other godly conduct books. The genre as a whole was determined by the perceived social need to draw up the boundaries and rules of the domestic godly 'little commonwealth'. Dorothy Leigh's *The Mother's Blessing* (1616) was validated by the godliest commonwealth of all – the royal family. The work was dedicated to Princess Elizabeth, daughter of Charles I, in the belief that her name on the text would ensure its dissemination and survival. Leigh's hope was fulfilled and *The Mother's Blessing* passed through 15 imprints by 1630 with a further three by the end of the century. Leigh seems to have filled a niche in the print market and in the conduct book genre itself; many women faced the possibility of predeceasing their children and *The Mother's Blessing* became a generic instruction manual that women could leave as their legacy to children who were young and 'most in need of instruction'. Leigh told her readers that she herself had been 'wearied with feare lest my children should not find the right way to heaven'. Here she alluded to Arthur Dent's *Plain Man's Pathway* of 1605. Leigh believed it her duty to tell her children about the 'false paths they should finde' and by publishing her advice she told many more children besides. The posthumous nature of Leigh's work would not

have been lost on other women and she gained authority through her death. She told her children she knew they might 'marvaile … why I do not according to the usual custom of women, exhort you by word and admonitions, rather then by writing, a thing so unusual among us [*sic*]' but motherly affection (which, in early-modern parlance, incorporated duty) compelled her to 'forget my selfe' or transcend her sex.[149] Despite her modesty, in effect she had found a way to publish a feminised sermon.

It was more than death and duty that underpinned the godly motherhood manuals. At their very heart was the anxiety-making doctrine of sin. The prevalent belief that sin entered the world because of Eve's transgression was relieved only by the idea that God promised woman that her seed would crush the serpent's head. Thus, women like Leigh were not only concerned with the instruction of their children in how to live a godly life, they also believed that their words had the power of salvation. Leigh told her three grown sons that by writing she did not aim to upset 'the usuall order of women'; on the contrary she laboured to prove their secondary place 'because wee must needs confesse, that sin entred by us into our posterity'. However, by writing she could 'shew how careful we [women] are to seek to Christ to cast it out of us, and our posterity [i.e. children]'. She drove this home further with instructions to them about how to save their own posterity through the choice of good wives and instruction of their children in the Bible. The godly commonwealth was theirs to instruct and shape, as long as they gave their children 'good names' (both nominally and symbolically), ordered their servants well and governed their families according to the Scriptures.[150]

Elizabeth Joscelin put a new twist on the matter in 1624 with an immensely successful tract addressed to her unborn child that went through five reprints. Joscelin was the granddaughter of the puritan bishop, William Chaderton, was educated by him and may have been his sole heir. Thus, when *The Mother's Legacy*, her only work, was published in 1622 it joined the ranks of other godly conduct books written by men of her own social (and occupational) class. Joscelin legitimised her writing in a letter addressed to her husband, Torrell Joscelin, in which she stressed her mother's zeal, a zeal that compelled her to write in case she died in childbirth. As it happened, she did, and when the tract appeared the pathos of her terrible death was not lost on her reading audience. Between 1622 and 1633 *The Mothers Legacy* was reprinted seven times, with further editions appearing in 1684, 1722 and 1724.[151]

Thus, the Reformation resulted in Protestant women gaining an area of spiritual power that can also be seen in the evidence of the striking and powerful church monuments of women holding babies that lie in churches throughout England. In Hereford Cathedral one woman lies prostrate with her dead infant wound into the folds of her [marble] dress by her feet. Margaret Leigh holds her infant, eyes closed and hand to her breast, in Fulham, Middlesex. In Lydiard Tregoze, Wiltshire, John St John portrayed his wife in stone clutching their swaddled dead infant. In Suffolk, Elizabeth Coke, who died in 1627, lies prostrate in stone, a swaddled infant held at her lace-encased breast.[152] Both mother and child look upwards to heaven, as if locked together for the final judgement, the baby's eternal life

forever bound up with its mother's godly life as if its salvation depended entirely on proximity to its mother in death.

As Crawford has pointed out, mother's milk had spiritual significance and this can be seen in both verbal and visual imagery of early-modern women in death. Elizabeth Brand, who died in 1636, is depicted in her funeral brass with hands clasped in prayer, described as the mother of six sons and six daughters 'all nurs'd with her unborrowed milk'.[153] In Derbyshire, Elizabeth Lydelton, who died in 1676, breastfeeds her infant for eternity in stone.[154] Children were sometimes seen as 'holy innocents', the monument of the swaddled babe by the mother represented as having attained 'the kingdom of God'. Women's central role in that journey marked them out as spiritual guides of considerable power.[155] By the later seventeenth century Samuel Clarke, the Protestant biographer, took this idea to its logical extension, revering ordinary godly wives, and sanctifying them by drawing on funeral sermons. Women constructed themselves similarly. When Elizabeth Brackley died in childbirth in 1663, her sister, Jane Cavendish, wrote in rhyming couplets of 'God's judgements' and observed that '[a] greater Saint earth did never bear'.[156]

Women's godly power could extend to grandchildren: when her daughter Lucy lost a child in 1649 Eleanor Davies wrote one of her prophetic tracts in response to his funeral in which she conflated the identity of her daughter with Sion 'the mother of all', revealing poignant details of her daughter's last bedside vigil for her dying son.[157] The salvation of children, thus, became a female responsibility and men as well as women acknowledged this as a woman's role. Robert Filmer's *In Praise of the Vertuous Wife* argued that women were the 'occasion' and not the 'cause' both of original sin and salvation. The 'privileges' given to women, of the law or gospel, meant that while childbearing was the curse laid upon Eve for her disobedience, childrearing by her 'daughters' could mean human salvation. Indeed, salvation of her children ensured a woman's own salvation: 'not with-standing through bearing children she shal be saved if they continue in faith and love and holiness with modestie or rather as our new translation hath it (she shal be saved in childbearing)'.[158] Thus, it can be argued that godly motherhood became a more generalised permission for women to write and for childless women to treat writing as a substitute to motherhood. Women whose experience of maternity went awry needed to find a replacement for this critical role in the godly com-monwealth. In 1652 the exiled Royalist writer of *Eliza's Babes* described her poems as 'babes…brought forth by me, but…proceeding from divinity'.[159] The spiritual authority of motherhood could also be used as a polemical tool. *A Mothers Tears over Hir Seduced Sonne* in 1627 was ostensibly written by a woman trying to draw her son back from the Catholic college at Douai. She advised him to read Dorothy Leigh's *The Mothers Blessing* and cried 'Oh, I shall be robbed of my son…[h]earken to thy mother child, that the Lord may hearken unto me.'[160] In other words, for a woman the puritan imperative was doubled, incorporating symbiotically the imperative to seek her own salvation with the salvation of her children.

The puritan imperative encouraged also the roles of spiritual guides and prophets, or saints, in the invisible church of the elect. Esther Cope has suggested that

Eleanor Davies's writings, which 'brought life to the world, replaced the children (two sons) who had died'.[161] Puritan women deployed a providential interpretation of events and regarded themselves as engaged in what Alexandra Walsham has called 'the street wars of religion'.[162] For Protestant women this began with the Elizabethan prophesyings of the 1570s, particularly in market towns like Coventry. These followed the Swiss Calvinist model in which a minister preached to lay men and women who sat with the Geneva Bible open on their laps before openly discussing the interpretation of the text. By the 1580s conventicles gathered to sing psalms and read Foxe's *Book of Martyrs*. The Dedham Conference even discussed whether or not women would be better suited to lead prayers than their husbands. Female prophets came to be revered by some in this context. For example, Ursula Grey in Wisbech came to be regarded as a preacher and prophet of considerable authority.[163] Elizabethan puritanism blurred the distinction between individual interpretation of God's message and prophesying or more publicly interpreting that message. Prophecy and preaching must, therefore, be seen as connected and even synonymous in puritan pastoral theology opening the way for women's preaching outside church walls.

Phyllis Mack, Elaine Hobby and Patricia Crawford amongst others have uncovered the careers of women prophets and several conclusions have emerged from their work. First, women prophesied more than men and their methods of presentation were partly determined by their gender training. Mack has argued that female prophecy often involved a transcendence of the gendered self, with women being more inclined than men to prophesy in a trance and claiming to speak with the voice of a man. Using the idea of the English Jeremiad, or sermon based on the prophetic stories of the Old Testament Hebrew prophets, women presented themselves as Isaiah, Ezekiel and Daniel, issuing warnings and attempting to save Israel. Prophetic expression was more than just preaching; it was the expression of belief in the prophet's direct covenant with God and some women prophets claimed to be speaking the word of God himself.[164] There were several categories of woman prophet who emerged from the 1570s. Ottavia Niccoli has spoken of the 'marketplace prophet' who needs to be distinguished from the holy woman or lay prophet, not so much because of her message, but because of her self-representation and projected audience.[165] One crucial distinguishing feature was that the marketplace prophet was a member of a spiritual community. Prophecy was the resort of the sex that was not supposed to speak in public and, therefore, women's prophecies should be read as what Quentin Skinner would term political 'speech acts'.[166] Women prophets challenged the gender order, even if not consciously.[167]

Before the Civil War the only woman prophet who made a big impact in Protestant England was Eleanor Davies, the daughter of George Touchet, 1st Earl of Castlehaven.[168] She married Sir John Davies, who was nearly 20 years older than herself, in 1609. He was the king's attorney in Ireland and a poet of some note. After marriage, she began a prophetic career, styling herself as 'the Lady Eleanor'. Esther Cope, has divided Davies' prophetic career into three periods according to her social circumstance and output and suggests that the one outstanding feature of her entire prophetic life was that her prophecies were very

self-referential. Unlike most early-modern female prophets Eleanor Davies did not fast, trance, talk with two or more voices or wait for others to record and publish her words. From the morning in 1625 when the prophet Daniel woke her up by shouting at her 'Nineteen years and a half to the judgement and you as the meek Virgin' Eleanor Davies relentlessly pursued the occupational identity of prophet. She produced over 70 prophetic works, only one of which was given licence. All of her works were published at personal and financial cost to herself. Her prophecies caused her problems with kin and social contacts and brought about heavy debts that ultimately landed her in the Fleet Prison.[169]

Cope's three suggested periods for the prophetic life of Davies are 1625 to 1633 during the final stages of her first marriage and the early stages of her second marriage to Sir Archibald Douglas, 1633 to 1640, after her social reputation had been shattered by being called before the High Commission and before she gained freedom to pursue her prophetic life and from 1640 to her death in 1652, during the civil wars and interregnum. The first period began with *Warning to the Dragon* (1625), a 50-page exposition of Daniel's visit to her bedside, intended for James I and presented to Archbishop Abbot soon after Charles I ascended the throne. Davies warned that '[t]hese flouds the Serpent will cast out of his Mouth, a time and times and halfe a times, to trie them of the holy covenant'. *Warning to the Dragon* was an exegetical work that used Daniel chapters 7 to 12 to warn of a day of judgement before which the faithful (or covenanted Saints) would be tested. Davies warned vaguely of traitors and worldly dalliances that could turn to what she called whoredom. The language she used was that of the predestinarian accounting system: the elect were numbered, the damned were numbered and the days were numbered, indeed 'the whole world [was] numbered'. '[T]he Temple of God is measured, and them that worship therein. Measuring is for numbering, place is put for time, and sometimes space a thousand six hundrede furlongs'. Taking Daniel's warning that there were 19½ years left until the day of judgement from 28 July 1625 she anticipated the Apocalypse in early 1645.[170]

All of Davies' prophetic works used the Old Testament extensively, especially the books of Daniel and Revelation. However, she also issued uncomfortable warnings that were immediate and aimed at friends and family. She told her husband he would die within three years and began wearing mourning. He did indeed die, on 7 December 1626. She foretold the death of the duke of Buckingham in 1628 and when he also dropped dead she became feared because she was inclined to issue prophecies about infant deaths.[171] However, she published nothing further about the fate of England until 1633 when Archbishop Laud burnt her books and called her before the Court of High Commission. A broadside she had printed in Amsterdam in 1633 called *Woe to the House* made portentous anagrams out of the names of female kin – Anne Stanley became 'A Lye Satan' and Elizabeth Stanley became 'That Jezebel Slain' to accuse them of family conspiracies, but in *All the Kings of the Earth* of the same year she identified Queen Elizabeth I as the defender of Britain against a Babylonian fate and equated the history of Babylon (from Daniel) with the present.[172] This prompted Sir John Lambe, dean of the Court of Arches, to come up with an anagram of his own, replacing Eleanor Davies'

self-fashioning as 'Reveale O Daniel' to 'Never Soe Mad a Ladie' and the church authorities did indeed ultimately declare her mad and in the late 1630s she was put in Bethlehem (Bedlam) Hospital before being transferred to the Tower and not released until 6 September 1640.[173] However, Eleanor Davies was not simply mad; hers was the voice of puritan protest at what many regarded as Arminian corruption of the Protestant Church under Archbishop Laud. Two tracts caused her incarceration: *Bathe Daughter of BabyLondon* which conflated the Biblical Babylon and London and described Bath as the Whore of Babylon described in Revelation 17, and her one page *Spiritual Anthem* which spoke of men's possession by the devil. *Spiritual Anthem* was written and published in Lichfield where she had co-opted the bishop's throne in the cathedral and despoiled the altar cloth in protest at Archbishop Laud's replacement of communion tables with altars.[174]

The intellectual framework Eleanor Davies used in her first prophetic work had an unquestionable legitimacy in 1625 and when she declared that 'such as doe wickedly against the covenant…shall fall by the sword', she echoed the same puritan covenant theology that was espoused by the Calvinist clergy and prominent theologians such as William Perkins, Robert Rollock and Archbishop James Ussher.[175] Davies and the godly mothers of pre-civil war England were driven by the same puritan ideas and motivations as their male co-religionists and gender expectations alone defined Dorothy Leigh as Saint and Eleanor Davies as mad. Therefore, Davies is a highly enlightening figure – she knew herself to be of the Saints and this self-knowledge of the elect puritan woman became a defining feature of thousands of women in the 1640s.

Civil war and God's providence

In the middle of the seventeenth century Britain witnessed political turmoil and internal warfare on a scale not seen again since. Once understood by historians as a struggle for political sovereignty between parliament (more particularly, the House of Commons) and an absolutist King Charles I the English Civil War is now viewed as a more complicated struggle in which parliamentarian and royalist were not divided by class difference, or even solely by political goals, but rather by religion. It is also now recognised that the Civil War was not just English, but British. The English Civil War that started in 1642 was preceded by rebellions in Scotland in 1638 and then Ireland in 1641. The Scots rebelled against the introduction of the English Prayer Book and to defend a Calvinist faith that was doctrinally more reformed than that encapsulated by the English Thirty-Nine Articles, and Irish Catholics rebelled against Protestant English and Scottish colonisation. Religion motivated rebellion and created internal allegiances and intra-national alliances; Glenn Burgess has pointed out that if English members of parliament fought the king over constitutional issues it was because 'it was the law that guaranteed to Englishmen the Christian faith'. According to Burgess 'the constitutional concerns of the puritan pamphleteers were not an alternative to their religious concerns…[but rather] the means of expressing [them]'. According to William Lamont most puritans fought their king in England because after the

Irish Rebellion they felt compelled to defeat the Catholic Antichrist, and other historians, like Patrick Collinson and John Spurr, have labelled parliament's supporters as Christian soldiers and godly soldiers in a war for 'holy commonwealth'.[176]

How do women fit into this picture?[177] There are two strands in the historiography of women and the Civil War. The first is the heroic which has focused on women as victims caught up in the struggle but bravely responding to the challenge and the second has involved focus on women's religious activism especially in the religious sects that sprung up in the 1640s. The heroic strand roughly maps onto old explanations of the Civil War that focused on the struggle between Cavaliers (Royalists) and Roundheads (Parliamentarians), though the second fits more comfortably with newer ideas about the Civil War as a 'war of religion'. Both approaches reveal much about female gender identity. Men's lives were disrupted by the Civil War and John Adamson has argued that chivalric masculinity died a death with the earl of Essex when he was the last at his funeral in 1646 to be popularly portrayed as St George the dragon slayer.[178] However, while joining an army or a trained band disrupted men's family lives it did not disrupt gendered ideas about men's bravery or public responsibilities, whereas women who joined armies and defended castles and estates did disrupt gender roles.[179] There were several cases of women joining armies and it was not something new as sensationalist ballads from the late sixteenth century like *The Maiden Sailor* and stories about the she-soldier Mary Ambree demonstrated.[180] However, the extent of female participation in warfare was greater than anything seen before and pamphlets like *The Gallant She-Soldier* of 1655 extolled the bravery of a woman who followed her husband to war. The reality was often more prosaic, involving women acting as messengers and nurses though there were also high profile cases of women defending castles and estates.[181] Amongst the Royalist heroines Charlotte de la Tremouille, countess of Derby, who defended Lathom House in 1644 with a garrison of 300, is probably the best known. However, other Royalist heroines included Lady Elizabeth Cholmley, who stayed with her husband Hugh Cholmley in Scarborough Castle during a long siege, before travelling in 1645 over the North Yorkshire Moors to reclaim her house at Whitby from parliamentarian troops, and Mary Bankes, who refused to give up Corfe Castle during a siege between 1643 and 1645. Amongst the Parliamentarian heroines Brilliana Harley, wife of MP Robert Harley, is perhaps the most well known because she left an extensive and often poignant correspondence to her son 'Ned'.[182] Whether Royalist or Parliamentarian, women such as these were described as adopting masculine attributes. Hugh Cholmley described his wife as 'though by nature according to her sex tymerous, yet in greatest danger would not bee da[u]nted but shewd a courridge even above her sex'.[183] Lady Bankes is described on her monument as showing 'a constancy and courage above her sex'. Mary Astell bitterly remarked half a century later that because men record history heroic women are portrayed as 'act[ing] above their sex [as if they]…were men in petticoats!'[184] Whether revered by husbands and friends or reviled as trying to 'wear the breeches' the woman who was what Antonia Fraser called the 'feminine figurehead' not only subverted prescribed femininity but also inverted gender roles.[185]

Joan Scott once asked the important question: 'If significations of gender and power construct one another, how do things change?' The answer, she suggested, was that the terms and organisation of gender may be revised when there is large-scale political upheaval.[186] There is a sense in which the women who fought from home demonstrated the courage of devoted wives and mothers and, therefore, did not challenge gender roles in the long term. Thomas Fairfax interestingly commented in his *Short Memorials of the Civil War* that during skirmishing between 1642 and 1644 his wife 'who run as great hazards with us...with as little expression of feare', nevertheless did not 'delight...in ye war' but instead endured it 'through a willing and patient suffering of this undesirable condition'.[187] In Ireland, too, the marquess of Ormond discovered that his wife Elizabeth gave no thought to her own 'particular sufferings'.[188] What both men perceived in their wives was endurance of suffering that was considered to be a quintessential early-modern feminine quality.[189] There was, therefore, a very fine line between women's masculine bravery and their feminine suffering.

While the historiography of women and war has often focused on female bravery without reference to political allegiance, there is much to be gained from gender analysis of how women's allegiances were formed and expressed. For example, Elizabeth Sherburne, a Catholic whose joint properties with her husband extended through Lancashire, Yorkshire and Lincolnshire, planned and executed deals with London lawyers to save their estates because she was the only one who could do this while her husband was politically disempowered by parliament. Her royalism was reactive and a defence of her Catholicism, though Hilda Smith has pointed out that royalist women also became empowered by a more secular outlook because of their experience of persecution and exile.[190] The allegiance of many parliamentarian women was determined by the hold of puritanism on their identities, so again it was religion that prompted gender inversion. The parliamentarian Brilliana Harley defended Brampton Bryan near Hereford from 25 July 1643 until October 1643 when she died. The whole area was royalist and she was threatened by the Royalist commander, Sir William Vavasour, who reputedly told her to get out or 'I have by this timely notice discharged those respects due to your sex and honour'. In her last letter to her son she said 'there are some souldiers come to Lemster and 3 troopes of hors to Heariford...but I hope the Lord will delever me'. Harley's allegiance was, like Sherburne's, reactive and partly induced by her belief that her family's religion was at stake.[191] Her son had joined the Scottish Covenanters and her puritan advice to him was that while 'theare is so much discourse of wars...it may well put us in minde of our spiritual warefare'.[192]

The second strand of the historiography on women and the English Civil War that has focused on women's active religious engagement during the 1640s and 1650s has been propounded by historians quick to see the relevance of religion to a more gendered analysis of events. In 1958 Keith Thomas argued that women were attracted to religious separatism during the Civil War because 'separatists laid great emphasis upon the spiritual equality of the two sexes' and the sects offered the possibility of 'equal share in church government.'[193] In other words,

while women were not the puritan members of the Long Parliament fighting the Antichrist, the war nevertheless created a space for female religious expression in a climate of covenanting with God in holy war. Where Thomas led, others have followed. Claire Cross, for example, pointed out that as early as 1640 a woman called Dorothy Hazzard covenanted together with several other people to form a separatist church at Broadmead in Bristol which gained a membership of 160 very quickly before moving to London.[194] There were three ways in which women's religious engagement turned into a highly politicised activism – through petitioning, preaching/prophesying, and writing.[195] Petitioning was both individual and collective.[196] On 4 February 1642 a crowd of women joined men petitioning against the bishops, though it is also the case that when war became imminent between the king and his parliament in August 1642 between 3,000 and 6,000 women petitioned for peace wearing white ribbons.[197] The evidence for women's prophetic activism is even more impressive. Phyllis Mack has identified more than 300 women prophets during the civil wars, over 200 of them being Quakers.[198] Crawford has calculated that 72 out of 92 prophetic titles by women appeared during the 1640s and 1650s and the evidence for women's writing generally is startling. In the decades 1600–1640 women only averaged between 3 and 7 new published works each decade. Between 1640 and 1650 that figure rose to 112 new works and 1650 to 1660 saw 122 new works by women, over half of which were prophetic. After 1660 the figure for each decade averaged just over 90 new works demonstrating a dramatic quantitative increase in women's writing sustained after the period of religious activism that generated the change.[199]

Historians are divided over the historical significance of women's religious engagement and political activism in the English Civil War. The question turns on whether or not women sectaries and religious writers can be defined as proto-feminist in some way. Anne Laurence, Elaine Hobby and Phyllis Mack amongst others have pointed out that women were always defined by their weakness and prevented from administering ordinances or entering any formal ministry despite the radicalism of the religious sects. Others including Patricia Crawford, Rachel Trubowitz and Hilary Hinds have argued that religion gave women preaching authority in 'the experiential Protestant sects' as they were empowered to 'speak and act in the power of the Lord' and their radical sectarian writing can be defined as feminist criticism against religious patriarchalism.[200]

Women's religious engagement was galvanized by the events of 1640 to 1643. Charles' military action against the Scottish Covenanting army led to the calling (to raise subsidies) and the swift collapse of the Short Parliament and then in November 1640 the convening of the Long Parliament which sat until 1653. From December 1640 the dominant mood in London was an iconoclastic attack on the established church and the bishops, especially Archbishop Laud. This was followed by an alliance forged between parliament and the Scottish Covenanters and the signing of the Anglo-Scots Solemn League and Covenant in August 1643 which committed England to religious reform in the name of establishing 'true religion'. The religious fervour drew in women and about a third of the signatories to the Solemn League and Covenant in some districts were women. However, by 1645–47

when the Westminster Assembly of Divines (a religious assembly set up by parliament) had produced a new confession of faith and statutes of church government along Scottish Presbyterian lines, all discipline in the church had dissipated and independent congregations and other sectarian churches like Baptist churches thrived. Women's involvement in new congregations was immediate. The women who petitioned the Long Parliament against the bishops in February 1642 claimed to be carrying out that 'duty we owe to God, and the cause of the Church', a sentiment partly driven by fear of Catholic invasion after the Irish Rebellion of 1641. A second petition by women combined its demands for a learned ministry with an attack on 'Popish Lords…in the House of Peers…[who] are disaffected to the Protestant Religion'. The women appealed for aid to relieve 'the distressed estate in Ireland…before it be too late'. Patricia-Ann Lee has pointed out that leaders of the Long Parliament such as John Pym in the early 1640s were 'fearful of participation by persons traditionally excluded from the political process'. One petition had been led by Anne Stagg – a brewer's wife.[201] Therefore, while the women petitioners shared the fearful and vitriolic anti-Catholicism of men such as John Pym, it was a tense gender collusion accompanied by a deepening of men's suspicion about the social disorder signified by women's religious partisanship. Stagg was typical of the social rank of woman most drawn to religious sectarianism – she was of the middling sort. The anonymous tract *A Discovery of Six Women Preachers in Middlesex* of 1641 named Anne Hempstall, Joan Bauford, Elizabeth Bancroft, Mary Milbrow, Susan May and Arabella Thomas, all of the middling sort. The author claimed to have heard of ancient prophetesses 'but not until of late heard of women preachers' whose appearance he put down to 'a deficiency of good men'.[202]

The context for women's preaching was also the breakdown in print censorship after 1640 that led to the streets being flooded with sermons and political pamphlets. Easy publication moved self-reflective works such as conversion narratives into the public sphere. Claire Cross has concluded that '[g]odly women achieved so much influence in certain churches during the Civil War because the whole trend of puritan practice for at least the previous century had been preparing them for such action'.[203] This is evident from the case of Katherine Chidley who was the single most important woman theological disputant of the English Civil War because she went beyond expressions of personal piety to tackle the question of church government. Her tract *Justification of the Independent Churches* came out in 1641 and in it she made reference to the conventicles with which she had been involved in Shrewsbury in the 1620s and 1630s. She also made reference to the imprisonment in the 1630s of William Prynne and other puritans whom she defended along with the New England separatists, for understanding God's true worship. *Justification of the Independent Churches* was a bold and systematic answer to Thomas Edwards' attack on religious separation in *Reasons against the Independent Government of Particular Congregations*. Chidley argued that Independent 'Congregations of the Saints ought not to have Dependancie in Government upon…any other than Christ their Head and Law-Giver' and that as the Canon [or Church] Law of the church had its origins in Rome, those who followed it were of 'the Popes

household' carrying out 'invented ceremonies'. Chidley rejected the claim that separation granted liberty to sin, arguing instead that the liberty she demanded was from the 'popish innovation' of the 'tyrannical government of the Canon Lawes'. Separation from the 'evil' and 'vile' was not only lawful but necessary for the 'edification of the body of Christ' in independent 'gathered' churches. She provided Scriptural proofs of congregations covenanting separately with God, free from the control of church synods and assemblies, and told Edwards that '[a]lthough you have some of Gods Ordinances amongst you; yet you have added unto them many Ordinances of your own devising, which doth utterly debarre the Lords people, which have knowledge of them, from communicating with you in any worship'. Chidley's was a truly radical line; though she talked in predestinarian ways about the difference between 'light and darkness' [representing election and damnation] she nevertheless rejected the notion of the limited number of the elect: if 'men were brought to beleeve in Christ', 'the number ought not to be limited, for the Churches of the New Testament were free, to multiply, not only in greatnesse but also in number'.[204]

There are three particularly notable things about Chidley's work. First, like the Scottish Covenanters and MPs of the Long Parliament, she envisaged holy war, identifying herself as being on the side of the 'Armies of the Living God' following the lead of 'Captain Christ' against the bishops and ministers who formed the 'Armies of the Man of Sin'. Second, her belief in holy war prompted her to search for Scriptural proofs that empowered her to make a direct attack on a male minister, Thomas Edwards. She found them, for example, in Luke 12:52–3 and Matthew 10:34–6, and argued that 'division in the first Family [i.e. Adam and Eve]' and beyond was 'the malice of Sathan [*sic*] in the seed of the Serpent' which she turned against Edwards to argue further that toleration was not the cause of division and that even Catholics were entitled to petition their case for toleration. It was an argument driven by her unshakeable belief in her own righteousness and right to speak (she sent Edwards a book so that he could 'learn better') and she told Edwards '[i]ndeed (I must tell you) in my judgement, no man can make way for a true Reformation, except hee declare what is evill before he shew what is good'.[205] Chidley's attack on Edwards was startling in its intellectual bravery: 'Truly (Mr Edwards) you shew your selfe a bloody minded man that would have the Innocent suffer for the faults of them that are guilty. Was not the sending of your Masse-bookes into Scotland the cause of the disturbance?'[206] The third notable thing about Chidley's *Justification of the Independent Churches* is that because of her division of the world into 'believers' ('Saints') and 'unbelievers' (the 'reprobate') she accepted the logical corollary that the hierarchies of the temporal world, modelled on the Christ as head and Church as body metaphor, could actually break down. For example, there could be 'unbeleeving Masters' (making necessary the revolt of the body/servants) and she cited I Corinthians 7 'which plainly declares that the wife may be a beleever, & the husband an unbeleever'. From this she asked the rhetorical question: 'If you have considered this text, I pray you tell me, what authority this unbelieving husband hath over the conscience of his beleeving wife.' The challenge to male authority in marriage was made all the

greater by the fact that Chidley made the case hypothetically and not because of personal circumstance.[207]

Katherine Chidley was an enormously important voice during the Civil War. In 1644 she published *A New-Years-Gift, or, a Brief Exhortation to Mr Thomas Edwards* as an answer to Thomas Edwards' *Antipologia*. She defended her past separatism from the church and claimed that '[t]he church of England was never so deformed as it is now.' She critically engaged with Samuel Rutherford's enormous work, *Lex Rex* of 1644, arguing that his defence of hierarchical church government played into the hands of the Pope. Thomas Edwards she claimed suffered from 'frothiness of reason' and she argued again that toleration was not toleration to sin and that it was also not against the duties of magistrates as defined in Scripture, the Reformation or the Solemn League and Covenant. Chidley was a skilled political rhetorician; she told Edwards that:[208]

> …you deal by the Covenant, as you deale by the scriptures, hack them and mangle them, and labour to make them fit your own turne…Now if you had beene a member of a true church, I could have admonished you in another way; But you (being in disorder) could not be dealt with by such an order.[209]

In 1645 Chidley defended once again Independency as consonant with God's law in *Good Counsell to the Petitioners for Presbyterian Government* claiming that in past times 'the Saints of God' (like herself) had been persecuted by the Pope and English bishops and were now about to be persecuted by the Westminster Assembly because its divines failed to 'preserve their peace according to the law of God'. Thomas Edwards called her 'a brazen-faced audacious old woman'. Unperturbed, in 1646 or 1647 she oversaw the establishment by a covenant or promise made with God of a tiny church of just eight people (with six children).[210] Chidley was driven by the belief that ordination of the ministry came solely from God and 'that all the Lords people, that are made Kings and Priests to God, have a free Voyce in the Ordinance of election'.[211] Katharine Gillespie has recently argued that Chidley's work called for a separation of church and state and that she and other women prophets and writers of the Civil War contributed to the developing discourse of liberal politics and feminism.[212] However, while Chidley's significance certainly lies in the theoretical attack she mounted on the authority of the [male] ministry, the church she envisaged that was separate from the state church paid homage to the ministry of Christ and eradicated the state in favour of a 'godly commonwealth' or 'invisible church' of the elect. In other words, she replaced state with theocracy, though in so doing she did replace a male ministry with an ungendered 'free Voyce' that chose freedom from men in favour of God's authority. In other words, if Chidley was a feminist, her feminism relied on a male Godhead.

In the changed circumstances of the Civil War Eleanor Davies also thrived, and these years were her most productive. Her work was in tune with the eschatological mood. In *Her Appeal to the High Court* of 1641 she claimed her alliance with the prophet Joseph and offered an interpretation of Nebuchadnezzar's dream in

Daniel 2. She equated King Charles' agreement to the attainder of the earl of Strafford with Nebuchadnezzar ordering the deaths of his wise men. In *Samson's Fall* (1642) and *Samson's Legacie* (1643) she argued that Charles' Delilah was Henrietta Maria and she repeated the warnings about the queen in a number of other prophetic tracts such as *Amend, Amend* (1643).[213] In *Samson's Fall* she posed the constitutional question about whether or not Charles I was upholding His Coronation promise to protect the laws and customs of Great Britain. In this she was closely following topical political debate. Davies' anticipation of the last days can be seen in her new designation as 'Elect Lady' in *Star to the Wise* (1643) and the Bride foretold in Revelation 2:9 who would become the 'Lamb's wife'. In *Apocalypsis Jesu Christi* (1644) she directly addressed the Westminster Assembly, hoping to influence their programme of religious reform. Davies' importance lies in her leading the way where other women prophets followed in the 1640s. In *The Brides Preparation* (1645) she told of her anticipation of the second coming of Christ and in *As Not Unknowne* (1645) she reminded her readers that Archbishop Laud's execution had taken place almost 19½ years from the time of her first prophecy in 1625:

> *Time made knowne of HIS coming*, with that Shift*: Who shall cut assunder that false Prophet*, or as the Word renders it, *Cut off* (to wit) his Head, with that Arch Hypocrite graceless *Judas*, bursting *Assunder* His very sentence, both served with one *Writ*.[214]

After this frightening lyricism she added: '[d]oubtlesse *an hour and a day* not dreamed of in his *Diarie*', taking gleeful pleasure out of the demise of her old enemy from the 1630s. When the second coming of Christ did not follow Archbishop Laud's death in 1645 Eleanor Davies cast about for signs and signals that it had taken place anyway. In *Word of God* (1645) she cast her deceased brother as a sinner saved and compared him with Laud, a sinner damned.[215] Her brother was the notorious Mervin Touchet who was executed in 1631 for the sodomy and rape of his wife. This personal element in her writing undermined her credibility as a prophet, though her daughter and biographer, Lucy, believed her a prophet and guarded carefully her reputation and memory.[216]

The works of Chidley and Davies were deeply shocking to some of their male contemporaries and there was a vitriolic backlash against female speech. *The Anatomy of a Woman's Tongue Divided in Five Parts: A Medicine, a Poison, a Serpent, Fire and Thunder* argued that women's 'voice is no less to be dreaded than their nakedness'. Dagmar Freist has pointed out '[f]emale speech was intrinsically suspect' and the rush of political opinion in the early 1640s became associated with the negative construction of woman as scold and gossip. One pamphlet represented dangerous opinion as a woman turning a wheel with men's heads set upon it surrounded by symbols of disorder like a spilt hour glass.[217] Lisa Jardine has argued that dangerous female sexuality lurked behind such images, the female tongue being equated with the assertiveness of the male penis.[218] *A Discovery of Six Women Preachers* (1641) called the women 'bibbing gossips' and decried the

'female Academies' that schooled them, suggesting Bridewell Prison or Bedlam as better locations for female speech.[219] *A Bull from Rome* (1641) warned that when St Peter found the devil flirting with a woman, he exchanged their heads, but the Devil's head still occupied the place of a woman's because it 'hath such an evill tongue within it'.[220] Another pamphlet of 1641 by Thomas Grantham, *A Marriage Sermon … Called a Wife Mistaken … or Leah Instead of Rachel*, used woman as a metaphor for the idolatrous church. *The Sisters of the Scabards Holiday* (1641) used 'Mrs Longacre' to attack civil lawyers, poke fun at the dissolution of the Short Parliament and rename several ministers as mistress and whore.[221] Someone calling himself by the imaginative name of 'Voluntas Ambulatoria' turned against John Taylor, who was a London ferryman turned hack writer and poet, declaring that 'poetes turne Divils' and the frontispiece depicted Taylor lying down in his Thames ferry, his mouth being polluted by the urine of a 'she-devil'.[222] The implication was obvious – his opinions were feminine, evil and corrupted.

In other words as the Civil War deepened, it was accompanied by a political discourse of anxiety driven by fear of the disordered world represented as female speech. The idea had its intellectual origins in the notion of woman as the weaker sex and in the prescription of female silence. The established church clergyman Daniel Rogers complained in 1642 that female preachers had 'shaken off the bridle of all subjection to their husbands'.[223] One report of the peace petitioners called them 'oyster wives' and 'dirty and tattered sluts'.[224] There were also attacks on men that discredited women by default. For example, immediately after war was declared by the king in August 1642 the pamphleteer who wrote *The Resolution of the Women of London to the Parliament* argued that women were sending parliamentarian husbands to war wearing cuckolds' horns. The tract poked repetitious fun at a king forced to 'withdraw', and the sexual *double entendre* was reinforced by the image of women who were '[sexually] discouraged' and 'wrangling'.[225] The association of social disorder with sexual depravity became ubiquitous.

Several publications in London in 1645 can be used to demonstrate men's anxiety about women inserting their voice into the politics of the 'wars of religion'. The most notable were John Brinsley's *A Looking-Glasse for Good Women* and Thomas Edwards' *Gangraena*. Both condemned female responsibility for religious schism. Brinsley argued that because of the 'simplicity of their hearts', women were attracted more easily to the 'errors of the Times', in just the way that Eve had been 'beguiled' by the serpent. He argued that there was 'a naturall aptitude, and inclination in that sex to be deceived' as well as a natural disposition to 'discontent' that resulted in women joining sects for lack of church discipline. His argument was that the serpent was seducing women to deceive husbands into sectarian activity so he offered men a face-saving plea to return to the established church, reminding them that Adam was not the one who transgressed.[226] Edwards' *Gangraena* was less rhetorical and more insistent, taking the form of what he called a catalogue of errors and evidence of the discovery of sectaries. The treatise named to shame men such as the Anabaptist (a believer in adult baptism) who told William Greenhill, the Independent minister, that he 'might as lawfully baptise a dog as a believers child'. He went on to complain

about Katherine Chidley who 'with a great deal of violence and bitternesse spake against all Ministers and people that meet in our Churches' and attempted to draw them away to Brownism. The stories and rumours flowed fast from Edwards' quill. There were women preachers in Lincolnshire and Hertfordshire. There were another three women in Bell Alley in Coleman Street, London, including a 'lace woman' who preached to an assembled congregation that 'now those dayes were come…That God would poure out his spirit upon the handmaidens, and they should prophecy'. Edwards registered his surprise that although the women were offered liberty to speak to their audience 'yet no man objected'. Edwards expressed theological anxiety about this incident; the women rejected the doctrine of reprobation, preaching instead the 'raign under the Law' through which 'Christ died for all' so that there was a 'generall Restauration' coming (an idea that directly contradicted the double predestination authorised by the Westminster Assembly). These errors coincided with his catalogue of 176 at the beginning of his work which included belief in the second coming of Christ and preaching Romans 8:2 – 'The Law of the Spirit of life hath freed me from the law of sin and death.' According to Edwards this was dangerous blasphemy and it gave ordinary people license to sin.[227]

Between 1645 and the king's execution in 1649 polemical pamphleteers had a heyday. Jason Peacey has recently made a distinction between polemic and propaganda, suggesting that propaganda involved greater connivance in sending a political message. Two points can be made about this in relation to women. The first is that because of the easier access to printing machines that women had in the 1640s and the cheaper more accessible nature of the pamphlets that appeared, an opportunity opened up for women's involvement in publication at a greater level than prior to the English Civil War. Peacey's evidence for a shift towards propaganda is newspapers like the *Kingdomes Weekly Intelligencer* and *Mercurius Britanicus* from 1643. Marcus Nevitt's work has been crucial in pointing out that not only did women read newspaper propaganda, but a few of them, like Elizabeth Alkin ('Parliament Joan'), were involved in writing and publishing propaganda.[228] Hannah Allen, the daughter of a bookseller, partnered her husband in producing and selling the tracts of Independent ministers and when her husband died in 1646 she went on churning out millenarian pamphlets. Ironically she worked at the sign of The Crown in Pope's Head Alley.[229] The second point is that the shift to a greater propagandist element led to the vigorous use of sex in political language. Woman as conduit and representation of disorder intensified, reaching quite extraordinary levels of superstition and hysteria in the decade up to 1655. Evidence for this can be found in the tales of monstrosity that abounded. *The World Turn'd Upside Down* of 1646, a verse pamphlet that carried a woodcut image of a man's head on top of a body that stood on its hands (it was probably John Taylor's work), told its readers that 'this monstrous picture plainly doth declare | This land (quite out of order) out of square'. The author's anxiety was that 'prating fooles brag of the Holy Ghost'.[230] The appeal of implicating women in the birth of monsters was too great for some pamphleteers to resist. *Strange Newes from Scotland* in 1647 depicted a 'prodigious Monster' with two heads, long rabbit's ears, a body

with fur around the lower abdomen and genital area, claws and hoofs with a pair of arms and hands protruding from the knees.[231] Monstrous births were read as signs of God's will or portents of pending disaster.[232] *A Declaration of a Strange and Wonderful Monster* (1645) told its readers that a Catholic woman called Mrs Haughton had given birth to a headless monster 'after the mother had wished rather to bear a childe without a head then a Roundhead [Parliamentarian]'.[233] In 1646 Mary Champion, an Anabaptist, was represented handing the decapitated head of her baby to her Presbyterian husband for him to baptise the child. In her case the deformity of her religion in refusing infant baptism was represented as her turning a perfect child into the classic symbol of the destroyed state – the headless monster.[234]

Print propaganda was mercurial by nature and it set out to confuse and deceive the reader.[235] Men called each other women in their war of words. *The Arraignment, Conviction and Imprisoning of Christmas* (1645) described 'Old Father Christmas' escaping prison leaving a bit of his beard behind. In real life he was the Franciscan friar, John Woodcock, who was, in fact, quickly recaptured and hanged a year later by parliament. The royalist writer of *The Arraignment* called Woodcock's adversaries [parliament] 'a Malignant Lady in London'. Female imper-sonation became a weapon in the propagandists' armoury. The author of *Medico Mastix* of 1645 pretended to be 'A She Presbyterian', but the pamphlet attacked 'Brother Bastwick', who was John Bastwick and Presbyterian author in that year of *Independency Not Gods Ordinance*. The author of *Medico Mastix* was neither a woman nor a Presbyterian, and aimed, in fact, to defend Independency while claiming in a voice of false innocence to be 'your sister but no Independent'.[236]

Thus, the study of women during the English Civil War encompasses the fake woman as much as the real woman and the two cannot be separated because they inform one another's gender construction. The fake was created in the *querelle des femmes* model, but the genre transmogrified in response to women's engagement in religious activism, theological disputation and separatism. A good example of this process at work is to be found in a series of five tracts claiming to be about a 'ladies parliament' that were published in 1647.[237] Some historians have mistakenly believed these to be the liberated voice of womanhood or early-modern femin-ism. They were, in fact, written by Henry Neville (and possibly some others). They have been described by Nicholas von Maltzahn as a 'libertine parody of the parliamentary publications at the time'.[238] However, they were not all the same, either in style or message. What they do have in common is the linguistic strategy in the propaganda war of feminising the enemy and the idea for them appears to have been put in place by the first tract – *A Parliament of Ladies* – which hinted at topical politics, but was essentially *querelle des femmes* in style.[239]

A Parliament of Ladies was selling on the London streets on 16 April 1647 and was immediately followed by a second print run. It featured the standard array of quarrelsome women found in *querelle des femmes* works – 'Anne Evercross', 'Rachel Rattlebooby', 'Tabitha Tireman' and 'Mrs Tattlewell' – and featured jokes about viragos plus the argument that England should follow the laws of ancient Rome in allowing men to have two wives, though this was countered by the opposite

argument put by the mother of Papirius Praetextus that women should be allowed two husbands because one alone cannot sexually satisfy them.[240] The political allusions came at the end and hinted at a startled and cuckolded parliament. The second in the series – *An Exact Diurnall* – followed on 6 May. On the front was an image featuring women assembled in the House of Commons with a 'Lady Speaker' arraigning a group of men (referred to in the text and including Prince Rupert). The courtroom setting was highly reminiscent of the earlier arraignment satire, *Swetnam the Woman Hater* (1620). The text took the form of a diarised journal, to send up the parliamentary news diurnals, and gave a fictitious account of women assembling, giving speeches and Moll Cut-Purse, sergeant at arms, bringing to the bench the delinquents who were charged with failing in military duties, for being 'disgracer[s] to their sex' and for causing divisions between 'ladies and their husbands'. The assembly having started on Monday, the prisoners were sentenced on Friday, one of them 'to serve the scouring women at court'. On Saturday they were all reprieved. The text named the accused – Henry Jermyn and George Digby (both royalists) – more readily than the ladies, but one was called 'the countess of Essex', who in reality was Robert Devereux, parliamentarian army leader and earl of Essex.[241]

The reception and popularity of the parliament of ladies pamphlets indicates the enormous propagandist value of sex and gender. *An Exact Diurnall* was followed by *The Parliament of Ladies*, *The Ladies Parliament* and *The Ladies a Second Time Assembled in Parliament* on 26 May, 15 July and 2 August 1647, respectively. The first two were almost the same as one another, but differed from what had gone before. They began with '[t]he Rattel-headed Ladyes being assembled at Kates in the Covent Garden' who complain about loss of trade (or men wanting prostitutes), military matters and religious reform. The 'Mungrel Parliament' was also the target. Henry Blunt's questioning by the House of Commons about his royalist ties was satirised as an accusation that he thought it 'better to converse with, and to resort to common women, then ladies of honour [i.e. parliament]'. Also satirised was the House of Commons' resort to the Westminster Assembly over whether or not it should be decreed church law, that 'all men are obliged to comfort their wives'. The Westminster Assembly was lampooned as lingering over pernickety Scriptural questions 'to prove the Presbitery'. A particular target was the firebrand preacher Obadiah Sedgewick, who was one of the House of Commons' most called-on preachers for their fast sermons. *The Ladies Parliament* ran the addition of a ballad that satirised parliament as a place of courting and sexual traffic and Obadiah Sedgewick was branded 'the Lady of Complaints'.[242] *The Ladies a Second Time Assembled* gleefully told its readers that 'the Females of great Brittaine shall have free leave, and licence in case of their husbands disability, to use the performances of their eldest servant, and if he faile of their neere neighbour'. Ironic thanks were sent to Sir Thomas Fairfax for his 'many able performances in the service of the Lady Denbigh'. Thanksgiving was also offered by 'the ladies' for Oliver Cromwell's 'performances'.[243] Neville revived his 1647 genre in 1650 with *Newes from the New Exchange or the Commonwealth of Ladies Drawn to the Life* which attacked the first Commonwealth Parliament by which time the language

of politics was as bawdy as pornography: 'Lady Carlisle' [Charles Howard] 'seven years since took saile with Presbytery, being charged in the foredeck by Master Hollis [Denzil Holles], in the poop by Master Pym [John Pym]'. Another 'lady' commonwealth man, who may as well 'erect a new commonwealth among the monkies' plays with an 'old Sophister (Dr. Smellsmock, alias Mr. Osbaston) who jerks her both behind, and before'. Members of parliament were depicted as sleeping with Cromwell's chaplains like Peter Sterry in a 'commonwealth of women' where there was no honesty to be found.[244] Thus, the model of the dishonest and lascivious woman was used in the late 1640s and early 1650s to attack male enemies by bringing seriously into question crucial components of their masculinity like honesty, sobriety and reputation, and, of course, their ability to control and sexually satisfy women.

Historians have commented on the use of woman as a propaganda model for disorder, though they have not always distinguished between textual context and purpose. For example, John Brinsley and Thomas Edwards used the idea of woman on top to stir fears about disintegrating religious order, but Henry Neville and the authors of the parliament of ladies pamphlets formed part of a reaction against the religious reformism, so they secularised the earnest men of the Westminster Assembly and House of Commons by reducing them to common whores and bawds. This friction between crusading puritans and their irritated critics can be clearly seen in another wonderful pamphlet that used women – one for each side of the debate – on the eve of the trial and execution of Charles I. *Women Will Have Their Will*, published 12 December 1648, called the members of the Rump Parliament names such as 'Cicely Sly-tricks' and joked about the consequences of female rule. In a dialogue between 'Mistress Custom' and 'Mistress Newcome', the latter defended puritan ideas and worship while 'Mistress Custom' argued that she could see no 'reason…for not keeping of Christmas'. She refuted the authority of parliament on the grounds that she had a husband and 'therefore the Devill take all other authority…for though my husband beats me now and then, yet he gives my belly full'. 'Mistress Newcome' warned her to be careful because her own husband is a member of 'the godly partie of the Army' [a reference to the New Model Army], though this was not before 'Mistress Custom' has accused her puritan adversary of being the child of 'an oyster woman' (a sexual reference) and 'the Devill in disguise'.[245] The author of this imaginary dialogue between a sluttish woman and a laughably zealous one was reacting against parliament's legislation against pagan ceremonies like Christmas.

The political disruption and raised religious stakes of the late 1640s led to a remarkable period of gender reconstruction in which the fake and the real woman jostled together in a new political culture driven as much by print as circumstance and contingency. Women petitioned, preached and prophesied, their opinions and motivations multiplying in a way that would not (could not) have been imagined prior to 1640. For Eleanor Davies, God's retribution and her own became conflated and never diminished in intensity. In *Blasphemous Charge* published in 1649 she attacked Aquila Weeks who had been her jailer 16 years earlier – he became symbolic of the Antichrist.[246] During the trial of Charles I she reminded the

king in *Her Appeal from the Court to the Camp* (1649) that she had been wrongly imprisoned. In 1650 she was calling herself 'the Lamb's Wife' as a signal that she thought Christ's coming had occurred and in *Restitution of Prophecy* (1651) she continued to weave together, as she had done throughout her prophetic life, politics, Biblical analogies, news of the second coming and anger about the death of her brother. In *The Benediction* (1651) she attempted to prove her centrality to God's plan and judgement day by linking the first letters of her family name in its new and old spelling – 'A' [Audley] and 'O' [Oldfield] – to 'Alpha' [beginning] and 'Omega' [end].[247] For other women the motivation was more clearly aligned to a family partisan position in politics. In April and May 1649 several women, organised by Elizabeth Lilburne and including Katherine Chidley, presented two petitions (allegedly signed by several thousand women) to the House of Commons asking for the release of the Leveller leaders (who were agitating for a wider male franchise), among them John Lilburne. The women's first petition was several pages long and detailed their 'continual fear of [for] our husbands' and determination 'in our weak endeavours for the same ends [native freedom and right]' to suffer and perish with them because of 'equal share and interest with men in the Commonwealth'. They pointed out that 'God hath wrought many deliverances for severall nations from age to age by the weake hand of women.' They asserted that they could see nothing treasonable in the Levellers' *Agreement of the People* (which was a list of demands put to the army's General Council during the Putney Debates), but the burden of their plea was mutual suffering with their men.[248]

Prophetic women multiplied in number and participated in the debate about regicide and political reconstruction. The works of the two most important – Mary Pope and Mary Cary – were published by Giles Calvert whose shop at the sign of the Black Spread Eagle near St Paul's Cathedral served as a central distribution point for godly literature.[249] Mary Pope was a widow, her husband having died in November 1646 leaving her with children to feed. She petitioned parliament several times and wrote three tracts that were critical of parliament in 1647 and 1648. Little is known about her. Pope's *A Treatise of Magistracy* (1647) was dedicated to Charles I and called him 'God's vice regent on earth'. Even more provocatively she argued that Independency and Presbyterianism were against God's will. She was immediately identified as pro-monarchist, though her biographers point out that her position was more subtle than this and that she combined her royalism with puritanism. Despite being harassed by parliament *Behold Here Is A Word* and *Heare, Heare, Heare, Heare* (both 1648) accused MPs and army officers of being covenant-breakers. She believed in a godly commonwealth or one regulated by the word of God, but believed also that the word of God devolved political power to the king as King of Israel. She pointed out that parliament illegally tried to 'non-king the king' and that the army (through Pride's Purge) 'hath non-parliamented the parliament'. She regarded the political result as blasphemy.[250] Mary Pope is significant because there has been a tendency in Civil War historiography to view religious radicalism as automatically tied to the parliamentary cause. It was not and propheticism allowed some women religious expression that rose above the

partisan boundaries established by war and could ally puritanism to the royalist cause.[251]

Mary Cary also believed in a godly commonwealth, but hers envisaged a King-dom of Saints, an idea drawn from the Book of Revelation. Two important works by Cary – *A Word in Season* and *The Resurrection of the Witnesses* – came out in 1647 and 1648 respectively. In the first, which took the form of a short appeal to those in political power, she argued that because God had 'wrought by his own arme great Deliverances for this kingdom', he expected 'fruit'. She warned that the road to destruction lay in oppression of the poor, allowing vice and preventing the prophets from preaching the Gospel. '[L]et none of his Saints be wronged, or trou-bled by you', she rumbled threateningly. She defended the right of the Saints to 'preach without ordination', so defending the religious separatists and, therefore, implicitly the right of prophetic women to speak. She rejected sectarian titles like Anabaptist and Seeker and insisted that it was not only the Presbyterians of parlia-ment and the Westminister Assembly who were the Saints.[252] *The Resurrection of the Witnesses* was a long prophetic work. Although different in genre from *A Word in Season* it shared with it some political concerns. For example, the preface to the reader pointed to 'neglect of justice' and 'oppression of the poor' as past sins for which God ought to punish the nation. It also eschewed labels like Independent claiming instead an all-embracing Kingdom of Saints in England that was non-denominational. Parts of the work were quite irenic and Cary made it clear that she thought it unjust to denigrate people as 'tub-preachers' and urged English people to 'unite, unite, unite' for 'deliverance'.[253]

Cary interpreted God's plan to an exact Biblical chronology and she assumed rather than mentioned God's providential dealings with His people. She argued that an age during which 'the Beast' (which was one of the many Antichrists in the Bible) reigned was ending after 1,260 years as the Saints stood up and walked and Christ was beginning to prevail (the end point of which would be Christ reigning in Sion). She drew on the idea of the witnesses in the Gospel of Luke to equate them with all past Saints prophesying and current-day Saints witnessing the fall of the 'mystical Babylon'. She referred to the ordinances of God 'whereby knowledge is dispensed ... for it is the Saints that are as lights in the World' who 'prophesy to edify one another'. She hinted at a new 'holy city', implying London. Cary claimed the interpretative authority of St John (who had the coming of Christ revealed to him through an angel) in what essentially was a prophetic 'how-to' manual, with a lengthy exposition followed by its specific application to current events. Spiritual blessings were attained by 'a frequent reading and hearing of the Word of God, waiting for the coming in of the Spirit'. Beyond the metaphorical and the spiritual was a very specific message that related prophetic chronology to political events. Cary argued that the 1,260 years of witnessing against the Beast had culminated in a period beginning in 1645 'wherein the witnesses should finish giving their testimony'. She linked this to the Beast mak-ing war in Ireland and then England, counting a spooky 1,260 days between 23 October 1641, or the date of the Irish Rebellion, and 5 October 1645, or the date of the foundation of the New Model Army. At this time the Saints 'stood upon their

feet': 'it is very wonderfull to consider, how by an over-ruling providence, the hearts of carnall men were commanded to stand up in defence of the Witnesses, against the Beast'. The end of the process she predicted would be 1664.[254]

There are two interesting things about the use of gendered language in *The Resurrection of the Witnesses*. The first is that when prophesying about the enemies of the Saints, Cary rendered them feminine using Revelation 17: 'And I saw a woman sit upon a scarlet coloured Beast...and upon her forehead was a name written Mystery Babylon...the Mother of Harlots...and I saw the woman drunken with the bloud of the saints.' The woman she classified doubly as Rome and the Catholic Church.[255] The second thing to note about Cary's important work is that it exemplifies the process by which the religious and political strife of the 1640s empowered the female voice through providential ideas about a war on the Antichrist. In the application of her prophecy Cary spoke of 'the sufferings of Saints worke[d] out for them a greater weight of glory' amongst whom she could not fail to be placed by her readers both male and female. 'To be a Teacher' she told them, 'is to be able to unfold the mysteries of the Gospel, and clearly to hold forth the truths of Christ'. She gendered the 'Teacher' and prophet as man, but she included herself in the universal man.[256]

The response of men to women's participation in religious politics was complex. Ralph Verney's view was that 'had St Paul lived in our times, I am confident he would have fixed a shame upon women for writing (as well as for their speaking) in the church'. He advised his god-daughter that 'the pride of taking sermon notes, hath made multitudes of women most unfortunate...I know your father thinks this false doctrine, but be confident your husband will be of my opinion'.[257] Individual and collective notes of ambivalence can be detected in the 1640s and 1650s because for every man appalled by women's speaking, there was another who found women's speech useful. Manfred Brod, biographer of the prophetess, Elizabeth Poole, has suggested that she had male associates in London who promoted her prophetic activity. Male friends gained her audiences with the army Council on 29 December 1648 and then again on 5 January 1649, in one case to mediate between the Levellers and the army officers and in the other to prophesy against executing the king. When prophesying to the army she used the metaphor of a sick woman to represent the state and appealed to their masculine duty of care to be 'a sacrifice for her' and cure her.[258] After the regicide Arise Evans, who always claimed that he had foretold the downfall of the king, claimed to be the only recipient of a mute woman's prophecy that the king's heir would succeed to the throne. She was 'very sensible and profound in what she spake to me' he told his readers. The woman was Eleanor Channel and her prophecy, not surprisingly, echoed Arise Evans' own irenic desire that 'the sword be stayed' and 'peace...and the true Gospel' reign. Evans claimed that 'the God of Abraham [an allusion to the covenant of law]...hath opened the mouth of the dumb to speak peace.'[259]

The extent to which the women attached to the Levellers were a voice separable from that of the Leveller men can also be difficult to gauge.[260] It is certainly the case that Patricia Higgins and others have seen in the Leveller women's petitions

a greater cry for sexual equality than was really there.[261] However, in April 1649 when their first petition was greeted by parliament with the response that they should go home and attend to their 'huswifery' the Leveller women instantly regrouped and put together a second petition that was indignant 'that we should appear so despicable in your eyes, as to be thought unworthy to petition'. At this stage, in May 1649, they changed tack and claimed 'an interest in Christ equal unto men, as also a proportionable share in the freedoms of this commonwealth'. They asked rhetorically how they could be expected not to defend the men who were 'Asserters of the Peoples freedoms' and demanded due process of law to challenge parliament to be 'glutted with our blood'. 'Let us all fall together: take the blood of one more: slay one, slay all', they said. Thus, the tone of their two petitions was quite different, one being a plea to conscience and the other a challenge to parliament to turn them into women martyrs.[262] John Lilburne, boasted of his wife that 'though a feminine yet [she was] of a gallant and true masculine spirit' demonstrating again men's willingness to use gender inversion to praise as well as undermine women according to whether or not they represented ally or enemy.[263]

The reverse vision of the Leveller women can be seen in John Crouch's *The Man in the Moon* (1649) which called them 'Levelling She-Saints' and 'lusty lasses' and *Mercurius Pragmaticus* which referred to them as 'the Civill-Sisterhood of Oranges and Lemons' and 'Troopes of Amazons' attempting 'a Rape Upon These Capons' [the houses of parliament], using their 'Tongues (as their best weapon), against tyranny and their tayles for propagation of the now sainted fraternity'.[264] The sexual references cuckolded Leveller men by imagining their wives and daughters as whores with tails and tongues [genitals] that wagged at and for men. It was not only the Levellers who were so treated in the pamphlet literature. By the 1650s the trend of using highly explicit or pornographic sexual reference to discredit the enemy was to be found in much of the propaganda that rolled off the London presses.[265] In *The Ranters Ranting* of 2 December 1650 a rough woodcut showed a woman allowing a man entry to a party at which men and women danced naked (the men with visibly erect penises) with the words 'welcome fellow creature'; another woman kneeled to lick between the buttocks of a man. On 17 December 1650 *The Ranters Declaration* talked of the Ranters 'black art' and possession by the devil and an image again showed men and women *in flagranté delicto*. Exactly the same image was then recycled in 1655 in *The Quakers Dream* to discredit Quaker 'shriekings, shakings, Quakings, Roarings, Yellings, Howlings [etc.]'.[266]

In the more formal setting of the High Court that tried Charles I, women's words were also brought into question in the war of words. Femininity was a shorthand for weakness and lack of reason. Thus, in his tract justifying the execution of Charles I, lawyer and regicide, John Cook, said 'Reason is the Life of the Law | Womanish pity to mourn for a tryant.' Addressing his readers he argued 'Words are but women, proofs are men, it is reason that must be the chariot to carry men to give their concurrence to this judgement [i.e. regicide].'[267] This is an extremely telling statement – it implies that women's words have not the force of action behind them and that only men have the required reasoning power for

difficult times. Marcus Nevitt points out that during his trial Charles I appealed to the masculinity of the judges through self-abasement, saying he had no knowledge of the law, yet implying that his own manhood gave him access to the reasoning powers required for his self-defence.[268]

Collusion and conflict in female and male participation in the revolutionary politics of the Regicide resulted from the rapidly changing religious discourse used by people to explain confused and frightening political events. There was blurred distinction between individual and corporate covenanting so making Eleanor Davies' claims to an alliance made between her and God look precocious in the 1630s but not exceptional at all in the 1640s.[269] At one stage Davies' self-referential propheticism reached dizzying heights when she claimed that her books had been burnt by Archbishop Laud on the same spot as Christ had been crucified.[270] The idea that had the most prophetic credibility as Charles I met his end, was one that envisaged a new future. Davies' *The New Jerusalem, at Hand* (1649) spoke in metaphorical ways about the king's lost inheritance, though she herself died in 1652 just before the full impact of the idea of New Jerusalem was felt.[271] She shared the idea with many men. Between 1647 and 1652 there were eight published works on the New Jerusalem including the anonymous tract *Builder of Zion* and Thomas Parker's *Visions and Prophecies of Daniel*.[272] In 1651 Mary Cary produced a similar work – *A New and More Exact Mappe or Description of Jersualem's Glory* – which used the Book of Daniel to prophesy full deliverance of Christ's kingdom in 1701. Her *Little Horn's Doom and Downfall* (1651) claimed that the fall of Charles I could be read from Daniel 7:25.

After the regicide women went on being involved in both the visualisation and realisation of 'God's plan', with similar levels of acceptance and rejection from men. Cary's *Little Horn's Doom and Downfall* (1651) had an introduction by one of Cromwell's chaplains, Hugh Peters, though there were mixed responses to her demands for the law reform and poor relief encapsulated in her *Twelve Humble Proposals* (1653).[273] Collusion and conflict between men and women continued in the godly commonwealth associated with the rise to power of Cromwell. When Susanna Parr moved from Lewis Stucley's small Independent congregation in Exeter to attend the sermons of the Presbyterian minister, Thomas Ford, Stucley responded by calling public meetings to denounce her and accused her of something akin to adultery.[274] Jane Turner's spiritual autobiography of 1653 was met by Burrough with the response that she was 'a servant in bondage in Babylon' and a 'mistresse of witchcraft'.[275] Of course, what is most enlightening is their mutual expectation of a heated debate, unthinkable before 1640. Sterry's failure to prevent a woman walking almost naked into one of his sermons in 1652 shouting 'Resurrection I am ready for thee' resulted in him being taken to task by David Brown for not preaching against the 'strumpet-like woman' and all 'the wicked and profane sort' of her 'diabolical sect'.[276] Use of woman as a sign of spiritual and moral decay was a non-denominational deployment of gender stereotype in the politics of enemies and friends. Some male pamphleteers responded to each new perceived threat to their religious position with recast anxieties. For example, the author of *The Ranters Monster* issued the warning that a woman called Mary Adams

believed that she had conceived 'the Saviour of the World' after being impregnated by the Holy Ghost. The printer reused the image of the woman with the headless baby from *A Declaration of a Strange and Wonderful Monster* and by this means the Catholic 'Mrs Haughton' of 1645 became the [Protestant] Antinomian Mary Adams of 1652.

Collusion of men with women could be a form of co-option of women's prophetic authority. For example, when the Baptist prophet Anna Trapnel fell into a 12-day trance after Cromwell declared himself Lord Protector in December 1653 she was surrounded by Fifth Monarchists who jotted down notes while she prophesied his downfall at the hands of God, her fasting and visions uniting her with members of the Barebones Parliament whom he had ousted.[277] There was a fine line between preaching and prophecy and the rejection both by men and women of formalist ceremonies like baptism had the consequence of raising the spiritual authority of women if men became convinced of the prophetic significance of their words.[278] The evidence of this in women's published works of the 1650s is inescapable. In turn, women felt their words authorised. When Jane Turner published *Choice Experiences of the Kind Dealings of God Before, In, and After Conversion* (1653) she claimed she only ever intended her autobiographical notes about God's providential dealings with her to be kept private, but she decided to make public her religious journey from puritan to Presbyterian and then Baptist. Her Antinomian ideas (or the belief that people were free from the moral law) provide a key to the shared theology of male and female sectarians. Turner made public an experiential theology which spoke positively of a journey from ignorance, during which life was only glimpsed 'through the glass of the law' [old covenant], to the Gospel [new covenant], which brings 'a new and living way by the blood of Jesus'. Experience – a word she used a lot – framed all the messages of salvation: experience came from 'true sanctified knowledge'; the 'Scripture rule' was 'experience[d]...in our hearts'; 'experience is more than a bare knowledge'; 'all experience is either an effect of knowledge, or by it we learn knowledge'; the Law is not 'Christian experience...[which is] truth brought home to the heart with life and power, by the Spirit of God conforming the soul in all things to the will of God'; 'by experience we find the word of God daily accomplished in us...for experience worketh hope'.[279] Experientialism helps to explain the religious radicalism of many women; they internalised a vision of the Calvinist doctrine of election and counted themselves among the saved in direct communion with God.[280]

The attraction of experiential religious radicalism can most fully be seen with the women Quakers about whom there is a rich historiography. Phyllis Mack, Christine Trevett, Catie Gill and Kate Peters have all explored the gendered political identity of Quaker women and their writings.[281] Between the early preaching of George Fox in 1651 and the mid-1650s the Quakers grew to several thousand strong. By 1659, when a Quaker petition against tithes was presented to the authorities, the signatures of '7000 handmaids [women] of the lord' were involved. Thus, the Quakers were a quite extraordinary phenomenon that Catie Gill explains as due to their solidarity and deep sense of communal purpose and identity.

Prior to the Quakers, women's sectarianism had been restless; with women moving between radical political groups and independent churches. However, Quakerism attracted and then held a large number of women, partly because of the sympathetic attitude of Fox, partly because of the prominence of Margaret Fell, who went on to marry him, and partly because Quakerism fostered godly female speech.[282] Quaker theology was simple and seductive. Fox demanded of believers that they heed the light within. His message to walk in the light rather than the darkness animated faith in God's imminence and cast the human body as the Temple of the Holy Spirit. Richard Farnworth, one of the most prolific Quaker writers, put it this way: 'The Church is in God the Father of our Lord Jesus Christ...and it is made of all living stones elect and precious...and the Saints their Bodyes are made fit Temples for the Holy Ghost to dwell in.'[283] It was a theology that in a sense ungendered, or at least regendered, the church. For example, Farnworth made a distinction between 'the woman or wisdom of the Flesh [who] is forbidden to speak in the Church' and the 'spirit [which] is born of God, either in male or female'. His further argument that God made the spirit manifest in Deborah and 'in her did administer justice to the Israelites' appealed to women's emotionalism and maternalism, though Phyllis Mack has pointed out that the idea of women as the 'nursing mothers of Israel' encouraged adoption of the female gender roles of providing charity and support.[284]

According to Mack, Quakerism empowered women to speak and preach only through negation of their gender; they sought legitimacy through identification with male prophets in a form of what she has called self-transcendence.[285] This case has recently been restated by Kate Peters who argues that, despite four tracts published favouring women's preaching in the movement, Quaker men were quick to restate women's traditional roles as carers and obedient wives so that the very organisation that helped to support women preachers was used also to restrain them.[286] However, in the 1650s the religious activism of women Quakers was quite aggressive and two of their tracts – *The Saints Testimony Finishing Through Sufferings* and *To the Priests and People of England*, both of 1655 – were written by women. '[Y]our Daughters they shall prophecy as well as Sons', said Richard Farnworth, and they did.[287] Elizabeth Hooton, a respected farmer's wife and former Baptist sectary, was one of the first people to preach Fox's ideas in her village of Skegby.[288] 'Christ is one in the male and the female', declared a group of women Quakers in *Saints Testimony*. Like other Quaker writings, it was written during a period of imprisonment.[289] Many women Quakers spent long spells in prison such as Barbara Siddall who was thrown into York jail for 13 months for verbally abusing a male minister.[290]

Quaker women were often confrontational. Temperance Hignell walked into Jacob Brent's church and issued a curse from God upon him that she later explained came from God himself.[291] Elizabeth Peacock was jailed repeatedly after walking into one London church after another to issue dire warnings to several congregations about their 'hypocritical worship'. Quaker women's worship was visually very arresting: according to Phyllis Mack they 'melted, wept and quaked in an atmosphere of ecstatic, sympathetic bonding'. They stood in marketplaces shaking and

quaking with the word of God. They bellowed at ministers that they were 'greedy dogs' and 'harlots', so inverting gender expectations of female silence in church. According to Mack they 'transformed themselves into visual signs of the corruption of church and state'. Sarah Goldsmith sewed a coat of sackcloth to wear and smeared herself with ashes before standing in front of the cross in the market-place of Bristol 'as a sign against the pride of the city of Bristol'.[292]

Quaker women also travelled far and wide in the name of religion. Mary Fisher, a maidservant in her thirties from Selby in Yorkshire, converted to Quakerism in 1652 and immediately began preaching in Selby before moving further afield. In 1654 she was arraigned for preaching in Pontefract and harassing the male priest there and spent 12 weeks in York jail.[293] When released she went a bit further afield and bothered the godly scholars in Cambridge where the authorities stripped and whipped her publicly. In 1655 she tried her luck in New England, but there her books were burnt and she was searched for the witch's mark. Eventually she was best received by the Quaker community in Barbados and preached there for several months. Mary Fisher did not act or travel alone. Quaker activity was often communal, bringing men and women together in preaching and missionary work. In 1657 she set off for Turkey with three men and two women with the aim of reaching Jerusalem. On the way they decided to visit the Sultan, Mohammed IV (a 16-year-old boy), because they felt he was the man who was most in need of their message. The English Consul at Smyrna attempted to divert the party to Venice, but they pressed on, crossing the Aegean Sea from Greece. In the final leg of the journey Mary Fisher travelled on foot alone to Adrianople where she caught up with the Sultan stationed with 20,000 men by the River Maritsa. She was granted an audience with him and was later to remark that 'he was very noble unto me … He received the words of truth without contradiction'. She added, very insightfully, that his Islamic faith induced in him a right fear of God.[294]

The English Civil War, therefore, inspired women to leave their homes to carry out global missionary work. The international community of Friends interpreted their travel as part of their collective suffering that indicated their salvation. As early as 1654 the Kendal Fund was set up to support Quaker travel and was administered by Margaret Fell.[295] By letter in 1655 Edward Burrough told her that Elizabeth Fletcher suffered because she travelled alone through dangerous places.[296] Hostile reception and imprisonment happened as frequently abroad as at home. Sarah Cheevers and Katherine Evans were jailed in Malta in 1659 and remained incarcerated for three years.[297] By contrast Mary Fisher spent the final 40 years of her life in New England as an affluent property owner who sheltered travelling Friends.[298] Quaker women's missionary travel had an important impact on colonial America and the West Indies (nearly 50 per cent of the Quakers who travelled to the New World were women). Susan Mosher Stuard, for example, has argued that their preaching abroad turned them in the eighteenth century into a movement for transforming society and that they later campaigned for the abolition of the slave trade. Quaker women's travel was the product of rather than the journey towards the inner light. In other words, when Mary Fisher visited the Sultan she went with the firm sense that her spiritual authority was both in

place and inviolable. Susan Wiseman points out that in their writings women Quakers literalised their spiritual journeys as travel so that travel narratives were, in themselves, discourses about being literally moved by the Spirit as well as identification with the life struggles of Christ.[299] The twinned imperatives of suffering and travel have resulted in high survival rates of women Quakers' spiritual autobiographies such as Martha Simmonds' *When the Lord Jesus Came to Jerusalem* of 1655 (which anticipated her trek into Bristol with James Naylor as a re-enactment of Christ's journey into Jerusalem) and Elizabeth Forster's *A Living Testimony from the Power and Spirit of Our Lord Jesus Christ* published in 1685.[300] Quaker women account for 20 per cent of the entire published output of women's writings in the seventeenth century. Amongst them are many tracts that exemplify the narrative of suffering and travelling that dominated the life stories of the Friends. For example, Barbara Blaugdone's *An Account of the Travels, Sufferings and Persecutions of Barbara Blaugdone* was entirely typical and informed its readers of her reception of the Cross, adoption of plain speech and clothing, rejection of 'steeple-houses' (churches), the persecution and suffering of herself and children because of her beliefs and constant movement from the north, to Marlborough, to Devon and to Ireland where she was 'in jeopardy of my life'. In her life journey she mimicked the life of Christ.[301]

Gender construction rendered women especially open to interpretation of their lives as passive within God's providential plan. The Civil War encouraged a form of providential activism that suited women and found its busiest expression in Quakerism. However, most women's providential exploration of their place in history took place between the covers of private diaries. Alexandra Walsham's book on early-modern providence has shown the degree to which 'providentialism played a pivotal role in forging a collective Protestant identity'.[302] The dualistic idea that God knows everything that will happen by his immutable decree while continually intervening in human affairs through 'particular' or 'special' providence turned women into chroniclers of the minutiae of their lives as they searched for communications from God and signs of their election through mercy or suffering. Elaine McKay has calculated that women's reflective diaries and spiritual autobiographies increased tenfold in the seventeenth century and although she has argued that there was little difference in content between men's and women's, the genre demanded that women make themselves the subject of the narrative in ways that overcame the constraints upon their sex.[303] The evidence, therefore, of a continuum between the private lives of godly women and the narratives of suffering of the Quakers is compelling. Lucy Davies begged God to have 'mercy upon me a miserable sinner' in her spiritual diary and then she began seeking an answer to the question 'how has God dealt with me in his providences'.[304] Elizabeth Pindar's bookplates read 'Elizabeth Pindar. Gods Providence is mine inheritance'.[305] The preface of Alice Thornton's autobiography stated that 'it is the duty of every Christian to remember and take notice of Allmighty God our Heavenly Father's gracious acts of providence over them'. She noted His requirement that she record acts of providence 'even from the wombe, untill the grave' and 'perticuler remembrances of His favours'. Thornton's own place in

history was partly assured because God was 'the great Creator and wise Disposer of all things and times' some of which was pre-ordained while some was due to a 'falling out' according to particular providence in God's chronology.[306]

When women did feel empowered to speak of their place in history, the private world then became public property but this did not matter because there was no distinction between private and public projection of the identity of one of God's elect.[307] In other words, providentialism ungendered women and allowed them to speak. Ann Collins in her *Divine Songs and Meditations* of 1655 spoke of 'the manifestation of divine truth' and she set the narrative of her life in the context of God's providence; in the action of writing she argued for the passivity of her life. She revealed a life of physical infirmity and her motivation was to convey to others her example of acquiescence: 'I would establish inwards peace | However outward crosses do increase'. Thus, through acceptance of God's will she was empowered.[308] Katherine Austen, writing her diary just after the war in the 1660s, examined closely not only her waking hours but also her dreams for signs of her place in history: 'God in a vision hath spoken to his Saints…These visions are revealed only to the elect of God' she wrote.[309] She spoke of compulsion to write: 'We must heighten our apprehensions of the divine power…God the great governour of the world ordered it by the variety of changes and accidents and very often…that which was a misfortune in the particular…becomes a blessing bigger than we hoped for'. In this way Austen interpreted positively her grief at the loss of her husband when she was only 29 and her decision to run his estates and bring up his children alone.[310]

In the providential thinking and the religious ideas of the 1640s and 1650s, then, were the seeds of gender reconstruction which for some women moved them from private introspection to public engagement in the religious radicalism and sectarian politics of the Civil War. When the concept of the individual pact or covenant made with God was transformed in the 1640s into the idea of collective covenanting in God's corporate plan, considerable legitimacy was gained for female speech in the form of preaching and prohesying often in published form. The result was not lost on contemporaries. In 1654 Dorothy Osborne observed to William Temple that women's preaching was 'a good way of preferment as the times are'.[311] The highly symbolic religious politics of the mass oath-taking of the Solemn League and Covenant and cycles of fasting and thanksgiving in sermons delivered before the House of Commons represented a form of ungendered crusading that drew women very willingly into religious war. Jane Turner's English Civil War did not involve heroic efforts to save castles like some of her sex; instead it represented the seamless end to her personal 'reformation' during which God 'through much mercy brought [her] out of Babylon into Sion'. There was no difference for her between the private and public life journey.[312] Women's political activism during the Civil War was defined even more than men's by the idea of carrying the sword for God because of their gender construction. Therefore, while many women just kept their accounting with God private, a great many more contributed disproportionately to the shaping of England's 'wars of religion'.

Religion and gender after 1660

The question that has dominated historical scholarship about the Restoration of the Stuart monarchy in 1660 is whether or not the political and religious culture and/or society of England was so qualitatively different afterwards that it is necessary to talk of 'a nation transformed'.[313] One of the key concepts used to explore and explain possible transformation has been secularisation, or, put rather simply, a loosening of the connection between religion and politics.[314] The gender component of this debate has been provided by Fletcher who has argued that secularisation led to changes in gender construction.[315] The aim of this section is to consider these questions against the backdrop of women's continued religious activism. There were two immediate responses to the Restoration. First, for some people it was a welcome relief and many royalists perceived the return of Charles II not just as a political event but a providential one and evidence of God's deliverance and mercy. Second, for those who believed in the establishment of Christ's kingdom on earth it was a puzzling sign from God. Nabil Matar has spoken of the 'doctrine of realized eschatology' adopted by Quakers and other puritan religious groups like Baptists after 1660 to transfer their belief from 'establishing the kingdom of God through militaristic means... [to] its realization in the souls of the saints enduring the Anglican persecution'.[316] Persecution came swiftly: Barry Coward has spoken of 'a great wave of militant Anglicanism' that led to the suppression of conventicles and the ejection of nonconformist ministers.[317] In 1660 'Anglican survivalism' became apparent, but so too did 'Quaker survivalism' and 'Catholic survivalism' as society became more pluralistic in response to difficulties in retaining a mono-confessional Protestant identity.[318]

The very first response to Restoration of the monarchy by some women was to approach Charles II with a direct appeal. 'A Woman Quaker (all in white) called Ahivah' presented to him *A Strange Prophecie* in which she claimed to have prophesied his return. She attributed the wars and transgression of the two previous decades to people's 'evil lust' and claimed that God gave the kingdom (which was rightfully His, i.e. God's) to whomever he pleased. Having claimed to have been 'chosen Messenger of your return', she asked in exchange (but on behalf of 'many thousands being of the same mind') 'some liberty for my own practice of my own Household Ordinances'. By this means 'Ahivah' attempted to domesticate what was essentially a bribe to leave the Saints alone or suffer 'speedy destruction'. 'I myself shall stand a mother in Gods house in these cases,' she told the new king. The level of confidence displayed by this one female Saint who petitioned the new political authority of England is remarkable and it raises questions about the survivalism too of women's newly-authorised religious voice. There is much evidence for women's continued and outspoken religious activism. The radical publisher and bookseller, Elizabeth Calvert, spent several months in jail between 1663 and 1664 for selling seditious pamphlets. Maureen Bell points out that she and other women booksellers were 'hounded by the authorities, with husbands dead, children to support and debts accumulating' yet still they carried on. Calvert, in particular, was 'an unrepentant religious and political radical who

believed that the Restoration of the monarchy would be met by violent punish-
ment from God'.[319]

The main statement about women's public religion came from Margaret Fell who
published *Womens Speaking Justified* on behalf of women Quakers in 1667. This
has been taken by some historians to be a straightforward statement of women's
right to speak and as almost a proto-feminist tract that was progressive. However,
it was neither, as both the content and the context of its publication demonstrate.
After spending most of the 1650s at Swarthmore Hall, looking after her family
and providing a central point for correspondence and funding for Quakers, in
1663 Fell made a 1,000-mile journey visiting imprisoned and suffering Friends in
northern England and the south-west.[320] Thus the context for *Womens Speaking
Justified* was one of persecution and it drew upon the earlier tracts that touched
upon female speech written by George Fox, Priscilla Cotton and Mary Cole and
Richard Farnworth, all of them a response to imprisonment. Fell's arguments
were more cautious than the earlier tracts, and this is in keeping with the context
of the even more repressive regime of the 1660s.[321] Priscilla Cotton and Mary Cole
had argued that 'it's the weakness that is the woman by the scriptures forbidden'
and they had equated 'the woman' with the unbeliever. In other words the right
to preach they had defended in the 1650s related directly to a person's spiritual
qualification to speak regardless of their sex. Margaret Fell argued basically the
same case in *Womens Speaking Justified*. After saying that God created man and
woman in his image she then made the case that despite women being deceived,
God's promise was to put enmity between woman and the serpent. She further
built the case for women preachers by using those Biblical women who could be
classified as God's instruments – this was a standard textual ploy. Fell then moved
to the Quaker antinomian argument that the woman who was supposed to live
under obedience and in silence was 'under the Law' and she drew a logical dis-
tinction between this woman and the woman of the Gospel who was empowered
to preach if she lived in the Spirit.[322] Fell put it this way:

> And whereas it is said, I permit not a woman to speak, as saith the Law; but
> where the women are led by the Spirit of God, they are not under the Law, for
> Christ in the Male and in the Female is one; and where he is made manifest in
> Male and Female he may speak, for he is the end of the Law for Righteousness
> to all them that believe.[323]

Mary Bayly, Jane Holmes and Elizabeth Hooton had argued from their prison
cell in York Castle in 1652 that only the words of genderless false prophets were
words to be feared and silenced. According to Fell 15 years later there were 'blind
priests' while the true woman was Christ's wife, and the wife of the false church
was 'the Pope's wife'.[324] The inexorable conclusion to which her logic led was that
a man who did not walk in the light of the Gospel was a woman personified as
'the Pope's wife'.

Margaret Fell responded to persecution of Quakers by calling Anglican cler-
gymen 'debauched smearmongers'.[325] She became critical to the survival of the

Quakers after 1660 though much of the activity engaged in by the movement (as well as its theology and rhetorical writings) were a continuation rather than an advance of their organisation and work earlier. For example, the two women's London meetings that emerged in the late 1650s – the Box Meeting and the Two Weeks Meeting – persisted and became a model for later women's meetings particularly from the 1670s. They were concerned largely with cooperative preaching, charity and mutual support. Ties developed and persisted also with meetings in America.[326] The support of George Fox in the establishment of women's meetings had been critical: 'Keep your meetings in the power of the Lord God that hath gathered you…that none may stand idle out of the vineyard,' he told them.[327] In 1671 the Swarthmoor Women's Monthly Meeting began under the auspices of Margaret Fell. A second was established in Kendal in 1672 and a third in Lancaster in 1676.[328]

The combination of this level of gender-segregated activity and state persecution led to Quaker women's activism gradually becoming more muted. In 1683 Elizabeth Bathurst drew together many of the Quaker arguments about female speech as *The Sayings of Women* in which she argued that 'the Lord poured out his spirit…not only on the male, but also on the female…as male and female are made one in Christ Jesus, so women receive an office in the truth as well as men…and must give an account of their stewardship to their lord, as well as the men'.[329] In this sense between 1660 and the 1680s what the Quaker women did was restate their case, assiduously begin the recording of their sufferings as evidence of God's favour and accommodate persecution as part of their armoury of belief in Christ's kingdom on earth as revealed by their suffering. It was indeed a 'realised eschatology'. In her 'Last Epistle to Friends' from Swarthmoor in 1698 Margaret Fell advised that George Fox's glad tidings persisted in his writings: 'We have lived under the teaching of that blessed eternal Spirit of the eternal God' and 'now it is good for us all to go on and continue hand in hand in the unity and fellowship of this eternal Spirit'.[330] Fell did not die until 1702. During much of her second marriage, to George Fox, part of her suffering was enduring the long absences of her husband as he either spent time in jail or in London preaching the Gospel. Phyllis Mack argues that the discipline that developed by the 1690s in the Quaker movement led to the scrutiny and restriction of women's movement and that even in the meetings, women's galleries were designed so that when they did stand to speak and preach it was to each other and not to male Friends.[331] There was a sense in which those women Quakers who travelled to the New World were better able to keep alive their religious activism. For example, Alice Curwen, who travelled with her husband to Rhode Island and New Jersey, was jailed and flogged for her outspoken speech against the practice of excluding African slaves from attending Quaker meetings in New England.[332]

Crawford and Charlton have both pointed out the degree to which female gender construction after the Restoration continued to be determined by piety and women's duty to society to be moral educators of their children. Women had agency through both their private and their public worship and prayer.[333] This held true for Catholics, nonconformist Protestants and Anglicans alike and

Crawford has argued that this gave women a uniquely powerful role in the shape of Anglicanism and in the perpetuation of religious nonconformity in both Catholic and Protestant variety.[334] Clive Field's research has indicated that over 60 per cent of Baptist and Congregational church attendance in London after 1660 comprised women.[335] The evidence for women being attracted in larger numbers than men to puritan theology is inescapable. Amanda Porterfield has pointed out that '[b]y 1660 women comprised the majority of communicants in every New England church where membership records have survived'. In New Haven the figure was 84 per cent in the 1660s and over 70 per cent in churches in Charlestown, New London, Boston and Salem in the 1670s and 1680s. Porterfield explains this in the same way as others such as Mack and Crawford – in terms of female attraction to the emotional content of the theology and the real and hoped-for spiritual authority that women could gain from being a member of a less hierarchical and exilic religious sect.[336] For women nonconformists, the gender imperative to act as a role model worked in combination with the desire for personal communication with the divine. Speaking the language of feminine submission to the demands of a masculine God, women were able to move from the model of private piety exemplified by their spiritual autobiographies to a public devotional stance validated by God himself.[337]

Women's Catholic activism remained a critical component also of Catholic survivalism and the more conducive environment enjoyed periodically by Catholics (despite high levels of popular persecution) during the reigns of Charles II and James II led to some institutional toleration of women's organisation. In 1669 Frances Bedingfield of the Mary Ward Institute began a Catholic school for girls in Hammersmith and in 1686 she established the Bar Convent in York which still exists today.[338] Religion provided the prescription of female silence, but this was gradually eroded by the demand for an activist piety created by the Reformation process itself. Women's religious expression initially became possible because their gender identity as the weaker sex gave them extra power to receive God's Word.[339] It was only a small step from this to Bathsua Makin commenting in favour of women's education in 1673 that despite the Pauline imperative of female silence: 'yet those extraordinarily inabled, to whom Paul speaks ... might ... [be] publickly imployed [to preach]'.[340] Although after the Civil War it is possible to see the slow containment of women Quakers and Baptists, they nevertheless continued to hold their own and the persistence of religious nonconformity was matched by a continuation of female prophecy; Elizabeth Bathurst thrived in a way she could not have done prior to 1640.[341] As a consequence, mock female prophecy such as *Mrs Sarah Bradman's Prophecy of Wonders* (1686) also thrived as part of the *querelle des femmes*.[342] Men continued to interpret female spirituality in terms of women's closer relationship with God. When Margaret Eliot died, almost certainly from puerperal fever, on 8 June 1675, she was reported at the end to be so spiritually-transported that she 'talked herself into joining the Lord'. The diarist hinted at being able to see her mystical union with the divine.[343]

Religious pluralism led also to the appearance of mystical groups that included and were sometimes led by female prophets. The most important example was

Jane Lead's Philadelphians.[344] Lead was the well-educated daughter of an affluent gentry family whose teenage introspection took on for her religious significance. Sent to live with her brother in London in 1642 she came under the influence of Antinomian and millenarian sectarian religious ideas. She was married in 1644 to William Lead and had four children but after his death in 1670 admitted that she thought her temporal marriage had always been an obstacle to her spiritual marriage to Christ. In about 1674 she joined a small spiritualist group led by John and Mary Pordage, followers of the theosophical ideas of Jacob Böhme. The latter, who died in the year Lead was born, wrote *The Way to Christ* (1624), which contained the idea of divine wisdom conceptualised by Böhme as having a female voice ('Sophia'). In a large number of texts written in the 1680s and 1690s Lead conflated divine wisdom with the idea of the Virgin and put the result together with the millenarian idea of the second coming of Christ. In her first two books, *Heavenly Cloud Now Breaking* (1681) and *Revelation of Revelations* (1683) she developed a rereading of the Scriptures that brought together the ideas of Böhme with the imaginative natural philosophy and cosmology of John Pordage's *Theologica Mystica* which she published with an introduction in 1683.[345]

In *The Heavenly Cloud* Lead visualised (literally) 'the Lord Christ's Ascension Ladder', sent down through the parting clouds to believers. This externalising and visualising the relationship with God was quite different from the internalising of the Quakers and had closer connection with Anglican ideas of women achieving a state of heavenly perfection. 'I am comissionated, as both Servant and Friend to my Lord, and Heavenly Bridegroom, to invite you to the Great Supper of God and the Lamb,' she said. The imagery was tactile, of tasting 'the Lord's Mystical Body' and she spoke of living in 'the last Age' during which 'the Rational Life' was the 'great Enmity', threatening the soul with darkness, before 'a quickening life' and 'Wisdom's Resurrection' before 'the Heavens do open, and the bright cloud breaks, as the open gate for Ascension'.[346] Thus in the 1680s world of new science, Lead drew upon gender construction to reject rationality. She at once looked backwards to a philosophical reading of nature to ascertain the divine, and forwards to a new millennial vision encapsulated in eschatological prophesying about the re-entry to the world, and human history, of a feminised divine being known by the shorthand of 'Virgin Wisdom'. She anticipated a genderless God and the arrival of 'Sophia' with the second coming of Christ.[347] Hers was a totally embodied spiritual faith: the Spirit did not just move within believers, 'it flies as a bird in the Air'. Although it seems a long way from the Calvinist doctrine of predestination, the ideas were a direct product of this formulation and the Glorious Saints who ascended the ladder through the clouds were, according to Lead, 'the Elected Seed'.[348] In *The Revelation of Revelations* she grounded her work more thoroughly in Biblical exegesis, taking the 'seven seals' and the concept of the New Jerusalem from the Book of Revelation for her text but then repeating, at length, the message about 'the living stones gathered' to 'glorification' and 'resurrection'. She called to the elect to ready themselves for Christ and put this together with cosmological ideas about natural harmony. She visualised the New Jerusalem in feminised ways as a 'Mother-City' and preached a message that used

the doctrine of election as a message of hope: 'The foundation of God's Election stood so firm in the Essentiality of the out-breathed Word (which was the Light of Adam's Life in the Center of Immortality) that the same word will restore all again.' Her conflation of this theology with a philosophy of the natural world can particularly be seen when she took the imaginative step away from the Book of Revelation to describe the Virgin and Wisdom's Children as 'conversant with the Deity'. This was signified by the Sun and Stars which were seen 'about the Head of the Woman in the Revelations' before moving to a mystical and cryptic explanation of their alignment with the planets. To achieve 'the Mystery of the Mysteries' Lead advised that 'where the Soul and God are to be in Private Counsell together' believers should give up worldly life to seek 'the Priviledge of divine inspiration'.[349]

The new biography of Jane Lead by Julie Hirst and biographical essay about her by Sylvia Bowerbank both argue for a late seventeenth-century figure who may personify the liberation of the female voice after the Civil War, but who is also a unique voice. In Lead it can be seen that the female voice, once liberated, was neither unitary nor completely predictable. Despite the homogenising tendencies of prescriptive femininity, the breakdown in confessional identity in England after 1660 allowed women greater freedom of religious expression. Lead drew upon earlier traditions when she wrote her spiritual autobiography, the three-volume *Fountain of Gardens*, but unlike the formulaic providentialism found in earlier women's diaries and meditations, it was a vehicle for presenting her daily visions and prophecies. However, in her prophetic work she also departed from the earlier form of Eleanor Davies. Lead wrote continuous prophecy in the first person that was not reliant upon the authority of a male Biblical prophet or even the Biblical texts. Her work was framed by some old Calvinist ideas, like that of the covenant with God (which she had entered into), but the God to whom she was covenanted had changed sex.[350]

The increased religious authority of women after 1660 can also be seen in Lead's pan-European impact. In the mid-1690s her ideas came to the attention of Baron Knyphausen. He gave her book *The Wonders of God's Creation Manifested in the Variety of Eight Worlds* (1695) to the German mystic Johanna Eleonora Petersen who was so impressed by Lead's revelatory visions and so convinced of their Biblical origins and authority that Knyphausen felt persuaded by Petersen (who was another female mystical theologian) to place Lead on a pension and arrange for her work to be translated into German. For 10 years, between 1694 and her death in 1704, Jane Lead was the life-force at the centre of a small religious group whose millenarian waiting (for Christ) involved belief in eventual return to Paradisian harmony. They called themselves The Philadelphian Society after the Greek word *philadelphos* ('brotherly love') implying the innocence and sinless communion enjoyed in the Garden of Eden. The power of Lead's visions over her followers, who included another female mystic, Ann Bathurst, was made the greater by her increasing blindness. From 1697 the group met at Baldwin Gardens, the house of Bathurst, whose manuscript diary reveals communities of women meditating and praying 'rhapsodically' and attempting collectively to

have visions. Bathurst's visions were even more embodied than those of Lead and the sexual content was explicit: [it is] 'as if some strange thing had happened unto me ... first as I said in the womb, then in the heart, then in the head ... I have felt for some time since some moving of travel between my breasts as some new manifestation'.[351]

Women's increased religious authority after the English Civil War involved a claim to powers of Biblical interpretation achieved through decades of spiritual autobiographical writing. Elaine Hobby has found that between 1649 and 1688, when women's actual preaching slowly suffered some decline, well over half of their published works were prophetic. The Quaker, Anne Wentworth, whose four prophetic tracts appeared between 1676 and 1679 to prepare people for the coming of Christ, threatened to leave her husband if he did not let her publish for the sake 'of the whole nation'. Temporarily a Baptist, she ultimately resisted all formalist religion in favour of a mystical spirituality that she clearly found more emotionally satisfying. She was able through her prophecy to transform her suffering into an escape route, away from an abusive marriage and towards eternal salvation. God had assured her, she told her readers in *A Vindication of A. W.* (1677), 'that the man of earth shall oppress me no more' and she was 'a daughter of Zion'. In *The Revelation of Jesus Christ* (1679) she told them that Christ had come to her one night, giving her 'a new body' and would 'avenge [her] cause'.[352] Hannah Allen recorded similar life-transforming dealings with God in *A Narrative of God's Gracious Dealings with the Choice Christian Mrs Hannah Allen* of 1683. The Devil had convinced her 'that I must dye and be with him ... I was *Magor-Missabib*, a Terrour to my self and all my Friends ... I am the Monster of the Creation ... the Devil himself was a Saint compared with me', she said. She tried to commit suicide, neglected her child and drove her relatives to despair until God rescued her soul. At the end of her journey to salvation was the publication of her autobiography.[353]

Katharine Gillespie has recently argued that women like Anne Wentworth and Hannah Allen were essentially religious 'freedom fighters' who used their newfound Biblical authority to demand a greater role for women in society and who contributed indirectly to modern principles of 'liberalism' and 'toleration'.[354] This is anachronistic interpretation. Anne Wentworth and the women moved by the spirit in seventeenth-century England gained their voices through an act of complete submission to God. They were not liberal feminists, but were instead looking backwards to a puritan age and an *anti*-secularism that demanded toleration of their submission only to the kingdom of God. Alexandra Walsham has recently demonstrated that, if anything, growing state tolerance (or, more accurately, less persecution) of religious nonconformity led to intensified popular intolerance especially of Catholicism and vicious, politicised ridicule in the new public sphere of print.[355] Thus, if women's religious authority increased from the 1660s, it did so in tandem with vicious satirical attacks on women Protestant dissenters and Catholics. Jane Lead was able to set up in a house in Hoxton Square in the late 1690s but, at the very same time, she and the Philadelphians were being mobbed while they prayed in Hungerford Market. Therefore, if England after 1660 was 'a nation transformed' by secularisation it was partly a response to what Crawford

has called the feminisation of religion and if Fletcher is right that gender was reconstructed after 1660 by secularisation then the motor for change was the desire of some women to wrest religion away from the state to satisfy very traditional gender expectations of female piety.

Conclusion

There are several interlocked sets of conclusions to draw from this chapter. The first is that early-modern gender construction was inextricably linked with religious politics, reformation and change. Christianity provided the intellectual foundations not only for women's subordination and silence but also the tools for women's religious and, therefore, political activism. The second is that women were critical to the Reformation process. In 1673 Bathsua Makin remarked that '[o]ur very reformation of religion seems to be begun and carried on by women'.[356] Makin's point was that women were involved not just at the level of personal piety, but were intrinsic to institutional religious reform and change too and her remarks need to be seen as reflecting a post–Civil War context in which women's religious authority had become a given.

Early-modern religion was both institutional and discursive and gender was interwoven with both. In terms of the institution, churches and ministries were almost exclusively monopolised by men. In the established Church congregations were sex-segregated and sexual differentiation persisted in the dissenting churches of the late seventeenth century. Discursively, the Godhead was male. The conduit for and to God and salvation – Jesus – was also male. The Apostles like St Paul were male, the Church Fathers like St Augustine were male and Old Testament prophets such as Isaiah, Ezekiel and Jeremiah were male. However, discursive gendering of the invisible church of believers was less straightforward and allowed women a route to some religious authority and ultimately to Jane Lead reconfiguring the Godhead as woman. The Church, as a concept, was often described as wife to Christ and mother to the believer. Stephen Marshall, in 1645, put it this way: 'It is their mother, in whose womb they have lain, whose breasts they have sucked.' He was speaking to the male members of the House of Commons at the time.[357] Equally, Protestants feminised Catholic Rome as the Whore of Babylon. Mack's work demonstrates that women Quakers believed that only erasure of the bodily self could reveal the soul, metamorphosing and ungendering the flesh from that of the base whore to the innocent babe.[358] Women could, thus, use religious discourse to banish the whore and construct themselves positively, more closely aligning their gender with a pure invisible church of the faithful and elect or, in the case of Catholics, with a community in exile.

Gendered spiritual authority was complicated also. Men, brought up to believe that they had been created first in the image of God, were able comfortably to adopt positions of religious authority in the family which reinforced their superior social roles exercised as fathers, husbands and heads of households. However, spirituality was essentially a private matter; piety might be prescribed but deeply-held beliefs could neither be artificially generated nor properly controlled by anyone but the

believer. The private world of the mind/soul constructed femininity from within in negotiation with prescription from the pulpit and conduct books. Therefore, the discourse of piety that was most important in providing the intellectual and social foundations of the ideal and unchanging chaste, silent and obedient woman in 1500 was the very discourse that enabled women to escape those chains of silence and obedience by 1700. The Bible provided examples of prominent women such as Esther, Judith and Deborah who were examples of defenders of Christianity, and female saints, especially the Virgin Mary, were examples of feminine good-ness which helped to undercut negative examples of female nature.[359] Mary Ward, the Catholic founder of the Institute of the Blessed Virgin Mary, rejected male arguments about women's spiritual inferiority and asserted that women's natural piety lead to their more perfect knowledge of God.[360] It was a sentiment repeated by the Protestant Mary Astell when she suggested women's monasteries for the improvement of society and it was one drawn upon by the women mystics and pietists of the late seventeenth century. Crawford and Gowing have argued that '[e]mbodiment was central to female religious experience, and women had dif-fering views from men about how their bodies, souls and gender were related.'[361] Hannah Allen in 1683 claimed that 'if the Body be out of frame and tune, the Soul cannot be well at ease'.[362] New notions of the body at the end of the seventeenth century intersected with gender, discursively excluding most men (except those willing to follow rather than lead) from the emotionalism required for any evan-gelical religion that equated the Word with nurturing mother's milk and the New Jerusalem with the Mother-City.[363]

There was, then, a very complex relationship between institutional and discursive constructions of religion and the church and gender construction in early-modern society. Despite men's monopolistic access to and power within the institution of the visible church, women had considerable if not greater access than men to what was understood as the invisible church of believers. This gave women the opportunity for gender self-fashioning and enormous spiritual (and, therefore, social) authority during the two centuries of Reformation when religion and pol-itics were inseparable. Both Catholic and Protestant activism (encouraged by the Reformation's demand for partisanship) allowed women to discover that Christian femininity demanded not silence 'but the articulate and resolute expression of [their] faith'.[364] Joan Wallach Scott's comment that the 'terms of gender' were revised by political upheaval appears correct in Reformation England. Gender, like any social identity, was affected by changes in discourse and what Mikhail Bahktin would define as the 'linguistic disorder' of war.[365] After the civil wars religion was left fragmented and the puritan reformation became exiled within England and abroad especially in New England where, in both places, congrega-tions were dominated by women. The political realm of court and parliament became fractured by partisan politics initially expressed as anti-Catholicism, though secularised in the sense that political debate and language was no longer mediated by the language of God's law. Men redefined themselves as rational creatures whose visible church and God became simply a part of the armoury of their social reputation. Thus gender and secularisation were part of the same

historical process – as religion became feminised, a masculine world of secular politics of state came into being and patriarchy reasserted itself partly through separation of church and state. The nation *had* been transformed by religious war, though it was a transformation that can only be fully explained with reference to women's agency in the historical process.

7
Education and Women's Writing

Introduction

This chapter summarises the literary output of women in early-modern England and analyses women's writing in the light of female education and gender training. The standard historical accounts of early-modern women's education can be found in a number of older works such as Myra Reynold's *The Learned Lady in England* (1920) which stressed women's educational attainment based upon the achievements of the elite.[1] More recently Kenneth Charlton has argued that all women's education was an extension of their religious training and a form of gender training that turned them not into scholars but pious wives and mothers.[2] Most girls were taught at home and most did not receive the Classical education that began to be offered in boys' grammar schools in the sixteenth century. When Richard Mulcaster, master of the new school set up in London by the Merchant Tailors, published *Positions* (1581) he argued that '[t]he bringing up of young maidens in any kind of learning is but an accessory'.[3] King James I was more cynical claiming that 'to make women learned and foxes tame has the same effect – to make them cunning'.[4]

Historians speak of an educational revolution by the early seventeenth century during which the grammar school curriculum had developed and Protestant teaching in the vernacular had made an impact on literacy.[5] The idea is based partly on the expansion of schooling and university entrance though this only affected boys, who were frequently sent to private schools at seven. Elizabeth I opened 138 schools in villages, but very few grammar schools actually admitted girls; in Banbury, for example, girls were admitted only till age nine.[6] In Christ's Hospital, a foundation for destitute children, endowments and donations ensured that the girls (all dressed in green skirts and blue bodices) learnt to sew, spin and read a bit. More important was the functional literacy gained through reading the Bible, catechisms and psalms in English after the Protestant Reformation. The need for a Protestant alternative to the nunneries and their attached schools had been identified by Thomas Becon as early as the 1550s when he argued that 'it is expedient that by public authority schools for women–children be erected and set up in every Christian commonweal'. The impact of puritanism from the 1580s

led to an emphasis on Bible repetition for girls, which taught them to read and to some extent write.[7] Margaret Hoby memorised sermons to write them down at home, took notes on them upon her return from church and asked her friend, Constance Fowler, to send her religious verses to stick in her commonplace book.[8] Unpublished women's manuscripts for the period tend to be commonplace books, written privately by women and also shared with family and friends in a sort of informal manuscript exchange and literary collaboration.[9] Catholic families after the Reformation sent daughters abroad, for example to Mary Ward's boarding school at St Omer, with the same if not greater effect on their functional and, indeed, politically-activist literacy.[10]

One of the first signs of educational advantage and change was an increase in women's book buying. Daniel Woolf has found that 1.5 per cent (or 11) of the subscribers to *The Great Historical, Geographical and Poetical Dictionary* of 1688 were women, though some titles, such as the 1718 edition of Geoffrey of Monmouth's *British History* and Nicholas Rowe's translation of *Lucan's Pharsalia* in 1719, were particularly popular and attracted more women buyers at 17 per cent and 7 per cent, respectively. Frances Wolfreston, for example, who was born in 1607, was an avid collector. In 1646 she bought an imprint of *A Chrystall Glasse for Christian Women* about the godly life and death of Katherine Stubbes and added it to her collection of no less than 50 'penny godlies'. She was not a monomaniacal puritan; she also owned 16 'penny merries' such as her *Booke of Merrie Riddles* (1617) and multiple works by John Taylor including *A Common Whore* (1625). Some of her books were rare when she bought them such as her 1519 edition of Catherine of Siena's *Orchard of Syon*. She bought books on plants and two *querelle des femmes* works – Joseph Swetnam's *The Arraignment of Lewde, Idle, Froward and Unconstant Women* (a 1645 reprint) and one defence of women, *The Good Womans Champion* of 1650, which she inscribed as 'in prais of women and a good one'. She owned popular works like *The Life and Death of...Saint George* (1660), several works of William Shakespeare and newsbooks of providential signs such as *Englands Summons* (1650) and *Englands Alarum Bell* (1652). There were no books of music and no deeply philosophical works; hers was a collection representative of the averagely-educated pious woman of seventeenth-century England.[11] When she wrote her will she owned over 1,000 titles which she left to her younger son with the proviso that if her other children borrowed them after her death they 'shall returne them to their places againe'.[12]

There has been enormous interest in early-modern women's writing and most work has been done by literary scholars rather than historians.[13] Full-text reproductions of women's works have been systematically produced in *The Early Modern Englishwoman* series and the Perdita Project aims to be a summary point of access to all women's manuscript writings.[14] One of the reasons for the interest in early-modern women's writing is the association made by some scholars with early feminism. For example, Doris Stenton's *The English Woman in History* (1957) focused on women's wealth and learning and spoke of 'the beginnings of English feminism' in the second half of the seventeenth century. Hilda Smith *Reason's Disciples* (1982) and Moira Ferguson's anthological *First Feminists: British Women*

Writers 1578–1799 (1985) also date feminism to this period when women's education and writing became more prominent. Feminism is a tricky term in this context. Writing can be defined as feminist if woman-centred, though there are also questions about whether or not feminist writing requires a critique of women's position in society. Additionally, there are questions about whether or not feminism needs to be contextualised because what is feminism in one age may not be in another.

Linked to the question of feminism are questions about language and voice in written works. Postmodernist literary scholars such as Michel Foucault and Jacques Lacan would argue that literary output, like knowledge, is so inextricably linked to the culture in which it is produced that all patriarchal societies generate a hegemonic male voice. However, feminist scholars such as Luce Irigiray argue that a *feminine ecriture* [woman text] can develop containing linguistic strategies that subvert the male literary position sometimes through appropriation of the male voice ('ventriloquization'). One of the purposes of this chapter is to consider the possibility of the appearance of a distinctly female voice and to consider its connections with early-modern feminism. Gerda Lerner has defined three criteria needed for defining and locating the female voice: first, that women recognise their autonomous authorship of work; second, that women claim a right to their own thinking; third, that women perceive their thought as arising from difference of experience.[15] The latter in particular assumes that voices are gendered and that women's participation in the production of culture adds to it, in some way, a strand that is distinctly feminine.

Humanist women 1500–1560

The philosophy underpinning elite female education at the beginning of the period was Christian humanist. Renaissance humanism, which originated in Italy in the fourteenth century and had spread to northern Europe by the early sixteenth century, was a philosophical movement, rejecting medieval scholasticism and reviving the Classical texts of ancient Rome and Greece as a blueprint for building the model society. Northern European humanism, associated with scholars such as Desiderius Erasmus, generated an educational movement that emphasised the importance of the study of Latin and Greek and Classical authors such as Plato, Aristotle and Petrarch in a character-forming exercise that created the individual of *virtù*. The so-called *studia humanitatis* dominated in universities and the growing number of grammar schools. However, humanism became overlaid in the late sixteenth century with a philosophical form of Calvinism associated with the work of European systematizing theologians such as Theodore Beza and Peter Ramus whose interest in binary constructions imposed rigour on godly forms of learning.

The humanist goal of fostering Christian duty rendered the educational programme theoretically open to women and some historians have, therefore, associated the Renaissance with at least a temporary flowering of female education in sixteenth-century England. There are several older studies of the education

of girls in England which are positive in their assessment of the period – such as Dorothy Gardiner's *English Girlhood at School* (1929), Josephine Kamm's *Hope Deferred* (1965) and Phyllis Stock's *A History of Women's Education* (1978). Stock argues that although the humanist impetus came late to England, it nevertheless encouraged 'a true rebirth of the intellect' that encompassed the female experience. Gardiner suggested that Renaissance humanists drew lessons from Plato and his generally favourable positioning of women in his utopian Republic. Kamm argued that there was a 'decay of learning' in the middle ages and in the sixteenth century 'the Renaissance, that splendid revival of art and letters which swept Europe, … acted as a spur to women of the leisured classes'.[16] Some academies in Renaissance Italy were open to women and according to Peter Burke, Baldassare Castiglione's *The Courtier* also encouraged Italian women to aspire to a social breeding that included learning and acted as a model for women's learning throughout Europe. Thus, the Renaissance led to a string of learned women, such as Christine de Pizan in France and Katherine of Aragon in Spain and then England.[17] Doris Stenton's classic study, *The English Woman in History* (1957), argued that the influence of the northern Renaissance was far-reaching in England, resulting in the learned lady of the wealthy English nobility and gentry.

More recent historiography on women's education has been more sceptical about the benefits of the Renaissance to women, demonstrating particularly the stark gender differences that resulted. Lisa Jardine and Christiane Klapisch-Zuber have painted a rather bleak picture of the Italian Renaissance as creating a society in which women gained accomplishment but not profession and in which their intellectual achievements were lauded but also controlled by men.[18] Their work answered in the negative Joan Kelly's famous question 'did women have a Renaissance?' which was based on her belief that the Renaissance was a masculine event that barely touched even wealthier women.[19] A number of studies in the 1980s and early 1990s confirmed the scepticism. Ian Maclean rejected the idea of progress for women, educationally and intellectually, arguing instead for a continuity of thought after medieval scholasticism about female sinfulness and ineducability.[20]

More recent studies of women in Renaissance England have repeated the gloomier verdict, emphasising particularly the stark differences in gender training that accompanied humanist learning. Helen Jewell has recently pointed out that boys received a humanist education through public institutions like grammar schools, the universities and the Inns of Court, whereas the girls who were lucky enough to receive an education did so through the more private and informal channel of support from male relatives, especially fathers. This was not simply because boys attended universities and girls did not. Theoretically, the Christian humanist programme of instilling civic virtue and piety extended to both sexes, but it was also training for a professional life from which women were excluded.[21] It is possible to argue, then, that instead of the Renaissance leading to a long line of learned women, it led to women who were more completely socialised into a subordinated role within marriage. Caroline André has suggested that not only was the humanist education programme for women designed to turn them into 'amiable companions' for

men, it also resulted in a debate about which Classical texts might 'not risk over-intellectualizing [and corrupting] a young woman'. Some men felt that teaching Greek to girls lead to them being able to read Homer and Virgil and that this would sully female chastity. Humanist educational principle rested on the belief that the active rather than the contemplative life was to be preferred in the creation of a model society in which all people were educated for the public rather than the private good. For this reason it simultaneously promoted wider female education and education that reflected social roles and therefore gender training. Men were educated to become public servants and good private citizens; women were educated to be good public servants through their virtuous private lives.[22]

Examination of the English case helps to reconcile these opposing views of the impact of the Renaissance on women. The humanist thinker and writer most responsible for encouraging a programme of female education in England was Juan Luis Vives. His *Instruction of a Christian Woman* was printed in Latin in 1523 and his 'Plan of Study for Girls' was written for Katherine of Aragon and intended for the education of the young Mary Tudor.[23] Together these works formed a blueprint for education that was used for female royalty and girls of the aristocracy for several decades. Vives' *The Office and Duty of a Husband* (1529; trans. 1555) defended women's rationality and encouraged husbands to attend to their wives' education. However, Vives had much to say on the need for constraint in and of women, especially by parents charged with the care of female virginity, and these works in themselves should not be seen as providing a detailed plan for the education of young girls. *Instruction of a Christian Woman* had only nine pages on curriculum. Rather, it was a text that promoted the idea that an education that combined good Scriptural knowledge with classical knowledge led to piety in women and moulded them into more companionable and chaste wives. However, Vives also deployed an argument against those who believed that 'the subtlety of learning' led to 'nourishment for the maliciousness of their nature'.[24]

Vives' programme for female education influenced and was also a part of the intellectual tradition that encompassed the works of Erasmus and Thomas More. David Wootton points out that Erasmus' essay 'The Sileni of Alcibiades' in the 1515 edition of the *Adages* opened up a view of a utopian communism that was replicated in More's *Utopia* of 1516. In More's utopian world, men and women received a vocational education that was reflected in More's own household. His employee, Richard Hyrde, was responsible for translating Vives' *Instruction of a Christian Woman* into English in 1529, demonstrating the highly familial nature of this ostensibly ungendered world of learning and Christian virtue.[25] Thomas More was an ascetic whose daily discipline involved rising at two in the morning in order to study until breakfast. As the patriarchal head of an extended household that included several female wards, he was demanding and austere. When his children married, most stayed at the large house in Chelsea, where his children were educated in the school that he established for his family. More's daughters, Margaret, Elizabeth, Cecily, his adopted daughter, Margaret Gigs, his ward Anne Cresacre and his niece Frances Staverton, were all trained in an intense intellectual environment alongside his son John. The defining image of this learned

man and his school of humanist women is a Holbein sketch of the family group.[26] More sits centrally with his father on his right-hand side and arranged around him, both seated and standing, are his second wife, daughters and female ward, reading and discussing books.

There is no question that the extent of education received by the women of Thomas More's household was remarkable and the result can be found in some of the earliest published works written by English women. Margaret More, who married William Roper in 1521, was a linguist who translated Erasmus' study of the Lord's Prayer published as *A Devout Treatise on the Pater Noster* in 1542. Reputedly Margaret More had a perfect grasp of philosophy and astronomy, logic, rhetoric and music. The bishop of Exeter, on reading one of the daily letters More demanded from his daughters in Latin, said that he could scarcely believe it had been written by a woman because of its perfection of vocabulary and style. Margaret's daughter, Mary Roper, inherited her talents. She was educated in her grandfather's school and worked on translations including one of her grandfather's final works, *Of the Sorrowe … of Christ*. Like her mother, she combined this scholarship with marriage and motherhood. Margaret's sisters, Elizabeth and Cecily, and her cousin, Frances, were also talented scholars, though her main intellectual rival was Margaret Gigs, whose algebraic and medical knowledge demonstrated her leaning towards science. In 1526 Gigs married John Clement, one of the scholars employed by More as a tutor in the school. She also combined motherhood and scholarship.[27]

Humanist scholars promoted a debate about female education amongst wealthy families. Thomas Elyot's *The Governour* was published in 1531 offering curriculum advice for a gender-inclusive education that embraced logic, rhetoric, music, dancing and painting. Like More, Elyot's programme for humanist learning enabled him to envisage a utopian commonwealth in which a monarchy was supported by a lesser magistracy educated in civic duty. He directed his educational programme, one that included law and government for older boys, to training this [male] lesser magistracy. Elyot's *Defence of Good Women* (1540) joined the *querelle des femmes* in support of women's potential for learning and judicious government. It drew on earlier Renaissance defences of women such as Boccaccio's *De Claris Mulieribus* (1361) to suggest that the classical civic virtues were attainable by women as well as men. The subject was the life of the Lady Zenobia, queen of Palymyra in Syria, a widow who was a Latin and Greek scholar and whose education of her children and government of her country were exemplary. But despite the example of Zenobia, Elyot's earlier work, *The Governour*, and arguments in *The Defence of Good Women* about Zenobia's exceptionality and her determination before widowhood to be subordinate to her husband, suggest exercises in rhetoric that never lost sight of women's essential inferiority. In this Elyot followed Plato who argued that while women were similarly endowed to men in all the 'gifts of nature', nevertheless, in 'all the pursuits of men … a woman is inferior to a man'.[28]

Gauging the impact of the humanist education debate on women in sixteenth-century England can be difficult to do. John Guy has recently suggested that one estimate of only 15 to 20 genuinely highly-educated women in Tudor England

may be a bit low.[29] It is certainly the case that Kathy Lynn Emerson's biographical dictionary of sixteenth-century women reveals almost 50 learned women. They include all the women of the More family and women in several other families in which girls and boys were taught in the same humanist curriculum. For example, the four daughters of Anthony Cooke, who was the tutor of Edward VI, all received humanist training. Mildred Cooke, who became the wife of William Cecil, Lord Burghley, was fluent in Latin and Greek and did a translation of St Chrysostom. Her sister, Ann, was also proficient in Latin and Greek and at 22 did a translation of the *Fouretene Sermons* (1550) of Italian Calvinist Bernardino Ochino. The Preface by 'B.B.' argued that though this might seem a subject 'meeter for Doctors of divinitye', women would benefit from applying themselves to works of rigorous theology rather than just 'warbl[e] wordes of scripture'. Ann Cooke later also worked on translating John Jewel's *An Apologie in Defence of the Church of England* (1564), so participating in the cultural process of legitimising Reformation. Elizabeth Cooke was able to compose epitaphs in several languages and Katherine Cooke had some mastery of Hebrew.[30]

Within those families closely connected with the royal court further highly educated women may be found. The daughters of Edward Seymour, duke of Somerset, were given an education similar to that received by the More and Cooke girls. Jane Seymour, niece of the eponymous queen, became a considerable scholar and poet. Mary Arundell, one of Queen Katherine Howard's household, translated epigrams in Greek and Latin. She was married to Henry Fitzalan, 12th earl of Arundel, and educated his daughters by his first wife. The result was that Joan Fitzalan became a proficient and fast translator of works in Greek and Latin such as Euripides' *Iphigenia in Aulis* and Mary had translated at least four volumes of Greek into Latin by the time she died at only 17 years of age. Lady Jane Grey was highly educated, as were all the daughters of Frances Brandon and Henry Grey, marquess of Dorset. Jane Howard, who was at court at the very beginning of the reign of Elizabeth I, was educated by Hadrianus Junius and John Foxe and had mastery of Greek and Latin. Frances Vere, daughter of the earl of Oxford, was a poet who ensured that her daughters and sons received equally high standards of education.[31]

What connects all of these women of the first humanist generation was that they were prodigiously learned while evading authorial autonomy; they did not claim their works. The daughters of Thomas More and Anthony Cooke engaged themselves in works of translation. The authority vested in the words was not personal but derived, always from male authors. Lack of intellectual autonomy for these women sprang from the very process of literary production. Their work was closely overseen by male mentors; Ros Ballaster has pointed out that Joan Fitzalan chose for her translation from the Greek a work that 'seems a particularly apt speaking choice for a daughter to produce for her father'. In *Iphigenia in Aulis*, Agamemnon's daughter, Iphigenia, surrenders herself as a sacrifice to the goddess, Diana, in order that her father's fleet of ships has wind to reach Troy for the rescue of the abducted Helen. The work exists in a manuscript of about 1550, written by Fitzalan around the time of her marriage to John Lumley.[32] John Guy has argued that Thomas More

trained his daughters into obedience through a humanist education that many contemporaries would have regarded as too feminine for their sons, and Merry Wiesner points out that Margaret Roper's only published work was a translation of a man's religious work. It was published anonymously, knowledge of its publication being shared only with friends. In other words, Margaret Roper was the showpiece of a male humanist – More himself. Margaret Gigs also did not claim authorial autonomy in her work, though the thorough education of her own daughters helped one of them to become prioress of St Ursula's in Louvain.[33]

Education was an important social asset and so the political ambition of families for their female members to enter court service drove the fashion for their education. A component of the gender training was woman as primary educator of children, a family service that ensured social and political advancement. The court fashion for educating daughters ensured that the reach of a humanist education for girls extended beyond the court itself and did not, for most, have as the primary aim writing for a public. Catherine Tishem's education enabled her to teach her son French, Italian, Latin and Greek. Elizabeth Lucor, who married a London merchant, had been educated in Latin, Spanish and Italian. The education of some women of the gentry led them into the post of governess at the royal court and began the tradition of educated women entering the paid teaching profession. Anne Pagenham was governess to Prince Edward though her remuneration would have been for her court office rather than her occupation.

The fashion for educating women in sixteenth-century England did not, as on the continent, lead women into scholarship and creative trades. Elizabeth Weston, whose education led to her being able to speak all the Czech languages by the time she died at the age of 30 years, became only a calligrapher after marrying Johann Leon and moving to Prague. Esther Inglis, a calligrapher and illuminator of manuscripts, was patronised by Elizabeth I but was born Esther Langlois in Dieppe where she learnt her craft from her mother. Lavina Bennick, was sponsored by the English royal court to paint miniatures, but was from Ghent. Susanna Hornebolt was not so lucky; an illuminator and miniaturist who had learnt her art from her father and gained a considerable reputation in her own right in her native Ghent, found herself without work when she came to England with him in 1528.[34] English girls who received training in Latin, Greek and Hebrew did translations to demonstrate their skills, as they would when they publicly played the lute, but they did not seek employment as calligraphers as they might have done in other parts of Europe. In other words, educated and literary women advertised their social training, but did not pursue the route to economic independence and occupational identity. The humanist generation claimed and attained female scholarly equality with men but this never translated into a challenge to male social superiority nor did it shake the belief in the essential inferiority of the female body and mind. Thus, the emergence of a female voice in published written works is not to be found in the period 1500 to 1560 despite fairly widespread and prodigious scholarship amongst women of the English aristocracy, gentry and mercantile classes.

Renaissance women writers

The courts of Elizabeth I and Anne of Denmark encouraged, to some extent, the means for women's literary output between about 1560 and 1620. If women had the contacts, they could arrange publication of their work and by the late sixteenth century a second generation of female humanist scholars emerged, though they were very small in number. All were highly trained in Classical and modern languages and they thrived in aristocratic circles. Elizabeth's liking for learned women arose very directly out of her experience as Katherine Parr's step-daughter and publication of works by women, such as *Lady Elizabeth Tyrwhit's Morning and Evening Prayers* (1574), was a feature of her reign. The women of Elizabeth's court were also influenced by the European example; it was an aristocratic woman who urged Sir Thomas Hoby to translate the Third Book of Castiglione's *The Courtesan* on female courtiers and this appeared prefaced with a dedication to Elizabeth I. Hoby was the son of Elizabeth Hoby, one of the learned daughters of Anthony Cooke.[35] Religious translations by women were lent new impetus and Louise Schleiner has talked about writing communities of women authorised by religion.[36] Women's religious writing had broadened by the late sixteenth century and fell into three categories including elegies such as the *Hecatodistichon* (1550) written by Anne, Margaret and Jane Seymour to Marguerite de Navarre, the French queen and Protestant sympathiser.[37] By 1582, so generalised was the authority given to women's religious works that Thomas Bentley published a successful anthology – *The Monument of Matrones* – that included virtual unknowns such as Frances Abergavenny and Dorcas Martin.[38]

The earliest extended and original historical work by a woman arose in this context of humanist training and religious imperative.[39] Called *The French Historie* and written by Anne Dowriche it appeared in 1589. *The French Historie* reproduced Jean de Serre's martyrologies for an English Protestant audience. It chronicled the sufferings of French Huguenots (Protestants) and resembled John Foxe's *Book of Martyrs*, though she started with a prose translation of de Serre by Thomas Tymme and turned it into rhyme, alternating iambic heptameters with hexameters. The speeches delivered by French martyrs functioned in the work as both sermons and puritan death narratives. Dowriche worked like a historian, identifying key moments in the Protestant struggle such as a 1557 attack on a prayer meeting, the execution of Protestant senator Annas Burgeus and the murder of Gaspard de Coligny, a member of the Huguenot nobility. However, there were touches of author's license as she dramatised the interaction of Satan, his victims (e.g. the French monarchy) and God. Anne Dowriche recognised the autonomous authorship of her work calling it 'this worke of mine' and she is important as a woman historical writer, authorised by religion but claiming collusion in a particular history shared with men. Dowriche was part of the second generation of humanist educated women, her father having specifically provided for her education in his will of 1560.[40]

Tina Krontiris has pointed out that the court was also a training ground for the production of secular works by women. The publication of European courtly

courtesy books, and the expansion of a female reading public, encouraged women's entry into the world of print.[41] The period 1560 to 1620 witnessed new departures in women's writing, both in form and genre, including secular historical narratives and poetry and Arcadian romances.[42] In the second generation of 'Renaissance women' gender and the expansion of genre were closely connected. Humanist education led to women's intellectual creativity, set free to some extent from the original debate about 'woman' and given impetus by the circulation of chivalric and secular courtly literature at a time when there was a reigning queen. If religion authorised women's writing, there were other cultural factors that encouraged female communities of scholarship and feminised the cultural practice of writing. Jane Donawerth has pointed out that the writing of poetry practiced by women like Anne Dowriche became incorporated into female courtly rituals of gift exchange and Victoria Burke has also pointed out that the exchange of poetry in manuscript miscellanies by women cemented friendships and authorised intellectual communities of women. Lady Anne Southwell's poetic miscellany functioned as a form of personal writing that detailed her network of friendships but also collated snippets from well-known courtiers like Sir Walter Ralegh. Similarly Georgianna Ziegler has pointed out that the illustrator, Esther Inglis, located something of herself in her manuscripts through their intricate and crafted designs, so that her gifts were at once personal yet supportive of scholarly community amongst women.[43]

While some Renaissance women writers were part of the court circle, others such as Anne Dowriche were only on its margins and others still were educated members of the bourgeosie who managed to publish without court patronage at all.[44] The patronage networks to some extent determined the form of the product. For example, some of the earliest published poetry – by Isabella Whitney – resembled in format the manuscript miscellanies that circulated privately.[45] Unpublished verse could be interactive, the manuscript essentially being the nexus between private female conversation and the faceless audience of public print. Isabella Whitney, about whose life little is known, published two miscellanies before her death in 1573. The first – *The Copy of a Letter* (1567) – was gendered in its subject matter and feminine in its concern, answering the accusations of men about women's sexual morality.[46] Betty Travitsky has described *The Copy of a Letter* as 'four jaunty love complaints, two in female and two in male voices' and points out that while there is some suggestion that Whitney may have written only the first two, a number of literary scholars argue that all the verses privilege the female point of view.[47] Danielle Clark supports this case, arguing that *The Copy of a Letter* uses the device of Ovid's *Heroides* of articulating women's grief at the betrayal of a man.[48] In the first verse in the female voice, entitled 'To Her Unconstant Lover', the subject complains that her lover chooses the single life or another woman over her and details the grief of Classical women, such as Dido whose heart was broken by Aeneas. 'These words I do spe[a]k, thinking | from thy new love to turn thee', the subject cries.[49] In the second, 'The Admonition of the Auctor', the subject addresses young women in love and warns them of men's capacity for deceit. The other two verses in *The Copy of a Letter* are autographed 'W.G.' and 'R.W.' and

Clarke points out that they focus on dishonour and deception, as if the entire collection is concerned with reciprocity in matters of love and morality.[50]

Whitney's second verse miscellany – *A Sweet Nosegay* – written in 1573 focused on flowers as a metaphor for friendship and drew upon Hugh Plat's *Floures of Philosophie* (1572) for its inspiration. In one of the verses, *The Manner of Her Will to London* (1573), Whitney made her poverty evident. An odd survival, written as a last will and testament in verse, she claimed to be departing from the city of her upbringing because of ill health leaving behind meat for butchers, jewels for goldsmiths and hosiery for women needle-workers. The illness may be mock heroics and Betty Travitsky points out that Whitney's *Sweet Nosegay* fits into the two genres of 'mock testament' and 'city rogue tracts'. 'For maidens poor, I widowers rich do leave' she promised, before taking her leave with the words 'no longer can I tarry'. Isabella Whitney's importance lies in her uniqueness as a female voice in the print trade of popular secular verse and several authors have argued that several other verses appearing in collections of popular verse may also have been by her.[51]

The other Renaissance woman writer about whom little is known except that she wrote verse was Amelia Lanyer. There is one surviving work definitely attributed to her – *Salve Deus Rex Judaeorum* (1611) – and an appended work – *The Description of Cookham*. *Salve Deus Rex Judaeorum* identified Lanyer as the wife of a Captain Alfonso Lanyer, a musician and one of King James' servants. She reputedly married him after getting pregnant by Lord Henry Cary. *Salve Deus Rex Judaeorum* was dedicated to Anne of Denmark, with prefatory verses also 'To All Virtuous Ladies in General' as well as several named women including the dowager countesses of Kent and Cumberland and the countesses of Bedford, Dorset and Suffolk. In different imprints the dedications to patrons changes, indicating her slightly precarious position on the edges of the court. Lucy, countess of Bedford was the important one, being Queen Anne's favourite and a close friend of her daughter, Princess Elizabeth.[52] *The Description of Cookham* was aimed at patrons, especially Anne Clifford: 'Yet you (great lady) mistress of that place... [did] think upon those pleasures past, | As fleeting worldly joys that could not last.' Clifford was mentioned by name in the verse as well as the countesses of Bedford and Dorset. *The Description of Cookham* is a romantic verse about a rural idyll. It is a 'country house poem', the tone of which remains ingratiating throughout: 'The gentle winds did take delight to be | Among those woods that were so graced by thee.'[53] *Salve Deus Rex Judaeorum* mixed classical imagery with historical and Biblical reference. Despite the religious content and reference to Satan drawing people from 'the spirit of grace' these verses were not puritan or very theologically reflective. Some literary scholars classify the poem as early feminism because of its treatment of the Biblical account of the Fall.[54] In one lengthy section Lanyer attributes the actions of Eve to the fault of 'too much love': 'But surely Adam cannot be excused | Her fault though great, yet he was most to blame... If any evil did in her remain | Being made of him, he was the ground of all'.[55]

There has been a rather fruitless historiographical debate about whether or not Lanyer's poetry is primarily a feminist rewriting of Biblical history or a cynical

work driven by sycophancy. Danielle Clarke claims that Lanyer's poetry represents 'revision of Biblical history', the story of Christ being retold from the perspective of women, emphasising the role of the women who wept over Christ and the pain of the Virgin Mary. [56] Lorna Hutson has pointed out that Renaissance 'poetic discourse is never disinterested but rather seeks to authenticate itself through the devices of rhetoric and the relations of patronage' and so Lanyer's feminist appeal to her patrons neither detracts from the feminism of the poetry nor the sincerity of its religious content the thrust of which was not actually unique and was replicated in a number of defences of women.[57] What is most striking about *Salve Deus Rex Judaeorum* is that it is beautiful and sexually charged religious poetry particularly in its description of the crucified Christ:

> His curled lockes so beauteous to behold
> Blacke as a Raven in her blackest hew
> His lips like scarlet threeds, yet much more sweet
> Than is the sweetest hony dropping dew.[58]

At almost 2,000 lines in length *Salve Deus Rex Judaeorum* is also the single most important piece of Biblical epic poetry written by a woman in early-modern England. Although A. L. Rowse and others have suggested that Lanyer was the mythical 'dark lady' of Shakespeare's sonnets, this is a suggestion rejected by Lorna Hutson and Lanyer is an author whose circumstances ensured that concrete details about her have disappeared without trace.[59] Her poetry if classified as early feminism was of the kind that rejected a central pillar of puritan femininity – Eve's sin.

All of women's secular writing in the period reflected the culture of the court even if the writer was not located at the centre of court social life. Margaret Tyler's *The First Part of the Mirrour of Princely Deeds and Knighthood* published in 1578 was the first courtly romance written by a woman, even if in translation. Margaret Tyler was a retainer of the Catholic duke of Norfolk. Her work was prefaced with disclaimers about being pushed into writing by friends against her better judgement. However, she also constructed a lengthy argument about how women could 'pen a story' as well as 'a man to address his story to a woman'.[60] In the act of writing and claiming intellectual property she staked a place for women in what had been a masculine genre. *The Mirrour of Princely Deeds* was a rough translation of Diego Ortunez de Calahorra's *Espejo de Principes y Cavelleros (El Caballero del Febo)*, a chivalric romance of epic proportions charting the fortunes (and misfortunes) of the Emperor Trebatio, his wife, Briana, and their two sons, the Knight of the Sun and Rosicleer. It ends with Trebatio reunited with Briana after years of a forced absence during which she remained a patient and devout widow in a monastery. Trebatio was a Greek hero – 'in the third discent from the great Achilles' – and his sons, born with shining signs on their bodies like gods ('so strange and rare for beauty'), visit castle after castle in the narrative encountering unicorns, and dragons and fighting enemy princes. The work was aimed primarily at the male reader but Tyler also pointed out that some women

in the story, like the Amazons, bore arms so her heroic subject matter allowed her to invert femininity at the same time as representing a conforming type of masculinity.[61]

Victory in war was of concern to both sexes she argued. Trebatio was 'the mirrour' of all princes – at eight-foot tall he was a larger-than-life figure for aspiring princes to observe and emulate. However, the message was also that 'gentlewomen' should be happy to make such a match. Spanish prose romances were to the Renaissance what soap opera is to modern media – the narrative wrapped conformist gender roles in a richly detailed story that never ended. *The Mirrour of Princely Deeds* simply terminates when Trebatio reveals his true identity to his wife but the reader was left aware of the unfinished stories of the various knights, princesses and gentlewomen who could be expected to appear in the sequels.[62]

The Mirrour was an odd work for a woman to translate. In her preface Tyler called the subject matter 'more manlike then becometh my sexe' and by her own admission Ortunez's story seems designed to 'set on fire the lustie courages of young gentlemen'; it would have appealed to the young men who built mock medieval castles for jousting festivals in the grounds of their houses.[63] However, while Briana does spend most of the story in the monastery, other women, when not being abducted or rescued by knights, are seen involved in espionage and carrying off giants and Tyler's reading audience does not seem to have been entirely male.[64] She prefaced her work with modest disclaimers about '[n]ot being greatly forwarde of myne owne inclination' but then pursued the argument that if men write for women then why should women not write as well for, although 'men lay in their claim to be sole possessioners of knowledge', women should also be able to 'discourse in learning'. Tyler claimed equal rights with men if not a separate voice when addressing women. Equality for Tyler lay in not being forced 'to write of divinitie', indicating that women did feel pressured to write or translate only works of religion.[65] Again, her feminism, while co-opting the masculine, also moved to secular themes. Such is the strength of Tyler's defence of women's writing that Janet Todd and Moira Ferguson have called *The Mirrour* the first feminist tract ever written in English.[66] They may have a point.

However, the single most important woman writer of the late sixteenth century was Mary Sidney who was a second generation humanist woman skilled in modern languages and Latin, rhetoric, music, accounting and household business, needlework and Scripture. She was born in 1561, the daughter of Sir Henry Sidney and Mary Dudley, the daughter of the duke of Northumberland. Sidney's close connection with the royal court had historical foundation – her father had been educated with Prince Edward and her mother had been a close friend of Queen Elizabeth, nursing her through smallpox before contracting the disease herself. Through her mother's family, she had connections with the Dudleys including Robert Dudley, earl of Leicester, Queen Elizabeth's favourite.[67]

In 1577, when 15, Mary Sidney became the third wife of Henry Herbert and became countess of Pembroke. She had four children between 1580 and 1584 and the family lived at Wilton Park near Salisbury, a country house that was destined to serve as a centre of literary activity until her husband died in 1601.[68] Wilton

Park became a retreat for poets, dramatists and theological writers such as Gervase Babington, Nicholas Breton and Samuel Daniel, and contemporary men described it as being 'like a college'. The scholars who passed through the house dedicated their works to her and her biographer, Margaret Patterson Hannay, has said that she was 'the first non-royal woman in England to receive a significant number of dedications'. Sidney was, thus, every bit the Renaissance woman patron, following the model of Castiglione's woman courtier.[69]

Critical to Mary Sidney's literary reputation was her role as literary executor of her brother Philip Sidney after his death in 1586. Philip Sidney, whose best known works – *In Defence of Poesy* and *The Countess of Pembroke's Arcadia* – established him as one of the most important of all Elizabethan male literary figures, is remembered for his chivalric idealisation of rustic society.[70] *Arcadia* was started at Wilton, as was much of his secular and religious poetry including sonnets and paraphrasings of the Psalms.[71] Mary Sidney lost not only her brother in 1586 but her father and mother a few months apart in the same year. She mourned for an extended period and Pearl Hogrefe has suggested that Sidney's own literary career not only began as a form of memorial to her brother, but that its content may also be explained by her need to come to terms with death in the family.[72] Mary Sidney translated Philippe de Mornay's *A Discourse of Life and Death* and Robert Garnier's *Antonius* in 1590 and they were both published in 1592. The latter was republished as *The Tragedy of Antonie* in 1595. She also translated the first two chapters of Petrarch's *Triumph of Death* (though this was not published in her lifetime). *A Discourse of Life and Death* is a work about the stoic acceptance of death: 'So is it in the life of man, life and death in man is all one. If we call the last breath death, so must we all the rest: all proceeding from one place and in the same manner.'[73] Mary Ellen Lamb has argued that *The Tragedy of Antonie* is also a play about the art of dying well. It does not deal with death in the same philosophical format, but is nevertheless a Senecan tragedy, exposing the human condition and appealing to philosophical acceptance of death. 'Die I must, and with brave end', says Antonius, 'I must a noble death ... that my last day | By mine own hand my spots may wash away'.[74] Hogrefe hints at Mary Sidney's influence in giving impetus to the Senecan tradition in Elizabethan dramatic works – one of her clients, Samuel Daniel, published the tragedy *Cleopatra* in 1594 at her urging.

Mary Sidney completed an edition of Philip Sidney's *Arcadia* in 1593 and revised for publication a volume of metrical psalms he had begun which she finished with her own. She translated and completed the psalm sequence from *Eructavit Cor Meum* (Psalm 45) to *Laudate Dominum* (Psalm 150). S. P Cerasano and Marion Wynne-Davies have argued that these are the most complex in style in the resulting volume, suggesting that Sidney's work in this regard surpassed that of her brother.[75] According to Margaret Patterson Hannay, Sidney consulted commentaries and prayer books, the Geneva Bible and psalm translations by Calvin and Beza, with quite remarkable and certainly erudite results.[76] One verse from Psalm 58 about God's judgement of 'Adam's race' shows not only these multiple references

at work, but also Sidney's complete control over metaphor and effective and per-
suasive use of alliterative technique:

Now when the just shall see
This justice justly done by justest Thee
On the unjust, and their no juster brood
They shall glad at so great a good
Bath righteous feet in wicked blood
And thus in heart shall say
Sure a reward doth for the righteous stay
There is a God whose justice never swerves
But good or ill to each man carves
As each man good or ill deserves.[77]

Sidney's humanist learning did not preclude her Calvinist piety. In Psalm 56
Miserere Mei she spoke of her life journey as a book into which all her actions were
written and accounted for by God: 'Thou didst O Lord with carefull counting
look | On evry journey I poor exile took |…These matters are all entred in Thy
book.'[78] However, Sidney is important because she was the first woman writer
whose reflections on life and death were classical and secular rather than driven
solely by a creative impulse reliant on the formula of the puritan life journeys and
death narratives of many of her female contemporaries.

There is no doubt that Mary Sidney stands alone in the late sixteenth century as
a woman whose literary output was prodigious. Some of her own poetry survives
in the form of two elegies to her brother entitled 'To the Angel Spirit' and 'The
Doleful Lady of Clorinda' and also *A Dialogue between Two Shepherds* which was
written in 1602 for a visit of the queen. There is one further poem dedicated to the
queen called 'Even Now that Care' which Helen Hackett points out draws upon
the language of courtly love and lament in a panegyric to the queen praising her
reign as a 'miracle' to which all men are drawn.[79] It could be argued that Sidney's
elegiac and devotional poems were in keeping with and reinforced gender con-
struction and that her work, at the very least, used her brother's work as scholarly
model and springboard. According to Mary Ellen Lamb heroic works translated
by women reflected the female author's 'heroics of constancy' to male writers
and Beth Wynne Fisken has suggested that in 'To the Angell Spirit…' Sidney paid
tribute to her brother as the 'model of excellence that enabled her to write as
herself'.[80] In other words, it was only through the inspiration of Philip Sidney
that Mary Sidney felt compelled to work in her own right. Therefore, even recent
historiography has had difficulty in disentangling Mary Sidney's reputation as an
author from that of Philip Sidney. Indeed, old historiography paid little attention
to Mary Sidney beyond claiming for her the role of editor of her brother's col-
lected works, and even Gary Waller's biography of 1979 claimed that she was con-
tinuing all the literary traditions of her brother thereby diminishing her agency
as an author.[81]

Tina Krontiris and others have claimed that Mary Sidney essentially hid behind the literary reputation of her brother (and other male authors by working on translations), only gaining a voice through stealth. However, Kim Walker has pointed out that she used some of the 'mastertexts' of the Renaissance, such as Petrarch's *Triumph*, in a way that 'belies the apparent conservatism of the translator's humble role'.[82] However, most recently Hannay has pointed to the sheer weight of Mary Sidney's literary output (represented by 18 extant manuscripts) to claim for her a voice of her own. The extensive scholarship Sidney demonstrated in her own psalm paraphrasings and the extraordinary ability she showed for writing poetry in multiple verse forms including acrostics, sonnets and some original stanzaic forms, lend Mary Sidney her own voice and a place in women's history as the single most important woman writer of the sixteenth century.[83]

Mary Sidney Herbert died of smallpox in 1621 in the same year that her niece, Mary Wroth, published an oddly-dystopic work called *Urania* that figured her (Sidney) as the Queen of Naples and the 'learned Clorina'. Mary Wroth was born about 1587 and was named for her aunt who became an important role model. However, Mary Sidney Wroth's education, at the end of Elizabeth's reign, reflected Castiglione's programme of training for girls in social manners more than the Classical humanist training received by her aunt and the elite women in the generation before.[84] She married Robert Wroth in 1604 and the couple were closely connected with the royal court, he with James' hunting and she with Anne of Denmark's playwrights and poets. Wroth appeared in two of the royal masques and Ben Jonson dedicated his play, *The Alchemist*, to her in 1610. Wroth had aspirations to be seen as a cultured Renaissance woman; when she had herself painted it was in a very formal pose with her right arm giving support to a theorbo (a large, double-headed lute) as a sign of her musical prowess, even athleticism, the instrument being as large as her.[85] Wroth was left in straitened circumstances, because the death of her husband in 1614 and her son in 1616 returned most of the Wroth estates to her husband's uncle and his heirs. Wroth's life was complicated. Her husband probably had venereal disease; they had only one child after 10 years of marriage and he died from gangrene of the genitals. She became romantically attached to her cousin William Herbert, the son of Mary Sidney, and reputedly had two further children by him.[86] The difficulties of her marriage and the social scandal that followed meant that when she did follow in her aunt's footsteps and write a book, the result was not only less influential, it reflected her less than satisfactory social circumstances.

Between 1618 and sometime in the early 1620s Wroth wrote *The Countess of Montgomery's Urania*. It was published in 1621 when she no longer had the protection of Queen Anne. The work was immensely long and she continued it in a manuscript edition in two books that remained unpublished. The frontispiece was illustrated with the archway to a romantic fantasy world where two lovers held hands and walked through a bucolic scene.[87] However, this was a romance told from the woman's perspective and *Urania* is different from Tyler's *Mirrour of Princely Deeds* not only in being fully authored by Wroth but in its privileging of women's speech, women in love, women's poetry and so on. Thus, Wroth is

important because she feminised the genre of romance and wrote entirely in a female voice. She was also the first woman writer in England to publish a 'secret history' because although *Urania* drew on courtly romances and was replete with lamenting lovers and chivalrous knights, it was also a thinly-disguised scandal sheet. Literary scholars have variously attributed influence to Philip Sidney's *Arcadia* and other works such as Spenser's *The Faerie Queene*, though the characters in the ever-shifting plots and dialogues have so much basis in Wroth and her social contacts that it is not constructive to see the work as too derivative. Mary Ellen Lamb has described *Urania* as having a 'diffuse plot...filled with hundreds of characters...loosely organised around the narrative of Pamphilia's constant love for the unfaithful Amphilanthus'. The manuscript postscript continued this love narrative through an imagined *de praesenti* marriage between the lovers who then go on to betray one another by marrying in Amphilanthus' case the daughter of the king of Slavonia and in Pamphilia's case the king of Tartaria.[88]

Urania is interspersed with poetry the subject of which is love and its sorrows. 'Deare, though unconstant, these I send to you | As witnesses, that still my Love is true,' reads one section. The rest of the verse outlines Dido's 'misery' at Aeneas' deceit, Ariadne's devotion to 'that false Prince Theseus', Phillis' 'ungrateful Demophon', Penelope's sadness and so on. 'Happy the comfort of a chaste loves bed | Blessed the pillow that upholds the head | Of loyal loving...' it continues.[89] *Urania* has no endpoints and no resolutions – it is a chivalric quest without end. It is outstanding as a marathon piece of writing by a woman, and it is also interesting in its assumption of female community – the Urania of the title is Pamphilia's friend, whom she rescues from a Tower and then confides in about her love trials. The autobiographical elements are confused and confusing. Lamb has argued that Wroth herself appears in snippets in the characters of Bellamira and Lindamira, though her portrayal of self as a Pamphilia who at one stage becomes a queen suggests a wish-fulfilment in textual form. Wroth used anagrams to indicate real people in topical events and most literary scholars agree that the first-cousin kinship between Pamphilia and Amphilanthus is supposed to indicate that between herself and William Herbert. Certainly, at the time, the text created uproar because Lord Denny assumed that he was figured as the father who nearly killed his own daughter for her adultery and Wroth was forced to try and call in copies of the book.[90]

Assessment of Mary Wroth as a writer has not always been kind though the feminist rereading of her work has been both thorough and enlightening. Wroth was not a scholar in the ilk of her aunt, but she was a frenetic writer and Lamb has said that 'the diffuse aesthetic of the *Urania* has become increasingly valued as a strength...[as she] freely adapt[ed] a traditional romance form to accommodate the experience and perceptions of a Jacobean woman'.[91] In addition to *Urania* she wrote a sonnet sequence called *Pamphilia and Amphilanthus* and a pastoral drama called *Loves Victory*.[92] Helen Hackett has argued that 'whereas Mary Sidney's poetry was generated by death, Wroth's is generated by the absence of the beloved'.[93] The scandal created by *Urania* has been attributed by Hackett to Wroth 'breach[ing] the decorum of gender and genre' and including 'too much recognisable fact'.[94]

On both counts Wroth overstepped gender boundaries and claimed independence of female authorship. It is recognised that Wroth's work capitalised on the sonnet craze begun by her aunt's publication of Philip Sidney's *Astrophil and Stella* in 1591 and that her Petrarchan poetry was derivative in form. However, recent feminist readings of Wroth also claim for her a specifically female early baroque style and a female voice that finds liberation in a world of adventure through love and enchantment. Kim Walker speaks of 'the labyrinth of love' that her female subjects are allowed to enter and Hackett speaks of a 'purposeful publication of privacy' that gives Wroth the licence to draw shamelessly on her famous literary heritage. In Wroth's sonnets, according to Hackett, 'the lyric voice is female' and in the character of Pamphilia in *Urania* Wroth put her own life on show as a series of 'erotic disappointments' in a pastoral setting that reflected her own exile from court.[95]

Mary Wroth was not the only woman of the Jacobean generation writing on the margins of respectability. Elizabeth Tanfield, who was born around 1585, received a humanist education and had learnt modern languages, plus Hebrew, Latin and Transylvanian as a child.[96] She was an only child with no male siblings for competition. Even so her parents, Elizabeth Symondes and Lawrence Tanfield (who became Lord Chief Baron of the Exchequer), reputedly banned candles so that their daughter could not continue reading long into the night. Undeterred, she is said to have borrowed candles from servants running up a debt to them of £100.[97] By the time of her marriage, to Henry Cary at the age of 15 in 1602 she had completed a translation of Abraham Ortellius's *The Mirror of the World*, written a critical commentary on Calvin's *Institutes of the Christian Religion*, written meditative poetry and written a play in verse about Tamburlaine (now lost). Cary had also completed a Senecan drama, *The Tragedy of Mariam*, based on Josephus' *Antiquities of the Jews*.

Diane Purkiss suggests that Cary wrote two plays at the time of her marriage only as a ritualistic display of her humanist learning. It is the case that Tamburlaine was dedicated to her husband and *The Tragedie of Mariam* was dedicated to her sister-in-law; she signed it 'E C' and declared, 'Your faire brother is to me the sunne.' Diane Purkiss argues that it is a mistake to read female subjectivity into her work; Cary's Mariam died not as a sign of women's oppression, but because a female writer annihilated her in exactly the same way a male writer would. Mariam's execution could be seen as being analogous to marriage: 'The trope of sacrifice as marriage gives meaning to the idea of marriage as a moment of dynastic creation.'[98] However not all historians take this view of Cary's motivations for writing and the subsequent results. For example, Stephanie Hodgson-Wright credits Cary with being 'the first female author to write original drama in English' revealing some female autonomy.[99] Elizabeth Cary was left with her husband's parents until 1606 while he pursued a professional military career. Her contact with the court was minimal though it has been suggested that the patronage of both Sir John Davies and the countess of Pembroke encouraged eventual publication of *The Tragedy of Mariam* in 1613.[100] Between 1609 and 1624 she had 11 children and accompanied her husband to Ireland when he became Lord Deputy in 1622 by which time he

was Viscount Falkland. Cary studied theology and learnt the Irish language, but infuriated her husband when she converted to Catholicism in 1625 and he sent her back to England.

Most of Cary's works in manuscript have been destroyed. However, her intellectual pursuits and output were recorded in a biography by one of her daughters (either Anne Cary [1615–1671] or Mary Cary [1622–1693]), both of whom joined the Benedictine convent at Cambrai after the death of their father. The printed works that survive have helped to maintain Cary's literary reputation, but have also led to controversy over their authenticity and the burden of their meaning. *The Tragedy of Mariam* is the least problematic in the sense that there is strong evidence of her authorship in a work told from the female perspective. The work tells the story of Herod, who ascended the throne of the Jews with the help of the Romans, and his second wife, Mariam, princess of the Maccabean family with a right to the throne. Herod was accused of murdering Mariam's brother and while away answering the charge he left Mariam in the care of his uncle, Josephus, who was married to Salome. Cary's choice of subject has often prompted scholars to read the work for signs of autobiography and the woman's perspective.[101] For example, Salome says that women have a right to hate as well as men. It is her accusation that condemns Josephus and leads Herod to ignore his love for Mariam and have her beheaded. However, the woman's point of view in the play is ambiguous. Mariam's persecution at the hands of a tyrannical husband is clear to see, but the play can be read also as a defence of her death. The end of the play features an exchange between Mariam and Herod's first wife, Doris, who has been cast aside by him. Mariam is appalled at being betrayed by the man she thought loved her but Doris points out that she also was betrayed and that Mariam has been living a life of adultery: 'Your soul is black and spotted, full of sinne ... | And heav'n will never let adultry in'. Doris' sentence is as stark as Mariam's death at the hands of the executioner. Mariam pleads her own chastity but Doris replies that *she* is Herod's lawful wife and Mariam is the cause of their separation. 'What did he hate me for?', Doris asks Mariam before cursing both her and her children. Even when Mariam begs Doris to curse only her and not her children, Doris presents herself as the wronged wife who has the right to curse 'the baseborne heads | That were begotten in unlawfull beds'. 'And Mariam' she darkly warns before Mariam dies, 'I doe hope this boy of mine | Shall one day come to be the death of thine'.[102]

Authenticating Cary's other published work, *The History of Edward II*, proves more difficult. It was first published in her husband's name in 1680 because it was found amongst his papers, but an address to the reader is signed 'E.F.' and the publisher praises if for displaying 'so Masculine a stile' hinting in reverse that he thought it written by a woman. Tina Krontiris also points out that Queen Isabel is more sympathetically treated in this work than others on the subject suggesting a female perspective. Despite her adultery there is 'a noticeable emphasis on the queen's suffering and abandonment in times of affliction'. The latter has been linked to the belief that Cary wrote the work in 1627 to occupy herself after her separation from her husband and her house arrest by Charles I.[103] The story of Edward II had been retold many times and the dominant interpretation during

the reign of James I was of a king manipulated by his favourites causing his down-
fall and his violent death. The story of Edward II admonishes kings, but Tanfield's
version privileged the end of the story and Queen Isabel's intervention to save the
kingdom for her son's posterity. Karen Nelson points out that the narrative reinforces
the gender role of mother though equally it can be said that the application of her
Renaissance education to historical chronicling by Cary differs considerably from
the godly motherhood tracts that were also a feature of the period.[104]

After Cary returned to England from Ireland she and her husband did not live
as husband and wife again. For several years he refused to pay her maintenance
and Hodgson-Wright has said that he 'was bent on a course of virtually starving
her into recanting her faith'.[105] He battled with her over custody of their children
but she was resolute in her conversion turning again to writing to express her
new identity. She worked on the lives of saints such as St Agnes and songs to the
Virgin Mary and turned her pen to the support of Catholicism, convinced that
Henrietta Maria was a sign that the Reformation would be reversed. She trans-
lated Catholic works of polemic, including *The Reply to the King of Great Britain* by
Cardinal Perron in 1630, which was dedicated to the queen, though this did not
stop it being burned by the public hangman as a warning.[106] Karen Nelson has
also argued that although *Edward II* is ostensibly a masculine historical work, it
provided a narrative of Queen Isabel that could be appropriated by the women
of the court of Henrietta Maria.[107] Strangely though, in 1633 Cary nursed
her husband during his final illness before dying herself in 1639. Her personal
legacy was that several of her children followed her into the Catholic Church.
Indeed she sent six of her daughters to the Continent to a convent and kidnapped
her sons to ensure their upbringing as Catholics. Lucius Cary, second Viscount
Falkland (1610–1643), inherited her intellectual interests and became an influ-
ential member of the Great Tew Circle.[108] Her greater legacy for historians is her
corpus of written work; it reveals the extent to which a Renaissance education
could transform an upper class woman into a scholar, providing her with the
wherewithal not only to pursue her intellectual interests but also to use them for
personal and political subversion.

Taken together the works of the second humanist generation of women did not
challenge the social superiority of men but nevertheless generated challenges to the
gender order. Margaret Tyler worked within a genre that was highly masculine. Her
translation of a Spanish romance came at a time when continental chivalric litera-
ture was being popularised by the longstanding fashion for a masculine chivalric
code of war and peace. According to Anthony Fletcher, '[s]heer physical courage was
central to the chivalric code from which the early-modern concept of [male] honour
evolved' and young men literally matured on a literary diet of romantic literature in
which they saw themselves portrayed as strong and heroic emulators of St George.[109]
John Adamson has pointed out that the chivalric male pervaded all aspects of mas-
culine political culture until the 1640s making Tyler's translation of *The Mirror of
Princely Deeds* look an even more unusual choice for a female translator.[110] Mary
Wroth's co-option of the genre then feminised and politicised it by creating chival-
rous knights and ladies whose basis in real people she barely disguised.

Wealthy and noble women born at the end of Elizabeth's reign often received an education identical to that of their brothers, though it was for them not just a social asset but specifically a marriage asset. Sir John Davies called Lucy Russell, countess of Bedford, Mary Herbert, countess of Pembroke and Elizabeth Cary, Viscountess Falkland, 'Glories of Women'.[111] However, the application of women's learning in both the Elizabethan and Jacobean courts did not straightforwardly lead to pursuit of writing and publication. Most Renaissance women played a dual role of patron and participant in an elaborate Renaissance court culture that involved dramatic production and performative rituals. Women were associated with knowledge and learning in a way that put them on display rather than promoted their scholarship as an occupation. Henry Peacham, the long-lived writer of books of rhetoric and conduct manuals, depicted 'Learning' as a woman in his *Minerva Britannia* of 1612: 'Heere Learning sits, a comely Dame in yeares ... Within her lap an opened booke appears ... Blind ignorance, expelling with that light | The Scepter shewes, her power and soveraigne might'.[112] The reference to Elizabeth I was there if a little opaque. Men dedicated works to Renaissance women of the court such as Lady Bedford. For example, John Florio dedicated to her his translation of Montaigne's *Essays* of 1603 in recognition of the fact that she was learned in modern languages. Unsurpassed as a patron, Lady Bedford was a powerful woman.

Thus, part of the courtly language of flattery for men was to trope women as 'muses to learning' and it is, therefore, difficult to disentangle women's scholarship and writing from their representation within the court context as Classical models of the concept of learning itself.[113] This was the case in the court of Elizabeth, but even more so in the court of Queen Anne partly because Anne was a consort but partly also because she could not match Elizabeth's own prodigious scholarship. Her main contribution was the commissioning of six remarkable court masques at Twelfth Night or Christmastide between 1604 and 1611 and her patronage of the architect Inigo Jones and several musicians.[114] Within this context the women of the court were represented as Renaissance women whether they had received and met the full challenge of a humanist education for women or not. Therefore, in Renaissance England educated women were fashionable; they were 'ornaments' whose education reflected the social status of their families. Purkiss has suggested that 'the very fact that a girl could not use an elaborate humanist education enhanced its value as conspicuously useless'.[115] However, even more than in the civic context of Renaissance Italy, the learned women of Renaissance England were more than this. They were walking emblems of political culture. In Samuel Daniel's early masque of 1604, Queen Anne and 11 women of her court were represented as ushering in the reign of the king in a *Vision of the Twelve Goddesses* – Venus signified 'Love', Pallas signified 'Wisdom', Juno signified 'Power' and so on. Therefore, much of the work of the Renaissance woman writer in Elizabethan and Jacobean England has to be seen in this context, though the accidental by-product of their fashionable education was the first autonomous published work by women and Mary Sidney has to stand alone as the single most important female scholar of her age.

Margaret Cavendish and the secular writers

The women writers of the 1640 to 1700 period were beneficiaries of the growth in formal structures of female education in the second half of the seventeenth century. The 1650s in particular represent a turning point when the informal method of schooling girls that had dominated since 1500 was replaced to some extent by a more formal tri-partite system of education at home, in charity schools and in private boarding schools. For example, in 1671 two of the 15 Quaker boarding schools were for girls and a further two were coeducational and by 1704 there were at least 745 girls being educated in charity schools alone, mostly in London. Many schools were established by private endowment – for example, Sir John Offley's will, which was proved in 1658, gave closely-detailed instructions for the building of a girls' charity school ('16 feet of length and 16 feet of breadth') in Madeley, Staffordshire to educate girls to read at a basic level and instruct them in a needlework trade.[116] Middle class girls benefited more than most through the development of a broad curriculum combining skills of literacy and numeracy with social skills such as singing in the small boarding schools of London such as Ladies Hall at Deptford. At Mrs Salmon's in Hackney the girls were gentlewomen or wards of the city of London and were paid for by the aldermen. The main expansion of boarding schools occurred in the 1650s which later fed into connections with the literary circles of London. For example, Gorges House in Chelsea, a 'boarding school for young ladies and gentlewomen', was the setting for the staging of the play *Beauty's Triumph* in 1676.[117]

Influential in the revival of female education was a tract by French educationalist, Fénelon, published in 1687 and translated into English by George Hickes in 1704. What set Fénelon apart from earlier educational writers was his interest in the connection between female psychology and an education that would lead to 'improvement'. Starting from the Cartesian assumption that 'the mind has no sex', Fénelon argued for a remedy against idleness, imagination and romance and found it in learning through play and instruction and books. Fénelon's programme for female education was primarily concerned with the instruction of young women as part of a programme of reforming society. He was, therefore, at the forefront of Enlightenment discourse and his ideas about women's education demonstrated interest in a combination of formal learning and conditioned social behaviour.[118] Josephine Kamm has suggested that women also became promoters of education for their own sex within the family and amongst friends. For example, Lady Mary Wortley Montagu, who was born in 1689 and wrote one of the greatest women's travelogues in English of all time – the so-called *Embassy Letters* from Constantinople between 1716 and 1718 – wrote encouraging her granddaughters to learn poetry, Greek, Latin, history, geography and, especially, mathematics which she called 'the best proof of understanding'.[119] In the public arena of print Hannah Woolley, in her *Gentlewoman's Companion* of 1675, made a plea also for women's education so that those forced to make a living had the skills she thought were needed.[120]

After 1650 there was a widening of women's literary activity as well as an increase in its production. Elaine Hobby has quantified 130 texts written by over 70 women between 1649 and 1688.[121] Some of the new literary activity reflected royalist women's experience of exile in France and the Netherlands with writers emerging whose idiom indicated a backlash against the religiosity that was and remained so important for many women in England even after 1660. Personal sacrifices made during the civil wars prompted women to write biographically and autobiographically of the historical events that had shaped their lives and Lucy Hutchinson's biography of her husband is still one of the classic memorials of the English Civil War. The 1650s also featured the reappearance of women's secular poetry (following something of a 'puritan moment' 1620–1650), followed by works from travel writers and scientists, antiquarians and genealogists and women whose interest in astronomy, the physical world and design matched that of the learned man of the early Enlightenment. Women also began to write over several genres, for example, Margaret Cavendish, Aphra Behn and Mary Astell. Between 1650 and 1675 the populist woman hack writer first made an appearance producing almanacs, medical treatises and manuals such as Hannah Woolley's *The Cook's Guide* of 1664 and her *The Ladies Delight in Choice Experiments and Curiosities* of 1672 and Jane Sharp's *The Midwives Book* of 1671. These aimed at the educated housewife, indicating that women teaching women became a greater component in prescriptive gender construction and that women were reading more widely.[122] Cookery books and domestic manuals were also written by women like Elizabeth Grey's *A Choice Manuall, or Rare and Select Secrets in Physick and Chyrurgery* which went through eight imprints between 1653 and 1687.

The first English woman to publish a volume of her own poetry was Anne Bradstreet who was born in 1612 or 1613.[123] She was from an affluent family and was well educated. Her father worked for Theophilus Clinton, the earl of Lincoln, and she was brought up in puritan circles on his Sempringham estates. In 1625 she moved with her family to Boston in Lincolnshire and became part of John Cotton's puritan congregation that sailed in 1630 for New England. By then she was married to Simon Bradstreet, a nonconformist minister. Both her father and husband spent time as governor of the colony of Massachusetts.[124] What is interesting about Bradstreet is that she was a godly woman who wrote secular as well as spiritual poetry. Her most famous lines are informed by her puritanism: 'Ah me! Conceived in sin, born in sorrow | A nothing, here today, but gone tomorrow.'[125] Contained in a poem about childhood, Bradstreet here explored the nature of original sin. She also wrote a poem in support of the Long Parliament in 1642 and was a voice in New England puritan support for godly reformation. Much of her poetry from the 1650s was meditative and spiritual. However, some of her other poems are both secular and woman-centred in their politics. *The Tenth Muse Lately Sprung Up in America* ... was one such example. Published in London in 1650, it started modestly enough:

To sing of wars, of captains, and of kings
Of cities founded, commonwealths begun,

> For my mean pen are too superior things…
> Let poets and historians set these forth…

However, it continued in a less modest vein:

> I am obnoxious to each carping tongue
> Who says my hand a needle better fits…
> For such despite they cast on female wits;
> If what I do prove well, it won't advance,
> They'll say it's stolen, or else it was by chance.[126]

There is some question over whether or not Bradstreet intended her poetry to reach a reading public in 1650, but N. H. Keeble points out that 'the project was clearly well planned' and that when her poems appeared in a revised edition containing new poems in 1678, she had compiled the volume herself before her death in 1672.[127]

The other woman writing secular poetry in the 1650s was Katherine Philips. Philips was born in 1632, the daughter of a cloth merchant, John Fowler, and his wife Katherine Oxenbridge. The family was puritan both in worship and social connections. She was sent to school at Mrs Salmon's in Hackney and there developed the first of several intense female friendships that she had throughout her life. At sixteen she married James Philips, who was 38 years older than herself and went to live in Wales. Her first attachment was with Mary Aubrey, who became 'Rosania' in her poems. When Aubrey married and moved away her main friend was Anne Owen, who became 'Lucasia'. One of her poems, *On Rosania's Apostacy and Lucasia's Friendship* explored the dynamics of her shifting affections with other young women prompting historians and literary scholars to consider her poetry as an avenue for same-sex erotics and the platonic (or possibly not) nature of the female culture of early girls' schools, kin networks and friendship circles involving 'coterie names'.[128] Styling herself 'Orinda', Philips asked of her friendship with Aubrey 'Great soul of friendship, whither art thou fled', replacing it with the following words: 'Then to the great Lucasia have recourse | There gather up new excellence and force…Lucasia and Orinda shall give thee | Eternity, and make even friendship live.' The intensity of Philips' 'friendship' for Owen built on the perceived betrayal of Aubrey and the jealousy sparked by her rejection: 'Hail, great Lucasia, thou shalt doubly shine | What was Rosania's own is now twice thine.'[129]

Philips' first printed poems appeared in William Cartwright's *Comedies* of 1651 and further poems were included in Henry Lawes' *Second Book of Ayres* of 1655.[130] Many of them dealt with the subject of friendship though many others had as their subject political events and moments in her personal life. Although her husband was a parliamentarian, Philips herself had strongly royalist sympathies. Her poem 'Upon the Double Murder of King Charles I' contained the line 'Silence were now a sin' and the poem reflected on the fact that the king's crime was tied up with his title, which had implications for all: 'Slander must follow

treason; but yet stay | Take not our reason with our King away.' Occasionally Philips' poetry hints at her devout upbringing, though she abandoned predestinarian thinking as revealed by lines such as 'our election is as free as angels'. Another poem on friendship with 'Lucasia' entirely secularised religion: 'There's a religion in our love,' she wrote.[131] One result of civil war, then, was a distancing of some women writers from their Calvinist upbringing. Hero Chalmers has recently argued that writing by royalist women recast femininity because, especially after 1649, royalism itself was an assertive political stand.[132]

Katherine Philips gained a smattering of a classical education and Warren Chernaik has claimed also an influence from the metaphysical poets, especially John Donne.[133] Both may be seen, for example, in a poem written as the epitaph for an infant son's grave. Philips drew upon Lucretius and the Classical secular notion of the soul/mind dichotomy to explain her son's departure from the temporal world:

> Too promising, too great a mind
> In so small room 'twill be confin'd ...
> So the subtle alchemist,
> Can't with Hermes seal resist
> The powerful spirit's subtler flight,
> But 'twill bid him long goodnight.[134]

Katherine Philips had just two children; the boy – Hector – who died aged 6 weeks in 1655 and a daughter – Frances – who survived just to the age of 13 before predeceasing her in 1660. She herself died young, at the age of only 32, from smallpox in 1664. Her literary reputation amongst contemporaries was considerable. In 1663 her translation of Corneille's play *La Mort de Pompée* was staged at the theatre in Dublin and a year later she became the first woman writer to have a play performed on stage in England after the Restoration of Charles II. The script sold out on the streets within weeks. Like her poetry, the emotive content of her dramatic work was about loyalty and Elaine Hobby has pointed out that Corneille's works had been very popular during the 1650s with English royalist exiles in France.[135] Katherine Philips is important because she became a role model that lent legitimacy to the women who followed her. Both Hobby and Easton have argued that what authorised Philips to write was a subtle deployment of acceptable feminine subjects, such as friendship and children, and that her poetry constituted a 'disguised female discourse' providing a peculiarly female perspective.[136]

Women turned to poetry partly because it grew out of the habit of keeping commonplace books. Sometimes the results stayed in manuscript form. Damaris, Lady Masham used poetry to cement her friendship with the philosopher, John Locke, who replied with verses confirming 'I friendship beg'd and did obtain'. He urged her to preserve and publish her poetry, but after her marriage to Francis Masham in 1685 she claimed to be bogged down with domestic affairs and joked that only the works of dead women were printed. One of her most beautiful pieces of poetry is preserved in Locke's manuscripts and comprises a lengthy address to the

figure of Death.[137] Masham's comment that one had to be dead to get into print referred to the death of Anne Killigrew whose poems appeared in a collected edition licensed for publication by her father in September 1685.[138] As with so many of the women poets, one of her works was about death which she called 'the safest end of all our woe'. Another poem she addressed to her painting of two of the huntress Diana's nymphs: 'We Bathe in Springs, to cleanse the Soil, | Contracted by our eager Toil; | In which we shine like glittering Beams, | Or Christal in the Christal Streams.' Another she addressed to 'Orinda' [Katherine Philips] 'Albions and Her Sexes Grace'. The sense of female literary community she acquired was in part fostered by men. This is demonstrated in her poem to Lord Colrane acknowledging the way her 'long…dull Muse in heavy slumbers lay'. Germaine Greer has pointed out that Killigrew's 'admirers depicted…[her] as the quintessential virtuous virgin, immune to the seductions of Charles II's court'. Like all women writers connected to the court and the theatre (her uncle was the theatre manager, Thomas Killigrew), Killigrew trod a fine line between autonomous creativity and exploitation (including sexual) by men.[139]

Following shortly after the publication of Killigrew's poems was Jane Barker's *Poetical Recreations* (1688) which Carol Barash has said was important because Barker 'repeatedly draws on patterns derived from the works of both Katherine Philips and Aphra Behn'. Like Philips, Behn and, indeed, Killigrew, Barker came from a family that was loyal to the Stuart monarchy and by 1688 her work was at odds with political events.[140] Some of her poetry was Jacobite and Barash has argued that she drew on the authority of being connected with the exiled Mary of Modena. Indeed Barker converted to Catholicism and devoted some time to writing a religious treatise, *The Christian Pilgrimage* in 1718.[141]

In the same year as the publication of Killigrew's volume of poetry another young woman, Sarah Fyge, published a long verse satire called *The Female Advocate*. Fyge was one of six daughters of a London physician who so disapproved of the poem when it came out that he sent her to the country and married her off to Edward Field, a lawyer. *The Female Advocate* attacked Robert Gould's *Love Given O're* (1682) and Fyge's importance lies in her singular and arguably feminist course in both her personal life and writing career. Her husband died early in their marriage and she remarried to a minister, Thomas Egerton. The second marriage was tempestuous and Fyge resumed her career as a poet with a contribution to *The Nine Muses* in 1700 and followed it shortly after with *Poems on Several Occasions* in 1703, the year her husband sued unsuccessfully for divorce.[142] Fyge's poetry was overtly rebellious reflecting the change in women's attitudes about gender relations already seen in the *querelle des femmes*:

> Shall I be one, of those obsequious Fools,
> That square their lives, by Customs scanty Rules;
> Condemn'd forever, to the puny Curse
> Of precepts taught, at Boarding-school or Nurse,
> That all the business of my Life must be,
> Foolish, dull Trifling, Formality.[143]

Fyge's reference to the boarding school in this poem – *The Liberty* – is enlightening in itself. *The Liberty* also contains references to the 'dreaded censure' of her sex and the silence demanded of women and she railed against the married state which confined her writing to 'transcribing old receipts of cookery…good cures for agues and a cancr'd breast'. On being forced to leave London she complained in verse, 'What cross impetuous Planets govern me, | That I'm thus hurry'd on to Misery.'[144] Of the late seventeenth-century women poets, Fyge alone appears not to have built her identity with the help of male agency and, indeed, she actively struggled against it. There is considerable evidence of women's learning becoming the social norm, acknowledged and promoted in some men's circles, despite the male counter-discourse against the *precieuse* or 'Female Virtuoso'.

At least two women's intellectual lives were given shape by close contact with a group of philosophers known as the Cambridge Platonists. The first, Anne Finch, who was born in 1631, was tutored at home through correspondence with Henry More, a member of the Cambridge Platonists, and married Edward Viscount Conway. The second was Damaris Masham, who was born somewhat later in 1658, and was the daughter of a Cambridge Platonist – Ralph Cudworth – who fostered in her a spirit of intellectual enquiry. The Cambridge Platonists were on a collective intellectual quest to replace Aristotelianism with a moral philosophy of human behaviour that was Cartesian and rationalist with the consequence that both Conway and Masham became rationalist theologians and philosophers through their immediate social circle. Anne Finch/Conway believed that atheism was disproved by reason and that human beings could reach perfection because they were created out of the spiritual substance of God. The latter was contained in her monadologic text, *Principia Philosophiae*, which was published posthumously by her Dutch physician, Van Helmont, in 1690.[145] Masham, who came under the tutelage of the philosopher, John Locke, published *A Discourse Concerning the Love of God* (1696) and *Occasional Thoughts in Reference to a Vertuous or Christian Life* (1705) both of which brought to bear on the subject of human morality the idea that reason led humans to a religious way of life.[146] Lynette Hunter and Sarah Hutton have demonstrated that a number of women were integrated into scientific circles of men and were integral to scientific experimentation from the 1650s. Hunter cites Alethea Talbot's *Natura Exenterata* of 1655 as one of the first books of pharmaceutical science by a woman. Women's household books of medical 'receipts', like the one owned by Katherine Jones, who was connected to the scientific circle of Samuel Hartlib, had importance in circles of home experimenters. Frances Harris has pointed out that women like Anne Finch/Conway were 'living in the neighbourhood of science', prompting their intellectual thinking and desire to write and sometimes prompting them to publish works of natural philosophy.[147]

The period of civil war created a climate for women's writing because of their developing sense of a place in history. A new breed of historical writers emerged as a consequence of what Helen Wilcox and Sheila Ottway have described as 'events of historical importance [being brought] to the domestic doorstep'.[148] Some women historians wrote identifying their place in God's providential plan,

but other women emerged from the maelstrom of war with a different outlook. Women's sense of the importance to posterity of events in the 1640s and 1650s can be gleaned from two autobiographies written by Anne Halkett and Ann Fanshawe.[149] Halkett and Fanshawe were contemporaries – Halkett being born in 1623 and Ann Fanshawe being born in 1625 – both in London. Halkett was the well-educated daughter of Thomas Murray who was provost of Eton College and Jane Drummond who became governess to the younger children of Charles I after her husband died. Ann Fanshawe was also well educated, the daughter of John Harrison, a Royalist MP who lost his estates to sequestration, and Margaret Fanshawe who died in 1640. Both Halkett and Fanshawe lost their only surviving parent during the 1640s. The autobiographical histories of Anne Halkett and Ann Fanshaw were both written *post facto* in the 1670s and were not published until 1875 and 1829, respectively. In 1979 John Loftis put them together in one edition, providing very vivid accounts of two women's war experiences.

Anne Halkett fell in love with Thomas Howard in the 1640s but he secretly married someone else in 1646 after which she became involved with the married royalist Colonel Joseph Bampfield. Between 1647 and 1648 she became involved in Bampfield's espionage work. Most famously she helped the duke of York to escape from captivity in April 1648 in women's clothes. Her account is rather fun: 'His highness called "Quickly, quickly, dress me" and putting off his clothes I dressed him in the women's habit that was prepared, which fitted his Highness very well...he was very pretty in it.'[150] In 1649 Halkett was forced to leave London because of Bampfield's imprisonment and the social scandal about their affair. The latter troubled her – she was a deeply pious woman who also wrote devotional material and a godly motherhood work – *The Mother's Will to Her Unborn Child*. Halkett steadfastly refused to believe that Bampfield was married and only in 1653 accepted the truth. In 1656 she finally turned her back on him and married Sir James Halkett, a widower with four children. Her account of nursing wounded royalist soldiers in Scotland after the regicide makes compelling reading. Her memoirs are written in an intimate style and convey the tension of the times. She died in 1699.

Ann Fanshawe moved to royalist Oxford in 1644 where she married her cousin, Richard Fanshawe, who was the newly appointed Secretary of War to Charles, prince of Wales. She then travelled with her husband to Bristol, the Scilly Isles and Jersey during war campaigns and in 1647 they went to Paris smuggling a packet of letters for Henrietta Maria. She also spent time in Ireland where they survived the Cork rebellion. Fanshawe's memoirs juxtapose political events with the hardships suffered by royalists whose loyalty she described as 'cost[ing] them dear'. She juxtaposed her tale of devotion to her husband with the story of 'nearly thirty years suffering by land and sea' including her husband's capture at the Battle of Worcester in 1651. Her writing style is highly pictorial, with descriptions of the Alhambra, the people of Madrid, the activities of Prince Charles and the queen, various lodging houses the family stayed in and their retreat in 1653 'into Yorkshire, where we lived an innocent country life'. There are also descriptions of her husband's embassies to Portugal and Spain in the 1660s. During their travels,

Ann Fanshawe had 14 live children (and 6 miscarriages). Many of her children predeceased her and she died in 1680.[151]

Kim Walker has argued that autobiographical writing is sometimes poised between the public and the private. Despite the fact that some women writers hid their written memoirs, the chronicling either of their own lives or the lives of husbands and family members enabled them to locate their lives and, indeed, themselves in history.[152] Both Anne Halkett and Ann Fanshawe had tales of travel, drama and loss to tell and both these autobiographies are a remarkable testament to their dedicated politics during the civil wars. Halkett wrote without apology for making herself the subject of historical narrative: 'The earnest desire I had to serve the king made me omit no opportunity wherein I could be useful, and the zeal I have for his Majesty made me not see what inconveniencies I exposed myself to.'[153]

The experience of civil war also prompted at least two women to write biographies of their husbands. One was Lucy Hutchinson who was born in the Tower of London on 29 January 1620. Her father had been Sir Allen Apsley, who was lieutenant of the Tower, and her mother, Lucy St John. Hutchinson recorded that it was because of her mother that she could read by the age of four and was able also to read and write in both Latin and French. Hutchinson became a supporter of the parliamentary cause. Her 'Life of John Hutchinson' was not published until the nineteenth century when it was retitled *Memoirs of the Life of Colonel Hutchinson*. What is learnt about John Hutchinson is that he became a member of the Long Parliament, Governor of Nottingham and its castle, a regicide and member of the Commonwealth's Council of State. He was imprisoned after being accused of plotting an uprising in 1663, leaving his wife and estate indebted, before his untimely death in 1664. Hutchinson's account of her husband reveals their shared puritanism and, unusually, republican sentiments. The biography provides a providential interpretation of events, but it is also very factually-detailed history.[154] Hutchinson drew on notebooks she had kept and synthesised her memories with other published accounts of the Civil War. She portrayed her husband as a republican hero, his actions being contrasted with unflattering portraits of other men. Unlike the royalist memoirists, in the longer term Hutchinson suffered also the anguish caused by the loss of 'the [puritan] Good Old Cause'. The Restoration might be viewed as a divine mercy by royalists, but for Calvinist parliamentarians it needed to be scrutinised for signs of God's displeasure. Lucy Hutchinson described her husband as 'a very faithful mirror, reflecting truly, though but dimly, his own glories upon him'. She portrayed him as the Classical Plutarchan hero and her superlatives about him were designed to preserve his memory in a changed political world and to answer larger questions about God's design in defeat.[155] Hutchinson's biography of her husband was not her only writing effort. As a very young woman she had done a translation of Lucretius' *De Rerum Natura* that has been described by David Norbrook as 'display[ing] considerable philological judgement and ... [being] attentive to the poetic effects of the original'. Her knowledge of Calvinist theology she attributed to her mother, who encouraged her to repeat sermons and study the Hebrew texts of the Bible.

Norbrook has also argued for her authorship of an anonymous meditative poem about the Fall – *Order and Disorder* (1679).[156] She died soon after its completion, in 1681.

The second woman writer to do a biography of her husband was Margaret Cavendish, who pursued publication more than any other woman mentioned so far. Cavendish was another royalist, born in about 1623. She was the daughter of Thomas Lucas and Elizabeth Leighton. Her father was already about 50 when she was born and she had brothers who were quite a bit older. Her father died when she was an infant and Cavendish attributed to her mother considerable bravery in raising the family and managing landed estates on her own. In 1642 she moved to royalist Oxford where she became a maid of honour to Henrietta Maria. She was a member of the queen's exiled entourage in 1644, travelling with her to Paris. She was not naturally suited to life at court, being shy and idiosyncratic as well as intellectual despite a patchy education. She began a courtship with William Cavendish, duke of Newcastle, in 1645, possibly because their shared intellectual interests overcame considerations of age – he was 30 years older than her and a widower with several children. They married despite objections put up by the queen and friends.[157]

Cavendish wrote her biography of her husband for publication while he was still alive. The *Life of the Thrice Noble...Duke* was published first in 1667 and reprinted in 1675. By the year of its publication the duke and duchess of Newcastle were already known as 'the odd couple'. They made no secret of the fact that they both wrote for publication. They had no children and Margaret Cavendish famously referred to her written words as surrogate babies. In 1667 they attended together a meeting of the Royal Society to the amazement of several people, including Samuel Pepys, who went primarily to catch sight of her and record for posterity the way she dressed (apparently theatrically). Also by the year of the publication of *Life of the Thrice Noble...Duke*, Margaret Cavendish had drawn attention to her own life in a short autobiographical work called *A True Relation of My Birth, Breeding and Life*. This she had appended to *Nature's Pictures* in 1656, a collection of florid morality tales about 'discreet virgins' and ladies. *Natures Pictures* grew out of her experience of being a court exile. However, so too did *A True Relation* because her sense of grievance during the civil wars, during which she lost her mother (in 1647), her brother who was executed (in 1648) and her husband's estates which were sequestered, created her desire to record her experiences. After Margaret Cavendish and the earl of Newcastle returned to England, he failed to gain office at court and, although retiring to the country suited her temperament, the rejection of her husband rankled. The result was a partisan biography of his role as a supporter of the king that styled him as 'prince' in his own life and celebrated his character and social pedigree and heroism as a royalist commander. Her intention, she said, was to tell 'after ages' what she called the 'truth'; therefore, she noted her husband's victory at Adwalton Moor in June 1643 to offset his losses at Marston Moor in 1644.[158]

Cavendish was the only woman biographer to reflect upon historical writing and despite her apology that she was 'ignorant of the rules of writing histories' she

developed a philosophy of history that was unique. In her biography of William Cavendish she claimed that 'truth cannot be defective' and that 'historical truth' could arise directly from the subject, in this case, the duke of Newcastle himself. She also claimed that many histories were applauded 'merely for their elegant style...well-observed method...[and] feigned orations' but she dismissed these as 'pleasant romances' and claimed for herself historical truth evident in her 'plain style'. She also developed an argument about the three 'chiefest' histories – these being 'general history' or the 'history of the known world', 'national history' and 'particular history' or biography. Her odd equation of the first and second with democratic and aristocratic polities respectively was a way of declaring her own political sympathies by privileging the worth of 'particular histories' which she associated with monarchy. In so doing she co-opted Classical historical methodology and veneration of the masculine hero. Therefore, as a writer Cavendish looked to the Classical past for her justification in becoming the first woman writer in English to publish a non-religious biographical history in the great man genre.

The royalist context for Cavendish's historical/biographical writing is important and it was also important for her writing across other genres. Her first book, *Poems and Fancies*, was published in 1653 and went through two further editions. In this she deployed poetic form to communicate her atomistic theory which was most likely derived from Epicurus. She followed the work in the same year with *Philosophical Fancies* which, oddly, repudiated atomism. Partly because of royalist exile she was able to establish herself quickly as a controversialist essay writer and philosopher and her *Philosophical and Physical Opinions* of 1655 critiqued the natural philosophy of Thomas Hobbes while her later work, *Philosophical Letters* of 1664, again took on Hobbes, but also René Descartes and other continental philosophers such as Van Helmont. In other words, her exile formed the backdrop to her intellectual engagement with European natural philosophers and her developing ideas on organic states and motility might not have been written without her marriage in exile to Newcastle, whose family patronised the political thinker, Thomas Hobbes.[159]

Some historians have taken Cavendish's contact with the works of the critical philosophers of her day as a sign that her own work reflected that of her husband whose own intellectual interests and developing reputation as a playwright were not insignificant. However, Hilda Smith has pointed out that Margaret Cavendish developed a politics separate from that of her husband; while he developed 'a Machiavellian statement' against political or religious tolerance, she broke with 'royalist orthodoxy over the standing of women in the state and family'.[160] Indeed, Smith makes a convincing case for an emergent feminist politics arising out of Cavendish's particular circumstances as exile. She points to the contradictions inherent in statements such as 'it cannot be expected I should write so wisely or wittily as men' and 'men from their first Creation usurped a supremacy to themselves, although we were made equal by Nature'. Her rejection of the absoluteness of Creation indicates the shift away from Calvinism that allowed a particular brand of thinking about sexual politics to develop for some late seventeenth-century

women such as Cavendish. Even more extraordinarily Cavendish argued that women had no reason to desire children as they only kept a man's family name alive for future generations and her sense of posterity clearly included her own posterity as a writer.[161]

Margaret Cavendish developed a wide repertoire of writing and Sidonie Smith has argued that even apart from her autobiography, Cavendish publicized her own life through her authorship of 'scientific treatises and works of poetry, philosophy, utopian fantasy, drama, biography', anticipating that her readers would read her as 'woman'.[162] Therefore, her work was a self-conscious form of accepting female identity as an author or what Sidonie Smith has called 'self disclosure'. Part of this was her construction of her identity as scientist and natural philosopher and this continued beyond her days of royalist exile. *Observations upon Experimental Philosophy* came out in 1666 attacking the empirical science of Robert Hooke's *Micrographia* and she published her revised atomistic ideas of *Poems and Fancies* in new editions of 1664 and 1668.[163]

Like Katherine Philips, Cavendish's self-disclosure also involved playwriting and she wrote two volumes of dramatic works earlier in the 1650s. They came out of the court context of staging masques for private audiences and were not really intended for the public stage, but Cavendish nevertheless proceeded with their publication, one collection in 1662 and a further collection in 1668. Elaine Hobby has pointed out the complexities of these dramatic works and Susan Wiseman has argued that Cavendish's plays are less important in their content (though this is arguable) than their message which included equality of the sexes.[164] Cavendish's plays were often very discursive with several unconnected groups of characters standing around discussing topical subjects. Her quintessential feminism lies in the importance of those subjects to women and in her portrayal of female roles. For example, in *Bell in Campo* Lady Victoria goes to war with her husband and organizes an army of female 'heroicks' to fight. In *The Female Academy* women's education gets an airing and in *The Convent's Pleasure* female characters discuss the advantages (or not) of marriage. In the latter the husband of the 'Citizen's Wife' is called 'Mr Negligent'.[165]

Genre can mask the important overlaps in both topic and style to be found in Cavendish's work. She was first and foremost an essayist who experimented with style. *The World's Olio* of 1655 comprised a series of pithy comments and observations on historical and topical subjects. It was followed in 1662 by *Orations of Divers Sorts* which went to a second edition in 1668 and which contained various set speeches and occasional addresses. As James Fitzmaurice has pointed out, some of these too were topical, including questions discussed but left unresolved about sexual equality and the causes of women's subordination in society.[166] In *CCXI Sociable Letters* of 1664 a series of essays were presented as women's letters and dialogues. Letter 32, for example, was *querelle des femmes* in construction, featuring a good wife whose 'good nature did excuse her husband's folly' and a bad wife who rowed with her husband, so 'leaving the angelic lady to be a pattern to her sex'. *Sociable Letters* can be read as confirming gender stereotype – there are parables about adultery being akin to murder (always found out) and courtesans

standing as examples to chaste and honest women. However, tellingly, in Letter 113, an imaginary woman narrator tells the story of 'the lady M. L.' [Margaret Lucas i.e. Cavendish herself] who argues that 'the mind's architecture' which produces 'poems, songs, plays, masks, elegies [etc]' is a way of 'building castles in the air'. The narrator argues the opposite so that Cavendish can invert herself in this narrative, saying that 'poetical castles are both profitable and lasting, and will be remembered when the Lady M. L. is forgotten'. In this one tale Cavendish demonstrated most clearly her understanding that a woman's written words could give her not only identity, but an enduring reputation that could pass for a form of Socratic immortality.[167]

Margaret Cavendish arguably also developed a critique of marriage in her work because, according to Sara Mendelson, despite the advantages that her own marriage offered 'marriage [usually] offered too many distractions from the contemplative life'.[168] One feature of what might be termed early-modern feminism was women's writing that imagined worlds of seclusion away from men. Hobby points out that in Cavendish's play *The Unnatural Tragedie* a bullied wife is avenged by 'the Sociable Virgins'. They are called 'First Virgin', 'Second Virgin', 'Third Virgin' and so on in an 'outrageous' plot containing 'a group of women whose gossip sessions include the musing that it might be quite easy to replace male dominance in the world by female government'.[169] In a hijack of a fairly standard *querelle des femmes* scenario, Cavendish could posit a more dangerous and permanent state of altered relations between the sexes. Both Sophie Tomlinson and Rebecca d'Monté have also argued that Margaret Cavendish employed the plot device of withdrawal into worlds of unique female power. For example, d'Monté argues that in both *The Female Academy* in 1662 and *The Convent of Pleasure* in 1668, Cavendish 'specifically makes use of separatist spaces to empower women'. She continues: '[i]nside these inner sanctums, the controlling male gaze has no strength and is transformed into a mutually supportive gaze between women.' She also argues that the Civil War inevitably led to women's imagining of female communities that were self-sufficient. For example, in *The Convent of Pleasure* 'Lady Happy' is 'the chief Counsellor'. Tomlinson points out that *Sociable Letters* is female community imagined and that some of the anecdotes use the old trope of cross dressing to comment on sexual equality. Cavendish could use her brain as 'the stage' in which the real world of women's subordination could be usurped and replaced by an imagined world of female agency. She could imagine women's public speaking, their equality as actors and their entry to 'the male world of heroic action and honour'.[170]

Nowhere was Margaret Cavendish's imagining of a world of female agency and liberation of the female voice more on display than in her short novel *The Description of a New World, Called the Blazing World* which came out in 1666. *New World* was a feminist or woman-centred text that drew upon the formula of past utopian and colonial writing such as Thomas More's *Utopia* (1515) and Joseph Hall's *The Discovery of a New World* (1605) to write a feminine equivalent. In it Cavendish created a parallel world to the male-dominated English polity. The story told was of a 'virtuous Lady' abducted by a man who loves her. The woman

sails away from known shores to the icy wastes of the North Pole where shipwreck is the means by which her chastity is rescued when all her travelling companions freeze to death. Coming upon a land filled with 'bear-like creatures', the woman meets the Emperor who persuades her into becoming Empress Margaret I in this 'new world'. The Empress sets about creating a well-ordered state and then in a rhetorical dialogic narrative reminiscent of that between Hythlodaeus and More in Thomas More's *Utopia* the Empress Margaret and the duchess of Newcastle muse on what it would be like to live in one another's worlds.[171]

Margaret Cavendish, duchess of Newcastle, meets all of Gerda Lerner's criteria for the female voice – she recognised her autonomy of authorship (despite the deference she paid at times to her husband) and she explored women's worlds as being different from those of men, imagining new worlds that subverted structures detrimental to women. Her claim to her own ideas was most forcefully demonstrated through what Sarah Irving has called her constant construction of 'a spectacle of her own identity' as she wrote herself into many of her works in a variety of disguises.[172] Margaret Cavendish died in 1673, three years before her, by then, very elderly husband. Her reputation in her lifetime was mixed – she was seen as mad ('Mad Madge'), but her writing was not totally dismissed either. Her reputation now is huge and growing, especially amongst literary critics and those interested in the history of science and political ideas.[173] However, for historians what her life and written work most clearly demonstrate is, first, that the 1640s and 1650s could not only liberate women writers but also produce one very prolific and ambitious woman writer and, second, that a woman royalist exile could emerge as one of the most significant feminist voices of the late seventeenth century.

Wider education, the experience of war and political partisanship, and changes in gender construction and the religious culture of England in the second half of the seventeenth century led to wide-ranging women's literary activity that might be described as secular. One of the consequences was that some women came to express their place in history in a temporal rather than providential sense. Women's historical writing came to surface in several areas such as family history or genealogy and antiquarianism. For example, Cassandra Willoughby, who was born in 1670 and lived at her family's property of Wollaton Hall in Nottinghamshire, constructed a family tree and began writing her three-volume history of the Willoughby family in about 1702, her antiquarian flair turning to transcriptions of medieval land title deeds and old family accounts and letters. By this means she wrote herself and her ancestors like the landowner Catherine Willoughby into a secular history of a small section of England.[174] Thus, while some women wrote in ways that revealed their religious subjectivity, the subjectivity of other women was quite different and resulted in works of poetry, romance, plays and histories, all of which fed back into female notions of the feminine self.

Aphra Behn and the playwrights

Aphra Behn was a poet, a major playwright of the Restoration stage and arguably the first woman novelist writing in English.[175] She was born in 1640. Although

the place of her birth has not been definitively proved, her biographer, Janet Todd, has established fairly convincing connections with Kent where her father was probably Bartholomew Johnson and her mother, Elizabeth Denham.[176] If Todd is correct she was born Eaffrey Johnson in the vicinity of Canterbury and in her early twenties she appears to have gone with her mother and siblings to stay on the plantation of Robert Harley in the English colony of Surinam. The details of Behn's early years are sketchy, but she seems to have become involved in spying both in Surinam and then in Antwerp before returning to London around 1664 where she married (and then quickly lost) a German or Dutch husband. She then became a spy for the court of Charles II, travelling to the Netherlands, but when not paid on her return she turned to writing. Aphra Behn wrote at least 19 plays for the Restoration stage and 14 pieces of prose fiction gaining for herself the reputation of first serious woman playwright and novelist and the first woman to try and live by writing. The height of her success was in the late 1670s with her play *The Rover*. She also published two volumes of original poetry and the scope of her work was such that Melinda Zook has pointed out that she has been portrayed as a feminist, a libertine 'and an abolitionist, writing one of the first anti-slavery novels in Western literature'. The latter reputation is based on her extraordinary story – *Oroonoko* – written at the end of her life. Of all the writers of the early-modern period she has attracted the most interest and there are multiple biographies of her life and work despite major problems with establishing biographical facts and literary attribution.[177]

Important to an understanding of Behn is her Tory political position. Zook has argued that while Behn was an apologist for Charles II and James II and involved in 'this highly disputatious political culture' hers was a more complicated political position than the average opportunist Tory, in part because gender altered her vision.[178] She slipped her Tory sympathy for the executed Charles I into her writing and Hobby has pointed out that the theatres had very close connections with the monarchy because the audiences were filled with royal courtiers. However, there are signs in her work that she became politically disillusioned in the late 1680s during her most successful period as a playwright. For example, she at first refused to write a celebratory poem on the coronation of William and Mary of Orange because of her support for the deposed James II, but she did ultimately write a poem to Mary perhaps out of deference to her sex.[179] She was also not receptive to the patriarchalism that underpinned the Tory cause, yet some of her works spectacularly set Cavalier male dominance, masculine honour and male social status on its head.[180]

Aphra Behn's ability to find work as a writer in Restoration London needs to be understood in the context of the buoyancy of theatre and bawdy culture. Carol Barash has said that Behn's use of the erotic in her political plays places her firmly at the centre of the Restoration literary community. Friendship, banter and intimacy between playwrights, players and actresses and members of the audience was a consequence of the layout of theatres, with stages that reached deep into the crowd some of whom came backstage after the show.[181] The duke of York's theatre was for a time managed by a woman who put on plays by Elizabeth Polwhele

and Frances Boothby before Aphra Behn approached her. Hobby suggests that Behn made a commercial decision to align herself with the Tory position, writing novellas and plays such as *The Dutch Lover* (1673) and *The Roundheads* (1681) that presented to an audience of courtiers the spectacle of dashing Cavaliers and humorous caricatures of 'the puritan'. *The Roundheads*, set in 1659, used the old trope of the 'council' or 'parliament of ladies' and set Cavaliers in the position of having to rescue their mistresses from the rioting mobs in a time of misrule.[182]

Aphra Behn's first staged play was *The Forc'd Marriage* in 1670 and it was followed by *The Amorous Prince* in 1671 and *The Dutch Lover* in 1673. Janet Todd argues that Behn was attracted to and had liaisons with abusive men, most notably John Hoyle, though she also seems to have had a quite close working relationship with the debauched earl of Rochester, writing an elegy upon his death in 1680. She moved between The Duke of York's Theatre and a new theatre at Dorset Garden. She was frequently let down financially by male associates and was always seeking payments and loans from theatre managers such as Thomas Betterton. Several more plays followed in the late 1670s – *The Town Fopp*, *The Debauchee*, *Sir Patient Fancy* and *The Feigned Curtizan*, the latter dedicated to one of the king's mistresses, Nell Gwyn.[183] Most of Behn's plays were comic or tragicomic though *Abdelazer* of 1676 was a tragic tale of revenge. Amongst the 1670s plays was her most successful – *The Rover* – which sold out in 1677 and for which she wrote a second part or sequel in 1681.[184]

The Rover was essentially a sex comedy. It was based on Thomas Killigrew's lengthy drama *Thomaso, or the Wanderer*. Behn was not unusual in writing works that were derivatives and Hobby has pointed out that financial exigency led to speed of production and dramatists sharing texts and classical plot lines.[185] Killigrew wrote *Thomaso* while a royalist exile in France in 1654. Centrally concerned with the love affairs in exile of a Cavalier, his work had autobiographical overtones and Behn reshaped it to caricature further both male and female stereotypes. The central male character is what Jane Spencer has called 'the Restoration rake hero, very much in charge of events as he wanders at his ease in a world full of whores'. His English masculinity is contrasted with that of Italian men who appear in a *carnivale* dressed in horns and flowers. 'Tis a satire against the whole sex' says one of the characters; 'they stumble on horns on every threshold', men's weakness and cuckolding caused by the loose sexual morals implied by the flowers. Spencer has pointed out that Behn gives one of the deserted mistresses, Angellica Bianca, the opportunity to chastise Thomaso, suggesting sympathy with the role of the jilted woman. Other female characters also take on a stronger role than in Killigrew's original. Florinda falls in love with someone other than her father's choice and she says she will not obey what she calls the 'unjust commands of her father'. Her sister, Hellena, responds to this with 'now hang me if I don't love thee for that dear disobedience'. Spencer suggests that Hellena is the character most altered by Behn's reworking of *Thomaso* and her role as witty heroine challenges that of Thomaso himself for audience sympathy, even to the point of taking some of his lines and having greater theatrical flourishes like disguises including breeches and a beard. Spencer also points out that the resolution of plot lines returns characters

to 'prevailing patriarchal structures' and this can be seen in the intervention of Florinda's brother who brings pressure to bear on her to marry as her father wishes. However, many lines given to the female characters argue against their subjection to male command. For example, Florinda says: 'I would not have a man so dear to me as my brother follow the ill customs of our country, and make a slave of his sister'.[186]

Arranged marriages and their disastrous consequences were a repeating theme in Behn's work and her first play was not only called *The Forc'd Marriage*, it also opened with the idea of a spy who represented a new 'party' – women. However, its main themes were courtship and marriage for women, and male power, which is inescapable in this context. *The Forc'd Marriage* concerns the trials of Erminia, a young woman given as a victory trophy to the king who is arranging her marriage with his favourite, Alcippus. Her thwarted love for his son Philander and struggle to have her vows to Alcippus made void dominate the action and there is a sub-plot in which the king's daughter, Gallatea, yearns for the pledged Alcippus.[187] In all of Behn's fiction sexual relationships formed by old men with young women are an important theme. In *The Lucky Chance*, which was staged in 1686, two young women find themselves unhappily linked to old men – Leticia (thinking her real husband dead) to Sir Feeble Fainwould and Julia to Sir Cautious Fulbank (a wittily named City banker). The resolution of the stories for both women turns on their proof of virtue – in Leticia's case to prove to her beloved, Belmour, that she has not consummated her marriage to Fainwould and in Julia's case to prove to her lover Gayman that she cannot sleep with him because she has already slept with her husband. Her virtue is lost when the two men reach a commercial arrangement over her, a twist that can be read as a critique of gender relations.[188]

Melinda Zook points out that Behn's plots sometimes critique the masculine honour system, as in *The Widow Ranter* when Nathaniel Bacon is 'tricked by lesser, unscrupulous men'. In other words, women are not the only victims and Behn's narratives of sex and power frequently figure the 'tragic masculine hero'.[189] This becomes a problem for Behn when the men are kings and questions of political honour arise. In her pastoral poem, 'The Golden Age', which was a translation and paraphrasing of Torquato Tasso's *Aminta* of 1573, she imagined a Paradisian pre-political age: 'Monarchs were uncreated then | Those arbitrary rulers over men.' In this utopia there was no pride or greed and no property rights to disturb peace-ful human relations. The golden age to which she referred was romantic without being chivalric, imagining no gender order of knights and ladies but rather a world in which 'the flow'ry meads, the rivers and groves | Were filled with little gay-wing'd Loves'. The sentiment reflected a new Restoration morality of love affairs and secret trysts: 'The yielding maid but kind resistance makes | Trembling and blushing are not marks of shame | But the effect of kindling flame.' If there is no puritan sexual anxiety in 'The Golden Age', neither is there any fearful obedience to 'gods and…fond religious cause' indicating a shift to a secularist *mentalité* for some women writers whose authorisation of their writing required no religious motivation, no providentialism and no overt spiritual message.[190] Much of Behn's work contains disguised political commentary and Todd has pointed out that

'[m]uch of the power of the utopia in "The Golden Age" comes from the invocation of its opposite, the leaden world of money, war, trade, merchandise and sexuality as commodity'. However, she was equally a captive to that world, particularly in her poetry which was frequently elegiac – for example, on the death of Charles II, 'A Pindarick on the Death of our Late Sovereign' – or celebratory of Stuart monarchy – for example, in her coronation ode to James II and Mary of Modena, 'Pindarick Poem on the Happy Coronation'.[191] These two odes taken together represent Behn at her most openly monarchist and Todd has described the Coronation poem as 'nearly 800 lines of baroque extravaganza'.[192]

Aphra Behn's was a more complicated political position than that of the average Tory in Restoration London, though like John Dryden some of her work demonstrates unequivocal criticism of the politics of resistance, both writers using their work to outlaw the rebellion of the duke of Monmouth. Dryden did it through poetics in *Absalom and Achitophel*, but Behn used the emerging feminine genre of the secret history or *roman à clef* in *Love Letters between a Gentleman and His Sister*, an early novel form that was epistolary. *Love Letters* was published in three parts between 1685 and 1687 and Helen Thompson has argued that this work 'must be read as a novel and as political philosophy at once' with commentary on social contract theory implicit in the text. Behn revived her use of the name Philander for the central male character, but attached it to a Whig protagonist who was a loose portrayal of Lord Grey, a co-conspirator of the duke of Monmouth. The novel is seen by Thompson as an extended exploration by Behn of political loyalty and the depth of men's obligation in a world that had moved beyond the certainties of non-resistance encapsulated by Thomas Hobbes' *Leviathan*.[193] In this way Behn stands not only as apologist for executed and deposed monarchy in England, but also as a representative of an *oeuvre* of women's Royalist writing that arose from exile contact with French women writers such as Madeleine de Scudéry. The romance between Philander and Silvia in *Love Letters* was a framing device, one that allowed a secret history to be told about Lord Grey who, in real life, abducted the 18-year-old Lady Henrietta Berkeley. Similarly de Scudéry satirised French society in her *Conversations* of 1680, the serialised version of which was immensely popular and both she and Behn were part of a wider tradition of early women's commercial writing.[194]

Behn's distaste for resistance to monarchy was arguably moderated by an even greater loathing of men's cruelty and the tragic figure of Cesario in *Love Letters*, who ends his life on the scaffold, can be seen as a sympathetic reading of the gruesome execution of the duke of Monmouth. However, the work in which Behn most revealed her dislike for men's casual inhumanity was *Oroonoko* which was the first genuine novel written in English. *Oroonoko* features a tussle between two men for the love of a young woman, Imoinda, and again features a critique of the mismatching of old men with young women. Oroonoko's grandfather, the king of Coromantien, who is described as being over 100 years old, takes Oroonoko's love, Imoinda, for a bride. Behn explores the full consequences of this for the young couple, including the sexual revulsion of Imoinda and the disgust of Oroonoko himself at her sexual sacrifice to the old king. Imoinda throws

herself onto a marble bath surround when the king commands her to take off her clothing and demands to know whether or not she is a virgin ('it being in vain for her to resist'). Oroonoko is horrendously torn between duty to the older man and rage: 'Nothing weighed so greatly with him as the king's old age.'[195] Behn was interested in abuses of familial power that resulted in women's powerlessness, but was equally interested in a social system that demanded not only women's obligation to men but younger men's obligation to older men. She also moderated her belief in obedience to monarchy by criticising the corrupting influences of sex and desire when linked to public power.[196] Behn's disgust at male cruelty reveals itself most fully in the sad end of *Oroonoko*, and Zook argues that Behn was most concerned in *Oroonoko* with the death, both real and figurative, of honourable men in an increasingly dishonourable world.[197] The description of Oroonoko's death is grotesque – he is represented as being dismembered completely while continuing to smoke a pipe, dying 'without a groan or reproach'. The narrative works as a device to build the reader's attachment to Oroonoko and his masculine grace and his goodness.

Oroonoko has frequently been viewed as an anti-slavery work though Behn's treatment of race and colour was, like her political commentary, not straightforward. For example, she contrasted Oroonoko's features and the colour of his skin with other Africans to highlight his nobility: 'His face was not of that brown rusty black which most of that nation are, but of perfect ebony...[and] his nose was rising and Roman, instead of African and flat.' However, it is also the case that in *Oroonoko* Behn was one of the first writers in English to attack the supposed superiority of Europeans. She spoke of South American Indians as beautiful, honourable and peace loving, and of Oroonoko himself as 'beautiful, agreeable and handsome' and Jane Spencer has suggested that the contrast Behn wished to draw was between Oroonoko's masculine perfection and the betrayal of civilised behaviour by men taking place in Europe. This is most startlingly apparent in Behn's treatment of the behaviour of Oroonoko – a Muslim – towards Imoinda which was 'aimed at nothing but honour', and the abandonment of women to 'shame and misery...practised in Christian countries'. Behn also equated Oroonoko's slavery with the slavery of women by exonerating his 'Great Mistress' and equating her position with the slavery of the tragic black hero himself. Thus, Behn arrived at a position of Enlightenment feminism (and racial equality) through her slow realisation that the politics of the Stuart court and the Williamite invasion revealed corruption and decay at the core of English (masculine) society.[198]

In a further short novel – *The Unfortunate Happy Lady* – which was not published until after Behn's death in 1698, Behn again wrote to subvert the gender order.[199] The heroine of the plot was Philadelphia, the sister 'of a gentleman of a good family in England' [Sir William Wilding] who becomes subject to his 'villainy'. After the death of their father, Philadelphia's brother leaves her in the care of Mrs Beldam, the owner of a brothel, to avoid paying her portion of £6,000. The tale was a standard cautionary one, of the innocent young woman falling prey to the older, debauched woman, caricatured by Behn as 'the true offspring of old mother Eve'. At Mrs Beldam's Philadelphia was subjected to a failed

seduction at the hands of Sir Gracelove who, despite the dishonourable intention of paying for Philadelphia's 'maidenhead', is described by Behn as 'a very honest, modest, worthy and handsome person [who] had the command...of many a thousand pounds [being]...a Turkey merchant [trader with the middle east]'. Philadelphia convinces Gracelove of her innocence and he rescues her, placing her with an old friend, a lawyer called – wittily – Fairlaw whom he first catches up with in a coffee house. Philadelphia proceeds to live with Counsellor Fairlaw, his ageing and sick wife and daughter of her own age. Gracelove pledges himself to her (even though she pleads poverty) with a diamond ring, but he is then sent on an embassy being shipwrecked *en route* not to return for many years. Her brother continues in his dissolute ways while she remains true to an absent Gracelove until the dying Mrs Fairlaw asks her husband to marry Philadelphia, which he does after his wife's death. Counsellor Fairlaw dies soon after and from the moment of widowhood, Philadelphia's character changes to that of a woman empowered; she toys with three suitors and her relationship to Fairlaw's daughter alters and she becomes mother-in-law with the power to arrange marriages. The twist comes when Gracelove returns in a clearly confused and broken state. He is recognised by the faithful Philadelphia, who rescues him from the streets (a returned favour) and into a life of wealth again. In an extraordinary double denouement Philadelphia holds a dinner in which she arranges the marriages both of herself to Gracelove and her daughter-in-law to her repentant brother. Therefore, Behn drew upon standard ideas about the woman's role in the late seventeenth century to write a narrative featuring woman as saviour of men from lives of destruction.[200]

Aphra Behn was a complex woman writer whose work is difficult to decode in its gender constructions. On the one hand she distanced herself from having anything in common with other female writers and on the other she claimed a desire for immortality through her verse by wanting association with Sapho and 'Orinda' [Katherine Philips].[201] Her politics can be summarised as a form of loyalism frustrated by the muddled partisanship and crises of royal succession in the 1680s, but the scenarios she presents to the reader of gender relations are more difficult to categorise. She wrote some of the bawdiest poetry ever written by a woman. For example, 'On a Juniper Tree, Cut Down to Make Busks' she used the device of allowing the reader to watch a couple having sex through the eyeless 'sight' of the juniper tree:

> I saw 'em kindle to desire,
> Whilst with soft sighs they blew the fire:
> Saw the approaches of their joy,
> He growing more fierce, and she less Coy,
> Saw how they mingled melting Rays,
> Exchanging Love a thousand ways.[202]

When 'Juniper Tree' first appeared in print, it was attributed to the outrageous earl of Rochester. *Poems Upon Several Occasions* (1684) contained further libertine

verses, though they were published alongside several verses of commendation by Thomas Creech.

Aphra Behn died on 16 April 1689 and was buried, despite her dubious breeding and penurious state, in Westminster Abbey. Germaine Greer has pointed out that it is difficult to assess the literary value and attribution of Behn's work because her poetry was heavily revised by several male associates and she was at the mercy of men who tampered with and edited her manuscripts, especially after she died. Greer takes issue with the modern feminist elegiac vision of Behn's life singling out Yvonne Roberts' description of Behn as 'all round bad girl ... [having] a bloody good time' as missing the point. Instead Greer suggests that Behn 'exhausted, destitute and racked with terrible pain' at the end of her difficult life may have committed suicide. Like all women playwrights, she was often in a position of being kept by a man financially and Greer points to the 'grimness of the situation of an unattached woman in Restoration society'. Like actresses, women playwrights looked for protectors and theirs was a short step to mistress and only a slightly larger one to courtesan.[203] Therefore, while Aphra Behn may have thought of herself as walking in the footsteps of Katherine Philips, ultimately she and the other women playwrights of Restoration England did not enjoy the protection of marriage and a familial situation, but rather had to seek protection from unrelated men associated with a libertine literary and theatre world.

Aphra Behn was the role model for the four notable women writers who followed in the next generation. They were Mary Pix, Susanna Centlivre, Delarivier Manley and Catharine Trotter and were all born during the reign of Charles II between about 1666 and 1674.[204] This small coterie of playwrights was primarily a product of the theatre world. They were not all well educated, nor were they born into the aristocratic and gentry families that had produced female Renaissance scholars and writers.[205] The timing of the appearance of their works was quite precise – 1695 to 1696. In those two years several plays by women were staged in London including Catharine Trotter's play *Agnes de Castro* at the Theatre Royal in Drury Lane in about December 1695. Trotter was very young at the time, though her biographer, Anne Kelley, points out that she had already published a short novel called *The Adventures of a Young Lady* in 1693. She was the daughter of a naval captain in the service of Charles II, though his death at sea had left Trotter and her mother in a precarious financial situation which Trotter appears to have alleviated through turning to writing. *Agnes* was an adaptation of Behn's translation of a French play of the same name. Like Behn, Trotter came under the auspices of male associates, most notably William Congreve, and her second play, *The Fatal Friendship*, was brought to the stage at Lincoln's Inn with his help. Three more plays followed – *Love at a Loss* (1700), *The Unhappy Penitent* (1701) and *The Revolution of Sweden* (1706). Trotter's most celebrated play, *The Fatal Friendship*, was a situation tragedy which centred on the secret marriage of Felicia and Gramont and ended with the deaths of Gramont and his friend Castalio accidentally at each other's hands. The ethical questions that lay at the heart of the play were peoples' choices in love and the dangerous consequences of secrets and lies. The final lines were a cry against the tyranny of men's certainty and rectitude: 'Let the

most resolute | Learn from this story to distrust themselves, | Nor think by fear the victory is less sure, | Our greatest danger's when we're most secure.'[206]

What is notable about Trotter is that all her plays except *Love at a Loss* were tragedies and she was not, by nature, a satirist. Kelley has described her as 'in the vanguard of the movement to reform the stage' and while connected with the political circle around Queen Anne's favourite, Sarah Churchill, duchess of Marlborough, her interest lay not in political argument but in the rather more earnest business of philosophy.[207] Indeed, Trotter attracted positive comment from some men for the morality of her plots and as some other women playwrights followed her lead in toning down the bawdy in their writing they moved further away from Behn as model.[208] After the success of her early plays Trotter turned to writing philosophical works, the first being *A Defence of the 'Essay of Human Understanding'*, a work designed to support the rationalist position of John Locke. In 1708 she married Patrick Cockburn, an Anglican minister, having converted from Roman Catholicism to Anglicanism about a year before. She seems to have been deeply affected by becoming acquainted with the wife of Dr Gilbert Burnet, a woman whose theological interests prompted Trotter to say 'I have not met such perfection in anyone of our sex'. Trotter and her husband lived until 1749 and she continued to write works of philosophy that defended a morality based on God-given reason. Kelley has said of her that '[h]er own life was an argument for female rationality and responsibility'. Her plays, like her philosophy, explored ethical questions.[209]

Catharine Trotter's entry as a writer for the London stage was quickly followed in 1696 by Delarivier Manley's *The Lost Lover, or the Jealous Husband* and *The Royal Mischief* and Mary Pix's *Ibrahim, the Thirteenth Emperor of the Turks* and *The Spanish Wives*. The most successful of these was *The Royal Mischief* prompting Pix to call Manley the 'pride of our sex, and glory of our stage' and Catharine Trotter to call her 'our champion'.[210] Thus, there was a feminist discourse of female community internal to the world of late Stuart theatre that was responded to by men critical of women writers, so adding mockery of them as a further strand in the *querelle des femmes*. In an anonymous play by a male writer, *The Female Wits*, that was staged at the Drury Lane Theatre in 1697, Delarivier Manley was caricatured as Marsilia in a play that joked about women playwrights. Marsilia bosses and bullies her maid Patience and Mary Pix appears as Mrs Wellfed (a reference to Pix's real-life plumpness) and Catharine Trotter as Calista. The play was a sniping romp, the female wits being depicted as vain ('Nothing but flattery brings my Lady into a good humour') and lascivious ('These are poetical ladies with a pox to em'). The men in contact with the female wits have dubious masculinity – Mr Praiseall sucks up to Marsilia and Lord Whiffle blurts out extravagant superlatives such as 'Your Lady's wit is almighty'. Mr Awdwell, 'a gentleman of sense and education', is given the last word: 'I'll leave the scribbler to her fops, and fate; | I find she's neither worth my love or hate.'[211]

In caricaturing the women playwrights in this way, the anonymous author set up a stereotype which masked the differences between the 1690s writers. Even though her first work was a novella (*The Inhumane Cardinal* [1696]) Mary Pix was

primarily a playwright, embedded in the theatrical scene and intermittently sup-ported by William Congreve. She wrote in both tragic and comic mode for stage, her comedies, according to Kelley, 'generally ingeniously plotted' and her trag-edies gripping and reliant upon the overdrawn emotions common to the late seventeenth-century stage. Her first play, *Ibrahim*, was a sexual drama set in a seraglio (or harem) in which the tragic heroine, Morena, says 'Death hath a thou-sand doors; Sure Morena, cursed Morena, may find out one' but Ibrahim's desire for her seals her fate. *The Different Widows* of 1703 empowered women in a sexual situation instead, centring on the affairs and intrigues of Lady Gaylove. Thus Pix's plays, whether tragic or comic, were rich with the politics of sex and, although Kelley has suggested that she 'tacitly endorses whig political theory', the plays seem mostly uninterested in politics.[212]

By contrast Delarivier Manley was a political journalist and critical of the domin-ant political culture. Like Richard Steele, the newspaper editor (with whom she was friends and then very public enemies), Manley wrote works of political correspond-ence and scandal and became heavily involved in argumentative exchanges in *The Tatler*, *The Guardian* and *The Examiner*. Her journalistic style led to interactivity between her life and her writing and autobiographical elements wove themselves through works as diverse in form as the epistolary *The Ladies Pacquet Broke Open* (1707), the prose fantasy/scandal *The New Atalantis* (1709) and the autobiograph-ical fiction *Adentures of Rivella* (1714) which she wrote under the pseudonym of 'Sir Charles Lovemore' all of which contain methodological echoes of Mary Wroth's *Urania*. Manley had a chaotic personal life compared with Trotter and Pix. She was the daughter of a royalist army officer, who entered into a bigamous marriage to her cousin, John Manley, and who later had a six-year affair with the governor of the Fleet prison. She was a Tory, or rather she enjoyed writing anti-Whig scandal. For example, *The New Atalantis*, an 'island in the Mediterranean', is the setting for the story of the innocent Delia (i.e. herself) and the travels of Astrea and Virtue who find all around them sexual corruption and political scandal. Atalantis is England, held in the grip of Lord Fortunatus (the duke of Marlborough), whose rise to polit-ical pre-eminence takes place because of his propitious marriage to Jeanita (Sarah, duchess of Marlborough). Jane Spencer has argued that *The New Atalantis* 'was probably the most effective attack on the Whigs at this time … [and] when Manley was imprisoned late in 1709 … it was for her considerable political nuisance-value'. However, her political satire, *Secret History of Queen Zarah and the Zarazians* (1705) was in many ways an even more unconcealed attack on the Churchills despite its camouflage as a scandalous French romance.[213]

Delarivier Manley's play *The Royal Mischief* was very successful and ran for six days at Lincoln's Inn Fields. It was a heroic love drama with an intricate plot. A lot of the action takes place in the exotic and imaginary castle of Phasia where a young woman, Homais, has been confined in the kingdom of Libardian. She is married to an impotent old prince, but has fallen in love with his nephew who is married to someone else. The Chief Visier, Osman, and his brother Ismael also attempt to woo Homais and her only trusted confidante is Acmat, a eunuch in

the castle. Homais ends up dead, but not before she has screamed at the Prince of Libardian '[t]hou dotard, impotent in all but mischief, | How could'st thou hope, at such an age, to keep | a handsome wife?'[214] Though intricately plotted, the writing of this play is tight and demonstrates Manley's competence as a writer. Of all of the playwrights to follow Behn, Manley was perhaps the most accomplished. A complex writer, her last play was a deeply nationalistic work of history called *Lucius, the First Christian King of Britain* (1717). Her complicated love life continued to the end of her life. She lived for the last few years with the unfaithful John Barber, a London printer, and died in 1724.

Delarivier Manley's only real woman rival in playwriting at the end of her life was Susanna Centlivre whose career as a writer was different again from those treated so far. Her debut was in the form of verse which went into a compendium volume called *The Nine Muses* which came out as a tribute to John Dryden at the time of his death in 1700. Her first play was a tragicomedy, *The Perjured Husband*, which was staged at Drury Lane and it was followed by at least 15 others written between 1700 and her death in 1723. Centlivre was more socially accepted than her contemporaries because she found early patronage from the Whig audience of the court of Queen Anne and her marriage to Joseph Centlivre, a minor official in the royal kitchen, protected her from scandal. Her plays had convoluted plots and played to good audiences on the whole. *The Gamester* of 1705 was particularly successful, as was *The Busybody* of 1709. The secret to Centlivre's success was that she took topical issues and played them to comic effect for a gossipy [mostly male] audience. *The Beau's Duel* of 1702, for example, featured fops in ludicrous situations. Lovers, gallants and heiresses trotted through her plays and topical farces such as *The Man's Bewitched* (1709) and *A Gotham Election* (1715) encouraged the audience to laugh at itself. Tory characters such as Sir David Watchum imprisoned women like Laura who tried to escape for the sake of love. Centlivre stuck close to the social world and literary tastes of her royal patrons supporting the Hanoverian succession and dedicating one of her most successful plays – *The Wonder: A Woman Keeps a Secret* (1714) – to George I.[215]

If one analyses 'the younger sisters' of Aphra Behn, what one finds is not a homogeneous group of female writers adhering either to the pejorative image as portrayed by the writer of *The Female Wits* of 1696 or the celebratory image of modern feminist literary scholars. Instead the group consisted of a playwright-philosopher (Trotter), a dabbler in writing tragedy and comedy for stage (Pix), an egotistical Tory journalist working in several idioms (Manley) and a conformist Whig who stuck closely to the needs of her audience of courtiers (Centlivre). In all four it can be said that in the act of using the stage to strike up careers they behaved in ways that were feminist. However, while some of their female characters showed independence and strength of character and their plots dissected gender relations, none of their writings was centrally concerned with the feminist issues of the day. All of them were like Aphra Behn in the sense that they used the world of London theatres as a point of entry to a writing career and they engaged in the public sphere culture of news, debate and partisan opinion.

Mary Astell and the feminists

Feminism in every age has a specific cultural context and set of meanings. The most important and influential late seventeenth-century feminist – Mary Astell – was a Tory, a monarchist and an Anglican loyalist. However, there were a few Whig women who wrote in feminist ways.[216] So what defines late seventeenth-century feminism? Essentially it had three features. First, it had at its core a debate about female education, its nature and social worth. Second, it was predicated on the assumption that there was a feminine perspective on the world and this led to a critique of the institution of marriage. Third, it rejected customary gender construction to legitimise for women what some writers called ambition, expressed sometimes as 'perfection', instead of inevitable corruption and the right to be heard or the right to a female voice. Underlying all three was the shifting philosophical debate about women's nature – the *querelle des femmes* – and rhetorical tracts about woman became linked to debates about education and marriage and women's writing, scholarship, place in the family and so on. Crucially, late seventeenth-century feminism featured women's entry into these debates; women essentially began complaining about their lack of an equal education with men, but later argued with one another about the relative benefits of being an educated woman or 'bluestocking'.

Two linked cultural events activated gender change – the booming print culture and women's increased entry into the world of print both as readers and writers. The more women wrote, the more they contributed to a process that Gerda Lerner once called 'women's authorization'.[217] The female voice developed in co-ordinated conflict with the debates and literary concerns of male authors. Men's debate about women's education was co-opted by women and turned into a feminist discourse that contributed to and ran parallel with the idea that women's conversation or speech was civilizing. The processes involved in this cultural change are difficult to pin down, but one factor was the transition from the belief that opinion was something corrupt *per se* (even feminine) to a public opinion that was expected to be integral to political culture. Fletcher has argued that there was a secularising backlash against the godly revolution and that this affected femininity. This is certainly a factor seen in the work of writers like Margaret Cavendish. However, the altered femininity of the late seventeenth century promoted simultaneously women's role in the private sphere of the morally-upright and Christian household and their voice in a more open and secular political society. Both roles were liberating and women exploited their newfound authority as role models at the moral centre of society and took up the challenge of entering public debate. They promoted religion, manners and politeness at home and through magazines, debating societies and churches and religious sects.

The collective authorisation of the female voice began with women's entry into the debate about women's education and there were several important texts by women that tackled the question. The first was Bathsua Makin's *Essay to Revive the Antient Education of Gentlewomen in Religion, Manners, Arts & Tongues* of 1673 which Myra Reynolds once called 'of great historical interest ... [because] it is the

first known attempt to organize a scheme of definite and solid study for girls'. Reynolds also pointed out that 'it was based on a novel and important conception of the value of genuine knowledge in languages and science for girls'.[218] Makin talked of a revival of women's Renaissance humanist learning and held up Queen Elizabeth I as an example of earlier feminine success. However, Makin's vision of female education was clearly more secular than the earlier Christian humanist concern with women's piety. Makin altered the Biblical idea of the woman as man's help-meet by introducing the notion of a woman's civilising influence through her 'constant conversation' as wife.[219] Makin was, at least accidentally, one of the late seventeenth-century 'moderns' in her thinking. She opened her text with a rejection of 'custom' which, she said, for some 'hath the force of Nature it self'. She went on to point out that only through 'custom' were women bred low when 'improvement by education' would be beneficial to all.[220]

Bathsua Makin was an interesting woman. Born in 1600, she spent her early life collaborating with her father at his school in St Mary Axe Street, in London. She was a linguist and educational theorist who wrote poetry in several languages – Latin, Greek, Hebrew. Sir Simonds D'Ewes described her at the time of her wedding in 1622 (to one of King James's courtiers) as 'being the greatest scholler, I thinke, of a woman in England'. Despite having seven children between 1623 and 1633 she came in demand at court to become tutor to Charles I's daughter, Elizabeth (later of Bohemia). During the 1640s and 1650s she continued to educate the children of the wealthy in London, despite having one further child quite late, in 1642. A widow from 1659, little is known about her activities in the 1660s, but her collaboration with Mark Lewis in opening a girls' half to his private school in Tottenham led to her writing her essay on female education.[221] Her reflections, therefore, came after a lifetime working in schools and privately educating girls. At the end of her tract was an advertisement for the school, outlining the education on offer as the basics 'ordinarily taught in other schools' – 'works, of all sorts, dancing, musick, singing, writing, keeping accompts [accounts]'. The last was in recognition of women's practical need for business management skills at home. However, for their £20 *per annum*, parents could also have their girls educated in Latin, French, Greek, Hebrew, Italian and Spanish in all of which Makin claimed 'a competent knowledge'. If they preferred, the girls could learn just one language combined with 'experimental philosophy', an indication of the extent to which the scholarly ambitions of Margaret Cavendish were shared – if not equalled – amongst women of her class.

The structure and argument of the *Essay to Revive the Antient Education of Gentlewomen* was rhetorical until the business-like end. It began with an address to 'all Ingenious and Vertuous Ladies' and argued that if women were educated their families and the nation would 'profit'. Makin appealed to them as perfectable 'creatures', or women who could 'polish your souls', and a preface to 'the reader' followed this by appealing to men with the argument that the woman who shakes off ignorance becomes more virtuous. This was followed by an epistolary argument, taking the objections to female education supposedly posed by a man and answering all of them in turn. Like a *querelle des femmes* defence text,

Makin provided a historical list of learned women from Zenobia onwards before arguing that 'the whole Encyclopedeia [*sic*] of Learning may be useful some way or other to them'. Makin argued her case for female education in every category of woman – unmarried, married and widowed – though her emphasis on the benefits of having an educated wife were a necessary selling point. If it has been 'against custom to educate gentlewomen' she argued, then '[b]ad customs ought to be broken, or else many good things would never come into use'. Interestingly, both the advertisement for her school and, therefore, the argument in favour of women's education were to be peddled through a coffee house on Tuesdays and a tavern on Thursdays.[222]

Bathsua Makin did not write in a vacuum. Ideas she suggested about how geography could be useful to women because it would help them to understand history exactly reflected the sort of learning that women born in the late seventeenth century went on to use in their travel journals, diaries, novels, political commentary and correspondence. Writing about the same time, in 1675, Hannah Woolley argued that 'Nature hath differed mankind into sexes, yet she never intended any great difference in the intellect'.[223] The idea that sexual difference did not, in itself, lead to differences of intellectual capacity was used by Makin and others to argue the case for female education. The debate was propagated within a circle of intellectual women; indeed within a female community of the kind imagined in Margaret Cavendish's *The Convent of Pleasure*. The place of religion in this education debate was never far from the surface, not least because of the critical role it had to play in the perceived social benefit of female education which was social 'improvement'. Hannah Smith has recently argued that women's 'improving' role in society was linked to concerns about stabilising the polity.[224] Therefore, feminism in the form of women's pro-education writing was embedded in a renegotiation of gender roles between men and women that forged a more prominent role for women in society to ameliorate political conflict and re-establish the religious *status quo*.

The second major text to appear on women's education written by a woman was Mary Astell's *A Serious Proposal to the Ladies for the Advancement of Their True and Greatest Interest*, published in two parts in 1694 and 1697. Astell came from an affluent mercantile background, her father making his money from Newcastle coal. Ruth Perry points out that Astell's education included the Cambridge Platonism of her uncle, Ralph Astell, who was a Church of England curate. When she came to London in the late 1680s she settled in the affluent area of Chelsea that was populated by the daughters of the rich in private schools.[225] In *A Serious Proposal to the Ladies* Mary Astell argued that women's 'incapacity, if there be any is acquired not natural' and she appealed to women 'to improve your Charms and heighten your Value' by concentrating attention not on 'a corruptible Body' because 'Your Glass [mirror] will not do you half so much service as a serious reflection on your own minds'. More than Makin, Astell hinted at the connection between social improvement and eternal reward in heaven. The curse of Eve's impact on female nature could be overcome by nurture. 'Custom, that merciless torrent that carries all before' has lead to 'ignorance and a narrow Education' which 'lay the

Foundation of Vice' in women. In the language of the 'modern' Astell cursed 'that Tyrant Custom ... [that] By an habitual inadvertancy we render ourselves incapable of any serious and improving thought'. Astell argued that learning the 'Principles and Duties of Religion' was not enough, and that women needed to gain a proper understanding of the 'Reasons and Grounds' of religion to acquire 'knowledge' and not just 'zeal'. In this way she upheld a rationalist Anglicanism in the face of others of her sex who 'having more Heat than Light' in their religion were led to sectarian excess. Astell suggested a 'retreat' or a 'seminary' to educate women out of 'that cloud of Ignorance, which Custom has involved us in'. Conformist religion and feminism, therefore, offered women whose lives were blighted by the dishonour that came with frivolous living new hope not only for their minds but for their souls. To a man, Astell offered the woman whose life was a model of 'ingenious Conversation [to] make his life comfortable'.[226]

Therefore, the case for female education turned on the concept of the civilising effect of women's speech on society.[227] Mary Astell's feminism in *Serious Proposal to the Ladies* of 1694 was identical in its intellectual and political assumptions to her *Letters Concerning the Love of God* of 1695. This work contained Astell's correspondence with John Norris, 'the last of the Cambridge Platonists'. In her *Letters* Astell outlined her belief that human pleasure and pain began and ended with God. The self-scrutiny and discipline implied in *Letters* was at one with her idea of a female retreat for the betterment of the female sex. She was primarily concerned with countering the overly rational treatment of God that she found in the work of John Locke and her aim was to make God 'the only worthy object of our love' which would be best attained in the case of women if they were dissuaded from narcissistic love of self and an overweening love of men.[228] In *A Serious Proposal* Part II of 1697 her thinking was taken further, as she pulled together contemporary philosophical opinion on the way knowledge came from God. She opposed the philosophy of *tabula rasa* of John Locke; the woman's mind was not a clean slate as such but rather inscribed with the imprint of God. She argued that women's improvement was thus dependent upon serious reflection about the moral purpose of women's lives. Education, then, would draw women away from frivolity and passion and the short-term pleasures of the senses, bringing them closer to a 'knowledge' that connected them with the divine and guaranteed their immortality.[229] *A Serious Proposal to the Ladies* conversed with the women already converted to female education. Astell, like Makin, argued for several advantages to be gained from education including women's wherewithal to reject fortune-seeking men. These were advantages with very real appeal to the capital-rich woman (and her family) of late seventeenth century London.

The philosophical debates and polemic about female education marked an irreversible change in the *querelle des femmes*. The early to mid-1690s witnessed not only Astell's contribution on the subject of women's power to change society. Tracts such as William Walsh's *A Dialogue Concerning Women, Being a Defence of the Sex* of 1691 and Nahum Tate's *A Present for the Ladies Being an Historical Vindication of the Female Sex* of 1692 blurred the boundaries between *querelle de femmes* and social prescription and were integrally tied to political debates emerging about

'breeding' and 'manners' in men.[230] Texts defending women rolled off the popular press. Timothy Rogers published his funeral sermon about Elizabeth Dunton in 1697, complete with a 'part of the Diary writ with her own hand'. The tract had a lengthy, prescriptive preface plus a list of historical 'good women' and the text of the sermon was the 'good wife' of Proverbs 31:10. The woman delineated by Rogers emulated Christ in her life and 'she strives to please God and her husband'.[231] Through this means a woman could lose the guilt of Eve's sin and gain immortality. Therefore, women were being offered an anti-Calvinist message about their own ability or freedom to determine their fate. However, the route to feminine freedom in *circa* 1700 was as a 'good wife' just as it had been in 1500.

Women were heavily engaged in the textual politics of education and marriage at the end of the seventeenth century, not only as writers but as readers. The increasing availability of printed books at an affordable price turned women into book owners which in turn encouraged individual thinking and the desire to join the print market.[232] As the print market was driven not by the conservative forces of gender construction but by profit, the potential for a large female readership encouraged the production of works aimed at women readers. Women's literacy grew so dramatically that anxieties surfaced about the dangers of women's reading. A woman reading to her children might signify traditional values, but a woman reading a romantic novel might indicate dangerous sexual liberation and a woman reading Homer might usurp male learned authority.[233] A woman who was reading occupied domestic space, but sat idle of domestic duty within that space. Reading allowed women to smuggle matters of public concern into private space. In a print of *circa* 1710, five women were represented as gathered around a table in a front parlour with a book open beside their tea tray. Two men surreptitiously peer through the window at the spectacle of women whose idleness is being excused by intellectual discussion. Ronald Huebert has argued that women's reading privacy was 'subject to invasion' by men in early-modern England, but men's power to dictate women's reading was limited.[234] Reading was conceptualised as performing different functions for men and women. For men it resulted in intellectual development, but for women reading became conceptualised as a source of bodily occupation and, therefore, potential bodily corruption.[235]

The topic of feminine corruption featured in sermons and polemical works which were answered by tracts such as *The Female Advocate* of 1700. In this the self-styled 'Eugenia' took issue with a sermon on the duties of wives preached by John Sprint on 11 May 1699. Following a short dedication to a woman, the author described herself as 'never yet came within the clutches of a husband', nor beautiful, nor rich, but learned in languages such as Greek and Latin. 'Eugenia' also claimed a wider education of 'Men and Manners' and she entered the debate about marriage in defence of women by calling marriage 'the House of Bondage'. The tract contained oblique references to Mary Astell – for example, 'the Lady that is Mr Norris's correspondent' – and spoke of the 'He-Brutes' that shackled women with their 'boundless limits' on the duties of wives. There were two main lines of attack on Sprint's argument. First, 'Eugenia' attacked the Biblical underpinning of the prescription of women's obedience, arguing, for example, that husbands

could not possibly have the same *jure divino* [divive right] to authority as Christ. Second, 'Eugenia' attacked Sprint's paradigm of marriage as one that crumbled under the weight of reason. Men who treated their wives like servants could not 'have any great opinion of their Persons or their Liberty'. Comfort for the man could not be gained from 'a slave sitting at his Footstool': 'I think it a much nobler Comfort to have a Companion'. The arguments common to *querelle des femmes* defences of women were used to share Eve's sin between man and woman, but the context was more secular with 'Eugenia' arguing a case against consigning women to 'Hell on earth' in marriage. Implicit in the argument about women not being turned into slaves in marriage was the feminist issue of female education. 'Ignorance is the Mother of all this Female Devotion', the author complained, before arguing that Sprint would have it 'that a Woman must not use her Reason so far as to judg[e] of the Laws that are pronounc'd to her'.[236]

The arguments of the more polemical works of feminism, such as *The Female Advocate*, tend to reveal the inseparability between education and marriage in debates about woman's nature and her role in society. On the one hand, education and marriage were spoken about in the same breath because of men's concern with the desirability (or not) of having an educated wife and on the other hand, women toyed with the dilemma of singleness and 'liberty' -*v*- marriage and slavery. *An Essay in Defence of the Female Sex* of 1696 argued that it was not the woman's 'Body' that needed discussion, but her mind, 'the Profit of which is the Improvement of Understanding'. There has been some discussion over who wrote *An Essay in Defence of the Female Sex* (it is signed 'by a Lady') and it was once thought to have been published anonymously by Mary Astell, in part because it was listed in Locke's library under 'Astell'.[237] It is now commonly believed to have been written by a woman called Judith Drake and Bridget Hill's biographical sketch of her suggests she was the wife of physician James Drake.[238] The content of the text alone does not firmly suggest a woman author rather than a male 'ventriloquist' writing mischievously. However, whether by a woman – either Drake, Astell or someone else altogether – or a man *incognito*, the arguments clearly enter the debate as both a defence of women and a playful attack on men. 'I shall not enter into any dispute, whether Men, or Women, be generally more ingenious, or learned', argued the author (disingenuously), because 'that Point must be given up to the advantages Men have over us by their Education, Freedom of Converse, and variety of Business and Company'. In other words, it was nurture and not natural superiority that gave men advantage and the author ended with the suggestion that because women offered great conversation there was nothing to stop them writing.

Hannah Smith has pointed out that *An Essay in Defence of the Female Sex* was defined by a rationalist argument that rejected nitpicking about the long line of 'illustrious ladies' in history.[239] However, it was also a work of rhetoric, entering 'the battle of the books' on the side of the 'moderns' against the 'ancients' not just in the name of rationalism but also to poke huge fun at 'Pedants and School-Boys' and make the case for female 'wit'. Men's improvement, according to the author could be attained through 'the Society of Women'; indeed, improvement and

understanding were ends that could 'be met with in the Conversation of Women' and this 'in greater measure than in men's'.[240] Thus, by focusing attention on the female mind, women's advantage could be gained through ridicule of men. In attacking men *An Essay in Defence of the Female Sex* went beyond the old paradigm of defence works of the *querelle des femmes* opening up a new arena of debate that could be termed a *querelle des hommes*. By contrast Mary Astell's work was more obviously a direct appeal to women. For example, *A Serious Proposal to the Ladies* Part II claimed 'a further perswasive to the Ladies to endeavour the improvement of their minds' and asked 'can you be in love with servitude and folly?'. 'I dare say you understand your own interest too well to neglect it so grossly', she said, 'and have a greater share of sense, whatever some men may affirm, than to be content to be kept any longer under their Tyranny in Ignorance and Folly'. 'It is in your power to regain your freedom, if you please but t'endeavour it', she argued.[241] Thus, Astell brought the issue of women's freedom from the power of men to the fore in Part II of *A Serious Proposal*, whereas Part I had spoken more of the delivery of women 'from the tyranny of custom'.[242] Placing men and 'custom' together as 'tyrants' forced rationalist man onto the back foot and made a direct appeal to the educated woman whose view of marriage and gender relations began to turn on how far they were willing to behave submissively.

Alessa Johns has argued that the essence of Mary Astell's feminism was expressed in her utopian thinking. Utopian visions of a world in which women were better educated and not enslaved by the gender construction of wife, then, are what define late seventeenth-century feminist thought, rather than just the rhetoric that blurred into *querelle des femmes*. Quite rightly Johns points out that 'nearly all utopian writing concerns itself with questions of love, friendship and marriage' in a perfect society, and herein lies the link not only with Astell's concern with female community, but also the need for perfected marriage partnerships.[243] In *Some Reflections Upon Marriage* (1700) Astell grappled with the real temporal world, whereas Margaret Cavendish had envisaged a utopian world that ran parallel to the real in *The Description of a New World, Called the Blazing World*. *Some Reflections Upon Marriage* was prompted by the high-profile divorce case of the duke and duchess of Mazarin and Astell's anxieties about social breakdown can be seen in her conclusion that because the marriage contract required total submission from women, any man chosen for a husband needed to be morally incorruptible because of his position of power.[244] Argued from the beginning was the case that education kept women in a state of ignorance, though here Astell also argued that 'Want of Learning' led women to be ignorant even of the fact that 'the Natural Inferiority of our Sex' was something 'our Masters lay down as Self-Evident and Fundamental Truth'. *Some Reflections Upon Marriage* was a blunt work that was cynical about men. Astell argued that men pretended enslavement to women before marriage as a strategy designed to make them captive. Her vision of marriage as commonly practiced was cynical too: 'Men have little reason to expect Happiness when they Marry only for the Love of Money, Wit or Beauty,' she argued, before noting that under such circumstances a woman ended up with 'the harder bargain' because she 'Elects a Monarch for Life ... [and puts] her

Fortune and Person entirely in his Powers'. Under the circumstances of marriage law in 1700, a woman cannot 'make a Fool her Head...for Covenants betwixt Husband and Wife, like Laws in an Arbitrary Government, are of little Force, the Will of the Sovereign is all in all'. 'Governors do not often suffer their Subjects to forget Obedience through their want of demanding it,' she warned her female readers.[245]

Mary Astell was first and foremost a writer of political thought. Her other works such as *A Fair Way with the Dissenters* and *An Impartial Enquiry into the Causes of Rebellion* both of 1704 set out her ideas on religion, war and state. Thus her reflections on sexual politics and the power distribution in gender relations were just one aspect of her broader thinking about power in society arising from her own experience as a woman. In *Some Reflections Upon Marriage* she argued that 'Power does naturally puff up, and he who finds himself exalted, seldom fails to think he ought to be so'.[246] Astell's deployment of the example of corrupting absolute rule indicates the degree to which late seventeenth-century feminism rode on the back of, but needed also to be separate from, Tory and Anglican politics. Notions of absolute rule were, after all, Whig obsessions predicated on long memories of the tyranny of King Charles I and his sons. Hannah Smith has pointed out that Anglicans promoted the education of women because 'they saw women as vital to the continuation of the Church of England'. Indeed, 'a fully "feminized" society could ensure a Tory, Anglican one'.[247] Astell was a Tory, but not one uncomplicated by a specific and self-conscious female perspective. In other words, Toryism itself was gendered and a further feature of late seventeenth-century feminism was its unprecedented capacity for permanently gendering political party and language.

Mary Astell died in 1731. Her work was genuinely feminist. At the end of *Some Reflections Upon Marriage* she closed with the dual observation that she had tried to do 'Justice' to 'the Female Reader' having 'said more than most Men will thank me for'.[248] Certainly Astell was the first woman political writer to have a considerable impact on the thinking of her contemporaries. She reflected and created the new female mood or moment that led Amey Hayward in *Female Legacy* of 1699 to urge women not to 'spend away your day of grace' but pay attention to your soul, 'value [it] at a higher rate' through 'labour'.[249] The impact of late seventeenth-century feminism was a questioning brand of femininity. Anne Finch (*née* Kingsmill), countess of Winchelsea, confided in her diary that she thought it was odd that reading, writing or thinking in a woman was thought to 'cloud [her] beauty and exhaust [her] time'. 'Happy the race of men! | Born to inform or to correct the pen' she complained, 'Whilst we beside you as cyphers stand | To increase your numbers and to swell th'account | Of your delights which from our charms amount.'[250] Lady Mary Chudleigh allowed her questioning verse into the public domain with *The Ladies Defence* in 1701: ''Tis hard we should be by the men despised | Yet kept from knowing what would make us most prized':

> Debarred from knowledge, banished from the schools
> And with the utmost industry bred fools;
> Laughed out of reason, jested out of sense,

And nothing left but native innocence,
Then told we are incapable of wit,
And only for the meanest drudgeries fit;
Made slaves to serve their [men's] luxury and pride...[251]

She continued her theme in 'To the Ladies' published in *Poems on Several Occasions* (1703) in which she warned women [in verse] to shun 'that wretched state' of marriage which she described as a form of slavery from the time the woman said the word obey. 'Wife and servant are the same' she complained, 'But only differ in the name... And man by law supreme has made'. The male tyrant, thus, became what might be called a *querelle des hommes* model of the 'bad man'. Marriage she described as a state of fear for women because it turned a man into a woman's 'god'.[252]

Therefore, by the end of the seventeenth century it is possible to identify not only a female voice that is self-conscious and concerned directly with the experience of women, it is also possible to identify the main feminist issues as education and marriage and conclude that women contributed their views on these subjects both in public and in private. In Astell's poem *Ambition* of 1684 she spoke of a glory and immortality that could put her beyond 'Mean spirited men'. 'How short's their immortality!' she claimed before saying: 'But oh a crown of glory ne'er will die | This I'me ambitious of'. Thus, she laid a claim to ambition, a characteristic that rejected old (male) prescriptions of femininity, and she linked feminism with the Enlightenment vision of feminine perfection evidenced by God's glorification of the soul.[253]

Conclusion

There can be no doubt that a qualitative difference existed between the world of learning and literature for women in 1500 and the one that existed in 1700. In 1500 a small number of women received a convent education. For some women during the sixteenth century this convent education was replaced by a rigorous Classical/Christian humanist education within the home. However, in 1600 there was no expectation that women would participate in the knowledge culture or intellectual debates of the age. There were women writers of the sixteenth century – but not many of them – and their range was limited. In court circles some opportunities existed for the educated talented woman like Mary Sidney to flourish and contribute to an essentially male literary culture, but no female voice entirely and separately existed in the age of Shakespeare. The imaginary 'Judith Shakespeare' was much better educated than modern feminists once believed, but constraints of piety, puritanism and sexual modesty acted powerfully to confine her within certain intellectual parameters. The hegemonic discourse was masculine and patriarchalism had its reflection in the reality of both a male world of print and the social subordination of women.[254]

However, by the end of the seventeenth century a more secular and all-round formal education reached larger numbers of women and the Classical Renaissance

methods of scholarship were rejected by the 'moderns', or those early philosophers in an Enlightenment discourse that emphasised reason. If religion liberated some women to write and publish, so too did the Enlightenment quest to collect, collate and catalogue facts. Cassandra Willoughby, without any training beyond her girl's education, became one of the first female historical writers using archival sources to write her family history, and Celia Fiennes recorded her journeys to the South of England between about 1685 and 1696 as well as her later travels to London, the West Country and the North between 1697 and 1703. Fiennes wrote not only of the history and mythology of Stonehenge, but also domestic architecture, occupations, geology, copper mining and so on. The colour of the River Humber interested her more than the romantic anecdotes that dominated the writing of some of her female contemporaries. Elizabeth Elstob turned her education into an intellectual interest in the hard facts of the Saxon language and the homilies of Alfric.[255] What sets these women apart as writers from the women writers of Chapter 6 is that their writing was not, in any way, framed within a religious *mentalité*.[256]

Between 1600 and 1700 there were 231 published women writers, mostly after 1650, suggesting considerable change in the late seventeenth century that led to the early bluestockings of the Enlightenment.[257] When Katherine Chidley wrote *Justification of the Independent Churches* in 1641 the minister William Greenhill called her work 'clamorous' and simplistic and when Elizabeth Avery produced a book of Scriptural prophecies in 1647 her brother complained that 'your printing of a book, beyond the custom of your sex, doth rankly smell'. Indeed, when Sarah Jinner published an almanac in 1658 she did so with a sense of her uniqueness. However, Mary Trye was able to say of her medical advice book, *Medicatrix*, in 1675 that 'it is of little novelty to see a woman in print'.[258] What were the processes by which this change took place so that women's participation in knowledge culture and the world of the printed word had at last become open to negotiation between the sexes? How did the female voice become established within what had been an exclusively male cultural terrain? Several answers to this question can be tentatively suggested. First, education became a feminist and not a humanist issue, still tied to gender prescription but colonised by the voice of a small number of women intellectuals. Second, women's writing (and, therefore, public female speech) gained legitimacy through several factors including the authorisation of a female subject position and changes in the religious culture of England that ultimately lent women authority to write in the secular idiom. Third, women's writing gained legitimacy through the gender-inclusive nature of printed political gossip and news exchange and through the dynamics of a growing commercial print culture. Several historians interested in literary culture including Carol Barash, Steven Zwicker and Paula Backsheider have pointed out the importance of the reconstruction of mutually-informing political and literary cultures in Restoration England that heralded a public sphere of opinion which included a female voice.[259]

There is a *caveat* to this vision of progress. It is a mistake to see such cultural changes in the late seventeenth century as simply representing a linear move

forwards for the female sex. John Brewer has warned that '[c]onstraints are not removed by the emancipatory culture of the printed or public word; they are changed', and it can be argued that print not only broke down male dictation of femininity, it accelerated the pace at which men could write works of prescription. It accelerated also women's collusion in a gender-specific informal education that inclined them to read romances rather than natural philosophy and magazines for ladies rather than Latin and grammar.[260] The social and sexual subordination of women continued with a different set of parameters after 1700, but equally the cultural and gender changes that took place were far-reaching because they allowed for a discourse of genuine gender role negotiation between the sexes. Lawrence Klein has argued that 'traditions of civility and civil conversation' that emerged with the notion of 'polite society' at the beginning of the eighteenth century, placed the female voice in the centre of a culture of so-called politeness that valued an educated gender training for women.[261] Indeed, the meta-language of politeness was so 'organised around the concern with form, sociability, improvement…and gentility' that it not only included women, but it could not exist without them.[262] The female voice contained within it an autonomous feminist voice arising out of access to education. However, late seventeenth-century feminism was one voice amongst many, because the female voice, once truly gained, liberated by print and free of the hegemony of male prescription, reflected a more self-defining femininity that ultimately became multiple in both its social and religious identity.

Conclusion: Femininity Transformed

'Vain man is apt to think we [women] were merely intended for the world's propagation and to keep its human inhabitants sweet and clean' complained Hannah Woolley in 1675. The interest value of this statement lies not in what is observed but in the fact that Woolley observed it all. It is a bold statement, critical about male prescription of the social role of women and about the audacity of men. Woolley continued: 'Nature hath differed mankind into sexes, yet she never intended any great difference of the intellect.'[1] This one sentence encapsulates the one critical change to femininity that occurred between 1500 and 1700. At the beginning of the period women's minds were thought to be enfeebled and embraced within a body that was imperfect, even unfinished because lacking the heat that had the power to transform the body into that of the classic active and contemplative Renaissance man. Biblical and Aristotelian ideas about the female body ensured that women became captive to their reproductive role in society, a role that brought for early-modern women over the entire period pleasure, pain, work and female bonding. In this sense, many women experienced life as an embodied journey tied up with maternity as well as loss and grief. By 1700 Cartesian philosophical separation of body and mind coincided with the new medical vision of two sexes to create a woman who was potentially as intelligent as man, with a mind that was freed from uterine control. There were traces of the earlier construction, for example, in the continuing association of the female sex with madness and men still feared women's potential equality of intellect. The woman educationalist Bathsua Makin said men regarded the learned woman as 'a comet, that bodes mischief, whenever it appears', though she turned it around on the male sex, arguing that this was because men believed in magic. Men fear, she said, that to 'offer to the world the liberal education of women is to deface the image of God in man' and indeed her contemporary, Mary Astell, was arguing that women could do just that through learning – refine their female minds to bring them closer and closer to the perfection that was God.[2]

What was femininity? One answer is that it was a cultural construction that had several parts which included prescription of the ideal woman, women's levels of uptake of prescription that took place outside of their female experience and feminine self-definition that was both individual and collective. It can be argued

that such was the strength of patriarchy in 1500, underpinned by the Bible and law, that men dominated the debate about the ideal woman (as well as the debate about her opposite) and that male-determined femininity strongly determined women's behaviour. There is some evidence that patriarchal domination of women was unchanged in 1700. Late seventeenth-century conduct books continued to stress the need for female modesty of apparel and behaviour, and, crucially, sexual purity; at a time when men's sexual behaviour became freer, women's reputation continued to depend on strict moral conduct. Anthony Fletcher has argued that this demand on women strengthened patriarchy and made women captive to men through the institution of marriage. There is also some evidence that women's claim to political authority diminished and some changes at law favoured men's property rights.

However, as prescription is just one element of femininity one needs to examine also its uptake by women. Mostly women embraced the role of pious and good wife. Fletcher has argued that this was because by 1700 their role was framed as an inherently positive one, rather than a set of demands previously placed on women to make them shake off the sins off Eve.[3] However, examination of the work of spokeswomen for female education and feminist critics at the end of the seventeenth century suggests that women themselves stridently advocated this element of pious femininity because they saw it as a way for women to reject the sins of men. The secularised religious model of womanhood outlined in Richard Allestree's *The Ladies Calling* of 1673 was not too different from the purity of intellectual and godly pursuit that Mary Astell envisaged for women in *A Serious Proposal to the Ladies* of 1694. However, whereas Allestree wanted a world filled with good wives, Astell envisaged a world in which women could escape the tyranny of bad husbands.

Construction of gender was relational in early modern England and it is, therefore, important to juxtapose the new religious femininity with changes in masculinity. The result is instructive. Masculinity too became freer of the constraints of Biblical law. The uptake by women of the role of sexual rectitude was not just a continuation of old puritan piety; it was a reaction against a reconstructed bawdy masculinity that placed good women in danger of becoming one of the 'ladies' and courtesans of the late Stuart court and playhouse. How did the erosion of masculine sexual morality come about? At the heart of the answer is the Civil War, for two reasons. First, the godliness and religiosity of the 1640s and 1650s created its own antithesis in the bawdy political rhetoric written by men to attack other men. During the Civil War and Restoration use of the term whore in the titles of political tracts increased dramatically.[4] As a term it swallowed whole the profanity and uncleanness of 'harlot' and 'jade' and 'queen', increasing its rhetorical power as a word and embedding negative femininity in political discourse.[5] Second, Charles II and James, duke of York, returned from France with a very different morality from their father and grandfather. *Querelle des femmes* constructions of the bad woman and good woman – or the 'whore' and the 'maid' – became twisted into expressions of an anti-morality exemplified in pamphlets and poems like John Wilmot's *Poems on Several Occasions* (1680) which described the 'whore'

as having a 'modesty' that 'is insolent', her 'cunt a common shore'.[6] Wilmot was the second earl of Rochester, a debauched courtier whose life of sexual scandal was fused with his political life. Janus-faced use of the term 'maiden' popped up in tracts everywhere using the model of the young and virtuous woman to joke about male inconstancy. Thus, the woman who was the 'whore' became the short-hand expression for a negative masculinity. The author of *The Maid's Complaint against the Batchelors* pretended to be a woman complaining about men shunning marriage because it 'forc[ed]...ripe and willing virgins to spin [into] miserable lives'. In *The Maidens Complaint against Coffee* (1663) the young 'maid', Dorothy, is heard to say 'before I'le fling myself away upon any such dry horson [man] as drinks coffee, I'le wrap my maidenhead in my smock and fling it into the ocean to be bugger'd to death by young lobsters'.[7]

Women writers responded to this altered gender representation partly just because they were able to in a world that featured their better functional education and literacy. The public sphere of print drew in female readership and participation as publishers, booksellers and writers. Female culture was, therefore, less hermetically sealed in 1700 than in 1500, bringing the two sexes into greater dialogue with each other about politics and about gender and gender relations. This allowed women their equivalent of the *querelle des femmes* in a sort of *querelle des hommes* which was obliquely pursued in tracts that were defences of women written by women. Women's own prescription of a collective femininity became more self-defining and their self-prescription came into greater dialogue with prescription of femininity by men. Therefore, if patriarchy was still firmly in place as a social and legal construct, its intellectual foundations and processes of masculine-only reproduction were seriously eroded by 1700. The evidence for this can also be found in the language of feminism that arose out of and was in dialogue with political thought and philosophy, especially the work of the 'moderns' and the contract theorist, John Locke. Histories of political thought urgently need some revision using gender analysis. Tory feminists, most notably Mary Astell, deployed the Whig rhetoric against slavery and tyranny to build their case against what they described as the 'absolute monarchy' of the husband at law. Therefore, femininity had at least two prescriptive and discursive strands by 1700 – the saintly woman of male (and to some extent female) prescription of femininity and the feminist critique of woman as man's slave nurtured in ignorance. However, there was also a third strand that ran into the complex femininity of the late seventeenth century, one that drew on old constructions of women as weak receivers and transmitters of God's word that transformed women into God's warriors during the Civil War and liberated the female religious voice from the Pauline prescription of women's silence in the church. This final thread recast the intellectual foundations of masculine religious structures, replacing them with women's visions of spiritual equality with men and even, at least in Jane Lead's case, to a regendering of God as female.

Patriarchy in 1700, then, was only strong in the sense that women were imagined as the moral centre of society residing in the private sphere and the law twisted and turned to keep them physically there through the institution of

marriage. However, in reality women were no longer so effectively excluded from the world of wide public sphere political debate and they continued to work outside the home, as they always had done. Therefore only in some respects was patriarchy more firmly in place.[8] Its intellectual foundations were in disrepair by 1700 and it was doomed to failure as a consequence. The feminist strand of femininity that emerged like a phoenix from the ashes of the puritan moment of the civil wars complained about the treatment of women not just because it fought against the injustices of patriarchy – it put up a fight because women held the moral high ground in a public sphere that was so porous women could not be excluded with the consequence that women themselves detected patriarchy's future demise.

Notes

Introduction: Contextualising Early-Modern Women

1. See Simone de Beauvoir, *The Second Sex* (Gallimard, Paris, 1949).
2. Margaret Mead, *Sex and Temperament in Three Primitive Societies*, (Routledge, London, 1935); Clifford Geertz, *Interpretation of Culture* (L. Hutchinson, London, 1975).
3. Natalie Zemon Davis, 'Women's History in Transition: the European Case, *Feminist Studies*, 3 (1976); Joan Wallach Scott, 'Gender: A Useful Category of Historical Analysis' in *Gender and the Politics of History* (Columbia University Press, New, 1988) and see also Joan Wallach Scott, *Feminism & History* (Oxford University Press, Oxford and New York, 1996).
4. Michel Foucault, *The History of Sexuality* (trans. Robert Hurley, Vintage, New York, 1990).
5. Cf. Wendy K. Kolmar & Frances Bartkowski (eds), *Feminist Theory: A Reader* (McGraw Hill, New York, 2005), pp. 45-7.
6. Patriarchy has been defined by different historians in different ways. For example, John Tosh has defined it as 'the power of the household head over his wife and children and, by extension, the power of men over women more generally' – John Tosh, *The Pursuit of History: Aims, Methods and New Directions in the Study of Modern History* (Longman, Harlow, 1999), p. 4. All historians accept the essential element of systemic male domination of women while arguing over its economic and social roots and causation and capacity for change.
7. Gerda Lerner, *Creation of Patriarchy* (Oxford University Press, New York, 1988).
8. For social histories of women see Anne Laurence, *Women in England 1500–1760: a Social History* (Weidenfeld and Nicolson, London, 1994); Jacqueline Eales, *Women in Early Modern England 1500–1700* (UCL Press, London, 1998); Sara Mendelson and Patricia Crawford, *Women in Early Modern England* (Oxford University Press, Oxford and New York, 1998). See also Christine Peters, *Women in Early Modern Britain 1450–1640* (Palgrave, Basingstoke, 2004).
9. See Judith Bennett, '"History that Stands Still": Women's Work in the European Past', *Feminist Studies*, 14:2 (1988) and 'Misogyny, Popular Culture and Women's Work', *History Workshop*, 31 (1991).
10. Linda Kerber, 'Separate Spheres, Female Worlds, Woman's Place: The Rhetoric of Women's History', *Journal of American History*, 75 (1988); Carroll Smith-Rosenburg, 'The Female World of Love and Ritual: Relations between Women in Nineteenth-Century America', *Signs*, 1 (1975). Cf. Judith Butler, 'Subjects of Sex/Gender/Desire' from *Gender Trouble* (Routledge, New York, 1999) reproduced in abridged form in *Feminist Theory: A Philosophical Anthropology* eds Ann E. Cudd and Robin O. Andreasen (Blackwell, Malden, Massachusetts, 2005).
11. Joan Wallach Scott, 'Gender: A Useful Category of Historical Analysis' in *Gender and the Politics of History* (Columbia University Press, New, 1988), pp. 42 ff.
12. For power sees various essays in Joan Wallach Scott (ed.), *Feminism & History* (Oxford University Press, Oxford and New York, 1996) and Victoria Robinson and Diane Richardson (eds), *Introducing Women's Studies* (2nd ed., Palgrave, Basingstoke, 1997). For association of men with high politics and historical fact see Bonnie G. Smith, *The Gender of History: Men, Women and Historical Practice* (Harvard University Press, Cambridge Massachusetts, 1998). For a general discussion of power see Amanda L. Capern and Judith Spicksley, 'Introduction' in *Women, Wealth and Power*, Special Issue, *Women's History Review*, 16:3 (2007).

13. This is not a new finding, but the chapter represents a lengthy new consideration of the phenomenon. See, for example, Keith Thomas, 'Women and the Civil War Sects', *Past and Present*, 13 (1958), pp. 42–62. I only privilege Thomas because he was one of the first with the observation, but the historiography on women's role in the Reformation and civil war sectarian activity is vast and can be found in full in Chapter 6.

14. It was so refreshing to hear Elaine Showalter say this for nineteenth-century American women writers at a public lecture she gave at Hull University on 25 April 2007.

1 Woman: Intellectual Foundations

1. See N. H. Keeble (ed.), *The Cultural Identity of Seventeenth-Century Woman: A Reader* (Routledge, London and New York, 1994); Kate Aughterson (ed.), *Renaissance Woman: Constructions of Femininity in England* (Routledge, London and New York, 1995), Joan Larsen Klein, *Daughters, Wives, Widows: Writings by Men about Women and Marriage in England 1500–1640* (University of Illinois Press, Urbana, 1992) and Suzanne Hull, *Women According to Men: The World of Tudor-Stuart Women* (Altamira Press, Walnut Creek, London, New Delhi, 1996). For an anthology that attempts to bring together ideas about woman from the female perspective see Patricia Crawford and Laura Gowing (eds), *Women's Worlds in Seventeenth-Century England: A Sourcebook* (Routledge, London and New York, 2000).

2. Gillian Clark, 'Adam's Engendering: Augustine on Gender and Creation', *Gender and Christian Religion* ed. R. N. Swanson, Papers read at the Ecclesiastical History Society 1996–7 (The Boydell Press, 1998), pp. 13–22 citing *Confessions* 13, xx, 28.

3. Cf. Merry Wiesner, *Women and Gender in Early Modern Europe* (Cambridge University Press, Cambridge, 1993), pp. 10–11; cf. Olwen Hufton, *The Prospect before Her: A History of Women in Western Europe I: 1500–1800* (Harper Collins, London, 1995), pp. 26–7; Margaret R. Sommerville, *Sex and Subjection: Attitudes to Women in Early-Modern Society* (Arnold, London and New York, 1995), pp. 26–8.

4. Cf. Wiesner, *Women and Gender in Early Modern Europe*, p. 11.

5. *Finch His Alphabet, or, A Godly Direction Fit to Be Perused of Each True Christian* (London, *circa* 1635) cited in Margaret Spufford, *Small Books and Pleasant Histories: Popular Fiction and Its Readership in Seventeenth-Century England* (Methuen & Co., London, 1981), p. 237.

6. Hufton, *The Prospect before Her*, pp. 24–7.

7. Joseph Swetnam, *The Arraignment of Lewd, Idle, Froward and Unconstant Women* (London, 1615) reprinted in Katherine U. Henderson and Barbara McManus (eds), *Half humankind: Contexts and Texts of the Controversy about Women in England, 1540–1640* (University of Illinois Press, Urbana and Chicago, 1985), pp. 193–4. John Marston, *The Insatiate Countess* in the *Works*, ed. A. H. Bullen (John C. Nimmo, London, 1887), iii, 199 cited in Katharine M. Rogers, *The Troublesome Helpmate: A History of Misogyny in Literature* (University of Washington Press, Seattle and London, 1966), p. 125; John Brinsley, *A Looking-Glasse for Good Women* (London, 1645), p. 3 cited in Chilton Latham Powell, *English Domestic Relations 1487–1653: A Study of Matrimony and Family Life in Theory and Practice as Revealed by the Literature, Law and History of the Period* (Columbia University Press, New York, 1917), p. 151.

8. Swetnam, *The Arraignment of Lewd, Idle, Froward and Unconstant Women* in Henderson and McManus (eds), *Half humankind*, p. 193; Marston, *The Insatiate Countess* in *Works*, ed. Bullen, iii, 199 cited in Rogers, *The Troublesome Helpmate*, p. 125; Brinsley, *A Looking-Glasse for Good Women*, p. 3 cited in Powell, *English Domestic Relations 1487–1653*, p. 151.

9. Ian Maclean, *The Renaissance Notion of Woman: A Study in the Fortunes of Scholasticism and Medical Science in European Intellectual Life* (Cambridge University Press, Cambridge, 1980), pp. 17–18 citing Leviticus 12:2–5; Leviticus 15:19–27.

10. 'The Form of the Solemnization of Matrimony', *Book of Common Prayer*, reprinted in Keeble (ed.), *The Cultural Identity of Seventeenth-Century Woman*, pp. 122, 124–5.

11. *Finch His Alphabet* cited in Spufford, *Small Books and Pleasant Histories*, p. 237.

12. A feminist reading of this is Megan McLaughlin, 'Gender Paradox and the Otherness of God', *Gender and History*, 3:2 (1991), pp. 147–159. McLaughlin suggests that God's use of women in Biblical texts was a way of 'convey[ing] information on the sacred – the otherness of women informed the otherness of God'. In other words God's use of the 'weaker vessel' was a parable about the mysterious way in which God worked in the world of *men*.

13. The Biblical text for the 'weaker vessel' was 1 Peter 3:7 – 'Likewise you husbands, live considerately with your wives, bestowing honour on the woman as the weaker sex, since you are joint heirs of the grace of life.' This message was used in the early-modern marriage service, combining as it does notions of spiritual equality with a husband's duty of love that is based on his superiority and the common conception of women's 'weakness' from which was deduced female lack of reason. See also Maclean, *The Renaissance Notion of Woman*, p. 9; the Biblical text for women's salvation being linked to the birth of children was 1 Timothy 2:15 – see Maclean, *The Renaissance Notion of Woman*, p. 13.

14. See for example John S. Coolidge, *The Pauline Renaissance in England: Puritanism and the Bible* (Clarendon Press, Oxford, 1970), *passim* and Rosemary Agonito, *History of Ideas on Woman: A Source Book* (Perigee, 1977), pp. 69–72 and Charles Seltman, *Women in Antiquity* (Thames and Hudson, London and New York, 1956), pp. 184–8 reprinted in Susan Groag Bell (ed.), *Women from the Greeks to the French Revolution* (Stanford University Press, Stanford California, 1977), pp. 79–83.

15. 1 Corinthians 11:3–10 (from the 1611 authorised translation, reprinted in Aughterson (ed.), *Renaissance Woman*, pp. 13–14).

16. Ephesians 5:21–24 (reprinted in Aughterson [ed.], *Renaissance Woman*, p. 15); Colossians 3:18.

17. 1 Corinthians 14:34–35; 1 Timothy 2:11–14; Proverbs 31:10–28 (from the 1611 authorised translation, reprinted in Aughterson [ed.], *Renaissance Woman*, pp. 13–15).

18. 'The Form of the Solemnization of Matrimony', *Book of Common Prayer*, reprinted in Keeble (ed.), *The Cultural Identity of Seventeenth-Century Woman*, p. 125; the relevant text was 1 St Peter 3:1–6.

19. Sommerville, *Sex and Subjection*, p. 31.

20. Relevant sections are reprinted in Agonito, *History of Ideas on Woman*, pp. 75–80 from *Works of Aurelius Augustine*, trans. Marcus Dods (T. & T. Clark, Edinburgh, 1871), i , 12, 14, 19. Some of what follows is drawn from this source.

21. See Susan Dwyer Amussen, *An Ordered Society: Gender and Class in Early-Modern England* (Columbia University Press, New York, 1988), esp. chpts, 2, 4 and Anthony Fletcher and John Stevenson (eds), *Order and Disorder in Early-Modern England* (Cambridge University Press, Cambridge, 1985), esp. chpts. 4, 7.

22. Graham Gould, 'Women in the Writings of the Fathers: Language, Belief and Reality', in *Women in the Church*, eds W. J. Sheils and Diana Wood, Studies in Church History, 27 (Oxford University Press, Oxford, 1990), pp. 1–5, 7.

23. Rogers, *The Troublesome Helpmate*, pp. 14–22 – reprinted in Bell (ed.), *Women from the Greeks to the French Revolution*, pp. 84–9.

24. Gould, 'Women in the Writings of the Fathers', pp. 2–4 citing John Chrysostom, *Homilies on Romans*, 30 and 31, PG, cols. 661–76.

25. Rogers, *The Troublesome Helpmate*, pp. 14–22 – reprinted in Bell (ed.), *Women from the Greeks to the French Revolution*, pp. 84–9.

26. The context was a sermon on marriage, divorce and chastity; in other places Gregory of Nazianus called Eve 'mother of sin'. See Gould, 'Women in the Writings of the Fathers', p. 8 citing Gregory of Nazianus, *Oration*, 37:7, PG 36, col. 289C and 8:14, col. 805C.

27. Jane Tibbetts Schulenburg, 'The Heroics of Virginity: Brides of Christ and Sacrificial Mutilation', in *Women in the Middle Ages and the Renaissance: Literary and Historical Perspectives*, ed. Mary Beth Rose (Syracuse University Press, Syracuse, 1986), pp. 29–72.

28. Eamon Duffy, *The Stripping of the Altars: Traditional Religion 1400–1580* (Yale University Press, New Haven and London, 1992), pp. 171–183 and 'Holy Maydens, Holy Wyfes: The Cult of Women Saints in Fifteenth and Sixteenth Century England', *Women in the Church*, eds Sheils and Wood, pp. 175–196.

29. Agonito, *History of Ideas on Woman*, p. 91.

30. See, for example, John Knox, *The First Blast of the Trumpet against the Monstrous Regiment of Women* (1558) reprinted in Marvin A. Breslow (ed.), *The Political Writings of John Knox* (Folger Books, Washington, 1985).

31. Knox, *First Blast of the Trumpet against the Monstrous Regiment of Women* (1558).

32. Bell, *Women from the Greeks to the French Revolution*, p. 132; Hufton, *The Prospect before Her*, p. 28.

33. Bell, *Women from the Greeks to the French Revolution*, p. 132.

34. Olwen Hufton presents a less optimistic picture, arguing that women were told from the pulpit that Mary was 'alone of all her sex…She was not and never could be a model', only her traits of chastity, silence, obedience *and* suffering could be emulated by women – Hufton, *The Prospect before Her*, p. 28; cf. Maclean, *The Renaissance Notion of Woman*, p. 23.

35. Phyllis Mack, *Visionary Women: Ecstatic Prophecy in Seventeenth-Century England* (University of California Press, Berkeley, Los Angeles and Oxford, 1992), p. 18.

36. Maclean, *The Renaissance Notion of Woman*, p. 23.

37. See Christopher Haigh, *The English Reformation Revised* (Cambridge University Press, Cambridge, 1987); Tessa Watt, *Cheap Print and Popular Piety, 1550–1640* (Cambridge University Press, Cambridge, 1991).

38. Helen Hackett, *Virgin Mother, Maiden Queen: Elizabeth I and the Cult of the Virgin Mary* (Macmillan, Basingstoke and London, 1995), p. 82.

39. Watt, *Cheap Print and Popular Piety*, p. 177 and see also chpt. 5.

40. Watt, *Cheap Print and Popular Piety*, pp. 174–176; what follows is my description of the poster reprinted by Watt p. 175 using the Society of Antiquaries broadside no. 305.

41. Watt, *Cheap Print and Popular Piety*, p. 216.

42. Hackett, *Virgin Mother, Maiden Queen*, p. 25. This argument is suggested as a counter-point to the bleaker interpretation of the construction of womanhood before 1660 offered by Anthony Fletcher, *Gender, Sex and Subordination in England 1500–1800* (Yale University Press, New Haven and London, 1995).

43. Bell, *Women from the Greeks to the French Revolution*, pp. 10–17.

44. Bell, *Women from the Greeks to the French Revolution*, pp. 10–21; Maclean, *The Renaissance Notion of Woman*, p. 60.

45. Sommerville, *Sex and Subjection*, pp. 13–14.

46. Maclean, *The Renaissance Notion of Woman*, pp. 8, 61; Sommerville, *Sex and Subjection*, p. 13; see also Walter J. Ong, *Ramus, Method and the Decay of Dialogue* (1958; reprinted University of Chicago Press, Chicago, Illinois, 2004).

47. Sommerville, *Sex and Subjection*, p. 13, 15; Maclean, *The Renaissance Notion of Woman*, pp. 49–56.

48. Aughterson (ed.), *Renaissance Woman*, p. 137 citing Louis le Roy, *Aristotle's Politiques* (1598), pp. 55–7.

49. Bell, *Women from the Greeks to the French Revolution*, p. 20 citing Aristotle, *Aristotle's Politics and Poetics*, trans. By B. Jowett and T. Twining (Viking Press, New York, 1957), Bk. 1, chpt. 12, p. 21.

50. Bell, *Women from the Greeks to the French Revolution*, p. 19 citing Aristotle, *The Ethics of Aristotle*, trans. by J. A. K. Thomson (Penguin Books, Baltimore, Maryland, 1953), Bk. 8, chpt. 10, p. 247.

51. Aughterson (ed.), *Renaissance Woman*, p. 137 citing Louis le Roy, *Aristotle's Politiques* (1598), p. 58.
52. Sommerville, *Sex and Subjection*, p. 34.
53. Sommerville, *Sex and Subjection*, p. 10.
54. Henderson and McManus (eds), *Half Humankind*, p. 5.
55. Marilyn J. Boxer and Jean H. Quataert (eds), *Connecting Spheres: Women in the Western World, 1500 to the Present* (Oxford University Press, New York and Oxford, 1987), p. 23; Maclean, *The Renaissance Notion of Woman*, p. 8.
56. Aristotle, *Generation of Animals*, trans. by A. L. Peck, The Loeb Classical Library (Harvard University Press, Cambridge Massachusetts, 1943), p. 406 and Thomas Aquinas, *Basic Writings of Saint Thomas Aquinas*, ed. by Anton C. Pegis (Random House, New York, 1945), i, p. 880 as cited in Bell, *Women from the Greeks to the French Revolution*, pp. 18, 122 (relevant passages also cited, with slightly different translations, by Maclean, *The Renaissance Notion of Woman*, p. 8).
57. Maclean, *The Renaissance Notion of Woman*, pp. 9–10; Wiesner, *Women and Gender in Early Modern Europe*, p. 21.
58. Sara Mendelson and Patricia Crawford, *Women in Early Modern England* (Oxford University Press, Oxford, 1998), p. 80 citing C. Peters, 'Women and the English Reformation', unpublished history paper, 'Women, Text and History' seminar, Oxford, 15 May 1990. See also Christine Peters, *Patterns of Piety: Women, Gender and Religion in Late Medieval and Early-Modern England* (Cambridge University Press, Cambridge, 2003).
59. Mendelson and Crawford, *Women in Early Modern England*, p. 62 citing S. Butler, *Genuine Remains*, 2 vols. (1759), 'Miscellaneous Thoughts', I, 246; John Donne, *Paradoxes, Problemes, Essayes and Characters* (1652; written 1603–1610), pp. 28–9.
60. Maclean, *The Renaissance Notion of Woman*, p. 13 citing Aquinas, *Summa Theologica*, 1a.93.4.
61. Anthony Fletcher has argued that Aristotelian dualities of male/female and perfection/imperfection rested on an understanding of the human body and sexuality that was 'terrifyingly unstable' and therefore in need of intense scrutiny and vigilance – Anthony Fletcher, 'Men's Dilemma: The Future of Patriarchy in England 1560–1660', *Transactions of the Royal Historical Society*, iv (1994), p. 69.
62. Wiesner, *Women and Gender in Early Modern Europe*, p. 25; Fletcher, *Gender, Sex and Subordination*, pp. 31–3.
63. Fletcher, *Gender, Sex and Subordination*, p. 34 citing T. Laqueur, *Making Sex: Body and Gender from the Greeks to Freud* (Cambridge, Massachusetts, 1990), pp. 4, 25–8 and L. Schiebinger, *The Mind Has No Sex?* (Cambridge, Massachusetts, 1989), p. 163; see also Robert Martensen, 'The Transformation of Eve: Women's Bodies, Medicine and Culture in Early Modern England', in Roy Porter and Mikuláš Teich (eds), *Sexual Knowledge, Sexual Science: The History of Attitudes to Sexuality* (Cambridge University Press, Cambridge, 1994), p. 110.
64. Martensen, 'The Transformation of Eve', in Porter and Teich (eds), *Sexual Knowledge, Sexual Science*, p. 110.
65. Fletcher, *Gender, Sex and Subordination*, pp. 34, 42; Fletcher cites *Aristotle's Master-Piece* – 'For those that have the strictest searchers been, Find women are but men turned outside in, And men, if they but cast their eyes about, May find they're women with their insides out' from R. Porter and L. Hall (eds), *The Facts of Life: The Creation of Sexual Knowledge in Britain 1680–1950* (London, 1995), p. 52 but see all of Porter and Hall, chpt. 2.
66. Fletcher, *Gender, Sex and Subordination*, pp. 36, 41–2.
67. Fletcher, *Gender, Sex and Subordination*, pp. 37–9, 42; Maclean, *The Renaissance Notion of Woman*, p. 33.
68. Fletcher, *Gender, Sex and Subordination*, p. 42 citing Jane Sharp, *The Midwives Book* (London, 1671), pp. 40, 42.

69. Fletcher, *Gender, Sex and Subordination*, p. 38 citing Helkiah Crooke, *Microcosmographia* (1631 ed.), pp. 20–4, 211–16, 238; Helkiah Crooke, *Microcosmographia* (1618), pp. 270–1 reprinted in Aughterson (ed.), *Renaissance Woman*, p. 55.

70. Martensen, 'The Transformation of Eve', in Porter and Teich (eds), *Sexual Knowledge, Sexual Science*, pp. 108, 113; Fletcher, *Gender, Sex and Subordination*, p. 33.

71. Keeble (ed.), *The Cultural Identity of Seventeenth-Century Woman* p. 21 citing Robert Burton, *Anatomy of Melancholy* (1621), I, i, 2 (2) [I, 147–8] following Galen closely.

72. Fletcher, *Gender, Sex and Subordination*, p. 33; Wiesner, *Women and Gender in Early Modern Europe*, p. 26.

73. Fletcher, *Gender, Sex and Subordination*, p. 44.

74. Natalie Zemon Davis and Arlette Farge (eds), *A History of Women: Renaissance and Enlightenment Paradoxes* (Belknap Press, Cambridge Massachusetts, 1993), pp. 46–51.

75. Fletcher, *Gender, Sex and Subordination*, pp. 33, 44; Wiesner, *Women and Gender in Early Modern Europe*, p. 26.

76. Maclean, *The Renaissance Notion of Woman*, pp. 8, 30, 35.

77. Laura Gowing, *Common Bodies: Women, Touch and Power in Seventeenth-Century England* (Yale University Press, New Haven and London, 2003), p. 3.

78. Martensen, 'The Transformation of Eve', in Porter and Teich (eds), *Sexual Knowledge, Sexual Science*, p. 124; Hilda Smith, 'Gynecology and Ideology in Seventeenth-Century England', in Berenice A. Carroll (ed.), *Liberating Women's History: Theoretical and Critical Essays* (University of Illinois Press, Urbana and Chicago, 1976), p. 112; Mendelson and Crawford, *Women in Early Modern England*, p. 316 citing J. Donnison, *Midwives and Medical Men: A History of Inter-Professional Rivalries and Women's Rights* (1977), pp. 13–20; Doreen Evenden, *The Midwives of Seventeenth Century London* (Cambridge University Press, New York, 2000). Hull, *Women According to Men*, pp. 96–8 citing Sharp, *The Midwives Book*, pp. 43, 45, 59.

79. Carolyn Merchant, *The Death of Nature: Women, Ecology and the Scientific Revolution* (Harper and Row, San Fransisco, 1980), *passim* – Merchant's ideas are combined with a Marxist determinism e.g. '[William] Harvey's theory of biological reproduction is compatible with new scientific values based on the control of nature and women integral to the new capitalist modes of production' (p. 156); Wiesner, *Women and Gender in Early Modern Europe*, p. 29; Mendelson and Crawford, *Women in Early Modern England*, p. 30; Maclean, *The Renaissance Notion of Woman*, p. 44.

80. Martensen, 'The Transformation of Eve', in Porter and Teich (eds), *Sexual Knowledge, Sexual Science*, pp. 116, 120; see also Smith, 'Gynecology and Ideology in Seventeenth-Century England', in Carroll (ed.), *Liberating Women's History*, pp. 105–6 and Ilza Veith, *Hysteria: The History of a Disease* (University of Chicago Press, Chicago, 1965), pp. 132–4.

81. Martensen, 'The Transformation of Eve', in Porter and Teich (eds), *Sexual Knowledge, Sexual Science*, pp. 120–2; Fletcher, *Gender, Sex and Subordination*, p. 384.

82. Merry Wiesner-Hanks, *Christianity and Sexuality in the Early Modern World: Regulating Desire, Reforming Practice* (Routledge, London and New York, 2000), p. 263; David Cressy, *Birth, Marriage and Death: Ritual, Religion and the Life Cycle in Tudor and Stuart England* (Oxford University Press, Oxford, 1997), pp. 17–24. See also Michel Foucault, *The History of Sexuality* (Random House, New York, trans. 1990) and Vern Bullough and Bonnie Bullough, *Sexual Attitudes: Myths and Realities* (Prometheus, New York, 1995).

83. This idea and the social implications of this have been most fully explored by Fletcher, *Gender, Sex and Subordination* and 'Men's Dilemma: The Future of Patriarchy in England 1560–1660'.

84. Smith, 'Gynecology and Ideology in Seventeenth-Century England', in Carroll (ed.), *Liberating Women's History*, pp. 102–3 citing *The Compleat Midwifes Practice Enlarged* (1659 ed.), pp. 284–5.

85. Gowing, *Common Bodies*, p. 1 citing Devon Record Office, Q/SB (1611).

86. *The Complete Midwife's Practice Enlarged*, p. 47 cited in Aughterson, *Renaissance Woman*, p. 66; Nicholas Culpeper, *A Directory for Midwives: Or a Guide for Women* (1675), p. 103.

87. Fletcher, *Gender, Sex and Subordination*, p. 38 citing Laqueur, *Making Sex*, pp. 126–8.

88. Fletcher, *Gender, Sex and Subordination*, p. 33.

89. Maclean, *The Renaissance Notion of Woman*, p. 35.

90. Hilda Smith has said that 'seventeenth-century gynaecology was a combination of ignorance about internal medicine [and a] bias against women' – see Smith, 'Gynecology and Ideology in Seventeenth-Century England', in Carroll (ed.), *Liberating Women's History*, p. 99.

91. Wiesner, *Women and Gender in Early Modern Europe*, p. 27.

92. Nicholas Fontanus, *The Womans Doctour* (1652), p. 51 reprinted in Aughterson (ed.), *Renaissance Woman*, p. 63.

93. Wiesner, *Women and Gender in Early Modern Europe*, p. 27; Zemon Davis and Farge (eds), *A History of Women*, p. 361; Maclean, *The Renaissance Notion of Woman*, pp. 41–2.

94. Wiesner, *Women and Gender in Early Modern Europe*, pp. 28–9; Smith, 'Gynecology and Ideology in Seventeenth-Century England', in Carroll (ed.), *Liberating Women's History*, pp. 100–1 citing Nicholas Fontanus, *The Womans Doctour: Or, an Exact and Distinct Explanation of All Such Diseases as are Peculiar to that Sex with Choise and Experimental Remedies against the Same* (1652), pp. 2–3.

95. E.g. Martin Akakia, *On Women's Illnesses* in Johann Spachius (ed.), *Gynacea* (1597) – sections reprinted in Aughterson (ed.), *Renaissance Woman*, pp. 49 ff.

96. Keeble (ed.), *The Cultural Identity of Seventeenth-Century Woman* pp. 19 and 32 citing [William Whately], *A Bride-Bush* (1617), pp. 44–5.

97. Patricia Crawford, 'From the Woman's View: Pre-Industrial England, 1500–1750', in Patricia Crawford (ed.), *Exploring Women's Past* (Sisters Publishing Ltd., Carlton, South Victoria, 1983), pp. 56–6.

98. L. Lemnius, *The Secret Miracles of Nature in Four Books* (1658), p. 124 cited in Mendelson and Crawford, *Women in Early Modern England*, p. 26.

99. Wiesner, *Women and Gender in Early Modern Europe*, p. 45 citing Isabella de Moerloose, *Gegeven van den Hemel door Vrouwen Zaet...* (Amsterdam, 1695) quoted in Herman W. Roodenburg, 'The Autobiography of Isabella de Moerloose: Sex, Childrearing and Popular Beliefs in Seventeenth-Century Holland', *Journal of Social History*, 18 (1985), p. 529.

100. Smith, 'Gynecology and Ideology in Seventeenth-Century England', in Carroll (ed.), *Liberating Women's History*, p. 100.

101. Nicholas Fontanus, *The Womans Doctour* (1652), pp. 1 ff. reprinted in Aughterson (ed.), *Renaissance Woman*, p. 60.

102. Smith, 'Gynecology and Ideology in Seventeenth-Century England', in Carroll (ed.), *Liberating Women's History*, p. 101 citing Nicholas Fontanus, *The Womans Doctour*, pp. 17–20; Crawford, 'From the Woman's View', in *Exploring Women's Past*, p. 67 citing Royal College of Physicians MS 654, f. 73.

103. Mendelson and Crawford, *Women in Early Modern England*, p. 24 citing Burton, *The Anatomy of Melancholy* (1621), p. 576. See Helen King, *The Disease of Virgins: Greensickness, Chlorosis and the Problems of Puberty* (Oxbow Books, London, 2004). See also P. Laslett, 'Age at Menarche in Europe since the Eighteenth Century', *Journal of Interdisciplinary History*, 2, (1971–2) and Patricia Crawford, 'Attitudes to Menstruation in Seventeenth-Century England', *Past and Present*, 91 (1981), pp. 47–73 reprinted in Patricia Crawford, *Blood, Bodies and Families in Early Modern England* (Pearson, Harlow, 2004).

104. Fletcher, *Gender, Sex and Subordination*, pp. 48–9; J. Pechey, *The Store-House of Physical Practice* (1695), p. 315 cited in Mendelson and Crawford, *Women in Early Modern England*, p. 23; British Library MS C.40.m.10 (141) reprinted in Patricia Crawford, 'Sexual Knowledge in England, 1500–1750', in Porter and Teich (eds), *Sexual Knowledge,*

Sexual Science, p. 95; Sarah Jinner, *An Almanac* (1658), ff. B4r-B8v reprinted in Aughterson, *Renaissance Woman*, p. 127. Information owed to Judith Spicksley – Wellcome Library, Lady Frances Catchmay, *A Book of Medicens* (c.1625), MS 184a p. 10, Elizabeth Okeover, *Collection of Medical Receipts*, (c. 1675–c. 1725), MS 3712, pp. 96, 108.

105. For women practicing medicine and the tense relationship between women and licensed male medical practitioners see, Margaret Pelling, *Medical Conflicts in Early Modern London: Patronage, Physicians and Irregular Practitioners 1550–1640* (Clarendon Press, Oxford, 2003), chpt. 6, 'Defensive Tactics: Networking by Female Medical Practitioners in Early Modern London' in *Communities in Early Modern England* eds A. Shepherd & P. Withington (Manchester University Press, Manchester, 2000) and 'Female and Male Surgeons in Early Modern England', *Medical History*, 42 (1998); Hilary Marland and Margaret Pelling, *The Task of Healing: Medicine, Religion and Gender in England and the Netherlands 1450–1800* (Erasmus Publishing, Rotterdam, 1996), chpt. 5. For European examples see Susan Broomhall, *Women's Medical Work in Early Modern France* (Manchester University Press, Manchester, 2004).

106. Andrew Wear, *Knowledge and Practice in English Medicine 1550–1680* (Cambridge University Press, Cambridge, 2000), p. 141.

107. Lynette Hunter, 'Women and Domestic Medicine: Lady Experimenters 1570–1620' in *Women, Science and Medicine 1500–1700* eds Lynette Hunter and Sarah Hutton (Sutton Publishing, Stroud, 1997). For general texts, see Roy Porter, *Disease, Medicine and Society in England, 1550–1860* (Macmillan, Basingstoke, 1987) and for the European comparison, Mary Lindemann, *Medicine and Society in Early Modern Europe* (Cambridge University Press, Cambridge, 2000).

108. Nicholas Fontanus, *The Womans Doctour* (1652), pp. 1 ff., 51–60 reprinted in Aughterson (ed.), *Renaissance Woman*, pp. 60–4; Mendelson and Crawford, *Women in Early Modern England*, pp. 23–5 citing L. Lemnius, *A Discourse Touching Generation* (1667), p. 268; Cf. Davis and Farge (eds), *A History of Women*, p. 362.

109. Keith Thomas, 'The Double Standard', *Journal of the History of Ideas*, 20 (1959), especially pp. 195–8, 210; Laura Gowing, *Domestic Dangers: Women, Words and Sex in Early Modern London* (Clarendon Press, Oxford, 1996), pp. 1–8.

110. Mendelson and Crawford, *Women in Early Modern England*, pp. 20–1.

111. Sharp, *The Midwives Book*, p. 43 reprinted in Aughterson, *Renaissance Woman*, p. 129.

112. Mendelson and Crawford, *Women in Early Modern England*, p. 25 citing L. Lemnius, *A Discourse Touching Generation* (1667), p. 356.

113. Juan Luis Vives, *The Instruction of a Christian Woman* (1529) ed. Richard Hyrde trans. (1540), Bk. 3, chpt. 7 reprinted in Aughterson (ed.), *Renaissance Woman*, pp. 73–4.

114. Jeremy Taylor, 'Rules', in *The Whole Works*, (12 vols, 1848), iii, 62 cited in Crawford, 'Sexual Knowledge in England', in Porter and Teich (eds), *Sexual Knowledge, Sexual Science*, p. 91; Antonia Fraser, *The Weaker Sex: Woman's Lot in Seventeenth-Century England* (Methuen, London, 1984), pp. 89–90; Mendelson and Crawford, *Women in Early Modern England*, pp. 68–9 citing M. P. Tilley, *A Dictionary of the Proverbs in England in the Sixteenth and Seventeenth Centuries*, p. 722; Barbara J. Todd, 'The Remarrying Widow: A Stereotype Reconsidered', in, Mary Prior (ed.), *Women in English Society 1500–1800* (Routledge, London, 1985), pp. 54–92.

115. See Dorothy McLaren, 'Marital Fertility and Lactation, 1570–1720', in Prior (ed.), *Women in English Society 1500–1800*, 'Fertility, Infant Mortality and Breast Feeding in the Seventeenth Century', *Medical History*, 22 (1978) and 'Nature's Contraceptive. Wet-Nursing and Prolonged Lactation: The Case of Chesham, Buckinghamshire, 1578–1601', *Medical History*, 23 (1979), pp. 426–41; Linda Campbell, 'Wet-Nurses in Early-Modern England: Some Evidence from the Townshend Archive', *Medical History*, 33 (1989), pp. 360–70; Fraser, *The Weaker Sex*, pp. 65–8.

116. Patricia Crawford, '"The Sucking Child": Adult Attitudes to Child Care in the First Year of Life in Seventeenth-Century England', *Continuity and Change*, 1 (1986), p. 27 citing Jacob Rueff, *The Expert Midwife* (London, 1637), p. 153.

117. Hull, *Women According to Men*, p. 98 citing Fontanus, *The Womans Doctour*, p. 133; Crawford, 'Sexual Knowledge in England', in Porter and Teich (eds), *Sexual Knowledge, Sexual Science*, p. 84.

118. Wiesner, *Women and Gender in Early Modern Europe*, p. 25; Karen Harvey, 'The Substance of Sexual Difference: Change and Persistence in Representations of the Body in Eighteenth-Century England', *Gender and History*, 14:2 (2002), pp. 205, 209.

119. Cf. Gowing, *Common Bodies*, p. 112.

120. Gowing, *Common Bodies*, pp. 60–1 and pp. 92–3 citing Somerset Archives and Record Service, Q/SR 100/45. See also Crawford, 'From the Woman's View', in Crawford (ed.), *Exploring Women's Past*, p. 64.

121. Culpeper, *A Directory for Midwives*, pp. 96 ff., Jinner, *An Almanac*, ff. B4r-B8v reprinted in Aughterson (ed.), *Renaissance Woman*, pp. 126–8; Smith, 'Gynecology and Ideology in Seventeenth-Century England', in Carroll (ed.), *Liberating Women's History*, p. 99.

122. Culpeper, *A Directory for Midwives*, pp. 68 ff. reprinted in Aughterson (ed.), *Renaissance Woman*, p. 125; Fontanus, *The Womans Doctour*, pp. 51–60 reprinted in Aughterson (ed.), *Renaissance Woman*, p. 62.

123. Nicholas Culpeper, *A Directory for Midwives* (1651), rep. in Aughterson (ed.), *Renaissance Woman*, pp. 125–6.

124. For Sarah Savage see Mendelson and Crawford, *Women in Early Modern England*, p. 150 Chester City RO, D/Basten/8.

125. William Perkins, *Christian Economy: Or, a Short Survey of the Right Manner of Erecting and Ordering a Family According to the Scriptures* (London, 1609) rep. Larsen Klein, *Daughters, Wives and Widows*, p. 170.

126. Mendelson and Crawford, *Women in Early Modern England*, p. 27; Crawford, 'From the Woman's View', in *Exploring Women's Past*, pp. 68–9 citing Devon Record Office Q/SB 58, examination of Deborah Brackley, 3 September, 1651; Sarah Jinner, *An Almanac*, f. B4r reprinted in Aughterson (ed.), *Renaissance Woman*, p. 127–8. See Angus McLaren, '"Barrenness Against Nature": Recourse to Abortion in Pre-Industrial England', *Journal of Sex Research*, 17:3 (1981), pp. 224–37 and *Reproductive Rituals: The Perception of Fertility in England from the Sixteenth Century to the Nineteenth Century* (Methuen, London, 1984).

127. Cf. Linda Pollock, *A Lasting Relationship: Parents and Children over Three Centuries* (Fourth Estate, London, 1987), p. 19. See also Mendelson and Crawford, *Women in Early Modern England*, p. 151 citing J. Sharp, *The Midwives Book* (1671), p. 103 and Devon Record Office MSS, QSB Box 58, no. 16; Keeble (ed.), *The Cultural Identity of Seventeenth-Century Woman*, pp. 18–19, 22–8 and Aughterson (ed.), *Renaissance Woman*, pp. 104, 108–110. Alice Thornton recorded 'conseption' after only seven weeks of marriage, and this was followed by several weeks of sickness before 'I was quicke with childe' (Alice Thornton, *The Autobiography of Mrs Alice Thornton of East Newton Co. York*, Publications of the Surtees Society (Andrews & Co, Durham, 1873), p. 84). However, more common was the woman who, in 1651, could state with precision that she had been 'quick three weeks and two or three days' than the woman who could state with any accuracy when conception had taken place.

128. Cambridge University Library MS Add. 3071, f. 19v.

129. Cressy, *Birth, Marriage and Death*, pp. 35–41; Eucharius Roeslin, *The Birth of Mankind* (1545) is rep. in Barbara Kanner, *The Women of England from Anglo Saxon Times to the Present* (Mansell, London, 1980); Sarah Jinner, *An Almanac* (1658) rep. in Aughterson (ed.), *Renaissance Woman*, p. 128; Mendelson and Crawford, *Women in Early Modern England*, p. 148.

130. Maclean, *The Renaissance Notion of Woman*, pp. 37–8.

131. Eucharius Roesslin, *The Byrth of Mankind* (1540), LXXXV, cited in Hull, *Women According to Men*, p. 102.

132. *The Complete Midwife's Practice Enlarged* (1656), pp. 46–7, cited in Aughterson (ed.), *Renaissance Woman*, p. 66.

133. James Guillemeau, *Child-Birth or, the Happy Deliverie of Women* (1612), p. 10, cited in Hull, *Women According to Men*, p. 102.

134. Mendelson and Crawford, *Women in Early Modern England*, p. 28.

135. Mack, *Visionary Women*, pp. 35–6.

136. Gowing, *Common Bodies*, pp. 22–6.

137. Thomas Willis, *The London Practice of Physick: Or the Whole Practical Part of Physick Contained in the Works of Dr Willis* (1685), pp. 631–2 cited in Smith, 'Gynecology and Ideology in Seventeenth-Century England', in Carroll (ed.), *Liberating Women's History*, p. 106.

138. Cambridge University Library MS Add. 3071, ff. 32v, 38, 43v, 58v.

139. Cressy, *Birth, Marriage and Death*, pp. 17–28.

140. A. Wilson, *The Making of Man Midwifery: Childbirth in England 1660–1770* (1995).

141. Cambridge University Library MS Add. 3071, f. 58v.

142. Robert Barrett, *Companion for Midwives* (1699), p. 36 reprinted in Keeble (ed.), *The Cultural Identity of Seventeenth-Century Woman*, p. 178. Cressy, *Birth, Marriage and Death*, pp. 84–6 citing F. P. Wilson (ed.), *The Batchelars Banquet* (rep. 1929), 68 and 22 and *The Pleasures of Matrimony* (1688), pp. 127–8 and chpt. 9; Adam Fox, *Oral and Literate Culture in England 1500–1700* (Clarendon Press, Oxford, 2000), chpt. 3. For 'churching', see also, David Cressy, 'Purification, Thanksgiving and the Churching of Women in Post-Reformation England', *Past and Present*, 141 (1993), pp. 106–46 and Will Coster, 'Purity, Profanity and Puritanism: The Churching of Women 1500–1700' in Sheils and Wood (eds), *Women in the Church*.

143. Crawford, 'From the Woman's View', in Crawford (ed.), *Exploring Women's Past*, p. 58 citing C. Severn (ed.), *Diary of the Rev John Ward* (London, 1839), p. 102.

144. Culpeper, *A Directory for Midwives*, pp. 96 ff. reprinted in Aughterson, *Renaissance Woman*, pp. 126–8; Crawford, 'From the Woman's View', in Crawford (ed.), *Exploring Women's Past*, p. 65; T. Cogan, *The Haven of Health* (London, 1596), p. 240 cited in Fletcher, *Gender, Sex and Subordination*, p. 46; Robert Cleaver, *A Godly Form of Household Government* (1598) pp. 236–8 cited in Hull, *Women According to Men*, p. 120; McLaren, 'Marital Fertility and Lactation 1570–1720', in Prior (ed.), *Women in English Society 1500–1800* , p. 26; Elizabeth Clinton, countess of Lincoln, *The Countess of Lincolns Nurserie* (Oxford, 1622).

145. Valerie Fildes, *Wet Nursing: A History from Antiquity to the Present* (Blackwell, Oxford, 1988), chpts. 5–6; Crawford, 'The Sucking Child'; Cressy, *Birth, Marriage and Death*, pp. 87–92 with quotation from John Sadler, *The Sick Woman's Private Looking Glass* (1636), Jane Sharp, *The Midwives Manual* (1671), p. 353 and Henry Newcome, *The Compleat Mother. Or an Earnest Perswasive to All Mothers (Especially Those of Rank and Quality) to Nurse Their Own Children* (1695); Elizabeth Clinton, *The Countess of Lincoln's Nursery* (1622) rep. in Aughterson (ed.), *Renaissance Woman*, pp. 116–20; Mendelson and Crawford, *Women in Early Modern England*, pp. 155–6 citing Katherine Parker, commonplace book, Folger Library MS V.a.387 recipes 2 and 8; As late as 1994 one small maternity hospital in New Zealand grew cabbages, the leaves of which were boiled and applied to the breasts of women who suffered engorgement in the early stages of breastfeeding.

146. Mendelson and Crawford, *Women in Early Modern England*, p. 29 citing W. Harris, *An Exact Enquiry into ... the Acute Diseases of Infants* (1693), p. 17.

147. Fraser, *The Weaker Sex*, p. 87 citing Sharp, *The Midwives Book*, p. 353; J. Starsmare, *Childrens Diseases Both Outward and Inward from the Time of Their Birth to Fourteen Years of Age* (Oundle, Northampton, 1664) cited in Fraser, *The Weaker Sex*, p. 87.

148. Fletcher, *Gender, Sex and Subordination*, p. 72 citing Lemnius, *The Secret Miracles of Nature*, p. 11; Crawford, 'The Sucking Child', pp. 26, 31 citing Daniel Featley, *The Dippers Dipt* (London, 1645), p. 42 and A. Malloch, *Finch and Baines: A Seventeenth-Century Friendship* (Cambridge, 1917), p. 66; Crawford, 'From the Woman's View', in Crawford (ed.), *Exploring Women's Past*, p. 65; Vives, *The Instruction of a Christian Woman*, Bk. 3, chpt. 7 reprinted in Aughterson (ed.), *Renaissance Woman*, pp. 73–4.

149. See, for example, Melchior Lorch, *Allegory of Nature* (1565) in Wiesner, *Women and Gender in Early Modern Europe*, pp. 28–9; Mack, *Visionary Women*, pp. 36, 40 and *passim*.
150. Fletcher, *Gender, Sex and Subordination*, pp. 30, 283–8, 296, 385, 389, 394–6, 402, 407.
151. Karen Harvey, 'The Century of Sex? Gender, Bodies and Sexuality in the Long Eighteenth Century', *The Historical Journal*, 45:4 (2002), p. 901 and 'The Substance of Sexual Difference', p. 219.

2 *Querelle des Femmes*

1. Joan Wallach Scott, 'Gender: A Useful Category of Historical Analysis' in *Gender and the Politics of History* (Columbia University Press, New York, 1988), p. 43.
2. Suzanne Hull, *Chaste, Silent and Obedient: English Books for Women 1475–1640* (Huntington Library, San Marino, 1982), especially p. 108 and *Women According to Men: The World of Tudor-Stuart Women* (Altamira Press, Walnut Creek, London and New Delhi, 1996).
3. Merry Wiesner, *Women and Gender in Early Modern Europe* (Cambridge University Press, Cambridge, 1993), pp. 17–18.
4. Kirby Farrell, Elizabeth H. Hageman, Arthur F. Kinney (eds), *Women in the Renaissance: Selections from English Literary Renaissance* (University of Massachusetts Press, Amherst, 1988), p. 31.
5. Wiesner, *Women and Gender in Early Modern Europe*, p. 15; Gerda Lerner, *The Creation of Feminist Consciousness from the Middle Ages to Eighteen-Seventy* (Oxford University Press, Oxford and New York, 1993), p. 264; *The Nutbrown Mayde* (1503) reprinted in Farrell, Hageman and Kinney (eds), *Women in the Renaissance*, pp. 13–27.
6. Anne M. Haselkorn and Betty Travitsky (eds), *The Renaissance Englishwoman in Print: Counterbalancing the Canon* (University of Massachusetts Press, Amherst, 1990), pp. 211–23.
7. Katherine Usher Henderson and Barbara F. McManus, *Half Humankind: Contexts and Texts of the Controversy about Women in England, 1540–1640* (University of Illinois Press, Urbana and Chicago, 1985), pp. 10–11; Francis Utley, *The Crooked Rib: An Analytical Index to the Argument about Women in English and Scots Literature to the End of the Year 1568* (Ohio State University, Columbus, 1944), p. 36.
8. William Heale, *An Apologie for Women or an Opposition to Mr Dr G His Assertion. Who Held in the Act at Oxforde. Anno. 1608 That It Is Lawfull for Husbands to Beate Their Wives* (Oxford, 1609), p. 1.
9. Wiesner, *Women and Gender in Early Modern Europe*, p. 17; Utley, *The Crooked Rib*, pp. 80–1 citing Magdalene College, Cambridge MS Pepys 2553; Katharine M. Rogers, *The Troublesome Helpmate: A History of Misogyny in Literature* (University of Washington Press, Seattle, 1966), p. 107; Linda Woodbridge, *Women and the English Renaissance: Literature and the Nature of Womankind 1540–1620* (The Harvester Press, Brighton, Sussex, 1984), p. 273.
10. Louis B. Wright, *Middle Class Culture in Elizabethan England* (University of North Carolina Press, Chapel Hill, 1935), pp. 465–507; Utley, *The Crooked Rib*; Carroll Camden, *The Elizabethan Woman* (Elsevier, Texas, Houston, 1952), pp. 241–71; Ruth Kelso, *Doctrine for the Lady of the Renaissance* (University of Illinois Press, Urbana, 1956), pp. 5–37; Rogers, *The Troublesome Helpmate*; Coryl Crandall (ed.), *Swetnam the Woman-Hater: The Controversy and the Play* (Purdue University Studies, West Lafayette Indiana, 1969); Hull, *Chaste, Silent and Obedient*, pp. 106–26; Joan Kelly, 'Early Feminist Theory and the *Querelle des Femmes*, 1400–1789', *Signs*, 8 (1982), pp. 4–28 reprinted in *Women, History and Theory: The Essays of Joan Kelly* (University of Chicago Press, Chicago, 1984), chpt. 4; Felicity Nussbaum, *The Brink of All We Hate: Satires on Women in Restoration and Eighteenth-Century England* (University Press of Kentucky, Kentucky, 1983); Woodbridge, *Women and the English Renaissance*; Henderson and McManus, *Half Humankind*; Maryanne Cline Horowitz, 'The Woman Question in Renaissance Texts', *History of European Ideas*, 8 (1987), pp. 587–95.

11. Utley, *The Crooked Rib*, pp. 36–7, 39 ff.
12. Henderson and McManus, *Half Humankind*, pp. 11, 32–3 included witchcraft pamphlets: Joshua Sylvester, *Monodia* (1594); John Mayer, *A Pattern for Women* (1619); *The Honour of Virtue* (1620); *The Arraignment and Burning of Margaret Ferneseede* (1608); *A Pitiless Mother* (1616); *The Wonderful Discovery of the Witchcrafts of Margaret and Philippa Flower* (1618).
13. Woodbridge, *Women and the English Renaissance*, pp. 6–8, 63–6 citing *Jane Anger Her Protection for Women* (1589), Sig. B; Utley, *The Crooked Rib*, pp. 83–6; Henderson and McManus, *Half Humankind*, pp. 37, 41; Rogers, *The Troublesome Helpmate*, p. 115.
14. Thomas Nashe, *An Almond for a Parrat* (1590) in *Works* (Oxford, 1958) e.d R. B. McKerrow and F. P. Wilson, iii, 348 cited in Ian Maclean, *The Renaissance Notion of Woman: A Study in the Fortunes of Scholasticism and Medical Science in European Intellectual Life* (Cambridge University Press, Cambridge, 1980), p. 12, see also p. 31; Sara Mendelson and Patricia Crawford, *Women in Early Modern England* (Clarendon Press, Oxford, 1998), p. 19.
15. Constance Jordan, *Renaissance Feminism: Literary Texts and Political Models* (Cornell University Press, Ithaca and London, 1990); Kelly, 'Early Feminist Theory and the *Querelle des Femmes*', in *Women, History and Theory*, pp. 66–7, 71; Moira Ferguson, *First Feminists: British Women Writers from 1578–1799* (Feminist Press, Old Westbury New York, 1985). Berenice Carroll argues that Christine de Pizan was more than just a writer on gender interests and that her corpus of work shows a wide agenda including statecraft, military and legal organisation and that in her work 'the origins of peace theory' may also be seen – Berenice Carroll, 'Christine de Pizan and the Origins of Peace Theory', in *Women Writers and the Early Modern British Political Tradition* ed. Hilda L. Smith (Cambridge University Press, Cambridge, 1998).
16. Hilda Smith, 'Feminism and the Methodology of Women's History', in ed. Berenice A. Carroll (ed.), *Liberating Women's History: Theoretical and Critical Essays* (University of Illinois Press, Urbana, 1976), p. 370 and Henderson and McManus, *Half Humankind*, pp. 25–31. Merry Wiesner has gone a step further and drawn a distinction between defences and 'feminist' defences by some women. This approach allows for some writers having commitment to their arguments and others having no necessary commitment at all – Wiesner, *Women and Gender in Early Modern Europe*, p. 16. See Hilda Smith, *Reason's Disciples: Seventeenth-Century English Feminists* (University of Illinois Press, Urbana, 1982).
17. Henderson and McManus, *Half Humankind*, p. 8. The following account of the early controversy including the works of John Heywood and William Dunbar is based on Utley, *The Crooked Rib*, pp. 65–8.
18. Cf. Utley, *The Crooked Rib*, pp. 68–70. Linda Woodbridge disputes the idea that Thomas Elyot's *The Defence of Good Women* was a defence particularly of Catherine of Aragon, who had been dead four years on its publication; Woodbridge, *Women of the English Renaissance*, p. 21. See Chapter 7 for a full exploration of the debate on women's education.
19. Anon., *The Scholehouse of Women* as reprinted in Henderson and McManus, *Half Humankind*, pp. 137–155.
20. Anon., *The Scholehouse of Women* as reprinted in Henderson and McManus, *Half Humankind*, pp. 137–155, especially 147–9.
21. Edward Gosynhill, *The Praise of All Women, Called Mulierum Paean: Very Fruitful and Delectable Unto All Readers* as reprinted in Henderson and McManus (eds), *Half Humankind*, pp. 157–170.
22. Utley, *The Crooked Rib*, pp. 251–6, 276.
23. Woodbridge, *Women and the English Renaissance*, pp. 25, 45.
24. Woodbridge, *Women and the English Renaissance*, pp. 22–4; Utley, *The Crooked Rib*, p. 73.
25. Woodbridge, *Women and the English Renaissance*, pp. 38–41, 72.

26. Woodbridge, *Women and the English Renaissance*, p. 49; Utley, *The Crooked Rib*, p. 73.
27. Utley, *The Crooked Rib*, p. 74.
28. Hull, *Chaste, Silent and Obedient*, p. 112.
29. Woodbridge, *Women and the English Renaissance*, p. 44.
30. Hull, *Chaste, Silent and Obedient*, pp. 111, 121 – information deduced from Suzanne Hull's analysis of Francis Utley's bibliography in *The Crooked Rib* especially pp. 64, 71.
31. Anthony Fletcher, *Gender, Sex and Subordination in England 1500–1800* (Yale University Press, New Haven, 1995), pp. 23–5 and 'Men's Dilemma: The Future of Patriarchy in England 1560–1660, *Transactions of the Royal Historical Society*, 4 (1994), pp. 61–81.
32. Jean E. Howard and Phyllis Rackin, *Engendering a Nation* (Routledge, London and New York, 1997), chpt. 5; Jean E. Howard, 'Cross-Dressing, the Theatre and Gender Struggle in Early Modern England', *Shakespeare Quarterly*, 39 (1988), pp. 418–40.
33. Laura Levine, *Men in Women's Clothing: Anti-Theatricality and Effeminization* (Cambridge University Press, Cambridge and New York, 1994), pp. 1–25.
34. Fletcher, *Gender, Sex and Subordination*, chpt. 5 quotations from pp. 87, 91; see also the work of literary scholars such as Levine, *Men In Women's Clothing* and Susan Zimmerman (ed.), *Erotic Politics: Desire on the Renaissance Stage* (Routledge, London and New York, 1992).
35. Jane Anger, *Jane Anger, her Protection for Women To defend them against the Scandalous Reports of a late Surfeiting Lover* (1589) partially reprinted in Henderson and McManus, *Half Humankind*, pp. 173–4; reprinted in Simon Shepherd, *The Women's Sharp Revenge: Five Women's Pamphlets from the Renaissance* (Fourth Estate, London, 1985), pp. 29–46.
36. Anger, *Jane Anger, Her Protection for Women* reprinted in Henderson and McManus, *Half Humankind*, pp. 172, 174–5, 177, 180, 185–6.
37. Henderson and McManus, *Half Humankind*, p. 36; Jordan, *Renaissance Feminism*, p. 242 n.; Woodbridge, *Women and the English Renaissance*, pp. 63–6.
38. Diane Purkiss, 'Material Girls: the Seventeenth-Century Woman Debate', in Clare Brant and Diane Purkiss (eds), *Women, Texts and Histories 1575–1760* (Routledge, London and New York, 1992), pp. 70–1.
39. Shepherd, *The Women's Sharp Revenge*, p. 30.
40. Anger, *Jane Anger, Her Protection for Women* reprinted in Shepherd, *The Women's Sharp Revenge*, pp. 45–6.
41. Purkiss, 'Material Girls', in Brant and Purkiss (eds), *Women, Texts and Histories*, pp. 82–5.
42. Anger, *Jane Anger, her Protection for Women* reprinted in Henderson and McManus, *Half Humankind*, p. 177.
43. Woodbridge, *Women and the English Renaissance*, pp. 14–15, 74–6; Hull, *Chaste, Silent and Obedient*, p. 116.
44. Partially reprinted in Henderson and McManus, *Half Humankind*, pp. 190–216.
45. Woodbridge, *Women and the English Renaissance*, p. 81; Ann Rosalind Jones, 'Counterattacks on "the Bayter of Women": Three Pamphleteers of the Early Seventeenth Century', in Anne M. Haselkorn and Betty S. Travitsky (eds), *The Renaissance Englishwoman in Print: Counterbalancing the Canon* (The University of Massachusetts Press, Amherst, 1990), p. 45.
46. Joseph Swetnam, *The Arraignment of Lewd, Idle, Froward, and Unconstant Women* (1615) in Henderson and McManus, *Half Humankind*, pp. 190–2; Purkiss, 'Material Girls', in Brant and Purkiss (eds), *Women, Texts and Histories*, pp. 74–8.
47. Swetnam, *The Arraignment of Lewd, Idle, Froward, and Unconstant Women* (1615) in Henderson and McManus, *Half Humankind*, p. 193.
48. For negative contemporary proverbs and anecdotes about women, including their mischievousness and insubordination, see Mendelson and Crawford, *Women in Early Modern England* , pp. 60–2.

49. Swetnam, *The Arraignment of Lewd, Idle, Froward, and Unconstant Women* (1615) in Henderson and McManus, *Half Humankind*, pp. 197, 199.
50. Swetnam, *The Arraignment of Lewd, Idle, Froward, and Unconstant Women* (1615) in Henderson and McManus, *Half Humankind*, p. 201.
51. Swetnam, *The Arraignment of Lewd, Idle, Froward, and Unconstant Women* (1615) in Henderson and McManus, *Half Humankind*, pp. 198, 205, 207, 214, 192, 191.
52. The evidence from the continent is that from the late sixteenth century female authors did join the *querelle des femmes*. For example, in France, Marie de Gournay argued that the equality of men and women was written into divine law in a text of 1622 – Wiesner, *Women and Gender in Early Modern Europe*, p. 19.
53. Rachel Speght, *A Mouzell for Melastomus, The Cynical Bayter of, and Foule Mouth Barker against Evah's Sex* (1617) is reprinted in Shepherd (ed.), *The Women's Sharp Revenge*, partially reprinted in Kate Aughterson (ed.), *Renaissance Woman: Constructions of Femininity in England* (Routledge, London and New York, 1995).
54. Speght, *A Mouzell for Melastomus* in Aughterson (ed.), *Renaissance Woman*, pp. 271–2.
55. Swetnam, *The Arraignment of Lewd, Idle, Froward, and Unconstant Women* (1615) in Henderson and McManus (eds), *Half Humankind*, pp. 198, 200, 202, 212; Speght, *A Mouzell for Melastomus* in Aughterson (ed.), *Renaissance Woman*, pp. 271–3.
56. Speght, *A Mouzell for Melastomus* in Aughterson (ed.), *Renaissance Woman*, pp. 274–5.
57. Purkiss, 'Material Girls', in Brant and Purkiss (eds), *Women, Texts and Histories*, pp. 90–4.
58. [Esther Sowernam], *Esther Hath Hanged Haman; Or, an Answer to a Lewd Pamphlet Entitled The Arraignment of Women…* (1617) partially reprinted in Henderson and McManus, *Half Humankind*, pp. 217–43 and reprinted in Shepherd, *The Women's Sharp Revenge*.
59. Megan Matchinske, *Writing, Gender and State in Early Modern England: Identity Formation and the Female Subject* (Cambridge University Press, Cambridge, 1998), chpt. 3.
60. Purkiss, 'Material Girls', in Brant and Purkiss (eds), *Women, Texts and Histories*, p. 84.
61. [Sowernam], *Esther Hath Hanged Haman* reprinted in Henderson and McManus, *Half Humankind*, pp. 218, 220, 222, 224–6, 228–30.
62. [Sowernam], *Esther Hath Hanged Haman*, reprinted in Shepherd, *The Women's Sharp Revenge*, pp. 233 ff., 116.
63. [Sowernam], *Esther Hath Hanged Haman* reprinted in Henderson and McManus, *Half Humankind*, pp. 218–19.
64. Purkiss, 'Material Girls', in Brant and Purkiss (eds), *Women, Texts and Histories*, pp. 86–7.
65. Constantia Munda, *The Worming of a Mad Dogge: Or, a Soppe for Cerberus the Jaylor of Hell* (1617) partially reprinted in Henderson and McManus, *Half Humankind*, pp. 244–63; reprinted in Shepherd, *The Women's Sharp Revenge*.
66. Munda, *The Worming of a Mad Dogge* reprinted in Shepherd, *The Women's Sharp Revenge*, pp. 245–7, 130–2.
67. Munda, *The Working of a Mad Dogge* reprinted in Shepherd, *The Women's Sharp Revenge*, pp. 134, 136–7.
68. Shepherd, *The Women's Sharp Revenge*, pp. 12–13, 15.
69. Jones, 'Counterattacks on the "Bayter of Women"', in Haselkorn and Travitsky (eds), *The Renaissance Englishwoman in Print*, p. 45.
70. Purkiss, 'Material Girls', in Brant and Purkiss (eds), *Women, Texts and Histories*, *passim* and p. 84.
71. Woodbridge, *Woman and the English Renaissance*, pp. 99–103.
72. *Hic Mulier; or, The Man–Woman: Being a Medicine to Cure the Coltish Disease of the Staggers in the Masculine–Feminines of Our Times* (1620) and *Haec Vir* reprinted in Henderson and McManus, *Half Humankind*, pp. 265–89. For Francis Howard and the symbolic significance of the yellow ruff see Alastair Bellany, 'Mistress Turner's Deadly Sins: Sartorial Transgression, Court Scandal, and Politics in Early Stuart England', *Huntington Library Quarterly*, 58:2 (1997), pp. 179–210.

73. Woodbridge, *Woman and the English Renaissance*, pp. 76–9; Hull, *Chaste, Silent and Obedient*, p. 116 citing William Goddard's *A Satirycall Dialogue or a Sharplye Invective Conference, betweene Allexander the Great, and That Truly Woman-Hater Diogynes* (1616), Sig. B^v.

74. Hull, *Chaste, Silent and Obedient*, p. 117.

75. Personal observation of the portraits at Burton Agnes Hall.

76. David Cressy, 'Gender Trouble and Cross-Dressing in Early Modern England', *Journal of British Studies*, 35 (1996), especially pp. 453–5, 459, 462.

77. Samuel Butler, *Hudibras, The Second Part* (London, 1664; reprinted Menston, Yorkshire, 1970), pp. 117–18 (Canto II) quoted in Anne Parten, 'Falstaff's Horns: Masculine Inadequacy and Feminine Mirth in *The Merry Wives of Windsor*', *Studies in Philology*, 82 (1985), p. 186.

78. Anonymous report of an incident in Oxford, from Hatfield House, Hertfordshire (Cecil Papers, MS 62/16, 9 June 1598) and Thomas Cranley, *Amanda, or the Reformed Whore* (1635), sigs. F2 ^r-v, both reprinted in S. P. Cerasano and Marion Wynne-Davies (eds), *Renaissance Drama by Women: Texts and Documents* (Routledge, London and New York, 1996), p. 165, 168.

79. *Calendar of State Papers, Domestic Series* (PRO, SP14/12/14, 10 January 1605) and Sir Dudley Carleton to Ralph Winwood, 6 January 1605 (Boughton House, Winwood Papers III, Northamptonshire Record Office) reprinted in Cerasano and Wynne-Davies (eds), *Renaissance Drama by Women*, pp. 168–9 and p. 80, Robert White citing Suzanne Gosset, '"Man-Maid Begone!": Women in Masques', in *Women in the Renaissance*, p. 120.

80. Stephen Orgel, 'The Subtexts of *The Roaring Girl*', in Zimmerman, *Erotic Politics*, pp. 13, 15–17 – the drawing is in the Devonshire Collection at Chatsworth House.

81. John Chamberlain to Dudley Carleton, 16–25 February 1620, *The Letters of John Chamberlain* ed. N. E. McClure (Philadelphia, 1939), II, 289 quoted in Sandra Clark, '*Hic Mulier, Haec Vir*, and the Controversy over Masculine Women', *Studies in Phililogy*, 82 (1985), p. 166; Cressy, 'Gender Trouble and Cross-Dressing in Early Modern England', pp. 442–6.

82. Woodbridge, *Woman and the English Renaissance*, p. 120.

83. Coryl Crandall, 'The Cultural Implications of the Swetnam Anti-Feminist Controversy in the 17th Century', *Journal of Popular Culture*, 2 (1968), p. 146. Another summary of tracts and plays that combine debate about the nature of women with social commentary on female dress may be found in Clark, '*Hic Mulier, Haec Vir*, and the Controversy over Masculine Women', pp. 157–183.

84. Crandall, 'The Cultural Implications of the Swetnam Anti-Feminist Controversy', pp. 136–48.

85. Constance Jordan, 'Gender and Justice in *Swetnam the Woman Hater*', in Mary Beth Rose (ed.), *Renaissance Drama* (Northwestern University Press, Evanston, 1987), p. 149.

86. The account of the contents of the play is reconstructed from Crandall, 'The Cultural Implications of the Swetnam Anti-Feminist Controversy', pp. 140–44; Jordan, 'Gender and Justice in *Swetnam the Woman Hater*', pp. 150–164.

87. Henderson and McManus (eds), *Half Humankind*, pp. 18–19.

88. Christopher Newstead, *An Apology for Women: Or, Women's Defence* (1620), pp. 3, 22–4, 29.

89. *Woman's Worth* was acquired by the Bodleian Library between 1620 and 1634 and has been attributed to a clergyman, Dr William Page (1590–1663). It is transcribed in a further manuscript held in City Records at Leigh, Lancashire – Penny Wark, 'Woemen doe excel men', *The Times*, 26 July 2002.

90. Dagmar Freist, *Governed by Opinion: Politics, Religion and the Dynamics of Communication in Stuart London 1637–1645* (I. B. Taurus, London and New York, 1997), pp. 285–7 citing Lisa Jardine, *Still Harping on Shakespeare's Daughters: Women and Drama in the Age of Shakespeare* (Harvester Wheatsheaf, Hemel Hempstead, 1989).

91. Bernard Capp, *The World of John Taylor the Water Poet 1578–1653* (Clarendon Press, Oxford, 1994), pp. 1–10.

92. John Taylor, *Workes*, ii, 52 quoted in Capp, *The World of John Taylor*, p. 116.

93. See Capp, *The World of John Taylor*.

94. John Taylor, *A Juniper Lecture, with the Description of All Sorts of Women, Good and Bad ... The Second Impression, with Many New Additions. Also the Author's Advice How to Tame a Shrew or Vex Her* (1639), partially reprinted in Henderson and McManus, *Half Humankind*, pp. 291–6, 299.

95. Taylor, *A Juniper Lecture*, partially reprinted in Henderson and McManus, *Half Humankind*, p. 297.

96. John Taylor, *Divers Crab Tree Lectures*, pp. 73–4 quoted in Capp, *The World of John Taylor*, pp. 118.

97. 'Mary Tattlewell and Joan Hit-Him-Home', *The Women's Sharpe Revenge: Or an Answer to Sir Seldom Sober* (London, 1640), reprinted in large part in Shepherd, *The Women's Sharp Revenge*, pp. 162–3; the pamphlet is also partially reprinted in Henderson and McManus, *Half Humankind*, pp. 305–25.

98. 'Mary Tattlewell and Joan Hit-Him-Home', *The Women's Sharpe Revenge*, reprinted in Shepherd, *The Women's Sharp Revenge*, p. 170.

99. Henderson and McManus, *Half Humankind*, pp. 20, 91; Shepherd, *The Women's Sharp Revenge*, pp. 160–1; Haselkorn and Travitsky (eds), *The Renaissance Englishwoman in Print*, pp. 356–7; Lerner, *The Creation of Feminist Consciousness*, p. 311.

100. 'I. H. Gentleman', *A Strange Wonder or a Wonder in a Woman, Wherein Is Plainely Expressed the Nature of Most Women* (1642) (Thomason Tract E.144[5]), pp. 2–4; Anon., *The Ghost: Or, the Woman Wears the Breeches. A Comedy Written in the Year MDCXL* (1653) (Thomason Tract E.710[8]), pp. 10–11, 16, 22.

101. 'I. H. Gentleman', *A Strange Wonder or a Wonder in a Woman*, pp. 1, 4.

102. Lucy de Bruyn, *Woman and the Devil in Sixteenth-Century Literature* (The Compton Press, Wiltshire, 1979).

103. Anon, *A Bull from Rome, Consisting of 15. Pardons for Delinquents in These Kingdomes. With a Declaration of the Popes Election in the Chaire at Rome, Where the Cardinalls (with Their Stript up Armes) Doe Use to Feele (Before His Consecration) Whether He Bee a Man or Woman. Whereunto is Occasionally Related by Them; the Originall Cause of Womens Vailes and of Their Wicked Tongues. According to the Coppie Printed at Rome* (1641) (Thomason Tract E.173[7]), SigA2-SigA3v.

104. ['K. R.'], *Taylors Physicke Has Purged the Divel, or the Divel Has Got a Squirt ... by Voluntas Ambulatoria* (1641) (Thomason Tract E.163[9]), SigA2; Thomas Grantham, *A Marriage Sermon. A Sermon Called a Wife Mistaken ... or Leah Instead of Rachel* (1641) (Thomason Tract E.172[19]).

105. Fletcher, *Gender, Sex and Subordination*, especially chpts. 3, 14, 19.

106. Robert Gould, *Love Given O're: Or, a Satyr against Woman* (1682) reprinted by The Augustan Reprint Society in *Satires on Women* (University of California, Los Angeles, 1976) edited with an introduction by Felicity A. Nussbaum, pp. iii, Sig A2v, 1–2.

107. Gould, *Love Given O're* reprinted in *Satires on Women*, pp. 2–5.

108. Robert Martensen, 'The Transformation of Eve: Women's Bodies, Medicine and Culture in Early Modern England', in Roy Porter and Mikulás Teich (eds), *Sexual Knowledge, Sexual Science: The History of Attitudes to Sexuality* (Cambridge, University Press, Cambridge, 1994); Walter Charleton, *The Ephesian Matron* (1668), reprinted by The Augustan Reprint Society, 172–3, edited with an introduction by Achsah Guibbory (University of California Press, Los Angeles, 1975).

109. Gould, *Love Given O're* reprinted in *Satires on Women*, pp. 6–7, 9–10.

110. [Richard Ames], *The Folly of Love; or an Essay upon Satyr against Woman* (1691) reprinted in *Satires on Women*, pp. SigA2v, 1–3, 5.

111. [Ames], *The Folly of Love* reprinted in *Satires on Women*, pp. 3, 7–8, 17.

112. [Sarah Fyge or Fige], *The Female Advocate: Or an Answer to a Late Satyr against the Pride, Lust and Inconstancy of Woman* (1687) reprinted in *Satires on Women*, p. SigA2; [Richard Brathwaite], *Ar't Asleepe Husband: A Boulster Lecture* (1640) (STC 3555), 71, 95–6; see

also Ferguson, *First Feminists*, pp. 154–67; Joanne Shattock (ed.), *The Oxford Guide to British Women Writers* (Oxford University Press, Oxford and New York, 1993), pp. 146–7; Kelly, 'Early Feminist Theory and the *Querelle des femmes*', in *Women, History and Theory*, p 77.

113. [Fige], *The Female Advocate* as reprinted in *Satires on Women*, pp. 2–3, 5–6, 17, 22ff.

114. [Fige], *The Female Advocate* as reprinted in *Satires on Women*, pp. 23–4.

115. Shattock (ed.), *The Oxford Guide to British Women Writers*, pp. 146–7; Kelly, 'Early Feminist Theory and the *Querelle des femmes*', in *Women, History and Theory*, p. 77.

116. Kelly, 'Early Feminist Theory and the *Querelle des femmes*', in *Women, History and Theory*, p. 77; Doris Mary Stenton, *The English Woman in History* (George Allen & Unwin, London, 1957), pp. 204–7; Shattock (ed.), *The Oxford Guide to British Women Writers*, p. 102.

117. There is some debate over the attribution of this tract and some historians claim it was written by Mary Astell. However, the most recent work on her has been done by Hannah Smith – 'English "Feminist" Writings and Judith Drake's *An Essay in Defence of the Female Sex* (1696)', *The Historical Journal*, 44:3 (2001), pp. 727–47 – and although Smith can find no exact date of birth or death, she finds enough evidence of her existence to confirm it. See Stenton, *The English Woman in History*, pp. 211–12 citing *An Essay in Defence of the Female Sex* (London, 1696), pp. 4–5, 26, 28–9, 55 ff.

118. This work was addressed to 'Eugenia', possibly the author of *The Female Advocate; or a Plea for the just Liberty of the Tender Sex* (1699).

119. Stenton, *The English Woman in History*, pp. 210–12 citing Nahum Tate, *A present for the Ladies* (1692), p. 101.

120. Shattock (ed.), *The Oxford Guide to British Women Writers*, p. 165; Anon., *The Female Wits or the Triumvirate of Poets at Rehearsal* (c.1697) reprinted in Fidelis Morgan, *The Female Wits: Women Playwrights of the Restoration* (Virago, London, 1981), pp. 390–433 quoting from pp. 392, 433.

121. Fletcher, *Gender, Sex and Subordination*, pp. 367–8.

122. Shattock (ed.), *The Oxford Guide to British Women Writers*, p. 146.

3 Femininity: Prescription, Rhetoric and Context

1. Joan Wallach Scott, 'Gender: A Useful Category of Historical Analysis' in *Gender and the Politics of History* (Columbia University Press, New York, 1988), p. 43.

2. There is no single book on early-modern femininity. The analysis of prescribed femininity in three chapters of Anthony Fletcher's *Gender, Sex and Subordination in England 1500–1800* (Yale University Press, New Haven and London, 1995), chpts. 17–19 is the most sustained analysis of male treatment of women and gender relations so far (though see also the works of Lawrence Stone such as *The Family, Sex and Marriage* of 1977). Sara Mendelson and Patricia Crawford offer a different approach in *Women in Early Modern England* (Clarendon Press, Oxford, 1998), treating prescriptions of womanhood as only the ideas that formed a 'context' for women's lived experience. There have been several surveys and anthologies of conduct literature relating to women, the earliest being Ruth Kelso's *Doctrine for the Lady of the Renaissance* (University of Illinois Press, Urbana, Illinois, 1956) and more recently N. H. Keeble's *Cultural Identity of Seventeenth-Century Woman* (Routledge, London, 1994) and Kate Aughterson's *Renaissance Woman* (1995). See as well Suzanne Hull, *Chaste, Silent and Obedient* (Huntington Library, San Marino, California, 1982; rep. 1988) and *Women According to Men: The World of Tudor-Stuart Women* (Altamira Press, Walnut Creek, 1996), Joan Larsen Klein (ed.), *Daughters, Wives and Widows: Writings by Men about Women and Marriage in England 1500–1640* (University of Illinois Press, Urbana, 1992).

3. Jacques le Goff, *Medieval Civilization 400–1500* (Oxford, 1988), p. 261; Sara Heller Mendelson, *The Mental World of Stuart Women: Three Studies* (The University of Massachusetts Press, Amherst, 1987), p. 2; Margaret R. Sommerville, *Sex and Subjection: Attitudes to Women in Early-Modern Society* (Arnold, London and New York, 1995), pp. 20–3.

4. Ruth Kelso, *Doctrine for the Lady of the Renaissance*, chpts. 6, 8, p. 97.
5. N. H. Keeble (ed.), *The Cultural Identity of Seventeenth-Century Woman: A Reader*, p. 54.
6. Kelso, *Doctrine for the Lady of the Renaissance*, pp. 95–108.
7. Kelso, *Doctrine for the Lady of the Renaissance*, pp. 109–115.
8. Arthur Dent, *The Plaine Man's Pathway to Heaven* (1607), p. 40 cited in Keeble, *The Cultural Identity of Seventeenth-Century Woman*, p. 83. See also Anne Laurence, 'Women, Godliness and Personal Appearance in Seventeenth-Century England', *Women's History Review*, 15:1 (2006), pp. 69–81.
9. John Milton, *Paradise Lost* (1667), viii.
10. Richard Lovelace, *Gratiana Singing and Dancing* from *Lucasta* (1649), p. 25 reprinted in Keeble (ed.), *The Cultural Identity of Seventeenth-Century Woman*, pp. 57, 59.
11. John Davies, *Orchestra, or, a Poem on Dancing* reprinted in *Silver Poets of the Sixteenth Century* edited by Gerald Bullett (J. M. Dent, London, 1984), p. 332.
12. Davies, *Orchestra* reprinted in *Silver Poets of the Sixteenth Century* edited by Bullett, p. 338.
13. Keeble (ed.), *The Cultural Identity of Seventeenth-Century Woman*, p. 54.
14. Personal observation plus information from Susan Cunliffe Lister, *Burton Agnes Hall* (1990).
15. Hull, *Women According to Men*, pp. 177–9 citing Thomas Becon, *The Catechism* (Cambridge University Press, Cambridge, 1844, p. 370 originally in his *Workes* (1560–1564), cccccxxxviv [cccccxxxiiv].
16. Kelso, *Doctrine for the Lady of the Renaissance*, pp. 78, 81.
17. Mendelson and Crawford, *Women in Early-Modern England*, pp. 354–6 – portrait on p. 354 from Rapin de Thoyras, *History of England* (1744), ii, 50 in the private collection of Alan Mendelson.
18. Thomas Tuke, *A Discourse against Painting and Tincturing of Women* (1616), p. 10 quoted in Hull, *Women According to Men*, p. 182; Natalie Zemon Davis and Arlette Farge (eds), *A History of Women in the West: Renaissance and Enlightenment Paradoxes* (Harvard University Press, Cambridge, Massachusetts, and London, 1993), pp. 60–1 citing R. Haydocke's translation of G. P. Lomazzo, *A Tracte Containing the Artes of Curious Paintinge Caruinge & Buildinge* (Oxford, 1598), quoted in Carroll Camden, *The Elizabethan Woman: A Panorama of English Womanhood, 1540 to 1640* (Cleaver Hume, London and New York, 1952); Caroline S. Andre, 'Some Selected Aspects of the Role of Women in Sixteenth Century England', *International Journal of Women's Studies*, 4 (1981), p. 83 citing Maggie Angeloglou, *A History of Make-Up* (Macmillan, London, 1970), p. 50.
19. Philip Stubbes, *The Anatomy of Abuses* (1583) fos. E7v f. reprinted in Aughterson, *Renaissance Woman*, p. 75.
20. See Ellen Chirelstein, 'Lady Elizabeth Pope: The Heraldic Body' in *Renaissance Bodies: The Human Figure in English Culture c.1540–1660* eds Lucy Gent and Nigel Llewelyn (Reaktion Books, London, 1990), pp. 40–1.
21. Nicholas Breton, *The Good and the Badde* (1615), pp. 272–4 cited in Keeble, *The Cultural Identity of Seventeenth-Century Woman*, p. 80.
22. Thomas Bentley, *The Monument of Matrons* (1582), p. 21 cited in Hull, *Women According to Men*, p. 33.
23. Ste. B., *Counsel to the Husband* (1608), p. 62 cited in Hull, *Women According to Men*, p. 42.
24. Cf. Jacqueline Eales, *Women in Early Modern England 1500–1700* (UCL Press, London, 1998), pp. 24–5.
25. Robert Burton, *The Anatomy of Melancholy* 1621; rep. J. M. Dent & Sons, London, Melbourne and Toronto, 1978), iii, 308.
26. Keith Thomas, 'The Double Standard', *Journal of the History of Ideas*, 20 (1959), pp. 195–216 especially p. 196 citing *Miscellanies by the Right Noble Lord, the Late Marquess of Halifax* (London, 1700), p. 17.

27. Sommerville, *Sex and Subjection*, pp. 142–6, 150, 152–3, 162–6.
28. Sommerville, *Sex and Subjection*, pp. 118, 127–8, 132, 145; Anon, *The Laws Resolutions of Women's Rights* (London, 1632), Sect. xxiii reprinted in Klein (ed.), *Daughters, Wives and Widows*, p. 38; Henry Smith, *A Preparative to Marriage* (London, 1591), p. 108 and Richard Baxter, *A Christian Directory* (1673), II. ix [IV.158–61] in William Orme (ed.), *The Practical Works*, 23 vols. (James Duncan, London, 1830) both as reprinted in Keeble (ed.), *The Cultural Identity of Seventeenth-Century Woman*, pp. 137–8.
29. Fletcher, *Gender, Sex and Subordination*, p. 98.
30. Bernard Capp, 'The Double Standard Revisited: Plebeian Women and Male Sexual Reputation in Early Modern England', *Past and Present*, 162 (1999), pp. 70–2 citing *The Diary of Ralph Josselin, 1616–1683* ed. Alan Macfarlane (London, 1976), pp. 139–40; Laura Gowing, *Domestic Dangers: Women, Words and Sex in Early-Modern London* (Oxford University Press, Oxford, 1996).
31. Smith, *A Preparative to Marriage*, pp. 108–9 as reprinted in Keeble (ed.), *The Cultural Identity of Seventeenth-Century Woman*, p. 137; cf. Thomas, 'The Double Standard', p. 203.
32. Sommerville, *Sex and Subjection*, p. 149; Thomas Becon, *The Book of Matrimony* in *Works* (London, 1564), f.627 as reprinted in Aughterson (ed.), *Renaissance Woman*, pp. 110–11.
33. Fletcher, *Gender, Sex and Subordination*, pp. 343 and 93 citing E. Partridge, *Shakespeare's Bawdy* (London, 1968), pp. 16–42,
34. Sommerville, *Sex and Subjection*, p. 149; Fletcher, *Gender, Sex and Subordination*, *passim*.
35. Lawrence Stone, *Road to Divorce: England 1530–1987* (Oxford University Press, Oxford, 1990), p. 56; Anon., *The Lawes Resolutions* in Klein (ed.), *Daughters, Wives and Widows*, p. 38.
36. Stone, *Road to Divorce*, pp. 149–50.
37. Thomas, 'The Double Standard', p. 202.
38. See Christopher Durston, '"Unhallowed Wedlocks": The Regulation of Marriage during the English Revolution', *The Historical Journal*, 31:1 (1988); *The Family in the English Revolution* (Clarendon Press, Oxford, 1989) and *Cromwell's Major Generals: Godly Government during the English Revolution* (Manchester University Press, Manchester, 2001).
39. Sommerville, *Sex and Subjection*, p. 143, Patricia Crawford, 'From the Woman's View: Pre-Industrial England, 1500–1750' in *Exploring Women's Past* (1983), p. 61 citing Keith Thomas, 'The Puritans and Adultery: The Act of 1650 Reconsidered' in David Pennington and Keith Thomas (eds), *Puritans and Revolutionaries* (Oxford, 1978), pp. 257–82.
40. Gabriel Towerson, *An Explication of the Decalogue* (1676), p. 206 cited in Sommerville, *Sex and Subjection*, p. 141.
41. Sommerville, *Sex and Subjection*, p. 141; Fletcher, *Gender, Sex and Subordination*, chpt. 6.
42. Gowing, *Domestic Dangers*, pp. 74–5 citing Alice Amos *c.* Richard and Susan Symonds (1579) (Consistory Court Records) DL/C 629, fos. 176ᵛ176, 177ᵛ; James Sharpe, 'Defamation and Sexual Slander in Early-Modern England: The Church Courts at York', Borthwick Paper 58 (York, 1980); Bernard Capp, *The World of John Taylor, the Water Poet* (Oxford University Press, Oxford, 1994); Fletcher, *Gender, Sex and Subordination*, pp. 103, 271–2.
43. William Perkins, *Christian Economy or, A Short Survey of the Right Manner of Erecting and Ordering a Family According to the Scriptures* trans. By Thomas Pickering (London, 1609) reprinted in Klein, *Daughters, Wives and Widows*, pp. 158–9.
44. Richard Brathwait, *The English Gentleman* (1628), *passim* and *The English Gentlewoman* (1631), *passim*.
45. Brathwait, *The English Gentlewoman*, p.157. Anne Laurence has pointed out to me that the distinction between 'Gentleman' (life stages) and 'Gentlewoman' (qualities) extended to funeral sermons, as if summing up a person's journey as lived out by pre-scribed social roles and codes of behaviour in conduct manuals and puritan advice manuals.

46. Brathwait, *The English Gentlewoman* (1631).

47. Juan Luis Vives, *The Instruction of a Christian Woman* (1523) translated by Richard Hyrde (1540), i, chpt. 8 as reprinted in Aughterson, *Renaissance Woman*, p. 69.

48. Alexander Niccholes, *A Discourse of Marriage and Wiving* (1615) reprinted in *The Harleian Miscellany* ii, p. 180; Richard Allestree, *The Ladies Calling* (1673), p. 148.

49. Brathwait, *The English Gentlewoman*, p. 187 and see 'Honour' pp. 191–221.

50. [Richard Brathwait], *Ar't Asleepe Husband: A Boulster Lecture* (1640), Sig. aA, Sig. A_4-A_4^v, 6, 40, 47, 71, 95–6.

51. Hull, *Women According to Men*, pp. 42–3 citing John Taylor, *The Needles Excellency* (1631), Sig. A-Av; The much-used phrase 'hotter sort of Protestant' was originally used by Patrick Collinson, *The Elizabethan Puritan Movement* (Jonathan Cape, London, 1967), p. 27 quoting Percival Wiburn, *A Checke or Reproof of M. Howlet's Untimely Screeching* (1581), f. 15v.

52. Brathwait, *The English Gentleman* (1630) and *The English Gentlewoman*, (1631).

53. Fletcher, *Gender, Sex and Subordination, passim*; Mendelson and Crawford, *Women in Early Modern England*, p. 17 puts a qualified case; see also Crawford, 'Sexual Knowledge in England', in Porter and Teich (eds), *Sexual Knowledge, Sexual Science: The History of Attitudes to Sexuality* (Cambridge University Press, Cambridge, 1994), p. 100.

54. Crawford, 'The Sucking Child', *Continuity and Change* 1 (1986), p. 25 citing Wellcome Institute (London), MS 751.

55. Crawford, 'From the Woman's View', in *Exploring Women's Past*, p. 58 citing C. Severn (ed.), *Diary of the Rev. John Ward* (London, 1839), p. 102.

56. Thomas, 'The Double Standard', p. 196 citing *Miscellanies by…the Late Marquess of Halifax*, p. 17.

57. John Wolferston to his sister [name not known], 1 December 1627, Huntington Library, Temple Family, Addenda Collection, HM 46,530.

58. John Wolferston to his sister [name not known], 1 December 1627, Huntington Library, Temple Family, Addenda Collection, HM 46,530.

59. William Shakespeare, *Troilus and Cressida* (c.1603) ed. by Louis B. Wright and Virginia A. LaMar (Washington Square Press, New York, 1966), I, iii, pp. 21–3.

60. Shakespeare, *Troilus and Cressida* ed. by Wright and LaMar, II, ii, pp. 37–40.

61. Shakespeare, *Troilus and Cressida* ed. by Wright and LaMar, II, ii, pp. 43, 38.

62. Shakespeare, *Troilus and Cressida* ed. by Wright and LaMar, II, ii, pp. 131, 133, 135.

63. Capp, 'The Double Standard Revisited', p. 73 quoting *The Diary of Samuel Pepys* eds R. C. Latham and W. Matthews, 11 vols. (London, 1970–83), ix, 363.

64. The extraordinary frontispiece to Thomas Hobbes's *Leviathan* springs immediately to mind, a visual representation of the king as giant, his crowned head sitting atop a body composed of all the subjects of his kingdom, all but one of whom appear to be gazing upwards to his head, a startling and graphic metaphor representing the way in which the component parts of the body came together to seek direction from the head.

65. See Susan Amussen, *An Ordered Society: Gender and Class in Early Modern England* (Columbia University Press, New York, 1994); Anthony Fletcher and John Stevenson (eds), *Order and Disorder in Early Modern England* (Cambridge University Press, Cambridge, 1985); Fletcher, *Gender, Sex and Subordination*, chpts. 5, 6.

66. Kelso, *Doctrine for the Lady of the Renaissance*, pp. 59, 71–3, 76, 91.

67. Christine Peters, 'Single Women in Early Modern England: Attitudes and Expectations', *Continuity and Change*, 12 (1997), p. 329.

68. Juan Luis Vives, *Instruction of a Christian Woman* (1523) from trans. Richard Hyrde (1529) Books 1–4 in Klein, *Daughters, Wives and Widows*, pp. 100–102.

69. Juan Luis Vives, *Instruction of a Christian Woman* (1523) from trans. Richard Hyrde (1529) Books 1–4 in Klein, *Daughters, Wives and Widows*, pp. 109–113 and *The Office and Duty of an Husband* (1529) in Klein, *Daughters, Wives and Widows*, pp. 122–36.

70. Vives, *Instruction of a Christian Woman* (1523) from trans. Hyrde (1540) Book 1 chpts. 7, 8, 11, 12, Book 3 chpt. in Aughterson *Renaissance Woman*, pp. 69–73, 169–171 and in Klein (ed.), *Daughters, Wives and Widows*, pp. 105–6, 108–9.

71. Doris Mary Stenton, *The English Woman in History* (George Allen & Unwin, 1957), pp. 123–4 citing John Stow, *The Survey of London* (London, 1598) as quoted in George Ballard, *Memoirs of Several Ladies of Great Britain Who Have Been Celebrated for Their Writings, or Skill in the Learned Languages or Arts and Sciences* (Oxford, 1752) from the 1633 enlarged edition of Stow.

72. Klein, *Daughters, Wives and Widows*, pp. 65–8 (Richard Taverner's translation of *Encomium Matrimonii* is reprinted pp. 70–89); Rosemary Masek, 'Women in an Age of Transition' in Barbara Kanner (ed.), *The Women of England: From Anglo-Saxon Times to the Present: Interpretative Bibliographical Essays* (Archon Books, Hamden, Connecticut, 1979), p. 154.

73. Kanner, *The Women of England*, p. 149; Henry Bullinger, *The Christian State of Matrimony* (1541) reprinted in Aughterson, *Renaissance Woman*, pp. 106–8.

74. Margo Todd, 'Humanists, Puritans and the Spiritualized Household', *Church History*, 49 (1980) and Margaret Sommerville, *Sex and Subjection: Attitudes to Women in Early-Modern Society* (Arnold, London, 1995) summarised in Jacqueline Eales, *Women in Early Modern England 1500–1700* (UCL Press, London, 1998), p. 11.

75. Christopher Hill, *Society and Puritanism in Pre-Revolutionary England* (Secker and Warburg, London, 1964); James T. Johnson, 'English Puritan Thought on the Ends of Marriage', *Church History*, 38 (1969), pp. 429–36, *A Society Ordained by God: English Puritan Marriage Doctrine in the First Half of the Seventeenth Century* (Nashville, Tennessee and New York, 1970) and 'Puritans on the Covenant and on Marriage', *Journal of the History of Ideas*, 32 (1971), pp. 107–18; Lawrence Stone, *The Family, Sex and Marriage* (Weidenfeld and Nicolson, London, 1977), chpt. 5 especially pp. 138, 145–6.

76. Kelso, *Doctrine for the Lady of the Renaissance*, pp. 59–60; Masek, 'Women in an Age of Transition' in Kanner (ed.), *The Women of England*, p. 154; Pearl Hogrefe, *Tudor Women: Commoners and Queens* (Iowa State University Press, Ames, 1975), p. 5.

77. cf. Eales, *Women in Early Modern England*, p. 11; Anthony Fletcher, 'The Protestant Idea of Marriage in Early Modern England', in Anthony Fletcher and Peter Roberts (eds), *Religion, Culture and Society in Early Modern Britain: Essays in Honour of Patrick Collinson* (Cambridge University Press, Cambridge, 1994), pp. 161–81 citing Patrick Collinson, *The Birthpangs of Protestant England: Religious and Cultural Change in the Sixteenth and Seventeenth Centuries* (Macmillan, London, 1988), pp. 62–3, 70, 93.

78. William Gouge, *Domesticall Duties* (1622) as reprinted in N. H. Keeble (ed.), *The Cultural Identity of Seventeenth-Century Woman: A Reader* (Routledge, London and New York, 1994), pp. 152–3. Peters, 'Single Women in Early Modern England', p. 328; Anthony Fletcher, 'Men's Dilemma: the future of patriarchy in England 1560–1660', *Transactions of the Royal Historical Society*, 4 (London, 1994), pp. 61–81, *Gender, Sex and Subordination*, *passim* and 'The Protestant Idea of Marriage in Early Modern England', in Fletcher and Roberts (eds), *Religion, Culture and Society in Early Modern Britain*, *passim*, especially, p. 162; Jacqueline Eales, 'Gender Construction in Early Modern England and the Conduct Books of William Whateley (1583–1639)', in R. N. Swanson (ed.), *Gender and Christian Religion*, Studies in Church History, 34 (The Boydell Press, 1998), pp. 163–74.

79. Peters, 'Single Women in Early Modern England', *passim*.

80. Anthony Stafford, *The Femall Glory* (1635), *passim*.

81. Thomas, 'The Double Standard', pp. 212–13 citing Daniel Rogers, *Matrimonial Honour* (London, 1642), p. 308.

82. Bodleian Library MS Rawlinson D.78 (Diary of Elizabeth Delaval, Lady Livingston), ff. 226–8 reprinted in Ralph Houlbrooke, *English Family Life 1576–1716* (Basil Blackwell, Oxford, 1988), pp. 27–8.

83. Mendelson and Crawford, *Women in Early Modern England*, p. 112.

84. Stenton, *The English Woman in History*, pp. 104–7; the homilies were written by Bishop Bonner, Archbishop Cranmer, Nicholas Harpsfield and others under the initial authority of Henry VIII and rewritten by Archbishop Parker, Bishop Pilkington and others under the authority of Elizabeth I – Klein, *Daughters, Wives and Widows*, p. 11.

85. *An Homily of the State of Matrimony* from *The Second Tome of Homilies* (London, 1563) reprinted in Klein, *Daughters, Wives and Widows*, pp. 13–25.

86. Gordon Schochet, *The Authoritarian Family and Political Attitudes in 17th Century England: Patriarchalism in Political Thought* (Transaction Books, New Brunswick and London, 1988), p. 64; Richard Hooker, *Of the Laws of Ecclesiastical Polity*, iii, 393 quoted in Katharine M. Rogers, *The Troublesome Helpmate: A History of Misogyny in Literature* (University of Washington Press, Seattle and London, 1966), p. 142.

87. Erickson, *Women and Property in Early Modern England*, p. 54 citing Markham, *The English Housewife* (9th ed., 1683), title page; for a lengthy description of women's work and occupational identities see Mendelson and Crawford, *Women in Early Modern England*, chpt. 6 but also Christina Hole, *The English Housewife in the Seventeenth Century*, chpt. 6.

88. Sommerville, *Sex and Subjection*, pp. 174–5 citing William Perkins, *Works* (Cambridge, 1618), iii, 681; William Whateley, *A Bride-Bush, or, A Direction for Married Persons* (1623), p. 38 quoted in Rogers, *The Troublesome Helpmate*, p. 144 and Henderson and McManus, *Half Humankind*, p. 78; Chilton Latham Powell, *English Domestic Relations 1487–1653* (Columbia University Press, New York, 1917), p. 135.

89. Keith Wrightson, *English Society 1580–1680* (Hutchinson, London, Melbourne, Sydney, Auckland and Johannesburg, 1982), p. 91 citing Roger Thompson, *Women in Stuart England and America: A Comparative Study* (London and Boston, 1974), chpt. 8 and K. Davies, '"The Sacred Condition of Equality" – How Original Were Puritan Doctrines of Marriage?', *Social History*, 5 (1977), pp. 566, 570.

90. Fletcher, *Gender, Sex and Subordination*, p. 254.

91. Amy Erickson, *Women and Property in Early Modern England* (Routledge, London and New York, 1993), pp. 53–4; Fletcher, *Gender, Sex and Subordination*, pp. 226–30.

92. Thomas Tusser, *The Points of Housewifery, United to the Comforts of Husbandry* (London, 1580) reprinted in *Daughters, Wives and Widows*, pp. 205–8, 230; for a discussion of Tusser and the importance of frugality see also Michael Roberts, 'To Bridle the Falsehood of Unconscionable Workmen, and for Her Own Satisfaction': What the Jacobean Housewife Needed to Know about Men's Work, and Why', *Labour History Review*, 63 (Spring, 1998), p. 14.

93. Tusser, *The Points of Housewifery* reprinted in *Daughters, Wives and Widows*, pp. 209–30 with quotations from pp. 221–2; Roberts, 'To Bridle the Falsehood of Unconscionable Workmen', pp. 4, 13, 21–2 citing Markham, *The English Housewife*, pp. 160, 165, 169–70, 178, 189.

94. Markham, *The English Housewife*, quoted in Hole, *The English Housewife in the Seventeenth Century*, p. 99.

95. Tusser, *The Points of Housewifery* reprinted in *Daughters, Wives and Widows*, pp. 209–30 with quotations from pp. 221–2; Roberts, 'To Bridle the Falsehood of Unconscionable Workmen', pp. 4, 13, 21–2 citing Markham, *The English Housewife*, pp. 160, 165, 169–70, 178, 189.

96. William Perkins, *Christian Economy: Or, a Short Survey of the Right Manner of Erecting and Ordering a Family According to the Scriptures* trans. by Thomas Pickering (1609) reprinted in Klein, *Daughters, Wives and Widows*, pp. 158–9.

97. Fletcher, *Gender, Sex and Subordination*, pp. 175–180 citing W. and M. Haller, 'The Puritan Art of Love', *Huntington Library Quarterly*, 5 (1941–2), pp. 235–72 and E. Leites, 'The Duty to Desire: Love, Friendship and Sexuality in Some Puritan Theories of Marriage', *Journal of Social History*, 15 (1982), pp. 383–408 and Dod and Cleaver, *A Godly Form of Household Government*, Sig. K8.

98. Whateley, *A Bride Bush*, p. 43 reprinted in Keeble, *The Cultural Identity of Seventeenth-Century Woman*, p. 31.

99. Fletcher, *Gender, Sex and Subordination*, *passim* but especially Part II; Breitenberg, *Anxious Masculinity in Early Modern England*, p. 98.

100. Ralph Houlbrooke, *The English Family 1450–1700* (Longman, London, 1984).
101. Wrightson, *English Society 1580–1680*, pp. 91, 103–4; Stone, *Family, Sex and Marriage*.
102. Cf. Henderson and McManus, *Half Humankind*, p. 78 discussing William Gouge, *Of Domesticall Duties* (London, 1622).
103. James I, *Works* (London, 1616) ed. James, Bishop of Winchester, pp. 172–3 quoted in Stenton, *The English Woman in History*, p. 142.
104. Schochet, *The Authoritarian Family and Political Attitudes in 17th Century England*, p. 57 citing Michael Walzer, *The Revolution of the Saints: A Study in the Origins of Radical Politics* (Cambridge, Massachusetts, 1965), p. 49 and Schochet pp. 75–81.
105. Hill, *Society and Puritanism in Pre-Revolutionary England*, p. 446 quoted in Schochet, *The Authoritarian Family and Political Attitudes in 17th Century England*, p. 57.
106. J. R. Kent, 'Attitudes of Members of the House of Commons to the Regulation of Personal Conduct in Late Elizabethan and Early Seventeenth-Century England', *Bulletin of the Institute of Historical Research*, 45 (1972), p. 55 cited in Fletcher, *Gender, Sex and Subordination*, p. 220; Conrad Russell, *The Causes of the English Civil War* (Clarendon Press, Oxford, 1990), pp. 66–7.
107. Stone, *Uncertain Unions and Broken Lives*, pp. 299–303 citing Boteler -v- Boteler, Lambeth Palace Court of Arches MS D.206; Fletcher, *Gender, Sex and Subordination*, chpt. 10; Perkins, *Christian Economy* reprinted in Kanner, *Daughters, Wives and Widows*, p. 172.
108. William Gouge, *Of Domesticall Duties* (London, 1622), Sig. A2v.
109. William Gouge, *Of Domesticall Duties* (London, 1622), Sig. A1; there is a discussion of Gouge's work in Kelso, *Doctrine for the Lady of the Renaissance*, pp. 93–4.
110. Susan Amussen, *An Ordered Society: Gender and Class in Early Modern England* (Columbia University Press, New York, 1988), p. 43 and quoting Edmund Tilney, *A Brief and Pleasant Discourse of Duties in Marriage, Called the Flower of Friendshippe* (London, 1571), Sig. Ei; Gouge, *Of Domesticall Duties*, Sig. A3v-A4.
111. Gouge, *Of Domesticall Duties*, table of contents.
112. Gouge, *Of Domesticall Duties*, table of contents; his aberrations included ambition (women)/want of wisdom (men); a conceit that wives are their husbands equals/too mean account of wives; unreverend speeches/bitter speeches and a stout standing on her own will/losing of his authority.
113. Gouge, *Of Domesticall Duties*, pp. 267–73, 349 ff.
114. Schochet, *The Authoritarian Family and Political Attitudes in 17th Century England*, pp. 63–74 citing John Dod and Robert Cleaver, *A Godly Form of Household Government, for the Ordering of Private Families* (1598 and 1630), Sigs. Z5 and AA5.
115. Amussen, *An Ordered Society*, p. 38.
116. Dod and Cleaver, *A Godly Form of Household Government*, Sigs. L6v-L7 and Brathwait, *The English Gentleman*, p. 155 quoted in Amussen, *An Ordered Society*, pp. 47, 37.
117. Hull, *Women According to Men*, pp. 134–5.
118. Ralph Verney to Dr Denton, in Frances Parthenope Verney, *Memoirs of the Verney Family during the Civil War*, 4 vols. (1892), iii, 66 quoted in Antonia Fraser, *The Weaker Vessel: Woman's Lot in Seventeenth-Century England* (Methuen, London, 1984), p. 158.
119. Eales, 'Gender Construction in Early Modern England', p. 173.
120. Robert Filmer, *Patriarcha and Other Writings* ed. Johann P. Sommerville (Cambridge University Press, Cambridge, 1991), pp. 1–2, 7 ff. For a good text on early-modern social order see, Michael J. Braddick and John Walter (eds), *Negotiating Power in Early Modern Society: Order, Hierarchy and Subordination in Britain and Ireland* (Cambridge University Press, Cambridge, 2001).
121. Joan Wallach Scott, 'Gender: A Useful Category of Historical Analysis' in *Gender and the Politics of History* , pp. 48–49.
122. William Shakespeare, *The Taming of the Shrew* ed. by Ann Thompson (Cambridge University Press, Cambridge, 1984), pp. 62, 88, 91, 151–3.

123. Schochet, *The Authoritarian Family and Political Attitudes in 17th Century England*, pp. 115–19.

124. Roberts, 'To Bridle the Falsehood of Unconscionable Workmen', pp. 7–8 quoting Tessa Watt, *Cheap Print and Popular Piety 1550–1640* (Cambridge University Press, Cambridge, 1991), chpts. 5, 7; Adriaen van Ostade, 'The Violin Player' of 1673 is in the Mauritshuis, The Hague; see Watt, *Cheap Print and Popular Piety 1550–1640*, chpt. 6 especially pp. 225–6.

125. Eales, *Women in Early Modern England*, p. 32.

126. Anne Laurence, *Women in England 1500–1760: A Social History* (Weidenfeld and Nicolson, London, 1994), p. 66 quoting *Art of Courtship* in Margaret Spufford, *Small Books and Pleasant Histories* (Cambridge University Press, Cambridge, 1981), pp. 159–60.

127. Eales, *Women in Early Modern England*, p. 32.

128. Samuel Rowlands, *The Bride* (1617), f. E1 reprinted in S. P. Cerasano and Marion Wynne-Davies, *Renaissance Drama by Women: Texts and Documents* (Routledge, London, 1996), p. 161.

129. Rowlands, *The Bride*, f. E1 reprinted in Cerasano and Wynne-Davies, *Renaissance Drama by Women*, p. 161.

130. *Long Meg of Westminster* (1582), Samuel Pepys' *Penny Merriments*, II, no. 26 quoted in Spufford, *Small Books and Pleasant Histories*, p. 245.

131. Roberts, 'To Bridle the Falsehood of Unconscionable Workmen', p. 6 quoting John Aubrey, *Brief Lives* ed. Oliver Lawson Dick (Harmondsworth, 1972), p. 29; Watt, *Cheap Print and Popular Piety 1550–1640*, p. 304.

132. *Elinor Fettiplace's Receipt Book* ed. Hilary Spurling (Harmondsworth, 1986); Mary Thompson's 'Booke of Receapts', Brynmor Jones Library MS DDHO/19/1.

133. Fraser, *The Weaker Vessel*, pp. 158–60 citing John Batchiller, *The Virgin's Pattern: In the Exemplary Life and Lamented Death of Mrs Susanna Perwick* (1661) and Dorothy Gardiner, *English Girlhood at School: A Study of Women's Education through Twelve Centuries* (1929).

134. Eales, *Women in Early Modern England*, p. 29.

135. Fraser, *The Weaker Vessel*, pp. 66–7 citing Anthony Walker, *The Holy Life of Mrs Elizabeth Walker*, new ed. abridged and revised by Rev. J. W. Brooks (1823), pp. 44, 33.

136. Eales, *Women in Early Modern England*, p. 29; Anthony Fletcher gives the figure of twenty-four editions between 1591 and 1637 – Fletcher, *Gender, Sex and Subordination*, p. 348.

137. Joshua Sylvester, *Monodia: An Elegie in Commemoration of the Vertuous Life and Godlie Death of... Dame Hellen Branch* (1594) reprinted in Henderson and McManus (eds), *Half Humankind*, pp. 329–34; see also p. 65.

138. Sylvester, *Monodia* reprinted in Henderson and McManus (eds), *Half Humankind*, p. 333.

139. Fletcher, *Gender, Sex and Subordination*, pp. 348–9.

140. John Mayer, *A Pattern for Women, Setting Forth the Most Christian Life and Most Comfortable Death of Mrs Lucy... Thornton* (1619) reprinted in Henderson and McManus (eds), *Half Humankind*, pp. 336–42, see also p. 64.

141. Mayer, *A Pattern for Women* reprinted in Henderson and McManus (eds), *Half Humankind*, pp. 336–42, see also p. 64.

142. *The Honour of Virtue: or, The Monument Erected... to the Immortal Memory of... Elizabeth Crashaw* (1620), reprinted in Henderson and McManus (eds), *Half Humankind*, pp. 344–50; see also pp. 65–6.

143. Samuel Clarke, *A Collection of the Lives of Ten Eminent Divines* (1662) and *The Lives of Thirty-Two English Divines* (1677).

144. Samuel Clarke, *Lives of Sundry Eminent Persons in this Later Age* (1683), ii, 140, 184, 198, 200.

145. Gerda Lerner, 'Placing Women in History: A 1975 Perspective', in Berenice Carroll (ed.), *Liberating Women's History: Theoretical and Critical Essays* (University of Illinois Press, Urbana and Chicago, 1976), pp. 357–9; Mendelson and Crawford, *Women in*

Early Modern England. P. 128; Fletcher, *Gender, Sex and Subordination*, pp. 349–51; J. Eales, 'Samuel Clarke and the "Lives" of Godly Women in Seventeenth-Century England', in W. Sheils (ed.), *Women in the Church*, Studies in Church History, 27 (Blackwell, Oxford, 1990); Peter Lake, 'Feminine Piety and Personal Potency: The Emancipation of Mrs Jane Ratcliffe', *The Seventeenth Century*, ii (1987), pp. 160–1.

146. Sarah Savage wanted her diary to be a 'means to make me the more watchful of the frame of my heart when it must be kept on record'. Susanna Hopton's *Daily Devotions* (1673) is one example of a woman who turned spiritual diarising into a public activity. See Sara Heller Mendelson, 'Stuart Women's Diaries and Occasional Memoirs' in Mary Prior (ed.), *Women in English Society 1500–1800* (Routledge, London and New York, 1985), p.186 and n. 35, p. 206.

147. Eales, *Women in Early Modern England*, p. 29 citing Elizabeth Joceline, *The Mother's Legacy* (1624); Dorothy Leigh, *The Mother's Blessing: Or, the Godly Counsel of a Gentlewoman Not Long since Deceased, Left Behind for Her Children* (1616) reprinted in Kanner, *Daughters, Wives and Widows*, pp. 287–302.

148. Fletcher, *Gender, Sex and Subordination*, pp. 350–2 citing Peter Lake, 'Feminine Piety and Personal Potency: The 'Emancipation' of Mrs Jane Ratcliffe', *Seventeenth Century*, 1:2 (1987), pp. 150–3.

149. Henderson and McManus, *Half Humankind*, pp. 47–63; Mendelson and Crawford, *Women in Early Modern England*, pp. 58–71.

150. Natalie Zemon Davis and Arlette Farge (eds), *A History of Women: Renaissance and Enlightement Paradoxes*, vol. iii of Georges Duby and Michelle Perrot (eds), *A History of Women in the West* (Belknap, Harvard University Press, Massachusetts, 1993), p.1.

151. Fletcher, *Gender, Sex and Subordination*, chpts. 19–20 and pp. 387–96 citing F. A. Childs, 'Prescriptions for Manners in English Courtesy Literature 1690–1760 and Their Social Implications' (DPhil Thesis, Oxford University, 1984).

152. Fletcher, *Gender, Sex and Subordination*, pp. 385–7; Richard Allestree, *The Ladies Calling* (1673), i, pp. 1–79.

153. Fletcher, *Gender, Sex and Subordination*, p. 387.

154. Lawrence Stone, *The Family, Sex and Marriage in England 1500–1800* (Weidenfeld and Nicolson, London, 1977).

155. Allestree, *The Ladies Calling*, frontispiece, pp. 79, 177–9.

156. Davies, *A Contention betwixt a Wife, a Widow and a Maid* reprinted in *Silver Poets of the Sixteenth Century* ed. Bullett, p. 411.

157. Examples include Marcantonio Raimandi's print of Adam and Eve of *c*.1515 and Hans Holbein's 'The Old and the New Law' of 1533–5.

4 Law and Private Life

1. This definition of patriarchy was originally used in a slightly different form in Amanda L. Capern, 'The Role of Women in English Society 1558–1660, *Historical News* (New Zealand), 69 (1994), p. 7. Cf. John Tosh, *The Pursuit of History: Aims, Methods and New Directions in the Study of Modern History* (Longman, Harlow Essex, 1999), p. 4.

2. Patricia Springborg, 'Republicanism, Freedom from Domination, and the Cambridge Contextual Historians', *Political Studies*, 49 (2001), Abstract, 851; John Locke, *Two Treatises of Government* (Everyman, London, 1993), pp. 153, 155; Carole Pateman, *The Sexual Contract* (Polity Press, Cambridge, 1988).

3. See Patricia Crawford, 'Public Duty, Conscience and Women in Early-Modern England', in John Morrill, Paul Slack and Daniel Woolf (eds), *Public Duty and Private Conscience in Seventeenth Century England* (Clarendon Press, Oxford, 1993), pp. 59–61; David Cressy, *Birth, Marriage and Death: Ritual, Religion and the Life Cycle in Tudor and Stuart England* (Oxford University Press, Oxford, 1997); Bernard Capp, 'Separate Domains? Women and Authority in Early-Modern England' in Paul Griffiths, Adam

Fox and Steve Hindle (eds), *The Experience of Authority in Early-Modern England* (Macmillan, Basingstoke, 1996), pp. 117–45; Stephen Pincus, '"Coffee Politicians Does Create": Coffee Houses and Restoration Political Culture', *Journal of Modern History*, 67 (1995), pp. 807–34; Brian Cowan, 'What Was Masculine about the Public Sphere? Gender and the Coffee House Milieu in Post-Restoration England', *History Workshop Journal*, 51 (2001). See also general discussion on gender and power Amanda L. Capern and Judith Spicksley, 'Introduction' to *Women, Wealth and Power*, Special Issue of *Women's History Review*, 16:3 (2007) and for post-modern accounts of power see Michel Foucault, *Power/Knowledge* (Pantheon, New York, 1980); all the works of Pierre Bourdieu including *Male Domination* (Polity Press, Oxford, 2001) and Nicholas B. Dirks, Geoff Eley and Sherry Ortner (eds), *Culture/Power/History: A Reader in Contemporary Social Theory* (Princeton University Press, Princeton, 1994).

4. Cf. Sara Mendelson and Patricia Crawford, *Women in Early Modern England* (Oxford University Press, Oxford and New York, 1998), p. 36. David Hey (ed.), *The Oxford Companion to Local and Family History* (Oxford University Press, Oxford, 1996), pp. 77–8. See also Laurence, *Women in England 1500–1760* , chpt. 15. Women could preside in manorial courts – for example, Catherine Willoughby's manorial court records are in Lincolnshire Record Office, Ancaster MSS.

5. Cf. Laurence, *Women in England 1500–1760*, p. 227.

6. Mendelson and Crawford, *Women in Early Modern England*, p. 36; Patricia Crawford, 'Women and Property: Women as Property', *Parergon*, 19:1 (2002), pp. 152 ff.

7. Cf. Mendelson and Crawford, *Women in Early Modern England*, pp. 35–7 citing in particular W. R. Prest, 'Law and Women's Rights in Early-Modern England', *The Seventeenth Century*, 6 (1991) and Amy Erickson, *Women and Property in Early Modern England* (Routledge, London and New York, 1993).

8. Joan Larsen Klein, *Daughters, Wives and Widows: Writings by Men about Women and Marriage in England 1500–1640* (University of Illinois Press, Urbana and Chicago, 1992), p. 28; Anon., *The Lawes Resolutions of Womens Rights*, pp. 396 ff.

9. Anon., *The Lawes Resolutions of Womens Rights*, pp. 6–24.

10. Anon., *The Lawes Resolutions of Womens Rights*, p. 52.

11. Anon., *The Lawes Resolutions of Womens Rights*, pp. 52–7; with sections reprinted in Klein, *Daughters, Wives and Widows*, pp. 34–44; Anne Somerset, *Unnatural Murder: Poison at the Court of James I* (Weidenfeld and Nicholson, London, 1997), *passim*.

12. Lawrence Stone, *Road to Divorce: England 1530–1987* (Oxford University Press, 1990), p. 301; Anon., *The Lawes Resolutions of Womens Rights*, pp. 57–68; with sections reprinted in Klein, *Daughters, Wives and Widows*, pp. 35–9; Introduction to Milton's divorce tracts in *Complete Prose Works of John Milton*, ii, ed. Ernest Sirluck (Yale University Press, New Haven, 1959), pp. 145–6; John Milton, *The Judgment of Martin Bucer Concerning Divorce, Written to Edward the Sixt* (London, 1644).

13. Anon., *The Lawes Resolutions of Womens Rights*, pp. 71–115; with sections reprinted in Klein, *Daughters, Wives and Widows*, pp. 39–44.

14. Anon., *The Lawes Resolutions of Womens Rights*, pp. 116–330; with sections reprinted in Klein, *Daughters, Wives and Widows*, pp. 44–54; cf. Suzanne Hull, *Women According to Men: The World of Tudor-Stuart Women* (Altamira Press, Walnut Creek, London and New Delhi, 1996), p. 32 citing *The Lawes Resolutions of Womens Rights* p. 130 and William Gouge, *Of Domesticall Duties* (1622), p. 298.

15. Klein, *Daughters, Wives and Widows*, p. 28; Anon., *The Lawes Resolutions of Womens Rights*, pp. 3–4.

16. Mendelson and Crawford, *Women in Early Modern England* pp. 47–8, 106–7; Anon., *The Lawes Resolutions of Womens Rights*, pp. 128–9, 376–80.

17. For a clear discussion of the legalities and complexities of early-modern marriage see Chilton Latham Powell, *English Domestic Relations 1487–1653* (Columbia University Press, New York, 1917), chpt. 1 Pt. I.

18. Lawrence Stone, *Uncertain Unions and Broken Lives: Marriage and Divorce in England 1660–1857* (Oxford University Press, Oxford, 1995), pp. 225–38.

19. Stone, *Uncertain Unions and Broken Lives*, pp. 68–87.
20. Vivien Brodsky has established that women working away from home in London arranged their own marriages and tended to marry later than women whose families were in London to men who were only slightly older than themselves rather than much older – 'Single Women in the London Marriage Market: Age, Status and Mobility 1598–1619, in R. B. Outhwaite (ed.), *Marriage and Society: Studies in the Social History of Marriage* (Europe, London, 1981).
21. Brynmor Jones Library, Hull University, 'Sir Hugh Cholmley's Memoirs', MS DCY/17/4; Ralph Houlbrooke (ed.), *English Family Life, 1576–1716: An Anthology from Diaries* (Basil Blackwell, Oxford, 1988), p. 254.
22. Mary Chan, *Life into Story: The Courtship of Elizabeth Wiseman* (Ashgate, Aldershot, 1998), pp. xi–xvi, 23–7 [Document 12 'The Lady Wiseman's relation concerning Mr Spencer' Oct. 1686]; Stone, *Road to Divorce*, p. 192.
23. See Anne Laurence on the connection between beauty and the modesty of the godly woman in 'Women, Godliness and Personal Appearance in Seventeenth-Century England', *Women's History Review*, 15:1 (2006), pp. 69–81.
24. Houlbrooke (ed.), *English Family Life*, pp. 26–7 citing Latham and Matthews (eds.), *Diary of Samuel Pepys*, vi, pp. 157–61, 176.
25. Alice Thornton, *The Autobiography of Alice Thornton of East Newton, Co. York*, Publications of the Surtees Society (Andrews & Co, Durham, 1873), pp. 76–7; Mendelson and Crawford, *Women in Early Modern England*, p. 129.
26. Edmund Lodge, *Illustrations of British History, Biography and Manners, in the Reigns of Henry VIII, Edward VI, Mary, Elizabeth and James I* (Chidley, London, 1838), vol. ii, 571 – reference owed [with thanks] to Simon Healy, unpub. *History of Parliament* essay (Sir Henry Grey) and Helen Payne.
27. See Sasha Roberts, 'Lying among the Classics: Ritual and Motif in Elite Elizabethan and Jacobean Beds', in Lucy Gent (ed.), *Albion's Classicism: The Visual Arts in Britain, 1550–1660* (Yale University Press, New Haven, 1995).
28. Mendelson and Crawford, *Women in Early Modern England*, pp. 129–31.
29. Keith Thomas, 'The Double Standard', *Journal of the History of Ideas*, 20 (1959), pp. 212–13.
30. Stone, *Uncertain Unions and Broken Lives*, p.184; his behaviour caused the destruction of the relationship and Edward Griffin's marriage to another woman despite public consummation of his clandestine marriage to Elizabeth.
31. Stone, *Uncertain Unions and Broken Lives*, p. 45.
32. Donald F. Harris, 'The More Children of the Mayflower: Their Shropshire Origins and the Reasons Why They Were Sent Away with the Mayflower Community', *The Mayflower Descendant: A Magazine of Pilgrim Genealogy and History*, I, 43:2 (1993), pp. 123–31 citing More Family Papers 1037/10/1–3, Shropshire Record Office; More Family Papers, Family Tree, Linley Hall, Shropshire and St James church parish register, Shipton.
33. Harris, 'The More Children of the Mayflower', II, 44:1 (1994), pp. 11–12 citing More Family Papers 1037/9/82–3, 1037/10/41, Shropshire Record Office; Stanton Long parish register and A. R. Wagner, 'The Origin of the Mayflower Children, Jasper, Richard and Ellen More', *NEHGR*, 114 (1960), pp. 163–8 – transcription of a petition to Sir James Ley, Lord Chief Justice of the King's Bench in The More Family Papers, Linley Hall, Shropshire.
34. Harris, 'The More Children of the Mayflower', II, pp. 12, 16–17 citing More Family Papers 1037/9/83, Shropshire Record Office; Wagner, 'The Origin of the Mayflower Children', pp. 163–8 – transcription of a petition to Sir James Ley, Lord Chief Justice of the King's Bench in The More Family Papers, Linley Hall, Shropshire.
35. Harris, 'The More Children of the Mayflower', II, pp. 17–19 citing More Family Papers 1037/9/83, Shropshire Record Office; Wagner, 'The Origin of the Mayflower Children', pp. 163–8 – transcription of a petition to Sir James Ley, Lord Chief Justice of the King's Bench in The More Family Papers, Linley Hall, Shropshire; Harris, 'The More Children of the Mayflower', III, pp. 21–5.

36. Harris, 'The More Children of the Mayflower', II, pp. 18–19 citing More Family Papers 4572/5/88, Shropshire Record Office; Wagner, 'The Origin of the Mayflower Children', pp. 163–8 – transcription of a petition to Sir James Ley, Lord Chief Justice of the King's Bench in The More Family Papers, Linley Hall, Shropshire; Harris, 'The More Children of the Mayflower', III, pp. 21–5.

37. Lawrence Stone, *The Family, Sex and Marriage in England 1500–1800* (Penguin, New York, 1977), *passim*, citing p. 88. Stone's dating of the shift to the 'affective family' is rather uncertain. See Amanda Vickery, *The Gentleman's Daughter: Women's Lives in Georgian England* (Yale University Press, New Haven and London, 1998) for a clear demonstration of the *non sequitur* Lawrence Stone creates between affection and equality.

38. Patricia Crawford, 'Katherine and Philip Henry and Their Children: A Case Study in Family Ideology', *Transactions of the Historic Society of Lancashire and Cheshire*, 134 (1984), p. 39.

39. Ralph Houlbrooke, *The English Family, 1450–1700* (1984) and (ed.), *English Family Life 1576–1716* , exemplary anthology.

40. 'Mrs Penruddock's last letter to her honourable and dear husband', 3 May 1655, Brynmor Jones University MSS, DDSY/101/1. For more on women's grief see Ralph Houlbrooke (ed.), *Death, Ritual and Bereavement* (Routledge, London and New York, 1989), 'The Puritan Deathbed, 1560–1660' in Christopher Durston and Jacqueline Eales (eds), *The Culture of English Puritanism 1560–1700* (Macmillan, Basingstoke, 1996) and *Death, Religion and Family in England 1480–1750* (Oxford University Press, Oxford, 1998).

41. See Sara Heller Mendelson, *The Mental World of Stuart Women: Three Studies* (The Harvester Press, Brighton, 1987), especially pp. 96–114; Charlotte Fell Smith, *Mary Rich, Countess of Warwick (1625–1678): Her Family and Friends* (Longmans, Green and Co., London, 1901).

42. Fletcher, *Gender, Sex and Subordination*, pp. 180–1.

43. Cressy, *Birth, Marriage and Death*, pp. 234–5 citing G. E. Aylmer (ed.), *The Diary of William Lawrence Covering Periods between 1662 and 1681* (Beaminster, 1961), p. 52.

44. See Margaret Hunt, 'Wife Beating, Domesticity and Women's Independence in Eighteenth-Century London', *Gender and History*, 4 (1992); Fletcher, *Gender, Sex and Subordination*, chpt. 10.

45. Stone, *Uncertain Unions*, pp. 37–9, Boteler -v- Boteler pp. 299–303.

46. Stone, *Road to Divorce*, p. 202 citing Lambeth Palace, Court of Arches MSS D.602, 71, 76, 80–98, 104–7, 143, 149–50, 156–60.

47. Stone, *Road to Divorce*, p. 186 and *Uncertain Unions and Broken Lives*, pp. 304–13.

48. Huntington Library, Temple MSS.

49. With thanks to Helen Good for sharing this case with me. Articles and answers in a case, the Ecclesiastical Commissioners of York against Melchior Smith, 1563/4 [Cause Papers, R.VII.G.1396] rep. in *Tudor Parish Documents of the Dioces of York* ed. J. S. Purvis (Cambridge University Press, Cambridge, 1948), pp. 209–25.

50. Fletcher, *Gender, Sex and Subordination*, *passim*, but especially chpt. 10 quoting from pp. 192–4, 196; see also Susan Amussen, '"Being Stirred to Much Unquietness": Violence and Domestic Violence in Early Modern England', *Journal of Women's History*, 6:2 (1994), pp. 70–89; Wendy Langford, 'Romantic Love and Power' in Tess Cosslett, Alison Easton and Penny Summerfield (eds), *Women, Power and Resistance: An Introduction to Women's Studies* (Open University Press, Buckingham, Philadelphia, 1996), especially p. 31. Cf. Erickson, *Women and Property in Early Modern England*, p. 7.

51. Crawford, 'Katherine and Philip Henry and Their Children, pp. 47, 57 with citation from Diary of Sarah Savage, Chester City Record Office, 19 April 1687.

52. Pollock, *With Faith and Physic: The Life of a Tudor Gentlewoman, Lady Grace Mildmay 1552–1620* (Collins and Broan, London, 1993), pp. 10, 40–1. This section has also been greatly informed by Patrick Collinson's ideas about the Calvinist ideology in 'godly

families' in *Godly People: Essays on English Protestantism and Puritanism* (Hambledon Press, London, 1983).

53. Anon., *The Lawes Resolutions of Womens Rights*, pp. 331–374; with sections reprinted in Klein, *Daughters, Wives and Widows*, pp. 49–55; see Antonia Fraser, *The Weaker Vessel: Woman's Lot in Seventeenth-Century England* (Methuen, London, 1984), chpt. 5 citing Richard Brathwait, *The English Gentlewoman* (1631), *Letters from Dorothy Osborne to Sir William Temple (1652–54)*, ed. E. A. Parry (1914), p. 123 and Richard Allestree, *The Ladies Calling* (1670), p. 42.

54. Huntington Library MSS, STT 2403.

55. Thornton, *The Autobiography of Mrs Alice Thornton*, pp. 246–9.

56. See, for example, Barbara Todd, 'The Remarrying Widow: A Stereotype Reconsidered', in Mary Prior (ed.), *Women in English Society* (Routledge, London and New York, 1985), p. 65; Pamela Sharpe, 'Survival Strategies and Stories: Poor Widows and Widowers in Early Industrial England' and Elizabeth Foyster, 'Marrying the Experienced Widow in Early Modern England: the Male Perspective', both in Sandra Cavallo and Lyndan Warner (eds), *Widowhood in Medieval and Early Modern Europe* (Longman, Harlow, 1999); Margaret Pelling, 'Old Age, Poverty, and Disability in Early Modern Norwich: Work, Remarriage and Other Expedients' in Margaret Pelling and Richard Smith (eds), *Life, Death and the Elderly: Historical Perspectives* (Routledge, London and New York, 1991). See also Judith Bennett and Amy Froide (eds), *Single Women in the European Past 1250–1800* (University of Pennsylvania Press, Philadelphia, 1999).

57. Powell, *English Domestic Relations* , pp. 7–12.

58. See D. A. Kent, '"Gone for a Soldier": Family Breakdown and the Demography of Desertion in a London Parish 1750–91' and Pamela Sharpe, 'Marital Separation in the Eighteenth and Early Nineteenth Centuries', both in *Local Population Studies*, 45 (1990); E. P. Thompson, *Customs in Common* (Penguin, 1993), chpt. 7 – Thompson relates the early case in 1692 of John Whitehouse who sold his wife to Mr Bracegirdle. S. Menefee, *Wives for Sale: An Ethnographic Study of British Popular Divorce* (Oxford University Press, Oxford, 1981).

59. Stone, *Road to Divorce*, pp. 110–115, 141, 144–5, 149, 183, 191 and *Uncertain Unions and Broken Lives* (Oxford University Press, Oxford and New York, 1995), pp. 254–7 citing Tipping v. Roberts, Lambeth Palace, Court of Arches MSS D.2075:14, 55–72, 78, 81–9, 97–8, 107–8, 112, 116, 122, 131–2, 139–.140, 142–6, 148, 150–1, 153, 165–6, 168–9, 185, 188, 191–3, 215, B/39a, 50.

60. Stone, *Road to Divorce*, pp. 309–13.

61. See Stone, *Road to Divorce*, pp. 313–17 – Stone does not use the printed propaganda surrounding the case and is too quick to assume that Mary, duchess of Norfolk, colluded with her husband to obtain a divorce and marry her lover.

62. *A Vindication of Her Grace Mary Dutchess of Norfolk. Being a True Account of the Proceedings before the House of Lords (from Jan. 7ᵗʰ 1691 to Febr. 17ᵗʰ following) upon his Grace the Duke of Norfolk's bill…Published by the direction of her Grace the Dutchess of Norfolk* (London, 1693). Wing V478.

63. *The Duke of Norfolk's Case: with reasons for passing his bill* (London, 1700). Wing D2514 and D2515.

64. *The Lady's Answer to a Divorce: Or, a Vindication of the State of Matrimony* (1700) is a broadside pamphlet that only seems to survive in the Archives and Special Collections at Brynmor Jones Library, University of Hull, DDEV/68/154; there is a variation entitled *The Case of Mary Dutchess of Norfolk* (London, 1700), Wing C949. It was answered by *An Answer to a Printed Paper, Entituled the Case of Mary Dutchess of Norfolk* (London, 1700), Wing A3339A.

65. Stone, *Road to Divorce*, p. 316.

66. I am currently working on a joint article on this with Judith Spicksley provisionally titled 'Infertility and Impotence in Early Modern England'.

67. Introduction to Milton's divorce tracts in *Complete Prose Works of John Milton*, ii, ed. Sirluck , pp. 147–50 and *The Doctrine and Discipline of Divorce* in *Complete Prose Works*, pp. 245, 350, 254 ff; Stone, *Road to Divorce*, pp. 301–17.

68. See for the early period tracts such as: Samuel Saxey, *A Straunge and Wonderfull Example of the Judgement of Almighty God, Shewed upon Two Adulterous Persons in London* (London, 1583), Edmund Bunny, *Of Divorce for Adulterie, and Marrying againe: That There Is No Sufficient Warrant So To Do* (London, 1610), *Bloody Downfall of Adultery* (Overbury case: London, 1616); see for the later period works such as: Thomas Pollen, *The Fatal Consequences of Adultery…with a Defence of the Bill…1771 Intituled 'An Act to Restrain Persons Who Shall Be Divorced for the Crime of Adultery, from Marrying, or Contracting Matrimony with the Party'* (London, 1772).

69. *Essay towards a General History of Whoring* (London, 1697), Wing G959.

70. For a legalistic discussion see Jean Gailhard, *Four Tracts. I. A Short Discourse about divorce and Its Causes, Fornication and Adultery etc.* (London, 1699). The prurient interest literature is enormous and includes scandals and whisperings in periodicals such as *The Spectator*, printed transcripts of trials and cases such as individual cases such as *The Second Part of the Trial of the Hon. Mrs. Catherine Newton…upon…the Crime of Adultery…Containing the Whole Evidence…* (London, 1782) and collected cases as in *Adultery Anatomized: In a Select Collection of Trials, for Criminal Conversation. Brought Down from the Infant Ages of Cuckoldom in England, to Its Full Growth in Present Times. In Two Volumes…* (London, 1761), satires such as Mordecai Moxon, *The Manchester Daemoniack, or, the White She Devil Ejected: In a Sermon against Adultery…before the Worshipful Mr. R-t D-s Woollen Draper…Occasioned by His Playing at Water Wag Taile with the Shoemakers Wife* (London, 1703) and plays such as Thomas Southerne, *The Fatal Marriage: Or, the Innocent Adultery* (Dublin, 1722; rep. several times in London through eighteenth century).

71. Lincolnshire Record Office, AS/4/1, Agreement 10 June 1731.

72. See Roderick Phillips, *Putting Asunder: A History of Divorce in Western Society* (Cambridge University Press, Cambridge, 1988).

73. See Amy Froide, 'Hidden Women: Rediscovering the Singlewomen of Early-Modern England', *Local Population Studies*, 68 (2002) and *Never Married: Singlewomen in Early-Modern England* (Oxford University Press, Oxford, 2005).

74. For a fuller examination of widowhood see Cavallo and Warner (eds), *Widowhood in Medieval and Early Modern Europe* (Longman, Harlow, 1999).

75. For rituals surrounding use of the maiden's garland see John Donald, 'Maiden's Garlands', *North Country Folk Art* (1989), pp. 196–9. In St Mary's Church, where the ashes of my dear friend Alison Hoppen are scattered, there is a 'priest's cupboard' containing the oldest maiden's garland in the country dated 1689 and with the young girl's name and age at death still visible.

76. Christine Peters, 'Single Women in Early Modern England: Attitudes and Expectations', *Continuity and Change*, 12 (1997), pp. 325–45 especially p. 325 citing Worcester Record Office, Consistory Court Wills, vol. 7 f. 52v.

77. Cambridge University Library MS Mm. 1.52, f. 217v.

78. Klein (ed.), *Daughters, Wives and Widows*, pp. 114–16.

79. Mendelson and Crawford, *Women in Early Modern England*, pp. 138–9 citing British Library, Trumbull MS D/ED/c 13 Anne Dormer to Lady Elizabeth Trumbull, 20 July and 10 March 1688.

80. Lady Mary Chudleigh, 'To the Ladies', *Poems on Several Occasions* (1703) reprinted in N. H. Keeble (ed.), *The Cultural Identity of Seventeenth-Century Woman* (Routledge, London, 1994), p. 284.

81. Locke, *Two Treatises of Government* ed. Peter Laslett, Cambridge Texts in the History of Political Thought, pp. 172–5 and Mary Astell, *Some Reflections upon Marriage* (1700) ed. Patricia Springborg, *Astell: Political Writings* (Cambridge University Press, Cambridge, 1996), pp. 9, 17–21 and 54–5, 63–4.

82. Astell, *Astell: Political Writings* ed. Springborg, pp. 9, 17–21.
83. Chudleigh, *Poems on Several Occasions* rep in Keeble (ed.), *The Cultural Identity of Seventeenth-Century Woman*, pp. 285.
84. Sarah Egerton, 'Emulation' in *Poems on Several Occasions* (1703) rep in Keeble (ed.), *The Cultural Identity of Seventeenth-Century Woman*, p. 285.
85. Carroll Smith Rosenburg, 'The Female World of Love and Ritual: Relations between Women in Nineteenth-Century America', *Signs*, 1 (1975).
86. Mendelson and Crawford, *Women in Early Modern England*, p. 148.
87. Mendelson and Crawford, *Women in Early Modern England* , pp. 156, 164; For maternity, see especially Patricia Crawford, 'The Construction and Experience of Maternity in Seventeenth Century England' in Valerie Fildes (ed.), *Women and Mothers in Pre-Industrial England* (Routledge, London and New York, 1990); Linda Pollock, *Forgotten Children: Parent Child Relations from 1500–1900* (Cambridge University Press, Cambridge, 2001); David Cressy, *Birth, Marriage and Death*, pp. 17–24, 27–8.
88. Dorothy McLaren, 'Marital Fertility and Lactation 1570–1720', in *Women in English Society 1500–1800* ed. Mary Prior (Routledge, London and New York, 1985).
89. See Mendelson and Crawford, *Women in Early Modern England*, p. 149 using P. E. H. Hair, 'Bridal Pregnancy in Rural England in Earlier Centuries', *Population Studies*, 20 (1966), pp. 233–43, 'Bridal Pregnancy in Earlier Rural England Further Examined', *Population Studies*, 24 (1970), pp. 59–70 and R. Finlay, *Population and Metropolis: The Demography of London 1580–1650* (Cambridge University Press, Cambridge, 1981).
90. Dorothy Evenden, 'Mothers and Their Midwives in Seventeenth Century London' in Hilary Marland (ed.), *The Art of Midwifery: Early Modern Midwives in Europe* (Routledge, London and New York, 1993), p. 9. For occupational identity of midwives, one of the best primary sources is the anonymous diary of a London midwife used by Evenden and held in the Bodleian Library, Rawlinson MS D 1141. See also Audrey Eccles, *Obstetrics and Gynaecology in Tudor and Stuart England* (Croom Helm, London, 1982) and Margaret Pelling, 'Defensive Tactics: Networking by Female Medical Practitioners in Early-Modern England' in *Communities in Early Modern England* eds A. Shepherd and P. Withington (Manchester University Press, Manchester, 2000) and 'Female and Male Surgeons in Early Modern England', *Medical History*, 42 (1998).
91. Cressy, *Birth, Marriage and Death*, pp. 50–123 – for quotations, pp. 71–2, 118, 107–9 citing Alan Macfarlane (ed.), *The Diary of Ralph Josselin 1616–1683* (1976) and W. H. Frere and W. P. M. Kennedy, *Visitation Articles and Injunctions of the Period of the Reformation*, 3 vols (1910) ii, 50, 58.
92. See Linda Pollock, 'Embarking on a Rough Passage: The Experience of Pregnancy in Early Modern Society' in Fildes (ed.), *Women and Mothers*.
93. Houlbrooke (ed.), *English Family Life 1576–1716* , p. 69 citing Public Record Office, Shaftsbury Papers, 30/24, 8 pt. 2 (1649).
94. Thornton, *The Autobiography of Mrs Alice Thornton* , pp. 94–8.
95. See Adrian Wilson, 'The Ceremony of Childbirth and Its Interpretation' in Fildes (ed.), *Women and Mothers*. Cf. Mendelson and Crawford, *Women in Early Modern England*, p. 153.
96. Mary Robinson's accounts, Brynmor Jones Library MS DDBH/24/2.
97. Thornton, *The Autobiography of Mrs Alice Thornton*, pp. 95, 123, 139–41, 148.
98. Thornton, *The Autobiography of Mrs Alice Thornton*, pp. 145–7.
99. Houlbrooke (ed.), *English Family Life 1576–1716* , p. 99 citing London Guildhall Library MS 204, ff. 401, 410, 419.
100. See *The Mothers Legacy to Her Unborn Child* by Elizabeth Joscelin ed. Jean LeDrew Metcalfe (University of Toronto Press, Toronto, Buffalo, 2000).
101. See Roger Schofield, 'Did the Mothers Really Die?' in L. Bonfield, R. Smith and K. Wrightson (eds), *The World We Have Gained* (Basil Blackwell, Oxford and New York,

1986) and cf. Mendelson and Crawford, *Women in Early Modern England*, p. 152; Judith Lewis, '"Tis a Misfortune to Be a Great Ladie": Maternal Mortality in the British Aristocracy', *Journal of British Studies*, 37 (1998), pp. 49–53; Cressy, *Birth, Marriage and Death*, pp. 30–1; Lincolnshire Record Office, LCC Wills 1692/ii/97, Will of Sarah Smith (this reference and transcription I owe to Dr Judith Spicksley); Houlbrooke (ed.), *English Family Life 1576–1716*, pp. 125–7, 131–2 reprinting sections of the diaries of Samuel Woodforde (Bodleian Library MS Eng. Misc.) and Elias Pledger (Dr Williams' Library, MS 28.4).

102. Cressy, *Birth Marriage and Death*, pp. 50–123 – for quotations, pp. 71–2, 118, 107–9 citing Macfarlane (ed.), *The Diary of Ralph Josselin 1616–1683* (1976) and W. H. Frere and W. P. M. Kennedy, *Visitation Articles and Injunctions of the Period of the Reformation*, 3 vols (1910) ii, 50, 58.

103. Illegitimacy rates have been calculated as far as possible from parish registers for baptism (which inevitably and unavoidably fails to count children born illegitimately who died or were not baptised) by several historians. See, for example, essays in Peter Laslett *et al.* (eds), *Bastardy and Its Comparative History* (Cambridge, Massachusetts, 1980) and the detailed study of Richard Adair, *Courtship, Illegitimacy and Marriage in Early Modern England* (Manchester University Press, Manchester, 1996).

104. Bernard Capp, 'The Double Standard Revisited: Plebeian Women and Male Sexual Reputation in Early-Modern England', *Past and Present*, 162 (1999), pp. 81–2 citing Guildhall Library BCB2, ff. 256v-257v; BCB3 25 Sept. 1579.

105. Laurence, *Women in England 1500–1760*, p. 83.

106. Fraser, *The Weaker Vessel*, p. 65.

107. Houlbrooke (ed.), *English Family Life 1576–1716*, p. 108 citing F. R. Raines (ed.), *Journal of Nicholas Assheton*, Chetham Society, Old Series 14 (1848), p. 81.

108. Fairfax Family Notes, Cambridge University MS Dd.14.25, ff. iii–viii.

109. Digby Family Memoranda Book, Lincolnshire Record Office, 3 ANC/2/4; James Digby recorded the births of his five children in the 1650s.

110. Stone, *The Family, Sex and Marriage in England 1500–1800*, pp. 52, 54–5, 66; Houlbrooke, *English Family Life 1576–1716*, chpt. 4 with citation from Elizabeth Egerton's diary p. 152 (British Library, Egerton MS 607, ff. 232–6); Fraser, *The Weaker Vessel*, pp. 80–1; Laurence, *Women in England 1500–1760*, pp. 75, 83–6.

111. Cited in Fraser, *The Weaker Vessel*, p. 81.

112. Thornton, *The Autobiography of Mrs Alice Thornton*, pp. 86, 94–6, 124–5. Patricia Crawford points out that their most disturbing dreams featured the deaths of children: 'Women's Dreams in Early Modern England', *History Workshop Journal*, 49 (2000), p. 135.

113. Valerie Fildes, *Wet Nursing: A History from Antiquity to the Present* (Blackwell, Oxford, 1988), chpts. 5–6; Patricia Crawford, '"The Sucking Child": Adult Attitudes to Child Care in the First Year of Life in Seventeenth-Century England', *Continuity and Change*, 1 (1986); Cressy, *Birth, Marriage and Death*, pp. 87–92 with quotation from Henry Newcome, *The Compleat Mother. Or an Earnest Perswasive to all Mothers (Especially Those of Rank and Quality) to Nurse Their Own Children* (1695); Elizabeth Clinton, *The Countess of Lincoln's Nursery* (1622) rep. in Kate Aughterson (ed.), *Renaissance Woman: Constructions of Femininity in England* (Routledge, London and New York, 1995), pp. 116–20.

114. Cited in Linda Pollock, *A Lasting Relationship: Parents and Children over Three Centuries* (Fourth Estate, London, 1987), pp. 62, 56–7.

115. Hull, *Women According to Men*, chpt. 4; Ralph Houbrooke, *The English Family 1450–1700* (Longman, Harlow, Essex, 1984), chpt. 6; Pollock, *With Faith and Physic*, p. 113.

116. Hull, *Women According to Men*, pp. 70, 117–18, 121–4; Kenneth Charlton, *Women, Religion and Education in Early Modern England* (Routledge, London and New York, 1999), pp. 188–95.

117. Fletcher, *Gender, Sex and Subordination*, chpt. 11 citing *The Diary of Samuel Pepys* eds Latham and Matthews, vi, 39 and viii, 164; citing Houlbrooke, *English Family Life*, p. 93 (Diary of John Richards, Dorset Record Office MS D.884); citing Pollock, *Forgotten Children* , pp. 147–8; citing Stone, *Family, Sex and Marriage*, p. 168.
118. Temple Papers, Huntington Library.
119. Houlbrooke, *English Family Life 1576–1716* p. 171, 194–7 citing New College MSS, Steer 9507, ff. 21–6, 34, 39, 41, 43, 48, 50, 51, 53; Pollock, *Forgotten Children* and *a Lasting Relationship*, pp. 250–2; Elizabeth Foyster, 'Parenting Was for Life, Not Just for Childhood: the Role of Parents in the Married Lives of Their Children in Early-Modern England', *History*, 86 (2001), pp. 313–27.
120. Borthwick Institute, Probate Register 62A, f. 9v, 81v.
121. Borthwick Institute, Dean and Chapter vol. 5, Inventory, 20/8/1605 and loose will dated 5/10/1649 in probate bundle for June 1650.
122. Christina Hole, *The English Housewife in the Seventeenth Century* (Chatto and Windus, London, 1953), pp. 62, 70–1.
123. Hole, *The English Housewife in the Seventeenth Century* , chpt. 4; see also Alison Sim, *The Tudor Housewife* (Oxford University Press, 1997); T. K., *The Kitchen Physician: Or, a Guide for Good Housewives* (1680); Pollock (ed.), *With Faith and Physic*, pp. 126–7, 136.
124. Pollock (ed.), *With Faith and Physic*; D. M. Meads (ed.), *The Diary of Lady Margaret Hoby, 1599–1605* (1930) reprinted (extract) in Houlbrooke, *English Family Life*, p. 59; Fletcher, *Gender, Sex and Subordination*, pp. 233–4.
125. Erickson, *Women and Property in Early Modern England*, pp. 54–5; Fletcher, *Gender, Sex and Subordination*, p, 233 citing C. F. Otten (ed.), *English Women's Voices 1540–1700* (Miami, 1992), pp. 176, 184–5; frontispiece of Hannah Wolley, *The Accomplisht Lady's Delight* (1675) printed in Mendelson and Crawford, *Women in Early Modern England*, p. 304; see also Hull, *Women According to Men*, chpt.6. For woman physicians see also Margaret Pelling, *The Common Lot: Sickness, Medical Occupations and the Urban Poor in Early-Modern England* (Longman, London, 1998), 'Defensive Tactics: Networking by Female Medical Practitioners In Early-Modern London', in Alexandra Shepherd and Phil Withington (eds), *Communities in Early Modern England* (Manchester University Press, Manchester, 2000) and Margaret Pelling and Frances White, *Medical Conflicts in Early-Modern London: Patronage, Physicians and Irregular Practitioners 1550–1640* (Oxford University Press, Oxford, 2003).
126. Mendelson and Crawford, *Women in Early Modern England*, pp. 281–9, 334–5; Laurence, *Women in England 1500–1760* , pp. 138–9; Clark, *Working Life of Women in the Seventeenth Century* ed. Amy Erickson, p. 251; Richelle Munkhoff, 'Searchers of the Dead: Authority, Marginality and the Interpretation of Plague in England, 1574–1665', *Gender and History*, 11:1 (1999), p. 3; see also Diane Willen, 'Women in the Public Sphere', *Sixteenth Century Journal*, 19 (1988), pp. 559–75.
127. Recipe Book 1688–1727, Wellcome MS 3500 reprinted in Patricia Crawford and Laura Gowing (eds), *Women's Worlds in Seventeenth Century England: A Sourcebook* (Routledge, London and New York, 2000), pp. 103–4; Brynmor Jones Library, Hull University MS DDHO/19/1.
128. An example of the integrated nature of these areas of work activity that I particularly like is that after brewing, the dregs of the beers could be brewed up with cumin, salt, lavender, fennel and rosemary to clean out the mating cavities of the pigeon house or dovecote – E. A. B. Barnard, 'The Savages of Broadway', *Transactions of the Worcestershire Archaeological Society*, x (1933), pp. 56–7.
129. Tusser, *The Points of Housewifery* reprinted in Kanner, *Daughters, Wives and Widows*, p. 222.
130. Capern, 'The Role of Women in English Society 1558–1660'.
131. Brynmor Jones Library, University of Hull, countess of Cumberland's accounts with Amy Foster, MSS DDCV/204/48, 58 23 Feb 1641 to 15 March 1642.

132. For a survey, see Jacqueline Eales, *Women in Early Modern England 1500–1700* (UCL Press, London, 1998), pp. 75–7 and for a case study in women's unspecialised agricultural labour see Keith Wrightson and David Levine, *Poverty and Piety in an English Village: Terling 1525–1700* (Clarendon Press, Oxford, 1995).

133. Mendelson and Crawford, *Women in Early Modern England*, p. 315; Marland (ed.), *The Art of Midwifery*, p. 2 and see chpts. 1–3 regional case studies of early-modern English midwifery. Also H. Marland and A. Wilson *The Making of Man Midwifery: Childbirth in England 1660–1770* (1995).

134. Thomas Tusser, *The Points of Housewifery* (1580) rep. in *Daughters, Wives and Widows: Writings by Men about Women and Marriage in England 1500–1640*, ed. Joan Larsen Klein (University of Illinois Press, Urbana and Chicago, 1992), pp. 205–30. For housewives' manuals see Michael Roberts, '"To Bridle the Falsehood of Unconscionable Workmen, and for Her Own Satisfaction": What the Jacobean Housewife Needed to Know about Men's Work, and Why', *Labour History Review*, 63:1 (1998), pp. 4–30 – Roberts controversially argues that the integrated nature of women's and men's work resulted in an equality rather than division of labour; Mendelson, *The Mental World of Stuart Women*, pp. 8–9.

135. A short but rather good description of the housewife's daily routine is to be found in Caroline S. Andre, 'Some Selected Aspects of the Role of Women in Sixteenth Century England', *International Journal of Women's Studies*, 4 (1981), p. 82.

136. Amanda L. Capern, 'The Landed Woman in Early Modern England', *Parergon*, 19:1 (2002), pp. 198, 209.

137. Lady Anne Cheyne's Household Account Book, Huntington Library MSS, EL 10753. An account book in print is that of Mary Worsley of Hovingham, 'The MS Account and Memorandum Book of a Yorkshire Lady Two Centuries Ago' ed. Lord Hawksebury, *The Transactions of the East Riding Antiquarian Society*, ix (1901), pp. 1–57 – Worsley listed all her household expenses and menus.

138. Jane Cavendish's Household Account Book, Huntington Library MSS, EL 10773.

139. See Patricia Crawford, '"The Only Ornament in a Woman": Needlework in Early Modern England' in *All Her Labours: Embroidering the Framework* (Sydney, 1984) and Susan Frye, 'Sewing Connections: Elizabeth Tudor, Mary Stuart, Elizabeth Talbot and Seventeenth-Century Anonymous Needleworkers' in *Maids and Mistresses, Cousins and Queens: Women's Alliances in Early Modern England* eds Susan Frye and Karen Robertson (Oxford University Press, New York and Oxford, 1999), chpt. 10.

140. The anonymous reader of this book was kind enough to alert me to this.

141. Sue Wright, '"Churmaids, Huswyfes and Hucksters": the Employment of Women in Tudor and Stuart Salisbury', in *Women and Work in Pre-Industrial England* (Croom Helm, London and Sydney, 1985), p. 109.

142. The terminology of the 'economy of makeshift' originates with Olwen Hufton, *The Prospect Before Her: A History of Women in Western Europe: Volume One 1500–1800* (Harper Collins, London, 1995).

143. Huntington Library, Apprentice agreement of Thomas and Abigail Bull with Conquest Taylor, 2 October 1648, MS STT Personal Box 10 (14).

144. Wright, '"Churmaids, Huswyfes and Hucksters": the Employment of Women in Tudor and Stuart Salisbury', in *Women and Work in Pre-Industrial England* eds Lindsey Charles and Lorna Duffin (Croom Helm, London and Sydney, 1985), p. 102 citing Paul Slack (ed.), *Poverty in Early Stuart Salisbury* (Wiltshire Record Society, 1975), p. 89 and pp. 108–9.

145. Tessa Watt, *Cheap Print and Popular Piety 1550–1640* (Cambridge University Press, Cambridge, 1991), p. 18 citing Thomas Wright (ed.), *Songs and Ballads, with Other Short Poems, Chiefly in the Reign of Philip and Mary* (1860), p. 158.

146. Peter Earle, 'The Female Labour Market in London in the Late Seventeenth and Early Eighteenth Centuries', especially Appendix A, *Economic History Review*, 42 (1989), pp. 328–53.

147. Wright, '"Churmaids, Huswyfes and Hucksters": the Employment of Women in Tudor and Stuart Salisbury', in *Women and Work in Pre-Industrial England*, pp. 112–13.

148. Crawford and Gowing (eds), *Women's Worlds in Seventeenth Century England*, pp. 87–8 citing Southampton Record Office, Court Leet Records: Stall and Art Rolls, 6/1/73 (1698), 6/1/74 (1701) and Hampshire Record Office, A107 Will of Alice Zains (16 July 1701).

149. Pamela Sharpe, 'Gender at Sea: Women and the East India Company in Seventeenth-Century London' in Penelope Lane, Neil Raven and K. D. M. Snell, *Women, Work and Wages in England 1600–1850* (Boydell, Woodbridge, 2004); Susan Staves, 'Investments, Votes, and "Bribes": Women as Shareholders in the Chartered National Companies', in Hilda L. Smith (ed.), *Women Writers and the Early-Modern Political Tradition* (Cambridge University Press, Cambridge, 1998).

150. Mendelson and Crawford, *Women in Early Modern England*, chpts. 5–6; Peter Earle, 'The Female Labour Market in London in the Late Seventeenth and Early Eighteenth Centuries', *Economic History Review*, 42 (1989), pp. 328–53 rep. Pamela Sharpe (ed.), *Women's Work: The English Experience 1650–1914* (Arnold, London and New York, 1998), pp. 121–49; Laurence, *Women in England 1500–1760*, pp. 127, 132; Pamela Sharpe, 'A Woman's Worth: A Case Study of Capital Accumulation in Early Modern England', *Parergon*, 19:1 (2002), pp. 173–84; A. Bennett, 'The Goldsmiths of Church Lane, Hull 1527–1784', *Yorkshire Archaeological Journal*, 60 (1988), pp. 113–126.

151. J. A. Johnston (ed.), *Probate Inventories of Lincoln Citizens 1661–1714*, Publications of the Lincoln Record Society, 80 (Lincoln, 1991), p. lxii.

152. Olive Schreiner, *Woman and Labor* (Frederick A. Stokes Co., New York, 1911); Clark, *Working Life of Women*; Ivy Pinchbeck, *Women Workers and the Industrial Revolution 1750–1850* (1930, new eds 1969, 1981). Clark and Pinchbeck were both products of the London School of Economics and their thinking on women's work was informed by the emerging social and economic histories of the labour movement, its academic arm in institutions such as Ruskin College, and the debates about the role of labour generated by groups such as the Fabian Society.

153. One of the standard Marxist overviews was provided by Joan Kelly in 1980. She argued that the feudal household was replaced in the sixteenth century with a patriarchal pre-industrial household which was in turn replaced by the industrial household when 'the household ceased to be a center of production'. Joan Kelly, 'Family and Society' in *Family Life: A Historical Perspective* ed. by Renate Bridenthal, Joan Kelly, Amy Swerdlow and Phyllis Vine (Feminist Press, Old Westbury, New York, 1980) rep in Joan Kelly, *Women, History and Theory: The Essays of Joan Kelly* (University of Chicago Press, Chicago, 1984), quotation from p. 125. For a further New Women's History classic on women's work that followed the lead of Schreiner, Pinchbeck and Clark see L. A. Tilly and J. W. Scott, *Women, Work and Family* (Holt, Rinehart and Winston, New York, 1978). The most paradigmatic Marxist account of early-modern women's work is Susan Cohn, *Industry of Devotion: The Transformation of Women's Work in England 1500–1660* (Columbia University Press, New York, 1987).

154. Schreiner, *Woman and Labor*, , pp. 46–48, 69, 75ff, 106, 110, 113–14.

155. Clark, *Working Life of Women in the Seventeenth Century*, p. xxxiii.

156. Clark, *Working Life of Women in the Seventeenth Century*, *passim*, especially Conclusion, and with quotations from pp. 9–11.

157. Pinchbeck, *Women Workers and the Industrial Revolution 1750–1850* .

158. For a good summary of the 'critical-pessimistic tradition' that demonstrates the way in which these early authors collapsed industrialism and capitalism see Chris Middleton, 'Women's Labour and the Transition to Pre-Industrial Capitalism' in *Women and Work in Pre-Industrial England* eds Lindsey Charles and Lorna Duffin (Croom Helm, London and Sydney, 1985), chpt. 5.

159. See essays by Pamela Sharpe and Peter Earle in Sharpe (ed.), *Women's Work*; Mendelson and Crawford, *Women in Early Modern England* and see also the shorter earlier survey

by Patricia Crawford, 'From the Woman's View: Pre-Industrial England 1500–1750', in *Exploring Women's Past* (Sister Publishing Limited, Carlton, South Victoria, 1983), pp. 54 ff. and the anthology of primary sources for women's work in Crawford and Gowing (eds), *Women's Worlds in Seventeenth Century England*, chpt. 3. The accounts of English women's work are further enriched by the surveys of European women's work by Olwen Hufton, *The Prospect Before Her: A History of Women in Western Europe* (Harper Collins, London, 1995), vol. 1 and Merry Wiesner, *Women and Gender in Early Modern Europe* (Cambridge University Press, Cambridge, 1993) chpt. 3.

160. Judith Bennett, '"History that Stands Still": Women's Work in the European Past', *Feminist Studies*, 14 (1988), pp. 269–83, 'Feminism and History', *Gender and History*, 1 (1989), pp. 251–72, 'Misogyny, Popular Culture and Women's Work', *History Workshop*, 31 (1991), pp. 166–88, 'Women's History: A Study in Continuity and Change', *Women's History Review*, 2 (1993), pp. 173–84; Bridget Hill, 'Women's History: A Study in Change, Continuity or Standing Still?', *Women's History Review*, 2 (1993), pp. 5–22.

161. Mendelson and Crawford, *Women in Early Modern England*, chpts. 5–6 especially pp. 318–19; Peter Earle, 'The Female Labour Market in London in the Late Seventeenth and Early Eighteenth Centuries', *Economic History Review*, 42 (1989) rep. Sharpe (ed.), *Women's Work*, pp. 121–49.

162. For the concept of 'industrious revolution' see Jan de Vries, 'Between Purchasing Power and the World of Goods: Understanding the Household Economy in Early Modern Europe' in R. Porter and J. Brewer (eds), *Consumption and the World of Goods* (Routledge, London, 1994 rep. in Sharpe, *Women's Work*, chpt. 8).

163. See, for example, Joan Thirsk, 'Industries in the Countryside', in *Essays in the Economic and Social History of Tudor and Stuart England* ed. F. J. Fisker (Cambridge University Press, Cambridge, 1961).

164. See, for example, David Green and Alastair Owens, 'Gentlewomanly Capitalism? Spinsters, Widows and Wealth Holding in England and Wales c. 1800–1860', *Economic History Review*, 56:3 (2003), pp. 510–36; Anne Laurence, 'Women Investors, "That Nasty South Sea Affair" and the Rage to Speculate in Early Eighteenth Century England', *Accounting, Business and Financial History*, 16:2 (2006), pp. 245–64.

165. See Katrina Honeyman and Jordan Goodman, 'Women's Work, Gender Conflict and Labour Markets in Europe 1500–1900', *Economic History Review*, 44:4 (1991), pp. 608–28 rep. Robert Shoemaker and Mary Vincent (eds), *Gender and History in Western Europe* (Arnold, London, 1998), pp. 353–71; Daryl M. Hafter (ed.), *European Women and Pre-Industrial Craft* (Indiana University Press, Bloomington and Indianapolis, 1995); Amanda Vickery, 'Golden Age to Separate Spheres? A Review of the Categories and Chronology of English Women's History', *Historical Journal*, 36 (1993), pp. 383–414 rep. in Robert Shoemaker and Mary Vincent (eds), *Gender and History in Western Europe* pp. 294–331; Katrina Honeyman, *Women, Gender and Industrialisation in England 1700–1870* (Macmillan, London, 2000), pp. 6–8, 14.

166. The main work on women and property has been done by Amy Erickson the main conclusion from which is that women owned more property, even when married, than previously thought. See Erickson, *Women and Property in Early Modern England* and see also 'Coverture and Capitalism', *History Workshop Journal*, 59:1 (2005), pp. 1–16 and 'Possession – And the Other One Tenth of the Law: Assessing Women's Ownership and Economic Roles in Early Modern England' in *Women, Wealth and Power* ed. Amanda L. Capern and Judith Spicksley, Special Issue of *Women's History Review*, 16:3 (July, 2007); Crawford, *Women and Property*, pp. 151–84.

167. Erickson, *Women and Property in Early Modern England*; Susan Staves, *Married Women's Separate Property, 1660–1833* (Harvard University Press, Cambridge, Massachusetts, 1990); W. R. Prest, 'Law and Women's Rights in Early Modern England', *The Seventeenth Century*, 6 (1991), pp. 169–87; cf. Mendelson and Crawford, *Women in Early Modern England*, p. 35.

168. See Capern, 'The Landed Woman in Early Modern England', pp. 186–7; Erickson, *Women and Property in Early Modern England*, p. 6; Pamela Sharpe, 'Dealing with Love: the Ambiguous Independence of the Single Woman in Early Modern England', *Gender and History*, 11:2 (1999), p. 226; Mendelson and Crawford, *Women in Early Modern England*, pp. 434–5.
169. Eileen Spring, 'The Family, Strict Settlements and Historians', *Canadian Journal of History*, 18 (1983); John Habakkuk, 'Marriage Settlements in the Eighteenth Century', *Transactions of the Royal Historical Society*, Fourth Series, 32 (1950).
170. Mary Prior, 'Wives and Wills 1558–1700', in J. Chartres and D. Hey (eds), *English Rural Society, 1500–1800: Essays in Honor of Joan Thirsk* (Cambridge University Press, Cambridge, 1990), pp. 139–43.
171. Capern, 'The Landed Woman in Early Modern England', pp. 204–8 citing Brynmor Jones Library [Hull University] MSS DDEV and Peter Roebuck, *Yorkshire Baronets 1640–1760: Families, Estates and Fortunes* (Hull University Press, Hull, 1980).
172. See Lawrence Stone and Jeanne Fawtier Stone, *An Open Elite? England 1540–1880* (Clarendon Press, Oxford, 1984) pp. 118–26. Eileen Spring, *Law, Land and Family: Aristocratic Inheritance, 1300–1800* (University of North Carolina Press, Chapel Hill and London, 1993), chpt. 1. For an example of small landowners, Barbara Todd has found that in Long Wittenham there were seven occasions when daughters inherited land and in two cases they did so at the expense of sons: 'Freebench and Free Enterprise: Widows and Their Property in Two Berkshire Villages' in John Chartres and David Hey (eds), *English Rural Society, 1500–1800: Essays in Honour of Joan Thirsk* (Cambridge University Press, Cambridge, 1990), p. 198. See also John Habakkuk, *Marriage, Debt and the Estates System: English Landownership 1650–1950* (Clarendon Press, Oxford, 1994).
173. Barbara English and John Saville, *Strict Settlement: A Guide for Historians* (University of Hull Press, Hull, 1983); Lloyd Bonfield, *Marriage Settlements 1601–1740: The Adoption of the Strict Settlement* (Cambridge University Press, Cambridge, 1983).
174. Lincolnshire Record Office, Ancaster MSS, 1 ANC/5/C/2–3, 2 ANC/3/C/45, 49–50, 57–8, 61, 63.
175. Erickson, *Women and Property in Early Modern England*, p. 209; Borthwick Institute, Will of Sarah Brighouse, 7/2/1699 Probate Register 62A, f. 19v.
176. Eileen Spring, *Law, Land and Family: Aristocratic Inheritance, 1300–1800* (University of North Carolina Press, Chapel Hill and London, 1993), p. 65 citing Statutes, 5 Anne, *c.* 3 and British Library, Blenheim Papers 61451 f. 172.
177. Erickson, *Women and Property in Early Modern England*, p. 209 citing Borthwick Institute for Historical Research, York, Will of Anne Nicholson (1642); Lincolnshire Record Office, 1 ANC/10/A/11 Inventory 27 March 1725.
178. Brynmor Jones Library MS DDBH/24/2, 'Disbursement of Widow Hunt's Goods', 11 November 1681.
179. Crawford, 'Women and Property: Women as Property', pp. 152–3; Papers of Sarah Ogle, Lincolnshire Record Office, 1 ANC/9/4/A.
180. Lincolnshire Record Office MSS, 1 ANC 2A/10/4 Deed of title of George Dickens to Mary Dickens, 19 September 1648.
181. Lincolnshire Record Office, 2 ANC/3/C/22 Will of Gregory Warmouthe, 3 June 1616.
182. Cf. Hull, *Women According to Men*, p. 32 citing *The Lawes Resolutions of Womens Rights* (p. 130) and William Gouge, *Of Domesticall Duties* (p. 298).
183. Capern, 'The Landed Woman in Early Modern England', pp. 191–5 citing Brynmor Jones Library [Hull University] MSS DDHO/12 especially DDHO/12/8 and British Library Add. MSS 36,191 f. 293 [will of Arabella Alleyn]. See also Amanda L. Capern, 'Early Modern Women Lost and Found: Case Studies in the Selection and Cataloguing of Historical Sources and the (In)visibility of Women', *Women's History Notebooks*, 5:2 (1998), pp. 15–22.

184. English and Saville, *Strict Settlement*, p. 60 citing C. T. Gatty, *Mary Davies and the Manor of Ebury* (2 vols. 1921), pp. 188–9.

185. Huntington MSS, Hastings Collection, Personal Papers Box 14, #24, Indenture 28 October 1609.

186. For an extended treatment of this subject, see Capern, 'The Landed Woman in Early Modern England', pp. 185–214.

187. Spring, *Law, Land and Family*, p. 51.

188. Capern, 'The Landed Woman in Early Modern England', pp. 196–7; Tim Stretton, *Women Waging Law in Elizabethan England* (Cambridge University Press, Cambridge, 1998), p. 122 citing Henry and Jane Thrapp v. Thomazin Buckford, Public Record Office Req. 2/277/54 A; Erickson, *Women and Property in Early Modern England*, pp. 226–7; Barbara Todd, 'Demographic Determinism and Female Agency: The Remarrying Widow Reconsidered…Again', *Continuity and Change*, 9:3 (1994), p. 428 and 'The Remarrying Widow: A Stereotype Reconsidered', in Mary Prior (ed.), *Women in English Society 1500–1800* (Routledge, London and New York, 1991), especially pp. 54–6, 83; Lady Warwick's will dated 3 December 1645 (Probate granted 13 February 1646): Huntington Library Twisse MS f. 20 (with thanks to Barbara Donagan for the reference); Katherine Austen's account of her widowhood and property concerns is to be found at British Library Add. MS 4454 quotations from ff. 40, 49, 93 – Barbara Todd also points out that one of the four reasons Austen gives for not remarrying is 'her awareness that marriage would rob her of her capacity to preserve and increase the fortunes of her daughters and two sons', 'The Remarrying Widow', p. 77.

189. Lincolnshire Record Office MSS, AH/1/10/1/4/1, 7.

190. Huntington Library MSS, Temple Family Addendum 46,536 (post-1667).

191. Lincolnshire Record Office MSS, 1 ANC 11/A Lady Susan Bellasise, will dated 28 September 1710 (died 11 March 1712).

192. For a 'female culture' of property see Mendelson and Crawford, *Women in Early Modern England*, especially chpt. 4; Amanda L. Capern, 'The Landed Woman in Early Modern England', *Parergon*, 19:1 (2002), pp. 208–10 citing Susan Frye, 'Sewing Connections: Elizabeth Tudor, Mary Stuart, Elizabeth Talbot, and Seventeenth-Century Anonymous Needleworkers' in Susan Frye and Karen Robertson (eds), *Maids and Mistresses, Cousins and Queens: Women's Alliances in Early-Modern England* (Oxford University Press, Oxford, 1998) and Pearl Hogrefe, *Tudor Women: Commoners and Queens* (Iowa State University Press, Ames, Iowa, 1975), p. 22.

193. Jane Cavendish Household Account Book, Huntington Library MSS, EL 10773.

194. For one of the best discussions about widespread petty criminality see Robert B. Shoemaker, *Prosecution and Punishment: Petty Crime and the Law in London and Rural Middlesex, c. 1660–1725* (Cambridge University Press, Cambridge, 1991).

195. Jenny Kermode and Garthine Walker (eds), *Women, Crime and the Courts in Early Modern England* (UCL Press, London, 1994), p. 90 citing PRO CHES 21/3 f. 144 and 24/118.

196. R. B. Manning, 'Patterns of Violence in Early Tudor Enclosure Riots', *Albion*, 6:2 (1974), pp. 120–33; Mendelson and Crawford, *Women in Early Modern England* , pp. 386–7, 393–4.

197. Anon., *The Lawes Resolutions of Womens Rights*, p. 4.

198. Brynmor Jones Library, University of Hull MSS DDLO/20/98.

199. Laura Gowing, citing Somerset Quarter Sessions QSR/92/34 and QSR/95/2/41 Articles against Mary Combe 4 May 1655, 27 December 1656, 8 January 1656/7 – conference paper, Women's History Network Conference, Brighton, 1997.

200. Richard Smith's Obituary Book, Cambridge University Library MS Mm.4.36, ff. 1–2.

201. *Yorkshire Notes and Queries and Folklore Journal*, 2 (1890), p. 202.

202. See, for example, Laura Gowing, 'Language, Power and the Law: Women's Slander Litigation in Early Modern England' p. 31 citing Greater London Record Office, DL/C 630 f. 330v, Bowles con Heale 21 January 1634 and James Sharpe, 'Women, Witchcraft

and the Legal Process', pp. 109–110 citing *A True and Exact Relation of the Several Informations, Examinations and Confessions of the Late Witches Arraigned and Executed in the County of Essex* (London, 1645), p. 26 and J. Boys, *The Case of Witchcraft at Coggeshall, Essex in the year 1699* (London, 1909), pp. 21–2 both in Kermode and Walker (eds), *Women, Crime and the Courts in Early Modern England*.

203. David Cressy, *Travesties and Transgressions in Tudor and Stuart England* (Oxford University Press, 2000), chpt. 2. The 'cat' was delivered after a labour of many days at 51 weeks of pregnancy. Cressy suggests possible cover up by the midwives to protect Agnes Bowker from prosecution for infanticide. But most infanticide cover-ups ran a smoother course. It is possible that the body removed by the midwives was a long-dead but also long-retained foetus. The drawing is suggestive of a witch's familiar so implicating the work of the Devil. That Bowker was not charged with witchcraft can only be explained by the lack of a human body to generate the charge of 'murder by witchcraft'.

204. Gowing, *Domestic Dangers*, all examples used are in chpt. 3 and cases/quotations from pp. 59 and 74 citing (respectively) Margery Hipwell *c.*Phoebe Cartwright (1613), Greater London Record Office, DL/C 221 f. 1409v.

205. Gowing, *Domestic Dangers*, citing Richard and Susan Symonds (1579), Greater London Record Office, DL/C 629 ff. 1756v, 177v. For further discussion of the way that female sexual morality was 'something that demands speech and exposure' see Laura Gowing, 'Gender and the Language of Insult in Early Modern London', *History Workshop*, 35 (1993), pp. 1–21.

206. Fletcher, *Gender, Sex and Subordination*, pp. 271, 201; Gowing, *Domestic Dangers*, pp. 100, 103.

207. Steve Hindle, 'The Shaming of Margaret Knowsley: Gossip, Gender and the Experience of Authority in Early Modern England', *Continuity and Change*, 9 (1994), *passim* but especially pp. 400–410 and quoting p. 409; Shoemaker, *Prosecution and Punishment*, pp. 210–11.

208. Fletcher, *Gender, Sex and Subordination*, p. 201 citing M. Ingram, 'Ridings, Rough Music and the "Reform of Popular Culture" in Early Modern England', *Past and Present*, 105 (1984), pp. 79–113.

209. For important work on this see Garthine Walker, *Crime, Gender and Social Order in Early Modern England* (Cambridge University Press, Cambridge, 2003).

210. Mendelson and Crawford, *Women in Early Modern England*, pp. 295–8 citing *Middlesex Sessions Records*, iii, 3, 4, 242, 288; Guildhall, Microfilm 515, Bridewell Royal Hospital, Court Minutes, Vol. 8, 1634–42, p. 25; *Bristol Corporation of the Poor*, p. 57; *Hertford County Records: Notes and Extracts from the Session Rolls, 1699–1850*, ii, I. See also G. R. Quaife, *Wanton Wenches and Wayward Wives: Peasants and Illicit Sex in Early Seventeenth Century England* (Croom Helm, London, 1979) – Quaife has been most assiduous in identifying locations where sex was on sale.

211. Examination of Margaret Atkinson, Bridewell Hospital Records, Guildhall Library, BCB 6, 23 Sept. 1617 reprinted in Crawford and Gowing (eds), *Women's Worlds in Seventeenth Century England*, pp. 75–6.

212. *The Life and Death of Mal Cutpurse* (1662) reprinted in Janet Todd and Elizabeth Spearing (eds), *Counterfeit Ladies: The Life and Death of Mary Frith, The Case of Mary Carleton* (William Pickering, London, 1994), pp. 22–3, 41–3.

213. Jodi Mikalachki, 'Women's Networks and the Female Vagrant: A Hard Case', in *Maids and Mistresses, Cousins and Queens: Women's Alliances in Early Modern England* (Oxford University Press, New York and Oxford, 1999), chpt. 3.

214. William Heale, *An Apologie for Women* (Oxford, 1609), STC 1304. Stone, *Road to Divorce*, p. 211 citing Lambert Palace, Court of Arches MSS D.75.98.

215. Julia Rudolph, 'Rape and Resistance: Women and Consent in Seventeenth Century English Legal and Political Thought', *Journal of British Studies*, 39 (2000), especially pp. 171–9.

216. Garthine Walker, 'Re-Reading Rape and Sexual Violence in Early Modern England', *Gender and History*, 10:1 (1998), pp. 1–25 (the figure of 7–10% is based upon averaging felony counts done by several historians); see also Barbara Baines, 'Effacing Rape in Early Modern Representations', *English Literary History*, 65 (1998), pp. 69–98 and Miranda Chaytor, 'Husband(ry): Narratives of Rape in the Seventeenth Century, *Gender and History*, 7:3 (1995), pp. 378–407; Cynthia B. Herrup, 'The Patriarch at Home: the Trial of the 2nd Earl of Castlehaven for Rape and Sodomy', *History Workshop*, 41 (1996), pp. 1–18 and *A House in Gross Disorder: Sex, Law and the Second Earl of Castlehaven* (Oxford University Press, New York, 1999); *Natures Cruell Step-Dames: Or, Matchlesse Monsters of the Female Sex* (1637) and Thomas Brewer, *The Bloudy Mother* (1609).

217. J. M. Beattie, 'The Criminality of Women in Eighteenth-Century England', *Journal of Social History*, 8 (1974–5), 'The Pattern of Crime in England', *Past and Present*, 72 (1974) and *Crime and the Courts in England 1600–1800* (Clarendon Press, Oxford, 1986). See also J. S. Cockburn, *Crime in England 1550–1800* (Methuen, London, 1977).

218. Garthine Walker, 'Women, Theft and the World of Stolen Goods', in Kermode and Walker (eds), *Women, Crime and the Courts*.

219. Jacqueline Eales, *Women in Early Modern England 1500–1700* (UCL Press, London, 1998), pp. 103–4; Martin Ingram, *Church Courts, Sex and Marriage in England, 1570–1640* (Cambridge University Press, Cambridge, 1987), pp. 1–3.

220. Mendelson and Crawford, *Women in Early Modern England*, pp. 384–7; Anne Carter and others, 'The Cry of the Country and Her Own Want' examination of 1629 Maldon rioters rep. in Crawford and Gowing (eds), *Women's Worlds in Seventeenth-Century England*, pp. 247–9; see also the summary in Jacqueline Eales, *Women in Early Modern England 1500–1700*, pp. 100–1 and the more detailed examination in J. Walter, 'Grain Riots and Popular Attitudes to the Law: Maldon and the Crisis of 1629' in J. Brewer and J. Styles (eds), *An Ungovernable People: The English and Their Law in the Seventeenth and Eighteenth Centuries* (Hutchinson, London, 1980). Much work has been done on popular protest, most notably, Buchanan Sharp, *In Contempt of All Authority: Rural Artisans and Riot in the West of England 1586–1660* (University of California Press, Berkley, 1980), David Underdown, *Revel, Riot and Rebellion: Popular Politics and Culture in England 1603–1660* (Clarendon Press, Oxford, 1985), R. B. Manning, *Village Revolts: Social Protest and Popular Disturbance in England 1509–1640* (Oxford University Press, Oxford, 1988) and E. P. Thompson, *Customs in Common* (Merlin Press, London, 1991; rep Harmondsworth, 1993), 'The Moral Economy of the English Crowd in the Eighteenth Century', *Past and Present*, 50 (1971), pp. 76–136.

221. Martin Ingram, '"Scolding Women Cucked or Washed": a Crisis in Gender Relations in Early Modern England' in Kermode and Walker (eds), *Women, Crime and the Courts*, chpt. 3 and Introduction, by Kermode and Walker, p. 18 citing Cheshire Record Office, QJF 49/1 QJF/55/1–2; David Underdown, 'The Taming of the Scold: The Enforcement of Patriarchal Authority in Early Modern England' in Anthony Fletcher and John Stevenson (eds), *Order and Disorder in Early Modern England* (Cambridge University Press, Cambridge, 1985), chpt. 4; Lucy de Bruyn, *Woman and the Devil in Sixteenth Century Literature* (Compton Press, Wiltshire, 1979), pp. 129–36.

222. Ingram, *Church Courts, Sex and Marriage in England 1570–1640* , chpt. 8 esp. pp. 239, 252 citing Wiltshire Record Office, D/BD 32 ff. 128v-133v; Susan Amussen, *An Ordered Society: Gender and Class in Early Modern England* (Columbia University Press, New York, 1988), pp. 99–100; Mendelson and Crawford, *Women in Early Modern England*, pp. 295–6; Laura Gowing, 'Language, Power and the Law: Women's Slander Litigation in Early Modern London' in Kermode and Walker (eds), *Women, Crime and the Courts*, chpt. 2; Hogrefe, *Tudor Women, Commoners and Queens*, p. 87; Paul Griffiths, 'Meanings of Nightwalking in Early Modern England', *The Seventeenth Century*, 13:2 (1998) and see also 'The Structure of Prostitution in Elizabethan London', *Continuity and Change*, 8 (1993), pp. 39–63.

223. Garthine Walker, 'Women, Theft and the World of Stolen Goods' in Kermode and Walker (eds), *Women, Crime and the Courts*, chpt. 4 citing Cheshire Record Office, CHES 24 [unfoliated] 117–2, Chester Diocesan Records, EDC 5 (1624) 5 and QJF 97/2 ff. 82, 133; *Counterfeit Ladies* eds Todd and Spearing p. xxx.

224. See Garthine Walker, 'Just Stories: Telling Tales of Infant Death in Early Modern England' in Margaret Mikesell and Adela Seeff (eds), *Culture and Change: Attending to Early Modern Women* (University of Delaware Press, Newark, 2003).

225. For infanticide see especially, Laura Gowing, 'Secret Births and Infanticide in Seventeenth-Century England', *Past and Present*, 156 (1997), pp. 87–115 and Peter C. Hoffer and N. E. H. Hull, *Murdering Mothers: Infanticide in England and New England 1558–1803* (New York, 1981); I. A., *News from the Dead. Or a True and Exact Narration of the Miraculous Deliverance of Anne Greene* (1651); Jacqueline Eales, *Women in Early Modern England 1500–1700* (UCL Press, London and Pennsylvania, 1998), pp. 102–3; James Sharpe, *Crime in Early Modern England 1550–1750* (Longman, London, 1984; rep. 1999), p. 60 citing the Cheshire Crown Books 1580–1709; Mendelson and Crawford, *Women in Early Modern England*, pp. 45–9; Amussen, *An Ordered Society*, pp. 111–14, Norfolk Record Office, DEP/31 Ex Offic. Ff. 433–41v; Keith Wrightson, 'Infanticide in Earlier Seventeenth Century England', *Local Population Studies*, 15 (1975), pp. 10–22.

226. C. Z. Wiener, 'Sex Roles and Crime in Late Elizabethan Hertfordhsire', *Journal of Social History*, 8 (1975), pp. 38–59' especially p. 49; J. M. Beattie, 'The Criminality of Women in Eighteenth-Century England', *Journal of Social History*, 8 (1974–5), especially pp. 83, 86. See also Frances E. Dolan, *Dangerous Familiars: Representations of Domestic Crime in England 1550–1700* (Cornell University Press, 1994).

227. See Somerset, *Unnatural Murder: Poison at the Court of James I.*

228. Public Record Office, ASSI 16/26/4 cited in Susan Amussen, 'Punishment, Discipline and Power: The Social Meanings of Violence in Early Modern England', *Journal of British Studies*, 34:1 (1995), p. 16 (the mother was acquitted despite fairly damning witness statements); Anon., *Horrid News of a Barbarous Murder Committed at Plymoth* (London, 1676); *A Perfect Narrative of the Robbery and Murder…of John Talbot* (1669).

229. Frances E. Dolan, *Dangerous Familiars: Representations of Domestic Crime in England 1550–1700* (Cornell University Press, Ithaca and London, 1994), chpt 1 especially pp. 36–41.

230. Huntington Library, MSS EL 3305, 4652, 5025.

231. The historiography of witchcraft is very rich and the references too vast in number to repeat here. The following shortlist is not exhaustive but covers the most important collections of printed primary source material as well as secondary works: Barbara Rosen, *Witchcraft in England 1558–1618* (University of Massachusetts Press, Amherst, 1969) commentary and primary source material; *English Witchcraft 1560–1736* eds James Sharpe *et al.* (Pickering and Chatto, London, 2003) 6 vols, Primary source material; Marion Gibson, *Early Modern Witches: Witchcraft Cases in Contemporary Writing* (Routledge, London, 2000) and *Reading Witchcraft: Stories of Early English Witches* (Routledge, London and New York, 1998); Darren Oldridge, *The Witchcraft Reader* (Routledge, London and New York, 2002); Geoffrey Scarre and John Callow, *Witchcraft and Magic in Sixteenth and Seventeenth Century Europe* (Palgrave, end ed. 2001); Alan MacFarlane, *Witchcraft in Tudor and Stuart England* (Routledge, London and New York, 1999); Brian Levack, *New Perspectives on Witchcraft, Magic and Demonology* (Routledge, New York, 2001) and *The Witchcraft Sourcebook* (Routledge, London and New York, 2002); Stuart Clark, *Thinking with Demons: The Idea of Witchcraft in Early Modern Europe* (Oxford University Press, Oxford, 1999); Stuart Clark (ed.). *Languages of Witchcraft: Narrative, Ideology and Meaning in Early Modern Culture* (Macmillan, Basingstoke, 2001) Essays (p. 4 sums up current historiography); Alan McFarlane and James Sharpe, *Witchcraft in Tudor and Stuart England: A Regional and Comparative Study* (Routledge, London and New York, 1999); James Sharpe, *Witchcraft in Early Modern England* (Longman, London, 2001); James Sharpe, *Instruments of*

Darkness: Witchcraft in England 1550–1750 (Hamish Hamilton, London, 1996); Briggs, *Witches and Neighbours* and Clark, *Thinking with Demons*; Christina Larner, *Enemies of God* (John Donald, Edinburgh, 2000; rep. of 1981 book about Scotland and a classic text). For interesting essays see Jonathan Barry *et al.* (eds), *Witchcraft in Early Modern Europe* (Cambridge University Press, Cambridge, 1996) and Claude J. Summers and Ted Larry Pebworth (eds), *Representing Women in Renaissance England* (University of Missouri Press Columbia and London, 1997). For a good, recent article on social context see Malcolm Gaskill, 'Witchcraft in Early Modern Kent: Stereotypes and the Background to Accusations', in *Witchcraft in Early Modern Europe: Studies in Culture and Belief* eds Jonathan Barry, Marianne Hester and Gareth Roberts (Cambridge University Press, Cambridge, 1996).

232. Brian Levack, *The Witch-Hunt in Early-Modern Europe* (Longman, London and New York, 2nd edn 1995), p. 25.

233. Briggs, *Witches and Neighbours*, *passim* but see especially pp. 8, 22.

234. See H. R. Trevor-Roper, *The European Witch-Craze of the Sixteenth and Seventeenth Centuries* (Penguin, London, 1990 [1967]); Robin Briggs, '"Many Reasons Why": Witchcraft and the Problem of Multiple Explanation' and Brian Levack, 'State Building and Witch Hunting in Early Modern Europe' in *Witchcraft in Early-Modern Europe: Studies in Culture and Belief* eds Jonathan Barry, Marianne Hester and Gareth Roberts (Cambridge University Press, Cambridge, 1998); William Monter, *Witchcraft in France and Switzerland: The Borderlands during the Reformation* (Cornell University Press, Ithaca and London, 1976).

235. Sharpe, *Witchcraft in Early Modern England* p. 42.

236. Lara Apps and Andrew Gow, *Male Witches in Early Modern Europe* (Manchester University Press, Manchester and New York, 2003), pp. 2–9 – the main works they cite in relation to these points are Briggs, *Witches and Neighbours* and Clark, *Thinking With Demons*; William Monter, *Witchcraft in France and Switzerland: The Borderlands During the Reformation* (Cornell University Press, Ithaca and London, 1976) and 'Toads and Eucharists: the male witches of Normandy, 1564–1660', *French Historical Studies*, 20:4 (1997).

237. Sharpe, *Witchcraft in Early Modern England* , p. 13.

238. Witchcraft accusation and conviction was less focused on women as perpetrators in Scotland than England.

239. *Daemonologie* (1597) cited in G. B. Harrison, *The Trial of the Lancaster Witches 1612* (Peter Davies, London, 1929), p. xxi.

240. Reginald Scot, *The Discoverie of Witchcraft* (1584), p. 1 (ed. John Rodker, 1930).

241. Hole, *Witchcraft in England*, chpt. 2 and pp. 32–3; Clive Holmes, 'Women: Witnesses and Witches', *Past and Present*, 140 (1993), p. 68; Malcolm Gaskill, 'Witches and Witnesses in Old and New England' in Clark (ed.), *Languages of Witchcraft: Narrative, Ideology and Meaning in Early Modern Culture*. The witchcraft statutes are reprinted in Rosen, *Witchcraft in England 1558–1618* .

242. Reprinted in Rosen, *Witchcraft in England 1558–1618* , pp. 369–84; for drawing blood from the victim see, for example, John Hammond, *A Most Certain, Strange and True Discovery of a Witch* (1642).

243. Briggs, *Witches and Neighbours*, maps.

244. Rowlands, 'Witchcraft and Old Women', pp. 52, 58 citing Sona Rosa Burstein, 'Aspects of the Psychopathology of Old Age Revealed in Witchcraft Cases of the Sixteenth and Seventeenth Centuries', *British Medical Bulletin*, vi (1949) and Lyndal Roper, 'Sex, Bodies and Age: Misogyny and the Witch Hunt' (Unpub. paper given at the Women's History Seminar, Institute of Historical Research, London, 4 June 1999).

245. Alison Rowlands, 'Witchcraft and Old Women in Early Modern Germany', *Past and Present*, 173 (2001) pp. 51, 56, 69–74 citing Keith Thomas, *Religion and the Decline of Magic* (London, 1971) and MacFarlane, *Witchcraft in Tudor and Stuart England*.

246. Reprinted in Harrison, *The Trial of the Lancaster Witches 1612* and Rosen, *Witchcraft in England 1558–1618*.

247. Adam Fox, *Oral and Literate Culture in England 1500–1700* (Clarendon Press, Oxford, 2000), p. 186.
248. James Sharpe, *The Bewitching of Anne Gunter* (Profile Books, London, 2000); Rosen, *Witchcraft in England 1558–1618*, pp. 32–4.
249. Malcolm Gaskill, 'Witchcraft in Early Modern Kent: Stereotypes and the Background to Accusations' in *Witchcraft in Early Modern Europe: Studies in Culture and Belief* eds Jonathan Barry, Marianne Hester and Gareth Roberts (Cambridge University Press, Cambridge, 1996), especially pp. 285–6; Peter Rushton, 'Texts of Authority: Witchcraft Accusations and the Demonstration of Truth in Early Modern England' in Clark (ed.). *Languages of Witchcraft*, p. 29; Frances E. Dolan, *Dangerous Familiars: Representations of Domestic Crime in England 1550–1700* (Cornell University Press, Ithaca and London, 1994), pp. 172, 175; See also Malcolm Gaskill, *Crime and Mentalities in Early Modern England* (Cambridge University Press, Cambridge, 2000); Richard Deacon, *Matthew Hopkins: Witch Finder General* (London, 1976) and James Sharpe, *Instruments of Darkness: Witchcraft in England 1550–1750* (Hamish Hamilton, London, 1996), chpt. 5.
250. Harrison, *The Trial of the Lancaster Witches 1612*, *passim* especially pp. 18, 20–1, 23–7, 33, 44–5, 54–5, 59–60, 82–3, 96–102, 149–151.
251. Rowlands, 'Witchcraft and Old Women in Early Modern Germany', p. 80.
252. Harrison, *The Trial of the Lancaster Witches 1612*, p. xxx, xxxiv.
253. Rowlands, 'Witchcraft and Old Women', pp. 72–3 citing Purkiss, *The Witch in History*, esp. chpt. 4; Deborah Willis, *Malevolent Nurture: Witch-Hunting and Maternal Power in Early Modern England* (Ithaca, 1995); Nancy Hayes, 'Negativizing Nurture and Demonizing Domesticity: The Witch Construct in Early Modern Germany' in Naomi J. Miller and Naomi Yavneh (eds), *Maternal Measures: Figuring Caregiving in the Early Modern Period* (Aldershot, 2000).
254. Harrison, *The Trial of the Lancaster Witches 1612*, pp. x–xi; Rowlands, 'Witchcraft and Old Women in Early Modern Germany', p. 50 citing Lyndal Roper, '"Evil Imaginings and Fantasies": Child Witches and the End of the Witch-Craze', *Past and Present*, 167 (2000) and H. C. Erik Midelfort, *Witch Hunting in Southwestern Germany, 1562–1684* (Stanford, 1972). See also Lynn Botelho, 'Images of Old Age in Early Modern Cheap Print: Women, Witches and the Poisonous Female Body' in Susannah Ottaway, *Old Age in Pre-Industrial Society* (Westport, Connecticut, 2002). For the ageing woman see Lynn Botelho and Pat Thane, *Women and Ageing in British Society since 1500* (Longman, Harlow, 2001).
255. James Sharpe, 'Women, Witchcraft and the Legal Process' in Kermode and Walker (eds), *Women, Crime and the Courts*, p. 110 citing J. Boys, *The Case of Witchcraft at Coggeshall, Essex, in the Year 1699* (London, 1909), pp. 21–2.
256. Clives Holmes, 'Women: Witnesses and Witches', *Past and Present*, 140 (1993), p. 46, 49, 51.
257. Susan Amussen has suggested that the association of women and witchcraft may partly be because the violence is indirect, though I am not completely convinced as there is a sense in which indirect violence is more to be feared. Susan Amussen, 'The Gendering of Popular Culture in Early Modern England' in Tim Harris (ed.), *Popular Culture in England, c.1500–1850* (Macmillan, London, 1995), p. 63.
258. Larner, *Witchcraft and Religion*.
259. Scott McGinnis, '"Subtiltie" Exposed: Pastoral Perspectives on Witch Belief in the Thought of George Gifford', *Sixteenth Century Journal*, 33:3 (2002), pp. 665–86.
260. Harrison, *The Trial of the Lancaster Witches 1612*, p. 153 and xxviii–xxx citing St Oses 1582 Sig. F2.
261. Gaskill, *Crime and Mentalities in Early Modern England*; for Matthew Hopkins see also James Sharpe, 'The Devil in East Anglia: the Matthew Hopkins Trials reconsidered' in *Witchcraft in Early-Modern Europe: Studies in Culture and Belief* eds Jonathan Barry, Marianne Hester and Gareth Roberts (Cambridge University Press, Cambridge, 1998).

262. Anon., *An Account of the Tryal and Examination of Joan Buts, for Being a Common Witch and Inchantress...March 27. 1682*. (1682) Wing A413; For an understanding of the concept of 'Puritan Revolution' see works by Samuel Rawson Gardiner and Christopher Hill.

263. Mary Daly, *Gyn/Ecology: The Metaethics of Radical Feminism* (Women's Press, London, 1979); Marianne Hester, *Lewd Women and Wicked Witches* (1992); Carol Karlsen, *The Devil in the Shape of a Woman* (New York, 1987; rep. Norton, 1998); Andrea Dworkin, *Woman Hating* (Dutton, New York, 1974); Diane Purkiss, *The Witch in History: Early Modern and Twentieth Century Representations* (Routledge, London, 1996), pp. 7–8; Barbara Ehrenreich and Deidre English, *Witches, Midwives and Nurses: A History of Women Healers* (Feminist Press, New York, 1973); Elizabeth Reis, *Damned Women: Sinners and Witches in Puritan New England* (Cornell University Press, Ithaca, 1997); Jean Brink *et al. The Politics of Gender in Early Modern Europe* (1989). For the gender and feminist/anti-feminist debate on witchcraft see also Brian Easlea, *Witch-hunting, Magic and the New Philosophy: An Introduction to the Debates of the Scientific Revolution* (Harvester Press, Brighton, 1980); Hugh McLaughlin, 'Witchcraft and Anti-Feminism', *Scottish Journal of Sociology* (1980); Stuart Clark, 'Inversion, Misrule and the Meaning of Witchcraft', *Past and Present* (1980).

264. See, for example, Purkiss, *The Witch in History*, chpt. 6 on 'choosing to be a witch'. Malcolm Gaskill, 'The Devil in the Shape of a Man: Witchcraft, Conflict and Belief in Jacobean England', *Historical Research*, 71:175 (1998); Lyndal Roper, *Oedipus and the Devil: Witchcraft, Sexuality and Religion in Early Modern Europe* (Routledge, London and New York, 1994), pp. 199–248 and 'Witchcraft and Fantasy in Early Modern Germany' in *Witchcraft in Early-Modern Europe: Studies in Culture and Belief* eds Jonathan Barry, Marianne Hester and Gareth Roberts (Cambridge University Press, Cambridge, 1998).

265. Alan Macfarlane has emphasised that English male witches were usually related to a female witch at the centre of the accusations: Macfarlane, *Witchcraft in Tudor and Stuart England*.

266. Sharpe, *Instruments of Darkness*, pp. 169, 188–9; Apps and Gow, *Male Witches in Early Modern Europe* , p. 127. Lara Apps and Andrew Gow point to the case of Johannes Junius, 1628, to illustrate male suffering: 'innocent I was tortured...the executioner came and put the thumbscrews on me...so that the blood ran out at the nails...I suffered horrible agony', p. 31 and Appendix. Merry E. Wiesner, *Women and Gender in Early Modern Europe* (Cambridge University Press, Cambridge, 1995), chpt. 7; William Monter, 'Toads and Eucharists: the Male Witches of Normandy, 1564–1660', *French Historical Studies*, 20:4 (1997), pp. 581–4.

267. *Tudor Parish Documents of the Diocese of York* ed. J. S. Purvis (Cambridge University Press, Cambridge, 1948), pp. 198–200.

268. For the argument that scepticism had always been apparent and that equally witchcraft theory had an intellectual following even after 1700 (it was just no longer political mainstream), see Ian Bostridge, *Witchcraft and Its Transformations* (Clarendon Press, Oxford, 1997).

269. Hole, *Witchcraft in England* , chpt. 2.

270. Holmes, 'Women: Witnesses and Witches', pp. 47, 66, 69–75; Rosen, *Witchcraft in England 1558–1618*, p. 17.

271. Thomas Heywood (and Richard Broome), *The Late Lancashire Witches. A Well Received Comedy, Lately Acted at the Globe* (London, 1634) rep. in *The Poetry of Witchcraft* ed. James O. Halliwell (Private Circulation, Brixton Hill, 1853) – includes also Thomas Shadwell, *The Lancashire Witches and Tegue o Divelly the Irish Priest* (London, 1632). Huntington Library copy.

272. John Webster, *The Displaying of Supposed Witchcraft* (1677).

273. Keith Thomas, *Religion and the Decline of Magic* (Weidenfeld and Nicholson, London, 1971); Malcolm Gaskill, 'Witchcraft and Power in early Modern England: the Case of Margaret Moore', in Kermode and Walker (eds), *Women, Crime and the Courts*.

274. See also Malcolm Gaskill, *Hellish Nell: The Last of England's Witches* (Fourth Estate, London, 2001).
275. The only historian who has attempted to bring us closer to understanding this private sphere is Patricia Crawford, 'Women's Dreams in Early Modern England', *History Workshop Journal*, 49 (2000), pp. 129–41.
276. The classic account that argues for a private sphere of female culture and influence is Linda Kerber, 'Separate Spheres, Female Worlds, Woman's Place: The Rhetoric of Women's History', *Journal of American History*, 75 (1988), pp. 9–39.
277. Cf. Dorothy O. Kelly and Susan Reverby, *Gendered Domains: Rethinking Public and Private in Women's History* (Ithaca, New York, 1992).
278. For assertion of the case for clear distinctions made in the early-modern period between public and private see Retha Warnicke, 'Private and Public: The Boundaries of Women's Lives in Early Stuart England', in *Privileging Gender in Early Modern England* ed. Jean R. Brink, Sixteenth Century Essays and Studies (1993).
279. Cf. Dale Hoak (ed.), *Tudor Political Culture* (Cambridge University Press, Cambridge, 1995).
280. Gordon Schochet, 'Vices, Benefits and Civil Society', in Backscheider and Dykstal (eds), *The Interaction of the Public and Private Spheres in Early Modern England* , pp. 244, 247, 258.
281. Joan B. Landes, 'The Private and Public Sphere: A Feminist Reconsideration' in Johanna Meehan (ed.), *Feminists Read Habermas: Gendering the Subject of Discourse* (Routledge, London and New York, 1995), p. 98.
282. Lawrence E. Klein, 'Gender and the Public/Private Distinction in the Eighteenth Century: Some Questions about Evidence and Analytic Procedure', *Eighteenth-Century Studies*, 29:1 (1995), p. 104; Locke, *Two Treatises of Government* ed. Peter Laslett, chpts. II and III especially pp. 150–1, 161, 174–8, 184–5, 189; John Brewer, 'This, That and the Other: Public, Social and Private in the Seventeenth and Eighteenth Centuries', in David Castiglione and Lesley Sharpe (eds), *Shifting the Boundaries: Transformation of the Languages of Public and Private in the Eighteenth Century* (University of Exeter Press, Exeter, 1995), p. 9; Davidoff, *Worlds Between*, pp. 223, 227–9.

5 Politics

1. Jon Lawrence, 'Political History' in *Writing History: Theory and Practice* eds Stefan Berger, Heiko Feldner and Kevin Passmore (Hodder Arnold, London, 2003), pp. 183–7 citing Thomas Macauley, *History of England* (1848–61), Herbert Butterfield, *The Whig Interpretation of History* (1931) and Lewis Namier, *Structure of Politics at the Accession of George III* (1929). The quotation is often incorrectly attributed to Sir John Seeley.
2. Merry E. Wiesner, *Women and Gender in Early Modern Europe*, p. 239; Shoemaker and Vincent (eds), *Gender and History in Western Europe* (Cambridge University Press, Cambridge, 1993), p. 281 and Natalie Zemon Davis, 'Women on Top' in Robert Shoemaker and Mary Vincent (eds), *Gender and History in Western Europe* (Arnold, London,1998), pp. 285–6, 298–301. For Elizabeth's 'men of business' see Michael Graves, 'Thomas Norton, the Parliament Man: An Elizabethan MP, 1559–1581', *Historical Journal*, 23 (1980), pp. 17–35, 'The Management of the House of Commons: The Council's Men of Business', *Parliamentary History*, 2 (1983), pp. 11–38, 'The Common Lawyers and the Privy Council's Parliamentary Men of Business 1584–1601', *Parliamentary History*, 8 (1989), pp. 189–215; Patrick Collinson, 'Puritans, Men of Business and Elizabethan Parliaments', *Parliamentary History* (1988), pp. 187–211.
3. An example of a good political narrative with a woman at the centre of the enquiry is Francis Harris, *A Passion for Government: The Life of Sarah, Duchess of Marlborough* (Clarendon Press, Oxford, 1991). The first detailed rewriting of early-modern political history is to be found in Mendelson and Crawford, *Women in Early Modern*

England 1550–1720. Hilda Smith (ed.), *Writers and the Early Modern British Political Tradition* (Cambridge University Press, Cambridge, 1998) and James Daybell (ed.), *Women and Politics in Early Modern England 1450–1700* (Ashgate, Aldershot, 2004) are important collections of essays which together fill out the picture of women's political reach, their political thought and writings and the gender politics of intellectual authority.

4. Mendelson and Crawford, *Women in Early Modern England*, pp. 343, 345.

5. Carole Levin, 'Gender, Monarchy and the Power of Seditious Words' in *Dissing Elizabeth: Negative Representations of Gloriana* (Duke University Press, Durham and London, 1998), pp. 82, 89; Anne Laurence, *Women in England 1500–1760: A Social History* (Weidenfeld and Nicolson, London, 1994), p. 242.

6. Ian Maclean, *The Renaissance Notion of Woman: A Study in the Fortunes of Scholasticism and Medical Science in European Intellectual Life* (Cambridge University Press, Cambridge, 1980), pp. 49, 50, 60.

7. Jean Bodin, *Six Books of a Commonweale* (London,1606), p. 753 quoted in Wiesner, Women and Gender in Early Modern Europe, p. 20; Gordon Schochet, *The Authoritarian Family and Political Attitudes in 17th Century England: Patriarchalism in Political Thought* (Transaction Books, New Brunswick and London, 1988), pp. 31–2, 35.

8. *Aristotle's Politiques* trans, Louis le Roy (1598) in Kate Aughterson (ed.), *Renaissance Woman: Constructions of Femininity in England* (Routledge, London and New York, 1995), p. 137.

9. Wiesner, *Women and Gender in Early Modern Europe* , p. 240; Crawford, 'Public Duty, Conscience and Women in Early Modern England' in Morrill, Slack and Woolf (eds), *Public Duty and Private Conscience in Seventeenth-Century England*, p. 60.

10. Susan Staves, 'Investments, Votes and "Bribes": Women as Shareholders in the Chartered National Companies', in Smith (ed.), *Women Writers and the Early Modern British Political Tradition* , chpt. 12.

11. Anon. *The Lawes Resolutions of Womens Rights: Or, the Lawes Provision for Women* (London, 1632), p. 6.

12. For lists of women officeholders see Charlotte Carmichael Stopes, *British Freewomen* (London, 1894) and Rose Graham, 'The Civic Position of Women at Common Law before 1800', *Journal of the Society of Comparative Legislation*, 17:1/2 (1917), pp. 178–93.

13. Crawford, 'Public Duty, Conscience and Women in Early Modern England' in Morrill, Slack and Woolf (eds), *Public Duty and Private Conscience in Seventeenth-Century England*, p. 63; *The Accounts of the Wardens of the Parish of Morebath, Devon, 1520–1573* (Exeter, 1904) ed. J. E. Binney; Pearl Hogrefe, *Tudor Women: Commoners and Queens* (Iowa State University Press, Ames, 1975), pp. 27–8; Eamon Duffy, *The Voices of Morebath: Reformation and Rebellion in an English Village* (Yale University Press, New Haven and London, 2001), Appendix pp. 191–99 and pp. 124 and 160.

14. Mendelson and Crawford, *Women in Early Modern England*, p. 379 citing *Calendar of State Papers Domestic, 1667–8*, pp. 174, 195, 196, 210.

15. Anon. *The Lawes Resolutions of Womens Rights*, p. 6.

16. Zemon Davis, 'Women on Top', reprinted in Shoemaker and Vincent (eds), *Gender and History in Western Europe*, p. 292; cf. Mendelson and Crawford, *Women in Early Modern England*, pp. 418, 428–9.

17. Michael K. Jones and Malcolm G. Underwood, *The King's Mother: Lady Margaret Beaufort, Countess of Richmond and Derby* (Cambridge University Press, Cambridge, 1992), pp. 34–5.

18. Jones and Underwood, *The King's Mother: Lady Margaret Beaufort*, pp. 37–40, 59, 94–8, 137.

19. Rosemary O'Day, *The Longman Companion to the Tudor Age* (Longman, London and New York, 1995), pp. 3–4; Jones and Underwood, *The King's Mother: Lady Margaret Beaufort*, pp. 62–3.

20. David Loades, *The Tudor Court* (B. T. Batsford, London, 1986), p. 137; S. B. Chrimes, *Henry VII* (Eyre Methuen, London, 1972, rep. 1977), p. 57; Hogrefe, *Tudor Women*, pp. 27,

34–6 citing Rachel Reid, *The King's Council in the North* (London and New York, 1921), pp. 87–91.

21. Jones and Underwood, *The King's Mother: Lady Margaret Beaufort*, Appendix 2, 'Lady Margaret's Estates', pp. 262–8, calculated from Public Record Office MS E36/177, Appendix 3, 'Officers, Servants and Scholars in Lady Margaret's Household, c. 1499–1509', pp. 268–87 and pp. 97 ff, chpts. 7–8; Loades, *The Tudor Court*, p. 137; O'Day, *The Longman Companion to the Tudor Age*, pp. 5–8.

22. Jones and Underwood, *The King's Mother: Lady Margaret Beaufort*, pp. 91–2; O'Day, *The Longman Companion to the Tudor Age*, p. 9.

23. Barbara Harris, *English Aristocratic Women 1450–1550* (Oxford University Press, New York and Oxford, 2002), pp. 3–5.

24. Barbara Harris, 'Women and Politics in Early Tudor England', *The Historical Journal*, 33:2 pp. 259–60, 269–70, 281; cf. Eales, *Women in Early Modern England, 1500–1700*, p. 47; Pearl Hogrefe, *Women of Action in Tudor England: Nine Biographical Sketches* (Iowa State University Press, Ames, Iowa, 1977), chpt. 4.

25. Harris, *English Aristocratic Women*, chpt. 6.

26. Harris, 'Women and Politics in Early Tudor England', *The Historical Journal*, 33:2 (1990), p. 264; Loades, *The Tudor Court*, p. 133.

27. Harris, 'Women and Politics in Early Tudor England', *The Historical Journal*, pp. 259–64 and Harris, *English Aristocratic Women*, pp. 70–1; Hogrefe, *Women of Action in Tudor England*, chpt. 3; Trevor Lummis and Jan Marsh, *The Woman's Domain: Women and the English Country House* (Penguin Books, London, 1990), chpt. 2.

28. Harris, 'Women and Politics in Early Tudor England', *The Historical Journal*, pp. 281, 265–8, 271 (quotation citing British Library, Cotton MSS Vespasian, F xiii, fo. 154 and *Lisle Letters*, iv, no. 882); Hogrefe, *Women of Action in Tudor England*, p. 90.

29. Harris, 'Women and Politics in Early Tudor England', *The Historical Journal*, pp. 268, 271–3 citing Public Record Office, SP1/122, f. 60 (26 March 1528–30); Lambeth Palace, Shrewsbury 3205, f. 12; Public Record Office, SP1/118, f. 225 (April 1537); Public Record Office, SP1/104, f. 117; Public Record Office, SP1/194, f. 20; British Library, Cotton MSS Vespasian F.xiii, f. 180.

30. Harris, 'Women and Politics in Early Tudor England', *The Historical Journal*, p. 270 citing British Library, Cotton MSS Caligula B. II 207d and pp. 275–8 and *English Aristocratic Women*, pp. 210, 216–17; Eales, *Women in Early Modern England, 1500–1700*, pp. 51–2.

31. Elizabeth of York's two daughters were used by her son and mother-in-law to establish political alliances. At nineteen Mary was married to the elderly Louis XII of France, and at fourteen Margaret was married to James IV of Scotland, suffering in an unhappy marriage until he was killed, by her own brother's army, at Flodden in 1513. See Maria Perry, *Sisters to the King* (André Deutsch, 1999), *passim*; Carolly Erickson, *Bloody Mary* (Book Club Associates, London, 1978) pp. 22–3.

32. Trinity College Cambridge MS. 0.9.34.

33. Erickson, *Bloody Mary*, pp. 9–10, 16–17, 33–4, 37; C. S. L. Davies and John Edwards, 'Katherine of Aragon', *Oxford Dictionary of National Biography* (www.oxforddnb.com, 2004).

34. The drama of Henry's multiple marriages turned into melodrama is exemplified in works like David Starkey, *Six Wives: The Queens of Henry VIII* (Vintage, 2004). Earlier collective biographies include Antonia Fraser, *Six Wives of Henry VIII* (Mandarin, 1993; rep. Weidenfeld and Nicolson, 2004) and Alison Weir, *The Six Wives of Henry VIII* (Pimlico, London, 1997).

35. Davies and Edwards, 'Katherine of Aragon', *Oxford Dictionary of National Biography*.

36. Biographies of this short-lived queen consort include Paul Friedman, *Anne Boleyn*, 2 vols. (Macmillan, London, 1884); M. L. Bruce, *Anne Boleyn* (1972); H. W. Chapman, *Anne Boleyn* (1974); Eric Ives, *Anne Boleyn* (Blackwell Press, Oxford, 1986).

37. E. W. Ives, 'Anne Boleyn', *Oxford Dictionary of National Biography* (www.oxforddnb.com, 2004).

38. After Mary Boleyn married William Carey, gentleman of the privy chamber, she became the king's mistress, possibly bearing him a son. Retha Warnicke, *The Rise and Fall of Anne Boleyn: Family Politics at the Court of Henry VIII* (Cambridge University Press, Cambridge, 1989), chpt. 2; Ives, *Anne Boleyn*, chpts. 2–3 especially pp. 47–9 and with a quotation from p. 23. For an odd account of Anne Boleyn see David Starkey, *The Reign of Henry VIII: Personalities and Politics* (George Philip, London, 1985), chpt. 5 – 'She functioned as an honorary man'; 'On the other hand, of course, though Anne handled power like a man, she had got it – if not through witchcraft as Henry later professed to believe – then certainly through female wiles'. Starkey also says she 'was brilliant, talkative and assertive'; her sister Mary is labelled a 'silly slut'.

39. Warnicke, *The Rise and Fall of Anne Boleyn*, chpt. 2; Ives, *Anne Boleyn*, chpt. 2 especially pp. 25–7.

40. See Jasper Ridley (ed.), *The Love Letters of Henry the Eighth* (1988) and Retha Warnicke, 'The Conventions of Courtly Love and Anne Boleyn' in *State, Sovereigns and Society in Early Modern England: Essays in Honour of A J Slavin*, eds Charles Carlton *et al.* (Sutton, Stroud, 1998).

41. John E. Paul, *Catherine of Aragon and Her Friends* (Burns & Oates, London, 1966), chpts. 7–9, 16 with quotations from pp. 204, 126; Warnicke, *The Rise and Fall of Anne Boleyn*, p. 60.

42. Davies and Edwards, 'Katherine of Aragon', *Oxford Dictionary of National Biography*.

43. Ann Weikel, 'Mary I', *Oxford Dictionary of National Biography* (www.oxforddnb.com, 2004); Davies and Edwards, 'Katherine of Aragon', *Oxford Dictionary of National Biography*.

44. Ives, *Anne Boleyn*, chpt. 7 and pp. 60, 251, 255; Warnicke, *The Rise and Fall of Anne Boleyn*, Introduction and Appendix A and Retha Warnicke, 'Sexual Heresy at the Court of Henry VIII', *Historical Journal*, 30:2 (1987), 247–68.

45. Ives, *Anne Boleyn*, chpt. 12 especially pp. 258–9, 262, chpt. 14, 298. See also the literature on Anne Boleyn and Protestant reform: M. Dowling, 'Anne Boleyn and Reform', *Journal of Ecclesiastical History*, 35 (1984), 30–46; George W. Bernard, 'Anne Boleyn's Religion', *Historical Journal*, 36 (1993), 1–20; Eric Ives, 'Ann Boleyn and the Early Reformation in England: the Contemporary Evidence', *Historical Journal*, 37 (1994), pp. 389–400; Thomas S. Freeman, 'Research, Rumour and Propaganda: Anne Boleyn in Foxe's *Book of Martyrs*', *Historical Journal*, 38 (1995), 797–819; Mendelson and Crawford, *Women in Early Modern England*, p. 368; Paul F. Zahl, *Five Women of the English Reformation* (Eerdmans, Cambridge, 2001).

46. Ives, *Anne Boleyn*, pp. 273–9 citing *Ballads from Manuscript* ed. F. J. Furnivall, Ballad Society (1868–72) and 106–7 citing H. Savage (ed.), *Love Letters of Henry VIII* (1949), pp. 34–6, 27–8, 343 citing *Letters and Papers, Foreign and Domestic, of the Reign of Henry VIII*, ed. J. S. Brewer *et al.* (1862–1932), iv, 3325, 3221, x, 199 and *Calendar of State Papers...between England and Spain, 1536–8*, ed. G. A. Bergenroth *et al.* (1862–1954), p. 28; Ives, 'Anne Boleyn'.

47. Eric Ives, 'Faction at the Court of Henry VIII: The Fall of Anne Boleyn', *History*, 57 (1972), pp. 169–88; Retha Warnicke, 'The Fall of Anne Boleyn: a Reassessment', *History*, 70 (1985), pp. 1–15; George W. Bernard, 'The Fall of Anne Boleyn', *English Historical Review*, 106 (1991), pp. 584–610; Retha Warnicke, 'Anne Boleyn Revisited', *Historical Journal*, 34:4 (1991), pp. 953–4; Eric Ives, 'The Fall of Anne Boleyn Reconsidered', *English Historical Review*, 107 (1992), pp. 651–64; George Bernard, 'The Fall of Anne Boleyn: A Rejoinder', *English Historical Review*, 107 (1992), pp. 665–74; Retha Warnicke, 'The Fall of Anne Boleyn Revisited', 108 (1993), pp. 653–65; Greg Walker, 'Rethinking the Fall of Anne Boleyn', *Historical Journal*, 45:1 (2002), pp. 1–29.

48. Walker, 'Rethinking the Fall of Anne Boleyn', pp. 1–3 and *passim*.

49. Walker, 'Rethinking the Fall of Anne Boleyn', p. 11.

50. Ives, *Anne Boleyn*, chpts. 15–16; Walker, 'Rethinking the Fall of Anne Boleyn', p. 5.

51. Walker, 'Rethinking the Fall of Anne Boleyn', p. 19.

52. Ives, *Anne Boleyn*, chpts. 17–18. Officially, male courtiers were supposed to remain an exact physical distance between themselves and the queen – see, Retha Warnicke, 'Family and Kin Relations at the Henrician Hospital: the Boleyns and Howards' in Dale Hoak (ed.), *Tudor Political Culture* (Cambridge University Press, Cambridge, 1995), pp. 36–7.

53. See Henry Ansgar Kelly, *The Matrimonial Trials of Henry VIII* (Stanford University Press, Stanford California, 1976); O'Day, *The Longman Companion to the Tudor Age*, pp. 12–15; Davies and Edwards, 'Katherine of Aragon'.

54. Jane Seymour is an under-studied figure. See Pamela Gross, *Jane, the Quene, Third Consort of King Henry VIII* (Edward Mellen, New York, 1999).

55. Barret L. Beer, 'Jane Seymour', *Oxford Dictionary of National Biography* (www.oxforddnb.com, 2004).

56. Jane Seymour to Sir Edward Willoughby, 12 October 1537 [STC 1175].

57. Beer, 'Jane Seymour', *Oxford Dictionary of National Biography* (www.oxforddnb.com, 2004).

58. Retha M. Warnicke, *The Marrying of Anne of Cleves: Royal Protocol in Early Modern England* (Cambridge, University Press, 2000), *passim* but especially pp. 252–5; Retha Warnicke, 'Anne of Cleves', *Oxford Dictionary of National Biography* (www.oxforddnb.com, 2004). See also Juliana Ditsche, 'Richmond's First Lady of the Manor – Anne of Cleves', *Richmond Local History Society Journal*, 22 (2001) and Mary Saaler, *Anne of Cleves, Fourth Wife of Henry VIII* (Rubicon, London, 1995). See also Kelly, *The Matrimonial Trials of Henry VIII*.

59. Retha Warnicke, 'Katherine Howard', *Oxford Dictionary of National Biography* (www.oxforddnb.com, 2004).

60. Kathy Lynn Emerson, *Wives and Daughters: The Women of Sixteenth Century England* (Whitson, New York, 1984), p. 41.

61. Hogrefe, *Women of Action in Tudor England*, chpt. 8; Janet Mueller (ed.), Katherine Parr, Part 1, vol. 3, *The Early Modern Englishwoman in Print: A Facsimile Library of Essential Works, 1500–1640*, eds Betty S. Travitsky and Patrick Cullen (Scolar Press, Aldershot, Hants, UK and Brookfield, Vermont, USA), pp. ix–xiii; James, *Kateryn Parr: The Making of a Queen* and 'Katherine Parr', *Oxford Dictionary of National Biography* (www.oxforddnb.com, 2004). See also Janet Mueller, 'A Tudor Queen Finds Voice: Katherine Parr's Lamentation of a Sinner', in *The Historical Renaissance* eds Heather Dubrow and Richard Strier (Chicago, 1988); Fenno Hoffman, 'Catherine Parr as a Woman of Letters', *Huntington Library Quarterly*, 23 (1959); William Haugaard, 'Katherine Parr: the Religious Convictions of a Renaissance Queen', *Renaissance Quarterly*, 22 (1969) and Sheryl Kujana-Holbrook, 'Katherine Parr and Reformed Religion', *Anglican and Episcopal History*, 72:1 (2003), pp. 55–78.

62. Susan James, *Kateryn Parr: The Making of a Queen* (Ashgate, Aldershot, Hants., 1999) chpt. 10.

63. For detailed work on her patronage see James, *Kateryn Parr*, chpt. 9.

64. James, 'Katherine Parr', *Oxford Dictionary of National Biography*. The Sudeley Castle anecdote about the exhumation of Katherine Parr made its way into eighteenth and nineteenth century local history and archaeology magazines.

65. James, *Kateryn Parr*, chpt. 8.

66. Some would include the brief and disputed rule of Mathilda.

67. David Chambers' *Discourse de la Legitime Succession de Femmes* was another legalistic defence that appeared later in 1579 and answered the Catholic condemnations of female rule and the assertion from the Huguenot [Protestant] Francois Hotman in *Francogallia* (1573) that female rule led to 'calamities' because of the turning loose of the untamed and unnatural beast of a woman ruler. The French [Catholic] philosopher, Jean Bodin, similarly argued that 'gynecocracy is squarely against the laws of nature that give men the strength, the prudence, the arms, and the power to command and take away from women' and the *querelle des femmes* nature of the

debate is clearly demonstrated by the way it crossed the denominational bound-
aries in Reformation Europe. Lisa Hopkins, ' "Monstrous Regiment": Staging Female
Rule' in *The Iconography of Power: Ideas and Images of Rulership on the English
Renaissance Stage* eds György Szönyi & Roland Wymer (Szeged, 2000), p. 77; Thomas
Craig, *The Right of Succession to the Kingdom of England, in Two Books; against the
Sophisms of Parsons the Jesuit... Written Originally in Latin about 100 Years Since*
(London, 1703), p. 83; Jean Bodin, *Six Books of the Commonweale* (1606), p. 753 cited
in Merry Wiesner, *Women and Gender in Early Modern Europe* (Cambridge, University
Press, Cambridge, 1993), p. 20. For Knox's supporters see, Christopher Goodman,
How Superior Powers Ought to be obeyed (1558) and Anthony Gilby, *An Admonition to
England and Scotland* (1558).

68. Weikel, 'Mary I', *Oxford Dictionary of National Biography*.
69. H. F. M. Prescott, *Mary Tudor* (1952); Jasper Ridley, *The Life and Times of Mary Tudor*
(1973; the title of Ridley's latest work on Mary is instructive – *Bloody Mary's Martyrs: The
Story of England's Terror* [2002]); Carrolly Erickson, *Bloody Mary* (Book Club Associates,
London, 1978); David Loades, *Mary Tudor: A Life* (Blackwell, Oxford, 1989); Robert
Tittler, *The Reign of Mary I* (Longman, London, 1991); David Loades, *The Reign of Mary
Tudor: Politics, Government and Religion in England, 1553–58* (Longman, London, 1991);
Josh Brooman, *Bloody Mary* (Longman, London, 1998). For 're-catholicisation' see Claire
Cross, 'The Reconstitution of Northern Monastic Communities in the Reign of Mary
Tudor', *Northern History*, 29 (1993), 200–24 and Jennifer Loach, 'Mary Tudor and the
Re-Catholicisation of England', *History Today*, 44:11 (1994), pp. 16–22.
70. Loades, *The Reign of Mary Tudor: Politics, Government and Religion in England*, 1553–58,
chpt. 3.
71. Helen Hackett, *Virgin Mother, Maiden Queen: Elizabeth I and the Cult of the Virgin Mary*
(Macmillan, Basingstoke, 1995), pp. 34–7.
72. Weikel, 'Mary I', *Oxford Dictionary of National Biography*.
73. Mendelson and Crawford, *Women in Early Modern England*, pp. 352–3.
74. Anna Whitelock, 'A Woman in a Man's World: Mary I and Political Intimacy, 1553–
1558', in *Women, Wealth and Power*, eds Amanda L. Capern and Judith Spicksley, Special
Issue of *Women's History Review*, 16:3 (2007), pp. 299–310.
75. Weikel, 'Mary I', *Oxford Dictionary of National Biography*; Mendelson and Crawford,
Women in Early Modern England , p. 352; Judith M. Richards, 'Mary Tudor as Sole Quene'?:
Gendering Tudor Monarchy', *Historical Journal*, 40:4 (1997), p. 895 citing 'A Sermon
Made att the Burial of Queen Mary', British Library, Cotton Vespasian, D XVIII, x, f. 104
and pp. 902, 915 ff, '"To Promote a Woman to Beare Rule": Talking of Queens in Mid-
Tudor England', *Sixteenth Century Journal*, 28 (1997), pp. 101–22, 'Gender Difference and
Tudor Monarchy: The Significance of Queen Mary I', *Parergon*, 21:2 (2004), pp. 27–46.
See also, Jennifer Loach, *A Mid-Tudor Crisis?* (HA, London, 1992); David Loades, *The
Mid-Tudor Crisis* (Macmillan, Basingstoke, 1992); Robert Tittler, 'The Local Community
and the Crown in 1553: The Accession of Mary Tudor Revisited', *Bulletin of the Institute
of Historical Research*, 57 (1984), pp. 131–9.
76. See for example Margaret Simpson, *Rivals for the Crown* (Scolastic, London, 2003) and
David Starkey, *Elizabeth* (Chatto and Windus, London, 2000), chpts, 21 ff. For more
serious-minded work see David Loades, *Chronicles of the Tudor Queens* (Sutton, Stroud,
2002). Cf. Lisa Hopkins, *Writing Renaissance Queens: Texts by and about Elizabeth I and
Mary, Queen of Scots* (University of Delaware Press, Newark and London, 2002 argues
similarly that Elizabeth I has been pitted against Mary Stuart 'in a culturally loaded
contest for the meaning of femininity', p. 89.
77. Starkey, *Elizabeth*, pp. 177–82, 224–5. Mary's personal physical suffering was known to
the women closest to her – Elizabeth wrote to her on 27 October 1552 about her 'sick-
ness' and calling it 'your old guest that is wont oft to visit you' – *Elizabeth I: Collected
Works* eds Leah S. Marcus, Janel Mueller & Mary Beth Rose (University of Chicago Press,
Chicago and London, 2000), p. 37.

78. Judith Richards, 'Love and a Female Monarch: The Case of Elizabeth Tudor', *Journal of British Studies*, 38 (1999), pp. 143–5 citing Sydney Anglo, *Images of Tudor Kingship* (London, 1992); Starkey, *Elizabeth*, pp. 268–9.

79. Ernst H. Kantorowicz, *The King's Two Bodies: A Study in Medieval Political Theology* (Princeton University Press, New Jersey, 1957), pp. 78–9, 87, 194–207, 261, 277, 316–17, 364, 369, 376, 403, 407 citing Chief Justice Brook in Plowden *Reports*, 175–6.

80. Richards, 'Love and a Female Monarch: The Case of Elizabeth Tudor', pp. 140–3; Starkey, *Elizabeth*, pp. 236–44, 52–3.

81. John Knox, *The First Blast of the Trumpet against the Monstrous Regiment of Women* (1559) reprinted in Martin A. Breslow, *Political Writings of John Knox* (Folger Books, Washington DC, 1985), *passim*.

82. See, for example, Amanda Shepherd, *Gender and Authority in Sixteenth Century England* (Ryeburn Publishing, Keele University, 1994); Richard L. Greaves, 'The Gynecocracy Controversy' in *Theology and Revolution in the Scottish Reformation* (Christian University Press, Grand Rapids, Michigan, 1980); Melanie Hansen, 'The Word and the Throne: John Knox's *The First Blast of the Trumpet against the Monstrous Regiment of Women*' in Kate Chedgzoy, Melanie Hansen & Suzanne Trill (eds), *Gender and Sexuality in Early Modern Writing* (Edinburgh University Press, Edinburgh, 1998; 1st ed. Keele UP, 1996); Maureen Meikle, 'John Knox and Womankind: A Reappraisal', *The Historian* (2003), pp. 9–14; Maria Abreu, 'John Knox: Gynaecocracy, "The Monstrous Empire of Women"', *Reformation and Renaissance Review*, 5:2 (2003), pp. 167–88; Patrick Collinson, 'John Knox, the Church of England and the Women of England' in Roger Mason (ed.), *John Knox and the British Reformations* (Ashgate, Aldershot, 1998) provides a different perspective; Sharon, L. Jansen, *The Monstrous Regiment of Women: Female Rulers in Early Modern Europe* (Palgrave, Basingstoke, 2002) uses Knox as a starting point for a discussion of networks of European ruling women.

83. Though Robert Healey has controversially argued that Knox was willing to accept female rule as a 'suspension of [God's] divine commandment' if women quickly proved themselves to be a second Deborah – Robert Healey, 'Waiting for Deborah: John Knox and Four Ruling Queens', *Sixteenth Century Journal*, 25:2 (1994), pp. 371–86.

84. See, for example, Constance Jordan, 'Woman's Rule in Sixteenth Century British Political Thought', *Renaissance Quarterly*, 40 (1987), 419–51.

85. Constance Jordan, *Renaissance Feminism: Literary Texts and Political Models* (Cornell University Press, Ithaca and London, 1990), pp. 116–33; Paula Louise Scalingi, 'The Scepter or the Distaff: The Question of Female Sovereignty, 1516–1607', *The Historian* (1978), pp. 60–2, 66–75; Richards, '"To Promote a Woman to Beare Rule"', pp. 108–9, 117; John Aylmer, *An Harborowe for Faithful and True Subjects* (1559); Carole Levin, 'John Foxe and the Responsibilities of Queenship', in Mary Beth Rose (ed.), *Women in the Middle Ages and the Renaissance* (Syracuse University Press, Syracuse, 1986), p. 117; Shepherd, *Gender and Authority*, pp. 135–6, 148–9.

86. Franklin le van Baumer, *The Early Tudor Theory of Kingship* (Yale University Press, New Haven, 1940), p. viii and chpt. 5; Edward O. Smith, 'Crown and Commonwealth: A Study in the Official Elizabethan Doctrine of the Prince', *Transactions of the American Philosophical Society*, 66:8 (1976), pp. 6, 12–17.

87. Richards, 'Love and a Female Monarch', p. 142 citing PRO SP 12/1/7 and John Knox to Elizabeth I, 20 July 1559, British Library, Add. MS 32091 ff. 167–9.

88. Edmund Plowden, *Commentaries or Reports [1571]* (London, 1816) 212a cited in Kantorowicz, *The King's Two Bodies*, p. 7.

89. Marie Axton, *The Queen's Two Bodies: Drama and the Elizabethan Succession* (Royal Historical Society, London, 1977), p. 12; Kantorowicz, *The King's Two Bodies*, chpt. 2.

90. Axton, *The Queen's Two Bodies*, pp. 1 and chpt. 2.

91. One of the most famous and standard biographies is J. E. Neale, *Queen Elizabeth* (Jonathan Cape, London, 1934). Feminist biography includes Maria Perry, *The Word of a Prince* (The Boydell Press, Woodbridge, 1990); Susan Bassnett, *Elizabeth I: A Feminist*

Perspective (Berg, Oxford, New York and Hamburg, 1988); Philippa Berry, *Of Chastity and Power* (Routledge, London, 1994); Carole Levin, Jo Carney Eldridge and Debra Barrett-Graves (eds), *Elizabeth I: Always Her Own Free Woman* (Ashgate, Vermont, 2003). More recent biographies are Christopher Hibbert, *Virgin Queen: Personal History of Elizabeth I* (Penguin, London, 1992); Wallace McCaffrey, *Elizabeth I* (Edward Arnold, London, New York, Melbourne and Auckland, 1993); Christopher Haigh, *Elizabeth I* (Longman, London, 2nd ed. 1998); Somerset, *Elizabeth I*; Alison Weir, *Elizabeth the Queen* (Pimlico, London, 1999); David Starkey, *Elizabeth* (Chatto and Windus, London, 2000); David Loades, *Elizabeth I* (Hambledon, London, 2003). Assessments of her reign include Christopher Haigh (ed.), *The Reign of Elizabeth I* (Macmillan, Basingstoke, 1984); Susan Doran, *Elizabeth I and Religion 1558–1603* (Lancaster Pamphlets, Routledge, 1993); John Warren, *Elizabeth I: Religion and Foreign Affairs* (Hodder & Stoughton, London, 1993; rep. 2002); Carole Levin, *Heart and Stomach of a King: Elizabeth I and the Politics of Power* (University of Pennsylvania Press, Pennsylvania, 1994) and *The Reign of Elizabeth I* (Palgrave, Basingstoke, 2001); S. Adams, *Elizabeth I: Government and Politics 1558–1603* (Longman, London, 1997); Paul Hammer, *Elizabeth's Wars* (Palgrave, Basingstoke, 2003); Susan Doran and Thomas S. Freeman (eds), *The Myth of Elizabeth* (Palgrave, Basingstoke, 2003); essays in Susan Doran and Glenn Richardson (eds), *Tudor England and Its Neighbours* (Palgrave, Basingstoke, 2005); Roger Mason, '"Never Any Realm Worse Governed": Queen Elizabeth and Ireland', Lisa Jardine, 'Gloriana Rules the Waves: Or, the Advantage of Being Excommunicated (and a Woman) and David Armitage, 'The Elizabethan Idea of Empire' all in *Transactions of the Royal Historical Society*, 6th series, 14 (2004), pp. 295–308, 209–22 and 269–77. An important essay is Patrick Collinson, 'Elizabeth I and the Verdicts of History, *Historical Research*, 76:194 (2003), pp. 469–91. Quite a bit of work has been done on the cultural life of the Elizabethan court led by the works of Roy Strong – *The Cult of Elizabeth: Elizabethan Portraiture and Pangeantry* (Thames and Hudson, London, 1977) and *Gloriana: The Portraits of Elizabeth* (Pimlico, London, 2003) – and Francis Yates, *Astraea: The Imperial Theme in the Sixteenth Century* (Pimlico, London, 1975) – but see also the following cultural assessments – Helen Hackett, *Virgin Mother, Maiden Queen: Elizabeth I and the Cult of the Virgin Mary* (Macmillan, Basingstoke, 1996); John Guy (ed.), *The Reign of Elizabeth I: Court and Culture in the Last Decade* (Cambridge University Press, Cambridge, 1995); Susan Frye, *Elizabeth I: The Competition for Representation* (Oxford University Press, Oxford and New York, 1993); S. P. Cerasano & Marion Wynne-Davies, *Gloriana's Face: Women, Public and Private, in the English Renaissance* (Harvester Wheatsheaf, London and New York, 1992); Susan Doran and Thomas S. Freeman (eds), *The Myth of Elizabeth I* (Palgrave, Basingstoke, 2003); Julia M. Walker (eds.), *Dissing Elizabeth: Negative Representations of Gloriana* (Duke University Press, Durham and London, 1998); 'Power, Politics and Sexuality: Images of Elizabeth I' in *The Politics of Gender in Early Modern Europe*, Sixteenth Century Essays and Studies, xii eds Jean R. Brink *et.al.* (1989); Catherine Bates, *The Rhetoric of Courtship in Elizabethan Language and Literature* (Cambridge University Press, Cambridge, 1992); William Leahy, *Elizabethan Triumphal Processions* (Ashgate, Aldershot, 2005). New editions of the works of A. L. Rowse have also appeared to commemorate the 400th anniversary of her death as *The Expansion of Elizabethan England* (Palgrave, Basingstoke, 2003) and *The England of Elizabeth* (Palgrave Basingstoke, 2003) and an international exhibition curated by David Starkey was accompanied by a collection of essays that assess different aspects of her reign – Susan Doran (ed.) *Elizabeth* (Chatto and Windus/ National Maritime Museum, London, 2003). The Royal Historical Society bibliography lists 3298 titles at the time of writing. www.rhs.ac.uk accessed 9/6/2005.

92. This painting is described in Susan Doran's exhibition catalogue as being of the Flemish School and dated *c.* 1546.

93. Lisa Hopkins has gone so far as to argue that, for Elizabeth, image was more important than words, though this is debateable – *Writing Renaissance Queens: Texts by and about Elizabeth I and Mary, Queen of Scots* (University of Delaware Press, Newark, 2002), p. 19.

94. John Cannon, 'Elizabeth I' in *The Oxford Companion to British History* ed. John Cannon (Oxford University Press, Oxford, 1997), p. 342; Amanda L. Capern, 'Review Article: Elizabeth I in Her Own Words', *Renaissance Forum*, 6:1 (2002) with citations from *Elizabeth I: Collected Works* eds Leah S Marcus, Janel Mueller and Mary Beth Rose (University of Chicago Press, Chicago, Illinois, 2000), *passim*; Smith, 'Crown and Commonwealth: A Study in the Official Elizabethan Doctrine of the Prince', p. 37.

95. Susan Doran, *Monarchy and Matrimony: the Courtships of Elizabeth I* (Routledge, London and New York, 1996), *passim* but with cited argument from p. 130.

96. See Wallace MacCaffrey, 'The Anjou Match and the Making of Elizabethan Foreign Policy' in *The English Commonwealth1547–1640: Essays in Politics and Society Presented to Joel Hurstfield* eds Peter Clark, A. G. R. Smith and Nicholas Tyacke (Leicester, 1979) and Natalie Mears, 'Love-making and Diplomacy: Elizabeth I and the Anjou Marriage Negotiations, *c.*1578–1582', *History*, 86:284 (2001), pp. 442–66. See also, Hibbert, *The Virgin Queen*, p. 79.

97. Doran, *Monarchy and Matrimony*, pp. 11, 217.

98. *Elizabeth I: Collected Works* eds Leah S Marcus, Mueller and Beth Rose, p. 97.

99. See, Susan Doran (ed.), *Elizabeth*, p. 83; Roy Strong, *Gloriana: The Portraits of Elizabeth* and Francis Yates, *Astraea: The Imperial Theme in the Sixteenth Century* (Pimlico, London, 1975), pp. 112–13.

100. Patrick Collinson's works have collectively demonstrated that Elizabeth's reign became associated with a brand of Protestantism that defined the English nation – *The Birthpangs of Protestant England: Religious and Cultural Change in the Sixteenth and Seventeenth Centuries* (Macmillan, Basingstoke, 1988), *The Religion of Protestants: The Church in English Society 1559–1625* (Oxford University Press, Oxford, 1985) and *Godly People: Essays on English Protestantism and Puritanism* (Hambledon Press, London, 1983).

101. Susan Doran, 'Virginity, Divinity and Power: The Portraits of Elizabeth I' in *The Myth of Elizabeth* (Palgrave, Basingstoke, 2003), p. 172.

102. Helen Hackett, *Virgin Mother, Maiden Queen: Elizabeth I and the Cult of the Virgin Mary* (Macmillan, Basingstoke, 1995), esp. pp. 76–8.

103. Carole Levin, 'Power, Politics and Sexuality: Images of Elizabeth I', *The Politics of Gender in Early Modern Europe* eds Jean R. Brink, Allison P. Coudert an Maryanne C. Horowitz, xii, Sixteenth Century Essays and Studies (1989), p. 98 and *The Heart and Stomach of a King: Elizabeth I and the Politics of Sex and Power* (University of Pennsylvania Press, Philadelphia, 1994), pp. 28–9. See also, Anne McLaren, 'Gender, Religion and Early Modern Nationalism: Elizabeth I, Mary Queen of Scots and the Genesis of English Anti-Catholicism', *American Historical Review*, 107:3 (2002). pp. 739–67. David Cressy, *Bonfires and Bells: National Memory and the Protestant Calendar in Elizabethan and Stuart England* (Weidenfeld and Nicolson, London, 1989).

104. See, for example, Margaret Christian, 'Elizabeth's Preachers and the Government of Women: Defining and Correcting a Queen', *Sixteenth Century Journal*, 24:3 (1993), pp. 561–76; Patrick Collinson, *Archbishop Grindal, 1519–1583* (University of California Press, Berkeley, 1979).

105. Puritanism began with the vestiarian controversy which was a conflict over the wearing of Church vestments thought by some to be residual 'popery' and the Presbyterian movement pushed for a church government by elders and presbyters, like that in Scotland and Geneva, rather than bishops (again, a hierarchical structure thought to resemble that of the Catholic church).

106. Cf. Haigh, *Elizabeth I*, pp. 31–2.

107. Capern, 'Review Article: Elizabeth I in Her Own Words' with citations *passim* and *Elizabeth I: Collected Works* eds Marcus, Mueller and Rose, pp. 135–8, 152.

108. Haigh, *Elizabeth I*, pp. 116, 120.

109. The word 'puritan' was first used as a label of abuse for very zealous Protestant reformers in the English church.

110. For one of the best accounts of the ecclesiastical polity see John Guy, 'The Elizabethan Establishment and the Ecclesiastical Polity', Patrick Collinson, 'Ecclesiastical Vitriol: Religious Satire in the 1590s and the Invention of Puritanism' and Jenny Wormald, 'Ecclesiastical Vitriol: The Kirk, the King and the Future King of England' all in *The Reign of Elizabeth I: Court and Culture in the Last Decade* ed. John Guy (Cambridge University Press, Cambridge, 1995).

111. See J. E. Neale, *Elizabeth I and Her Parliaments*, 2 vols. (Jonathan Cape, London, 1953) and Norman L. Jones, *Faith by Statute: Parliament and the Settlement of Religion 1559* (Royal Historical Society, London, 1982). For Geoffrey Elton's work on parliament as a sporadically sitting body see, for example, *The Parliament of England 1559–1581* (Cambridge University Press, Cambridge, 1986).

112. 1st quotation cited in Haigh, *Elizabeth I*, p. 111 quoting from T. E. Hartley (ed.), *Proceedings in the Parliaments of Elizabeth I 1558–1581* (Leicester, 1981), 175 and 2nd quotation cited in Capern, 'Review Article: Elizabeth I in Her Own Words', with quotation from *Elizabeth I: Collected Works* eds Marcus, Mueller and Rose.

113. Haigh, *Elizabeth I*, pp. 112, 114–15, 118, 126; Michael Graves, 'Thomas Norton the Parliament Man', *The Historical Journal*, 23 (1980).

114. Somerset, *Elizabeth I*, pp. 65–6 citing James Froude, *History of England* (1893), vi, 16. As a qualifier to this, it should be said that Elizabeth did not always attend Council meetings and that her delegation of various matters to her councillors led to them being able to present a united front against her at times – Simon Adams, 'Eliza Enthroned? The Court and Its Politics' in *The Reign of Elizabeth I* ed. Haigh, p. 75.

115. Catherine Bates, *The Rhetoric of Courtship in Elizabethan Language and Literature* (Cambridge University Press, Cambridge, 1992) and John Guy, *Reign of Elizabeth I*, pp. 3–4; Paul Hammer, '"Absolute and Sovereign Mistress of Her Grace"? Queen Elizabeth I and Her Favourites 1581–1592' in *The World of the Favourite* eds J. H. Elliott and L. W. Brockliss (Yale University Press, New Haven and London, 1999), pp. 40–51 and see also Natalie Mears, *Queenship and Public Discourse in the Elizabethan Realms* (Cambridge University Press, Cambridge, 2005).

116. For the contours of this debate see Wallace MacCaffrey, 'Place and Patronage in Elizabethan Politics' in *Elizabethan Government and Society* eds S. T. Bindoff *et.al.* (London, 1961); Simon Adams, 'The Patronage of the Crown in Elizabethan Politics: the 1590s in Perspective' in *The Reign of Elizabeth I: Court and Culture in the Last Decade* ed. John Guy (Cambridge University Press, Cambridge, 1995) and *Elizabeth I: Government and Politics 1558–1603* (Longman, London, 1997); Haigh, *Elizabeth I*, chpts. 4–5.

117. Guy, *Reign of Elizabeth I: Court and Culture in the Last Decade*, p. 13; Haigh, *Elizabeth I*, pp. 71, 76, 82–7, 119; *Elizabeth I: Collected Works* eds Marcus, Mueller and Rose, Petition of House of Commons, 1576, pp. 171–2.

118. Haigh, *Elizabeth I*, p. 70. For a qualification of this view and the idea that ministers did not always act cohesively in their opposition to Elizabeth's policies see Natalie Mears, 'Counsel, Public Debate, and Queenship: John Stubbs's *The Discoverie of a Gaping Gulf, 1579*', *The Historical Journal*, 44:3 (2001), pp. 629–50.

119. Neville Williams, 'Elizabeth: The Sun Queen' in *The Courts of Europe: Politics, Patronage and Royalty* ed. A. G. Dickens (Thames and Hudson, London, 1977), p. 165.

120. Grace Tiffany, 'Elizabethan Constructions of Kingship and the Stage' in *The Iconography of Power* eds György E. Szönyi and Rowland Wymer (Szeged, 2000), p. 93.

121. See William Leahy, *Elizabethan Triumphal Processions* (Ashgate, Aldershot, Hants., 2005), *passim* esp. p. 32 and Stephen Greenblatt, *Renaissance Self-Fashioning: From More to Shakespeare* (Chicago University Press, Chicago, 1980).

122. Paul Johnson, *Elizabeth I: A Study in Power and Intellect* (Weidenfeld and Nicolson, London, 1974), pp. 12–13; Neville Williams, 'Elizabeth: The Sun Queen' in *The Courts of Europe: Politics, Patronage and Royalty* ed. A. G. Dickens (Thames and Hudson, London, 1977), pp.164–5. There is a very good study of her portraiture in all forms, for

example, in printed books and other media – Susan Doran, 'Virginity, Divinity and Power: The Portraits of Elizabeth I' in *The Myth of Elizabeth* eds Susan Doran and Thomas S. Freeman (Palgrave, Basingstoke, 2003), chpt. 7. See also Roy Strong, *The Cult of Elizabethan Portraiture and Pageantry* (Thames and Hudson, London, 1977) and Andrew and Catherine Belsey, 'Icons of Divinity: Portraits of Elizabeth I' in *Renaissance Bodies: The Human Figure in English Culture c.1540–1660* eds Lucy Gent and Nigel Llewellyn (Reaktion Books, London, 1990). The essays in *Tudor Political Culture* ed. Dale Hoak (Cambridge University Press, Cambridge and New York, 1995) is instructive on the combination of image and word in sixteenth-century political thought.

123. This is an argument based on reading *Elizabeth I: Collected Works* eds Marcus, Mueller and Rose and is to be found also made in Amanda L. Capern, 'Review Article: Elizabeth I in her own words', *Renaissance Forum*, 6:1 (2002), n.p. For a comparative reading, see Frances Teague, 'Queen Elizabeth in Her Speeches' in *Gloriana's Face: Women, Public and Private, in the English Renaissance* eds S. P. Cerasano and Marion Wynne-Davies (Harvester Wheatsheaf, New York and London, 1992).

124. Strong, *Gloriana: The Portraits of Elizabeth*.

125. *Elizabeth I: Collected Works* eds Marcus, Mueller and Rose, pp. 93–103, 263–4, 291–7. Elizabeth was not consistent in her treatment of James – in some exchanges it would be consanguinal kin reference of 'cousin and sister/cousin and brother', but in others she positively encouraged James to think of her as a surrogate mother, for example, in a letter of 27 June 1585 she said she would treat James 'as a loving mother wold use hir naturall and devoted chylde', but she quickly cut off his response in kind – John Bruce, *Letters of Queen Elizabeth and James VI of Scotland* (Camden Society, 1849), pp. 14 ff.

126. Haigh, *Elizabeth I*, pp. 143–4.

127. Leah S. Marcus, 'Shakespeare's Comic Heroines, Elizabeth I, and the Political Uses of Androgyny' in *Women in the Middle Ages and the Renaissance* ed. Mary Beth Rose (Syracuse University Press, 1986), p. 137.

128. Neville Williams, 'Elizabeth: The Sun Queen' in *The Courts of Europe: Politics, Patronage and Royalty* ed. A. G. Dickens (Thames and Hudson, London, 1977), pp. 162, 164–5. It is worth pointing out as a qualification of this that Susan Doran points out that many of the paintings of Elizabeth were done in the mannerist style and that England soaked up European cultural influences, so Elizabeth's emerging image was, to some extent, that of the European queen – Susan Doran, 'Virginity, Divinity and Power: The Portraits of Elizabeth I' in *The Myth of Elizabeth* eds Susan Doran and Thomas S. Freeman (Palgrave, Basingstoke, 2003), p. 193. Susan Frye, *Elizabeth I: The Competition for Representation* Oxford University Press, New York and Oxford, 1993) speaks of Elizabeth's representational strategies that were co-opted by others for their own purposes and that 'competed' with one another. Hibbert, *The Virgin Queen*, pp. 100–1 points out that Elizabeth's Privy Chamber dressing ritual every morning was elaborate and the attention to dress and cosmetic detail resulted in her emerging as her paintings show her.

129. Susan Watkins, *In Public and Private: Elizabeth I and Her World* (Thames and Hudson, London, 1998), p. 7; *Elizabeth I: Collected Works* eds Marcus, Mueller and Rose, p. 337.

130. This section on Elizabeth's final days is informed by the dramatic descriptions in J. E. Neale, *Queen Elizabeth* (Jonathan Cape, London, 1934), pp. 389–90 and Katherine Duncan-Jones, 'Review article: Regular Royal Queen', *Times Literary Supplement*, 9 May 2003, p. 3.

131. For Elizabeth's posthumous reputation, see Cressy, *Bonfires and Bells*.

132. A modern edition is *The History of the Most Renowned and Victorious Princess Elizabeth* ed. Wallace McCaffrey (Chicago University Press, 1970). Huntington Library MSS, Stowe, Temple Papers, Parliament Box 1 (12) – Sir John Finch to Charles I when asking to be removed from the Speakership, 19 March 1628.

133. Cf. Axton, *The Queen's Two Bodies*, p. 68.

134. Diana Primrose, *A Chaine of Pearle. Or, a Memoriall of the Peerless Graces and Heroick Vertues of Queene Elizabeth of Glorious Memory* (London, 1630), Huntington Library Copy, *passim* but esp. Sig. 1b. Later female chroniclers of Elizabeth I have not always taken an adulatory tone – in the 19th century Agnes Strickland, who championed the cause of Mary Queen of Scots and edited her letters, argued that popular memory of Elizabeth I should not blind people to her faults (*The Life of Queen Elizabeth*, abr. Hutchinson & Co., London, 1904, pp. 1–2). More recently, a collection of essays on negative representations and signs of disrespect shown for Elizabeth is quite interesting – Julia M. Walker (ed.), *Dissing Elizabeth: Negative Representations of Gloriana* (Duke University Press, Durham and London, 1998).

135. Hackett, *Virgin Mother, Maiden Queen*, p. 213 citing Francis Yates, *Astraea: The Imperial Theme in the Sixteenth Century* (Pimlico, London, 1975).

136. Cf. John Brewer, 'This, That and the Other', in Castiglione and Sharpe (eds), *Shifting the Boundaries*, p. 17.

137. Robert Filmer, *Patriarcha and Other Writings* ed. Johann P. Sommerville (Cambridge University Press, Cambridge, 1991), p. 7.

138. Filmer, *Patriarcha and Other Writings* ed. Sommerville, p. 7.

139. Filmer, *Patriarcha and Other Writings* ed. Sommerville, p. 10.

140. Filmer, *Patriarcha and Other Writings* ed. Sommerville, pp. 11–12.

141. Filmer, *Patriarcha and Other Writings* ed. Sommerville, pp. 34–5.

142. James VI and I, *Political Writings* ed. Sommerville, pp. 1, 12, 33–5.

143. James VI and I, *Political Writings* ed. Sommerville, p. 34.

144. James VI and I, *Political Writings* ed. Sommerville, p. 38.

145. James VI and I, *Political Writings* ed. Sommerville, p. 42.

146. James VI and I, *Political Writings* ed. Sommerville, p. 49.

147. James VI and I, *Political Writings* ed. Sommerville, pp. 64–78.

148. James VI and I, *Political Writings* ed. Sommerville, pp. 132–46.

149. David Stevenson, *Scotland's Last Royal Wedding: The Marriage of James VI and Anne of Denmark* (John Donald, Edinburgh, 1997), chpt. 2 and pp. 26, 40, 57, 63, 74–5. For an epithalamium see *De Augustissimo Iacbi 6. Scotorum Regus & Anna Frederici* (Edinburgh, 1589). The main biography is Ethel Carleton Williams, *Anne of Denmark* (Longman, London, 1970) and there is a very good account by Maureen Meikle and Helen Payne, 'Anna of Denmark', *Oxford Dictionary of National Biography* (www.oxforddnb.com). Also good is Leeds Barroll, *Anna of Denmark, Queen of England: A Cultural Biography* (University of Pennsylvania Press, Philadelphia, 2001).

150. Williams, *Anne of Denmark*, pp. 70–1; *Letters to King James the Sixth from the Queen, Prince Henry, Prince Charles, the Princess Elizabeth and Her Husband Frederick, King of Bohemia, and from Their Son Prince Frederick Henry*. From the Originals in the Library of the Faculty of Advocates (Private Printing, Edinburgh, 1835), pp. xxix–xxxiv and facsimile letters from Anna of Denmark to James VI and I; Meikle and Payne, 'Anna of Denmark'.

151. Linda Levy Peck, *Court Patronage and Corruption in Early Stuart England* (Routledge, London, 1990), p. 70.

152. For a letter about the earl of Somerset see *Letters to King James the Sixth from the Queen, Prince Henry, Prince Charles, the Princess Elizabeth and Her Husband Frederick, King of Bohemia, and from Their Son Prince Frederick Henry. From the Originals in the Library of the Faculty of Advocates* (Private Printing, Edinburgh, 1835); Leeds Barroll, 'The Court of the First Stuart Queen' in *The Mental World of the Jacobean Court* ed. Linda Levy Peck (Cambridge University Press, Cambridge, 1991), p. 207.

153. Barroll, 'The Court of the First Stuart Queen' in *The Mental World of the Jacobean Court* ed. Peck, p. 204; Cambridge University Library MS, Dd.1.26, f. 13.

154. Peck, *Court Patronage and Corruption*, p. 68; Leeds Barroll, 'The Court of the First Stuart Queen' in *The Mental World of the Jacobean Court* ed. Linda Levy Peck (Cambridge University Press, Cambridge, 1991), p. 191 and pp. 200–201, 205.

155. Library of the Inner Temple, The Petyt Collection, MS 515, vol. 7, f. 20 and vol. 8, ff. 24–37; Cerasano and Davies, *Gloriana's Face: Women, Public and Private in the English Renaissance*, p. 169.

156. Barrell, 'The Court of the First Stuart Queen' in *The Mental World of the Jacobean Court* ed. Peck, p. 208.

157. Jacqueline Eales, *Women in Early Modern England 1500–1700* (UCL Press, London, 1998), p. 54; see also Barbara Lewalski, 'Lucy, Countess of Bedford: Images of a Jacobean Courtier and Patroness' in *Politics of Discourse: The Literature of Seventeenth Century England* eds K. Sharpe and S. Zwicker (University of California Press, Berkeley, 1987).

158. Jonathan Goldberg, *Rewriting the Renaissance: The Discourses of Sexual Difference in Early Modern Europe* (University of Chicago Press, Chicago and London, 1986), pp. 9, 30.

159. Jerzy Limon, 'The Masque of Stuart Culture' in *The Mental World of the Jacobean Court* ed. Peck, p. 209.

160. Sarah Gristwood, *Arbella: England's Lost Queen* (Bantam Books, London, 2003), esp. pp. 94; *The Letters of Lady Arbella Stuart* ed. Sara Jayne Steen (Oxford University Press, New York and Oxford, 1994), Arbella Stuart to John Dodderidge for Edward Seymour, 25 December 1602, pp. 120–1 and Arbella Stuart to Robert Cecil, 14 June 1603, pp. 176–7; Rosalin K. Marshall, 'Lady Arabella Stuart', *Oxford Dictionary of National Biography* (www.oxforddnb.com, 2004).

161. Alastair Bellany, 'Frances Howard', *Oxford Dictionary of National Biography* (www.oxforddnb.com) citing Bodleian MS Malone 19, f. 74v. Recent accounts of the episode include David Lindley, *The Trials of Frances Howard: Fact and Fiction at the Court of King James* (Routledge, New York, 1993) and Anne Somerset, *Unnatural Murder: Poison at the Court of James I* (Weidenfeld and Nicolson, London, 1997) esp. p. 378.

162. Ronald G. Asch, 'Elizabeth Stuart', *Oxford Dictionary of National Biography* (www.oxforddnb.com, 2004). Elizabeth went on to lead a difficult life of exile, financial difficulty and personal tragedy before her death in London in 1662.

163. Meikle and Payne, 'Anna of Denmark'; James Maxwell, *Carolanna, That Is to Say, a Poem in Honour of Our King James, Queene Anne and Prince Charles* (1619), Sig. B^1.

164. Their coronation celebrations included symbolic minting of coins that were handed out and attendance at public bear-baiting after a visit to the royal menagerie to see the lions kept in the Tower – Caroline Bingham, *James I of England* (Weidenfeld and Nicolson, London, 1981), pp. 41–2.

165. Caroline M. Hibbard, 'Henrietta Maria', *Oxford Dictionary of National Biography* (www.oxforddnb.com, 2004). An older biography is Carola Oman, *Henrietta Maria* (Hodder and Stoughton, London, 1936).

166. Cambridge University Library MS, Dd.2.23, 'A Brief State of the Houses, Manors and Lands Within the Queens Jointure', 1631.

167. Caroline M. Hibbard, 'The Role of a Queen Consort: The Household and Court of Henrietta Maria 1625–1642', in Ronald G. Asche and Adolf M. Birke, *Princes, Patronage and the Nobility: The Court at the Beginning of the Modern Age* (Oxford University Press, Oxford, 1991), p. 411.

168. Nicholas Tyacke, *Anti-Calvinists: The Rise of English Arminianism 1590–1640* (Clarendon Press, Oxford, 1987); Amanda L. Capern, 'The Caroline Church: James Ussher and the Irish Dimension', *The Historical Journal*, 39 (1996), 57–85.

169. For the definitive account see Kevin Sharpe, *The Personal Rule of Charles I* (Yale University Press, New Haven and London, 1992).

170. Judith Richards, '"His Now Majestie" and the English Monarchy: The Kingship of Charles I before 1640', *Past and Present*, 113 (1986), pp. 70–96. For example, Charles I stopped holding audiences with his subjects to 'touch for the king's evil' and he

abolished progresses, pageants and so on. His interests in the arts were personal, his collecting of paintings private, his patronage very personal and so on.

171. Jonathan Goldberg, 'Fatherly Authority: The Politics of Stuart Family Images', in Margaret W. Ferguson, Maureen Quilligan and Nancy Vickers (eds), *Rewriting the Renaissance: The Discourses of Sexual Difference in Early Modern Europe* (University of Chicago Press, Chicago and London, 1986), chpt. 1 and Kevin Sharpe, 'The Caroline Court Masque', in Sharpe, *Criticism and Compliment: The Politics of Literature in the England of Charles I* (Cambridge University of Press, Cambridge, 1987), quotation from p. 183. Belinda Roberts, *Marriage in Seventeenth-Century English Political Thought* (Palgrave, Basingstoke, 2004) argues that the model of marriage as the basis for political authority through a contract of duty in exchange for obedience is invalidated in the mid-seventeenth century with the emergence of social contract theory.

172. Hibbard, 'The Role of a Queen Consort: The Household and Court of Henrietta Maria 1625–1642', in Asche and Birke, *Princes, Patronage and the Nobility*, chpt. 15; Meikle and Payne, 'Anna of Denmark', *Oxford Dictionary of National Biography* (www.oxforddnb. com, 2004) and Peter Davidson and Thomas M. McCoog, 'Father Robert's Convert: The Private Catholicism of Anne of Denmark', *Times Literary Supplement*, November 24 (2000), pp. 16–17.

173. Mary Anne Everett Green (ed.), *Letters of Queen Henrietta Maria, Including Her Private Correspondence with Charles I* (Richard Bentley, London, 1857), pp. 9–10.

174. Danielle Clark, 'The Iconography of the Blush: Marian Literature of the 1630s' in *Voicing Women, Gender and Sexuality in Early Modern Writing* eds Kate Chedgzoy, Melanie Hansen and Suzanne Trill (Edinburgh University Press, Edinburgh, 1998).

175. British Library, Egerton MS 2987, ff. 35–44.

176. Everett Green (ed.), *Letters of Queen Henrietta Maria, Including Her Private Correspondence with Charles I* Gregory Panzani to M. de Chavigny and dispatch, 25 August 1636, pp. 29–32.

177. There is a new book on the subject – Michelle White, *Henrietta Maria and the English Civil Wars* (Ashgate, Aldershot, 2006).

178. Sharpe, *The Personal Rule of Charles I*, p. 541.

179. Conrad Russell, *The Fall of the British Monarchies 1637–1642* (Clarendon Press, Oxford, 1987), pp. 58, 78, 262; David Mathew, *Scotland under Charles I* (Eyre and Spottiswood, London, 1955), p. 212.

180. William Fraser, *Book of Caelaverock* (2 vols, 1873), ii, Abstract of Printed Letters, 23–4 Charles I to Robert, Earl of Nithsdale, 15 September 1640 and Henrietta Maria to Robert, Earl of Nithsdale 5 April [1640] and account in i, pp. 349 ff. Original paper in Brynmor Jones Library, Constable-Maxwell Papers, DDEV. See also, Mark Charles Fissel, *The Bishops' Wars 1638–1640* (Cambridge University Press, Cambridge, 1994) and P. H. Donald, *An Uncounselled King: Charles I and the Scottish Troubles 1637–1641* (Cambridge University Press, Cambridge, 1990).

181. Sharpe, *The Personal Rule of Charles I*, pp. 172–3; Hibbard, 'The Role of a Queen Consort', in Asche and Birke, *Princes, Patronage and the Nobility*, p. 412.

182. *Diurnal Occurrences in Parliament* (London, 1641) cited in Everett Green (ed.), *Letters of Queen Henrietta Maria*, pp. 36–7.

183. British Library, Harleian MS 7379. f. 16 cited in Everett Green, *The Letters of Queen Henrietta Maria*, pp. 52–4.

184. British Library, Harleian MS 7379. f. 73 cited in Everett Green, *The Letters of Queen Henrietta Maria*, pp. 59–63. See also Hibbard, 'Henrietta Maria'.

185. Oman, *Henrietta Maria*, p. 99.

186. Little female commander or general.

187. Prince Rupert was the son of Charles I's daughter Elizabeth and her husband Frederick.

188. Oman, *Henrietta Maria*, pp. 144–7.

189. Hibbard, 'Henrietta Maria', *Oxford Dictionary of National Biography*.

190. See Craig Calhoun (ed.), *Habermas and the Public Sphere* (MIT Press, Cambridge, Massachusetts, 1992); G. Eley, 'Rethinking the Political: Social History and Political Culture in Eighteenth and Nineteenth-Century Britain', *Archiv für Sozialgeschichte*, 21 (1981), pp. 427–57; D. Goodman, 'Public Sphere and Private Life: Towards a Synthesis of Current Historiographical Approaches to the Old Regime', *History and Theory*, 31 (1992), pp. 1–20; John Brewer, *Party, Ideology and Popular Politics at the Accession of George III* (Cambridge University Press, Cambridge, 1976).

191. Craig Calhoun, 'Introduction: Habermas and the Public Sphere' in Calhoun (ed.), *Habermas and the Public Sphere*, p. 1. This is a collection of essays on the model of the 'public sphere' and on the liberal tradition more generally with further essays applying the model to eighteenth-century France and America.

192. Historians such as Adam Fox, Natalie Mears, Alexandra Halasz and Mark Knights have suggested that the rise of the public sphere even pre-dates the civil war period and that perhaps its origins may be seen in the Jacobean or even Elizabethan period. David Zaret, 'Printing and the Invention of Public Opinion in Seventeenth-Century England' in Penelope Gouk (ed.), *Wellsprings of Achievement: Cultural and Economic Dynamics in Early-Modern England and Japan* (Ashgate Publishing, Hampshire, 1995), especially pp. 182, 184 citing Richard Cust, 'News and Politics in Early Seventeenth-Century England', *Past and Present*, 112 (1986), pp. 60–90; 'Petitions and the "Invention" of Public Opinion in the English Revolution', *American Journal of Sociology*, 101: 6 (1996), especially pp. 1497–9, 1532, 1542; Zaret, 'Religion, Science and Printing in the Public Spheres in Seventeenth-Century England' in Calhoun (ed.), *Habermas and the Public Sphere*, pp. 213, 216–7; *Origins of Democratic Culture: Printing, Petitions and the Public Sphere in Early-Modern England* (Princeton University Press, Princeton New Jersey, 2000), especially pp. 16, 133 and chpt. 8; Ann Hughes, 'The King, the Parliament and the Localities during the English Civil War', in Richard Cust and Ann Hughes (eds), *The English Civil War* (Arnold, London, 1997), p. 278 citing Göran Therborn, *What Does the Ruling Class Do When It Rules?* (London, 1980), pp. 62–6; Adam Fox, *Oral and Literate Culture in England 1500–1700* Oxford Studies in Social History (Clarendon Press, Oxford, 2000); Mark Knights, Review of David Zaret *Origins of Democratic Culture: Printing, Petitions and the Public Sphere in Early-Modern England*, H-Albion, H-Net Reviews, September 2000, URL www.h-net.msu.edu/reviews/showrev.cgi?path=23451969480497; Natalie Mears, *Queenship and Public Discourse in the Elizabethan Realms* (Cambridge University Press, Cambridge, 2005); Alexandra Halasz, *The Marketplace of Print: Pamphlets and the Public Sphere in Early Modern England*, Cambridge Studies in Renaissance Literature and Culture, 17 (Cambridge University Press, Cambridge, 1997) pp. 42–5, 113, 161–3 and quoting from p. 4.

193. Fox, *Oral and Literate Culture in England 1500–1700*, pp. 352–3 citing Public Record Office SP 16/321/19, 360–2, 402 citing Middlesex County Records ed. Jeaffreson, iv, 66–9.

194. Joad Raymond, 'The Newspaper, Public Opinion, and the Public Sphere in the Seventeenth Century' in Joad Raymond (ed.), *News, Newspapers, and Society in Early Modern Britain* (Frank Cass, London and Portland Oregon, 1999), p. 115 citing *Letters Addressed from London to Sir Joseph Williamson while Plenipotentiary at the Congress of Cologne in the Years 1673 and 1674*, 2 vols. (Camden Society, New Series, London, 1874), II, 67–8.

195. Judith Drake, *An Essay in Defence of the Female Sex* (1696), pp. 87–8, 95.

196. See Steve Pincus, '"Coffee Politicians Does Create": Coffee Houses and Restoration Political Culture', *Journal of Modern History*, 67 (1995), pp. 807–34; Fox, *Oral and Literate Culture in England 1500–1700*, p. 376.

197. Fox, *Oral and Literate Culture in England 1500–1700*, p. 18 citing David Cressy, *Literacy and the Social Order: Reading and Writing in Tudor and Stuart England* (Cambridge University Press, Cambridge, 1980).

198. Habermas, *The Structural Transformation of the Public Sphere*, pp. 31–47, 51, 89 in Hohendahl, 'Jürgen Habermas: "The Public Sphere" (1964)', *New German Critique*, p. 46.

199. John Brewer, 'This, That and the Other' in Dario Castiglione and Leslie Sharpe (eds), *Shifting the Boundaries: Transformation of the Languages of Public and Private in the Eighteenth Century* (University of Exeter Press, Exeter, 1997), pp. 2–3 citing Reinhart Koeselleck, *Critique and Crisis: Enlightenment and the Pathogenesis of Modern Society* (1959; translation 1988).

200. Sonya Wynne, 'Catherine of Braganza', *Oxford Dictionary of National Biography* (www.oxforddnb.com).

201. Robert L. Woods, 'Charles II and the Politics of Sex and Scandal' in Charles Carlton *et al.* (eds), *State, Sovereigns and Society in Early Modern England* (Sutton, Stroud, 1998), pp. 119–22.

202. Woods, 'Charles II and the Politics of Sex and Scandal' citing Earl of Rochester, *Complete Poems*, pp. 60–1; Sonya Wynne, 'Eleanor [Nell] Gwyn' and 'Louise de Kéroualle'; Olive Baldwin and Thelma Wilson, 'Mary ['Moll'] Davis', all in *Oxford Dictionary of National Biography* (www.oxforddnb.com). See also, Charles Carlton, *Royal Mistresses* (Routledge, London, 1990) and Derek Parker, *Nell Gwyn* (Sutton, Stroud, 2000). Nell Gwyn's son was Charles Beauclerk, who became 1st duke of Albans and Louise de Kéroualle's son was Charles Lennox, 1st duke of Richmond and duke of Aubigny.

203. Charles Carlton, *Royal Mistresses* (Routledge, London and New York, 1991) p. 78; Wynne, 'Eleanor [Nell] Gwyn' and 'Louise de Kéroualle' in *Oxford Dictionary of National Biography* (www.oxforddnb.com); Parker, *Nell Gwyn*, p. 153 and chpt. 9.

204. Mark Knights, *Representation and Misrepresentation in Later Stuart Britain* (Oxford University Press, Oxford, 2005), pp. 5–6, 10, 245, 269 and *passim*.

205. Melissa M. Mowry, *The Bawdy Politic in Stuart England 1660–1714: Political Pornography and Prostitution* (Ashgate, Aldershot, 2004).

206. *Elizabeth Cellier*, vol. 5, Early Modern Englishwoman in Print: A Facsimile Library of Essential Works, Printed Writings, 1641–1700, Series 2, Part 3 ed. Mihoko Suzuki (Ashgate, Aldershot, 2006).

207. For Elizabeth Cellier and anti-Catholicism see Frances E Dolan, *Whores of Babylon: Catholicism, Gender and Seventeenth-Century Print Culture* (Cornell University Press, Ithaca, New York, 1999), chpt. 4 and Rachel Weil, '"If I Did Say so, I Lyed": Elizabeth Cellier and the Construction of Credibility in the Popish Plot Crisis' in Susan D. Amussen and Mark A. Kishlansky (eds), *Political Culture and Cultural Politics in Early Modern England* (Manchester University Press, Manchester, 1995), chpt. 8.

208. Fox, *Oral and Literate Culture in England 1500–1700*, pp. 352–3 citing Public Record Office SP 16/321/19, 360–2, 402 citing Middlesex County Records ed. Jeaffreson, iv, 66–9.

209. Helen Berry, *Gender, Society and Print Culture in Late Stuart England: The Cultural World of the Athenian Mercury* (2003).

210. Fox, *Oral and Literate Culture in England 1500–1700*, p. 375 citing Alan Everitt, *The English Urban Inn, 1560–1760* in Alan Everitt (ed.), *Perspectives in English Urban History* (London, 1973), pp. 399, 404 citing *Calendar of State Papers Domestic, 1689–90*, 216, 378–9 citing Public Record Office SP 29/401/60, 355 n. citing Public Record Office PL/27/1 (Hodgkinson -v- Walker 1689).

211. Brynmor Jones Library, DDEV/79J/94 Petitions of Lucy Douglas.

212. Paul Seaward, 'Charles II', W. A. Speck, 'James II and VII', Andrew Barclay, 'Mary of Modena', all in *Oxford Dictionary of National Biography* (www.oxforddnb.com).

213. Anon., *The Poor Whores Lamentation* (1685).

214. Carlton, *Royal Mistresses*, p. 81; W. A. Speck, 'James II and VII', John Callow, 'Arabella Churchill', Andrew Barclay, 'Catharine Sedley', all in *Oxford Dictionary of National Biography* (www.oxforddnb.com).

215. Barclay, 'Mary of Modena', Gregg, 'Anne' citing B. C. Brown, *The Letters and Diplomatic Instructions of Queen Anne*, p. 34, Speck, 'Mary II', all in *Oxford Dictionary of National*

Biography (www.oxforddnb.com) including citing countess Bentinck (ed.), *Lettres et Memoires de Marie, Reine d'Angleterre* (1880) pp. 71, 92–3.

216. Speck, 'Mary II', *Oxford Dictionary of National Biography* (www.oxforddnb.com) and *Reluctant Revolutionaries: Englishmen and the Revolution of 1688* (Oxford University Press, Oxford and New York, 1989), pp. 102–3 citing Anchitell Grey, *Debates of the House of Commons from the Year 1667 to the Year 1694*, 10 vols. (1763), ix, 23, 55–6.

217. *Depositions Taken the 22d of October 1688* (Edinburgh, 1688), pp. 7, 18, 20.

218. Dolan, *Whores of Bablyon*, pp. 154–5.

219. [John Norris], *A Murnival of Knaves: Or, Whiggism Plainly Display'd* (1683), *passim*; Anonymous [a 'person of character'], *The Character of a Jacobite* (1690), p. 25.

220. Maureen Waller, *Ungrateful Daughters: The Stuart Princesses Who Stole Their Father's Crown* (Hodder, London, 2002); Jonathan Scott, *England's Troubles: Seventeenth-Century English Political Instability in European Context* (Cambridge University Press, Cambridge, 2000). See also Paul Hoftijzer and C C Barfoot (eds), *Fabrics and Fabrications: the Myth and Making of William and Mary* (Rodopi, Amsterdam, 1990), Introduction.

221. Aphra Behn, *Love Letters between a Nobleman and His Sister* in *The Works of Aphra Behn* ed. Janet Todd, 7 vols (Ohio State University Press, Columbus Ohio, 1993); see also Helen Thompson's exploration of Behn's thinking on Hobbesian obligation theory in '"Thou Monarch of my Panting Soul": Hobbesian Obligation and the Durability of Romance in Aphra Behn's *Love Letters* in Jennie Batchelor and Cora Kaplan (eds), *British Women's Writing in the Long Eighteenth Century* (Palgrave, Basingstoke, 2005), pp. 107–20.

222. Both are published by the Augustan Reprint Society (New York, 1981, 1995).

223. Mark Goldie, Introduction in *Two Treatises of Government* (Everyman, London, 1993), pp. xviii–xix, xxiii, xviii–xxxix; Gordon Schochet, 'Vices, Benefits and Civil Society: Mandeville, Habermas and the Distinction Between Public and Private', in Paula R. Backscheider and Timothy Dykstal (eds), *The Interaction of the Public and Private Spheres in Early Modern England* (Cass, London, 1996), p. 253. John Brewer argues that even after 1689 there was 'a remarkable interpenetration of public and private', Brewer, 'This, That and the Other', in Castiglione and Sharpe (eds), *Shifting the Boundaries*, p. 17.

224. John Locke, *Two Treatises of Government* ed. Peter Laslett (Cambridge University Press, Cambridge, 1970), I:47, II:52, 82; Carole Pateman, 'Feminist Critiques of the Public/Private Dichotomy' in *The Disorder of Women: Democracy, Feminism and Political Theory* (Polity Press, Cambridge, 1989), pp. 120–2.

225. Lois Schwoerer, 'Images of Queen Mary II, 1689–1695', *Renaissance Quarterly*, 42:4 (Winter, 1989), pp. 717–48, quotations from pp. 729–30.

226. There have been no major biographies of Mary II recently, the last major interest being exhibited three decades ago – Hester Chapman, *Mary II, Queen of England* (Cedric Chivers, Bath, 1972) and Elizabeth Hamilton, *William's Mary* (Hamilton, London, 1972). For a cultural and political history see, Robert Maccubbin & Martha Hamilton Philips, *The Age of William III and Mary II* (College of William and Mary, Virginia, 1989).

227. Speck, 'Mary II' in *Oxford Dictionary of National Biography* (www.oxforddnb.com); Schwoerer, 'Images of Queen Mary II', pp. 717, 730.

228. Schwoerer, 'Images of Queen Mary II', pp. 727 citing Schwoerer, 'A Journal of the Convention at Westminster begun the 22 of January 1688/9', *Bulletin of the Institute of Historical Research*, 49 (1976), 738 ff.

229. See, Harris, *A Passion for Government* and Ophelia Field, *The Favourite: Sarah* (Hodder and Stoughton, London, 2002). Crawford & Mendelson, *Women In Early Modern England* , pp. 371–5.

230. Tom Harris, *Politics under the Later Stuarts: Party Conflict in a Divided Society 1660–1715* (Longman, London and New York, 1993), p. 147; Barry Coward, *The Stuart Age: England 1603–1714*, 3rd ed. (Longman, London, 2003), pp. 395, 400.

231. Gregg, 'Anne', *Oxford Dictionary of National Biography* (www.oxfordnb.com).
232. Schwoerer, 'Images of Queen Mary II', p. 734; J. Van den Berg, in Hoftijzer and Barfoot (eds), *Fabrics and Fabrications*, p. 37.
233. Wiesner, *Women and Gender in Early Modern Europe*, pp. 240–1, 249–50.
234. This view is slightly different to that of Merry Wiesner who makes a distinction between power or the ability to shape events and political authority or 'power which is formally recognised and legitimated' to argue that women had no formal political authority throughout the period – Wiesner, *Women and Gender in Early Modern Europe*, p. 240.
235. Fox, *Oral and Literate Culture in England 1500–1700*, pp. 375 citing Alan Everitt, *The English Urban Inn, 1560–1760* in Alan Everitt (ed.), *Perspectives in English Urban History* (London, 1973), 399, 404 citing *Calendar of State Papers Domestic, 1689–90*, 216, 378–9 citing Public Record Office SP 29/401/60, 355 n. citing Public Record Office PL/27/1 (Hodgkinson -v- Walker 1689); Bob Harris, 'Review Article: Historians, Public Opinion, and the "Public Sphere"', *Journal of Early Modern History*, 1:4 (1997), pp. 369–77 – the books reviewed included Castiglione and Sharpe (eds), *Shifting the Boundaries: Transformation of the Language of Public and Private in the Eighteenth Century*; H. T. Dickinson, *The Politics of the People in Eighteenth-Century Britain* (Macmillan, London, 1994); Kathleen Wilson, *The Sense of the People: Politics, Culture and Imperialism in England, 1715–1785* (Cambridge University Press, Cambridge, 1995).
236. Harris, *A Passion for Government*, p. 195 Sarah Jenyns, Duchess of Marlborough to Robert Jenyns, 4/15 June 1713.

6 Religion and Civil War

1. Patricia Crawford, *Women and Religion in England 1500–1720* (Routledge, London & New York, 1993); Claire Walker, *Gender and Politics in Early-Modern Europe* (Palgrave, Basingstoke, 2003); Megan Hickerson, *Making Women Martyrs in Tudor England* (Palgrave, Basingstoke, 2005); Phyllis Mack, *Visionary Women: Ecstatic Prophecy in Seventeenth-Century England* (University of California Press, Berkley, 1992); Kate Peters, '"Women's Speaking Justified": Women and Pamphleteering' in *Print Culture and the Early Quakers* (Cambridge University Press, Cambridge, 2005); Catie Gill, *Women in the Seventeenth-Century Quaker Community: A Literary Study of Political Identities 1650–1700* (Ashgate, Aldershot, 2005); Marcus Nevitt, *Women and the Pamphlet Culture of Revolutionary England 1640–1660* (Ashgate, Aldershot, 2006).
2. See especially J. S. Morrill, 'The Religious Context of the English Civil War', *Transactions of the Royal Historical Society*, 5th Series, 34 (1984) and Conrad Russell, *The Causes of the English Civil War* (Clarendon Press, Oxford, 1990) and *The Fall of the British Monarchies 1637–1642* (Clarendon Press, Oxford, 1991). Cf. Amanda L. Capern, 'The Caroline Church: James Ussher and the Irish Dimension', *The Historical Journal*, 39:1 (1996).
3. Lyndal Roper, *The Holy Household: Women and Morals in Reformation Augsberg* (Clarendon Press, Oxford, 1989).
4. Keith Thomas, 'Women and the Civil War Sects', *Past and Present*, 13 (1958), pp. 42–62.
5. Diane Willen, 'Women and Religion in Early Modern England', in Sherrin Marshall (ed.), *Women in Reformation and Counter-Reformation Europe: Public and Private Worlds* (Indiana University Press, Bloomington and Indianapolis, 1989), pp. 140–1. See also Marilyn J. Boxer and Jean H. Quataert (eds), *Connecting Spheres: Women in the Western World 1500 to the Present* (Oxford University Press, New York and Oxford, 1987), p. 25.
6. Merry Wiesner, 'Beyond Women and the Family: Towards a Gender Analysis of the Reformation', *Sixteenth Century Journal*, 18:3 (1987), pp. 311–21. One of Wiesner's main contributions to changing the intellectual parameters of the Reformation is *Christianity and Sexuality in the Early Modern World: Regulating Desire, Reforming Practice* (Routledge,

London, 2000). Lyndal Roper, '"The Common Man", "the Common Good", "Common Women": Reflections on Gender and Meaning in the Reformation German Commune', *Social History*, 12 (1987), pp. 1–21.

7. Diarmaid MacCullough, 'The Impact of the English Reformation', *Historical Journal*, 38 (1995); Robert Whiting, *The Blind Devotion of the People: Popular Religion and the English Reformation* (Cambridge University Press, Cambridge, 1989); Christopher Haigh, 'The English Reformation: A Premature Birth, a Difficult Labour and a Sickly Child', *Historical Journal*, 33 (1990).

8. Michael Questier, *Conversion, Politics and Religion in England 1580–1625* (Cambridge University Press, Cambridge, 1996), especially pp. 4, 8.

9. Alexandra Walsham, *Providence in Early Modern England* (Oxford University Press, Oxford, 2001), pp. 4, 88, 114, 247 and *Church Papists: Catholicism, Conformity and Confessional Polemic in Early Modern England* (Boydell Press, Woodbridge, 1993); Tessa Watt, *Cheap Print and Popular Piety 1550–1640* (Cambridge University Press, Cambridge, 1991); Nicholas Tyacke (ed.), *England's Long Reformation 1500–1800* (UCL Press, London, 1997).

10. Crawford, *Women and Religion in England, 1500–1720*, pp. 98, 100–2; Patricia Crawford and Laura Gowing (eds), *Women's Worlds in Seventeenth-Century England: A Sourcebook* (Routledge, London and New York, 2000).

11. Scott McGinnis, '"Subtiltie" Exposed: Pastoral Perspectives on Witch Belief in the Thought of George Gifford', *Sixteenth Century Journal*, 33:3 (2002), pp. 665–86.

12. Eamon Duffy, *The Voices of Morebath: Reformation and Rebellion in an English Village* (Yale University Press, New Haven and London, 2001); see also Eamon Duffy, *The Stripping of the Altars: Traditional Religion in England 1400–1580* (Yale University Press, New Haven and London, 1992).

13. Claire Cross, 'Northern Women in the Early Modern Period: The Female Testators of Hull and Leeds 1520–1650', *The Yorkshire Archaeological Journal*, 59 (1987), p. 91 citing Borthwick Institute, Probate Register 23 Pt. I ff. 94v–95r (Jackson).

14. One contemporary comment was that 'a Church-Papist is one that parts his Religion betwixt his conscience and his purse…his wife is more zealous and therefore more costly' – John Earle, *Earle's Microcosmography* ed. Alfred S West (Cambridge, 1897) quoted in Walsham, *Church Papists*, p. 96.

15. Huntington Library MSS, Ellesmere 2159–2169.

16. Watt, *Cheap Print and Popular Piety 1550–1640*, p. 327.

17. Norman Jones, *The English Reformation: Religion and Cultural Adaptation* (Blackwell, Oxford, 2002); Christopher Haigh, *The English Reformation Revised* (Cambridge University Press, Cambridge, 1987), 'The English Reformation: A Premature Birth, a Difficult Labour and a Sickly Child', *Historical Journal*, 33 (1990) and *English Reformations: Religion, Politics and Society under the Tudors* (Clarendon Press, Oxford, 1993), quotation from p. 224; Walsham, *Church Papists*. See also, Patrick McGrath, 'Elizabethan Catholicism: A Reconsideration', *Journal of Ecclesiastical History*, 35 (1984), Diarmaid MacCullough, *The Later Reformation in England 1547–1603*, 2nd ed. (Palgrave, Basingstoke, 2001) and Peter Lake and Michael Questier, *The Antichrist's Lewd Hat: Protestants, Papists and Players in Post-Reformation England* (Yale University Press, New Haven and London, 2002).

18. Albert Peel (ed.), *The Notebook of John Penry 1593*, Camden 3rd Series, vol. 67 (Royal Historical Society, London, 1944), p. 38 (Huntington Library MSS, Ellesmere 483).

19. Peel (ed.), *The Notebook of John Penry 1593*, p. 54.

20. Alexandra Walsham, '"Yielding to the Extremity of the Time": Conformity, Orthodoxy and the Post-Reformation Catholic Community', in Peter Lake and Michael Questier, *Conformity and Orthodoxy in the English Church c.1560–1660* (Boydell Press, Suffolk, 2000), p. 211 citing Anthony G. Petti (ed.), *Recusant Documents from the Ellesmere Manuscripts* (Catholic Recusant Society, 60, 1968), p. 87.

21. Huntington Library MSS, Ellesmere 2101–2158. Bound book of examinations.

22. Cf. Walsham, *Church Papists*, p. 94.

23. John Brewer, 'This, That and the Other: Public, Social and Private in the Seventeenth and Eighteenth Centuries' in David Castiglione and Lesley Sharpe (eds), *Shifting the Boundaries: Transformation of the Languages of Public and Private in the Eighteenth Century* (University of Exeter Press, Exeter, 1995), pp. 2–3, 16–17.

24. The seminal work on the transforming power of print is Elizabeth Eisenstein, *The Printing Press as an Agent of Change: Communications and Cultural Transformations in Early Modern Europe* (Cambridge University Press, Cambridge, 1979).

25. Lake and Questier, *The Antichrist's Lewd Hat*.

26. Joseph Foster, *Pedigrees of the County Families of Yorkshire*, iii (1874–5); Norman James Miller, *Winestead and Its Lords* (1932), pp. 95–6; Brynmor Jones Library, University of Hull, MSS DDWB/25/6.

27. Haigh, *English Reformations*, p. 294.

28. Mary R. Mahl and Helene Koon, *The Female Spectator: English Women Writers Before 1800* (Indiana University Press, Bloomington, Illinois and London, 1977), pp. 12–13.

29. Eileen Power, *Medieval Women* ed. M. M. Postan (Cambridge, University Press, 1975, p. 89. Another useful source is John H. Tillotson, *Marrick Priory: A Nunnery in Late Medieval Yorkshire*, Borthwick Paper no. 75 (York, 1989) – account rolls for Marrick Priory survive at Brynmor Jones Library, University of Hull MSS, DDCA(2)29/108 and these indicate (amongst many other things) the big discrepancy in living standards between the nuns and the monks at Marrick. See also David Knowles, *The Religious Orders in England 3: The Tudor Age* (Cambridge University Press, Cambridge, 1959).

30. Power, *Medieval English Nunneries*, pp. 131–2; Agnes Jordan, *The Myroure of Our Ladye* ed. John Henry Blunt, Early English Text Society, Extra Series No. 19 (N. Tribner and Co., London, 1873), pp. x, xxvi–xxviii,, xxxvi, 2–4.

31. Haigh, *English Reformations*, pp. 143–5.

32. John A. F. Thomson, *Early Tudor Church and Society 1485–1529* (Longman, London and New York, 1993), p. 228.

33. Haigh, *English Reformations*, pp. 91–2.

34. Katherine Bulkeley to Thomas Cromwell, 5 November 1537 reprinted in J. P. Earwaker, *East Cheshire: Past and Present*, 2 vols. (London, 1877), i, 205.

35. Crawford, *Women and Religion in England 1500–1720*, p. 30 citing G A J Hodgett (ed.), *The State of the Ex-Religious and Former Chantry Priests of the Diocese of Lincoln, 1547–1574*, Lincoln Record Society, 53 (1959), xvi–xxi.

36. 'On Ministering to "Certayne Devoute and Religious Women": Bishop Foxe and the Benedictine Nuns of Winchester Diocese on the Eve of the Dissolution' in W. J. Sheils and Diana Wood (eds), *Women in the Church*, Studies in Church History, 27 (Oxford University Press, Oxford, 1990), p. 235.

37. A. F. C. Bourdillon, *The Order of Minoresses in England* (Manchester University Press, Manchester, 1965), chpt. 7 and Appendix I; Michael Hodgetts, 'The Godly Garret 1560–1660' in *Catholics of Parish and Town 1558–1778* ed. Rowlands, p. 40.

38. Thompson, *The Early Tudor Church*, p. 194.

39. Crawford, *Women and Religion in England 1500–1720*, p. 30.

40. Mary Prior, 'Reviled and Crucified Marriages: The Position of Tudor Bishops' Wives', in Mary Prior (ed.), *Women in English Society 1500–1800* (Routledge, London and New York, 1985), pp. 118–48.

41. Haigh, *English Reformations*, p. 100.

42. See for example Alfred D. Cheney, 'The Holy Maid of Kent', *Transactions of the Royal Historical Society*, 18 (1904), pp. 108–29 and Alan Neame, *The Holy Maid of Kent: The Life of Elizabeth Barton 1506–1534* (London, 1971).

43. Crawford, *Women and Religion in England 1500–1720* , pp. 28–9 citing Alan Neame, *The Holy Maid of Kent: The Life of Elizabeth Barton, 1506–1534* (1971) and pp. 67–8; Kathy Lynn Emerson, *Wives and Daughters: The Women of Sixteenth Century England* (Witston Publishing Co., Troy, New York, 1984), pp. 8–9; Haigh, *English Reformations*, pp. 137–40.

44. Rowlands (ed.), *Catholics of Parish and Town 1558–1778* , pp. 13–14 citing Jan Rhodes, 'English Books of Martyrs, *Recusant History*, 22:1 (1994) and C. Sullivan, *Dismembered Rhetoric: English Recusant Writing 1580–1603* (1995). However, it is worth noting that out of 71 people who died in prison during 1588, 27 of them were women.

45. Emerson, *Wives and Daughters*, p. 216.

46. Crawford, *Women and Religion in England 1500–1720*, pp. 63, 65; Rowlands, *Catholics of Parish and Town 1558–1778*, p. 16.

47. John Mush's *Life of Margaret Clitherow* is rep. in *The Troubles of Our Catholic Forefathers Related by Themselves* (Burn and Oates, London, 1877), iii, 333 ff. There are many biographies, mostly hagiographical – older hagiographies include Margaret T. Munro, *Blessed Margaret Clitherow* (Burns Oates and Washbourne, London, 1948); the newest is John Rayne-Davis, *Margaret Clitherow: Saint of York* (Highgate, Beverley, 2002). The account of Margaret Clitherow and her daughter in Megan Matchinske, *Writing, Gender and State in Early Modern England: Identity Formation and the Female Subject* (Cambridge University Press, Cambridge, 1998), pp. 83–5 is fiction based on source-creation and should be read with this in mind. Clitherow's body was reputedly buried in waste ground but later disinterred by Catholics, who reburied it, but kept one of her hands as a relic. The Clitherow house in the Shambles in York remains a Catholic shrine to the memory of this tragic woman whose 'liberation in martyrdom' might be considered a Pyrrhic victory.

48. Duffy, *The Voices of Morebath*, pp. 73–8.

49. Personal observation of saints in Westhall, Suffolk. For a marvellous account of the impact of church symbolism and church placement see Margaret Aston, 'Segregation in Church' in Bill Sheils and Diana Wood (eds), *Women in the Church*, Church Studies, 27 (Oxford University Press, Oxford, 1990).

50. A very fine account of women's recusancy is Marie B. Rowlands, 'Recusant Women 1560–1640' in Prior (ed.), *Women in English Society*.

51. Haigh, *English Reformations*, pp. 258–67; John Bossy, *The English Catholic Community 1570–1850* (Darton, Longman and Todd, London, 1975), p. 153.

52. Lisa McClain, 'Without Church, Cathedral or Shrine: The Search for Religious Space among Catholics in England, 1559–1625', *The Sixteenth Century Journal*, 33:2 (Summer, 2002), pp. 381–99.

53. Frances Dolan, *Whores of Babylon: Catholicism, Gender and Seventeenth-Century Print Culture* (Cornell University Press, Ithaca, New York, 1999), pp. 44–5 and *passim*.

54. Emerson, *Wives and Daughters*, pp. 18–19.

55. Emerson, *Wives and Daughters*, pp. 72–3.

56. Emerson, *Wives and Daughters*, pp. 181, 64.

57. Emerson, *Wives and Daughters*, pp. 204–5, 120–1.

58. Emerson, *Wives and Daughters*, p. 49.

59. Emerson, *Wives and Daughters*, pp. 80–1, 232.

60. Questier, *Conversion, Politics and Religion in England* , pp. 4, 155–7 citing BI, HCAB 11, ff. 348v, HCAB 12, ff. 8v, 15r, 80v, 211r.

61. *Calendar of State Papers, Domestic Series*, ccxliv, pp. 316–18, Examinations of Jane Shelley, 16–17 February 1593; ccxlviii, pp. 470, 492–3, Benjamin Beard to Morgan Jones, 25 March 1594 & 29 April 1594.

62. Rowlands (ed.), *Catholics of Parish and Town 1558–1778* , pp. 14, 42–3, 49, 137, 139; Bossy, *The English Catholic Community 1570–1850*, pp. 81, 157; Haigh, *English Reformations*, p. 260; J. C. H. Aveling., *The Handle and the Axe: The Catholic Recusants in England from Reformation to Emancipation* (Blond and Briggs, London and Essex, 1976), pp. 55–7, 59–60, 68.

63. Joseph Putterbaugh, '"Your Selfe be Judge and Answer Your Selfe": Formation of Protestant Identity in *A Conference betwixt a Mother a Devout Recusant and Her Sonne a Zealous Protestant*', *Sixteenth Century Journal*, 21:2 (2002), p. 422.

64. John Morris (ed.), *The Troubles of Our Catholic Forefathers* (Burns and Oates, London, 1872), I, p. 208.

65. Rowlands (ed.), *Catholics of Parish and Town 1558–1778*, p. 49 citing the case of Katherine Edwards, Lichfield Record Office, B/C/5/1629 and see also p. 17.
66. Suzanne Trill, 'Religion and the Construction of Femininity', in Helen Wilcox (ed.), *Women and Literature in Britain 1500–1700* (Cambridge University Press, Cambridge, 1996), pp. 35–6.
67. Susan Broomhall, 'Reformation', pp. 451–5 and 'Religion', p. 458, Amanda Capern, 'Renaissance', p. 469, Charlotte Woodford, 'Convents and Writings by Nuns', pp. 107–8, 111 all in Mary Spongberg, Barbara Caine and Ann Curthoys (eds), *Companion to Women's Historical Writing* (Palgrave, Basingstoke, 2005).
68. Jane Owen, *An Antidote against Purgatory* (1634), STC 18984, Preface, pp. 3, 8, 178–9.
69. Sara Mendelson and Patricia Crawford, *Women in Early Modern England* (Clarendon Press, Oxford, 1998), p. 163.
70. Walker, *Gender and Politics in Early Modern Europe*, pp. 5, 13–20, 176–7; Marie B. Rowlands, 'Recusant Women 1560–1640' in Prior (ed.), *Women in English Society* , pp. 166–7; Retha Warnicke, *Women of the English Renaissance and Reformation* (Greenwood Press, Westport, Connecticut and London, 1983), p. 174.
71. Crawford, *Women and Religion in England 1500–1720*, pp. 63–4, 85; Aveling, *The Handle and the Axe*, pp. 90–104; Patricia Ranft, *Women and the Religious Life in Premodern Europe* (London, 1996), pp. 124–8. A feminist reading of Mary Ward is Lowell Gallager, 'Mary Ward's "Jesuitresses" and the Construction of a Typological Community' in Susan Frye and Karen Roberston (eds), *Maids and Mistresses, Cousins and Queens: Women's Alliances in Early Modern England* (Oxford University Press, Oxford and New York, 1999). Gallagher argues that Ward's communities provoked the ire of the male authorities because they mimicked 'male action and agency' – however, there is a sense in which all convents did that prior to and after the Reformation and it is no accident that powerful nuns were often described in the way that other powerful women in early-modern society were described – as having 'masculine virtue'.
72. Claire Walker, 'Combining Martha and Mary: Gender and Work in Seventeenth-Century English Cloisters', *Sixteenth Century Journal*, 30:2 (1999), pp. 397–418 *passim* but quotation from p. 418.
73. Jane Owen, *An Antidote against Purgatory* (1634), STC 18984, Preface, pp. 178–9, 183–4, 186.
74. Lincolnshire Record Office, MSS ANC/15/115 – Mary Stevens to John Cotton, 29 October 1612.
75. Huntington Library, Ellesmere 2085–7, Letters of Lord Burghley.
76. *Chronicle of St Monica's* and 'Recollections of Sister Grace Babthorpe' reprinted in *The Troubles of Our Catholic Forefathers Related by Themselves* ed. John Morris (Burn and Oates, London, 1872), pp. 219 ff. especially p. 281.
77. The Popish Plot, which led to a series of executions, began with the accusation of Titus Oates that some Catholics and Jesuits were trying to kill Charles II. The anti-Catholic outburst included a frenzy over the so-called Meal Tub Plot in which the Catholic midwife, Elizabeth Cellier was accused of concealing documents implicated in a further scheme to shift the blame onto Presbyterians. There were a series of pamphlets about Cellier's trial and punishment – for a good account, see Dolan, *Whores of Babylon*, chpt. 4.
78. Thomas Hunter, *An English Carmelite*, 8 vols. (London, 1876); Walker, *Gender and Politics in Early Modern Europe*, pp. 92–3; C. E. Chambers, *Life of Mary Ward* (London, 1882); Trill, 'Religion and the Construction of Femininity' in Helen Wilcox (ed.), *Women and Literature in Britain 1500–1700*, p. 35; Isobel Grundy, 'Women's History? Writing by English Nuns' in Isobel Grundy and Susan Wiseman (eds), *Women, Writing, History 1640–1740* (B. T. Batsford Ltd, London, 1992), pp. 126–38.
79. Walker, *Gender and Politics in Early Modern Europe*, p. 11.
80. Claire Cross, 'The Religious Life of Women in Sixteenth Century Yorkshire', in Sheils and Wood (eds), *Women in the Church*, Studies in Church History, 27, pp. 318–19.

81. Crawford, *Women and Religion in England 1500–1720*, p. 1.
82. Diane Willen has argued for a 'continuous tradition' linking female Protestant activists of the sixteenth century with sectarians of the seventeenth century. Diane Willen, 'Women and Religion in Early Modern England', in Sherrin Marshall (ed.), *Women in Reformation and Counter-Reformation Europe*, p. 146.
83. Haigh, *English Reformations*, p. 227 citing Ralph Houlbrooke, *Church Courts and People during the English Reformation 1520–1570* (Oxford University Press, Oxford, 1979), p. 182.
84. Diane Watt, *Secretaries of God: Women Prophets in Late Medieval and Early Modern England* (Brewer, Cambridge, 1997), pp. 103–4.
85. Charles Bruce (ed.), *The Book of English Noblewomen: Lives Made Illustrious by Heroism, Goodness, and Great Attainments* (William P. Nimmo, London and Edinburgh, 1875), pp. 12–13.
86. Ann Askew, *The Lattre Examinacyion of the Worthye Servant of God...Anne Askewe* (1646), Selected and Introduced by John N. King in vol. 1 *The Early Modern Englishwoman: A Facsimile Library of Essential Works. Part 1: Printed Writings, 1500–1640*, ed. Betty S. Travitsky and Patrick Cullen (Scolar Press, Aldershot, Hants., 1996), for example, f. 22v.
87. Ann Askew, *The First Examinacyon of Anne Askewe, Latelye Martyred in Smythfelde, by the Romish Popes Upholders, with the Elucydacyon of Johan Bale* (1545), Selected and Introduced by John N. King in *The Early Modern Englishwoman: A Facsimile Library of Essential Works. Part 1: Printed Writings, 1500–1640*, ed. Betty S. Travitsky and Patrick Cullen (Scolar Press, Aldershot, Hants., 1996), ix, 27 and *The Lattre Examinacyion of the Worthye Servant of God...Anne Askewe* (1646), ff. 10–11, 14v.
88. Askew, *The First Examinacyon of Anne Askewe*, ff. 10–10v.
89. Askew, *The First Examinacyon of Anne Askewe*, ff. 8v, 13v-14, 28v-29.
90. Cf. Crawford, *Women and Religion in England, 1500–1720*, p. 30.
91. *The Early Modern Englishwoman: A Facsimile Library of Essential Works. Part 1: Printed Writings, 1500–1640*, vol. 3, Katherine Parr, ed. Janel Mueller, p. xii.
92. Askew, *The Lattre Examinacyion of the Worthye Servant of God...Anne Askewe*, f. 45.
93. Askew, *The Lattre Examinacyion of the Worthye Servant of God...Anne Askewe*, ff. 31, 32, 37.
94. Askew, *The Lattre Examinacyion of the Worthye Servant of God...Anne Askewe*, f. 45.
95. Askew, *The Lattre Examinacyion of the Worthye Servant of God...Anne Askewe*, ff.47 ff.; Bruce (ed.), *The Book of English Noblewomen*, p. 23.
96. Bruce (ed.), *The Book of English Noblewomen*, p. 11; Askew, *The Lattre Examinacyion of the Worthye Servant of God...Anne Askewe*, for example, ff. 61v-62.
97. Katherine Parr, *The Lamentacion of a Synner* (1547) Selected and Introduced by Janel Mueller in vol. 3 *The Early Modern Englishwoman: A Facsimile Library of Essential Works. Part 1: Printed Writings, 1500–1640*, vol. 3, Katherine Parr, eds Travitsky and Cullen; Emerson, *Wives and Daughters*, pp. 214–15.
98. Mueller, Introduction *The Early Modern Englishwoman: A Facsimile Library of Essential Works*, vol. 3, p. xi and Katherine Parr, *Prayers or Medytacions* in *The Early Modern Englishwoman: A Facsimile Library of Essential Works*, ed. Travitsky and Cullen, vol. 3, n.p.
99. Parr, *The Lamentacion of a Synner*, vol. 3 *The Early Modern Englishwoman: A Facsimile Library of Essential Works. Part 1: Printed Writings, 1500–1640*, Travitsky and Cullen, Preface, ff. A1-A3v, A4, B3, D5, D8v, E2, E4-E5, F5v, G5, H3v.
100. Leah S. Marcus, Janel Mueller and Mary Beth Rose (eds), *Elizabeth I: Collected Works* (University of Chicago Press, Chicago and London, 2000), p. 9.
101. Duffy, *The Voices of Morebath*, pp. 152–3, citing Catley and Townsend (eds), *Acts and Monuments*, vol. 8, pp. 497–503.
102. See Megan Hickerson, 'Gospelling Sisters "going up and downe": John Foxe and Disorderly Women', *Sixteenth Century Journal*, 35:4 (2005), pp. 1035–51.

103. Hickerson, *Making Women Martyrs in Tudor England*, pp. 6, 8. See also Steven Mullaney, 'Reforming Resistance: Class, Gender and Legitimacy in Foxe's *Book of Martyrs*', in Arthur F. Marotti and Michael D. Bristol (eds), *Print Manuscripts and Performances: the Changing Relations of the Media in Early Modern England* (Ohio State University Press, Columbus, 2000); Ellen Macek, 'The Emergence of a Female Spirituality in *The Book of Martyrs*', *Sixteenth Century Journal*, 19:1 (1988), pp. 63–80.

104. Crawford, *Women and Religion in England 1500–1720* , pp. 33–4 citing Warnicke, *Women in the English Renaissance and Reformation*, p. 74 and John Foxe, *Actes and Monuments* ed. S.R. Cattley (1939), viii, 495.

105. Haigh, *Reformations*, pp. 196, 230ff.

106. Haigh, *Reformations*, p. 195.

107. Haigh, *Reformations*, p. 228.

108. Patrick Collinson, *Godly People: Essays on English Protestantism and Puritanism* (The Hambledon Press, 1983), pp. 279–80. For accounts of Elizabeth and Majory Bowes and Anne Locke, see Roland Bainton, *Women of the Reformation from Spain to Scandinavia* (Augsburg Publishing House, Mineaplos, 1977), pp. 69–88.

109. Collinson, *Godly People*, p. 274.

110. Joseph Putterbaugh, '"Your Selfe be Judge and Answer Your Selfe": Formation of Protestant Identity in *A Conference betwixt a Mother a Devout Recusant and Her Sonne a Zealous Protestant*', *Sixteenth Century Journal*, 21:2 (2002), pp. 419–30.

111. It is also the case, though, that demographic change in the late sixteenth century did not result in singleness being devalued as a state (rather than a choice) in society because the rate of singleness rose sharply from about 3% to 10% and eventually in the seventeenth century 20%.

112. Colin B. Atkinson and Jo B. Atkinson, 'The Identity and Life of Thomas Bentley, Compiler of *The Monument of Matrones* (1582)', *Sixteenth Century Journal*, 31:2 (2000), *passim* and quoting p. 323.

113. Virginia Blain, Isobel Grundy and Matricia Clements (eds), *The Feminist Companion to Literature in English: Women Writers from the Middle Ages to the Present* (Yale University Press, New Haven and London, 1990), pp. 335, 1103–4; *The Early Modern Englishwoman: A Facsimile Library of Essential Works: Printed Writings, 1500–1640*, vol. 9, Anne Wheathill, selected and introduced by Patrick Cullen (Scolar Press, Aldershot, Hants, 1996), p. xi.

114. See Lorna Sage, *The Cambridge Guide to Women's Writing in English* (Cambridge University Press, Cambridge, 1999), p. 662; Blain, Grundy and Clements (eds), *The Feminist Companion* p. 1155; Ann Wheathill, *A Handful of Holesome (though Homelie) Hearbs* (1584) partly reprinted in Suzanne Trill, Kate Chedgzoy and Melanie Osborne (eds), *Lay By Your Needles Ladies, Take the Pen: Writing Women in England 1500–1700* (Arnold, London and New York, 1997), pp. 50–6.

115. See Walsham, *Providence in Early Modern England*, pp. 305; Perry Miller, *The New England Mind* (Harvard University Press, Cambridge, Massachusetts, 1953) and Michael McGiffert, 'Grace and Works: The Rise and Division of Covenant Divinity in Elizabethan Puritanism', *Harvard Theological Review*, 75 (1982) and 'From Moses to Adam: The Making of the Covenant of Works', *Sixteenth Century Journal*, 19 (1988).

116. Questier, *Conversion, Politics and Religion in England*, p. 92.

117. See Collinson, *Godly People*, pp. 279–80.

118. Most historians and literary scholars accept Locke's authorship of the sonnet sequence. However, Locke's dedication admits the work to be 'delivered me by my friend with whom I knew might be so bolde to use and publishe it as pleased me'. See Collinson, *Godly People*, p. 280. This does not in itself mean much. Women commonly employed disclaimer strategies in the prefaces to their published written works and in a work such as a translation or a Biblical paraphrase authorship is problematised anyway because the author is trying to prove their capacity to be derivative and highlight not their own authority but that of the original text.

119. Susan Waduba, 'Shunamites and Nurses of the English Reformation: The Activities of Mary Glover, Niece of Hugh Latimer', *Studies in Church History*, 27 (1990).

120. Collinson, *Godly People*, pp. 274–5, 282–4.

121. Anthony Fletcher, *Gender, Sex and Subordination in England 1500–1800* (Yale University Press, New Haven and London, 1995), p. 354.

122. Sara Heller Mendelson, 'Stuart Women's Diaries and Occasional Memoirs' in Prior (ed.), *Women in English Society*, pp. 181, 184, 195; Anthony Fletcher, 'Beyond the Church: Women's Spiritual Experience at Home and in the Community' in *Gender and Christian Religion*, Studies in Church History, 34 (Boydell Press, London, 1998), pp. 194–5. See also D. G. Greene (ed.), *The Meditations of Lady Elizabeth Delaval*, Surtees Society CXC (1975) [Bodleian MSS, Rawlinson D.78].

123. Hoby appears to have given up keeping her diary long before her death in 1633.

124. Margaret Hoby had been brought up by Henry and Catherine Hastings, the earl and countess of Huntingdon and they had arranged all three of her marriages, first to Walter Devereux (brother of Robert, earl of Essex), second to Thomas Sidney (brother of Philip and Mary Sidney) and third to Thomas Posthumous Hoby, son of Lady Elizabeth Russell by her first husband, Sir Thomas Hoby of Berkshire. For the Cooke sisters, see Roland Bainton, *Women of the Reformation from Spain to Scandinavia* (Augsburg Publishing House, Mineapolis, 1977), pp. 100–16.

125. Margaret Hoby's diary commences in 1599; Grace Mildmay's spiritual diaries begin *circa* 1603 (or, possibly, later, in the period 1617–20). See Dorothy M. Meads (ed.), *Diary of Lady Margaret Hoby 1599–1605* (Houghton Mifflin, Boston and New York, 1930), p. 223; Joanna Moody (ed.), *The Private Life of an Elizabethan Lady: The Diary of Lady Margaret Hoby 1599–1605* (Sutton, Stroud, Gloucestershire, 1998) and Linda Pollock (ed.), *With Faith and Physic: The Life of a Tudor Gentlewoman, Lady Grace Mildmay 1552–1620* (Collins & Brown, London, 1993), especially pp. 25, 51, 53, 71 and chpt. 6.

126. Cf. Pollock (ed.), *With Faith and Physic*, pp. 52–3.

127. Moody (ed.), *The Private Life of an Elizabethan Lady*, pp. xxvii–xxxxi; Meads (ed.), *Diary of Lady Margaret Hoby*, pp. 28–33.

128. Meads (ed.), *Diary of Lady Margaret Hoby*, pp. 201, 220, 223.

129. Patricia Caldwell, *The Puritan Conversion Narrative: The Beginnings of American Expression* (Cambridge University Press, Cambridge, 1983), especially pp. 2, 20–2; Owen C. Watkins, *The Puritan Experience: Studies in Spiritual Autobiography* (Routledge and Kegan Paul, London, 1972); David E. Stannard, *The Puritan Way of Death: A Study of Religion, Culture and Social Change* (Oxford University Press, Oxford and New York, 1977), especially p. 87.

130. Walsham, *Providence in Early Modern England*, p. 20.

131. T Crofton Croker (ed.), *Autobiography of Mary, Countess of Warwick*, Percy Society, 2 (1848), p. 24 cited in Crawford, *Women and Religion in England 1500–1720* , p. 76; see also Mendelson, *The Mental World of Stuart Women: Three Studies*, II:iii; Charlotte Fell Smith, *Mary Rich, Countess of Warwick (1625–1678): Her Family and Friends* (Longmans, Green and Co, London, 1901), especially p. 154.

132. Sage, *The Cambridge Guide to Women's Writing in English*, p. 662; Blain, Grundy and Clements (eds), *The Feminist Companion to Literature in English* p. 1155; Ann Wheathill, *A Handful of Holesome (though Homelie) Hearbs* (1584) partly reprinted in Trill, Chedgzoy and Osborne (eds), *Lay By Your Needles Ladies*, pp. 50–6.

133. *The Early Modern Englishwoman*, vol. 9, Anne Wheathill, selected and introduced by Cullen, pp. x–xi.

134. Anne Wheathill, *A Handfull of Holesome (though Homelie) Hearbs* (1584) in *The Early Modern Englishwoman*, vol. 9, with quotation from pp. 97v–98.

135. Philip Stubbes, *A Christal Glasse, for Christian Women* (1591), reprinted in Trill, Chedgzoy, Osborne (eds), *Lay by Your Needles Ladies*, pp. 57–62.

136. Alexandra Walsham, 'Philip Stubbes/Katherine Stubbes', *Oxford Dictionary of National Biography* (www.oxforddnb.com).

137. Rachel Speght, *Mortalities Memorandum* (1621), *passim*.
138. Virtually nothing is known about Alice Sutcliffe. She was the daughter of Thomas Woodhouse of Norfolk whose family attended Prince Henry and was married by 1624 to John Sutcliffe who attended James I. She appears particularly to have been a client of the duke of Buckingham's wife. Sage, *The Cambridge Guide to Women's Writing in English*, p. 612; Blain, Grundy and Clements, *The Feminist Companion to Literature in English*, p. 1048; *The Early Modern Englishwoman: A Facsimile Library of Essential Works: Printed Writings, 1500–1640*, vol. 7 *Alice Sutcliffe* Selected and Introduced by Patrick Cullen (Scolar Press, Aldershot, Hants., 1996), especially pp. ix–xii. See also Ruth Hughey, 'Forgotten Verses by Ben Jonson, George Wither, and Others to Alice Sutcliffe', *Review of English Studies*, 10 (1934), pp. 156–64 and Germaine Greer, Susan Hastings, Jeslyn Medoff, Melinda Sansone (eds), *Kissing the Rod: An Anthology of Seventeenth-Century Women's Verse* (The Noonday Press, New York, 1988, pp. 90–3.
139. *The Early Modern Englishwoman*, vol. 7 *Alice Sutcliffe* Selected and Introduced by Cullen, p. 141.
140. *The Early Modern Englishwoman*, vol. 7 *Alice Sutcliffe* Selected and Introduced by Cullen, pp. 145–6.
141. *The Early Modern Englishwoman*, vol. 7 *Alice Sutcliffe* Selected and Introduced by Cullen, pp. 160–1, 196–7.
142. *The Early Modern Englishwoman*, vol. 7 *Alice Sutcliffe* Selected and Introduced by Cullen, introductory dedications to *Meditations of Man's Mortality* (1634 ed.).
143. Alice Sutcliffe, *Meditations of Mans Mortalitie. Or, the Way to True Blessedness* (1634), Sig, A4ᵛ, pp. 9–10, 28, 36–8, 59, 116–17, 125, 156.
144. Jacqueline Eales, *Women in Early Modern England 1500–1700* (UCL Press, London, 1998), p. 60 citing Nicholas Fontanus, *The Woman's Doctor* (1652); Fraser, *The Weaker Vessel*, pp. 72 citing *Mordaunt Private Diarie*, pp. 28, 38, 152, 183 and pp. 79, 82 citing John Duncon, *A Letter Containing Many Remarkable Passages in the Most Holy Life and Death of the Late Lady, Lettice, Viscountess Falkland* (1649), p. 175; Mendelson and Crawford, *Women in Early Modern England*, p. 150 citing Chester City RO, Diary of Sarah Savage (1686–8), D/Basten/8; See also Patricia Crawford, 'The Construction and Experience of Maternity', in V. Fildes (ed.), *Women as Mothers in Pre-Industrial England* (Routledge, London, 1990).
145. Willen, 'Women and Religion in Early Modern England', in Marshall (ed.), *Women in Reformation and Counter-Reformation Europe*, pp. 149, 151.
146. Kenneth Charlton, *Women, Religion and Education in Early Modern England* (Routledge, London, 1999), p. 5 and chpts. 4–7.
147. Katherine Austen, 'Meditations', British Library Add MSS 4454 ff. 43, 92–3v.
148. Elizabeth Grymeston, *Miscelanea, Meditations, Memoratives* (1604), STC 12407, Sig. A3-Sig A4, Sig. C4 v, Sig. D4v.
149. Dorothy Leigh, *The Mother's Blessing* (1616), STC 15402, Sigs. A2-A4v, pp. 3–5.
150. Leigh, *The Mother's Blessing*, pp. 14–17 and *passim*.
151. Elizabeth Joscelin, *The Mothers Legacy to Her Unborn Child* ed. by Jean le Drew Metcalfe (Toronto Press, Buffalo and London, 2000); see also Amanda L. Capern, 'Review: *The Mothers Legacy to Her Unborn Child*', *Sixteenth Century Journal*, 32:4 (2001), pp. 1231–2. At the height of the Victorian 'cult of domesticity' in the mid-nineteenth century, it enjoyed a revival with three more editions. Sarah Josepha Hale reproduced it for an American audience and Randall Davidson placed its 'earnest piety' again before a later Victorian English audience in 1894. Its enduring popularity is testament to a 'puritan' piety that persisted in femininity long after the puritan revolution of the 1640s and 1650s had ended.
152. Nikolas Pevsner reveres this as the most beautiful church monument in England and it is the case that Elizabeth Coke looks realistic and the lace looks soft and real. Even the baby, unusually, looks real.

153. Patricia Crawford, '"The Sucking Child": Adult Attitudes to Childcare in the First Year of Life in Seventeenth-Century England', *Continuity and Change*, 1 (1986), p. 31; Valerie Fildes, *Wet-Nursing: A History from Antiquity to the Present* (Blackwells, Oxford, 1988), pp. 86–7.

154. Personal observation of monument. For insights, see also Nicholas Penny, 'Monuments to Women Who Died in Childbirth', *Journal of the Warburg and Courtauld Institutes*, 38 (1975).

155. See Jean Wilson, 'Holy Innocents: Some Aspects of the Iconography of Children on English Renaissance Tombs', *Church Monuments*, v (1990), pp. 57–63.

156. Germaine Greer et al., *Kissing the Rod*, p. 118.

157. Esther S. Cope (ed.), *Prophetic Writings of Lady Eleanor Davies* (Oxford University Press, Oxford and New York, 1995), *Sions Lamentation* (1649), pp. 271–5.

158. Robert Filmer, *In Praise of the Vertuous Wife*, Appendix I in Margaret Ezell, *The Patriarch's Wife: Literary Evidence and the History of the Family* (University of North Carolina Press, Chapel Hill and London, 1987), p. 170.

159. Elaine Hobby, *Virtue of Necessity: English Women's Writing 1649–88* (University of Michigan Press, 1989), p. 57; Fraser, *The Weaker Vessel*, pp. 77–8.

160. *A Mothers Teares over Hir Seduced Sonne* (1627), Sig. A2, pp. 1, 7, 31, 42–3.

161. Esther S. Cope, *Handmaid of the Holy Spirit: Dame Eleanor Davies, Never Soe Mad a Ladie* (University of Michigan Press, Ann Arbor, 1992), pp. 21–2.

162. For Protestantism and national identity see particularly Patrick Collinson, *The Birthpangs of Protestant England: Religious and Cultural Change in the Sixteenth and Seventeenth Centuries* (Macmillan Press, Basingstoke, 1988); Walsham, *Providence in Early Modern England*, pp. 264, 273.

163. Patrick Collinson, *The Elizabethan Puritan Movement* (Clarendon Press, Oxford, 1967), pp. 168–76, 379–80.

164. Cf. Walsham, *Providence in Early Modern England*, chpt. 6.

165. See Richard L. Kagan, *Lucrecia's Dream: Politics and Prophecy in Sixteenth-Century Spain* (University of California Press, Berkley, Los Angeles and Oxford, 1990), Introduction on the political prophecies of Lucrecia de Léon and citing Ottavia Niccoli, 'Profezie in piazza: Note sul profetismo populare nell'Italia del primo cinquecento', *Quaderni Storici*, 41 (1979), pp. 500–39.

166. See, for example, Quentin Skinner, 'Meaning and Understanding in the History of Ideas', *History and Theory*, 8 (1969), pp. 3–53. Skinner adopted the 'speech act' idea originally from J. L. Austin.

167. Finally, Patricia Crawford has argued that prophecy existed on a continuum of women's religious experience that included visions and dreams and 'altered states' in which women had auditory and visual hallucinations. She cites Anna Trapnel who fasted continuously and prophesied for hours, often in rhyming couplets – Crawford, *Women and Religion in England 1500–1720*, pp. 106–7 citing Anna Trapnel, *A Legacy for Saints* (1654). Women prophets came from all social classes, though they tended to be women of some means and single, widowed or orphaned – see Mack, *Visionary Women*, p. 94.

168. See Cope, *Handmaid of the Holy Spirit*, pp. xi, 53–5; Cynthia Herrup, *A House in Gross Disorder: Sex, Law, and the 2nd Earl of Castlehaven* (Oxford University Press, New York and Oxford, 1999).

169. Cope, *Handmaid of the Holy Spirit*, especially, pp. 2–3, 16–17, 33.

170. Cope, *Handmaid of the Holy Spirit*, pp. 5, 33; *The Prophetic Writings of Lady Eleanor Davies* ed. by Esther S. Cope, especially pp. 28–8, 53–5.

171. Cope, *Handmaid of the Holy Spirit*, pp. 42–3, 49–52.

172. It later became *Strange and Wonderful Prophecies* in 1649, her only licensed tract, reproduced as a piece of prophetic propaganda against Caroline rule after the execution of Charles I.

173. Cope, *Handmaid of the Holy Spirit*, pp. 60–4, 70; *Woe to the House* (1633) and *Given to the Elector* (1633; later *Strange and Wonderful Prophecies* [1649]) are reprinted in Cope, *Prophetic Writings of Lady Eleanor Davies*, pp. 57–69.

174. Cope, *Handmaid of the Holy Spirit*, pp. 86–97; *Bathe Daughter of BabyLondon* (1636) and *Spiritual Anthem* (1636) are reprinted in Cope, *Prophetic Writings of Lady Eleanor Davies*, pp. 71–4.

175. *The Prophetic Writings of Lady Eleanor Davies* ed. Cope, pp. 44–5.

176. The classic statements about constitutional struggle were contained in the works of Samuel Rawson Gardner in the nineteenth century. John Morrill, 'The Religious Context of the English Civil War' in Morrill, *Nature of the English Revolution* (Longman, London, 1993), p. 68; Glenn Burgess, 'Was the English Civil War a War of Religion? The Evidence of Political Propaganda', *Huntington Library Quarterly*, 61:2 (2000 for 1998), p. 201; William Lamont, 'Richard Baxter, "Popery" and the Origins of the English Civil War', *History*, 87:287 (2002), pp. 336–7; Patrick Collinson, 'Wars of Religion', chpt. 5 in Collinson, *The Birthpangs of Protestant England: Religious and Cultural Change in the Sixteenth and Seventeenth Centuries* (Macmillan, Basingstoke, 1988), p. 131; John Spurr, *English Puritanism 1603–1689* (Macmillan, Basingstoke, 1998), chpt. 7. There is a third strand to the historiography, which classifies the English Civil War as a class struggle. Its finest and most refined proponent was Christopher Hill in his many works, one of the most exciting of which was *The World Turned Upside Down* (Penguin, London, 1972). It has recently had a blunt and unconvincing restatement in James Holstun, *Ehud's Dagger: Class Struggle in the English Revolution* (Verso, London and New York, 2000). It includes the demand that 'revisionists' factor-in women to consider a 'trinary model' of class conflict (p. 257).

177. For some lively stories about women in the civil war including Henrietta Maria, see Diane Purkiss, *The English Civil War: A People's History* (Harper Perennial, London, 2007).

178. Fletcher, *Gender, Sex and Subordination*, chpt. 16 and John Adamson, 'Chivalry and Political Culture in Caroline England' in Kevin Sharpe and Peter Lake (eds), *Culture and Politics in Early Stuart England* (Macmillan, Basingstoke, 1994).

179. Fraser, *The Weaker Vessel*, Part Two, quotation from p. 184. Even more florid and, in parts, frankly, ghastly, is Stevie Davies, *Unbridled Spirits: Women of the English Revolution 1640–1660* (The Women's Press Ltd., London, 1998).

180. Dutch sources for the seventeenth century indicate that at least 100 women joined armies on the continent and the practice carried on in Europe. Hannah Snell was immortalised in a pamphlet of 1750 after she dressed as a soldier in 1745 to go looking for her missing husband. In 1796 Mistress Taylor wrote to William, 1st Lord Hotham requesting a certificate to prove that she had served on the *Britannia* before being captured and imprisoned in France for two years. David Cressy, 'Gender Trouble and Cross-Dressing in Early-Modern England', *Journal of British Studies*, 35 (1996), p. 461; Sarah Todd, 'The Ladle and the Sword: Female Aggression in Seventeenth-Century Popular Literature', *Women's History Notebooks*, 2:1 (1995), pp. 20–3; *The Female Soldier: Or, the Surprising Life and Adventures of Hannah Snell* (1750) Intro. by Dianne Dugaw, The Augustan Reprint Society, 257 (University of California, Los Angeles, 1989), pp. v–x; Brynmor Jones Library MSS, DDHO/5/3 Mistress Taylor to William, 1st Lord Hotham. 19 Aug. 1796.

181. Anne Laurence, 'Women's Work and the English Civil War', *History Today*, 42 (June 1992), pp. 20–5.

182. *Letters of the Lady Brilliana Harley, Wife of Sir Robert Harley, of Brampton Bryan*, ed. by Thomas Taylor Lewis for the Camden Society, I, 58 [1853] (Rep. AMS Press, New York and London, 1968).

183. Jack Binns (ed.), *The Memoirs and Memorials of Sir Hugh Cholmley of Whitby 1600–1657*, Yorkshire Archaeological Society (The Boydell Press, 2000), especially p. 55; Hugh Cholmley, *Memoirs of Hugh Cholmley* (1787); Brynmor Jones Library MSS, DCY/17/4, 19/2.

184. Mary Astell, *The Christian Religion* (London, 1705), pp. 292–3 in Crawford and Gowing (eds), *Women's Worlds in Seventeenth-Century England*, p. 263.
185. Fraser, *The Weaker Vessel*, pp. 185, 190, 193–7, 250;
186. Joan Wallach Scott, 'A Useful Category of Historical Analysis' in *Gender and the Politics of History* (Columbia University Press, New York, 1988), p. 49.
187. Thomas Lord Fairfax, 'Short Memorials of the Civil War', *Yorkshire Archaeological and Topographical Journal*, 8 (1884), p. 215.
188. *Calendar of Manuscripts of the Marquess of Ormonde*, Historical Manuscripts Commission, New Series, vol. 2 (Eyre and Spottiswood, London, 1903), p. 367.
189. The 'heroic' woman, patient in her suffering and fighting for husband, home and hearth, finds modern expression in Roger Hudson's *The Grand Quarrel* which pastes together extracts from the most well-known women's memoirs of the period so that women become adjuncts in a male military drama. Roger Hudson (ed.), *The Grand Quarrel: Women's Memoirs of the English Civil War* (Sutton, Stroud, 2000), Introduction, p. xx and chpt. 1.
190. For Elizabeth Sherburne see Amanda L. Capern, 'The Landed Woman in Early Modern England', *Parergon*, 19:1 (2002), pp. 204–8; Hilda Smith, *Reasons Disciples: Seventeenth-Century English Feminists* (University of Illinois Press, Urbana, Chicago, 1982).
191. Fraser, *The Weaker Vessel*, pp. 197–204; *Letters of the Lady Brilliana Harley*, 9 October 1643, p. 209.
192. *Letters of the Lady Brilliana Harley*, 23 May 1639 and 21 June 1639, pp. 56–8.
193. Keith Thomas, 'Women and the Civil War Sects', *Past and Present*, 13 (1958), p. 44.
194. Claire Cross, 'He-Goats Before the Flocks: A Note on the Part Played by Women in the Founding of Some Civil War Chuches', in G. J. Cuming and Derek Baker (eds), *Popular Belief and Practice* (Cambridge University Press, Cambridge, 1972), pp. 195–7; Crawford, *Women and Religion in England 1500–1720* , p. 138.
195. The groundbreaking work done on this is to be found in Crawford, *Women and Religion in England 1500–1720* and the rest of what follows is indebted to the work of Trish Crawford.
196. Patricia Higgins, 'The Reactions of Women, with Special Reference to Women Petitioners', in Brian Manning ed., *Politics, Religion and the English Civil War* (Arnold, London, 1973), p. 184.
197. Ellen Macarthur, 'Women Petitioners and the Long Parliament', *English Historical Review* (1909), 24, pp. 698–709.
198. Mack, *Visionary Women*, p. 1.
199. Crawford, *Women and Religion in Early Modern England 1500–1720*, pp. 106, 108, 124–5, 'Women's Published Writings, 1600–1700' in Prior (ed.), *Women in English Society* and 'The Challenges to Patriarchalism: How Did the Revolution Affect Women?', in John Morrill (ed.), *Revolution and Restoration: England in the 1650s* (Collins & Brown, London, 1992), pp. 123–4; Hobby, *Virtue of Necessity*, p. 26. Although the rise in published works was also considerable for men, the percentage rise for women was proportionally greater. They also began to publish different types of work, including secular poetry and historical biographies, beginning in the 1650s and hinting at a significant qualitative change.
200. Anne Laurence, 'A Priesthood of She-Believers: Women and Congregations in Mid-Seventeenth-Century England' in Sheils and Wood (eds), *Women in the Church*, Studies in Church History, 27, especially pp. 345, 348, 350–1, 363; Hobby, *Virtue of Necessity*, pp. 43–7; Patricia Crawford, 'Historians, Women and the Civil War Sects', *Parergon*, 6 (1988), 'The Challenges to Patriarchalism: How Did the Revolution Affect Women?' in John Morrill (ed.), *Revolution and Restoration: England in the 1650s*, quoting p. 115, 'Public Duty, Conscience and Women in Early Modern England' in John Morrill, Paul Slack and Daniel Woolf (eds), *Public Duty and Private Conscience in Seventeenth-Century England* (Clarendon Press, Oxford, 1993), pp. 66–7 and 'Women and Citizenship in

Britain 1500–1800' in Patricia Crawford and Philippa Maddern (eds), *Women as Australian Citizens: Underlying Histories* (Melbourne University Press, Carlton South, Victoria, 2001), quoting p. 66; Rachel Trubowitz, 'Female Preachers and Males Wives: Gender and Authority in Civil War England' in James Holstun (ed.), *Pamphlet Wars: Prose in the English Revolution* (Frank Cass, London, 1992); Hilary Hinds, *God's Englishwomen: Seventeenth-Century Radical Sectarian Writing and Feminist Criticism* (Manchester University Press, Manchester and New York, 1996) and '"Who May Binde Where God Hath Loosed?": Responses to Sectarian Women's Writing in the Second Half of the Seventeenth Century', in S. P. Cerasano and Marion Wynne-Davies (eds), *Gloriana's Face: Women, Public and Private in the English Renaissance* (Harvester Wheatsheaf, New York, 1992). See also Bernard Capp, 'Gender, Conscience and Casuistry: Women and Conflicting Obligations in Early Modern England', in Harald Braun and Edward Vallance (eds), *Contexts of Conscience in Early Modern Europe 1500–1700* (Palgrave, Basingstoke, 2004).

201. *A True Copy of the Petition of Gentlewomen and Tradesmen's Wives, in and about the City of London*, 4 February 1641[2] – this tract is reprinted in *The Harleian Miscellany: A Collections of Scarce, Curious and Entertaining Pamphlets and Tracts* (White and Cochrane, London, 1811), pp. 605–7, also John Pym's response, p. 608; Patricia-Ann Lee, 'Mistress Stagg's Petitioners February 1642', *The Historian* [East Lancing, Michigan], 60:2 (1988), pp. 241–3, 245, 247, 250–2; *To the Right Honourable, the High Court of Parliament, the Humble Petition of Many Hundreds of Distressed Women, Tradesmens Wives and Widdowes* (1642). For some of the early women's petitioning see also Ann Marie McEntee, '"The [Un]Civill-Sisterhood of Oranges and Lemons": Female Petitioners and Demonstrators, 1642–53', in James Holstun (ed.), *Pamphlet Wars: Prose in the English Revolution* (Frank Cass, London, 1992).

202. *A Discovery of Six Women Preachers in Middlesex* (1641), Sig A².

203. Cross, 'He-Goats Before the Flocks: A Note on the Part Played by Women in the Founding of Some Civil War Chuches', in Cuming and Baker (eds), *Popular Belief and Practice*, p. 202.

204. Katherine Chidley, *The Justification of the Independant [sic] Churches of Christ* (1641), Title Page and pp. 2, 12–13, 22, 34–5, 38, 46, 50. Cf. also Ian Gentles, 'London Levellers in the English Revolution: The Chidleys and Their Circle', *Journal of Ecclesiastical History*, 29:3 (1978), pp. 284–5.

205. Katherine Chidley, *The Justification of the Independant [sic] Churches of Christ* (1641), p. 60.

206. Katherine Chidley, *The Justification of the Independant [sic] Churches of Christ* (1641), p. 61.

207. Katherine Chidley, *The Justification of the Independant [sic] Churches of Christ* (1641), p. 26; Ian Gentles, 'Katherine Chidley', *Oxford Dictionary of National Biography* (www.oxforddnb.com).

208. Katherine Chidley, *A New-Yeares Gift or a Brief Exhortation to Mr Thomas Edwards* (1644), Sig A2 and pp. 8, 10, 13 (2 folios)16–20.

209. Katherine Chidley, *A New-Yeares Gift or a Brief Exhortation to Mr Thomas Edwards* (1644), pp. 17, 23.

210. Katherine Chidley, *The Justification of the Independant [sic] Churches of Christ* (1641) and *Good Counsell to the Petitioners for Presbyterian Government* (1645); See also Cross, '"He-Goats Before the Flocks": A Note on the Part Played by Women in the Founding of Some Civil War Chuches', in Cuming and Baker (eds), *Popular Belief and Practice*, pp. 199–200; Crawford, *Women and Religion 1500–1720*, pp. 132–3 and Gentles, 'London Levellers in the English Revolution: The Chidleys and Their Circle', pp. 281–309 and 'Katherine Chidley', *Oxford Dictionary of National Biography* (www.oxforddnb.com). For *Gangraena*, see Ann Hughes, 'Print, Persecution and Polemic: Thomas Edwards' *Gangraena* (1646) and Civil War Sectarianism', in Julia C. Crick and Alexandra Walsham

(eds), *The Uses of Script and Print 1300–1700* (Cambridge University Press, Cambridge, 2004).

211. Katherine Chidley, *The Justification of the Independant* [sic] *Churches of Christ* (1641), pp. 4–5.

212. Katharine Gillespie, *Domesticity and Dissent in the Seventeenth Century: English Women's Writing and the Public Sphere* (Cambridge University Press, Cambridge, 2004).

213. Cope, *Handmaid of the Holy Spirit*, pp. 76, 78, 122–3, 138, 107, 109; *Samson's Legacie* (1643) is reprinted in Cope, *Prophetic Writings of Lady Eleanor Davies*, pp. 87–100.

214. Eleanor Davies, *As Not Unknowne* (1645) as reprinted in Cope, *Prophetic Writings of Lady Eleanor Davies*, p. 139; see also Cope, *Handmaid of the Holy Spirit*, p. 124.

215. Cynthia B. Herrup, *A House in Gross Disorder: Sex, Law and the 2nd Earl of Castlehaven* (Oxford University Press, New York and Oxford, 1999).

216. Cope, *Handmaid of the Holy Spirit*, pp. 101, 107, 118, 112–13, 121, 99, 115–16, 124, 163; *Her Appeal to the High Court* (1641), *Star to the Wise* (1643) are reprinted in Cope, *Prophetic Writings of Lady Eleanor Davies*, pp. 75–84, 101–13.

217. Dagmar Freist, *Governed by Opinion: Politics, Religion and the Dynamics of Communication in Stuart London 1637–1645* (I. B. Tauris, London and New York, 1997), pp. 284–8.

218. Lisa Jardine, *Still Harping on Daughters: Women and Drama in the Age of Shakespeare* (Harvester Wheatsheaf, New York, 1983).

219. *A Discovery of Six Women Preachers* (1641), Sig A²v, Sig A⁴.

220. *A Bull from Rome, consisting of 15 pardons for delinquents in these kingdoms* (1641), Sig A²v, Sig A³.

221. Thomas Grantham, *A Marriage Sermon…Called a Wife Mistaken…or Leah Instead of Rachel* (1641); *The Sisters of the Holiday* [holy-day]: *Or, a Dialogue between Two Reverent and Very Vertuous Matrons, Mrs Bloomesbury and Mrs Longacre Her Neare Neighbour* (1641), pp. 1–5. Jerome Friedman, *Miracles and the Pulp Press during the English Revolution* (UCL Press, London, 1993) discusses this text along with multiple others to demonstrate the misrepresentation of women during the English Civil War, but he does a very poor job of contextualising the material.

222. 'Voluntas Ambulatoria', *Taylors Physicke Has Purged the Divel, or the Divel Has Got a Squirt…* (1641), quoting Sig A².

223. Daniel Rogers, *Matrimoniall Honour* (1642) cited in Hilary Hinds, '"Who May Binde Where God Hath Loosed?": Responses to Sectarian Women's Writing in the Second Half of the Seventeenth Century', in S. P. Cerasano & Marion Wynne-Davies (eds), *Gloriana's Face: Women, Public and Private in the English Renaissance* (Harvester Wheatsheaf, New York and London, 1992), p. 207.

224. Fraser, *The Weaker Vessel*, pp. 256–7.

225. *The Resolution of the Women of London to the Parliament* (1642).

226. John Brinsley, *A Looking-Glasse for Good Women* (1645), Title page and pp. 1–3, 6–11, 22–7, 32–41, 46–8.

227. Thomas Edwards, *Gangraena* (1645), pp. 77–9, 84–9, 18–37. See Ann Hughes, *Gangraena and the Struggle for the English Revolution* (Oxford University Press, Oxford, 2004) and Ann Geneva, *Astrology and the Seventeenth-Century Mind: William Lilly and the Language of the Stars* (Manchester University Press, Manchester, 1995).

228. Jason Peacey, *Politicians and Pamphleteers: Propaganda during the English Civil Wars and Interregnum* (Ashgate, Aldershot, 2004), pp. 2–4, 317. See also David Wootton, 'From Rebellion to Revolution: The Crisis of the Winter 1642/3 and the Origins of Civil War Radicalism', *English Historical Review*, 105 (1990); Marcus Nevitt, 'Women in the Business of Revolutionary News: Elizabeth Alkin, "Parliament Joan", and the Commonwealth Newsbook', in Joad Raymond (ed.), *News, Newspapers and Society in Early Modern Britain* (Frank Cass, London and Portland, Oregon, 1999), pp. 84–108

quoting p. 86. See also Paula McDowell, *The Women of Grub Street: Press, Politics and Gender in the London Literary Marketplace 1678–1730* (Oxford University Press, Oxford and New York, 1998), Introduction.

229. Maureen Bell, 'Hannah Allen/Chapman', *Oxford Dictionary of National Biography* (www.oxforddnb.com).

230. *The World Turn'd Upside Down: Or, a Briefe Description of the Ridiculous Fashions of These Distracted Times* (1646/7).

231. *Strange Newes from Scotland: Or, a Strange Relation of a Terrible and Prodigious Monster, Borne to the Amazement of All Those That Were Spectators, in the Kingdom of Scotland, in a Village Neere Edinburgh* (1647), Frontispiece.

232. See, for example, Julie Crawford, *Marvelous Protestantism: Monstrous Births in Post-Reformation England* (Johns Hopkins, Baltimore, 2005) and for the later period, William E Burns, *An Age of Wonders: Prodigies, Politics and Providence in England 1657–1727* (Manchester University Press, Manchester and New York, 2002).

233. *A Declaration of a Strange and Wonderful Monster Born in Kirkham Parish in Lancashire* (1645).

234. *Bloody Newes from Dover Being a True Relation of the Great and Bloudy Murder, Committed by Mary Champion* (1646/7).

235. Jason Peacey, *Politicians and Pamphleteers*, p. 257.

236. *Medico Mastix* (1645), frontispiece and *passim*.

237. For a good account of the patriarchal imagery and sources of these pamphlets see Gaby Mahlberg, 'The Politics of Patriarchalism in 17th Century Pamphlet Literature', *Women's History Magazine*, 46 (2004), pp. 4–9 – Mahlberg argues that the pamphlets reflect the plebeian culture of patriarchalism in a language of 'sexual slander'. There is a longer account in German: 'A Parliament of Ladies und die Oeffentlichkeit des Privaten: Politischer Diskurz im England des 17. Jarhrunderts' in Caroline Emmelius *et al.* (eds) *Offen under Verbogen: Vorstellungen und Praktiken des Offentlichen und Privaten in Mitellelater und Freuher Neuzeit* (Goettingen, 2004). I am grateful to Gaby Mahlberg for an interesting discussion on these pamphlets. See also Sharon Achinstein, 'Women on Top in the Pamphlet Literature of the English Revolution' in *Gender, Literature and the English Revolution*, Special Issue of *Women's Studies*, 24 (1994), p. 350.

238. Nicholas von Maltzahn, 'Henry Neville', *Oxford Dictionary of National Biography* (www.oxforddnb.com).

239. I am conscious as I write that ideas for my thinking on gender and civil war propaganda have been greatly shaped by discussions with Ann Hughes to whom I owe an intellectual debt. See her *Women, Men and Politics in the English Civil War* (Inaugural Lecture, Keele University Press, 1999). See also '"Speaking Abroad": Gender, Female Authorship and Pamphleteering' in Joad Ramond, *Pamphlets and Pamphleteering in Early Modern Britain*, (Cambridge University Press, Cambridge, 2003).

240. Gaby Mahlberg, 'The Politics of Patriarchalism in 17th Century Pamphlet Literature', *Women's History Magazine*, 46 (2004), p. 4.

241. [Henry Neville], *The Exact Diurnall of the Parliament of Ladyes* (1647), pp. 1–8.

242. [Henry Neville], *The Parliament of Ladies* and *The Ladies Parliament* (1647), quoting Sig A1-A3, B2ᵛ.

243. [Henry Neville], *The Ladies a Second Time Assembled* (1647), pp. 5, 7. The 'parliament of ladies' pamphlets generated responses and propagandist sub-plots. On 29 July 1647 the anonymous author of *Match Me These Two, or the Conviction and Arraignment of Britanicus and Lilburne* spoke of parliament's attack on a 'Trinity of Libellers', being Frances Cheynell for his *Hue and Cry Sent Forth after Britanicus*, John Lilburne (the Leveller leader) and the author of the parliament of ladies 'who could not be found'. It may also have been written by Henry Neville.

244. [Henry Neville], *Newes from the New Exchange or the Commonwalth of Ladies Drawn to their Life* (1650), pp. 3 ff.

245. *Women Will Have Their Will: Or, Give Christmas His Due* (1648), quoting pp. 7, 10–11, 13.

246. Cope, *Handmaid of the Holy Spirit*, pp. 153, 160, 158; *Restitution of Prophecy* (1651) and *The Benediction* (1651) are reprinted in Cope, *Prophetic Writings of Lady Eleanor Davies*, pp. 343–68, 341–2.

247. Cope, *Handmaid of the Holy Spirit*, pp. 76–8, 158.

248. I owe this insight to discussions with Ann Hughes. See, for example, Richard Overton, *The Commoners Complaint: A Dreadful Warning from Newgate* (1647) and for an extended argument on the Leveller image of the godly household assailed see Ann Hughes, 'Gender and Politics in Leveller Literature' in Susan Amussen and Mark Kishlansky, *Political Culture and Cultural Politics in Early Modern England: Essays Presented to David Underdown* (Manchester University Press, Manchester, 1995), pp. 162–88 especially p. 181.

249. Ariel Hessayon, 'Giles Calvert', *Oxford Dictionary of National Biography* (www.oxforddnb.com).

250. Mary Pope, *A Treatise of Magistracy* (1647), Dedication and *passim, Behold Here Is a Word or an Answer to the Late Remonstrance of the Army* (1648), pp. 1–2, 4–7, 13–14, 24–5, *Heare, Heare, Heare, Heare, a Word or Message from Heaven* (1648), *passim*; Catie Gill, 'Mary Pope, *Oxford Dictionary of National Biography* (www.oxforddnb.com) citing D. P. Ludlow, '"Arise and Be Doing": English "Preaching" Women 1640–1660' (unpublished PhD, Indiana University, 1978). There is an article on Mary Cary by Bernard Capp in the *Oxford Dictionary of National Biography* that does not do her justice.

251. Mary Pope's royalist 'puritanism' was also a 1640s phenomenon and her voice was not a lone one. John Pennyman was another royalist 'puritan', who joined the Quakers, but then spent years writing against them. Another was Arise Evans whose prophetic career was similar to Eleanor Davies's before the Civil War, but whose prophetic pamphlets attacked religious sectarianism in the 1640s and regicide in the 1650s. See Caroline L. Leachman, 'John Pennyman' and Thomas N. Corns, 'Arise Evans', *Oxford Dictionary of National Biography* (www.oxforddnb.com).

252. Mary Cary, *A Word in Season to the Kingdom of England* (1647), pp. 1–3, 7, 11.

253. Mary Cary, *The Resurrection of the Witnesses and Englands Fall from (the Mystical Babylon) Rome* (1648), pp. 96, 172.

254. Mary Cary, *The Resurrection of the Witnesses and Englands Fall from (the Mystical Babylon) Rome* (1648), *passim*, but especially Preface unpaginated, Preamble pp. 4, 13–14, 20–22, 24, 34–7, 58, 61 ff., 82 ff., 98 ff. quoting p. 94.

255. Mary Cary, *The Resurrection of the Witnesses and Englands Fall from (the Mystical Babylon) Rome* (1648), pp. 46, 52–3, 56–9.

256. Mary Cary, *The Resurrection of the Witnesses and Englands Fall from (the Mystical Babylon) Rome* (1648), pp. 116, 123–4.

257. Verney, *Memoirs of the Verney Family* (Longmans, Green and Co., London, 1892), ii, pp. 72–4, 239–40.

258. Manfred Brod, 'Elizabeth Poole' *Oxford Dictionary of National Biography* (www.oxforddnb.com); Elizabeth Poole, *An Alarum of War Given to the Army* (1649), frontispiece and Sig. A2.

259. Elinor Channel [Arise Evans], *A Message from God by a Dumb Woman* (1654).

260. The Levellers were a group demanding extension of manhood suffrage with 'agitators' in the Army.

261. Patricia Higgins, 'The Reactions of Women, with Special Reference to Women Petitioners', in Manning (ed.), *Politics, Religion and the English Civil War*; Ellen Macarthur, 'Women Petitioners and the Long Parliament', *English Historical Review*,

24 (1909), pp. 698–709; Crawford, *Women and Religion in England 1500–1700*, p. 134 and for lengthier account, '"The Poorest She": Women and Citizenship in Early Modern England' in Michael Mendle (ed.), *The Putney Debates of 1647: The Army, the Levellers and the English State* (Cambridge University Press, Cambridge, 2001), p. 210.

262. *To the Supream Authority of This Nation ... the Humble Petition of Divers Wel-Affected Women* and *To the Supream Authority of England ... the Humble Petition of Divers Wel-Affected Women* (both 1649) quoting pp. 4 in the former.

263. In Higgins, 'The Reactions of Women, with Special Reference to Women Petitioners', in Manning ed., *Politics, Religion and the English Civil War*, p. 180.

264. *The Man in the Moon, Discovering a World of Knavery under the Sunne* (1649), p. 11 and *Mercurius Pragmaticus* (23–30 April 1649), Sig. A2 cited in Ann Marie McEntee, '"The [Un]Civill-Sisterhood of Oranges and Lemons": Female Practitioners and Demonstrators, 1642–53', in James Holstun (ed.), *Pamphlet Wars*, pp. 100–1; Nigel Smith, *Literature and Revolution in England, 1640–1660* (Yale University Press, New Haven and London, 1994), p. 68.

265. Colin Davis, *Fear, Myth and History: The Ranters and the Historians* (Cambridge University Press, Cambridge, 1988).

266. See also Tom Hayes, 'Diggers, Ranters and Women Prophets: The Discourse of Madness and the Cartesian *cogito* in Seventeenth-Century England', *Clio*, 26:1 (1996).

267. John Cook, *King Charls his Case: Or, an Appeal to All Rational Men Concerning His Tryal at the High Court of Justice* (1649), frontispiece and Preface Sig. A2ᵛ; Wilfred Prest, 'John Cook', *Oxford Dictionary of National Biography* (www.oxforddnb.com).

268. See Nevitt, *Women and the Pamphlet Culture*, chpt. 2.

269. Walsham, *Providence in Early Modern England*, p. 307.

270. Cope, *Handmaid of the Holy Spirit*, p. 64 citing Public Record Office, State Papers 16/255/20.

271. Eleanor Davies, *The New Jerusalem at Hand* (1649) in *Prophetic Writings of Lady Eleanor Davies* ed. Cope, pp. 259–69.

272. Francis J. Bremer, 'Thomas Parker', *Oxford Dictionary of National Biography* (www.oxforddnb.com, 2004).

273. Published in the name of Mary Rande.

274. Karen O'Dell Bullock, 'Susanna Parr', *Oxford Dictionary of National Biography* (www.oxforddnb.com) and Susanna Parr, *Susanna's Apologie Against the Elders* (1659).

275. Edward Burrough, *Something in Answer to a Book Called Choice Experiences* (1654), p. 3.

276. [David Brown], *The Naked Woman, or a Rare Epistle Sent to Mr Sterry* (1652), pp. 2–3, 5–10, 14. Brown was in pamphlet conflict with Samuel Chidley at the time – see also *Cloathing for the Naked Woman, or, the Second Part of the Dissembling Scot* (1652). For Sterry, see Vivien de Sola Pinto, *Peter Sterry: Platonist and Puritan 1613–1672* (Greenwood Press, New York, 1968). Cf. Neviit, *Women and the Pamphlet Culture*, chpt. 4.

277. Stevie Davies, 'Anna Trapnel', *Oxford Dictionary of National Biography* (2004) (www.oxforddnb.com); Anna Trapnel, *The Cry of a Stone* (1654) and *Strange and Wonderful Newes from Whitehall* (1654), *passim*; Owen Watkins, *The Puritan Experience* (Routledge and Kegan Paul, London, 1972), pp. 91–3.

278. Cf. Mack, *Visionary Women*, p. 138.

279. Jane Turner, *Choice Experiences of the Kind Dealings of God Before, In, and After Conversion* (1653), 'A Word from the Author' [unpaginated], pp. 1, 11–12, 22–3, 61, 26, 38–9, 50, 57 ff especially 79, 89; Owen Watkins, *The Puritan Experience*, p. 89, quoting gobbets from pp. 193–203.

280. Barry Reay, *The Quakers and the English Revolution* (Hounslow, 1985), p. 9; cf. Crawford, *Women and Religion in England 1500–1720* , p. 160.

281. Christine Trevett, *Quaker Women Prophets in England and Wales 1650–1700* (Edwin Mellen Press, New York, 2000); Kate Peters, '"Women's Speaking Justified": Women and Discipline in the Early Quaker Movement 1652–1656', in *Gender and Christian Religion* ed. R. N. Swanson, Studies in Church History, 34 (1998), pp. 205–34 and *Print Culture and the Early Quakers* (Cambridge University Press, Cambridge, 2005); Gill, *Women in the Seventeenth Century Quaker Community*.

282. Crawford, *Women and Religion in England 1500–1720*, p. 161.

283. Richard Farnworth, *A Woman Forbidden to Speak in the Church* (1654), p. 2; Richard Greaves, 'Richard Farnworth', *Oxford Dictionary of National Biography* (www.oxforddnb.com).

284. Richard Farnworth, *A Woman Forbidden to Speak in the Church* (1654), pp. 3. See also Mack, *Visionary Women*, Parts 2 and 3. See also S Fang Ng, 'Marriage and Discipline: the Place of Women in Early Quaker Controversies', *Seventeenth Century*, 18:1 (2003), pp. 113–40.

285. See, for example, Peters, '"Women's Speaking Justified": Women and Discipline in the Early Quaker Movement 1652–1656', in *Gender and Christian Religion* ed. R. N. Swanson, Studies in Church History, 34 (Boydell Press, London, 1998), p. 210 and Mack, *Visionary Women*, chpt. 4.

286. Kate Peters, '"Women's Speaking Justified": Women and Discipline in the Early Quaker Movement 1652–1656', in *Gender and Christian Religion* ed. R. N. Swanson, Studies in Church History, 34 (Boydell Press, London, 1998) and a modified version in *Print Culture and the Early Quakers* (Cambridge University Press, Cambridge, 2005), chpt. 5 esp. p. 150. The four tracts were: Richard Farnworth, *A Woman Forbidden to Speak in the Church* (1654); Ann Audland, *The Saints Testimony Finishing Through Sufferings* (1655); Priscilla Cotton and Mary Cole, *To the Priests and People of England* (1655); George Fox, *A Woman Learning in Silence* (1656). See also Catherine M. Wilcox, *Theology and Women's Ministry in Seventeenth-Century English Quakerism: Handmaids of the Lord* (Edwin Mellen, Lampeter, 1995).

287. Richard Farnworth, *A Woman Forbidden to Speak in the Church* (1654), p. 7.

288. Mack, *Visionary Women*, p. 127.

289. Peters, '"Women's Speaking Justified": Women and Discipline in the Early Quaker Movement 1652–1656', p. 219 citing Audland *et al.*, *The Saints Testimony*, p. 2.

290. Brynmor Jones Library MSS, DDQR/18/1 p. 12. My thanks to Gareth Shaw for providing me with a transcription of this account of the 'sufferings' of Barbara Siddall.

291. Crawford, *Women and Religion in England 1500–1720*, p. 162 citing George Bishop *et al.*, *The Cry of Blood* (1656), pp. 114–17.

292. Mack, *Visionary Women*, pp. 166–8 citing *Great Book of Sufferings* (1661), 1:139.

293. Brynmor Jones Library MSS, DDQR/18/1 p. 12. My thanks to Gareth Shaw for providing me with a transcription of this account of the 'sufferings' of Mary Fisher.

294. See accounts of Quaker women's travel and Mary Fisher in Mack, *Visionary Women*, pp. 168–70, 207–8 and Crawford, *Women and Religion in England 1500–1720*, p. 163. For another view see Trevitt, *Women and Quakerism in the Seventeenth Century*.

295. Hugh Barbour and Arthur O. Roberts (eds), *Early Quaker Writings 1650–1700* (William B. Ferdmans Publishing Co., Grand Rapids, Michigan, 1973), pp. 474–6.

296. Edward Burrough to Margaret Fell, Dublin 1655 rep. in Abram Rawlinson Barclay (ed.), *Letters etc. of Early Friends* (London, 1841) cited in Mack, *Visionary Women*, p. 207.

297. Sarah Cheevers and Katherine Evans, *To All the People on the Face of the Earth* (1663) cited in Crawford, *Women and Religion in England 1500–1720* , p. 163.

298. Brynmor Jones Library, University of Hull, DQR 18/1/11–12; Mack, *Visionary Women*, pp. 168–70 citing Thomas Adam to Margaret Fell, 1653, Swarthmore Manuscripts 3/42

(I, 37) and Henry Fell to Margaret Fell, Barbados, November 3, 1656, Swarthmore Manuscripts 1/66 (II, 101); Mary Fisher to Thomas Killam, Thomas Aldam and John Killam, March 13, 1658, William Caton MSS, vol. 320, I/165, Library of the Society of Friends, London; Fraser, *The Weaker Vessel*, pp. 414–17.

299. Susan Wiseman, 'Read Within: Gender, Cultural Difference and Quaker Women's Travel Narratives' in Chedgzoy, Hansen and Trill (eds), *Voicing Women: Gender and Sexuality in Early Modern Writing*, pp. 153–6, 169. See also Susan Mosher Stuard, 'Women's Witnessing: A New Departure' in Elizabeth Potts Brown and Susan Mosher Stuard (eds), *Witnesses for Change: Quaker Women over Three Centuries* (Rutgers University Press, New Brunswick, 1989) and Moira Ferguson, *Subject to Others: British Women Writers and Colonial Slavery* (Routledge, London, 1992). The most recent is Rebecca Larsen, *Daughters of Light: Quaker Women Preaching and Prophesying in the Colonies and Abroad 1700–1775* (University of North Carolina Press, Chapel Hill, 1999).

300. For the collected works see: David Booy (ed.), *Autobiographical Writings by Early Quaker Women 1500–1750* (Ashgate, Aldershot, 2004). Crawford, 'Women's Published Writings 1600–1700', in Prior (ed.), *Women in English Society*, p. 222. See Maureen Bell, 'Martha Simmonds', *Oxford Dictionary of National Biography* (www.oxforddnb. com).

301. Crawford, 'Women's Published Writings 1600–1700', in Prior (ed.), *Women in English Society*, p. 213, 239; Barbara Blaugdone, *An Account of the Travels, Sufferings and Persecutions of Barbara Blaugdone* (1691), pp. 5–6, 27 and *passim*.

302. Walsham, *Providence in Early Modern England* , pp. 5, 9–10, 15, 20, 229.

303. Elaine McKay, 'English Diarists: Gender, Geography and Occupation 1500–1700', *History*, 90:2 (2005), pp. 191–212 quoting p. 194; Megan McLaughlin, 'Gender Paradox and the Otherness of God', *Gender and History*, 3:2 (1991), pp. 147–59.

304. Betty S. Travitsky, '"His Wife's Prayers and Meditations": MS Egerton 607' [Elizabeth Egerton], in Anne M. Haselkorn and Betty S. Travitsky (eds), *The Renaissance Englishwoman in Print: Counterbalancing the Canon* (University of Massachusetts Press, Amherst, 1990), pp. 241–60; Huntington Library MSS, Ellesmere 6871 [Elizabeth Stanley] and Hastings Collections Religious Box 1 # 15, 21 [Lucy Davies/Hastings].

305. Elizabeth Pindar, Bookplate (1608) STC 3368.5.

306. Alice Thornton, *The Autobiography of Mrs Alice Thornton of East Newton, Co. York*, Publications of the Surtees Society (Andrews & Co, Durham, 1873), pp. 1–2, 17–19, 32–5, 73–5, 'deliverances' are *passim*.

307. Janel Mueller, Introduction, *The Early Modern Englishwoman: A Facsimile Library of Essential Works: Part 1: Printed Writings, 1500–1640* ed. Betty S. Travitsky and Patrick Cullen (Scolar Press, Aldershot, Hants, 1996), vol. 3, p. ix.

308. An Collins, *Divine Songs and Meditations* (1655), Preface, as reprinted in *Her Own Life: Autobiographical Writings by Seventeenth-Century Englishwomen* ed. Elspeth Graham *et al.* (Routledge, London and New York, 1989), pp. 54–6; Joanne Shattock, *The Oxford Guide to British Women Writers* (Oxford University Press, Oxford and New York, 1993), pp. 112–13.

309. Katherine Austen, 'Meditations', British Library Add MSS 4454 f. 7. On Austen see Raymond A. Anselment, 'Katherine Austen and the Widow's Might', *The Journal for Early Modern Cultural Studies*, 5:1 (2005).

310. Katherine Austen, 'Meditations', British Library Add MSS 4454 f. 29, 31v–32, 34, 37.

311. Fraser, *The Weaker Vessel*, p. 290.

312. Jane Turner, *Choice Experiences of the Kind Dealings of God Before, In, and After Conversion* (1653), p. 109.

313. See, for example, the important collection of essays Alan Houston and Steven Pincus (eds), *A Nation Transformed: England After the Restoration* (Cambridge University Press, Cambridge, 2001).

314. Blair Worden, 'The Question of Secularisation' in Huston and Pincus (eds), *A Nation Transformed: England after the Restoration*.
315. Fletcher, *Gender, Sex and Subordination*.
316. Nabil Matar, 'Peter Sterry', *Oxford Dictionary of National Biography* (www.oxforddnb. com).
317. Barry Coward, *The Stuart Age: England 1603–1714* (Longman, London, 2003), p. 282.
318. Crawford, *Women and Religion in England 1500–1720*, pp. 188–9. For 'Anglican survivalism' see John Morrill, 'The Attack on the Church of England in the Long Parliament 1640–1642' in Derek Beales and Geoffrey Best (eds), *History, Society and the Churches: Essays in Honour of Owen Chadwick* (Cambridge University Press, Cambridge, 1985), pp. 105–24.
319. Maureen Bell, 'Seditious Sisterhood: Women Publishers of Opposition Literature at the Restoration', in Chedgzoy, Hansen and Trill (eds), *Voicing Women: Gender and Sexuality in Early Modern Writing*, pp. 185–7; Nigel Smith and Maureen Bell, 'Andrew Marvell and the "Femina Periculosa": the Poet's Connections with the Underground Radical Press', *Times Literary Supplement*, January 26, 2001, p. 14.
320. A nice account of this period is to be found in Isabel Ross, *Margaret Fell: Mother of Quakerism* (Longmans Green and Co., London, 1949), chpts. 4–6. Margaret Fell/Fox had been widowed in 1658, spent time in 1659 campaigning for the release from prison of George Fox and in 1660 also petitioned Charles II to let Quakers live peaceably. In 1664 she lost her property for refusing to take the Oath of Allegiance and was imprisoned for four years. David Latt, Introduction in *Womens Speaking Justified* [and others], Augustan Reprint Society, 194 (William Andrews Clark Memorial Library, University of California, Los Angeles, 1979), pp. iii–iv; Bonneylynn Young Kunze, 'Margaret Fell', *Oxford Dictionary of National Biography* (www.oxforddnb.com, 2004) and *Margaret Fell and the Rise of Quakerism* (Macmillan, Basingstoke, 1993), p. 138.
321. Hobby, *Virtue of Necessity*, p. 45.
322. Margaret Fell, *Womens Speaking Justified* (1667), pp. 3–12.
323. Margaret Fell, *Womens Speaking Justified* (1667), p. 13.
324. Margaret Fell, *Womens Speaking Justified* (1667), p. 17.
325. Bonneylynn Young Kunze, 'Margaret Fell', *Oxford Dictionary of National Biography* (www.oxforddnb.com) and *Margaret Fell and the Rise of Quakerism* (Macmillan, Basingstoke, 1993), p. 20.
326. See W. C. Brathwaite, *The Second Period of Quakerism* (William Sessions, York, 1979); Trevitt, *Women and Quakerism in the Seventeenth Century*; M. R. Brailsford, *Quaker Women 1650–1690* (Duckworth & Co., London, 1915); M. Bacon, 'The Establishment of London Women's Yearly Meeting: A Transatlantic Concern', *The Journal of Friends Historical Society*, 57:2 (1995), pp. 151–65. I would like to thank and acknowledge Gareth Shaw for letting me read the draft of his doctoral chapter on the development of women's meetings. See also Isabel Ross, *Margaret Fell: Mother of Quakerism* (Longmans Green and Co., London, 1949), pp. 284–5 (See Gareth Shaw, 'Tolerance and Toleration: The Experience of the Quakers in East Yorkshire *c*. 1660–1699', unpublished Hull University PhD, 2006).
327. George Fox, 'An Exhortation to Set Up Women's Meetings' [1667] in Christine Trevitt (ed.), *Womens Speaking Justified and Other Seventeenth-Century Quaker Writings about Women* (Invicta Press, kent, 1989), p. 19.
328. Ross, *Margaret Fell: Mother of Quakerism*, pp. 289–90.
329. Hobby, *Virtue of Necessity*, pp. 43–5 citing Elizabeth Bathurst, *The Sayings of Women* (1683), pp. 6–7; *Women and the Literature of the Seventeenth Century: An Annotated Bibliography Based on Wing's Short Title Catalogue*, compiled by Hilda L. Smith and Susan Cardinale (Greenwood Press, New York and London, 1990), p. 9 citing Elizabeth [Anne] Bathurst, *The Sayings of Women* (1683) and Mary Bayly *et al.*, *False Prophets and the False Preachers Described* (1652).

330. Margaret Fell, 'Last Epistle to Friends' (1698) in Hugh Barbour and Arthur O. Roberts (eds), *Early Quaker Writings 1650–1700* (William B. Eerdmans, Grand Rapids, Michigan, 1973), p. 565.

331. Mack, *Visionary Women: Ecstatic Prophecy in Seventeenth-Century England*, pp. 364–7.

332. Michael Mullett, 'Thomas and Alice Curwen', *Oxford Dictionary of National Biography* (www.oxforddnb.com, 2004).

333. Crawford, *Women and Religion in England 1500–1720*, p. 188 and Charlton, *Women, Religion and Education, passim* esp. chpt. 6.

334. Patricia Crawford, 'The Challenges to Patriarchalism: How Did the Revolution Affect Women?', in John Morrill (ed.), *Revolution and Restoration: England in the 1650s* (Collins & Brown, London, 1992), p. 123.

335. Clive Field, 'Adam and Eve: Gender and the Free Church Constituency', *Journal of Ecclesiastical History*, 44 (1993), pp. 63–79 cited in Crawford, *Women and Religion in England 1500–1720*, p. 189.

336. Amanda Porterfield, 'Women's Attraction to Puritanism', *Church History*, 60 (1991), p. 196 and *passim*.

337. Maria Magro has made a case for 'the Bad Girls of the English Revolution' in a chronologically-dislocated article that argues for the emergence of 'female authorial consciousness' and the need to reinstate women's contribution to the *genre* of spiritual autobiography. The way in which women gained a 'voice' from the 1640s is more subtle than this. Maria Magro, 'Spiritual Autobiography and Radical Sectarian Women's Discourse: Anna Trapnel and the Bad Girls of the English Revolution', *Journal of Medieval and Early Modern Studies*, 34:2 (2004), pp. 405–37. For a much better piece on spiritual autobiography, see Effie Botonaki, 'Seventeenth-Century English Women's Spiritual Diaries: Self-Examination, Covenanting and Account-Keeping', *Sixteenth Century Journal*, 30 (1999), 3:21.

338. Crawford, *Women and Religion in England 1500–1720*, p. 192.

339. Hobby, *Virtue of Necessity: English Women's Writing 1646–1688*, pp. 38, 48.

340. Bathsua Makin, *An Essay to Revive the Antient Education of Gentlewomen* (1673), pp. 8–9.

341. Patricia Crawford's work on the congregation of the Maze Pond Baptists Church also reveals gradual containment of women's activity in the 1690s. Crawford, *Women and Religion in England 1500–1720*, pp. 198–9.

342. Patricia Crawford, 'Women's Published Writings 1600–1700', in Prior (ed.), *Women in English Society*, p. 262.

343. Cambridge University Library MSS, 'John Livingstone His Life', Kk.5.20, f. 27.

344. Crawford, *Women and Religion in England, 1500–1720*, pp. 207–8 citing Hillel Schwartz, *Knaves, Fools, Madmen, and That Subtile Effluvium: A Study of the Opposition to the French Prophets in England, 1706–1710* (University of Florida Mongraphs, 62, 1978) and *The French Prophets. The History of a Millenarian Group in Eighteenth-Century England* (Berkeley, California, 1980) and 'Lincoln's Inn Fields: The French Prophets', *Notes and Queries*, 6th Series, (1885), pp. 21–2.

345. Sylvia Bowerbank, 'Jane Lead', *Oxford Dictionary of National Biography* (www.oxforddnb. com); Barbara Becker-Cantarino, 'Introduction', *The Life of Lady Johanna Eleonora Petersen* (University of Chicago Press, Illinois, 2005), p. 23. See also the fine new biography of Lead: Julie Hirst, *Jane Leade: Biography of a Seventeenth-Century Mystic* (Ashgate, Aldershot, 2005), *passim*.

346. Jane Lead, *The Heavenly Cloud Now Breaking* (1681), frontispiece and Sig A², pp. 7, 10, 21–2, 28 ff.

347. Sylvia Bowerbank, 'Jane Lead', *Oxford Dictionary of National Biography* (www.oxforddnb. com); Julie Hirst, *Jane Leade: Biography of a Seventeenth-Century Mystic* (Ashgate, Aldershot, 2005), *passim*.

348. Lead, *The Heavenly Cloud Now Breaking* (1681), pp. 38, 40.

349. Jane Lead, *The Revelation of Revelations* (1683), *passim* and quoting or especially pp. 8, 42, 125.

350. Bowerbank, 'Jane Lead', *Oxford Dictionary of National Biography* (www.oxforddnb.com); Julie Hirst, *Jane Leade: Biography of a Seventeenth-Century Mystic* (Ashgate, Aldershot, 2005), *passim*.

351. Bowerbank, 'Jane Lead', *Oxford Dictionary of National Biography* (www.oxforddnb.com); Barbara Becker-Cantarino, 'Introduction', *The Life of Lady Johanna Eleonora Petersen* (University of Chicago Press, Illinois, 2005), pp. 15–17; Sylvia Bowerbank, 'Ann Bathurst', *Oxford Dictionary of National Biography* (www.oxforddnb.com).

352. Catie Gill, 'Anne Wentworth', *Oxford Dictionary of National Biography* (www.oxforddnb. com); Hobby, *Virtue of Necessity*, pp. 49–53; Crawford, 'Public Duty, Conscience and Women in Early Modern England', in Morrill, Slack and Woolf (eds), *Public Duty and Private Conscience*, p. 74.

353. Hannah Allen, *A Narrative of God's Gracious Dealings with the Choice Christian Mrs Hannah Allen* (1683), *passim*, quoting pp. 9, ix, 28, 12, 27, 40, 43, 48, 59, 72.

354. Gillespie, *Domesticity and Dissent in the Seventeenth Century*.

355. Alexandra Walsham, *Charitable Hatred: Tolerance and Intolerance in England 1500–1700* (Manchester University Press, Manchester and New York, 2006), *passim* but see especially pp. 136–9 on mob mentality and 'popular intolerance', pp. 204–6 on the crazy equating of Catholicism with Quakerism during the Popish Plot, p. 263 on declining state persecution and 322 on 'pluralism being ineradicable'.

356. Bathsua Makin, *An Essay to Revive the Antient Education of Gentlewomen* (1673), p. 28.

357. This section draws on Crawford, *Women and Religion in England 1500–1720*, Introduction. Quotation from Stephen Marshall, *The Strong Helper* (1645) reprinted in *Fast Sermons to the Long Parliament*, vol. 16, p. 402.

358. Mack, *Visionary Women*, *passim* but see especially pp. 7, 18–20, 23.

359. See for example, Caroline Bynum, *Fragmentation and Redemption: Essays on Gender and the Human Body in Christian Religion* (Zone Books, New York, 1992) and Christine Peters, *Patterns of Piety: Women, Gender and Religion in Late Medieval and Reformation England* (Cambridge University Press, Cambridge, 2003).

360. Crawford, *Women and Religion in England 1500–1720*, pp. 1, 10 citing examples from M. Emmanuel Orchard (ed.), *Till God Will: Mary Ward Through Her Writings* (1985), p. 58.

361. Crawford and Gowing (eds), *Women's Worlds in Seventeenth-Century England*, p. 43.

362. Hannah Allen, *A Narrative of God's Gracious Dealings with the Choice Christian Mrs Hannah Allen* (1683), p. i.

363. Crawford, *Women and Religion in England, 1500–1720*, pp. 14–15, 109. Quotations from 'Ann Bathurst rhapsodies', 1693–6, Bodleian Library MSS Rawlinson D1262, ff. 45–6 and Elizabeth Poole, *A Prophecie Touching the Death of King Charles* (1649), sig. A3. For an extended discussion of the gender ambiguities inherent in religious discourse, see Mack, *Visionary Women*.

364. Trill, 'Religion and the Construction of Femininity' in Wilcox, *Women and Literature in Britain 1500–1700*, pp. 35–6, 41–2.

365. Joan Wallach Scott, 'Gender: A Useful Category of Historical Analysis', in Scott, *Gender and the Politics of History* (Columbia University Press, New York, 1988), p. 49; Mikhail Bakhtin, 'The Problem of Speech Genres' in *Speech Genres and Other Late Essays* (University of Texas Press, Austin, Texas, 1986), pp. 60–102 discussed in Smith, *Literature and Revolution in England*, p. 4.

7 Education and Women's Writing

1. See also Dorothy Gardiner, *English Girlhood at School* (Oxford University Press, Oxford, 1929), Josephine Kamm, *Hope Deferred* (Methuen, London, 1965) and Phyllis Stock, *Better than Rubies* (Capricorn Books, New York, 1978). Newer work in surveys include

Helen Jewell, *Education in Early Modern England* (Macmillan, Basingstoke, 1998) and Barbara Whitehead's *Women's Education in Early Modern Europe* (Garland, New York, 1999). Kenneth Charlton, *Women, Religion and Education in Early Modern England* (Routledge, London, 1999) is an account of the relationship between gender training and puritan education for girls and as such has much on curriculum.

2. Charlton, *Women, Religion and Education*.
3. Richard Mulcaster, *Positions Wherin Those Primitive Circumstances Be Examined, Which Are Necessarie for the Training vp of Children either for Skill in Their Booke, or Health in their Bodie* (1581), pp. 133–4.
4. Cited in Kamm, *Hope Deferred*, p. 53.
5. See, for example, Jewell, *Education in Early Modern England* , pp. 26–7.
6. Ezell, *The Patriarch's Wife*, p. 11; Antonia Fraser, *The Weaker Vessel: Woman's Lot in Seventeenth-Century England* (Methuen, London, 1984), pp. 138, 152–3; Roger Thompson, *Women in Stuart England and America* (Routledge and Kegan Paul, London, Henley and Boston, 1974), pp. 190–2.
7. Fraser, *The Weaker Vessel*, p. 143; Thompson, *Women in Stuart England and America*, pp. 190–1.
8. Huntington Library MS, HM 904 cited in Victoria Burke, 'Women and Early Seventeenth-Century Manuscript Culture: Four Miscellanies', *Sixteenth Century Journal*, 12 (1997), p. 135.
9. Margaret Ezell, *The Patriarch's Wife: Literary Evidence and the History of the Family* (University of North Carolina Press, Chapel Hill and London, 1987), chpt. 3 especially pp. 64–5; see also George L. Justice and Nathan Tinker (eds), *Women's Writings and the Circulation of Ideas: Manuscript Publication in England 1550–1800* (Cambridge University Press, Cambridge, 2002).
10. See Charlton, *Women, Religion and Education, passim*; Kim Walker, *Women Writers of the English Renaissance* (Twayne, New.York, 1996), p. 5.
11. Paul Morgan, 'Frances Wolfreston and "Hor Bouks": A Seventeenth-Century Woman Book-Collector', *The Library*, Sixth Series, xi:3 (1989), pp. 197–213, citing her will dated 27 November 1677, Lichfield Record Office. See also Tessa Watt, *Cheap Print and Popular Piety 1550–1640* (Cambridge University Press, Cambridge, 1991), pp. 315–16.
12. D. R. Woolf, *Reading History in Early Modern England* (Cambridge University Press, Cambridge, 2001), pp. 296, 301, 306–8. For actresses see Elizabeth Howe, *The First English Actresses: Women and Drama 1660–1700* (Cambridge and New York, 1992).
13. The four best interpretative books on women writers are Kim Walker, *Women Writers of the English Renaissance*, Helen Wilcox (ed.), *Women and Literature in Britain 1500–1800* (Cambridge University Press, Cambridge, 1996), Anita Pacheco (ed.), *Early Women Writers 1600–1720* (Longman, London and New York, 1998) and Danielle Clarke, *The Politics of Early Modern Women's Writing* (Longman, Harlow, 2001). See also Danielle Clarke and Elizabeth Clarke (eds), *'This Double Voice': Gendered Writing in Early Modern England* (Macmillan, Basingstoke, 2000). For a fascinating account of women writing in Latin see Jane Stevenson, *Women Latin Poets: Language, Gender and Authority from Antiquity to the Eighteenth Century* (Oxford University Press, Oxford and New York, 2005).
14. There are websites dedicated to individual women that Googling will reveal though the websites for systematic reproduction of many women's texts are *Sunshine for Women* (www.pinn.net/~sunshine) and *A Celebration of Women Writers* (digital.library.upenn. edu/women) and for manuscript descriptions there is *Perdita* (human.ntu.ac.uk/ research/perdita). Good anthologies of women's writing include Paul Salzman, *Early Modern Women's Writing: An Anthology 1560–1700* (Oxford University Press, Oxford, 2000); Stephanie Hodgson-Wright, *Women's Writing of the Early-Modern Period 1588– 1688* (Edinburgh University Press, Edinburgh, 2002). Another is Randall Martin, *Women Writers in Renaissance England* (Longman, London and New York, 1997). There is also an anthology of correspondence – James Daybell (ed.), *Early Modern Women's*

Letter Writing (Palgrave, Basingstoke, 2001). Surveys of women's writing have been done by Fraser, *The Weaker Vessel*, chpt. 17; Patricia Crawford, 'Women's Published Writings 1600–1700' in Mary Prior (ed.), *Women in English Society 1500–1800* (Routledge, London and New York, 1985); Elaine Hobby, *Virtue of Necessity: English Women's Writing 1649–88* (Virago Press, London, 1988).

15. Elizabeth D. Harvey, *Ventriloquized Voices: Feminist Theory and English Renaissance Texts* (Routledge, London and New York, 1992), pp. 1, 4. See also Catherine Belsey, *The Subject of Tragedy, Identity and Difference in Renaissance Drama* (Methuen, London, 1985); Jonathan Goldberg, *Voice Terminal Echo: Postmodernism and English Renaissance Texts* (Methuen, New York, 1986) and Lisa Jardine, *Still Harping on Daughters: Women and Drama in the Age of Shakespeare* (Harvester Press, Brighton, 1983); Gerda Lerner, *The Creation of Feminist Consciousness from the Middle Ages to Eighteen-Seventy* (Oxford University Press, New York, 1993), p. 47.

16. Stock, *Better Than Rubies*, pp. 29, 49; Gardiner, *English Girlhood at School* , p. 142; Kamm, *Hope Deferred*, chpt. 2 and p. 35.

17. Doris Stenton, *The English Woman in History* (George Allen and Unwin, London, 1957), pp. 122–4; Stock, *Better Than Rubies*, chpt. 1; Gerda Lerner, *The Creation of Feminist Consciousness: From the Middle Ages to Eighteen-Seventy* (Oxford University Press, New York and Oxford, 1993), p. 262; Peter Burke, *The Fortunes of the Courtier: The European Reception of Castiglione's Cortegiano* (Polity Press, Cambridge, 1995), pp. 46–50. For 'learned women' of the European Renaissance see Patricia H. Labalme, *Learned Women of the European Past* (New York University Press, New York and London, 1984), especially chpts. 4–6.

18. Christiane Klapisch-Zuber, *Women, Family and Ritual in Renaissance Italy* (University of Chicago Press, Chicago and London, 1987); Lisa Jardine, '"O Decus Italiae Virgo": or, the Myth of the Learned Lady in the Renaissance', *The Historical Journal*, 28:4 (1985), 799–819.

19. Joan Kelly, 'Did Women Have a Renaissance? in *Women, History and Theory* (University of Chicago Press, Chicago and London, 1984, pp. 19–50.

20. Ian MacLean, *The Renaissance Notion of Woman* (Cambridge University Press, Cambridge, 1980).

21. For a good summary of Renaissance humanism and female education see Hilda L. Smith, 'Humanist Education and the Renaissance Concept of Woman', in Wilcox (ed.), *Women and Literature in Britain* , chpt. 1 (this paragraph draws upon pp. 9–10) or Stock, *Better Than Rubies*, Introduction and chpt. 1. Plato cited p. 19 from *The Dialogues of Plato*, trans. Benjamin Jowett (New York and London, 1892), III, 148; Jewell, *Education in Early Modern England*. Other useful sources for general education include J. Morgan, *Godly Learning: Puritan Attitudes towards Reason, Learning and Education 1560–1640* (Oxford University Press, Oxford, 1986) and David Cressy, *Education in Tudor and Stuart England* (St Martin's Press, London and New York, 1975).

22. Joan Kelly, 'Did Women Have a Renaissance?' (1975) reprinted in Renate Bridenthal and Claudia Koontz (eds), *Becoming Visible: Women in European History* (Houghton Mifflin, Boston, 1977), pp. 137–64; Smith, ', 'Humanist Education and the Renaissance Concept of Woman', in Wilcox (ed.), *Women and Literature in Britain 1500–1700*, pp. 13–15 citing Constance Jordan, *Renaissance Feminism: Literary Texts and Political Models* (Cornell University Press, Ithaca, New York, 1990); Maclean, *The Renaissance Notion of Woman*; Pamela Joseph Benson, *The Invention of the Renaissance Woman* (Pennsylvania University Press, University Park, 1992); Ruth Kelso, *Doctrine for the Lady of the Renaissance* (University of Illinois Press, Urbana, 1956); John Guy, *Thomas More* (Arnold, London and New York, 2000), pp. 74–5, 79; Caroline André, 'Some Selected Aspects of the Role of Women in Sixteenth Century England', *International Journal of Women's Studies*, 4 (1981), p. 80; Merry Wiesner, *Women and Gender in Early Modern Europe* (Cambridge University Press, Cambridge, 1993), p. 126.

23. These are reprinted in Foster Watson (ed.), *Vives and the Renasence Education of Women* (Edward Arnold, London, 1912).

24. Smith, 'Humanist Education and the Renaissance Concept of Woman', in Wilcox (ed.), *Women and Literature in Britain 1500–1700*, pp. 16–17; Juan Luis Vives, *Instruction of a Christian Woman* (trans. Richard Hyrde, 1529) as reprinted in Joan Larsen Klein (ed.), *Daughters, Wives and Widows: Writings by Men about Women and Marriage in England, 1500–1640* (University of Illinois Press, Urbana and Chicago, 1992), p. 101.

25. The definitive edition of *Utopia* was the 1518 edition. Modern editions are edited by George M. Logan, Cambridge Texts in the History of Political Thought (Cambridge University Press, Cambridge, 1989), see p. 50, and edited and translated by David Wootton (Hackett Publishing Company, Indianapolis, Indiana, 1999), see especially Introduction, pp. 23, 33.

26. Only copies of the original painting survive, one at the National Gallery in London.

27. Kathy Lynn Emerson, *Wives and Daughters: The Women of Sixteenth Century England* (The Whitson Publishing Company, New York, 1984), pp. 154–5, 185, 153, 92; Kamm, *Hope Deferred*, pp. 41–2 citing George Ballard, *Memoirs of Several Ladies of Great Britain* (1752), p. 41.

28. Smith, 'Humanist Education and the Renaissance Concept of Woman', in Wilcox (ed.), *Women and Literature in Britain 1500–1700*, pp. 17–19; Constance Jordan, 'Feminism and the Humanists: The Case of Sir Thomas Elyot's *Defence of Good Women*', in Margaret W. Ferguson, Maureen Quilligan and Nancy J. Vickers (eds), *Rewriting the Renaissance: The Discourses of Social Difference in Early-Modern Europe* (University of Chicago Press, Chicago and London, 1986), p. 242; Stock, *Better Than Rubies*, Plato cited p. 19 from *The Dialogues of Plato*, trans. Benjamin Jowett (New York and London, 1892), III, 148.

29. Guy, *Thomas More*, p. 74 citing J. Simon, *Education and Society in Tudor England* (Cambridge University Press, Cambridge, 1966).

30. Emerson, *Wives and Daughters*, pp. 56–8, 197–8, 26; Pearl Hogrefe, *Women of Action in Tudor England* (Iowa State University Press, Ames, Iowa, 1977), chpts. 1–2; Ann Cooke-Bacon, *Fouretene Sermons of Barnardine Ochyne* (1550) in Suzanne Trill, Kate Chedgzoy and Melanie Osborne (eds), *Lay By Your Needles Ladies, Take the Pen: Writing Women in England, 1500–1700* (Arnold, London and New York, 1997), pp. 28–32.

31. Emerson, *Wives and Daughters*, pp. 197–8, 3–4, 83–4, 99, 26, 120–1, 234 .

32. Ros Ballaster, 'The First Female Dramatists' and Betty S. Travitsky, 'The Possibilities of Prose' in Helen Wilcox (ed.), *Women and Literature in Britain 1500–1700*, pp. 270, 240 and Emerson, *Wives and Daughters*, p. 83.

33. John Guy, *Thomas More* (Arnold, London and New York, 2000), chpt. 4; Wiesner, *Women and Gender in Early Modern Europe* , p. 128.

34. Emerson, *Wives and Daughters*, pp., 169, 127, 14, 113; Stenton, *The English Woman in History*, pp. 123–4 citing John Stow, *The Survey of London* (1598).

35. Peter Burke, *The Fortunes of the Courtier: The European Reception of Castiglione's Cortegiano* (Polity Press, Cambridge, 1995), p. 148.

36. Louise Schleiner, 'Activist Entries into Writing: Lady Elizabeth Hoby/Russell and the Other Cooke Sisters' in *Tudor and Stuart Women Writers* (Indiana University Press, Bloomington and Indianopolis, 1994), chpt. 2.

37. For which see Patricia Demers, 'The Seymour Sisters: Elegizing Female Attachment', *Sixteenth Century Journal*, 30:2 (1999), pp. 343–55.

38. Betty S. Travitsky, 'The Possibilities of Prose' in Wilcox (ed.), *Women and Literature in Britain*, pp. 242–3.

39. Susan Broomhall has argued that '[t]he Reformation enabled women to find new means of authority to create historical and religious accounts … [and they] argued their authority to contribute to history on the basis that they were eyewitnesses to religious events'. Susan Broomhall, 'Reformation', in Mary Spongberg, Barbara Caine and Ann Curthoys (eds), *Companion to Women's Historical Writing* (Palgrave, Basingstoke, 2005), p. 451.

40. Virginia Blain, Isobel Grundy & Patricia Clements (eds), *The Feminist Companion to Literature in English* (Yale University Press, New Haven and London, 1990), p. 307; Walker, *Women Writers of the English Renaissance*, pp. 53–5; Kate Aughterson, 'Anne Dowriche (née Edgcumbe), *Oxford Dictionary of National Biography* (www.oxforddnb.com).

41. Tina Krontiris, *Oppositional Voices: Women as Writers and Translators of Literature in the English Renaissance* (Routledge, London and New York, 1992), pp. 14–15.

42. See Amanda L. Capern, 'Renaissance', in Spongberg, Caine and Curthoys (eds), *Companion to Women's Historical Writing*, pp. 473–4; Stephanie Hodgson-Wright, 'Elizabeth Cary (*née* Tanfield), Viscountess Falkland', *Oxford Dictionary of National Biography* (www.oxforddnb.com).

43. Jane Donawerth, 'Women's Poetry and the Tudor-Stuart System of Gift Exchange' and Georgianna Ziegler, '"More than Feminine Boldness": The Gift Books of Esther Inglis', in Mary E. Burke, Jane Donawerth, Linda L. Dove and Karen Nelson (eds), *Women, Writing and the Reproduction of Culture in Tudor and Stuart Britain* (Syracuse University Press, New York, 2000); Victoria Burke, 'Women and Seventeenth-Century Manuscript Culture: Four Miscellanies', *The Seventeenth Century*, 12:2 (1997), p. 136. Lady Anne Southwell's Miscellany is Folger MS V.b.198 and see Elizabeth H. Hageman, 'Women's Poetry in Early Modern Britain' in Wilcox (ed.), *Women and Literature in Britain*, p. 191.

44. Marion Wynne-Davies, *Women Poets of the Renaissance* (Dent, London, 1998), pp. ix–xx.

45. Elizabeth H. Hageman, 'Women's Poetry in Early Modern Britain' in Wilcox (ed.), *Women and Literature in Britain*, pp. 191–2 citing Ezell, *The Patriarch's Wife*.

46. Danielle Clark, 'Introduction', *Renaissance Women Poets* (Penguin Books, London, 2000), p. xiii.

47. Betty S. Travitsky, 'Isabella Whitney', *Oxford Dictionary of National Biography* (www.oxforddnb.com).

48. Clark, *The Politics of Early Modern Women's Writing* , pp. 195–6.

49. Danielle Clark, *Renaissance Women Poets* (Penguin Books, London, 2000), p. 32.

50. Clark, *Renaissance Women Poets*, pp. 199–200.

51. Betty S. Travitsky, 'Isabella Whitney', *Oxford Dictionary of National Biography* (www.oxforddnb.com); Isabella Whitney, *The Manner of Her Will* (1573) in Marion Wynne-Davies, *Women Poets of the Renaissance* (Dent, London, 1998), pp. 1–10.

52. See, for example, Barbara K. Lewalsky, 'Lucy, Countess of Bedford: Images of a Jacobean Courtier and Patroness', in Kevin Sharpe and Steven N. Zwicker (eds), *Politics of Discourse: The Literature and History of Seventeenth-Century England* (University of California Press, Berkley and London, 1987), chpt. 4.

53. Salzman, *Early Modern Women's Writing*, pp. xiv–xv, 55–57.

54. Barbara Lewalski is one example: 'Of God and Good Women: The Poems of Amelia Lanyer' in Margaret Patterson Hannay (ed.), *Silent But for the Word: Tudor Women as Patrons, Translators and Writers of Religious Works* (Kent State University Press, Ohio, 1985).

55. Amelia Lanyer, *Salve Deus Rex Judaeorum* in Salzman, *Early Modern Women's Writing*, p. 57.

56. Salzman, *Early Modern Women's Writing*, pp. xiv–xv and Amelia Lanyer, *Salve Deus Rex Judaeorum* in ibid. pp. 55–57; Clarke, *The Politics of Early Modern Women's Writing*, chpt. 4.

57. Clarke, *The Politics of Early Modern Women's Writing*, chpt. 4; Lorna Hutson, 'Why the Lady's Eyes Are Nothing Like the Sun', in Clare Brant and Diane Purkiss (eds), *Women, Texts and Histories 1575–1760* (Routledge, London and New York, 1992), p. 16.

58. Amelia Lanyer, *Salve Deus Rex Judaeorum* in Danielle Clarke (ed.), *Renaissance Women Poets* (Penguin Classics, London, 2000), p. 263.

59. Mary Ellen Lamb, 'Patronage and Class in Amelia Lanyer's *Salve Deus Rex Judaeorum*', in Mary E. Burke, Jane Donawerth, Linda L. Dove and Karen Nelson (eds), *Women, Writing and the Reproduction of Culture in Tudor and Stuart Britain* (Syracuse University Press, New York, 2000), pp. 38–57; Lorna Hutson, 'Why the Lady's Eyes Are Nothing Like the Sun', in Brant and Purkiss (eds), *Women, Texts and Histories*.

60. Louise Schleiner, 'Margaret Tyler', *Oxford Dictionary of National Biography* (www.oxforddnb. com, 2004); Betty S. Travitsky, 'The Possibilities of Prose', in Wilcox (ed.), *Women and Literature in Britain*, pp. 241–2.

61. Margaret Tyler, Preface, *The Mirrour of Princely Deeds and Knighthood* (1578) in *The Early Modern Englishwoman*, eds Travitsky and Cullen, vol. 8, reprinted in Ferguson (ed.), *First Feminists*, pp. 54–7; cf. Tina Krontiris, 'Breaking Barriers of Genre and Gender: Margaret Tyler's Translation of *The Mirrour of Knighthood*', *English Literary Renaissance*, 18 (1988) and E. D. Mackerness, 'Margaret Tyler: An Elizabethan Feminist', *Notes and Queries*, 190 (1946).

62. Margaret Tyler, *The Mirrour of Princely Deeds and Knighthood* (1578) in *The Early Modern Englishwoman: A Facsimile Library of Essential Works: I Printed Writings, 1500–1640*, eds Betty S. Travitsky and Patrick Cullen, vol. 8 (Scolar Press, 1996).

63. A surviving miniature jousting castle built at the beginning of the seventeenth century is to be found at Bolsover Castle, Derbyshire.

64. Lorna Sage, *The Cambridge Guide to Women's Writing in English* (Cambridge University Press, Cambridge, 1999), p. 637.

65. Margaret Tyler, *The Mirrour of Princely Deedes and Knighthood* (1578) rep. in Betty S. Travitsky and Patrick Cullen (eds), *The Early Modern Englishwoman: A Facsimile Library of Essential Works*, vol. 8 ed. by Kathryn Coad (Scolar Press, Aldershot, Hants.), Preface, Sig. A2, Sig. A4–Sig.A4v.

66. Janet Todd (ed.), *British Women Writers: A Critical Reference Guide* (Continuum, New York, 1989), pp. 680–1; Moira Ferguson (ed.), *First Feminists: British Women Writers 1578–1799* (Indiana University Press, Bloomington, 1985), p. 51. Martin Randall also points out that Tyler was both the first English woman to make such intellectual claims and the first English woman to publish a lengthy, secular prose narrative and on both counts her claim to female writing autonomy was considerable – Martin Randall, *Women Writers in Renaissance England* (Longman, London and New York, 1997), p. 15. Ortunez's's work was completed in three more parts by two further Spanish authors with translations later commissioned by Thomas East so that the whole was available in English by 1601. Tyler's translation of the first part went to two further editions in 1580 and 1599.

67. Margaret Patterson Hannay, 'Mary Herbert, Countess of Pembroke', *Oxford Dictionary of National Biography* (www.oxforddnb.com, 2004).

68. Hannay, 'Mary Herbert, Countess of Pembroke', *Oxford Dictionary of National Biography* (www.oxforddnb.com, 2004).

69. Hannay, 'Mary Herbert, Countess of Pembroke', *Oxford Dictionary of National Biography* (www.oxforddnb.com, 2004).

70. For Philip Sidney and the Arcadian tradition see Blair Worden, *The Sound of Virtue: Philip Sidney's Arcadia and Elizabethan Politics* (Yale University Press, New Haven, 1996).

71. Hannay, 'Mary Herbert, Countess of Pembroke', *Oxford Dictionary of National Biography* (www.oxforddnb.com, 2004).

72. Pearl Hogrefe, *Women of Action in Tudor England: Nine Biographical Sketches* (Iowa State University Press, Ames, Iowa, 1977), chpt. 5.

73. *A Discourse of Life and Death* (1592), Sig. D3 in (ed.) Gary Waller *Mary Sidney Herbert* in *The Early Modern Englishwoman: A Facsimile Library of Essential Works*, Part I: Printed Writings 1500–1640, vol. 6 (Scolar Press, Aldershot, 1996).

74. Mary Ellen Lamb, *Gender and Authorship in the Sidney Circle* (University of Wisconsin Press, Madison, 1991). *The Tragedy of Antonie* (1595) is reprinted in S. P. Cerasano and Marion Wynne-Davies (eds), *Renaissance Drama by Women: Texts and Documents* (Routledge, London and New York, 1996), quotation from p. 34. See also 'The Countess of Pembroke and the Art of Dying' in Mary Beth Rose (ed.), *Women in the Middle Ages and the Renaissance* (Syracuse University Press, 1986).

75. S. P. Cerasano and Marion Wynne-Davies (eds), *Renaissance Drama by Women*, p. 15.

76. Margaret Patterson Hannay, 'Mary Herbert, Countess of Pembroke', *Oxford Dictionary of National Biography* (www.oxforddnb.com, 2004).

77. Mary Sydney, 'Psalm 58 *Si Vere Utique*' in Danielle Clarke (ed.), *Renaissance Women Poets*, p. 74.

78. Mary Sydney, 'Psalm 56 *Miserere Mei*' in Danielle Clarke (ed.), *Renaissance Women Poets*, p. 70.

79. Joanne Shattock, *The Oxford Guide to British Women Writers* (Oxford University Press, Oxford and New York, 1993), pp. 333–4. For older biographies of the countess of Pembroke, see F. B. Young, *Mary Sidney Countess of Pembroke* (1912) and G. F. Waller, *Mary Sidney, Countess of Pembroke* (1979) (Waller also published some of her manuscript poetry like *The Triumph of Death* in 1977); for more recent scholarship see Margaret P. Hannay, *Philip's Phoenix: Mary Sidney, Countess of Pembroke* (1990) and *Silent But for the Word: Tudor Women as Patrons, Translators and Writers of Religious Works* (1985) and Anne M. Haselkorn and Betty S. Travitsky (eds), *The Renaissance Englishwoman in Print: Counterbalancing the Canon* (1990); Helen Halkett, 'Courtly Writing by Women', in Wilcox (ed.), *Women and Literature in Britain*, p. 177.

80. Shattock, *The Oxford Guide to British Women Writers*, p. 333; Hogrefe, *Women of Action in Tudor England*, pp. 130–2; Beth Wynne Fisken, '"To the Angell Spirit…": Mary Sidney's Entry into the World of Words', in Haselkorn and Travitsky (eds), *The Renaissance Englishwoman in Print*, p. 266, 273.

81. Cf. Walker, *Women Writers of the English Renaissance*, p. 72.

82. Walker, *Women Writers of the English Renaissance*, p. 87.

83. Margaret Patterson Hannay, 'Mary Herbert, Countess of Pembroke', *Oxford Dictionary of National Biography* (www.oxforddnb.com, 2004).

84. Peter Burke, *The Fortunes of the Courtier: The European Reception of Castiglione's Cortegiano* (Polity Press, Cambridge, 1995), pp. 27–8.

85. This painting of Mary Wroth is in the private collection of Viscount de L'Isle.

86. Mary Ellen Lamb, 'Lady Mary Wroth', *Oxford Dictionary of National Biography* (www.oxforddnb.com, 2004).

87. The best critical edition is Josephine A. Roberts (ed.), *The First Part of The Countess of Montgomery's Urania* (Renaissance English Text Society, New York, 1995) though there is also a facsimile of the original introduced by Roberts for *The Early Modern Englishwoman* series, Part I, vol. 10 (Scolar Press, Aldershot, 1996).

88. Mary Ellen Lamb, 'Lady Mary Wroth', *Oxford Dictionary of National Biography* (www.oxforddnb.com, 2004).

89. Mary Wroth, *The Countess of Montgomeries Urania* (1621) ed. Josephine Roberts (Renaissance English Text Society, New York, 1995), Lib. II, pp. 492–5.

90. Cf. Mary Ellen Lamb, 'Lady Mary Wroth', *Oxford Dictionary of National Biography* (www.oxforddnb.com, 2004).

91. Lamb, 'Lady Mary Wroth', *Oxford Dictionary of National Biography* (www.oxforddnb.com, 2004).

92. *Loves Victory* is in modern reprint: S. P. Cerasano and Marion Wynne-Davies (eds), *Renaissance Drama by Women: Texts and Documents* (Routledge, London, 1996). See also Margaret Anne McLaren, 'An Unknown Continent: Lady Mary Wroth's Forgotten Pastoral Drama, "Loves Victory"' and Naomi J. Miller, 'Re-Writing Lyric Fictions: The Role of the Lady in Lady Mary Wroth's *Pamphilia to Amphilanthus* both in Anne M. Haselkorn and Betty S. Travitsky, *The Renaissance Englishwoman in Print: Counterbalancing the Canon* (University of Massachusetts Press, Amherst, 1990).

93. Helen Hackett, 'Courtly Writing by Women' in Wilcox, *Women and Literature in Britain*, p. 182. See also Helen Hackett, '"Yet Tell Me Some Such Fiction": Lady Mary Wroth's *Urania* and the Femininity of Romance' in Pacheco (ed.), *Early Women Writers*.

94. Hackett, 'Courtly Writing by Women' in Wilcox, *Women and Literature in Britain*, p. 181.

95. Hackett, 'Courtly Writing by Women' in Wilcox, *Women and Literature in Britain*, pp. 182–3; Walker, *Women Writers of the English Renaissance*, chpt. 8; Josephine A. Roberts, 'Critical

Introduction', *The First Part of the Countess of Montgomery's Urania* (Renaissance English Text Society, New York, 1995), p. lxxxv; Susan Donahue, '"My Desires... Lie... Wrapt Up Now in Foldes of Losse": Lady Mary Wroth's Baroque Visions of Female Community in the Enchantment Episodes of *The Countess of Montgomery's Urania* (1621)' in Rebecca D'Monté and Nicole Pohl, *Female Communities 1600–1800: Literary Visions and Cultural Realities* (Macmillan, Basingstoke, 2000); Rosalind Smith, *Sonnets and the English Woman Writer 1560–1621: The Politics of Absence* (Palgrave, Basingstoke, 2005), chpt. 4.

96. For a summary of Elizabeth (Tanfield) Cary's life and her two printed works see Walker, *Women Writers of the English Renaissance*, chpt. 6.

97. Kamm, *Hope Deferred*, p. 46.

98. Diane Purkiss, 'Blood, Sacrifice, Marriage: Why Iphigenia and Mariam Have to Die', *Women's Writing*, 6:1 (1999), pp. 30–2.

99. Stephanie Hodgson-Wright, 'Elizabeth Cary', *Oxford Dictionary of National Biography* (www.oxforddnb.com, 2004).

100. Stephanie Hodgson-Wright, 'Elizabeth Cary', *Oxford Dictionary of National Biography* (www.oxforddnb.com, 2004).

101. Shattock, *The Oxford Guide to British Women Writers*, pp. 94–5; Sage, *The Cambridge Guide to Women's Writing in English*, p. 117; Blain, Grundy and Clements, *The Feminist Companion to Literature in English*, p. 354. The biography was edited by Richard Simpson as *The Lady Falkland, Her Life* (1883) and it generated two further biographies – Georgiana Fullerton, *Life of Elizabeth, Lady Falkland* (1883) and Kenneth B. Murdock, *The Sun at Noon* (1939). Most scholars believe the biography was written by Anne Cary. The manuscript is in the Imperial Archives, Lille. See Blain, Grundy and Clements, *The Feminist Companion to Literature in English*, p. 186. Diane Purkiss, 'Blood, Sacrifice, Marriage: Why Iphigenia and Mariam Have to Die', *Women's Writing*, 6:1 (1999), p. 30.

102. Sage, *The Cambridge Guide to Women's Writing in English*, p. 117; Blain, Grundy and Clements, *The Feminist Companion to Literature in English*, p. 354; [E.C.], *The Tragedie of Mariam, The Faire Queen of Jewry* (1613) facsimile reprint in *The Early Modern Englishwoman: A Facsimile library of Essential Works. Part 1: Printed Writings, 1500–1640*, vol. 2 (Scolar Press, Aldershot, Hants., 1996) Intro. By Margaret W. Ferguson, general eds Betty S. Travitsky and Patrick Cullen, Act. 2 Scene 8.

103. Blain, Grundy and Clements, *The Feminist Companion to Literature in English*, p. 354. There are two versions of the history of Edward II – *The History of the Life, Reign and Death of Edward II* and *The History of the Most Unfortunate Prince King Edward II*. Both were published in 1680 in Viscount Falkland's name. Scholars believe the former is the more likely to have been written by Elizabeth Cary, but there is no proof. Both have been reprinted in *The Early Modern Englishwoman: A Facsimile Library of Essential Works. Part 1: Printed Writings, 1500–1640*, vol. 2, 'Works by and attributed to Elizabeth Cary'. See also Donald Stauffer, 'A Deep and Sad Passion' in *The Parrott Presentation Volume* ed. Hardin Craig (Princeton University Press, Princeton, 1967) and Tina Krontiris, 'Style and Gender in Elizabeth Cary's Edward II' in Anne M. Haselkorn and Betty S. Travitsky (eds), *The Renaissance Englishwoman in Print: Counterbalancing the Canon* (University of Massachusetts Press, Amherst, 1990), pp. 137–53 quotation from p. 137.

104. Karen Nelson, 'Elizabeth Cary's *Edward II*', in Mary E. Burke, Jane Donawerth, Linda L. Dove and Karen Nelson (eds), *Women, Writing and the Reproduction of Culture* (Syracuse University Press, New York, 2000), pp. 157–163.

105. Stephanie Hodgson-Wright, 'Elizabeth Cary', *Oxford Dictionary of National Biography* (www.oxforddnb.com, 2004).

106. Shattock, *The Oxford Guide to British Women Writers*, pp. 94–5; Lorna Sage, *The Cambridge Guide to Women's Writing in English* (Cambridge University Press, 1999), p. 117; Virginia Blain, Isobel Grundy and Patricia Clements, *The Feminist Companion to*

Literature in English: Women Writers from the Middle Ages to the Present (Yale University Press, New Haven and London, 1990), p. 354.

107. Karen Nelson, 'Elizabeth Cary's *Edward II*', in Mary E. Burke, Jane Donawerth, Linda L. Dove and Karen Nelson (eds), *Women, Writing and the Reproduction of Culture*, pp. 157–8; Louise Schleiner, *Tudor and Stuart Women Writers* (Indiana University Press, Bloomington and Indianapolis, 1994), p. 175.

108. Shattock, *The Oxford Guide to British Women Writers*, pp. 94–5; Lorna Sage, *The Cambridge Guide to Women's Writing in English*, p. 117; Virginia Blain, Isobel Grundy and Patricia Clements, *The Feminist Companion to Literature in English: Women Writers from the Middle Ages to the Present*, p. 354. The Great Tew Circle was a group of Royalist intellectuals and writers based in Oxfordshire who met regularly to discuss questions of politics and religion. Their positions varied but they included Laudian and latitudinarian churchmen and may also have included the political philosopher, Thomas Hobbes.

109. Anthony Fletcher, *Gender, Sex and Subordination in England 1500–1800* (Yale University Press, New Haven and London, 1995), pp. 88–9, 129.

110. John Adamson, 'Chivalry and Political Culture in Caroline England' in Kevin Sharpe and Peter Lake (eds), *Culture and Politics in Early Stuart England* (Macmillan, Basingstoke, 1994).

111. Walker, *Women Writers of the English Renaissance*, p. 124 citing Sir John Davies, *Muses Sacrifice* (1612). It was perhaps an unfortunate observation given that he was married to Eleanor Davies and lived to regret his wife's writing pursuits.

112. Henry Peacham, *Minerva Britanna* (1612), p. 26; John Horden, 'Henry Peacham', *Oxford Dictionary of National Biography* (www.oxforddnb.com, 2004).

113. Barbara K. Lewalski, 'Lucy, Countess of Bedford: Images of a Jacobean Courtier and Patroness', in Kevin Sharpe and Steven N. Zwicker (eds), *Politics of Discourse: The Literature and History of Seventeenth-Century England* (University of California Press, Berkley and London, 1987), pp. 56, 59.

114. Maureen M. Meikle and Helen Payne, 'Anne [of Denmark]', *Oxford Dictionary of National Biography* (www.oxforddnb.com, 2004).

115. Purkiss, 'Blood, Sacrifice, Marriage: Why Iphigenia and Mariam Have to Die', pp. 40, 29.

116. Stock, *Better than Rubies*, pp. 70–2; Charlton, *Women, Religion and Education*, pp. 150–1; Myra Reynolds, *The Learned Lady in England 1650–1700* (Houghton Mifflin, Boston and New York, 1920), p. 260.

117. Reynolds, *The Learned Lady in England*, pp. 258–9; Kamm, *Hope Deferred*, pp. 64–76; Gardiner, *English Girlhood at School*, chpts. X–XI.

118. Whitehead, *Women's Education in Early Modern Europe*, pp. 173–181.

119. Kamm, *Hope Deferred*, pp. 102–3.

120. Stock, *Better than Rubies*, pp. 97–8.

121. Elaine Hobby, '"Discourse so Unsavoury": Women's Published Writings of the 1650s' in Isobel Grundy and Susan Wiseman (eds), *Women, Writing, History, 1640–1740* (Batsford, London, 1992), p. 16.

122. Suzanne Hull, *Women According to Men: The World of Tudor-Stuart Women* (Altamira Press, Walnut Creek, London, New Delhi, 1996), p. 25.

123. Anne Bradstreet was the daughter of Thomas Dudley and Dorothy Yorke.

124. N. H. Keeble, 'Anne Bradstreet', *Oxford Dictionary of National Biography* (www.oxforddnb.com, 2004).

125. Anne Bradstreet, 'Childhood' from *The Four Ages of Man* reprinted in Greer *et al.*, *Kissing The Rod*, p. 121.

126. Anne Bradstreet, Prologue to *The Tenth Muse* reprinted in N. H. Keeble, *The Cultural Identity of Seventeenth-Century Woman* (Routledge, London and New York, 1994), pp. 265–6.

127. N. H. Keeble, 'Anne Bradstreet', *Oxford Dictionary of National Biography* (www.oxforddnb. com). Her collected works were edited by J. R. McElrath and A. P. Robb (1981) and there have been several biographies including E. W. White, *Anne Bradstreet* (1971).

128. Warren Chernaik, 'Katherine Philips', *Oxford Dictionary of National Biography* (www. oxforddnb.com, 2004). See also Hariette Andreadis, *Sappho in Early Modern England: Female Same-Sex Literary Erotics 1550–1714* (Chicago University Press, Chicago, 2001) and 'The Sapphic-Platonics of Katherine Philip, 1632–1664', *Signs*, 15:1 (1989), pp. 34–60; Bronwen Price, 'A Rhetoric of Innocence: The Poetry of Katherine Philips, "The Matchless Orinda"' and Andrew Shifflet, '"Subd'd by You": States of Friendship and Friends of the State in Katherine Philips's Poetry' both in Barbara Smith and Ursula Appelt (eds), *Write or Be Written: Early Modern Women Poets and Cultural Constraints* (Ashgate, Aldershot, 2001). See also Nigel Smith, *Literature and Revolution in England 1640–1660* (Yale University Press, New Haven and London, 1994).

129. Katherine Philips, 'On Rosania's Apostacy and Lucasia's Friendship' reprinted in Germaine Greer, Susan Hastings, Jeslyn Medoff, Melinda Sansone (eds), *Kissing the Rod: An Anthology of Seventeenth-Century Women's Verse* (The Noonday Press, New York, 1988, pp. 194–5.

130. See Elaine Hobby, '"Discourse so Unsavoury": Women's Published Writings of the 1650s' in Isobel Grundy and Susan Wiseman (eds), *Women, Writing, History, 1640–1740* (Batsford, London, 1992), p. 17.

131. Katherine Philips, 'Friendships Mysteries' reprinted in Greer, Hastings, Medoff, Sansone (eds), *Kissing the Rod*, 1988, pp. 193–4.

132. Hero Chalmers, *Royalist Women Writers 1650–1689* (Clarendon Press, Oxford, 2004). See also Robert C. Evans, 'Paradox in Poetry and Politics: Katherine Philips in the Interregnum', in Claude J. Summers and T. Pebworth (eds), *The English Civil Wars in the Literary Imagination* (University of Missouri Press, Columbia, 1999). It has also been attributed with reviving amongst Royalist women writers courtly values which some women 'wrote' into their politics. See Warren Chernaik, 'Katherine Philips', *Oxford Dictionary of National Biography* (www.oxforddnb.com, 2004) citing P. Thomas, *Poems of Katherine Philips* (1990), p. 9.

133. Warren Chernaik, 'Katherine Philips', *Oxford Dictionary of National Biography* (www. oxforddnb.com, 2004).

134. Katherine Philips, 'Epitaph on Her Son H. P. at St. Syth's Church', reprinted in Greer, Hastings, Medoff, Sansone (eds), *Kissing the Rod*, 1988, pp. 195–6.

135. Elaine Hobby, *Virtue of Necessity: English Women's Writing 1649–88*, p. 103.

136. Elaine Hobby, 'Orinda and Female Intimacy' and Celia A. Easton, 'Excusing the Breach of Nature's Laws: The Discourse of Denial and Disguise in Katherine Philips' Friendship Poetry', both in Pacheco (ed.), *Early Women Writers*.

137. Greer *et al.* (ed.), *Kissing the Rod*, pp. 316–23.

138. Killigrew was the daughter of a London minister and was maid of honour to Mary of Modena to whom she addressed one of her poems. She died unmarried at only 25 and the collection contained commendatory poems to her character and achievements. A painting of James II once attributed to Lely was actually painted by Killigrew and John Dryden's commendatory poem to her provides the information that she was accomplished in pastoral painting as well as portraiture.

139. David Hopkins, 'Anne Killigrew', *Oxford Dictionary of National Biography* (www. oxforddnb.com, 2004); Greer *et al.* (ed.), *Kissing the Rod*, pp. 299–308; 'Anne Killigrew', *A Celebration of Women Writers* ed. Mary Mark Ockerbloom (digital.library.upenn.edu/ women).

140. In 1688 William and Mary of Orange were already contemplating invading England to depose her father, James II. The 'Tory' loyalism of many women writers of this generation was at odds with the slow triumph of the 'whigs' who supported the coronation of William III and Mary II.

141. Carol Barash, *English Women's Poetry 1649–1714: Politics, Community and Linguistic Authority* (Oxford University Press, Oxford, 1996), pp. 174–6, 178–9; Greer *et al.* (ed.), *Kissing the Rod*, pp. 354–5.

142. Richard Greene, 'Sarah Egerton', *Oxford Dictionary of National Biography* (www.oxforddnb.com, 2004); Greer *et al.* (ed.), *Kissing the Rod*, pp. 345–6.

143. Sarah Fyge/Egerton, *The Liberty*, in Greer *et al.* (ed.), *Kissing the Rod*, p. 346.

144. Sarah Fyge/Egerton, *The Liberty* and 'On my leaving London, June the 29', in Greer *et al.* (ed.), *Kissing the Rod*, pp. 347–8. Fyge struck up a close friendship with the playwright Delarivier Manley and outlived her second husband by only three years, dying in 1723.

145. The modern edition of Anne Conway's *Principia Philosophiae* Is *the Principles of the Most Ancient and Modern Philosophy Concerning God, Christ and Creatures* ed. by Peter Lapston (1982).

146. Marjorie Hope Nicolson (ed.), *The Conway Letters* (Clarendon Press, Oxford, 1992), Anne Conway to Henry More', 23 August 1662; Sarah Hutton, 'Anne Conway', *Oxford Dictionary of National Biography* (www.oxforddnb.com, 2004); Bridget Hill, 'Damaris Masham', *Oxford Dictionary of National Biography* (www.oxforddnb.com, 2004). See also George Ballard, *Memoirs of Several Great Ladies of Great Britain* (1752) and Mark Goldie, *John Locke and the Mashams at Oates* (Churchill College, Cambridge, 2004). An important article that looks at Conway with Margaret Cavendish is Stephen Clucas, 'The Duchess and the Viscountess: Negotiations between Mechanism and Vitalism in the Natural Philosophies of Margaret Cavendish and Anne Conway' in *In Between: Essays and Studies in Literary Criticism*, 9 (2000). See also Lisa Sarasohn, 'A Science Turned Upside Down: Feminism and the Natural Philosophy of Margaret Cavendish' in *Huntington Library Quarterly*, 47 (1984).

147. See Lynette Hunter, 'Sisters of the Royal Society: The Circle of Katherine Jones, Lady Ranelagh', Frances Harris, 'Living in the Neighbourhood of Science: Mary Evelyn, Margaret Cavendish and the Greshamites' and Sarah Hutton, 'Anne Conway, Margaret Cavendish and Seventeenth-Century Scientific Thought' all in Lynette Hunter and Sarah Hutton (eds), *Women, Science and Medicine 1500–1700* (Sutton, Stroud, 1997).

148. Helen Wilcox and Sheila Ottway, 'Women's Histories' in N. H. Keeble (ed.), *The Cambridge Companion to the Writing of the English Revolution* (Cambridge University Press, Cambridge, 2001), p. 148.

149. The account that follows uses: Janet Todd (ed.), *British Women Writers: A Critical Reference Guide* (Continuum, New York, 1989); Lorna Sage (ed.), *The Cambridge Guide to Women's Writing* (Cambridge University Press, 1999); Roger Hudson (ed.), *The Grand Quarrel: Women's Memoirs of the English Civil War* (Sutton, Stroud, 1993, 2000); Anne Halkett, Autobiography [original manuscript], British Library Add. MS 32,376; Ann Fanshawe, 'Memoirs', British Library Add. MS 41,161 and household account/recipe book, Wellcome Library MS 7133; John Loftis (ed.), *The Memoirs of Anne, Lady Halkett and Ann, Lady Fanshawe* (Oxford University Press, Oxford, 1979); David Stephenson, 'Anne Halkett', *Oxford Dictionary of National Biography* (www.oxforddnb.com, 2004) and 'A Lady and Her Lovers', King or Covenant: Voices from Civil War (1996); Amanda L. Capern, 'Ann Fanshaw' and 'Anne Halkett', in Mary Spongberg, Barbara Caine and Anne Curthoys (eds), *Companion to Women's Historical Writing* (Palgrave, Basingstoke, 2005), pp. 171–2, 233–4.

150. 'The Memoirs of Anne, Lady Halkett' in John Loftis (ed.), *The Memoirs of Anne Lady Halkett and Ann, Lady Fanshaw* (Clarendon Press, Oxford, 1979), p. 25.

151. Fanshaw's autobiography was her only known written work.

152. Walker, *Women Writers of the English Renaissance*, pp. 24–7, 36, 41.

153. 'The Memoirs of Anne, Lady Halkett' in John Loftis (ed.), *The Memoirs of Anne Lady Halkett and Ann, Lady Fanshaw* (Clarendon Press, Oxford, 1979), p. 53 ff.

154. Cf. D. R. Woolf, *The Global Encyclopaedia of Historical Writing* (Garland, New York and London, 1998), i, p. 434.

155. Cf. '"The Colonel's Shadow": Lucy Hutchinson, Women's Writing and the Civil War' in Thomas Healy and Jonathan Sawday (eds), *Literature and the English Civil War* (Cambridge University Press, Cambridge, 1990), pp. 227–47. Todd (ed.), *British Women Writers*; Lorna Sage (ed.), *The Cambridge Guide to Women's Writing* (Cambridge University Press, 1999); Roger Hudson (ed.), *The Grand Quarrel: Women's Memoirs of the English Civil War* (Sutton, Stroud, 1993, 2000); Lucy Hutchinson, *Memoirs of Colonel Hutchinson* ed. C. H. Firth (1906) and by J. Sutherland (1973); Amanda L. Capern, 'Lucy Hutchinson', in Mary Spongberg, Barbara Caine and Anne Curthoys (eds), *Companion to Women's Historical Writing* (Palgrave, Basingstoke, 2005), pp. 254–5. See also, Devoney Looser, *British Women Writers and the Writing of History 1670–1820* (Johns Hopkins University Press, Baltimore, 2000); Erica Longfellow, *Women and Religious Writing in Early Modern England* (Cambridge University Press, Cambridge, 2004); David Norbrook, '"Words more than civil": Republican Civility in Lucy Hutchinson's "The Life of John Hutchinson"' in Jennifer Richards (ed.), *Early Modern Civil Discourses* (Palgrave, Basingstoke, 2003), pp. 68–84.
156. Lucy Hutchinson, translation of Lucretius, *De Rerum Natura*, British Library Add. MS 19,333; David Norbrook, 'Lucy Hutchsinon', Oxford Dictionary of National Biography (www.oxforddnb.com, 2004) and *Order and Disorder* ed. by Norbrook (Blackwells, Oxford, 2001).
157. James Fitzmaurice, 'Margaret Cavendish, Duchess of Newcastle', *Oxford Dictionary of National Biography* (www.oxforddnb.com, 2004). For a good collection on Cavendish see Stephen Clucas (ed.), *A Princely Brave Woman: Essays on Margaret Cavendish Duchess of Newcastle* (Ashgate, London, 2003).
158 Part of this and the next paragraph is based on Amanda L. Capern, 'Renaissance', in Mary Spongberg, Barbara Caine and Anne Curthoys (eds), *Companion to Women's Historical Writing*, pp. 472–3.
159. Cf. James Fitzmaurice, 'Margaret Cavendish, Duchess of Newcastle', *Oxford Dictionary of National Biography* (www.oxforddnb.com, 2004) and for the Cavendish family and Hobbes see Quentin Skinner, 'Hobbes and the Renaissance *studia humanitatis*', in Derek Hirst and Richard Strier (eds), *Writing and Political Engagement in Seventeenth-Century England* (Cambridge University Press, Cambridge, 1999), pp. 74–5. See also Angela Battigelli, *Margaret Cavendish and the Exiles of the Mind* (University of Kentucky Press, Lexington, 1998); Jay Stevenson, 'The Mechanist-Vitalist Soul of Margaret Cavendish', *Studies in English Literature 1500–1900* (1996), pp. 527–43 and Stephen Clucas, 'The Atomism of the Cavendish Circle: A Reappraisal', *The Seventeenth Century*, 9:2 (1994), pp. 247–73.
160. Hilda L. Smith, '"A General War amongst the Men … but None amongst the Women": Political Differences between Margaret and William Cavendish', in Howard Nenner (ed.), *Politics and the Political Imagination in Later Stuart Britain: Essays Presented to Lois Green Schwoerer* (University of Rochester Press, New York, 1997), pp. 143–160 quoting from pp. 147–8, 154.
161. Hilda L. Smith, 'Though It Be the Part of Every Good Wife', in Valerie Frith (ed.), *Women & History: Voices of Early Modern England* (Coach House Press, Toronto, 1995), pp. 123, 126. For a different interpretation of Cavendish's 'feminism' see Catherine Gallagher, 'Embracing the Absolute: Margaret Cavendish and the Politics of the Female Subject in Seventeenth-Century England' in Pacheco, *Early Women Writers* – Gallagher argues that Cavendish's royalism meant that she embraced the concept of absolutism and applied it to the female subject to develop a 'feminist' concept of selfhood.
162. Sidonie Smith, '"The Ragged Rout of Self": Margaret Cavendish's *True Relation* and the Heroics of Self Disclosure', in Pacheco, *Early Women Writers* , p. 116.
163. A modern edition of *Observations upon Experimental Philosophy* is in the Cambridge Texts in the History of Philosophy series, ed. Eileen O'Neill (Cambridge University Press, Cambridge, 2001).

164. Elaine Hobby, *Virtue of Necessity: English Women's Writing 1649–88*, p. 107; Susan Wiseman, 'Gender and Status in Dramatic Discourse: Margaret Cavendish, Duchess of Newcastle', in Isobel Grundy and Susan Wiseman (eds), *Women, Writing, History 1640–1740* (Batsford, London, 1992).

165. *The Convent's Pleasure* is reprinted in part in Moira Ferguson, *First Feminists: British Women Writers 1578–1799* (Indiana University Press, Bloomington, 1985) and contains the line from 'Lady Happy' 'put the case I should marry the best of men', p. 87.

166. James Fitzmaurice, 'Margaret Cavendish, Duchess of Newcastle', *Oxford Dictionary of National Biography* (www.oxforddnb.com, 2004).

167. James Fitzmaurice *et al.* (eds), *Major Women Writers of Seventeenth Century England* (University of Michigan Press, Ann Arbor, 1997), pp. 155–6, 158–9, 164, 168.

168. Sara Mendelson, *The Mental World of Stuart Women: Three Studies* (University of Massachusetts Press, Amherst, 1987), p. 32.

169. Hobby, *Virtue of Necessity*, p. 108.

170. Rebecca d'Monté, 'Mirroring Female Power: Separatist Spaces in the Plays of Margaret Cavendish, Duchess of Newcastle', in d'Monté and Pohl (eds), *Female Communities 1600–1800*, chpt. 4; Sophie Tomlinson, '"My Brain the Stage": Margaret Cavendish and the Fantasy of Female Performance', in Brant and Purkiss (eds), *Women, Texts & Histories* , chpt. 5. Sylvia Bowerbank has argued that Margaret Cavendish developed a 'female voice' that failed to obey male rules and was somewhat anarchic. However, she defends this against those who would argue for this being representative of the specifically female imagination. The argument being forwarded here is less about unregulated language and more about deterministic content for 'female imagination' – see Sylvia Bowerbank, 'The Spider's Delight: Margaret Cavendish and the "Female" Imagination', in Kirby Farrell, Elizabeth H. Hageman and Arthur F. Kinney (eds), *Women in the Renaissance: Selections from English Literary Renaissance* (University of Massachusetts Press, Amherst, 1988), pp. 187–203.

171. There are several modern editions of Margaret Cavendish's *The Description of a New World, Called the Blazing World* including by Kate Lilley (Penguin Books, 1992) and in Salzman, *An Anthology of Seventeenth-Century Fiction* . The most recent and with a fine introduction is Susan James (ed.), *Margaret Cavendish: Political Writings* (Cambridge University Press, Cambridge, 2003).

172. Sarah Irving, in 'Margaret Cavendish', in Mary Spongberg, Barbara Caine and Ann Curthoys (eds), *Companion to Women's Historical Writing* (Palgrave, Basingstoke, 2005), p. 91.

173. See Hilda Smith, Mihoko Suzuki and Susan Wiseman (eds), *Women's Political Writings 1610–1740* (Pickering and Chatto, London, 2007).

174. C. & M. Baker, *The Life and Circumstances of James Brydges, First Duke of Chandos* (Oxford, 1949); Elizabeth Hagglund, 'Cassandra Willoughby', *Oxford Dictionary of National Biography* (www.oxforddnb.com, 2004); Joan Johnson, *Excellent Cassandra: the Life and Times of the Duchess of Chandos* (Sutton, Stroud, 1981); *Manuscripts of Lord Middleton*, Historical Manuscripts Commission (1911); Peter Thorold, *The London Rich: The Creation of a Great City from 1666 to the Present* (1999); Cassandra Willoughby, 'History of the Willoughby Family', Nottingham Archives, Middleton Manuscripts, *The Continuation of the History of the Willoughby Family* ed. A. C. Wood (1958) and her MS 'Letter Book 1713–1735' and genealogical notes at Canons 2 b 4, North London Collegiate School; Amanda L. Capern, 'Cassandra Willoughby', in Mary Spongberg, Barbara Caine and Anne Curthoys (eds), *Companion to Women's Historical Writing*, p. 589.

175. The comment here refers to England but there is an argument to be made for Aphra Behn being the first professional West Indian woman writer as well. For an anthology of the early women popular writers of fiction see, see Paula R. Backscheider and John J. Richetti (eds), *Popular Fiction by Women 1660–1730* (Clarendon Press, Oxford, 1996).

For one feminist reading of Behn see Angeline Goreau, 'Aphra Behn: A Scandal to Modesty' in Dale Spender (ed.), *Feminist Theorists: Three Centuries of Key Women Thinkers* (Pantheon Books, New York, 1983).

176. See Janet Todd, *The Secret Life of Aphra Behn* (Pandora, London, New York and Sydney, 2000) and 'Aphra [Aphara] Behn', *Oxford Dictionary of National Biography* (www.oxforddnb.com, 2004). See also the potted biography, Sara Heller Mendelson, *The Mental World of Stuart Women: Three Studies* (University of Massachusetts Press, Amherst, 1987).

177. Melinda Zook, 'Contextualising Aphra Behn: Plays, Politics, and Party, 1679–1689' in Hilda L. Smith (ed.), *Women Writers and the Early Modern British Political Tradition* (Cambridge University Press, Cambridge, 1998), p. 75. Earlier biographies and biographical sketches include George Woodstock, *The Incomparable Aphra* (Boardman, London, 1948), Maureen Duffy, *The Passionate Shepherdess: Aphra Behn 1640–1689* (Jonathan Cape, London, 1977) and Sara Mendelson in *The Mental World of Stuart Women: Three Studies* (University of Massachusetts Press, Amherst, 1987), chpt. 3. For Behn and libertinism see Warren Chernaik, *Sexual Freedom in Restoration Literature* (Cambridge University Press, Cambridge, 1995) and for anti-slavery see Carl Plasa and Betty J. Ring (eds), *A Discourse of Slavery: Aphra Behn to Toni Morrison* (Routledge, London and New York, 1994) and Margo Hendriks, 'Alliance and Exile: Aphra Behn's Racial Identity' in Susan Frye and Karen Robertson (eds), *Maids and Mistresses, Cousins and Queens: Women's Alliances in Early Modern England* (Oxford University Press, New York and Oxford, 1999), chpt. 15.

178. Carol Barash, *English Women's Poetry 1649–1714: Politics, Community and Linguistic Authority* (Oxford University Press, Oxford, 1996), p. 124; Melinda Zook, 'Contextualising Aphra Behn: Plays, Politics, and Party, 1679–1689' in Hilda L. Smith (ed.), *Women Writers and the Early Modern British Political Tradition* (Cambridge University Press, Cambridge, 1998), p. 76.

179. Paula McDowell, *The Women of Grub Street: Press, Politics and Gender in the London Literary Marketplace 1678–1730* (Clarendon Press, Oxford, 1998), p. 1–4.

180. Melinda Zook, 'Contextualising Aphra Behn: Plays, Politics, and Party, 1679–1689' in Hilda L. Smith (ed.), *Women Writers and the Early Modern British Political Tradition*, pp. 77–8, 82–3.

181. Intro by Jane Spencer, p. xi in Aphra Behn, *The Rover and Other Plays* (Oxford University Press, Oxford and New York, 1995).

182. Hobby, *Virtue of Necessity*, pp. 114–16.

183. Janet Todd, 'Aphra [Aphara] Behn', *Oxford Dictionary of National Biography* (www.oxforddnb.com, 2004) and Todd, *The Secret Life of Aphra Behn* , pp. 209–14.

184. Intro by Jane Spencer, p. ix in Aphra Behn, *The Rover and Other Plays*.

185. Hobby, *Virtue of Necessity*, pp. 116.

186. Aphra Behn, *The Rover and Other Plays*, Intro by Jane Spencer, pp. xiii–xv and *The Rover passim*.

187. Hobby, *Virtue of Necessity*, pp. 115, 120–1.

188. Jane Spencer, 'Introduction', *The Rover and other Plays*, pp. xvi–xviii and *The Lucky Chance passim*.

189. Melinda Zook, 'Contextualising Aphra Behn: Plays, Politics, and Party, 1679–1689' in Hilda L. Smith (ed.), *Women Writers and the Early Modern British Political Tradition*, p. 85.

190. Aphra Behn, 'The Golden Age' reprinted in Janet Todd (ed.), *The Works of Aphra Behn*, 7 vols. (1992–6). Biographical details that follow are from these two sources unless otherwise stated.

191. Todd, *The Secret Life of Aphra Behn*, pp. 205, 345–7.

192. Janet Todd, 'Aphra Behn', *Oxford Dictionary of National Biography* (www.oxforddnb.com, 2004). 'Pindaric' as a poetic form is taken from Peter Pindar.

193. Helen Thompson, '"Thou Monarch of my Panting Soul": Hobbesian Obligation and the Durability of Romance in Aphra Behn's *Love Letters*', in Jennie Batchelor and Cora Kaplan (eds), *British Women's Writing in the Long Eighteenth Century: Authorship, Politics and History* (Palgrave, Basingstoke, 2005), pp. 107–20 quoting p. 107. Janet Todd, 'Aphra Behn', *Oxford Dictionary of National Biography* (www.oxforddnb.com, 2004).

194. Amanda L. Capern, 'Renaissance' and 'Enlightenment' in Mary Spongberg, Barbara Caine and Ann Curthoys (eds), *Companion to Women's Historical Writing* (Palgrave, Basingstoke, 2005), pp. 156, 472.

195. Aphra Behn, *Oroonoko: Or the History of the Royal Slave* (Penguin Classics, London, 2003), *passim* and pp. 13, 19–20.

196. Cf. Carol Barash, *English Women's Poetry 1649–1714: Politics, Community and Linguistic Authority*, p. 115.

197. Melinda Zook, 'Contextualising Aphra Behn: Plays, Politics, and Party, 1679–1689' in Hilda L. Smith (ed.), *Women Writers and the Early Modern British Political Tradition*, pp. 88, 92.

198. Aphra Behn, *Oroonoko: Or the History of the Royal Slave* (Penguin Classics, London, 2003), *passim* and pp. 10–11, 14–15, 17, 76; Jane Spencer, *The Rise of the Woman Novelist: From Aphra Behn to Jane Austen* (Basil Blackwell, Oxford, 1986), pp. 48–50; Janet Todd, *The Secret Life of Aphra Behn*, p. 417.

199. Salzman, Intro. p. xxv, *An Anthology of Seventeenth Century Fiction*.

200. Aphra Behn, *The Unfortunate Happy Lady* (1698) in Salzman (ed.), *An Anthology of Seventeenth-Century Fiction* , *passim* with quotations from pp. 529, 533, 538.

201. See Spencer, *The Rise of the Woman Novelist*, pp. 28–30.

202. Aphra Behn, 'On a Juniper Tree, Cut Down to Make Busks', in Greer *et al.* (ed.), *Kissing the Rod*, p. 244.

203. Germaine Greer, *Slip-Shod Sibyls: Recognition, Rejection and the Woman Poet* (Penguin Books, London, 1995), chpts. 6–7 especially pp. 173, 196.

204. Jane Spencer has said of these women that they were Aphra Behn's 'successors in the theatre' and 'the first group of professional women writers'. Spencer, *The Rise of the Woman Novelist:*, pp. 29.

205. For an overview see Margarete Rubik, *Early Women Dramatists 1550–1800* (Macmillan, Basingstoke, 1998) and for an interpretation see Jeslyn Medoff, 'The Daughters of Behn and the Problem of Reputation', in Isobel Grundy and Susan Wiseman (eds), *Women, Writing, History 1640–1740* (Batsford, London, 1992), pp. 33–54.

206. Fidelis Morgan, *The Female Wits: Women Playwrights of the Restoration* (Virago, London, 1981), pp. 24–31; Morgan, *The Female Wits*, pp. 24–31 and Catharine Trotter, *The Fatal Friendship* 1695) in ibid. p. 207.

207. Anne Kelley, 'Catharine Trotter', *Oxford Dictionary of National Biography* (www.oxforddnb.com, 2004).

208. Cf. Spencer, *The Rise of the Woman Novelist*, pp. 31–2.

209. Anne Kelley, 'Catharine Trotter', *Oxford Dictionary of National Biography* (www.oxforddnb.com, 2004).

210. Ros Ballaster, 'Delarivier Manley' and Anne Kelley, 'Mary Pix' in *Oxford Dictionary of National Biography* (www.oxforddnb.com, 2004); Morgan, *The Female Wits:*, p. 390.

211. Anon., *The Female Wits* in Morgan, *The Female Wits*, pp. 392–433.

212. Anne Kelley, 'Mary Pix', *Oxford Dictionary of National Biography* (www.oxforddnb.com, 2004); Morgan, *The Female Wits*, pp. 44–50. Mary Pix died in 1709.

213. Ros Ballaster, 'Delarivier Manley', *Oxford Dictionary of National Biography* (www.oxforddnb.com, 2004); Morgan, *The Female Wits*, pp. 32–43; Spencer, *The Rise of the Woman Novelist*, pp. 53–4. See also Delarivier Manley, *The New Atalantis* ed. by Rosalind Ballaster (Pickering and Chatto, London, 1991). For a word of doubt see James Alan Downie, 'What if Delarivier Manley did not write *The Secret History of Queen Zarah?*', *The Library*, 7th series, 5:3 (2004), pp. 247–64.

214. Delarivier Manley, *The Royal Mischief* (1696), in Morgan, *The Female Wits*, quoting p. 259.

215. J. Milling, 'Susanna Centlivre', *Oxford Dictionary of National Biography* (www.oxforddnb. com, 2004); Morgan, *The Female Wits*, pp. 51–61. See also J. W. Bowyer, *The Celebrated Mrs Centlivre* (1952) and F. P. Lock, *Susanna Centlivre* (1979).

216. Rachel Weil, 'Mary Astell: The Marriage of Toryism and Feminism' in *Political Passions: Gender, the Family and Political Argument in England 1680–1714* (Manchester University Press, Manchester and New York, 1999), p. 142.

217. Gerda Lerner, *The Creation of Feminist Consciousness from the Middle Ages to Eighteen-Seventy* (Oxford University Press, Oxford, 1993), p. 157.

218. Reynolds, *The Learned Lady in England*, p. 280.

219. Bathsua Makin, *Essay to Revive the Antient Education of Gentlewomen in Religion, Manners, Arts & Tongues* (1673), p. 23.

220. Makin, *Essay to Revive the Antient Education of Gentlewomen*, Sig A2.

221. Frances Teague, 'Bathsua Makin', *Oxford Dictionary of National Biography* (www. oxforddnb.com, 2004).

222. Makin, *Essay to Revive the Antient Education of Gentlewomen, passim*.

223. Hannah Wolley, *The Gentlewoman's Companion* (1675), p. 29.

224. Hannah Smith, 'English "Feminist Writings" and Judith Drake's *An Essay in Defence of the Female Sex* (1696)', *The Historical Journal*, 44:3 (2001), pp. 727–47.

225. Ruth Perry, 'Mary Astell', *Oxford Dictionary of National Biography* (www.oxforddnb. com, 2004) and see Ruth Perry, *The Celebrated Mary Astell* (Chicago University Press, Illinois, 1986). The modern edition of *A Serious Proposal to the Ladies* appears in Patricia Springborg (ed.), *Astell: Political Writings* (Cambridge University Press, Cambridge, 1996).

226. Mary Astell, *A Serious Proposal to the Ladies, passim* in Patricia Springborg (ed.), *Astell: Political Writings* (Cambridge University Press, Cambridge, 1996), *passim*.

227. Hannah Smith, 'English "Feminist Writings" and Judith Drake's *An Essay in Defence of the Female Sex* (1696), *The Historical Journal*, 44:3 (2001), pp. 743–4.

228. Ruth Perry, 'Mary Astell', *Oxford Dictionary of National Biography* (www.oxforddnb. com, 2004). See also Sarah Ellenzweig, 'The Love of God and the Radical Enlightenment: Mary Astell's Brush with Spinoza', *Journal of the History of Ideas*, 64:3 (2003), pp. 379–97; J. K. Kinnaird, 'Mary Astell and the Conservative Contribution to English Feminism', *Journal of British Studies*, 19:1 (1979), pp. 53–75; Patricia Springborg, 'Astell, Masham, and Locke: Religion and Politics', in Hilda L. Smith (ed.), *Women Writers and the Early Modern British Political Tradition* (Cambridge University Press, Cambridge, 1998) and 'Mary Astell and John Locke' in Steven Zwicker (ed.), *The Cambridge Companion to English Literature 1650–1740* (Cambridge University Press, Cambridge, 1998), pp. 276–306. For Mary Astell see also Hilda L. Smith, Mihoko Suzuki and Susan Wiseman (eds), *Women's Political Writings 1610–1725* (Pickering and Chatto, 2007), vol. iv.

229. Cf. Ruth Perry, 'Mary Astell', *Oxford Dictionary of National Biography* (www.oxforddnb. com, 2004).

230. Cf. comments in chapter on *querelle des femmes*.

231. Timothy Rogers, *The Character of a Good Woman* (1697), especially Preface and pp. 9, 12, 99.

232. Cf. Cecile M. Jagodzinski, *Privacy and Print: Reading and Writing in Seventeenth-Century England* (University Press of Virginia, Charlottesville and London, 1999), especially chpts. 1–3.

233. Edith Snook, *Women, Reading and the Cultural Politics of Early Modern England* (Ashgate, London, 2005).

234. Ronald Huebert, 'The Gendering of Privacy', *The Seventeenth Century*, 16:1 (2001), p. 61.

235. Jacqueline Pearson, *Women's Reading in Britain 1750–1835: A Dangerous Recreation* (Cambridge University Press, Cambridge, 1999), *passim*, quoting pp. 1–2, 4; see also William B. Warner, *Licensing Entertainment: The Elevation of Novel Reading in Britain, 1684–1750* (University of California Press, Berkeley and London, 1998).

236. ['Eugenia'], *The Female Advocate* (1700), especially pp. v–vii, 3, 6, 8–9, 12, 17, 20, 22 ff, 46–8.

237. Mary Astell, *A Serious Proposal to the Ladies* ed. Patricia Springborg (Pickering and Chatto, London, 1997), p. 49 n. 21 citing John Harrison and Peter Laslett, *The Library of John Locke* # 1104, 1105 and 1914. *Early English Books Online* lists the three editions of *An Essay in Defence of the Female Sex* as being by Mary Astell, though the frontispiece claims only to be 'written by a Lady'.

238. Bridget Hill, 'Judith Drake', *Oxford Dictionary of National Biography* (www.oxforddnb. com, 2004); Hannah Smith, 'English "Feminist" Writings and Judith Drake's *An Essay in Defence of the Female Sex*', *Historical Journal*, 44:3 (2001), pp. 727–47 accepts the attribution.

239. Hannah Smith, 'English "Feminist" Writings and Judith Drake's *An Essay in Defence of the Female Sex*', *Historical Journal*, 44:3 (2001), p. 740.

240. [Judith Drake], *An Essay in Defence of the Female Sex* (1696), pp. 7–8. Joseph Levine, *Between the Ancients and the Moderns* (Yale University Press, New Haven, 1999).

241. Mary Astell, *A Serious Proposal to the Ladies* Part II (1697), pp. 71–4.

242. Mary Astell, *A Serious Proposal to the Ladies* Part I (1694), p. 33. See also Willian Kolbrener, 'Gendering the Modern: Mary Astell's Feminist Historiography', *The Eighteenth Century*, 44:1 (2003), pp. 1–24.

243. Alessa Johns, 'Mary Astell's "Excited Needles": Theorizing Feminist Utopia in Seventeenth-Century England', in d'Monté and Pohl (eds) *Female Communities 1600–1800* chpt. 6 and quoting from p. 131.

244. Cf. Ruth Perry, 'Mary Astell', *Oxford Dictionary of National Biography* (www.oxforddnb. com, 2004). For Astell on marriage, see also A. Lister, 'Marriage and Misogyny: The Place of Mary Astell in the History of Political Thought', *History of Political Thought*, 25:1 (2004), pp. 44–72 and J. Nadelhaft, 'The Englishwoman's Sexual Civil War: Feminist Attitudes towards Men, Women, and Marriage, 1650–1740', *Journal of the History of Ideas*, 43:4 (1982), pp. 555–79.

245. Mary Astell, *Some Reflections Upon Marriage* (1700) in *Political Writings* ed. Patricia Springborg, p. 9 and *passim*.

246. Mary Astell, *Some Reflections Upon Marriage* (1700) in *Political Writings* ed. Patricia Springborg, p. 55.

247. Hannah Smith, 'English "Feminist" Writings and Judith Drake's *An Essay in Defence of the Female Sex*', *Historical Journal*, 44:3 (2001), pp. 731, 747.

248. Mary Astell, *Some Reflections Upon Marriage* (1700) in *Political Writings* ed. Patricia Springborg, pp. 78–9.

249. Amey Hayward, *Female Legacy* (1699), A3v cited in Charlton, *Women, Religion and Education in Early Modern England*, p. 52.

250. Anne Finch, quoted in Fraser, *The Weaker Vessel*, p. 389 and Moira Ferguson (ed.), *First Feminists: British Women Writers 1578–1799* (Indiana University Press, Bloomington, 1985), pp. 248–9.

251. Mary Chudleigh, *The Ladies Defence* (1701) reprinted in Germaine Greer, Susan Hastings, Jeslyn Medoff, Melinda Sansone (eds), *Kissing the Rod: An Anthology of Seventeenth-Century Women's Verse* (The Noonday Press, New York, 1988), p. 283.

252. Mary Chudleigh, 'To the Ladies', *Poems on Several Occasions* (1703) reprinted in Greer, Hastings, Medoff, Sansone (eds), *Kissing the Rod*, pp. 284–5.

253. Mary Astell, *Ambition* reprinted in Greer, Hastings, Medoff, Sansone (eds), *Kissing the Rod*, pp. 334–5.

254. Burke, *The Fortunes of the Courtier*, p. 8.

255. Amanda L. Capern, 'Enlightenment', in Mary Spongberg, Barbara Caine and Anne Curthoys (eds), *Companion to Women's Historical Writing*, p. 158; Celia Fiennes, *The Journeys of Celia Fiennes* ed. Christopher Morris, Intro. G. M. Trevelyan (The Cresset Press, London, 1947); Stenton, *The English Woman in History*, pp. 238–9.

256. This is not the same as saying they were not religious.

257. Patricia Crawford, 'Women's Published Writings 1600–1700', in Prior (ed.), *Women in English Society*, see especially p. 214.

258. Crawford, 'Women's Published Writings 1600–1700', in Prior (ed.), *Women in English Society 1500–1800* p. 231 citing Sarah Jinner, *An Almanack* (1658), Sig. B and Mary Trye, *Medicatrix, or the Woman Physician* (1675), sig. A2.

259. Barash, *English Women's Poetry 1649–1714: Politics, Community and Linguistic Authority*, pp. 17–18 citing Steven N. Zwicker, *Lines of Authority: Politics and English Literary Culture 1649–89* (Ithaca, New York and London, 1993); Paula Backsheider, *Spectacular Politics: Theatrical Power and Mass Culture in Early Modern England* (Johns Hopkins University Press, Baltimore and London, 1993).

260. John Brewer, 'This, That and the Other: Public, Social and Private in the Seventeenth and Eighteenth Centuries' in Dario Castiglione and Lesley Sharpe (eds), *Shifting the Boundaries: Transformation of the Languages of Public and Private in the Eighteenth Century* (University of Exeter Press, Exeter, 1995), p. 15.

261. Lawrence Klein, 'Gender, Conversation and the Public Sphere in Early Eighteenth Century England', in Judith Still and Michael Worton (eds), *Textuality and Sexuality: Reading Theories and Practices* (Manchester University Press, Manchester and New York, 1993), pp. 102–4.

262. Lawrence Klein, 'Politeness and the Interpretation of the British Eighteenth Century', *The Historical Journal*, 45:4 (2002), p. 877.

Conclusion: Femininity Transformed

1. Hannah Woolley, *The Gentlewoman's Companion* (1675), pp. 1, 29.

2. Bathsua Makin, *An Essay to Revive the Antient Education of Gentlewomen* (1673).

3. Fletcher, *Gender, Sex and Subordination* (chpts 18–20).

4. A keyword search on 'whore' on *Early English Books Online* gives 108 hits for the 1620–1630 decade, with a marked increase from the 140s to 160s level in the 1630–1660 period, a dip to 120 in the decade 1660 to 1670 and then a dramatic rise to 182 in the decade 1670 to 1680 and 201 in the decade 1680 to 1690.

5. Conal Condren's classic theorisation of early-modern English political discourse – *The Language of Politics in Seventeenth-Century England* (1984) – pointed out that the expansion of vernacular language taking place through the transition from an oral/manuscript culture to a print culture led to transformation in language and ideas transfer. The several political crises from 1638 to 1690 resulted in what he termed 'rhetorical *necessita*' symbolised by the growth of the newspaper as a medium of communication and characterised by the use of a rhetorical vocabulary that suffered expansion coincidentally with elisions and conflations that he has called 'subsumptive synonymity'. What he meant by this was that some rhetorical terms became loaded with symbolic meanings. This can be illustrated by the two terms most associated with the bad woman and good woman – 'whore' and 'maid'. Conal Condren, *The Language of Politics in Seventeenth Century England* (St Martin's Press, Basingstoke, Hampshire, 1994), pp. 57, 72–3.

6. John Wilmot, 'On Mistress Willis', *Poems on Several Occasions* (1680), p. 45 cited in Keeble, *The Cultural Identity of Seventeenth-Century Woman*, p. 92; see also *Oxford DNB* entry on John Wilmot.

7. *The Maidens Complaint against Coffee* (1663). p. 3. The trail blazing work here is Hilda L. Smith (ed.), *Women Writers and the Early Modern British Political Tradition* (Cambridge University Press, Cambridge, 1998).
8. Cf. Kathryn Shevlow, *Women and Print Culture: The Construction of Femininity in the Early Periodical* (London, 1989), p. 1 cited in Lawrence Klein, 'Gender, Conversation and the Public Sphere in Early Eighteenth-Century England' in Judith Still and Michael Worton (eds), *Textuality and Sexuality: Reading Theories and Practices* (Manchester University Press, Manchester and New York, 1993), pp. 101–2.

Index